# Computational Synthesis and Creative Systems

**Series Editors**

François Pachet, Paris, France
Pablo Gervás, Madrid, Spain
Andrea Passerini, Trento, Italy
Mirko Degli Esposti, Bologna, Italy

Creativity has become the motto of the modern world: everyone, every institution, and every company is exhorted to create, to innovate, to think out of the box. This calls for the design of a new class of technology, aimed at assisting humans in tasks that are deemed creative.

Developing a machine capable of synthesizing completely novel instances from a certain domain of interest is a formidable challenge for computer science, with potentially ground-breaking applications in fields such as biotechnology, design, and art. Creativity and originality are major requirements, as is the ability to interact with humans in a virtuous loop of recommendation and feedback. The problem calls for an interdisciplinary perspective, combining fields such as machine learning, artificial intelligence, engineering, design, and experimental psychology. Related questions and challenges include the design of systems that effectively explore large instance spaces; evaluating automatic generation systems, notably in creative domains; designing systems that foster creativity in humans; formalizing (aspects of) the notions of creativity and originality; designing productive collaboration scenarios between humans and machines for creative tasks; and understanding the dynamics of creative collective systems.

This book series intends to publish monographs, textbooks and edited books with a strong technical content, and focuses on approaches to computational synthesis that contribute not only to specific problem areas, but more generally introduce new problems, new data, or new well-defined challenges to computer science.

More information about this series at http://www.springer.com/series/15219

Penousal Machado • Juan Romero
Gary Greenfield
Editors

# Artificial Intelligence and the Arts

Computational Creativity, Artistic Behavior, and Tools for Creatives

 Springer

*Editors*
Penousal Machado
Department of Informatics Engineering
University of Coimbra
Coimbra, Portugal

Juan Romero
Faculty of Computer Science
University of A Coruña
A Coruña, Spain

Gary Greenfield
Department of Mathematics and Computer Science
University of Richmond
Richmond, VA, USA

ISSN 2509-6575 ISSN 2509-6583 (electronic)
Computational Synthesis and Creative Systems
ISBN 978-3-030-59477-0 ISBN 978-3-030-59475-6 (eBook)
https://doi.org/10.1007/978-3-030-59475-6

This Springer imprint is published by the registered company Springer Nature Switzerland AG
The registered company address is: Gewerbestrasse 11, 6330 Cham, Switzerland

This book is dedicated to our parents for their unconditional love, support and encouragement.

# Preface

Be kind, resourceful, beautiful, friendly, have initiative, have a sense of humour, tell right from wrong, make mistakes, fall in love, enjoy strawberries and cream, make someone fall in love with it, learn from experience, use words properly, be the subject of its own thought, have as much diversity of behaviour as a man, do something really new. Alan Turing [1]

When people think about Artificial Intelligence, they tend to think about logic, reasoning, problem solving, natural language processing, image recognition, autonomous driving, rational thought and, most likely, machines plotting to kill us, enslave us, or take our jobs.

These associations and fears are justifiable. Artificial Intelligence research has focused, and to a large extent still does focus, on these areas of research; and the eventual rise of intelligent machines poses obvious risks. Nevertheless, this perspective reflects a rather limited view of Intelligence and of Artificial Intelligence research.

We posit that emotions, creativity, aesthetics, artistic behavior, divergent thoughts and curiosity are a fundamental part of the human experience. Furthermore, we consider them to be hallmarks of Human Intelligence and, possibly, a prerequisite or unavoidable consequence of Human-level Intelligence. As such, in our view, a system that lacks such abilities is likely to have considerable shortcomings and show a limited form of intelligence.

Although, we do not defend the imitation of Human Intelligence as the ultimate goal for Artificial Intelligence research, we consider that the previously mentioned characteristics are instrumental for the development of Human-Centered Artificial Intelligence systems able to relate, communicate, and understand human motivations, desires and needs.

For these reasons we are interested in the study and development of computational creativity and more specifically, in the development of systems that exhibit artistic behavior or that can improve humans' creative and artistic abilities.

We live in a wonderful world where Artificial Intelligence boldly goes where no machine has gone before, every single day. Major companies such as Google, Amazon or Tesla make spectacular advances in AI, while small companies create applied AI products for aesthetics prediction like PhotoIlike.com.

In recent years, the growth of the scientific community devoted to Computational Creativity and the developments in the field of Machine Learning – along with increasing computational power – has given rise to several novel possibilities for the application of Artificial Intelligence, most notably of Artificial Neural Networks, to fields like music, art, sound, architecture, and design. In fact, although techniques and applications such as deep learning, generative adversarial neural networks, variational auto-encoders, style transfer, deep fakes, deep dreams, etc., are currently widespread, they were implausible a few years ago.

This book is aimed at a wide audience including researchers, artists, experts and, generally speaking, all those who are interested in exploring the relationship between Artificial Intelligence and the arts, design and music, independently of their background or approach, and it endorses an all encompassing view of intelligence, which is, by no means, limited to anthropocentric approaches.

We strived to reach these goals by putting together a comprehensive set of chapters that synthesizes the current trends in the field, reflects upon it, and identifies the core challenges and opportunities that lie ahead, while also presenting novel contributions and applications that advance the state-of-the-art. The book is divided into five sections: Visual Arts, Music, 3D, Other Art Forms, and Artistic Perspectives.

In the opening section, Visual Arts, Gary Greenfield focuses on visual art based on swarming techniques, and virtual and physical robotics, as well as neural networks and deep learning; Colin G. Johnson addresses various aesthetic theories highlighting a number of areas that have been neglected by computer system builders and that could be considered future opportunities within the area; and Florian Uhde focuses on the transfer of artistic style, highlighting recent technologies and offering information on various approaches.

In the section on Music: Geraint A. Wiggins deals with the topic of musical composition from the perspective of Artificial Intelligence in a philosophical way; Maximos Kaliakatsos-Papakostas shows us a first step towards new methodologies of music generation that combine the strengths of other previously researched approaches; and James McDermott focuses on the training variational autoencoder neural networks in an unsupervised way using MIDI drum loops.

For the section on 3D Tom De Smedt, Ludivine Lechat, Ben Burtenshaw and Lucas Nijs provide their views on the research that the Experimental Media Research Group (EMRG) of the St. Lucas School of Arts in Antwerp has carried out over the past 15 years in relation to computer graphics and Artificial Intelligence; and Jonathan Eisenmann discusses the challenges and practical strategies for integrating machine learning into design software through

a case study, in which the software (Adobe Dimension) configures a 3D environment.

The section on Other Art Forms, starts with Pablo Gervás' review of computational approaches for the creation of narratives, comparing them with existing models of human performance in similar tasks. Michael Cook addresses the automated game design system ANGELINA. Antonio Liapis analyzes the prism of the six facets of creativity involved in the gaming experience, highlighting important examples of human creativity in commercial games and how Artificial Intelligence has been applied to generate content for each of these facets.

In the last section of the book, Artistic Perspectives, Alan Dorin presents a comparison between the collective and subconscious design of flowers, made by bees, and the human design process using computers. Miguel Carvalhais, on the other hand, focuses on the processes to achieve closure through a procedural reading in computational artworks that centre their aesthetic experiences on procedurality rather than form. Jon McCormack concludes the book by presenting new methods for hybrid design relationships between living organisms, human designers and programmable machines.

We hope that the book presents a fair and open-minded view of the area and puts forward two core propositions:

- Creative artistic behavior is one of the key challenges, possibly the ultimate challenge, of Artificial Intelligence research;
- Computer-Assisted Creativity and Human-Centered Artificial Intelligence systems are the driving forces for research in this area.

Considering current developments in the field of Artificial Intelligence, and the dangers they pose to democracy and even human rights, we take this opportunity to defend the assertion that Artificial Intelligence should contribute to strengthen social ties, promote consensus, encourage solidarity. AI developments should be guided by principles of social responsibility, promoting inclusion and equality. Thus, we need Artificial Intelligence systems that are able to actively collaborate with human beings, understand our motivations, and counterbalance our faults, ultimately making us better humans. And for all of that, we need creative Artificial Intelligence.

*Acknowledgement.* This book would have never been possible without the continuous support and dedication of many.

We take this opportunity to thank the authors for their willingness to participate in this project and for their contributions and patience. Likewise, we would also like to thank the reviewers for their dedication, expertise and feedback, for assisting the authors in further improving their chapters, and Iria Santos who provided invaluable help in the proofreading and editing tasks. We also express our gratitude towards Springer's editorial staff, especially Ronan Nugent, for their encouragement and support.

The research in this area of knowledge has been nurtured throughout the years by a large and varied group of researchers that have become part of our family and

enriched our lives. As such, we take this opportunity to thank and acknowledge the work done by the evoMUSART, evo* and Computational Creativity communities who created an environment that allowed this area to flourish.

A final word of thanks goes to our research groups and colleagues for being there whenever we needed them.

Coimbra, A Coruña, Richmond
October 2020

*Penousal Machado*
*Juan Romero*
*Gary Greenfield*

# References

[1] Turing, A.M.: Computing machinery and intelligence. Mind **LIX**(236), 433–460 (1950). DOI 10.1093/mind/LIX.236.433. URL https://doi.org/10.1093/mind/LIX.236.433

# Contents

# List of Contributors

**Natalie Alima**
SensiLab, Monash University,
Monash, Australia
alimanatalie@gmail.com

**Ben Burtenshaw**
University of Antwerp, Belgium
ben.burtenshaw@gmail.com

**Miguel Carvalhais**
INESC TEC & Faculty of Fine Arts,
University of Porto, Portugal
mcarvalhais@fba.up.pt

**Michael Cook**
Queen Mary University of London,
London, UK
mike@gamesbyangelina.org

**Alan Dorin**
Faculty of Information Technol-
ogy, Monash University, Monash,
Australia
alan.dorin@monash.edu

**J Eisenmann**
Adobe, San Francisco, CA, USA
j@adobe.com

**Pablo Gervás**
Facultad de Informática e Instituto
de Tecnología del Conocimiento,
Universidad Complutense de Madrid,
Madrid, Spain
pgervas@ucm.es

**Gary Greenfield**
University of Richmond, Richmond,
Virginia, USA
ggreenfi@richmond.edu

**Maximos Kaliakatsos-
Papakostas**
Institute for Language and Speech
Processing, Athena Research and
Innovation Centre, Marousi, Greece
maximos@athenarc.gr

**Ludivine Lechat**
St Lucas School of Arts, Antwerp,
Belgium
ludivinelechat@gmail.com

**Antonios Liapis**
Institute of Digital Games, Univer-
sity of Malta, Msida, Malta
liapis@um.edu.mt

**Penousal Machado**
University of Coimbra, Centre for
Informatics and Systems of the
University of Coimbra, Department
of Informatics Engineering, Coimbra,
Portugal
machado@dei.uc.pt

**Jon McCormack**
SensiLab, Monash University,
Monash, Australia
Jon.McCormack@monash.edu

**James McDermott**
National University of Ireland,
Galway, Ireland
james.mcdermott@nuigalway.ie

**Lucas Nijs**
St Lucas School of Arts, Antwerp,
Belgium
lucasnijs@gmail.com

**Juan Romero**
University of A Coruña, CITIC,
University of A Coruña,
Spain
jj@udc.es

**Tom De Smedt**
St Lucas School of Arts, Antwerp,
Belgium
tom@organisms.be

**Florian Uhde**
Volkswagen AG, Wolfsburg, Faculty
of Computer Science, University of
Magdeburg, Germany
florian.uhde@volkswagen.de

**Geraint A. Wiggins**
Vrije Universiteit Brussel, Brussel,
Belgium
geraint@ai.vub.ac.be

# Part I

## Visual Arts

# 1

# Artificial Life and Artificial Intelligence Advances in the Visual Arts

Gary Greenfield

University of Richmond, Richmond, Virginia, USA `ggreenfi@richmond.edu`

**Summary.** In *A Handbook on Evolutionary Art and Music*, Matthew Lewis gave a comprehensive survey of evolutionary visual art and design. His organizational framework establishes a baseline for introducing key developments that have occurred in the last decade relating to artificial intelligence (AI) and artificial life (AL) in the visual arts. It is our touchstone for focusing on visual art grounded in swarm techniques, virtual and physical robotics, and neural nets and deep learning as well as for consideration of the impact creativity driven research has had on the way practitioners approach and evaluate AI and AL influenced art.

## 1.1 Introduction

In *A Handbook on Evolutionary Art and Music* [93], Matthew Lewis [65] provided a comprehensive survey of evolutionary visual art and design that covered the years 1990-2007. Even though his principal focus was on the use of genetic algorithms in the visual arts, his survey touched upon some aspects of artificial intelligence (AI) by including commentary about the use of automated fitness functions in generative art, and neural nets, in addition to artificial life (AL) techniques in generative art, as well as the emergence of automated art critics, computational aesthetics and computational creativity. Since 2007 many more articles, surveys and artworks have continued to advance what one might call the "vanilla" generative art and genetic algorithms visual arts tradition. The classification scheme Lewis developed serves as a touchstone for surveying mainstream AI and AL themes that have come to the fore since 2007. Further, the exhaustive list of references Lewis tabulated, provide the time line necessary for documenting our survey of subsequent developments. More precisely, Lewis' references serve as our entry point for surveying AI and AL advances in the visual arts involving swarm art, robotic art (both virtual and physical), neural nets and deep learning, and creativity since 2007.

A few caveats. It is difficult to classify or categorize some of the works we will discuss. Several could be included under multiple topics and it must be emphasized that where we have placed them is therefore subjective. We also occasionally commingle AI and AL thematic work without trying to distinguish between the two. Moreover, in this survey we seldom include technical details or comments, referring

© Springer Nature Switzerland AG 2021

P. Machado et al. (eds.), *Artificial Intelligence and the Arts*, Computational
Synthesis and Creative Systems, https://doi.org/10.1007/978-3-030-59475-6_1

the reader to the references instead. We should also emphasize that this chapter is devoted wholly to visual fine art, thus material devoted to games and gaming appears elsewhere in this volume.

## 1.2 Swarm Art

When discussing swarm — art inspired by the flocking rules first formulated by Reynolds [90] — Lewis cites Kwong and Jacob [64] and also refers readers to a chapter by Jacob and Hushlak [60] which fleshes out their work. Lewis further cites the original "ant paintings" paper of Aupetit et al. [8] and Greenfield's extension of that work [42] as well as Urbano's work on software agents (which he viewed as ants) sensing environmentally produced simulated pheromones [107]. A chapter by Monmarché et al. [83] fills in technical details concerning ant paintings.

Since that time two survey articles, one by Greenfield and Machado [57] covering a variety of swarm art methodologies, and another by Greenfield and Machado [55] that is wholly devoted to ant and ant-colony inspired art, have appeared. In this section we update this topic.

### 1.2.1 Agent-Based Swarms

Jacob et al. [61, 67] have continued their exploration of swarm art using swarms in three dimensions via their *Swarmart* system. Urbano [110] has experimented with a two-dimensional time-based "firefly" system that yields video as artistic output. McCormack [76] has employed agent-based swarms for his "niche constructions". Barrass [10] explored the artistic potential of swarms *inspired* by ant behavior but using neural nets (see Figure 1.1). Video of his work is can be found online [11]. Barrass was very careful to distance himself from any notion that he was attempting to simulate ant biology or ant behavior as evidenced by the following quote, which explains why we have noted his work here rather than below:

> I should note that the ant metaphor is only a starting point for the work, and a convenient way to think about the agents in the system. I am not making any serious comparison with the behaviour of living creatures [10, p. 63]

### 1.2.2 Ant Paintings

As mentioned previously, Aupetit et al. [8] first introduced the term "ant paintings" in conjunction with interactively evolving abstract images where virtual agents treated color as a simulated pheromone. Greenfield [42] extended this method to evolve similar abstract imagery using fitness functions. Urbano [107, 108] created ant paintings where the environment exuded simulated scent that attracted ants and where image coloring was determined by which ants reached the scent first.

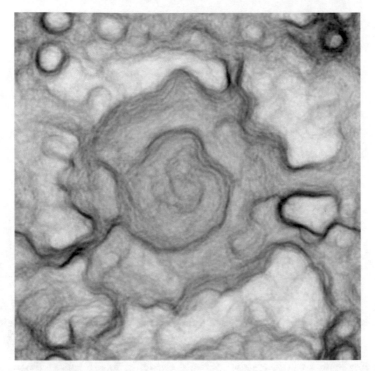

Fig. 1.1: somant329-50. Still from a video by Tim Barrass. ©Tim Barrass 2004

## Abstract Ant Paintings

Greenfield [45] combined many of these ideas in a multi-pheromone ant painting system in which the environment produces pheromones and ants deposit both an attracting and a repelling pheromone (see Figure 1.2). Greenfield and Machado [56] used a gray scale version of an ant painting model as a software component in an "artists and critics" simulation about which we will have more to say in Section 1.5. Greenfield [49] then followed up with a colorized version of the model to further explore the artistic potential of this genre of ant paintings.

## Representational Ant Paintings

Semet et al. [101] appear to be the first to combine image processing techniques with ant colony simulation methods to develop non-photorealistic rendering styles by using swarms of virtual ants roaming over digital photographs to yield representational, as opposed to abstract, imagery.

There are several contributions by al-Rifaie et al. in this domain [1, 2, 3, 4, 5, 14] although the titles of some of their papers don't always reflect this. Following on al-Rifaie et al. [1] and Bishop and al-Rifaie [14], the culmination is al-Rifaie et al. [2] which invokes a multi-stage algorithm using a swarm to stylize line drawings by

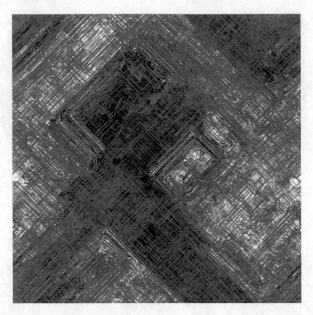

Fig. 1.2: LLs24031. A multi-pheromone ant paining. ©Gary Greenfield 2005

first having agents use stochastic diffusion search to locate salient lines and then dispersive flies optimization to generate corresponding stylized lines.

Fernandes and his various co-authors [27, 28, 29, 30, 31, 32] have used ant colony algorithms as a clustering technique for identifying and abstracting salient parts of images. Some impressive results have come from unleashing his version of virtual ants on digital reproductions of well-known paintings by Mondrian, Kandinsky, Miro and Pollock (see Figure 1.3) to "abstract the abstract" [28].

Machado and Pereira [72] describe the non-photorealistic rendering system *Photogrowth*, relying on a model where simulated ants roam over an image under the control of a fitness function while depositing "paint" on a separate virtual canvas (see Figure 1.4). Machado et al. [68, 70] later modified their system so that users could design fitness functions to guide evolution. Martins and Machado have also created a bot that is described in a web site [74] such that users can submit photos using Instagram and have them returned as ant painting reproductions.

Putri and Mukundan [89] use a (particle) swarm for image analysis to help guide stroke placement for non-photorealistic painterly rendering of an input image.

## Ant-Behavior Art

Advances in ant painting techniques have also come about by considering ant behaviors that are not related to pheromones. Urbano [109] initiated this line of inquiry by exploring artistic possibilities derived from the nest building behavior of *T. albipennis* ants who build circular bivouac nests by gathering and depositing grains of sand, an example of the principle of stigmergy. We include two artworks of this type as described by Greenfield [52, 54]: Figure 1.5 highlights the basic technique

wherein multiple ant colonies search, find, return and deposit sand grains according to the grain color they prefer, while Figure 1.6 uses the technique to reproduce as an ant painting an historic computer programmed design from the 1960s by computer art pioneer Manuel Quejido.

Greenfield [38] used a stylized model of the seed foraging behavior of *P. barbatus* ants — a species that strikes out from the nest individually, but repeatedly, in preferred directions to search, find and return with seeds — in order to make ant paintings (see Figure 1.7).

Following a model by Jones for simulating the formation of the nutrient transport networks of the slime mold *Physarum* that was implemented by using *remote* sensing of virtual pheromones by virtual ants [62], Greenfield [37] adapted this method to create abstracts that were overlays of the resulting patterns that are formed (see Figure 1.8). It should be noted that although remote visual sensing by ants has been reported in the literature, how widespread and to what extent it occurs is unknown.

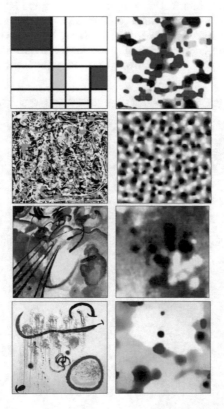

Fig. 1.3: Abstract ant paintings derived from well-known paintings. ©Carlos Fernandes 2014

## 1.3 Robotics

Lewis lists Moura and Ramos' "nonhuman art" [87] under swarm art since, even though these paintings were executed using a small number of physical robots, "swarm art" was part of the title of their 2002 paper. Moura and Pereira clarified this somewhat in 2004 [86] by referring to the paintings as "symbiotic art" and including "man + robots" in their title. Lewis also cites Greenfield [50] for his virtual robot simulation modeled after Khepera robots and includes a figure of one of his evolved virtual robot paintings.

### 1.3.1 Virtual Robots

Under virtual robots, we wish to include agent-based artwork where the agents use controllers to navigate in a simulated (usually two-dimensional) environment.

Greenfield has described further projects involving his Khepera inspired virtual drawing robots including: using an algorithm to transcribe mouse DNA into controller commands via look-up tables [44], evolving higher level language controller programs [39] and modifying his virtual robot design so that it supported curvilinear *pen* path motion while the robots traveled in a straight line [47].

Fig. 1.4: Dancer. ©Tiago Martins and Penousal Machado 2014

The difficulty in deciding what is or isn't a virtual robot painting comes into sharp focus with the work of Chappell [17, 18], who posits a software agent with multiple sensing mechanisms that responds to marks it has previously made. Greenfield [51] used a simplified version of Chappell's agents to create labyrinths drawn by a virtual robot executing a self-avoiding walk (see Figure 1.9). He also used multiple instances of these simplified robots to evolve both "avoidance drawings" [40] where robots avoid the paths of other robots but are allowed to recross their own paths (see Figure 1.10) and "deflection drawings" where, in addition, the robots must avoid physical obstacles strategically placed in their environment [43]. Another classification problem is presented by Greenfield [53] who, after modifying the agents discussed in Section 1.2 that were modeled after *T. Albipennis* ants, caused them to be re-conceptualized as "pick-up, carry and drop mobile automata" since the resulting grain collection patterns were no longer obtained by obeying a strike out radially from the nest and then return behavior. This blurring of software swarms, automata, and virtual robots has a long history reaching as far back as Turk's "Turmites" [22] and Annunziato's Nagual experiments [6, 7].

A rare exception to virtual robots operating in a two-dimensional environment is provided by Murray-Rust and von Jungenfeld [88] who describe *Lichtsuchende*,

Fig. 1.5: Stigmergy ant painting. ©Gary Greenfield 2012

an interactive installation built using a society of biologically inspired, cybernetic creatures — phototropic robots — who exchange light both as a source of energy and as a means of communication. Viewers interact with and influence the creatures using flashlights.

### 1.3.2 Physical Robots

Work with physical drawing robots since Moura has drawn less attention than software drawing robots. Bird et al. [12, 13] tackle the problem of evolving from scratch a controller for drawing curves. Yoyotte et al. have posted a tantalizing and intriguing video [116] showing a small group of drawing robots creating drawings that bear the hallmarks of Moura's symbiotic art. Also of interest, but equally hard to document and reference, is the work of Braumann and his students at Linz Art University with industrial KUKA robots [59]. The most definitive work has been done by McCormack [78]. As a continuation of his software agent niche construction drawings [76], McCormack designed and built drawing robots that would physically, as opposed to virtually, implement a niche establishment algorithm by reinforcing lines previously drawn (see Figure 1.11).

## 1.4 Neural Nets and Deep Learning

In his three short paragraphs devoted to neural nets, Lewis cites "The Artificial Painter" by Lund et al. [66], various projects based on the NeuroEvolution of Aug-

Fig. 1.6: Ant painting homage to M. Quejido. ©Gary Greenfield 2014

Fig. 1.7: Stylized ant painting based on a *P. barbatus* seed foraging model. ©Gary Greenfield 2013

mented Topologies (NEAT) infrastructure developed by Stanley [104], seminal work by Baluja et al. [9] on trying to automate fitness within a Sims' style genetic programming image generation system [102], a project to colorize gray scale images by Machado et al. [71] and work by Saunders and Gero [96] on using neural nets for aesthetic evolution. Since Lewis' goal was surveying evolutionary art, he did not include the work of Barrass [10, 11] mentioned in Section 1.2 who used one-dimensional Kohonen self-organizing maps as the "brains" for his simulated ants.

### 1.4.1 Neural Nets

Stanley, along with his students and collaborators, has continued to develop projects based on NEAT, most notably the interactive "PicBreeder" system [99, 100], as well as additional projects using compositional pattern producing networks [103, 105]. NeuroEvolution of Augmenting Topologies (NEAT) is a genetic algorithm for evolving artificial neural networks.

### 1.4.2 Deep Learning

Mordvintsev et al. [85] convincingly demonstrate why "deep learning", which refers to the use of convolutional neural nets with many hidden layers, is useful in evolutionary and generative art. As the time of this writing, this is the most active

Fig. 1.8: Overlay pattern formed by swarms of remote sensing virtual ants. ©Gary Greenfield 2011

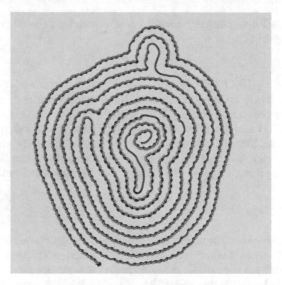

Fig. 1.9: Virtual robot labyrinth. ©Gary Greenfield 2015

area of AI visual art. Evidence for this comes from the recent sale at Christie's of a painting titled "The Portrait of Edmund Belamy" executed by deep learning AI software from the Paris based collective Obvious for US $432,500 even though the original auction estimate had been US $7,000-10,000 (see Molina [84] or Flynn [33]).

Fig. 1.10: Evolved avoidance drawing. ©Gary Greenfield 2015

Fig. 1.11: Niche construction robot drawing. ©Jon McCormack 2017

The roots of the use of deep learning in the arts lie in image style transfer which refers to the problem of trying to recolor an image so that it looks as though it was done in the style of a well-known painter. For example, one might seek to recolorize a landscape photograph so that it looks as though it might have been painted by, say,

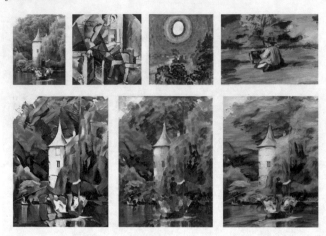

Fig. 1.12: Image style transfer examples by Gatys et al. ©Leon Gatys 2016

Van Gogh. Gatys et al. [35, 36] have achieved convincing results using convolutional neural nets (see Figure 1.12). Joshi et al. [63] describe its use in a production setting.

Generative adversarial nets (GANs) were first introduced by Goodfellow et al. [58]. The idea is similar to examples found in evolutionary art such as the co-evolutionary arms race designed by Greenfield featuring a competition between "hosts" (digital images) and "parasites" (digital filters) [48] or the system of Machado et al. [69] where an image generator process (a genetic programming algorithm) competes against an image discriminator process (a neural net). With GANs one neural net classifies images while a competing neural net tries to find data sets that challenge the accuracy of the classifier. Using this scheme to find novel imagery, Elgammal et al. [25] developed their "creative adversarial network" (CAN) system for generative art (see Figure 1.13).

Not all of the most recent work being done has appeared in the research literature. For example, in an online article Vincent [114] describes the creative process underlying a 2017 series of prints called "The Treachery of ImageNet" by Tom White of the School of Design at Victoria University of Wellington. These prints use as their starting point source imagery that machine learning algorithms misclassified as everyday objects such as lawnmowers or electric fans (see Figure 1.14). Similarly, Schwab [98] narrates the AI story behind Klingemann's "Memories of Passerby I" installation. Also relevant is a Google Arts and Culture app that allows users to take a selfie and attempt to match it with a famous work of art. The Christie's auction establishes that there are various individuals and collectives using GANs for art-making. McCormack et al. [81] provide a timely and erudite analysis of the impact of GANs on computer art.

### 1.4.3 Artistic Analysis

Addressing the problem of determining high aesthetic value in evolutionary art, Ciesielski et al. [19] use feature extraction methods from machine learning to identify the features most associated with differentiating aesthetics. For the photographic

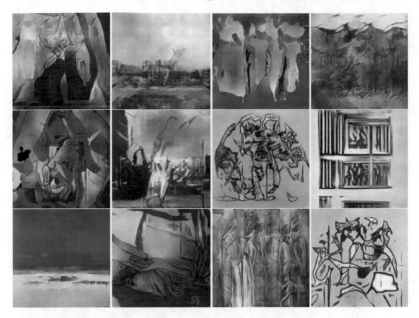

Fig. 1.13: Highly ranked aesthetic imagery from the generative adversarial network (GAN) system of Elgammal et al. ©Ahmed Elgammal 2017 — Art & AI Lab, Rutgers University.

image data set they used the key features were wavelet and texture features, while for the abstract image data set they used the key features were color-based features. Campbell et al. [15] first used self-organizing maps to try and identify key features in high quality images from a data set of *evolved* abstract images, and subsequently Campbell et al. [16] used deep learning to examine its efficacy in classifying and explaining the features of such high quality images.

Saleh et al. [94] use machine learning with a dataset containing a total of 1710 images of art works by 66 artists to analyze similarity between artists and influence among artists. Elgammal and Saleh [26] use machine learning and a dataset with over 62,000 paintings and sculptures to assess creativity in artworks.

Verkoelen et al. [112] take a first step towards developing a "robot curator" by using deep neural networks — restricted Boltzmann machines — to analyze semi-structured series of artworks in order to understand the relationship between works and series, uncover underlying features and dimensions, and generate new images.

## 1.5 Computational Aesthetics and Creativity

Lewis' coverage of automated aesthetics, artificial societies, and art theory and criticism is diffuse. Lewis cites Whitelaw's book [115] on "metacreation" and McCormack's seminal paper on open problems in evolutionary art [79]. When discussing automated fitness evaluation in evolutionary art he cites Romero et al. [92] who

Fig. 1.14: An electric fan. ©Tom White 2017.

coined the term "critics" for software agents that have this as all or part of their goal. In Lewis' (first chapter) conclusion section he refers readers to McCormack's last chapter [77] which provides a speculative essay on creativity that sets the tone for future research about this topic.

### 1.5.1 Computational Aesthetics

Consistent with the Romero et al. [92] sense of what a "critic" should be, Soderland and Blair [106] view their adversarial neural net as a critic and Vickers et al. [113] assert their HERCL programs whose inputs are generative art software outputs are critics.

McCormack et al. [80] address questions about aesthetics when adapting their open problems approach to evolutionary music and art to an open problems approach to generative computer art. Greenfield [46] examined the tangled and disparate use of terms such as simulated aesthetics, artificial aesthetics and computational aesthetics by tracing their history in his attempt to isolate "computational aesthetics" as the practice of developing software agents to make aesthetic judgments. This has not proved tenable as the annual Computational Aesthetics (CAe) conference which subsequently morphed into the annual Expressive symposium is primarily devoted to non-photorealistic rendering for graphics and animation not the practice of aesthetic judgments from software.

## 1.5.2 Computational Creativity

A 2009 editorial by Colton et al. [21] explains that "computational creativity is the study of building software that exhibits behavior that would be deemed creative in humans". And in that vein, as early as 2007 one finds a paper of Ritchie [91] addressing criteria for attributing creativity to a computer program. There is now an annual International Conference on Computational Creativity (ICCC) run by the Association for Computational Creativity (http://computationalcreativity. net/home/) as well as a new Springer series titled Computational Synthesis and Creative Systems (https://www.springer.com/series/15219) whose first volume edited by Veale and Cardoso [111] is "intended to be a canonical text for this new discipline". The book *Computers and Creativity* edited by McCormack and d'Inverno [82] includes six chapters under the heading "theory". Contributions range from Galanter [34] addressing creativity from a computational aesthetics standpoint (see also Greenfield [41]) to Schmidhuber [97] proposing a full-fledged formal model for creativity.

## 1.5.3 Knowledge-Based Agents

Machado and Cardoso [73] propose a theory for "constructed artists", i.e., computer programs capable of creating artworks with little or no human intervention. The essential characteristic of constructed artists is the capacity to make aesthetic judgments. The historical antecedent is Cohen's AARON [75]. The most prominent effort to construct a full-fledged *autonomous* gallery artist in software currently Colton's The Painting Fool [20].

## 1.5.4 Artificial Societies

Although it has "artificial creativity" in its title, Saunders and Gero [95] investigate a software model for a society of agents situated in a cultural environment such that agents interact with other agents to exchange artefacts and evaluations. They test their framework by giving each agent access to a Sim's like evolutionary art system. Similarly, Greenfield and Machado [56] attempt to simulate an artificial society populated by artists who produce ant paintings and critics who produce rankings in a back and forth exchange.

It is difficult to know how to categorize AL artwork inspired by societies in the form of ecosystems (see Dorin [23]). On the one hand, we listed the installation described by Murray-Rust and von Jungenfeld [88] under virtual robotics because the authors referred to their agents as robots. On the other hand, we listed the virtual software agent niche construction project by McCormack [76] which has "ecosystem" in its title under swarm art since it seems to pay homage to Annuziato [6] whose work has traditionally been regarded that way. Lying somewhere in between, for example, is Dorin [24] who describes an installation inspired by epidemiology that is much more faithful to biological principles and where the "society" has limited mobility but rich agent-agent interaction.

## 1.6 Conclusion

This overview of AI and AL advances in the visual fine arts has highlighted several key areas that rely on AI and Al techniques for creating visual art, assisting in art analysis and furthering art theory. It reinforces ongoing collaboration between artists and researchers as they seek to promote ways to combine software and hardware situated in an artificial intelligence or artificial life framework in the visual arts.

## References

[1] al-Rifaie, M., Cropley, A., Cropley, D. and Bishop, M.: On evil and computational creativity. Connection Science **28:2**, 171–193 (2016) doi: 10.1080/09540091.2016.1151862

[2] al-Rifaie, M., Ursyn, A., Zimmer, R. and Javid, M.: On symmetry, aesthetics and quantifying symmetrical complexity. In: Correia, J., Ciesielski, V. and Liapis, A. (eds.) Computational Intelligence in Music, Sound, Art and Design (EvoMUSART 2017), LNCS 10198, pp. 17–32 . Springer, Cham, Switzerland (2017) doi: 10.1007/978-3-319-55750-2_2

[3] al-Rifaie, M., Leymarie, F., Latham, W. and Bishop, M.: Swarmic autopoiesis and computational creativity. Connection Science **29:4**, 276–294 (2017) doi: 10.1080/09540091.2016.1274960

[4] al-Rifaie M. and Bishop J.: Swarmic paintings and colour attention. In: Machado, P., McDermott, J. and Carballal, A. (eds.) Evolutionary and Biologically Inspired Music, Sound, Art and Design, EvoMUSART 2013, LNCS 7834, pp. 97–108. Springer, Berlin, Heidelberg (2013) doi: 10.1007/978-3-642-36955-1_9

[5] al-Rifaie M. and Bishop J.: Swarmic sketches and attention mechanism. In: Machado, P., McDermott, J. and Carballal, A. (eds.) Evolutionary and Biologically Inspired Music, Sound, Art and Design, EvoMUSART 2013, LNCS 7834, pp. 85–96. Springer, Berlin, Heidelberg (2013) doi: 978-3-642-36955-1_8

[6] Annunziato, M.: The Nagual experiment. In: Soddu, C. (ed.) Proceedings 1998 International Conference on Generative Art, pp. 241–251 (1998)

[7] Annunziato, M. and Pierucci, P.: Relazioni emergenti: experiments with the art of emergence. Leonardo **35(2)**, 147–152 (2002)

[8] Aupetit, S., Bordeau, V., Monmarché, N., Slimane, M. and Venturini, G.: Interactive evolution of ant paintings. In: McKay, B., et al. (eds.) Congress on Evolutionary Computation Proceedings, pp. 1376–1383. IEEE Press (2003)

[9] Baluja, S., Pomerleau, D. and Jochem, T.: Towards automated artificial evolution for computer-generated images. Connection Science **6:2-3**, 325–354 (1994)

[10] Barrass, T.: Neural networks in new media art. Unpublished master thesis, Melbourne University (2005)

[11] Barrass, T.: Soma (self-organizing ant maps) tests: August 2003 - August 2004. http://www.youtube.com/watch?v=UOyqQashnQw.Cited26Aug2018

[12] Bird, J., Husbands, P., Perris, M., Bigge, B. and Brown P. (2008) Implicit Fitness Functions for Evolving a Drawing Robot. In: Giacobini, M. et al. (eds.) Applications of Evolutionary Computing, EvoWorkshops 2008, LNCS 4974, pp. 473–478. Springer, Berlin, Heidelberg (2008) doi: 10.1007/978-3-540-78761-7_50

[13] Bird, J. and Stokes, D.: Evolving minimally creative robots. In: Colton, S. and Pease, A. (eds.) Proceedings of the Third Joint Workshop on Computational Creativity, pp. 1–5 (2006)

[14] Bishop, J. and al-Rifaie, M.: Autopoiesis in creativity and art. In: Proceedings of the 3rd International Symposium on Movement and Computing, MOCO '16, pp. 27:1–27:6. ACM Press, New York (2016) doi: 10.1145/2948910.2948948

[15] Campbell, A., Ciesielski, V. and Trist, K.: A self organizing map based method for understanding features associated with high aesthetic value evolved abstract images. In: 2014 IEEE Congress on Evolutionary Computation (CEC), pp. 2274–2281. IEEE (2014)

[16] Campbell, A., Ciesielski, V. and Qin, A.: Feature discovery by deep learning for aesthetic analysis of evolved abstract images. In: Johnson C., Carballal A. and Correia J. (eds.) Evolutionary and Biologically Inspired Music, Sound, Art and Design (EVOMUSART 2015), Copenhagen, Denmark, 8-10 April 2015, LNCS 9027, pp. 25–38. Springer, Cham, Switzerland (2015) doi: 10.1007/978-3-319-16498-4_3

[17] Chappell, D.: Taking a point for a walk: pattern formation with self-interacting curves. In: Greenfield, G., Hart, G. and Sarhangi, R. (eds.) Bridges 2014 Conference Proceedings, pp. 337–340. Tessellations Publishing, Phoenix, Arizona (2014)

[18] Chappell, D.: Sinuous meander patterns: a family of multi-frequency spatial rhythms. Journal of Mathematics and the Arts **9:3-4**, 63–76 (2015)

[19] Ciesielski, V., Barile, P. and Trist, K.: Finding image features associated with high aesthetic value by machine learning. In: Machado, P., McDermott, J. and Carballal A. (eds.) Evolutionary and Biologically Inspired Music, Sound, Art and Design, EvoMUSART 2013, LNCS 7834, pp. 47–58. Springer, Berlin, Heidelberg (2013) doi: 10.1007/978-3-642-36955-1_5

[20] Colton, S.: The Painting Fool: stories from building an automated painter. In: McCormack, J. and d'Inverno, M. (eds.) Computers and Creativity, pp. 3–38. Springer, Berlin, Heidelberg (2012)

[21] Colton, S., de Mántaras, R. and Stock, O.: Computational creativity: coming of age. AI Magazine **30:3**, 11–14 (2009)

[22] Dewdney, A.: Two-dimensional Turing machines and Turmites make tracks on a plane. Scientific American **251:3**, 180–183 (1989)

[23] Dorin, A.: A survey of virtual ecosystems in generative electronic art. In: Romero, J., and Machado, P. (eds.) The Art of Artificial Evolution: A Handbook on Evolutionary Art and Music, pp. 289–309. Springer-Verlag, Berlin (2008)

[24] Dorin, A.: Artificial life, death and epidemics in evolutionary, generative electronic art. In: Rothlauf, F. et al. (eds.) Applications of Evolutionary Computing, EvoWorkshops 2005, LNCS 3449, pp. 448–457. Springer, Berlin, Heidelberg (2009) doi: 10.1007/978-3-540-32003-6_45

[25] Elgammal, A., Liu, B., Elhoseiny, M. and Mazzone, M.: CAN: Creative adversarial networks generating "art" by learning about styles and deviating from style norms. In: Eighth International Conference on Computational Creativity (ICCC), Atlanta, GA, June 20-22, 2017, pp. 47:1–47:8 (2017) https://computationalcreativity.net/iccc2017/ICCC_17_accepted_submissions/ICCC-17_paper_47.pdf. Cited 22 Aug 2018

[26] Elgamaal, A. and Saleh, B.: Quantifying creativity in art networks. In: Proceedings of the Sixth International Conference on Computational Creativity, pp. 39–46 (2015)

[27] Fernandes, C., Isidoro, C., Barata, F., Rosa, A. and Merelo, J.: From Pherographia to color Pherographia: color sketching with artificial ants. In: Proceedings of the 2011 IEEE Congress on Evolutionary Computation, pp. 1124–1131. IEEE Press (2011)

[28] Fernandes, C., Mora, A., Merelo, J. and Rosa, A.: KANTS: a stigmergic ant algorithm for cluster analysis and swarm art. IEEE Transactions on Cybernetics **44(6)**, 843–856 (2014) doi: 10.1109/TCYB.2013.2273495

[29] Fernandes, C.: Pherographia: drawing by ants. Leonardo **43(2)**, 107–112 (2010)

[30] Fernandes, C., Mora, A., Merelo, J. and Rosa, A.: Pherogenic drawings: generating colored 2-dimensional representations of sleep EEG with the KANTS algorithm. In: 4th International Conference on Evolutionary Computation Theory and Applications, pp. 72–82 (2012)

[31] Fernandes, C., Mora, A., Merelo, J., Cotta, C. and Rosa, A.: Photo rendering with swarms: from figurative to abstract pherogenic imaging. In: 2013 IEEE Symposium on Computational Intelligence for Creativity and Affective Computing, pp. 32–39. IEEE Press (2013)

[32] Fernandes, C., Ramos, V. and Rosa, A.: Self-regulated artificial ant colonies on digital image habitats. International Journal of Lateral Computing **2(1)**, 1–8 (2005)

[33] Flynn, M.: A 19-year-old developed the code for the AI portrait that sold for $432,000 at Christie's. In: Washington Post (2018) https://www.washingtonpost.com/nation/2018/10/26/year-old-developed-code-ai-portrait-that-sold-christies/.Cited26Oct.2018

[34] Galanter, P.: Computational aesthetic evaluation: past and future. In: McCormack, J. and d'Inverno, M. (eds.) Computers and Creativity, pp. 255–293. Springer, Berlin, Heidelberg (2012)

[35] Gatys, L., Ecker, A., Bethge, M.: Image style transfer using convolutional neural networks. In: Proceedings of the IEEE Conference on Computer Vision and Pattern Recognition, pp. 2414–2423 (2016)

[36] Gatys, L., Ecker, A. and Bethge, M.: Texture and art with deep neural networks. Current Opinion in Neurobiology **46**, 178–186 (2017)

[37] Greenfield, G.: Abstract overlays using a transport network model. In: Sequin, C. and Sarhangi, R. (eds.) BRIDGES 2011 Conference Proceedings, pp. 45–50. Tessellations Publishing, Phoenix, Arizona (2011)

[38] Greenfield, G.: Ant paintings based on the seed foraging behavior of *P. barbatus*. In Hart, G. and Sarhangi, R. (eds.) Bridges 2013 Conference Proceedings, pp. 43–48. Tessellations Publishing, Phoenix, Arizona (2013)

[39] Greenfield, G.: A platform for evolving controllers for simulated drawing robots. In: Machado, P. Romero, J. and Carballal, A. (eds.) EvoMUSART 2012, LNCS 7247, pp. 108–116. Spinger International Publishing, Switzerland (2012)

[40] Greenfield, G.: Avoidance drawings evolved using virtual drawing robots. In: Johnson, C., Carballal, A. and Correia, J. (eds.) Evolutionary and Biologically Inspired Music, Sound, Art and Design EvoMUSART 2015, LNCS 9027, pp. 79–88. Springer International Publishing, Switzerland (2015)

[41] Greenfield, G.: Computational aesthetics as a tool for creativity. In: Creativity and Cognition Proceedings 2005, pp. 232–235. ACM Press, New York (2005)

[42] Greenfield, G.: Evolutionary methods for ant colony paintings. In: Rothlauf, F. et al. (eds.) Applications of Evolutionary Computing, EvoWorkshops 2005 Proceedings, LNCS 3449, pp. 478–487. Springer-Verlag (2005)

[43] Greenfield, G.: Evolved deflection drawings. In: Tan, K. and Yen, G. (eds) IEEE WCCI 2016 Conference Proceedings, July 24-29, 2016,Vancouver, BC, IEEE CEC 2016, Ong, Y. (ed.), E-16542. IEEE, New York (2016)

[44] Greenfield, G.: Evolved look-up tables for for simulated DNA controlled robots. In: Li, X. et al. (eds.) Simulated Evolution and Learning Conference Proceedings (SEAL 2008), LNCS 5361, pp. 51–60. Springer, Berlin, Heidelberg (2008) doi: 10.1007/978-3-540-89694-4_6

[45] Greenfield, G.: On evolving multi-pheromone ant paintings. In: 2006 IEEE World Congress on Computational Intelligence, Vancouver, BC, Canada, WCCI06 Conference Proceedings, (DVD-ROM ISBN: 0-7803-9489-5), 7425–7431. IEEE Press (2006)

[46] Greenfield, G.: On the origins of the term "computational aesthetics". In: Purgathofer, W. et al. (eds.) Computational Aesthetics 2005, Eurographics Workshop on Computational Aesthetics in Graphics, Visualization and Imaging, pp. 9–12. Eurographics Association (2005)

[47] Greenfield, G.: On simulating drawing robots with straight line motion but curvilinear pen paths. In: Proceedings of the 14th International Conference on Geometry and Graphics (ICGG'10), Kyoto, Japan (2010)

[48] Greenfield, G.: On the co-evolution of evolving expressions. International Journal of Computational Intelligence and Applications 2:1, 17–31 (2002)

[49] Greenfield, G.: On variation within swarm paintings. In: Akleman, E. and Friedman, N. (eds) Proceedings of ISAMA 2009, Eighth Interdisciplinary Conference of the International Society of the Arts, Mathematics, and Architecture, Hyperseeing, Spring 2009, 5–12 (2009)

[50] Greenfield, G.: Robot paintings evolved using simulated robots. In: Rothlauf, F. et al. (eds.) Applications of Evolutionary Computing, EvoWorkshops 2006 Proceedings, LNCS 3907, pp. 611–621. Springer-Verlag (2006)

[51] Greenfield, G.: Self-avoiding random walks yielding labyrinths. In: Delp, K. and Sarhangi, R. (eds.) Bridges 2015 Conference Proceedings, pp. 247–252. Tessellations Publishing, Phoenix, Arizona (2015)

[52] Greenfield, G.: Stigmmetry prints from patterns of circles. In: Bosch, R., McKenna, D. and Sarhangi, R. (eds.) Bridges 2012 Conference Proceedings, pp. 291–298. Tessellations Publishing, Phoenix, Arizona (2012)

[53] Greenfield, G.: Target curves for pick-up, carry, and drop mobile automata. In: Greenfield, G., Hart, G., and Sarhangi, R. (eds.) Bridges 2014 Conference Proceedings, pp. 381–384. Tessellations Publishing, Phoenix, Arizona (2014)

[54] The computer art of Manuel Quejido revisited. Journal of Mathematics and Design (Mathematics & Design VII Conference Proceedings) 59–66 (2014)

[55] Greenfield, G. and Machado, P.: Ant and ant colony inspired a-life visual art. Artificial Life 21:3, 293–306 (2016)

[56] Greenfield, G. and Machado, P.: Simulating artist and critic dynamics — an agent-based application of an evolutionary art system. In: A. Dourado, A., Rosa, A. and Madani, K. (eds.) Proceedings of the International Joint Confer-

ence on Computational Intelligence, Funchal, Portugal, 5-7 October 2009, pp. 190–197 (2009)

[57] Greenfield, G. and Machado, P.: Swarm art. Leonardo **47:1**, 5–16 (2014) doi:10.1162/LEON_a_00695

[58] Goodfellow, I., Pouget-Abadie, J., Mirza, M., Xu, B., Warde-Farley, D., Ozair, S., Courville, A. and Bengio, Y.: Generative adversarial nets. In: Ghahramani, Z., Welling, M., Cortes, C., Lawrence, N., and Weinberger, K. (eds.) Advances in Neural Information Processing Systems 27, pp. 2672–2680. Curran Associates, Inc. (2014)

[59] Hieslmair, M.: Creative robotics: paint me! In: Ars Electronics Blog (2016) `https://ars.electronica.art/aeblog/en/2016/02/05/creativerobotics/` `.Cited5Feb.2016`

[60] Jacob, C. and Hushlak, G.: Evolutionary and swarm art design in science, at, and music. In: Romero, J., and Machado, P. (eds.) The Art of Artificial Evolution: A Handbook on Evolutionary Art and Music, pp. 145–166. Springer-Verlag, Berlin (2008)

[61] Jacob, C., Hushlak, G., Boyd, J., Sayles, M., Nuytten, P. and Pilat, M.: Swarmart: interactive art from swarm intelligence. Leonardo **40(3)**, 248–254 (2007)

[62] Jones, J.: Characteristics of pattern formation and evolution in approximations of Physarum transport networks. Artificial Life **16(2)**, 127–154 (2010)

[63] Joshi, B., Stewart, K. and Shapiro, D,: Bringing impressionism to life with neural style transfer in *Come Swim*. In: DigiPro '17 Proceedings of the ACM SIGGRAPH Digital Production Symposium, Article No. 5. ACM Digital Library (2017) doi: 10.1145/3105692.3105697

[64] Kwong, H. and Jacob, C.: Evolutionary exploration of dynamic swarm behavior. In: Sarker, R., Reynolds, R., Abbass, H., Tan, K. McKay, B., Essam, D. and Gedeon, T. (eds.) Prceedings of the 2003 Congress on Evolutionary Computation CEC2003, pp. 367–364. IEEE Press (2003)

[65] Lewis, M.: Evolutionary visual art and design. In: Romero, J., and Machado, P. (eds.) The Art of Artificial Evolution: A Handbook on Evolutionary Art and Music, pp. 3–37. Springer-Verlag, Berlin (2008)

[66] Lund, H., Pagliarini, L., and Miglino, O.: Artistic design with genetic algorithms and neural networks. In: Alander, J. (ed.) Proceedings of the First Nordic Workshop on Genetic Algorithms and their Applications (1NWGA). University of Vaasa, Vaasa (1995)

[67] von Mammen, S., Wong, J. and Jacob C.: Virtual constructive swarm compositions and inspirations. In: Giacobini, M. et al. (eds.) Applications of Evolutionary Computing, EvoWorkshops 2008, LNCS 4974, pp. 491–496. Springer, Berlin, Heidelberg (2008) doi: 10.1007/978-3-540-78761-7_53

[68] Machado, P., Martins, T., Amaro, H. and Abreu, P.: An interface for fitness function design. In: Romero, J., McDermott, J. and Correia, J. (eds.) Evolutionary and Biologically Inspired Music, Sound, Art and Design, EvoMUSART 2014, LNCS 8601, pp. 13–25. Springer, Berlin, Heidelberg (2014) doi: 10.1007/978-3-662-44335-4_2

[69] Machado, P., Romero, J., Manaris, B.: Experiments in computational aesthetics. In: Romero, J., and Machado, P. (eds.) The Art of Artificial Evolution: A Handbook on Evolutionary Art and Music, pp. 381–416. Springer-Verlag, Berlin (2008)

[70] Machado, P. and Amaro, H.: Fitness functions for ant colony paintings. In: International Conference on Computational Creativity, ICCC 2013, pp. 32–39 (2013)

[71] Machado, P., Dias, A., Duarte, N. and Cardoso, A.: Giving color to images. In: Cardoso, A. and Wiggins, G. (eds.) AI and Creativity in Arts and Science (AISB'02). Imperial College, United Kingdom (2002)

[72] Machado, P. and Pereira, L.: Photogrowth: non-photorealistic renderings through ant paintings. In: Soule, T. (ed.) Proceedings of the Fourteenth International Conference on Genetic and Evolutionary Computation Conference Companion — GECCO 2012, pp. 233–24 (2012)

[73] Machado, P. and Cardoso, A.: Generation and evaluation of artworks. In: Proceedings of the 1st European Workshop on Cognitive Modeling, CM'96, pp. 96–39 (2010)

[74] Martins, T, and Machado, P.: Insta.ants (2017) https://cdv.dei.uc.pt/insta-ants/.Cited30Aug2018

[75] McCorduck, P.: AARON's code: meta-art, artificial intelligence and the work of Harold Cohen. Freeman, New York (1991)

[76] McCormack, J.: Creative ecosystems. In: McCormack, J. and d'Inverno, M. (eds.) Computers and Creativity, pp. 39–60. Springer, Heidelberg (2012)

[77] McCormack, J.: Facing the future: evolutionary possibilities for human-machine creativity. In: Romero, J., and Machado, P. (eds.) The Art of Artificial Evolution: A Handbook on Evolutionary Art and Music, pp. 417–451. Springer-Verlag, Berlin (2008)

[78] McCormack, J.: Niche constructing drawing robots. In: Correia, J., Ciesielski, V. and Liapis, A. (eds.) 2017 Computational Intelligence in Music, Sound, Art and Design: 6th International Conference, EvoMUSART 2017, Amsterdam, The Netherlands. April 19-21, 2017 Proceedings, LNCS 10198, pp. 201–216. Springer, Cham, Swizerland (2017)

[79] McCormack, J.: Open problems in evolutionary music and art. In: Rothlauf, F., Branke, J., Cagnoni, S., Corne, D.W., Drechsler, R., Jin, Y., Machado, P., Marchiori, E., Romero, J., Smith, G. and Squillero, G. (eds.) EvoWorkshops 2005, LNCS 3449, pp. 428–436. Springer, Heidelberg (2005)

[80] McCormack, J., Bown, O., Dorin, A., McCabe, J., Monro, G. and Whitelaw, M.: Ten questions concerning generative computer art. Leonardo 47:2, 135–141 (2014)

[81] McCormack, J., Gifford, T. and Hutchngs, P.: Autonomy, authenticity, authorship and intention in computer generated art, EvoMUSART 2019, LNCS 11453, pp. 16–30. Springer, Cham, Switzerland (2019)

[82] McCormack, J. and d'Inverno, M. (eds.): Computers and creativity. Springer-Verlag, Berlin, Heidelberg (2012)

[83] Monmarché, N., Mahnich, I. and Slimane, M.: Artificial art made by artificial ants. In: Romero, J., and Machado, P. (eds.) The Art of Artificial Evolution: A Handbook on Evolutionary Art and Music, pp. 227–247. Springer-Verlag, Berlin (2008)

[84] Molina, B.: Christie's sells painting created by artificial intelligence for $432,500. In: USA Today (2018) https://amp.usatoday.com/amp/1759967002.Cited25Oct.2018

[85] Mordvintsev, A., Olah, C. and Tyka, M.: AI Blog: Inceptionism: Going Deeper into Neural Networks (2015) https://ai.googleblog.com/2015/06/inceptionism-going-deeper-into-neural.html.Cited22Aug2018

[86] Moura, L., and Pereira, H.: Man + Robots: Symbiotic Art. Institut d'Art Contemporain, Lyon/Villeurbanne, France (2004)

[87] Moura, L., and Ramos, V.: Swarm paintings — nonhuman art. In Maubant, J. et al. (eds.) Architopia: Book, Art, Architecture, and Science, pp. 5–24. Institut d'Art Contemporain, Lyon/Villeurbanne, France (2002)

[88] Murray-Rust, D. and von Jungenfeld, R.: (2015) Lichtsuchende: exploring the emergence of a cybernetic society. In: Johnson C., Carballal A. and Correia J. (eds.) Evolutionary and Biologically Inspired Music, Sound, Art and Design (EVOMUSART 2015), Copenhagen, Denmark, 8-10 April 2015, LNCS 9027, pp. 161–174. Springer, Cham, Switzerland (2015) doi: 978-3-319-16498-4_15

[89] Putri, T, and Mukundan, R.: Iterative brush path extraction algorithm for aiding flock brush simulation of stroke-based painterly rendering. In: Johnson, C., Ciesielski, V., Correia J. and Machado P. (eds.) Evolutionary and Biologically Inspired Music, Sound, Art and Design, EvoMUSART 2016, LNCS 9596, pp. 152–162. Springer, Cham (2016) doi: 10.1007/978-3-319-31008-4_11

[90] Reynolds, C.: Flocks, herds and schools: a distributed behavioral model. In: SIGGRAPH '87: Proceedings of the 14th Annual Conference on Computer Graphics and Interactive Techniques, pp. 25–34. Association for Computing Machinery. New York (1987) doi: 10.1145/37401.37406

[91] Ritchie, G.: Some empirical criteria for attributing creativity to a computer program. Minds and Machines **17:1**, 67–99 (2007) doi: 10.1007/s11023-007-9066-2

[92] Romero, J., Machado, P., Santos, A. and Cardoso, A.: On the development of critics in evolutionary computation artists. In: Raidl, G. et al. (eds.) Applications of Evolutinary Computing, EvoWorkshops 2003, LNCS 2611, pp. 559–569. Springer, Berlin, Heidelberg (2003) doi: 10.1007/3-540-36605-9_51

[93] Romero, J. and Machado, P. (eds.): The art of artificial evolution: a handbook on evolutionary art and music. Springer-Verlag, Berlin (2008)

[94] Saleh, B., Abe, K., Arora, R. and Elgamaal, A.: Toward automated discovery of artistic influence. Multimedia Tools and Applications **75:7**, 3565–3591 (2016) doi: 10.1007/s11042-014-2193-x

[95] Saunders, R. and Gero, J.: Artificial creativity: A synthetic approach to creative behavior. In: Gero, J. (ed.) Proceedings of the Fifth Conference on Computational and Cognitive Models of Creative Design, pp. 113–139. Key Centre of Design Computing and Cognition, Sydney (2001)

[96] Saunders, R. and Gero, J.: The digital clockwork muse: A computational model of evolution. In: Wiggins, G. (ed.) Proceedings of the AISB'01 Symposium on Artificial Intelligence and Creativity in Arts and Science, pp. 12–21. The Society for the Study of Artificial Intelligence and the Simulation of Behaviour, York, England (2001)

[97] Schmidhuber, J.: A formal theory of creativity to model the creation of art. In: McCormack, J. and d'Inverno, M. (eds.) Computers and Creativity, pp. 323–337. Springer, Heidelberg (2012)

[98] Schwab, K.: The future of AI art goes up for auction at Sotheby's for $50,000. In: Compass (2019) https://90305344/the-future-of-art-goes-up-for-auction-at-soothebys-for-50000

[99] Secretan, J., Beato, N., D'Ambrosio, D., Rodriguez, A., Campbell, A., Folsom-Kovarik, J. and Stanley, K.: 2011. Picbreeder: A case study in collaborative evolutionary exploration of design space. Evolutionary Computation **19(3)**, 373–403 (2011)

[100] Secretan, J., Beato, N., D'Ambrosio, D., Rodriguez, A., Campbell, A. and Stanley, K.: Picbreeder: evolving pictures collaboratively online. In: Proceedings of the Twenty-Sixth Annual SIGCHI Conference on Human Factors in Computing Systems (CHI 2008), pp. 1759–1768. ACM, New York (2008)

[101] Semet, Y., O'Reilly, U. and Durand, F.: An interactive artificial ant approach to non-photorealistic rendering, Genetic and Evolutionary Computation. In: Deb, K. et al. (eds.) Genetic and Evolutionary Computation GECCO 2004, LNCS 3102, pp. 188–20. Springer-Verlag (2004)

[102] Sims, K.: Artificial evolution for computer graphics. Computer Graphics **25:4**, 319–328 (1991)

[103] Stanley, K.: Compositional pattern producing networks: a novel abstraction of development. Genetic Programming and Evolvable Machines **8:2**, 131–162 (2007) doi: 10.1007/s10710-007-9028-8

[104] Stanley, K. and Miikkulainen, R.: Evolving neural networks through augmenting topologies. Evolutionary Computation **10(2)**, 99–127 (2002)

[105] Stanley, K.: Exploiting regularity without development. In: Proceedings of the AAAI Fall Symposium on Developmental Systems. Menlo Park, CA. AAAI Press (2006) http://eplex.cs.ucf.edu/papers/stanley_aaaifs06.pdf. Cited 23 Aug 2018

[106] Soderland, J. and Blair, A., Adversarial image generation using evolution and deep learning. In: Yen, G. (ed.) 2018 IEEE Congress on Evolutionary Computation (CEC) Conference Proceedings, July 8 – 13, Rio de Janeiro, pp. 1384–1391. IEEE, Piscataway, New Jersey (2018)

[107] Urbano, P.: Consensual paintings. In: Rothlauf, F. et al. (eds.) EvoWorkshops 2006, LNCS 3907, pp. 622–632. Springer, Berlin, Heidelberg (2007) doi: 10.1007/11732242_59

[108] Urbano, P.: Playing in the pheromone playground: experiences in swarm painting. In: Rothlauf, F. et al. (eds.) Applications of Evolutionary Computing, EvoWorkshops 2005 Proceedings, LNCS 3449, pp. 478–487. Springer-Verlag (2005)

[109] Urbano, P.: The *T. albipennis* sand painting artists. In: Applications of Evolutionary Computation. EvoWorkshops 2011 Proceedings, LNCS 6625, pp. 414–423. Springer-Verlag (2011)

[110] Urbano, P.: The light show: flashing fireflies gathering and flying over digital images. In: Liapis, A., Romero, J. and Ekárt, A. (eds.) Computational Intelligence in Music, Sound, Art and Design, EvoMUSART 2018, LNCS 10783, pp. 283–298. Springer, Cham, Switzerland (2018) doi: 10.1007/978-3-319-77583-8_19

[111] Veale, T., Cardoso, A.: Computational Creativity The Philosophy and Engineering of Autonomously Creative Systems. Springer, 2019. doi: 10.1007/978-3-319-43610-4

[112] Verkoelen, S., Lamers, M., van der Putten, P.: Exploring the *Exactitudes* portrait series with restricted Boltzmann machines. In: Correia, J., Ciesielski, V. and Liapis, A. (eds.) Computational Intelligence in Music, Sound, Art and De-

sign, EvoMUSART 2017, LNCS 10198, pp. 331–337. Springer, Cham, Switzerland (2017) doi: 10.1007/978-3-319-55750-2_22

[113] Vickers, D., Soderlund, J. and Blair, A.: Co-evolving line drawings with hierarchial evolution. In: Wagner, M. et al. (eds.) Artificial Life and Conputational Intelligence: Third Australasian Conference (ACALCI2017) Geelong, VIC, Jan 31 - Feb 2, 2017, LNAI 10142, pp. 39–49. Sringer International Publishing AG, Cham, Swizerland (2017)

[114] Vincent, J.: What algorithmic art can teach us about artificial intelligence. In: The Verge (2018) https://www.theverge.com/2018/8/21/17761424/ai-algorithm-art-machine-vision-perception-tom-white-treachery-imagenet.Cited21Aug2018

[115] Whitelaw, M.: Metacreation: art and artificial life. MIT Press, Cambridge (2004)

[116] Yoyotte, C., Rocheteau, P., Monmarché, M. and Gaucher, P.: Collective painting robots. http://youtu.be/GrxthHngARU.Cited21Aug2018

# 2

# Aesthetics, Artificial Intelligence, and Search-Based Art

Colin G. Johnson

School of Computer Science, University of Nottingham, UK Institute for Advanced Studies in the Humanities, University of Edinburgh, Edinburgh, UK

**Summary.** Why do people exhibit particular behaviour towards a class of objects called artworks? That is the topic of study in aesthetics. This paper explores how various theories of aesthetics can be interpreted in the context of artworks generated by artificial intelligence systems, in particular those that are grounded in the idea of search as a means of implementing intelligence computationally. A number of aesthetic theories are explored, including ideas of imitation, skill, form, expression, imagination, and focus. The paper concludes by highlighting a number of areas that, in light of these considerations, have been neglected by the makers of computer art systems and which provide future opportunities in this area.

## 2.1 Introduction

*Aesthetics* is the attempt to understand why and how people act in a particular set of ways to a certain class of objects in the world called artworks. Why do people exhibit particular forms of behaviour towards these objects, so called *aesthetic behaviour*? How do they form *aesthetic judgements*? Why do humans exhibit the behaviour of 'attending to objects for their own sake' [106, p72]? These questions form the core of the subject of aesthetics.

Recent decades have seen a large amount of work in the areas of computer-based art, artificial intelligence (AI) in the arts, and computational creativity, all applied to a wide variety of artistic domains. However, little attempt has been made to connect this with ideas and theories from aesthetics and the philosophy of art. The aim of this paper is to make an initial foray into this area, with a particular focus on the search-based approach to AI. The core of the paper consists of a consideration of various theories that have been proposed to explain aesthetics, and a consideration of how those theories link with ideas about how creative AI systems explore search spaces.

This paper begins with an overview of the ideas of AI in artistic creative domains, focusing on those approaches, such as evolutionary algorithms, that take a search-based approach to artistic creation. Computational and AI approaches have been applied to a wide range of artistic domains, and the principles discussed in this paper are similarly designed to be across the arts, though most of the examples in the paper

P. Machado et al. (eds.), *Artificial Intelligence and the Arts*, Computational
Synthesis and Creative Systems, https://doi.org/10.1007/978-3-030-59475-6_2

are drawn from the visual arts. Typically, aesthetic theories are also neutral with regard to artforms. Within the literature on aesthetics and the philosophy of art, a broad set of ideas concerned with emotion, imitation, form, expression, etc. have been explored, and then been applied to specific artforms and works.

Following this introduction, a number of topics in aesthetics are examined, and their relationship to AI systems for making art are explored. To a lesser extent the paper also explores AI systems that analyse and critique art. The aim of this exploration is to ask whether traditional aesthetic theories can be applied to such means of art-making, whether these theories need to be expanded or adapted to examine these forms of art, whether these aesthetic theories highlight gaps or hidden assumptions in our understanding of AI-based art, and whether computational and AI concepts might help us to understand human art-making.

## 2.2 Search, AI, and Art

There is an extensive literature on the links between art and artificial intelligence. One strand is embedded in the literature on computational creativity [82, 96, 119], and considers both the engineering of systems that act in creative ways, or which work in a co-creative way with people, as well as the evaluation of such systems [64]. Other work explores specific systems, either written by the creators of those systems [23, 29, 38, 73] or by external commentators [78].

Another strand explores theoretical and philosophical issues. These include attempts to unpack human creative processes and compare them to proposed creative AI systems [10], questions around attribution of creative responsibility and authorship [15, 61, 77], and works that compare the use of AI with previous technological changes in the artworld such as the introduction of photography [1, 56]. One issue is that publications on AI art focus on the technical achievements and methods, and much less on developing '*art* theories of evolutionary and generative art' [80]. This paper begins to address that by making links between AI art and the wider literature on aesthetics.

A key position in much artificial intelligence research and practice is that intelligent action and thought can be achieved by a search process operating in an appropriate search space. For example, much machine learning can be seen as a search in a space of hypotheses for a hypothesis that makes successful predictions based on a set of training data [84]. As another example, reinforcement learning [112] reframes the problem of learning to act intelligently as the search in a space of possible action policies for a policy that links appropriate actions to each situation.

A similar approach can be taken to creative, artistic domains. The key idea is that intelligent creative behaviour can be carried out by some kind of search process. Music creation can be seen as a search in a space of possible configurations of notes over a period of time. Literature could also be reframed as the task of searching in the space of all permutations of words, up to a certain number of words. In practice, such search domains are too large to be searched directly, and so some additional structures are included which give the search some additional domain knowledge. Choosing this search space therefore becomes one of the main design activities for the human creator of an AI art system.

Boden [10] has discussed these ideas at length, considering different ways in which AI search algorithms relate to the *conceptual spaces* in which creative AI sys-

tems work. In particular, she distinguishes between *exploratory* creativity, in which the conceptual space is fixed, and *transformational* creativity, in which the creative agent expands or transforms the space being explored. The latter are associated with the transformative moments in the history of an artform where assumptions are dropped, new media explored, or an expanded conceptual vocabulary becomes available.

An example of this from art history is the transition from perspective painting, which is already a vast space of possibilities, into cubist painting, which allows a whole new space to be explored, where multiple points of perspective are combined into a single work. As discussed by Wiggins [122, 123], these conceptual spaces might not be identical to traditional AI search spaces; they are more abstract spaces of ideas rather than enumerations of possible works. Also, it is important to get the level of granularity right when talking about such spaces; little is to be gained from considering literature as the exploration of all possible combinations of words up to a certain length; there is a whole ontology of concepts that help to subdivide this search space.

One difficulty with a traditional AI search approach to creative domains is that search algorithms typically assume that a particular point in the search space will be assigned the same objective function value regardless of when it is evaluated. For creative domains, it is not obvious that this assumption holds. Danto [33] has argued that most statements about aesthetic judgement also involve the context of the artwork being examined—both the personal knowledge of the person exhibiting the aesthetic behaviour, and, more importantly, a broader 'artworld' which influences individual's aesthetic judgements. A work can validly receive a particular judgement at one point in the history of art, but a different one at a different time. This points towards interesting areas of creative AI in a broader simulated world containing both AI artists and AI critics [74, 97].

### 2.2.1 What Drives Search in Creative Domains?

In order to apply a search-based AI technique, it is necessary to have some means of driving the search, which is typically a way of assigning a value or ranking to a specific point in the space. Such methods are known variously as objective functions, fitness functions, error measures, or loss functions. Going beyond the notion of assigning a simple score or rank, recent research has introduced the more general notions of *search drivers* [70], where the assessment of a point in the search space provides a richer judgement than a simple score or ranking.

The vast majority of applications tackled using search-based AI make use of an objective, clearly-defined function to act as this measure. For subjective application areas in the arts, a wider variety of fitness drivers has been used. In two earlier papers [60, 62], I outlined a taxonomy of fitness measures used in search-based (primarily evolutionary) art systems, based on a survey of many papers describing such systems. A major dimension of that taxonomy was the kind of fitness used—the *fitness basis*. This dimension consists of six classes:

AESTHETIC MEASURE. These are where the search is driven by a formula that gives a score or ranking to an object that reflects some aspect of its aesthetics. Such measures range from very generic measures that can be applied across different artforms, such as ways of measuring symmetry or balance, to measures that capture some aspect of a particular artform or style. Such measures can be critiqued from the

standpoint of creativity, because as soon as an idea of the aesthetically valuable is fixed, this provides a limitation on artistic creativity. Furthermore, once an aesthetic measure is fixed, it provides a challenge to future artists to find ways of making art that either are not measured well by, or are incapable of being measured by, those aesthetic criteria. Nonetheless, such measures retain value, in particular for the creation of novel works in a known style.

HUMAN INTERACTION. In these systems, the search is driven by a human collaborator or audience member examining candidate points in the space and assigning them some kind of score or rank, which then drives the search.

CORPUS. This is where the fitness is guided by a collection of material, the corpus. Most typically, this will be in the form of an 'inspiring set' [95], where the search is guided by similarity to that set, or similarity to patterns abstracted from that set. Alternatively, that corpus might be used as a collection of material for the search to plunder and reassemble.

SEEDS AND TARGETS. In these systems, the movement through the search space is driven by one or more externally provided examples. However, in contrast to the 'inspiring set' approach, these are used either as something from the search to work away from or towards. This includes systems that are given some initial state (a 'seed') and then the system elaborates on this or moves away from it; alternatively, a 'target' where the system starts from an arbitrary starting state and moves towards that state. Typically, it is not the final state that is the artistic focus of interest: it is the trajectory of the system as it moves through the search space that forms the artwork.

ENDOGENOUS. These systems use the idea of a fitness measure or driver, but that measure does not attempt to assign aesthetic value to an object. Instead, the measure drives some kind of evolutionary or learning process, and it is the result of that process that is observed as the object of aesthetic attention.

CRITICS AND CO-EVOLUTION. The creation of artworks doesn't happen in isolation. Audiences and critics respond to works, and artists respond to this network of feedback. Broader social concerns both inform, and are sometimes influenced by, such work. This category of systems consists of those systems that simulate or make use of such ideas of art-making being contextualised in a wider society. This class includes attempts to create agents that observe and critique work, the feedback cycles that are therefore generated, and systems that have some notion of co-evolution between different populations of agents.

Potentially, all of these kinds of search drivers can be applied at different levels. Most typically, they are applied to individual candidate artworks in a search space. However, they can also be applied to components of these artworks, and in [62] it was noted that a particularly large number of the systems using ENDOGENOUS fitness measures applied fitness to components of a work. Indeed, they have occasionally been applied to whole collections of works, for example in Bird et al. [8], where an evolutionary algorithm is applied to curating an exhibit, and each point in the search space represents a structured collection of works.

These AI agents are concerned with the creation of artworks. There is also, contrastingly, a category of AI agents that are designed to exhibit aesthetic behaviour, appreciate and critique artworks, and come to (perhaps simulated) aesthetic judgements. This is one role that agents can play as part of a CRITICS AND CO-EVOLUTION fitness basis.

## 2.3 Aesthetic Theories

Plato's dialogues in the *Greater Hippias* [92, 287b–292e] represent the earliest attempt to explore the idea that there is some general aesthetic theory—in this case, a theory of the 'beautiful'—abstracted from specifics. Having been asked by Socrates to explain 'what the beautiful is', Hippias responds with various examples: 'a beautiful maiden is beautiful', 'beautiful mares are bred in our country', and so on for pots, lyres, etc. However, for each specific example given, Socrates responds with a request for a generality, to unpack the idea that 'there is something by reason of which these things would be beautiful'.

Aesthetic theories attempt to unpack human aesthetic behaviour and aesthetic judgement, and to analyse the kinds of things that are the objects of such attention. One problem with such theories is that any attempt to pin down what makes something a worthy object of aesthetic attention eventually results in the space of objects thus defined being gradually exhausted; as a result, creative individuals seek means of aesthetic expression that either contradict, or cannot be readily analysed, by current aesthetic theories.

As a result, the broad history of aesthetic theory is one of increasing abstraction. Initially—as pointed out by Plato—aesthetic value was something ascribed to individual objects, each in their own way. Gradually, domain specific theories of aesthetic value emerged. For example, in music, theories of harmony were developed which attempted to identify features of harmony that were supposed to be pleasing to the ear. Over time, these rules were broken and expanded. In the last couple of centuries, aesthetic theories have become more abstracted still, focusing on broad features of artworks across different domains. Furthermore, this has been influenced by changes in technology—ideas such as skilful imitation and representation have been downplayed as parts of aesthetic judgement as mechanical reproduction reduces the skill level required for such representation. Changes in social mores also influence the focus of aesthetic theories: the attempt to distinguish between morally improving art and pseudo-art which appeals to baser instincts [66, 114] seems less relevant as society places less emphasis on art as a driver for these improving aspects.

This has produced a long history of theories that attempt to explain the aesthetic effect of artwork and to define what art is and why it is a distinctive part of human experience. Many of these are focused on the relationship between art-maker, artwork, and audience. The introduction of AI into this space adds a layer of complexity, particularly if the AI system is considered to be an additional component, whether as a sophisticated tool used by the art-maker or as a separate intelligent agent in that set of interactions. These theories have included:

- Ideas about imitation of the natural world and about whether items in the natural world can be considered works of art.
- Ideas about the necessity of skill or expertise in the production of the work.
- The idea that expression of emotion from the creator to the audience is a key role of art.
- The idea that the form or structure of the work is the key aspect that makes soomething a work of art.
- Ideas to do with the intention of the art-maker and the attitude of the audience towards the work.

- Ideas that explain art in the wider context of a social system and where the aesthetic effect is (partially) contingent on the particular social context in which the work is made or exhibited.

Some of these authors have asserted that their particular criterion is the sole defining criterion for assessing the aesthetic impact of a work. Others, such as Carroll [21] have argued that art is a family resemblance concept [124], where there are a number of defining characteristics, and examples of the concept typically exhibit most of those characteristics, but there is not a single one that can be seen as defining by itself. The scope of what are considered artworks shifts over the centuries and in different cultural contexts, which provides challenges to a theory that is dependent on a single core idea; these family resemblance concepts are more robust to these changes.

One such attempt to explain art as a 'cluster' concept is that of Dutton [39, 40], who has attempted to outline a set of 'universal features' for art. He is clear that these are not 'criterial for the presence of art', but that they represent a set of practices which, when brought together, broadly characterise much artistic practice. That is, not that every work will have all of these, nor will any of them be found in all art, but that most art will feature most of these characteristics. In particular, he argues that they characterise the uncontroversial core of art, and that too much attention has been paid to difficult edge-cases and examples, in particular those where the point of the work is deliberately to problematise the concept of art. The existence of such extreme cases shouldn't detract from a core of ideas about how the majority of art produces an aesthetic effect. These characteristics are [39]:

| | |
|---|---|
| Direct Pleasure | The artwork is valued directly in itself as a source of pleasure or aesthetic engagement. |
| Skill and Virtuosity | The production of the art requires some specialised skills. |
| Style | Artworks are produced within broad styles, which change and emerge with time. |
| Novelty and Creativity | An aspect of aesthetic appreciation is appreciation of the novelty of the work. |
| Criticism | There is a discourse of critique around the world of making and appreciating art. |
| Representation | Artworks represent aspects of the world (we could, though Dutton does not explicitly do this, extend this to the idea of representing mental and emotional characteristics of the world). |
| Special Focus | Art is appreciated in special places and times and is the focal point of the audience's attention. |
| Expressive Individuality | Art is expressive of the individual's personality. |
| Emotional Saturation | Emotional effect on the audience is a major part of the aesthetic effect of art. |
| Intellectual Challenge | Aesthetic appreciation involves the exercise of human intellectual capacity. |
| Art Traditions and Institutions | The production and appreciation of art is embedded in a social network of institutions and traditional practices. |

Imaginative Experience               Both the production and appreciation of art in-
                                     volve the exercise of the imagination.

It is interesting to compare these with the various attempts that have been
made in the computational creativity literature (starting from [10]) to define the
actions typical of a creative agent. The starting point for most of these is that
creativity certainly requires novelty—but, that *mere* novelty is not enough [120]. It
is easy, at least at a superficial level, to generate (or write code that generates) novel
artefacts or behaviour. A program that strings together random words is producing
novelty, but would not be regarded as acting creatively. So, it is common to add
some notion of *value* to the definition: these might be the values of the creator, of
the audience, or might [37] emerge from a social network of interactions between
creators and audiences. The majority of the characteristics that have been identified
in the aesthetics research literature represent aspects of value, such as the idea that
audiences value works with a strong formal structure, or that they value works
because of their emotional expressiveness.

Other characteristics that have been added include the exercise of skill [28, 64],
the surprisingness of the outcome of the creative process [10], the appropriateness
of the works to their context [37], and the intentionality of the system [120]. Again,
these replicate many of the characteristics that have been discussed in the aesthetics
literature, which has discussed whether skill and expertise are important for aesthet-
ics, and the importance of social factors in determining what is considered to have
aesthetic value.

The remainder of this chapter is structured around these ideas that have emerged
through the centuries of writings on aesthetics, and the relationship between maker,
work, and audience. These have not been structured around a single taxonomy of
characteristics such as that of Dutton, but have instead been grouped together from
the breadth of literature on aesthetics. These sections are:

- Imitation (Section 2.4)
- Skill and Expertise (Section 2.5)
- Expression (Section 2.6)
- Form (Section 2.7)
- Focus and Sake (Section 2.8)
- Imaginative Experience (Section 2.9)
- Criticism and the Artworld (Section 2.10)

Each section takes one such collection of ideas, gives a description of it, and examines
the relationship between those ideas and the new means of art-making that AI and
search-based art has introduced. This has focused on the philosophical literature on
aesthetics; a whole other literature considers aesthetics from the point of view of
psychology and cognitive science. Findings from the latter have occasionally been
mentioned in this paper, but a more thorough examination of this can be found in
a recent paper by Johnson et al. [63].

In particular, the various fitness bases introduced in Section 2.2.1 are used as
a language to discuss various examples of works and research projects that engage
with these different aesthetic concepts. However, there is not an attempt to make
a systematic comparison of each group of aesthetic ideas with each fitness basis.
Instead, each section draws on ideas and specific artworks that have connections
with that class of aesthetic theories, and the language of fitness bases is used to
clarify the ideas.

## 2.4 Imitation

Early aesthetic theories focused on the idea of imitation. Aesthetic attention was engaged by the artist producing effective reproductions of items in the world. As technologies such as photography were developed, the need for techniques such as drawing and painting as means of pure representation faded [6, 21]. As a result, imitation theories of aesthetics moved away from a focus on the reproduction of visual or other sensory features of an object, and towards the idea that what is being represented is the artist's response to the source, or to emphasise some aspect of the source that is not perceived on casual inspection. This leads towards the later development of expression theories of aesthetics, which are explored in Section 2.6 below.

One particularly prominent form of AI art that draws on ideas of imitation is that based on generative adversarial networks (GANs) [50], in particular their artistic application as creative adversarial networks [42]. These have been applied to work by artists such as Klingemann [68] and the Obvious collective [2019].

These are systems based on deep learning [49] that start from an *inspiring set* [94] of examples—for example, a set of images. The system then searches for two functions: a *generator* that creates examples of images, and a *discriminator* that learns to rate similarity of those generated images to the input set. During learning, both of these systems learn to be better at their tasks, with the end result being that the generator can produce images that imitate the broad style and subject matter of the input set. This is based on a mixture of having a CORPUS of examples, and a co-learning process that fits into the CRITICS AND CO-EVOLUTION fitness basis. The aesthetics of these is based on this ability to imitate, but, interestingly, the ability to imitate not too well; the works generated by GANs have a distinctive style based on the limitations of the models that they learn. For example, one common feature of GANist art when applied to portraiture is that facial features are distorted. The system is, perhaps, attempting to draw something that is a generalisation of *all* of the examples of that feature it has seen, rather than bringing to mind a specific one; or, perhaps, the training time has not been long enough to allow realistic reproduction. As a result of this tension, the end result is distorted.

Two further aspects of recent AI-based art show how ideas of the aesthetics of imitation can be used, but need to be expanded. The first of these is in works that use artificial life techniques to imitate some natural phenomenon, but rescaled so that it can be appreciated on a human scale. The second are works that disrupt and show the inner workings of algorithms that are designed to imitate. The remainder of this section discusses these two examples in detail.

### 2.4.1 Aesthetic Rescaling

Some artworks that use the ENDOGENOUS fitness basis demonstrate a new kind of computer-grounded aesthetic that is grounded in ideas of imitation. The kind of works under consideration are those where the fitness measure does not attempt to measure the aesthetic value of a specific point in the search space, but represents fitness in some kind of evolving or learning system that then generates an emergent system which is the object of aesthetic interest. This kind of work has been surveyed by McCormack [81]. For example, McCormack's 2001 installation *Eden* consists

of an artificial life simulation, with a large number of simulated agents which are represented both by projected graphics and by sounds relating to their actions in the simulated ecosystem.

Many phenomena have potential for being appreciated aesthetically, but this aesthetic engagement is difficult because the phenomena happen on vastly different temporal or spatial scales to regular human activity. A scientist who has studied these phenomena might get some aesthetic insight through an appreciation of the data, or mathematical models, or through developing a mind's eye visualisation of the phenomenon. Simulation, and turning these simulations into artworks, can reproduce salient aspects of these phenomena at a human scale, making this appreciation available to people who do not have that scientific knowledge and training. This can be seen as a new kind of imitation aesthetic: the computer artwork is reproducing a natural phenomenon at a temporal and spatial scale that facilitates more casual aesthetic appreciation of these phenomena, appealing to the immediate perceptions. This can be seen as a modern-day equivalent of the aesthetic value of drawings of distant flora and fauna in the era before travel, zoos, and nature documentaries; in that era, botanical and zoological artworks acted as translations of these to a wider audience. Aesthetic rescalings analogously transform complex natural phenomena to a scale and location where they can be the object of aesthetic attention.

This has connections to theories of *environmental aesthetics*, that is, theories that explore why people exhibit aesthetic behaviour towards natural scenes such as landscapes. Natural phenomena present problems for many traditional aesthetic theories. For example, expression theories, which characterise art as a means for transmission of emotion from art maker to audience, fail because of the lack of a maker in natural scenes. These theories fall into two broad categories. The first are those that argue that our aesthetic appreciation of the natural environment is grounded in and enhanced by our understanding natural history and environmental science [19, 100]. By contrast, others argue that aesthetic appreciation of nature is a more visceral kind of aesthetic behaviour [20], and that it is contrasted with appreciation of artworks made by people because people cannot readily separate themselves from the environment [7], and therefore cannot take the disinterested stance that is often seen as a prequisite for aesthetic judgement [66]. Works such as *Eden* based on this kind of *aesthetic rescaling* translate complex environmental phenomena into the gallery, and provide a mid-ground between these two theories of environmental aesthetics, allowing rich scientific theories to be appreciated on a more intuitive/perceptive level.

## 2.4.2 Exposing Inner Workings

Another category of works that can be interpreted using the aesthetic of imitation is the category of computer artworks that expose an aspect of the inner workings of an algorithm. Machado et al. [76] present an algorithm that explores a space of visual representations, using similarity to a collection of human faces as the fitness function. Thus far, this algorithm represents a straightforward application of the CORPUS fitness basis: there is a space of visual representations, and a set of ideal examples that the algorithm is using to guide its search through that space of visual representations. However, the final works that are presented are not the most accurate ones, but are ones with an intermediate fitness value. They represent explorations that the algorithm has made on its way to finding an accurate representation.

Similarly, in the *deep dreaming* images, a deep neural network trained to recognise objects in the world is cut off a few stages before converging on an accurate recognition of a scene [108, 110]. This results in an image consisting, in part, of failed attempts to match learned image schemata to components of the image being analysed. Whilst the process is less explicit, the GAN artworks discussed earlier in this section also have a similar flavour, because of the failings of the GAN system to produce images indistinguishable from the originals. There is a distinctive style to such images, based on inaccuracies of replication, which François Chollet has referred to as *GANism* [88].

These systems offer an interesting process for producing artworks from algorithms. This process is to take a system that is designed to imitate or understand the world, train it on some examples, and then sample from the middle of that process of imitation, giving a somewhat abstracted representation that nonetheless is grounded in the objects being imitated. This approach has echoes of the automatism of the surrealist movement, such as the automatic drawings of André Masson and others [85]. These attempt to expose aspects of hidden processes, in this case the processes in the pre-conscious areas of the mind, through the exercise of mental discipline aimed at removing the conscious control of the artist's movements. Similarly, these artworks expose aspects of the underlying algorithm.

## 2.5 Skill and Expertise

The idea that art practice requires skill and expertise is a common idea in aesthetics. It is one of the characteristics on Dutton's [2009] list, it commonly appears in the literature on aesthetics [21, 46], and is a common characteristic in definitions of computational creativity [64].

How is this encoded by the search drivers above? A CORPUS might act as a collection of examples of skilled manufacture or the exercise of skill, and pattern-finding algorithms might extract features that represent that skill. One kind of AESTHETIC MEASURE might be about skill in execution; for some artforms, such as notated music, this distinction between work and its execution is clearer than for others artforms such as the visual arts.

One example of the exercise of skill is the mark-making in nonphotorealistic rendering systems [25]. These are systems that take a photograph as input, and output an image that simulates the same image as generated by a particular artistic technique. Some of these systems are based on a search-based technique [116], though they apply this to the overall image, rather than to detailed mark making. In music, this might be seen in systems such as that described by Ramirez et al. [93], which take a piece of music and attempt to adjust the details of timing, volume, etc. to make an effectively expressive performance; in this paper, the authors use a CORPUS of existing recordings as the starting point.

A related strand of work to nonphotorealistic rendering is that of learned *style transfer* [45, 72]. These works take a set of source images, sometimes just a single image, and learn functions that can replicate the artistic style of the image by the application of a neural network. These have been very successful at demonstrating the skill of transferring the style, but as creative artworks the results are limited.

Overall, though, this aspect of aesthetics has been rather neglected in the AI art and computational creativity area. Perhaps this is because the problems cluster at

two extremes. Some skills that are challenging for people are trivial for machines: for example, accurate perspective drawing. By contrast, skills such as expressive musical performance have to date proven to be very hard computational challenges.

## 2.6 Expression

One important set of ideas in aesthetics is concerned with *expression*. This is the idea that the artwork is a medium through which the artist conveys emotions and ideas to the audience. From the nineteenth century, this began to take over as a key theoretical framework for describing aesthetic experience, taking over from the earlier dominance of theories concerning representation and imitation [21]. Indeed, this is reflected in ideas of artistic practice at the time, which saw the dominance of the idea of the romantic artist who is expressing their reaction to the world, rather than neutrally depicting it [117].

The core idea of expression is that the art-creator transfers an emotional state to their audience [21, 24]. The artist experiences an inner state, perhaps in response to something in the world, and uses their skills to convey this state to the audience. In a representational medium or style, this might consist of representing some item from the world in a way that emphasises a particular emotional state or trajectory through the way in which it is represented. In a more abstract medium such as instrumental music or abstract painting, the emotional content might be devoid of reference. Tolstoy [114] has described works of art as a 'medium of contagion' from the creator's emotions to the audience.

It has been noted (e.g. by Saw [102]) that there is a continuum of emotional response to a work of art, and that responses typically sit in the middle of this continuum. At one extreme, the audience member recognises the emotion being expressed, but in a purely disinterested and unengaged way. At the other extreme, the person is so emotionally drawn into a performance that the emotions blur their ability to distinguish between fact and fiction. The creator or performer also needs to have sufficient distance from the emotion to be able to carry out the creative or performative act [67]. This leads to the idea that the artist 'explores it [the emotion] deliberately' [21], rather than simply 'venting' it.

### 2.6.1 Can Soulless Computers Express?

One immediate objection to the idea of *expression* in the context of search-based art, and in AI arts and computational creativity more generally, is the computer has nothing to express. A machine has no intrinsic motivation or conscious stance—as Boden [11] says, '[t]he fact that a computer is following any goals at all can always be explained with reference to the goals of some *human* agent'. Given this, it can be argued that the machine has nothing to express. Similarly, Colton et al. [31] have discussed the complex question of whether autonomous creative systems can be seen as authentic. However, the *unpredictability* of some complex or randomised computer processes can mean that, whilst there is no self-motivated goal coming from the machine, nonetheless an AI art system can generate material that is surprising to 'the person who initiates the process' [86].

This is not a new argument. Similar arguments have been made about artworks produced by animals, and by objects in the natural environment that are the subject of aesthetic behaviour. This is summarised in this, rather crude, passage by Saw [102, p.49]:

> When asked whether the chimpanzee Congo's pictures were "works of art," almost every unsophisticated person answered that they could not be since a chimpanzee is not capable of expressing his preferences. [...] Rocks and stones worn by wind and rain so that they look like a piece by Henry Moore are similarly refused the title "work of art." In both these cases, sophisticated people tend to say that it entirely depends on the look—if Congo's paintings look well, they may be works of art and so may weatherbeaten rocks.

The perspective of the 'sophisticated person' here rather avoids the question, arguing that expression is not a key criterion for something being considered a 'work of art', and by extension, that expression is not an essential component of the audience taking an aesthetic stance towards an object.

Does this damn any attempt to use a theory of expression to understand the aesthetics of search-based and AI art? One counter-argument is that the program is the medium through which the programmer is being expressive. The position of the *metamaker*—the person who creates a system which then acts creatively—is an interesting one. Traditional art-makers have a rather direct relationship between the movements that they make and what the audience perceives. The expression might fail because of a disjunct between expectations, background, or vocabulary between creator and audience, or there may be a shift in audience assumptions over time, but, nonetheless, the paintbrush has little capacity to put down a radically different line to that intended by the painter, and the word-processor will transcribe faithfully the words in the head of the author.

The paintbrush or piano lies at one end of a spectrum of expressive tools (this spectrum was introduced initially by Rowe [99] in the context of interactive computer music systems, though it has wider applicability). A little further along are composers using musical notation, or playwrights writing a script, who accept the role of an interpretative intermediary as part of achieving their expression, and might see such interpreters as co-creators of the final work. Further along this continuum are systems, usually computer systems, where the interaction between action and outcome is less predictable—what Sanfilippo [101] has referred to as 'non-random unpredictability'. Indeed, some of the performative value of such systems is in the work of the performer in discovering the responsiveness of a system, much as a performer in a collaborative improvisation has to balance the task of presenting a performance to an audience whilst simultaneously trying to interpret and understand the actions of their fellow performers.

At the far end of this spectrum there is a divide into two main camps. One embraces the unpredictability, and plays with the idea that, as pattern-finding agents, members of a human audience will discover patterns in random actions, different performances presented simultaneously, or performances executed with skill and conviction but with unpredictable outcomes. This is exemplified in what Cage has described as *experimental actions*, defined as 'an action the outcome of which is not foreseen' [65, 69]. Such works are hard to explain using expression theories; indeed, a book collecting literary works that are based on found objects is called *Against*

*Expression* [41]. This title suggests that crators working with these techniques do not believe that theories of expression can explain the aesthetic basis of their work.

This unpredictability has been highlighted in an AI context by Moura [86], who has produced robotic painting systems where multiple mobile robots ('artbots') move around on a single surface to create a collaborative work. One of the inputs into the artbots is an image coming from the drawn trails made earlier in the drawing. This draws inspiration from stigmergy, the process whereby swarm insects learn from each other not by direct communication but by following each others' chemical signals in the environment [57]. This has been used widely in swarm intelligence algorithms [14]. Moura [86] notes that 'the resulting art works cannot be predetermined even by the person who initiates the process'.

Nonetheless, in such systems, there is some decision by the human creator about which system to use as the basis for the experimental action. Looking at John Cage's *Atlas Eclipticalis* [17], which generated music by transcribing star-maps onto musical staves, it is difficult to imagine that there was not some thought about the interestingness of those shapes for musical purposes. Similarly, with Moura's artbots, it is clear that the stigmergic, interactive nature of the process has been deliberately chosen to generate interesting material. There is detachment by the creator from the details of what is generated; but, nonetheless, the process has still been deliberately chosen.

The other category of works to be found at this end of the spectrum consists of algorithmic systems that discover how to communicate a thought/emotion, perhaps in a way that could not be anticipated by the creator of the system (the *metamaker*). This could be because the system is able to perform skills that the metamaker is unable to perform, or because the medium of expression requires processing data on a scale that could not tractably be processed by a human.

Alternatively, there is an intermediate point in between these two camps, where the metamaker is acting as a kind of facilitator of expression. For example, some computer based systems will gather together the expressions of many individual people, presenting them in a new way, either as a collection or by applying some kind of pattern-finding algorithm. This kind of meta-expression might be phrased as building a system that captures the zeitgeist of a moment—not the individual expression of the creator, but a *collective expression*. This can also be seen in systems such as *Electric Sheep* [38], where individuals interact with a single image on their screen, but these are collected and recombined on a central server that is running an evolutionary algorithm. This combines elements of the HUMAN INTERACTION fitness basis, but the collaborative aspect demonstrates aspects of the CRITICS AND CO-EVOLUTION basis too.

Of course, such unforeseenness can go wrong; the metamaker can discover that their creation creates something which they would never have wanted to create. Consider the Microsoft *Tay* chatbot, which learned what to say from interactions online. This can be seen as being an example of something driven by a mixture of two fitness bases. Firstly, the CORPUS fitness basis, because it learned from its collection of interactions. Secondly, AESTHETIC MEASURE in the the form of the programmed-in biases of the algorithm about how it learns from interactions. It was taken offline by its creators in less than a day because it was posting offensive material. Clearly, this posting is not something the creators wanted to happen, and is certainly not expressive of their viewpoint, as evidenced by the rapid takedown.

This can be seen as a new kind of co-creation; call this *collective expression*. The creators of the bot didn't express the content, but they facilitated the means for a wide group of people to pool their expressions. In this case, this expressive potential was adopted parasitically by a group of people who made a coordinated attempt to make a particular, offensive, expression, by interacting with it in a coordinated way. A better constructed system might be able to realise the advantages of this without the problems, but this is challenging.

This idea of a creator making something that is designed not to express their own emotions or ideas, but to facilitate new ways of combining or bringing together expressions by a collection of people, is something that technology is particularly suited to. This is hard to account with using traditional theories based around the idea that creative acts should be traceable to a single source—a single locus of responsibility for that creative act [61]. To bring these systems into explanatory frameworks such as expression theories needs new ideas of co-creation and collective expression.

### 2.6.2 Expression Without Transmission

An alternative perspective is that a work can be expressive without being transmissive of emotion. Carroll [21] discusses the case of a mystery writer, who 'need not feel suspense as he ratchets up the audience's apprehensiveness'. From this perspective, causing an emotional response in the audience does not need to involve the creator in having any related emotional state at all—merely, having the techniques to generate an emotional response. The lack of authentic emotion in the agent doing the transmission doesn't invalidate the effectiveness of the emotional expresssion.

Such effects are found in a number of AI-based artistic systems. One example is the collage painting system that is part of the wider *Painting Fool* system [71]. This system takes as input a newspaper article, uses an image search to discover images relevant to the article, and then produces a nonphotorealistic collage which uses simulated painting techniques to bring the collage into a coherent visual style. The results of this can be emotionally engaging, and can comment on a specific topic. The status of this agent seems no different to the mystery writer discussed above; again, there is no emotional activity by the agent producing the work, but this doesn't invalidate the emotional content of the work produced.

The mark-making component of the Painting Fool has a particular focus on emotional engagement with the audience. In its mark-making, the system searches within a parameterised set of marks, allowing it to find, for example, ways of making marks that are in between pencil marks and paint strokes. These are used 'to discover novel painting styles to enhance emotional content' [29]. The system can discover bespoke mark-making techniques by searching within its parameter space to convey a particular emotion. This was done by human feedback to the system, with the human trainer of the system identifying examples where the style chosen enhanced the desired emotional state; a kind of HUMAN INTERACTION. Indeed, the creator of the system emphasises that 'computer generated paintings can still evoke emotions in viewers without necessarily modelling human emotions' [29].

The MEXICA model of creative writing and storytelling [90] uses an idea of emotional trajectory in building its stories. The choice of the next action within a story is guided (alongside other factors) by a measure of *tension* (a scalar variable). Certain actions are associated with increased tension—for example, the setting up of

a conflict between two characters—and others reduce the tension. This bias changes as the story progresses. At the beginning actions that increase tension are favoured, to increase reader's engagement in the story. Towards the end, the opposite is true, with the system preferring actions that reduce tension and thus create a satisfying resolution to the story. Again, there are no actual emotional qualia in the system to be expressed, but the creator has imbued the system with a technique for eliciting an emotional trajectory in the reader. This can be seen as an AESTHETIC MEASURE— the creator of the system has made the decision that good stories consist, in part, in this build up and release of tension, and the tension measure drives the search towards stories that satisfy this.

### 2.6.3 Expression, Emotion, and Expression Systems

The *Painting Fool* [29] is a computer art system that exists in a number of versions, many of which are concerned with creating nonphotorealistic renderings of photographic input in a variety of artistic styles. Colton et al. [30] introduce a version of this system for portraits that is responsive to the emotional state conveyed by the input. facial sentiment analysis system based on neural networks classifies the input photograph into one of six of basic emotional categories (happiness, sadness, surprise, etc.) and then uses a set of brushstrokes, segmentation style, colour palette, and other features (chosen by the creators of the system) to create a nonphotorealistic rendering appropriate to the emotion being expressed in the photograph.

A more recent version of the system explicitly annotates pictures with some text concerning the emotional state of the artist at the time that the picture was created. This is an example of the use of *framing information* [22]—additional, usually textual information, which puts a creative act into a wider context. In this case, this information consisted of a description of why it chose the specific style— asserting that this was based on *its* mood, not the mood imputed from the human photograph being used as input—and an evaluation of its success in creating a picture that matched that mood:

> Like a human, it's sometimes pleased with its work and sometimes disappointed. "I was in a positive mood. So I wanted to paint a patterned portrait," it wrote in response to the portrait above. "This is a miserable failure—I'm very unhappy about that. And I'm also annoyed that the portrait is bleached, because that does not suit my mood." [111]

What, if anything, is being *expressed* here? Clearly, the computer is not in any traditional sense feeling those moods; there does not seem to be any meaningful mechanism for a computer to have emotional qualia [91]. Nonetheless, it can simulate or act out having moods, based on external factors that might be shared with its audience. The Painting Fool's expressed emotional state 'depended on where it had recently been in terms of reading the newspaper articles.' [103]. So, whilst it might not be expressing its own feelings, it is drawing on context to bring itself into *expressive alignment* with emotionally-capable agents in its environment.

Is such a system conning its audience? Would a naive viewer of these paintings change their view of the aesthetic value of them on learning that there was no experienced emotion underlying statements about mood? Responses to such revelations vary. The revelation that James Frey's book *A Million Little Pieces* was largely fictional, despite having been framed as autobiographical, was damned; the publisher

going as far as to 'provide refunds to readers who felt they were defrauded' [4]. Yet, it is accepted that a stage magician will be lying throughout their act about the cause of the effects presented.

One area where this has been explored in depth is in acting. An actor's relationship with the emotions explored in the text can exist on a continuum from pure 'technique', where the actor experiences none of the emotional qualia but expresses the emotion through learned gestures, expressions, etc., through to a 'method' approach at the other end of the continuum, where actors engage deeply in actually feeling the emotions being expressed by their characters [48, 113]. Indeed some actor training techniques explicitly mark themselves out as being in between these extremes, such as Alba Emoting [3], which presents itself as being a system that can generate effective emotion without the need for techniques such as personal emotional recall. Notably, the aim of the method approaches is to generate a more believably expressive performance, rather than the audience being expected to care more about the performance because they have been given framing information that such an approach has been used.

So, are systems such as the Painting Fool with emotional framing achieving their aesthetic effects through expression? Again, such systems appear to consist of expression without transmission. There is a kind of *expression system* which, without directly transmitting an emotional state from the system to the audience, nonetheless uses contextual clues such as the mood generated by newspaper articles to elicit emotional states that are broadly aligned with the environment in which the system is working. The system will not make an emotional error such as producing happy work on a day of great tragedy, because it uses shared information with the audience to align its actions with the environment.

### 2.6.4 Self-Contagion

One form of expression peculiar to systems based on the HUMAN INTERACTION fitness basis is that the audience member plays two roles. The first of these is as the person driving the expression of the system, and the second is receiving the results of that expression.

Consider a system such as NEvAr [73] or the interactive ant paintings by Aupetit et al. [2]. In systems such as these, the viewer is presented with a set of possible artworks drawn from the search space, and invited to select their preferred ones, or to rank them. At this point, the viewer is in the mode of making aesthetic judgements, making a value judgement between the different works. Once this judgement has been made, that judgement becomes an expression—an expression of preference, but also an expression of the viewer's feelings which is mediated through the system as a developed or meditated version of their expression.

Thus the system allows for a kind of *self-contagion*—the viewer finds the germ of an idea in the items presented by the machine, and the development of this germ is supported by the system in a positive feedback cycle, where the viewer collaborates with the system in developing that idea. Again, there are resonances of the continuum of interaction discussed by Rowe [99]. These interactive systems fit in the middle of Rowe's continuum, being inbetween the extremes of the predictable tool/instrument and the independently-minded collaborator.

Such systems can place the viewer/listener into the position of an art-maker, developing ideas from their errors and contingencies. It is an common pattern in

art-making for artists to extract ideas from their own errors. An artist will make a slip of the pencil during a drawing, but then develop that error into a part of the drawing. An improvising musician will make an unintended sound, which then gets takes up by another improviser in the group and developed further, taking the improvisation in a new direction. This has a long history; consider the following advice given by Leonardo da Vinci (quoted by Turner [115]):

> If you look upon an old wall covered with dirt, or the odd appearance of some streaked stones, you may discover several things like landscapes, battles, clouds, uncommon attitudes, humorous faces, draperies, etc. Out of this confused mass of objects, the mind will be furnished with an abundance of designs and subjects perfectly new.

Saw [102, p146] has attempted to unpack the difference between skilled artists and laïcs in their exercise of imagination:

> ...a non-artist might say "If it is imagining, anybody can do it. I can imagine paintings, vases, plays, and musical compositions. The difficulty is in making the thing.". This is not so at all. We only think that we have imagined these things, because we do not understand that imagination must be complete in every detail—in fact, to imagine it is to complete it.

Perhaps this a little simplistic about the creative process—it is not always the case that the art-maker conceives the whole work before beginning 'making the thing'. Furthermore, there is a feedback loop between actions of making, the unanticipated consequences of those making actions, and future imagination. Nonetheless, the systems that are driven by the HUMAN INTERACTION fitness basis provide some means of bridging this gap between naive imagination and realisation.

This ability to blur the distinction between audience and art-maker via this process of self-contagion is a distinctive expressive aesthetic of these human-in-the-loop systems.

### 2.6.5 Expression: Summary

At first, expression theories of aesthetics appear to have little to do with AI-based artworks. As machines have neither a sake nor emotional qualia, it is hard to see that they could either want to express or have any emotional state to express.

Yet, there are ways in which the behaviour of computer-artists can engage with ideas of expression. One is through facilitation of expression in new ways. Firstly, a system can exist that doesn't express the emotions of its creator, but which allows people to come together—either by making deliberate contributions to the system, or by the system learning from material posted online for other purposes—and contribute towards a collective expression. Secondly, we can divorce expression from transmission, and consider systems that are able to elicit an emotional response in an audience despite having no emotional qualia themselves. Moreover, these *expression systems* can align themselves with the audience by drawing on their shared environment with the audience. Finally, some systems can act as *self-contagion* systems, allowing the viewer/listener/etc. to explore and reinforce a germ of emotional expression in a positive feedback cycle.

Can such systems be driven by the search drivers discussed earlier? Clearly, the self-contagion systems are embedded in the idea of HUMAN INTERACTION. Expression

without transmission can be achieved from the AESTHETIC MEASURE driver, where the measure is some kind of closeness to a pre-specified emotional trajectory. It would be interesting to see if an expressive system could be built around the CORPUS driver. That is, the emotion (or emotional trajectory) to be expressed would be abstracted from one or more existing examples. This could perhaps be achieved if the computer analysis of the corpus were achieved by sentiment analysis of the members of the corpus, and then pattern finding applied to the results of that analysis and used to drive the search process—there are similarities here to a human learning a creative art by studying existing works and examining their emotional content and how that content is achieved.

Could a computer system be genuinely expressive? That is, not expressive of a simulated emotion or of a canned or learned emotional trajectory, but to express something about its state as a machine? Computational creativity has largely shied away from creating works that reflect on the computational. McCormack [80] has argued that computational creativity systems should shy away from a 'technical fetish', that audiences should appreciate the creativity and artistic achievement of an artistically creative AI system as such and not in the context of it being a computer system. Similarly, Colton [29] has argued that one aspect of audience engagement with AI artworks is their 'awe at the power of modern computing'.

Colton [29] has stated the ambition that the Painting Fool system should 'one day be taken seriously as a creative artist in its own right'. Yet, this seems like only the first step. If AI artists were to be accepted on a par with human artists, perhaps the next stage is for these machines to express—not their own experience, nor the emotional states that they lack, but some essence of computer. Perhaps environmental aesthetics might offer a framework for this, being a set of theories that discuss aesthetic value in the context of a system that generates aesthetically appreciable objects without needing a maker that is conscious of what it is creating.

## 2.7 Form

Another major set of aesthetic theories considers ideas of *form* as being a key aesthetic criterion. That is, a major component of aesthetic judgement and appreciation lies in the formal, structural aspects of a work. Audiences are assumed—whether through some preferences that have evolved over generations, or through acculturation—to appreciate aesthetically certain formal structures. This is one of the 'universal features' identified by Dutton [40], as a major part of what he terms *style*: 'art objects and performances, including fictional or poetic narratives, are made in recognizable styles, according to rules of form and composition.'

That is not to say that content is irrelevant or absent. The main point of these theories is that form—'significant form', as Bell [5] describes it—is the main differentiator between mere content, and broadly similar content that provokes aesthetic behaviour from its audience. Two photographs might contain representations of largely the same set of objects, but, formal theories would argue, one is a descriptive, journalistic photo, and the other an artistic one, based on the latter having a formal structure that is absent from the former.

The traditional way in which form is realised by human artists is by the artist making explicit decisions about the position, orientation, and scale of objects. In many AI art works, the decision of the artist is which algorithm to use. In works

such as Greenfield's avoidance, ricochet and deflection drawings [51, 52, 53] and Moura's artbots [86], the artist decides upon the algorithm, and the form emerges from the interactions.

A form could be a very general structure, such as an idea of symmetry or balance. For example, Birkhoff [9] discusses a very general notion of 'aesthetic measure' $M$ given by the broad-brush formula $M = O/C$, where $C$ represents some measure of the (perceptual) complexity, and $O$ represents a way of quantifying the order or organisation of a work. This is clearly an example of a formal notion of aesthetics—neither of the components of the formula are concerned with the content of the work, they are concerned with the organisation of those components. Form may also be specific to a particular artform. For example, musical works might have a form described in terms of a sequence of harmonic structures.

*Algorithmic congruence* is the idea that a coherent multimedia artwork can be created by realising the same algorithmic process in different media [43]. For example, an algorithm generates a sequence of numbers which are interpreted in a coordinated way as the animation of shapes on a projection, and the generation of musical notes. This is grounded in a form-based argument—the idea that it is the structural forms that elicit our aesthetic response, and realising those same algorithms in different media produces an aligned response from the audience.

### 2.7.1 Form and Aesthetic Measure

The most direct way in which these ideas of form interact with search-based art is in those systems that base their fitness directly on AESTHETIC MEASURE. Most of the proposed systems for aesthetic measure are based on measures that are concerned with form rather than content. For example, the *Ricochet Composition* images evolved by the program by Greenfield [51] are driven by a combination of measures such as the proportion of the image filled with colour, and the amount of symmetry in the images. The driver for the search is aiming to optimise formal aspects of the works produced. On a different scale, Bird et al. [8] discuss a search-based algorithm for the curation of works in an exhibition, choosing and grouping works to achieve clusters of semantically-related works, each cluster at a different site within the exhibition.

Colton [27] proposes a meta-level approach to aesthetic measures based on form (inspired by the ideas of Buchan [16] relating creativity to meta-reasoning). Rather than choosing a specific formula for measuring the aesthetic quality of a scene, the concept-generation system HR [26] is used to construct fitness functions. The idea of systems such as HR is that they take as input some simple base concepts, and then use a set of rules for combining and transforming concepts, together with high-level concepts of interestingness, and generate a body of new concepts by building out from the initial concepts. In this system, the base concepts are the descriptions of the basic graphical elements that are combined to make an image, and the system builds up a network of concepts, choosing one of the more high-level ones to use as its fitness function.

This can be seen as a high-level idea of form. A good fitness function is a sophisticated and neat theory about how components are put together, but isn't strongly related to the content, and certainly not to the external connotations of the content or its emotional connections. Indeed, the basic content in this system is supplied by the user as the initial base concepts.

A related idea is Schmidhuber's 1997 *low-complexity* art, which also uses a high-level form-based notion of aesthetics. In this case, that art generated using a small algorithm will be aesthetically engaging and that the 'algorithmic simplicity' of the image will be perceivable by the viewer and form part of their aesthetic judgement.

In creative writing and storytelling the link between form and content is more complex. In visual art or music, many aspects of form can be measured by simple algorithms and pattern-finding systems. In literary works, unpacking the structure of, say, a fictional story, requires a more complex cognitive engagement with the meaning of the story before its form can be described. For example, identifying a structural idea such as a dispute between two characters, and the subsequent resolution of that dispute, requires the reader to read the words, bring characters and their interactions to mind, and then match the interactions between those characters to a pattern. Rarely is form in literature concerned with basic material such as the choice of letters or words.

As a result, generate-and-test methods for driving stories towards an aesthetically satisfactory form, at least at the level of the final text, is difficult for computer systems, because it is difficult for the machine to extract such structure from the text. Most computer story generation systems [47] use a two-stage process, where the initial story generation system uses a graph of actions in the story, and a database describing how characters and their dispositions, locations, and objects, change over time. The AI search algorithms are applied to this representation, and then a second process converts that more formal structure into text.

This allows aesthetic measures to be applied that drive the search towards formal structures in the story that the metamaker of the system has decided are aesthetically valuable. For example, in the MEXICA system [90], a sequence of measurements of dramatic tension is measured for a story. If in the formal structure of the story, an event occurs that the metamaker of the system has decided increases tension (e.g., a secret is revealed), then the overall tension is increased; a tension-resolving event (e.g., a conflict within a family is resolved) has the opposite effect. This allows the system, through a sequence of measurement processes followed by modification processes, to search for a story with a particular formal structure: usually, a broad increase in tension in the first half of the story, and then a decrease towards the end.

Need all aesthetic measures be formal rather than content-based? One difficulty with computer-based measures of content is that they require a large amount of understanding of the meaning of the work being created, rather than its formal features. This requires both a depth of understanding largely beyond current AI systems, and a breadth of contextual understanding. One possibility is to base such measures on the 'connotational' value [59] of an object—how it fits into a network of concepts, which might be changing with time and responding to external events—rather than purely form-based measures.

## 2.7.2 Form and Corpus

Another way in which the idea of form is found in search-based art is in those systems which use the CORPUS fitness basis. Systems of this type often use the corpus of examples as an 'inspiring set' [95], that is, the system should take inspiration from the corpus and produce novel examples that fit into the same broad style.

Typically, this is achieved by using a machine learning algorithm to extract the key features of the inspiring set. By a similar argument to above, such features are more likely to be form-related than content-related. Most machine learning algorithms work from the information provided alone, without reference to a wider world context, and this amongst other things makes it difficult for them to extract patterns from the corpus that are focused on meaning or content. By contrast, machine learning algorithms can readily identify forms (at least, those forms that do not require wider context), and so are biased towards extracting formal features that are common or widespread in the corpus. Gatys et al. [44] have noted that a neural system designed for computer vision 'automatically learns image representations that allow the separation of image content from style' and link this to human ability to engage aesthetically with art.

It would be interesting to consider how to build a system that learned content features rather than formal features. If that were achievable, it might be possible to build a tunable pattern-extraction system, the biases of which could be tuned between form- and content-based features.

### 2.7.3 Form and Multicriterion Optimisation

Thinking about notions of form from a computational point of view is useful not only from the point of view of understanding how AI art systems can be built and unpacking the assumptions underlying existing systems of that kind; it also provides a set of tools of thought with which to unpack and critique the philosophical notions being considered (see the discussion by Sloman [109]).

One criticism of form-based notions of aesthetics is that, once laws of form are clearly articulated, construction of ideal works of art should be trivial—artists should simply follow those laws in the production of work. A criticism of that idea is that laws might be oracular rather than constructive—it might be possible to describe the aesthetic qualities of a given work, but the laws might not provide any constructive guidance as to how a work can be improved. Ideas of optimisation partially work against that criticism—given aesthetic measures of form, an optimisation procedure can be applied with that measure as its objective function. Again, ideas from computation come into play. Such functions might have local minima, thus disrupting naive attempts to optimise against them.

Furthermore, there is nothing intrinsic to laws of form that means that they must be reconcilable with each other, or measurable on the same scale. An artist—whether a search-based AI artist or a human one—might spend a lot of time trying to reconcile multiple laws of form which cannot be readily reconciled. As such, a major task for such an artist might consist in finding a point in the search space of possible works that represents an appropriate balance or trade-off between multiple laws of form—computationally, the idea of multi-criterion optimisation. This may be one of the tasks that artists are engaged in in their preliminary work such as sketching. Indeed, it would be interesting to take ideas of form and see whether ideas from multicriterion optimisation such as the Pareto front are useful for examining how differing requirements are traded off.

### 2.7.4 Form: Summary

Theories based around form, along with theories of expression, are some of the most important ideas in aesthetics. The idea of optimising against some measures of form is a key way in which aesthetic theories can be translated into an AI search procedure. Nonetheless, such measures might not be commensurable and might need to be traded off against each other. This leads to the idea of multicriterion optimisation of different aspects of form in a single search process.

The idea of valuing form aesthetically leads to the idea that artworks should have some underlying theory, and this leads to another intersection between AI and form. This is the idea of systems that discover their own laws of form, by searching for patterns or explainable regularities in a work, using an AI system that searches for compact explanations of pattern. This has the potential to lead to open-ended search-based systems that can not only optimise against existing aesthetic measures, but can also discover new measures.

## 2.8 Focus and Sake

Another of Dutton's [2013] characteristics is that art provides 'special and dramatic focus of experience'. Whilst art may occupy an incidental or instrumental practice in some aspects of life, in most cultures time, space and attention is put aside for engagement with artistic practice—what Dissanayake [35] terms 'making special'. Another of Dutton's criteria is that art exhibits 'nonutilitarian pleasure': it provides 'a source of pleasure in itself, rather than as a practical tool of source of knowledge'—it is appreciated for its own sake.

The typical outcome from the application of search-based processes in art is that the works should be exhibited and performed, and therefore be the focus of aesthetic attention for their own sake. Yet, the nature of this sake is more complex than for artworks created by people. The focus of audience attention is on the fact of it having been produced by artificial intelligence, rather than on the work as such; what McCormack [80] calls 'technical fetish or fascination'. He argues that search-based art should be capable of being taken seriously for its artistic contribution rather than the focus of experience being on the machine, and makes connections to the Turing test. This could change in the fullness of time: if AI-generated art becomes accepted, perhaps eventually some computer artists will make art that reflects on their status as machines, with the focus being on how this is expressed rather than mere astonishment that it can do it at all.

The HUMAN INTERACTION fitness driver provides a distinctive form of 'focus of experience' in that it, within a world created by the metamaker of the system, allows the audience member to create and develop the work being exhibited. This differs from many other forms of interactive art. In most interactive artworks, there is a sense of the (extant) work existing, and responding to the audience prompts. Typically, this will be reactive—the audience member does something, the work responds in some way, then settles back into its base state. In others, the interaction is more conversational between work and audience. In the search-based works with human interaction, the sense is more of exploration of a space of possible works—there isn't a fixed work that the audience member is interacting with, they are

playing a different role, one of guiding the creation of the work, or exploring the space of possible works.

This idea of special focus also comes into the ideas discussed earlier about works based on ENDOGENOUS fitness. Here the focus of attention is on the work itself as a work of art, but it also provides a means for people to focus on natural processes that take place on temporal or spatial scales that are not normally appreciable to human perception.

## 2.9 Imaginative Experience

Dutton [39] places an especial emphasis on imaginative experience as a characteristic typical of art. That is, both the creation of and the appreciation of artworks relies on the exercise of the imagination. The focus here will be on the creation of work.

The idea of imaginative experience in aesthetics has many links with arguments about novelty and creativity in the literature on computational creativity. In particular, there is a long debate about whether a search process can generate something novel [10, 12, 123]; ideas of imagination and novelty are closely linked. The argument against machine novelty revolves around the idea that once a search space is defined, the creativity of the system is constrained; anything the system does is 'mere generation' within an already-defined system [120]. However, search spaces can be vast; in a vast enough search space, the search *process* becomes much more significant.

Other than the production of *novel* ideas, what could it mean for an AI system to be said to be exercising *imagination*? One idea is simply that it is capable of exploring a search space in a way that leads to aesthetically valuable patterns; this is just a re-posing of the question of why people find certain patterns to be aesthetically valuable.

A deeper idea of imagination could be that the system is capable of bringing together different ideas. This could be literal visual ideas, as explored by systems such as *Vismantic*, which brings together aspects of two source images in an attempt to produce a new image that has aspects of the two. The idea is that the new image is a coherent image in its own right, but also one that has aspects of the two source images. At a more abstract level, this idea of imagination as combination leads to ideas of the computational generation of metaphor [58], which has been explored more extensively in computational linguistic creativity [118] rather than in visual creativity. Further developments in this area are likely to depend on computer systems that can build up a large store of knowledge about the world [18, 55, 107] so that the system can draw on this knowledge in exercising its imagination. This ability to draw on a vast store of information, and make novel connections, is at the core of what is meant by imagination for people, and would be one way to develop the imaginative sense in computers too.

## 2.10 Criticism and the Artworld

As discussed at length by Danto [32, 33], art does not exist in isolation. It is contextualised both in an 'artworld' of creators, audiences and critics, and in a wider

society. In particular, the same object might be regarded differently at different times and places because of this contextual information. A small number of AI art systems have started to explore this, and search can be driven by CRITICS AND CO-EVOLUTION fitness drivers. In these, the search space is not just one of artistic creators—a second population exists of critic agents that comment on the art being produced and influence how the search progresses [54, 74, 75, 97, 98].

There is a connection between this idea of critic agents and the GAN art [42] discussed in Section 2.4. A GAN learns two models from the data presented to it in a training set. The first is the *generator*, which builds examples based on the training data, and the second is a *discriminator* that learns to rate the similarity of the generated images to that training data. In applications of GANs in art, it is the outputs from the generator that are presented as artworks. The discriminator, however, can be seen as a critic/evaluator that emerges as a natural part of the design process. Perhaps as such critics become more sophisticated, they could be separated from their original context and become a useful output of the system in their own right, as a learned model of criticism.

## 2.11 Aesthetics as a Cluster Concept

The previous sections have reviewed AI art and search-based art-making through the individual lenses of particular aesthetic theories. It is important, however, to also consider the idea proposed by Dutton [39, 40] that art and aesthetics are 'cluster concepts'. That is, there are a number of characteristics that are typically found in artworks and human response thereto, but none of them are necessary or sufficient.

Section 2.7.3 introduced the idea that different, orthogonal notions of form can be explored using multicriterion optimisation. This could be generalised beyond a single class of aesthetic ideas. One way to operationalise aesthetics as a cluster concept is to see each of the characteristics as one (or more) orthogonal dimensions to be explored using a multicriterion optimisation system. So, for example, one dimension might be formal aspects of the artwork being produced, another its emotional expressivity, etc. The idea of combining multiple aesthetic measures has been explored by den Heijer and Eiben [34], but all of the measures draw on a broadly similar class of aesthetic theories. Along similar lines, Vouliouri [121] explores the idea of using multi-criteria optimisation to balance aesthetic and functional criteria in automated design.

A related idea is found in modular AI art systems such as the *Painting Fool* [29]. Such systems contain modules that handle different aspects of the system. For example, one module might be concerned with placing objects in a symmetrical fashion, another with analysing the emotional response of people to the artworks it is generating, another with generating framing information to accompany the work. Misztal and Indurkhya [83] have articulated particularly clearly one way of realising such a system, by using a *blackboard* architecture. This is where different putative components of a work are stored on a so-called 'blackboard' (a data structure) and various agents work to modify the components and bring them together, each of which is concerned with a different artistic skill. Furthermore, some agents are concerned with aesthetic evaluation, and multiply or remove items from the blackboard according to these evaluations. These demonstrate particular architectures that realise the idea of aesthetics as a cluster concept.

# 2.12 Conclusions

This paper has examined various theories of aesthetics and their relationship to the production of art in various media through AI systems, particularly search-based systems. Four questions were introduced towards the beginning of the paper. By means of a conclusion, these will now be revisited.

## 2.12.1 Aesthetic Theories and AI Art

The first question asked whether traditional aesthetic theories can be applied to search-based AI art-making. The key question here is whether the search drivers—the ways of scoring or ranking objects in the search space—are based on ideas from traditional aesthetic theories, or whether they are based on entirely new ideas. Overall, there is a strong alignment between the various characteristics of traditional aesthetic ideas and the search drivers used in AI art. For example, aesthetics of form are realised in AI art through measures of symmetry and balance, the idea of imitation in works that draw on inspiring sets, and theories of expression in systems that use humans in the search loop. This gives us confidence in these aesthetic theories—even with the radical shift presented by AI art, the underpinning aesthetic theories are still of relevance. Nonetheless, AI artworks can drive the expansion of these aesthetic theories. These are considered in the next section.

## 2.12.2 Expanding Theories for AI Art

The second question asked whether traditional themes in aesthetic theory need to be expanded or adapted to examine these new forms of art.

Early aesthetic theories concerning **representation and imitation** get new life through the idea of *aesthetic rescaling*. That is, the idea that technology can simulate and visualise phenomena at new temporal and spatial scales, allowing the audience to have an aesthetic engagement with phenomena that are not normally appreciable to human perception. These ideas also link to aesthetic theories of focus of attention and 'making special'.

Theories of **expression** provide a challenge for AI-based art, because machines do not experience qualia and emotions to be expressed. Yet, these theories can be re-interpreted in light of AI art systems. One way is to consider systems as expressions of their metamakers, the authors of the programs; that opens up an interesting discussion about the degree of control that is desirable between the metamaker and the final product. Another interesting area is those systems where having a human-in-the-loop allows that human to explore means of expression that are not readily available to them without the computer system—an expression facilitating or self-contagion system.

Theories concerned with **form** seem initially more amenable to computational realisation; formal aspects of many artistic media can be measured algorithmically and used as search drivers.

Other aspects of aesthetics have been more neglected in AI art to date. **Artistic skill** is rarely a focus of attention in AI artworks. Despite a couple of attempts, systems based around the idea of **critics** and embedding an AI artmaker into a **wider artworld context** are still at an early stage.

An interesting challenge for future work is the idea of new aesthetic theories that are distinctive to autonomous creative AI systems. The ideas of self-contagion and aesthetic rescaling show how existing ideas in aesthetics can be extended for computational creative systems. Recently, authors have begun to explore new aesthetic ideas, such the the idea of *explainability* as a meta-aesthetic explored by Bodily and Ventura [13].

### 2.12.3 Gaps and Assumptions

Are there gaps or hidden assumptions in our ways of understanding AI-based art? One point that emerges from the discussion in this chapter is the emphasis on aesthetics as a cluster concept. Because of the emphasis in AI search on the fitness function, there is a corresponding tendency for designers of such systems to choose a single aesthetic perspective as the driver of the system. Instead, this cluster-concept view emphasises the value of systems that have attempted to incorporate multiple aesthetic theories into a single system. Another point concerns responsibility and authorship: the existence of AI-created art problematises the idea of who or what created the art. Should the programmer of the AI systems used in creating the art be afforded with some credit? Should the system itself be credited?

### 2.12.4 Understanding Human Art-Making

Can computational and AI concepts help us understand human art-making? The search-based perspective on art-making provides a formalisation of spaces of possibility and the criteria that are used in moving through them. The classification of creativity into exploratory, combinational and transformational [10] gives a new way to think about the development of artistic style.

The requirement to be explicit about the driver of the search provides a new perspective on potential drivers for human art-making. Are similar drivers at work in human art-making? Or, are human art-makers much more driven by an 'engagement-reflection' cycle [105] where they are constantly swapping between the process of making and the process of reflecting on and contextualising what has just been made in order to drive the next moment of making? One radical difference between human art-making and search-based AI art is that in the latter the drivers are almost always decided before the search process begins. By contrast, the human artist appears to generate these during the development of a work, drawing on a lifetime of experience, knowledge, and emotion.

One useful concept that emerges from the discussion in this paper is the idea of trying to satisfy multiple criteria simultaneously. One of the great challenges of art is to produce a work that is *at the same time* formally well structured, emotionally expressive, and sufficiently well imitative of its subject matter (for example) that such representations can be understood by the viewer. Even within one set of aesthetic ideas (e.g. that of form), it may not be possible to simultaneously satisfy multiple aspects of form within the same work, necessitating a trade-off. Looking at art-making as a search process formalises this in terms of concepts from multi-criterion optimisation, and provides a language to describe such processes.

## 2.12.5 Future Directions

What challenges does this provoke for future work in AI art and computational creativity? One area is putting the AI art system into a wider context. One direction might be to build a system that tries to recapitulate through simulation the evolutionary origins of aesthetics (analogously to how researchers have simulated the origins of language [87]). Another context is that of a wider 'artworld' [32], where artists, audiences, critics, and a wider contextual world interact; this could consist entirely in a simulated world, or could involve search-based art which pays attention to the external world of human art and wider society.

This discussion of audience and critics leads to a broader question of AI art critics and audiences. Could computer systems develop aesthetic behaviour and judgement, particularly in the absence of qualia and emotional feeling? Some specific methods have been developed for the computational analysis of very specific kinds of art (e.g. [36]), but general AI art criticism and analysis has had little exploration.

This paper began with a discussion of the drivers for search-based art. Typically, as with other areas of AI, these drivers are very simple; a point in the search space is examined by an algorithm, and a numerical score or ranking is given. One technique which seems particularly amenable to this kind of work is the idea of richer search drivers [70], which provide not just a single figure but a richer description of the steps to take to explore the search space.

# References

[1] Blaise Agüera y Arcas. Art in the age of machine intelligence. *Arts*, 6(18), 2017. https://doi.org/10.3390/arts6040018.

[2] S. Aupetit, V. Bordeau, N. Monmarche, M. Slimane, and G. Venturini. Interactive evolution of ant paintings. In *The 2003 Congress on Evolutionary Computation, 2003. CEC '03.*, volume 2, pages 1376–1383, 2003.

[3] Angela Katherine Baker. Alba emoting: A safe, effective, and versatile technique for generating emotions in acting performance. Master's thesis, Brigham Young University, 2008. URL https://scholarsarchive.byu.edu/cgi/viewcontent.cgi?article=2456&context=etd.

[4] Laura Barton. The man who rewrote his life. *The Guardian*, 15th September 2006. URL https://www.theguardian.com/books/2006/sep/15/usa.world.

[5] Clive Bell. *Art*. Chatto and Windus, 1914.

[6] Walter Benjamin. The work of art in the age of mechanical reproduction. In Hannah Arendt, editor, *Illuminations*, pages 214–218, 1969. translated by Harry Zohn, originally published 1935,.

[7] Arnold Berleant. Environment as an aesthetic paradigm. *Dialectics and Humanism*, 15:95–106, 1988.

[8] Jon Bird, Joe Faith, and Andy Webster. *Tabula Rasa*: A case study in evolutionary curation. In Stefano Cagnoni et al., editors, *Applications of Evolutionary Computing: Evoworkshops 2003*, volume 2611 of *Lecture Notes in Computer Science*, pages 981–995. Springer, 2003.

[9] George David Birkhoff. *Aesthetic Measure*. Harvard University Press, 1933.

[10] Margaret Boden. *The Creative Mind: Myths and Mechanisms*. Abacus, 1990.

[11] Margaret Boden.     Robot says: Whatever.     *Aeon*, 2018.     URL
     https://aeon.co/amp/essays/the-robots-wont-take-over-because-
     they-couldnt-care-less.

[12] Margaret A. Boden. Creativity and artificial intelligence. *Artificial Intelli-
     gence*, 103(1–2):347–356, 1998.

[13] Paul M. Bodily and Dan Ventura. Explainability: An aesthetic for aesthetics in
     computational creative systems. In François Pachet et al., editors, *Proceedings
     of the 9th International Conference on Computational Creativity*, pages 153–
     160, 2018.

[14] Eric Bonabeau, Marco Dorigo, and Guy Theraulaz. *Swarm Intelligence*. Ox-
     ford University Press, 1999.

[15] Andreas Broeckmann.     The machine artist as myth.     *Arts*, 8(25), 2019.
     https://doi.org/10.3390/arts8010025.

[16] Bruce G. Buchan. Creativity at the meta-level. *AI Magazine*, 22(3):13–28,
     2001.

[17] John Cage. *Atlas Eclipticalis*. Edition Peters, 1961.

[18] Erik Cambria, Amir Hussain, Catherine Havasi, and Chris Eckl.  Common
     sense computing: From the society of mind to digital intuition and beyond.
     In Julian Fierrez et al., editors, *Biometric ID Management and Multimodal
     Communication*, pages 252–259. Springer, 2009.

[19] Allen Carlson.  Appreciation and the natural environment. *Journal of Aes-
     thetics and Art Criticism*, 37:267–276, 1979.

[20] Noel Carroll. On being moved by nature: Between religion and natural history.
     In Salim Kemal and Ivan Gaskell, editors, *Landscape, Natural Beauty and the
     Arts*. Cambridge University Press, 1995.

[21] Noël Carroll. *Philosophy of Art: A Contemporary Introduction*. Routledge,
     1999.

[22] John Charnley, Alison Pease, and Simon Colton. On the notion of framing in
     computational creativity. In Mary Lou Maher et al., editors, *Proceedings of
     the International Conference on Computational Creativity*, pages 77–81, 2012.

[23] Harold Cohen. The further exploits of AARON, painter. *Stanford Humanities
     Review*, 4(2):141–158, 1995.

[24] R.G. Collingwood. *The Principles of Art*. Oxford University Press, 1938.

[25] John Collomosse and Peter Hall. Salience-adaptive painterly rendering using
     genetic search. *International Journal on Artificial Intelligence Tools*, 15(4):
     551–576, 2006.

[26] Simon Colton. *Automated Theory Formation in Pure Mathematics*. Springer,
     2002.

[27] Simon Colton. Automatic invention of fitness functions with application to
     scene generation. In Mario Giacobini et al., editors, *Applications of Evolu-
     tionary Computing*, volume 4974 of *Lecture Notes in Computer Science*, pages
     381–391. Springer Berlin / Heidelberg, 2008.

[28] Simon Colton. Creativity versus the perception of creativity in computational
     systems. In *Proceedings of the AAAI Symposium on Creative Systems*, pages
     14–20, 2008.

[29] Simon Colton. The painting fool: Stories from building an automated painter.
     In Jon McCormack and Mark d'Inverno, editors, *Computers and Creativity*,
     pages 3–38. Springer, 2012.

[30] Simon Colton, Michel F. Valstar, and Maja Pantic. Emotionally aware automated portrait painting. In Sofia Tsekeridou et al., editors, *Proceedings of the Third International Conference on Digital Interactive Media in Entertainment and Arts, DIMEA 2008*, ACM International Conference Proceeding Series Volume 349, pages 304–311, 2008.

[31] Simon Colton, Alison Pease, and Rob Saunders. Issues of authenticity in autonomously creative systems. In François Pachet et al., editors, *Proceedings of the 9th International Conference on Computational Creativity*, pages 272–279, 2018.

[32] Arthur Danto. The artworld. *Journal of Philosophy*, 64(19):571–584, 1964.

[33] Arthur Danto. *The Transfiguration of the Commonplace*. Harvard University Press, 1981.

[34] E. den Heijer and A. E. Eiben. Evolving art using multiple aesthetic measures. In Cecilia Di Chio et al., editors, *Applications of Evolutionary Computation*, volume 6625 of *Lecture Notes in Computer Science*, pages 234–243. Springer Berlin / Heidelberg, 2011.

[35] Ellen Dissanayake. *Homo Aestheticus: Where Art Comes From and Why*. University of Washington Press, 1997.

[36] Neil A. Dodgson. Regularity and randomness in Bridget Riley's early op art. In Douglas W. Cunningham et al., editors, *Computational Aesthetics in Graphics, Visualization, and Imaging*. The Eurographics Association, 2008.

[37] Alan Dorin and Kevin B. Korb. A new definition of creativity. In Kevin Korb, Marcus Randall, and Tim Hendtlass, editors, *Artificial Life: Borrowing from Biology*, pages 11–21, 2009.

[38] Scott Draves. The electric sheep screen-saver: A case study in aesthetic evolution. In Franz Rothlauf et al., editors, *Applications of Evolutionary Computing*, volume 3449 of *Lecture Notes in Computer Science*, pages 458–467. Springer Berlin / Heidelberg, 2005.

[39] Denis Dutton. *The Art Instinct: Beauty, Pleasure, and Human Evolution*. Oxford University Press, 2009.

[40] Denis Dutton. Aesthetic universals. In Berys Gaut and Dominic McIver Lopes, editors, *The Routledge Companion to Aesthetics*, pages 267–278. Routledge, 2013.

[41] Craig Dworkin and Kenneth Goldsmith, editors. *Against Expression*. Northwestern University Press, 2011.

[42] Ahmed M. Elgammal, Bingchen Liu, Mohamed Elhoseiny, and Marian Mazzone. CAN: creative adversarial networks, generating "art" by learning about styles and deviating from style norms. In Ashok Goel, Anna Jordanous, and Alison Pease, editors, *Proceedings of the Eighth International Conference on Computational Creativie*, pages 96–103, 2017.

[43] Brian Evans. Integration of music and graphics through algorithmic congruence. In *Proceedings of the 1987 International Computer Music Conference*, pages 17–24, 1987.

[44] Leon A. Gatys, Alexander S. Ecker, and Matthias Bethge. A neural algorithm of artistic style. *CoRR*, abs/1508.06576, 2015. URL http://arxiv.org/abs/1508.06576.

[45] Leon A. Gatys, Alexander S. Ecker, and Matthias Bethge. Image style transfer using convolutional neural networks. In *2016 IEEE Conference on Computer Vision and Pattern Recognition (CVPR)*, pages 2414–2423, 2016.

[46] Berys Gaut and Dominic McIver Lopes, editors. *The Routledge Companion to Aesthetics*, 2013. Routledge.

[47] Pablo Gervas. Computational approaches to storytelling and creativity. *AI Magazine*, 30(3):49–62, 2009.

[48] Thalia Raquel Goldstein and Ellen Winner. A new lens on the development of social cognition: The study of acting. In Constance Milbrath and Cynthia Lightfoot, editors, *Art and Human Development*. Psychology Press (Taylor and Francis), 2012.

[49] Ian Goodfellow, Yoshua Bengio, and Aaron Courville. *Deep Learning*. MIT Press, 2017.

[50] Ian J. Goodfellow et al. Generative adversarial nets. In *Proceedings of the 27th International Conference on Neural Information Processing Systems - Volume 2*, pages 2672–2680. MIT Press, 2014.

[51] Gary Greenfield. Evolved ricochet compositions. In Mario Giacobini et al., editors, *Applications of Evolutionary Computing*, volume 5484 of *Lecture Notes in Computer Science*, pages 518–527. Springer Berlin / Heidelberg, 2009.

[52] Gary Greenfield. Avoidance drawings evolved using virtual drawing robots. In Colin Johnson, Adrian Carballal, and João Correia, editors, *Evolutionary and Biologically Inspired Music, Sound, Art and Design*, pages 78–88, 2015.

[53] Gary Greenfield. Evolved deflection drawings. In *2016 IEEE Congress on Evolutionary Computation (CEC)*, pages 4562–4569, 2016.

[54] Gary Greenfield and Penousal Machado. Simulating artist and critic dynamics—an agent-based application of an evolutionary art system. In *IJCCI 2009 - Proceedings of the International Joint Conference on Computational Intelligence*, pages 190–197, 2009.

[55] Emma Hart. Towards lifelong learning in optimisation algorithms. In *Proceedings of the 9th International Joint Conference on Computational Intelligence - Volume 1: IJCCI,*, pages 7–9. INSTICC, SciTePress, 2017. doi: 10.5220/0006810500010001.

[56] Aaron Hertzmann. Can computers create art? *Arts*, 7(18), 2018. https://doi.org/10.3390/arts7020018.

[57] Bert Hölldobler and Edward O. Wilson. *The Ants*. Springer, 1990.

[58] Bipin Indurkhya. On the role of metaphor in creative cognition. In Dan Ventura et al., editors, *Proceedings of the International Conference on Computational Creativity: ICCC-X*, pages 51–59, 2010.

[59] Colin G. Johnson. Connotation in computational creativity. *Cognitive Computation*, 4(3):280–291, 2012.

[60] Colin G. Johnson. Fitness in evolutionary art and music: What has been used and what could be used? In Penousal Machado, Juan Romero, and Adrian Carballal, editors, *Evolutionary and Biologically Inspired Music, Sound, Art and Design*, volume 7247 of *Lecture Notes in Computer Science*, pages 129–140. Springer Berlin / Heidelberg, 2012.

[61] Colin G. Johnson. Is it time for computational creativity to grow up and start being irresponsible? In Simon Colton et al., editors, *Procedings of the Fifth International Conference on Computational Creativity*, pages 263–267, 2014.

[62] Colin G. Johnson. Fitness in evolutionary art and music: a taxonomy and future prospects. *International Journal of Arts and Technology*, 9(1), 2016.

[63] Colin G. Johnson et al. Understanding aesthetics and fitness measures in evolutionary art systems. *Complexity*, 2019, 2019. Article ID 3495962.

[64] Anna Jordanous. A standardised procedure for evaluating creative systems: Computational creativity evaluation based on what it is to be creative. *Cognitive Computation*, 4(3):246–279, 2012.

[65] Branden W. Joseph. *Experimentations: John Cage in Music, Art, and Architecture*. Bloomsbury, 2016.

[66] Immanuel Kant. *Critique of the Power of Judgement*. Lagarde und Friedrich, 1790. translation by P. Guyer and A.W. Wood, Cambridge University Press, 2000.

[67] Peter Kivy. *Authenticities: Philosophical Reflections on Musical Performance*. Cornell University Press, 1998.

[68] Mario Klingemann. Quasimondo: Mario Klingemann, artist. Visited August 2019, 2019. URL http://quasimondo.com.

[69] Richard Kostelanetz and John Cage. The aesthetics of John Cage: A composite interview. *The Kenyon Review*, 9(4):102–130, 1987.

[70] Krzysztof Krawiec, Jerry Swan, and Una-May O'Reilly. Behavioral program synthesis: Insights and prospects. In R. Riolo, B. Worzel, M. Kotanchek, and A. Kordon, editors, *Genetic Programming Theory and Practice XIII*, pages 169–183. Springer, 2016.

[71] A. Krzeczkowska, J. El-Hage, S. Colton, and S. Clark. Automated collage generation—with intent. In Dan Ventura et al., editors, *Proceedings of the International Conference on Computational Creativity*, pages 36–40, 2010.

[72] Fujun Luan, Sylvain Paris, Eli Shechtman, and Kavita Bala. Deep painterly harmonization. *Computer Graphics Forum*, 37(4):95–106, 2018.

[73] Penousal Machado and Amílcar Cardoso. All the truth about NEvAr. *Applied Intelligence*, 16(2):101–118, 2002.

[74] Penousal Machado, Juan Romero, Mara Santos, Amlcar Cardoso, and Bill Manaris. Adaptive critics for evolutionary artists. In Günther Raidl et al., editors, *Applications of Evolutionary Computing*, volume 3005 of *Lecture Notes in Computer Science*, pages 437–446. Springer Berlin / Heidelberg, 2004.

[75] Penousal Machado, Juan Romero, and Bill Manaris. Experiments in computational aesthetics. In Juan Romero and Penousal Machado, editors, *The Art of Artificial Evolution*, pages 381–415. Springer, 2008.

[76] Penousal Machado, João Correia, and Juan Romero. Expression-based evolution of faces. In Penousal Machado, Juan Romero, and Adrian Carballal, editors, *Evolutionary and Biologically Inspired Music, Sound, Art and Design*, volume 7247 of *Lecture Notes in Computer Science*, pages 187–198. Springer Berlin / Heidelberg, 2012.

[77] Marian Mazzone and Ahmed Elgammal. Art, creativity, and the potential of artificial intelligence. *Arts*, 8(26), 2019. https://doi.org/10.3390/arts8010026.

[78] Pamela McCorduck. *Aaron's Code*. W.H. Freeman & Co, 1991.

[79] Jon McCormack. Eden: An evolutionary sonic ecosystem. In Josef Kelemen and Petr Sosík, editors, *Advances in Artificial Life, Proceedings of the 6th European Conference*, pages 133–142. Springer, 2001.

[80] Jon McCormack. Open problems in evolutionary music and art. In Franz Rothlauf et al., editors, *Applications of Evolutionary Computing*, volume 3449 of *Lecture Notes in Computer Science*, pages 428–436. Springer Berlin / Heidelberg, 2005.

[81] Jon McCormack. Creative ecosystems. In Jon McCormack and Mark d'Inverno, editors, *Computers and Creativity*, pages 39–60. Springer, 2012.

[82] Jon McCormack and Mark d'Inverno, editors. *Computers and Creativity*, 2012. Springer.

[83] Joanna Misztal and Bipin Indurkhya. Poetry generation system with an emotional personality. In Simon Colton et al., editors, *Proceedings of the 5th International Conference on Computational Creativity*, pages 72–81, 2014.

[84] Thomas Mitchell. *Machine Learning*. McGraw-Hill, 1997.

[85] Jemma Montagu. *The Surrealists: Revolutionaries in Art and Writing 1919–35*. Tate Publishing, 2002.

[86] Leonel Moura. Robot art: An interview with Leonel Moura. *Arts*, 7(3):28, 2018.

[87] Martin A. Nowak and David C. Krakauer. The evolution of language. *Proceedings of the National Academy of Sciences*, 96(14):8028–8033, 1999.

[88] Obvious. Obvious, explained. medium.com, visited August 2019, 2018.

[89] Obvious Collective. Obvious. Visited August 2019, 2019. URL https://obvious-art.com.

[90] Rafael Pérez y Pérez and Mike Sharples. MEXICA: A computer model of a cognitve account of creative writing. *Journal of Experimental and Theoretical Artifical Intelligence*, 13:119–139, 2001.

[91] Rosalind Picard. *Affective Computing*. MIT Press, 1997.

[92] Plato. *Cratylus. Parmenides. Greater Hippias. Lesser Hippias*. Harvard University Press, 1926. Loeb Classical Library Volume 167, Translated by Harold North Fowler.

[93] Rafael Ramirez et al. A sequential covering evolutionary algorithm for expressive music performance. In *Proceedings of the 18th Conference on Innovative Applications of Artificial Intelligence - Volume 2*, pages 1830–1835, 2006. ISBN 978-1-57735-281-5.

[94] Graeme Ritchie. Assessing creativity. In *Proceedings of the AISB Symposium on Artificial Intelligence and Creativity in Arts and Science*, pages 3–11. AISB Press, 2001.

[95] Graeme Ritchie. Some empirical criteria for attributing creativity to a computer program. *Minds and Machines*, 17:67–99, 2007.

[96] Juan Romero and Penousal Machado, editors. *The Art of Artificial Evolution*, 2008. Springer.

[97] Juan Romero, Penousal Machado, Antonio Santos, and Amilcar Cardoso. On the development of critics in evolutionary computation artists. In Stefano Cagnoni et al., editors, *Applications of Evolutionary Computing: Evoworkshops 2003*, volume 2611 of *Lecture Notes in Computer Science*, pages 559–569. Springer, 2003.

[98] Juan Romero, Penousal Machado, and Antonino Santos. On the socialization of evolutionary art. In Mario Giacobini et al., editors, *Applications of Evolutionary Computing*, volume 5484 of *Lecture Notes in Computer Science*, pages 557–566. Springer Berlin / Heidelberg, 2009.

[99] Robert Rowe. *Interactive Music Systems*. MIT Press, 1997.

[100] Yuriko Saito. Appreciating nature on its own terms. *Environmental Ethics*, 20:135–149, 1998.

[101] Dario Sanfilippo. Turning perturbation into emergent sound, and sound into perturbation. *Interference: Journal of Audio Culture*, 3, 2013. URL http://www.interferencejournal.org/turning-perturbation-into-emergent-sound/.

[102] Ruth L. Saw. *Aesthetics: An Introduction*. Macmillan, 1972.

[103] Nadja Sayej. This computer painting program has feelings. *Vice*, November 2013. URL `https://www.vice.com/en_us/article/4w7vvg/the-computer-painting-program-with-feelings`.

[104] Juergen Schmidhuber. Low-complexity art. *Leonardo*, 30(2):97–103, 1997.

[105] Mike Sharples. *How We Write: Writing as Creative Design*. Routledge, 1998.

[106] Anne Sheppard. *Aesthetics: An Introduction to the Philosophy of Art*. Oxford University Press, 1987.

[107] Daniel L. Silver, Qiang Yang, and Lianghao Li. Lifelong machine learning systems: Beyond learning algorithms. In *AAAI Spring Symposium: Lifelong Machine Learning*, pages 49–55. AAAI Press, 2013.

[108] Karen Simonyan, Andrea Vedaldi, and Andrew Zisserman. Deep inside convolutional networks: Visualising image classification models and saliency maps. In *Workshop at International Conference on Learning Representations*, 2014.

[109] Aaron Sloman. *The Computer Revolution in Philosophy*. The Harvester Press, 1978.

[110] Emily L. Spratt. Dream formulations and deep neural networks: Humanistic themes in the iconology of the machine-learned image. *Kunsttexte*, 4, 2017.

[111] Joseph Stromberg. These abstract portraits were painted by an artificial intelligence program. *smithsonian.com*, November 2013. URL `https://www.smithsonianmag.com/science-nature/these-abstract-portraits-were-painted-by-an-artificial-intelligence-program-180947590/`.

[112] Richard S. Sutton and Andrew G. Barto. *Reinforcement Learning: An Introduction*. MIT Press, 2018. Second Edition.

[113] Susan Leith Taylor. *Actor Training and Emotions: Finding a Balance*. PhD thesis, Edith Cowan University, 2006. URL `http://ro.ecu.edu.au/theses/1804`.

[114] Leo Tolstoy. *What is Art?* Oxford University Press, 1897. English Translation by Aylmer Maude, 1930.

[115] Christopher Turner. The deliberate accident in art. *Tate Etc.*, 21, Spring 2011.

[116] David Vanderhaeghe and John Collomosse. Stroke based painterly rendering. In Paul Rosin and John Collomosse, editors, *Image and Video-based Artistic Stylisation*. Springer, 2012.

[117] William Vaughan. *Romanticism and Art*. Thames and Hudson, second edition, 1994.

[118] Tony Veale. *Exploding the Creativity Myth: The Computational Foundations of Linguistic Creativity*. Bloomsbury Academic, 2012.

[119] Tony Veale and Amícar Cardoso, editors. *Computational Creativity ;The Philosophy and Engineering of Autonomously Creative Systems*, 2019. Springer.

[120] Dan Ventura. Mere generation: Essential barometer or dated concept? In François Pachet et al., editors, *Proceedings of the Seventh International Conference on Computational Creativity*, pages 17–24, 2016.

[121] Eirini Vouliouri. Merging aesthetics with functionality: An interactive genetic algorithm based on the principle of weighted mutation. In Cecilia Di Chio et al., editors, *Applications of Evolutionary Computation*, volume 6625 of *Lecture Notes in Computer Science*, pages 424–433. Springer Berlin / Heidelberg, 2011.

[122] Geraint A. Wiggins. A preliminary framework for description, analysis and comparison of creative systems. *Knowledge-Based Systems*, 19:449–458, 2006.

[123] Geraint A. Wiggins. Searching for computational creativity. *New Generation Computing*, 24:209–222, 2006.

[124] Ludwig Wittgenstein. *Philosophical Investigations*. Blackwell, 1953.

# 3

# Applicability of Convolutional Neural Network Artistic Style Transfer Algorithms

Florian Uhde

Volkswagen AG, Wolfsburg
Faculty of Computer Science, University of Magdeburg, Magdeburg, Germany
`florian.uhde@volkswagen.de`

**Summary.** Artistic Style Transfer is the process of using machine-learned separation between style and content of an image to create a novel piece of art, using a combination of the field of image attribution (extraction and recognition of style) and the problem of a texture transfer. This chapter highlights recent technologies and gives insights into different approaches for Artistic Style Transfer, which provide style-agnostic ways of Artistic Style Transfer. The aim of this chapter is to provide insights into selected current state-of-the-art methods, to conduct experiments on underlying fundamentals of the algorithms and to highlight different use cases, benefits, and shortcoming of these approaches.

Fig. 3.1: Style transfer renders the first image in the style of the second, resulting in a new artifact (right)

## 3.1 Artistic Style Transfer

This chapter highlights an image creation method called Artistic Style Transfer, a technique to create a novel image, based on given content, in a certain style, which is artistically pleasing. The following section highlights the overall concept and gives an agnostic view on how to approach Artistic Style Transfer. In Section 3.2 the reader is presented with different current approaches, their inner workings, and limitations to foster an understanding of this technique. Current points of research are highlighted later on, as well as comparisons and variations of established techniques, leaving the reader with a broad understanding of the process of Artistic Style Transfer.

© Springer Nature Switzerland AG 2021                                                     61
P. Machado et al. (eds.), *Artificial Intelligence and the Arts*, Computational
Synthesis and Creative Systems, https://doi.org/10.1007/978-3-030-59475-6_3

### 3.1.1 Concept

The core idea of Artistic Style Transfer is to create a novel image based on two user-provided guidance images. This leads to the search space for generated results being bound by the content and style of the source images, as the process shall always execute within the bound of the provided inputs. More specifically, resulting artifacts align with the content of the one image ($img_{content}$) and present this content in the style of the other image ($img_{style}$), see Figure 3.1 for an example of this procedure. The process will run offline, in the sense that after providing the guidance images no further user input is necessary to produce the resulting image. To accomplish this the procedure needs to define how to cope with certain questions [5]:

- Which parts of the content should be preserved (and to what extent) and which discarded or modified?
- Should edges and/or other elements in the content image be allowed to shift, and if so, how?
- Which color palette should the output adopt?
- How far should generated style elements be inserted in the regions where content is of no importance?
- Which parts from the style image qualify as style to be used, and which should be disregarded?

Especially the last question bears a certain interest: As validation and appreciation of art has traditionally been a very human feat, we see computer-aided techniques emerge in the validation objective [29], but to create an aesthetically pleasing result the procedure needs to have some function to evaluate appreciation. Artistic Style Transfer requires the style image for the purpose of defining the desired aesthetic, but still, the problem of extracting the relevant information is no trivial task.

While style transfer itself can be seen as a more specific task of texture synthesis, a well-researched topic ([1, 4, 16]), this chapter focuses on approaches making use of neural networks. With this scope, two kinds of techniques are commonly used to solve this problem: *Feed forward networks* that are trained to generate images in a certain style given the relevant inputs [3, 15, 25], or the transfer of the problem into a loss-minimization problem [8]. The following section, 3.1.1, gives an abstract definition of the style transfer problem, which is afterward dissected as an optimization problem, as in the work of Gatys and colleagues [8] which is used commonly as a baseline implementation for Artistic Style Transfer.

### Formalization of Artistic Style Transfer

Given the previous explanation we can formalize a general formula describing Artistic Style Transfer: An image $I$ can then be described by (3.1), as the combination of style ($I^S$) and content ($I^C$). Style transfer takes two guidance images, $I_{style}$ and $I_{content}$, extracts the respective element and combines them into a novel image, as defined in (3.2). To extract $I^S$ and $I^C$ from $I$ we define two functions (3.3,3.4).

$$I = combine(I^S, I^C) \tag{3.1}$$

$$I_{result} = ST(I_{style}, I_{content}) = combine(I^S_{style}, I^C_{content}) \tag{3.2}$$

$$style^{-1}(I) = I^S \tag{3.3}$$

$$content^{-1}(I) = I^C \tag{3.4}$$

This abstract formalization of the problem can be reduced into the definition of three operators: $combine(I^S, I^C)$, $style^{-1}(I)$ and $content^{-1}(I)$. The inverse of the last two functions which extract style and content from an image can be used to replace the combine operator. In this case $I_{candidate}$ is an initial image that we infuse with content and style.

$$I = combine(I^S, I^C) = style(I^S, content(I^C, I_{candidate}))$$ (3.5)

Putting all of this together we can build a formalization of general Artistic Style Transfer (3.6) that depends on a candidate image and the extracted content, as well as the style of the guidance input:

$$ST(I_{style}, I_{content}) = style(style^{-1}(I_{style}), content(content^{-1}(I_{content}), I_{candidate}))$$
(3.6)

The remaining problem with these equations is that the definition of style and content is still very fuzzy. For example, a color choice in the original image can be part of the content as well as of the style. Also, the algorithm should weight content-faithfulness and free-style-creation based on image content. When style-transferring a portrait the algorithm should be very content-faithful in the area of the face, as this is the content the picture is focused on. On the background, however, the algorithm can add details and elements of the target style. The core idea implemented by Gatys, et al., Herzmann, et al. and Olah, et al. [8, 13, 22] is the creation of a random candidate image and the calculation of two loss functions, which each rate the candidate in terms of style and content, and then gradually improve the image by, depending on the selected technique (Section 3.1.1), feeding it through a neural network or changing it slightly to reduce the loss using gradient descent.

The next section will introduce different peculiarities of this idea starting with a slightly simpler approach to style transfer, providing an additional input to formalize a relationship between style and content by user input.

## 3.2 State of the Art Style Transfer

This section will provide the reader with insights into various, composable parts of Artistic Style Transfer. It aims to give an understanding of the underlying techniques, their benefits, and shortcomings, as well as extensions that help to modify the techniques.

### 3.2.1 Analogy Style

This first technique is an extension to texture synthesis, which encompasses elements of Artistic Style Transfer. The work of Hertzmann et al. [13] uses a third image to define the exact mapping between style and content. By feeding the algorithm the images $I_{content}$, $I_{style}$ and $I'_{style}$ it can construct a mapping between $I_{style}$ and $I'_{style}$ and apply this mapping to then create the final image. Through this third image the user provides the computer with the $style^{-1}$ function, as defined in Section 3.1.1. The algorithm then applies this function to $I_{content}$, executing $style(style^{-1}(I_{style}), I_{content})$.

Figure 3.2 shows an example of this process. The two traditional input images are Figure 3.2a and Figure 3.2c, then a graphic program is used to desaturate Figure 3.2a, creating Figure 3.2b. These two images define the mapping function which is used as $style^{-1}$ and applied to Figure 3.2c. Only by analyzing the relationship between the first colored image and its gray-scaled counterpart, the algorithm can 'learn' a colorization filter, applying it to other images as well. As the procedure involves finding similar elements in both images it also requires that both images lie to some extent in the same content domain. This is visualized in Figure 3.2e and Figure 3.2f, where the same input mapping is applied to a content image from a slightly different domain (face shot vs. painting of a scene). While analogy-based transfer will still colorize the image, it will fail to produce meaningful results. The challenge, that this transfer only works well when a high quality mapping can be generated offline and provided to the algorithm, will be addressed in Section 3.2.2.

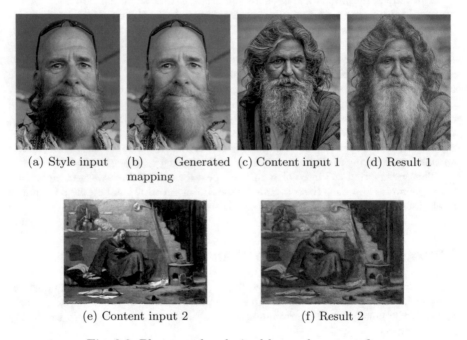

(a) Style input    (b)    Generated   (c) Content input 1    (d) Result 1
                   mapping

(e) Content input 2                    (f) Result 2

Fig. 3.2: Photograph colorized by analogy transfer

The use case of image analogies [13], closest to Artistic Style Transfer, is using a designated mapping texture to transfer style onto another schematic mapping. Figure 3.3 shows the inputs and result of such a process. A hand made, rough annotation of the style input was created (Figure 3.3b), as well as a content input (Figure 3.3c), denoting the desired composition of the result (Figure 3.3d). In this case small patches of features are sampled from the style input and placed into the corresponding areas of the content input, smoothly transitioning between different classes of content. The analogy transfer is good at persisting with the content map-

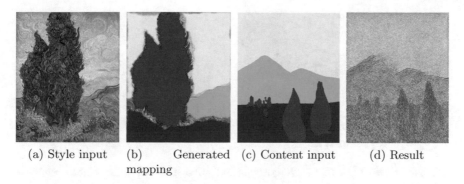

| (a) Style input | (b)     Generated mapping | (c) Content input | (d) Result |

Fig. 3.3: Style of Van Gogh transferred into a novel image

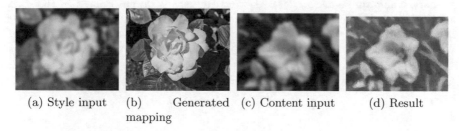

| (a) Style input | (b)     Generated mapping | (c) Content input | (d) Result |

Fig. 3.4: Unblur filter

ping provided, filling it with appropriate elements from the style image, yet images tend to look a bit blurry and washed out at the boundaries of single features. This could potentially be prevented by mapping images in luminance space [13] and by employing a more complex texture segmentation [19] to better align the features in mapping and content input. One influencial parameter on the quality of the result is the scale in which the features are transferred, as it directly influences the size of the features composing the resulting image [31].

Analogy transfer limitations show as soon as previously unknown data is involved. Figure 3.4 shows the process of an unblur / sharpen filter: Generating an unblurred image out of blurred input. While the result shows a partial success, as the overall resolution of the image seems to have increased, it fails at generating the necessary details to make the result look believable. The data to fill the 'blanks' is not present in the mapping as we require an enrichment of information to generate the result from the input. The algorithm will fall back onto known pairs from the provided mapping, creating the jagged, coarse look that is shown in Figure 3.4d. This limitation in hallucination capabilities can partly be avoided by providing more than one input pair as training reference for the algorithm, as done in the work by Hertzmann et al. [13], giving a broader choice of potential mapping and therefore enabling the process to interpolate missing information better. A more extreme example of missing information can be seen in Figure 3.5. The image is using the style input and mapping from Figure 3.3, but this time the content composition contains

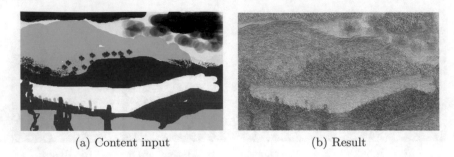

(a) Content input                                    (b) Result

Fig. 3.5: Style of Van Gogh transferred into a novel image *with unknown features*

formerly unknown segments. The lake and the clouds do not appear in the style source or annotation and can therefore not properly be matched. In this example the lake is rendered well, but for the clouds the algorithm picks up grass texture. This example will be revisited in the next section about *Neural Style*.

### 3.2.2 Neural Style

Fig. 3.6: Schematic design of a convolutional neural network [26].

In the previous section, a hand-constructed mapping between two images A and A' was used to generate B' from B. While this approach highlights important concepts it does not fully satisfy the requirements defined in Section 3.1.1, as the user was required to provide additional input besides the two guidance images. This directly ties the success of the algorithm to the quality of the provided mapping. In cases like blur filters or other already implemented manipulations this is a sufficient method, but when generating novel artistic images most often no pre-made filters exist. In that case, the quality of the result depends solely on a user's ability to create a sufficient mapping. Elad and Milanfar [5] propose a novel approach using

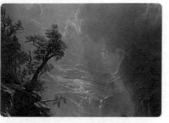
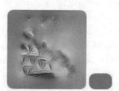

(a) Top activation in the first module in the first block [*mixed3a*], when looking at a tree

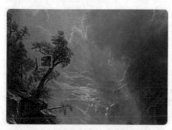

(b) Top activation in the fourth module in the second block [*mixed4d*], when looking at a tree

(c) Top activation of a dog ear in the fourth module in the second block [*mixed4d*]

(d) Top activation of a dog eye in the fourth module in the second block [*mixed4d*]

Fig. 3.7: Activation of different layers from the same Inception network [30] on diverse image locations. Orange regions define the patch fed into the network, the two images to the right show the strongest filter, with their relative activation strength visualized by the gray bar [23].

convolutional neural networks to generate these mappings. Neural networks consist of simple elements, called neurons or tensors, which are grouped together as layers, which in turn form the network. Each connection withing the network is assigned a weight which influences the numerical value passed along. To use such a network for a specific task, it is trained on sample data, shifting the weights on all those connections. Deep convolutional networks contain a multitude of size-reducing layers, as shown in Figure 3.6, and are well suited to work on multi-dimensional data, with spatial information. In the case of image detection, regions of the input image are convoluted together and transformed into a set of different filters on each consecutive layer [11, 30]. Each filter represents a certain pattern or composition of patterns, relevant for extracting information from the source image. The activation strength of those filters depends on the presence of the pattern in the observed region of the image.

In the case of the Inception network architecture [30] multiple convolutional layers are grouped together as so-called inception modules, which are stacked on top of each other, as blocks. In total the network consists of three blocks, with two (block one and three) or four (block two) inception modules each. Figure 3.7 shows how different layers of this network react when observing a certain part of the image (orange square). This network was trained on image detection for the *ImageNet Large-Scale Visual Recognition Challenge*[1] and can categorize up to 1000 different classes of objects. The visualization was done using the *Lucid* framework from *tensorflow*[2], which provides insights about what neural networks activate upon and therefore what they 'see'. The images show which two filters receive the strongest activation in certain layers when observing the area encapsulated by the orange square. In Figure 3.7a and Figure 3.7b the same image is shown, with activation of different layers.

While the first activation from layer *mixed3a* mostly recognizes patterns of scale like features and certain noisy patterns, the activation in the deeper layer *mixed4d* contains more semantic information: The top two filters look like a tree stump and like a flower, already hinting that the object in this particular position might be a tree. Note that the region of a single activation grows bigger in deeper layers because of the aforementioned convolution operation of the network [11].

Figure 3.7c uses the same layer as Figure 3.7b, but observes an image of dogs instead of landscape. This is reflected in the strongest filter activations, which contain shapes resembling dog heads with floppy ears. Looking at Figure 3.7d, which contains another image of dogs, we see that the network has very similar filter activations, despite observing a different part of the dog in a different picture, which means it is able to generalize the image in a way so that different pixel values, taken from a dog, are expressed using the same way. This shows the capabilities of these networks to work on richer data than just pixel values, building abstractions within the filter banks. A behavior crucial for the process of neural style transfer, as it allows to shift the mapping generating phase from the user to the algorithm [9].

The property, that deeper layers in the network will capture more explicit features of the source image [9] and therefore encapsulate more of the general content, instead of accurate pixel data, is the core idea of neural style. It makes use of the fact that a network trained on image data will learn and contain different mappings

---

[1]http://www.image-net.org/challenges/LSVRC/2014/, 22.08.2018
[2]https://github.com/tensorflow/lucid, 18.08.2018

that structure information within the image. By incorporating this information in the generative process, mappings can build ad-hoc, without any further user input. As neural networks develop a more explicit representation of training data along the hierarchy [9] it can be said that deeper layers encapsulate the content of the source image, while being relatively invariant to precise structures [10]. While initially exact pixel values are reconstructed, later on only the general shapes are represented.

Similar to the content representation the *style* of a source image can be represented by using the correlation of filter responses within the neural network. This correlation is encapsulated in a Gram matrix, which is the inner product between two vectorized feature maps in the same layer [10]. By calculating this correlation over multiple layers the information about texture and local distribution can be obtained while leaving the global arrangement of this information out [10].

This allows the network to construct a fuzzy understanding of content and style from the input images, which is used to evaluate the current candidate image. Figure 3.8 shows the example from the previous section. We input the lake photography (Figure 3.8a), on which the previous mapping (Figure 3.5a) is based, and Van Gogh's painting as the style image and use the neural style mechanism defined above to create Figure 3.8c. The neural style produces this result by analyzing the candidate image as well as content input and style input in terms of neural network filter activation in different layers of the network. The assumption is that, given two images which produce the same activation in a single layer, they should contain the same content, without necessarily containing the same pixel values. The effect of this behavior is observable in (Figure 3.8) the result of an optimization process trying to minimize the difference to the activation of content and style input. Similar to Figure 3.5 it closely matches the content of the source image, but this time the clouds are rendered in the likeness of the strokes from the style source. Due to aligning the result and style image in terms of the gram matrices of their filter activation in several network layers it mimics the style of Van Gogh and constrains the solution space to image elements that are presented in this form. This is quite interesting as it allows embedding objects into styles even if there is no reference to this object in original data [14], which appears to resembles transfer learning [24]. The effect of this is visible in Figure 3.9, where an abstract painting style is transferred onto the photograph of a canyon. Style transfer is able to render the canyon in the abstract style, although the content image does not contain any clearly defined information about how such a canyon should look.

Figure 3.10 is another example of neural style transfer, this time showing one of the limitations of this algorithm. The object of this image, a car, has many structural limitations, parts exist only as combinations of several large structural features and to keep the semantic meaning intact all of these limitations have to be upheld. The result is not even close to a restyled version of the first car, because of two main reasons. Neural networks and the use of gram matrices reduce to locality coherence of features, a property useful to generate the rich mapping we see in Figure 3.8, but harmful for objects that rely on structured composition to appear correct. Examples for this are man-made structures, like complex buildings, machines, or objects that are defined by the composition of subparts. Performing a photo to photo (instead of a photo to abstract style) transfer on faces is also problematic, as slight offsets tend to generate the *uncanny valley*[3] effect, making results look unnatural. In Figure 3.2.3

---

[3]https://en.wikipedia.org/wiki/Uncanny_valley, 23.08.2018

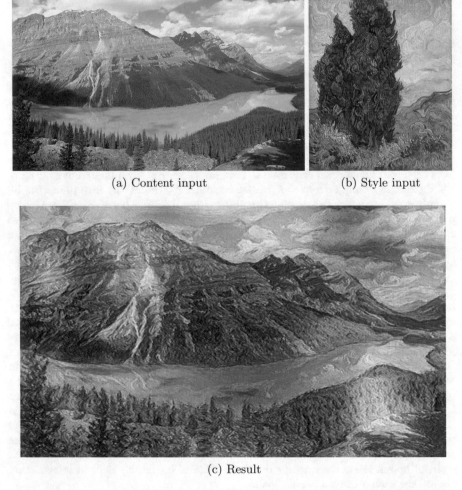

(a) Content input                    (b) Style input

(c) Result

Fig. 3.8: Style of Van Gogh transferred onto photo with neural style. Compare to Figure 3.5.

a method to diminish this effect for structural objects is highlighted. For faces, other approaches often produce better results [34]. The second reason is missing domain knowledge in the neural network. During training, the network is adjusted to classify a (huge) set of different images in different classes. The selection of classes and images ultimately define what kind of filters the network develops. As neural style transfer relies on these filters to build the content and style abstractions, some networks work better than others for certain tasks. Section 3.2.2 shows style transfer with a different network architecture as well as problems and possibilities arising from this. It remains to be investigated how infusing the process with very specific domain knowledge can help in style transfer. One approach to investigate further is the

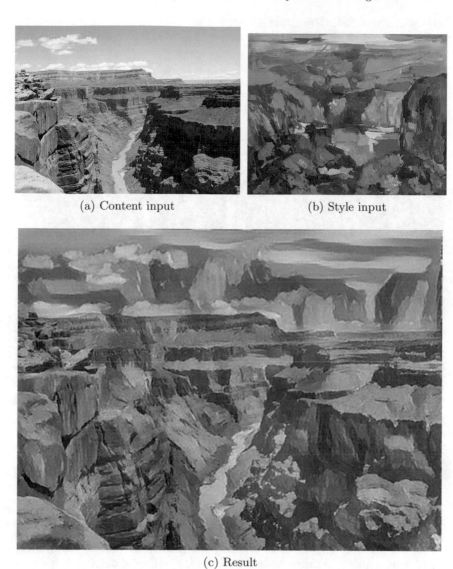

(a) Content input                     (b) Style input

(c) Result

Fig. 3.9: Transfer of painted style onto a photograph.

combination of Artistic Style Transfer with *Generative Adversarial Networks* [12], which use a tandem of networks to discover and learn domain-specific knowledge.

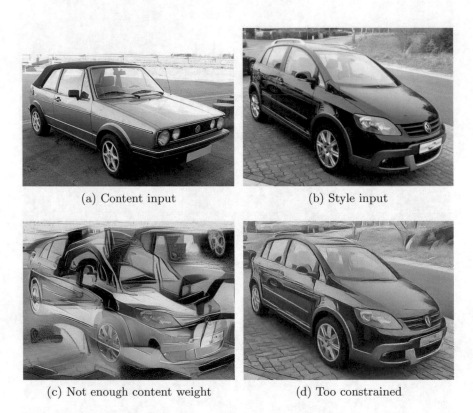

(a) Content input                    (b) Style input

(c) Not enough content weight        (d) Too constrained

Fig. 3.10: Neural style transfer fails on an image requiring specific domain knowledge

Given this initial understanding of neural style transfer and its limitations, the rest of this subsection focuses on extending the method to make it more suitable for different, sometimes niche, use cases. From the ability of different network architectures to generate different results in Section 3.2.2 to changing the approach bringing it close to interactive performance, the following sections show the versatility of this approach. In Section 3.2.3 an optimization is shown to keep the result closer to structured content input, allowing this algorithm to be used in more niche problem statements.

## Other Networks

Most applications of Artistic Style Transfer are done using the *Visual Geometry Group (VGG)* network architecture [28]. Experiments with other network architectures produced sub-par results compared with the same setup using the VGG

network. One hypothesis for this is that VGG contains additional information that is not relevant for classification, the task that networks are usually trained on, and therefore does not occur in other, slimmer architectures [20]. Furthermore, aggressive down-sampling and checkerboard artifacts in the gradients, which occur in other architectures, can limit the ability to perform Artistic Style Transfer [20]. In work by Mordvintsev and colleagues [20] the *Inception* [30] network is used with decorrelated parameterization based on previous work by Olah and Mordvintsev [22] to improve the style transfer capabilities. The main finding was that using Fourier transform instead of pixel space to describe an image can lead to appealing results, opening up other networks for the task of style transfer. Figure 3.11 shows a comparison between Artistic Style Transfer using the *VGG*- and *Inception*-architecture. With Figure 3.11c as a baseline it is clear that the Inception network generates worse results (Figure 3.11d), given the same parameterization. Using the decorrelation through Fourier transform from Mordvintsev et al.[20] it can produce results similar to the baseline (Figure 3.11e), yet keeping a very distinct look. This opens up further exploration and discovery of innate abilities within different network architectures to shape the result of an Artistic Style Transfer.

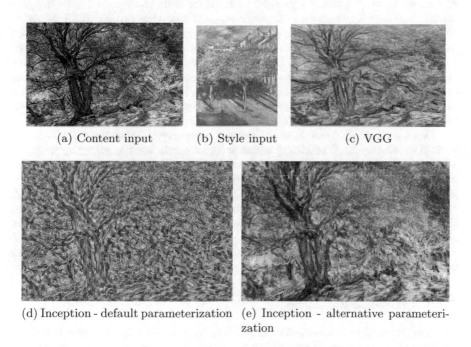

(a) Content input      (b) Style input      (c) VGG

(d) Inception - default parameterization   (e) Inception - alternative parameterization

Fig. 3.11: Style transfer with *VGG* (Figure 3.11c) vs *Inception_V1* with default (Figure 3.11d) and with Fourier parameterization (Figure 3.11e) [20]

## Fast Style Transfer

A problem is that neural style transfer needs to retrieve all the filter banks from the neural network processing an image and this takes a certain time, depending on the target hardware. A potential speedup comes from the idea that different style images still share a certain number of features. Work by Dumoulin et al. [3] uses a single conditional network based on the idea of instance normalization [33], which they train to generate the style-transferred image. Findings include a reduced runtime, as this network, trained on $N$ styles, only requires a single pass through to stylize a content image in $N$ different styles, contrary to the $N$ passes a non-augmented network would require. Furthermore, it allows for more stable training, as 99.8% of the learned parameters are shared between different styles, leaving only 0.2% as relevant parameters to differentiate between them [3]. Training single networks for each style results in a huge overhead, as these redundant parameters are retrained every time. This research also opens up the question of whether or not a general representation of style can be found, which would allow positioning different styles within it, to increase the understanding of artistic quality in general. Building upon this approach and combining it with the loss metrics ([8]), discussed above, the work of Johnson et al. [15] trains a *forward network* for style transfer, but uses the perceptual loss from a pre-trained *loss network* to validate the quality of a candidate. This benefits from more robust stability during training and an interactive runtime during evaluation. While producing similar results in terms of semantic understanding of input images the approach used in work by Johnson [15] runs three orders of magnitude faster, compared to Gatys's [8] technique as a baseline. The problem of super-resolution briefly touched on in Figure 3.4 in Section 3.2.1 is also revisited in Johnson's work [15] with reasonable results, again making use of the additional information included in the trained network.

Another approach that does not require extensive training beforehand is described by Chen and Schmidt [2] which tries to create a style mapping to doing a patch-wise swap using an inverse network. This approach aims to combine the benefits of feed-forward (efficiency and fast execution) based approaches with optimization (rich results) based approaches. By implementing their style swap based on a single layer in the network the process yields much faster results, which are similar content-wise. Furthermore, recurrent runs on the same data, as well as runs based on slightly different data sets, show only a small standard deviation in pixel values, which makes this technique interesting for style transfer on movies, as there is no additional stabilization mechanism required [2].

### 3.2.3 Structural Semantic

One limitation of the aforementioned techniques is masked by the selection of input images. The samples shown before have mainly used images with high entropy because the algorithm tends to produce more believable results when the results themselves are tolerant to a lack of formal structure. In the car example in Figure 3.10 the object in question is very structured and requires this structure to be present in the result. As briefly mentioned before, neural style transfer produces less appealing results as soon as the object to transfer onto either requires a lot of semantic information to make it look believable or is composed of large structural features that need to stay intact. The latter can be addressed by an optimization

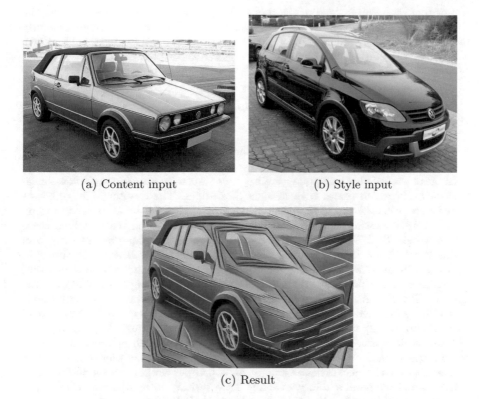

(a) Content input                    (b) Style input

(c) Result

Fig. 3.12: Better style transfer for cars using additional loss functions to stabilize features

which is commonly used in current works [2, 7, 17]. The base idea is to perform style transfer on overlapping patches of the image, instead of the whole image at once. This counters the property of spatial unrelatedness present in neural network filter activation, allowing local coherent features to be transported over. The image is split into a Gaussian pyramid of patches, which first allows the transport of larger structures and features and then gradually adds more details and smaller, more detailed features. This by itself is already helpful in scenarios where the local distribution of features is of high importance, like faces and architecture, and opens up interesting new ways of guiding style transfer. The approach in [17] uses Markov random fields to encapsulate local plausibility and to generate more lifelike results when transferring highly structured objects. Applying this to the example from Figure 3.10 allows for stronger stylization, while still producing something resembling a car. Figure 3.12 shows the same transfer with an added loss for local feature coherence. Compared to Figure 3.10 it falls in between the two extrema shown there, allowing for style features to show up, while still maintaining the local composition of the target object. While still not producing as good results as it does for artistic painting, some stylistic features can be observed in the resulting image: The open

tourer roof shows up instead of the roof rack, the succinct top tornado line on the side starts showing and the smooth curvature of the *CrossGolf* is rendered slightly more chiseled. This widens the solution space for more parameter combinations, which, together with domain-specific knowledge (see Section 3.3), might allow for further investigation for high structural style transfer.

## 3.3 Conclusion and Outlook

Starting from an abstract description of the style transfer problem in Section 3.1.1 this chapter dived into a simple approach to analogy driven style transfer in Section 3.2.1. Problems of this technique were improved upon by a neural style transfer in Section 3.2.2, which comes with its own limitations. The chapter highlighted selected improvements and their specific use cases, giving the tools to expand upon classical style transfer depending on the use case and desired result. Given these pieces Artistic Style Transfer remains as an interesting technique to generate novel artifacts, which are distinct from the usual results created by classical texture synthesis [1, 16], and offers interesting directions for further research. Given the current understanding, several real-world use cases can be tackled using the toolkit of Artistic Style Transfer. As described in Section 3.2.1 style transfer can effectively mimic image filters [13] and can also be extended to synthesize novel textures or extend them naturally [32]. It can be used to transfer photos into drawings, paintings into photos, or swap around the style of objects [8, 35]. Although not described here, some aspects can also be mapped to 3D space, allowing style transfer to manipulate three-dimensional object styles as well [6, 20, 21]. Other works focus on performance increases and temporal stability, enabling style transfer to be executed over image sequences such as movies [18, 27]. Recent work at NVIDIA uses similar approaches to synthesize video data, between different times of day, weather conditions, or even real footage and stimulated material [34].

Other challenges remain problematic, especially when a lot of additional requirements are present in the object of focus, which are not directly mapped in the image. Especially, highly complex objects with semantic meaning attached to small parts, such as cars, remain problematic. To tackle this challenge Artistic Style Transfer needs to be infused with extra guidance and novel loss aspects to limit the search space, while still providing room for artistic improvisation. Other approaches using *Generative Adversarial Networks* [12] to do unsupervised training show great results in learning the hidden concept of certain domains [34, 35] and can enrich the style transfer process further by providing custom tailored critics to rate images based on the correctness in those domains.

The technique of Artistic Style Transfer continues to produce interesting results and is often found in related research fields, while already producing value in different fields like procedural art generation, simulation [14] and understanding of art and aesthetics. Notably the latter holds promise for further exploration and enabling a deeper understanding of the complexity of aesthetics, and allowing for a further formalization of style and art.

# References

[1] Ashikhmin, M.: Synthesizing natural textures. Proceedings of the 2001 symposium on Interactive 3D graphics pp. 217–226 (2001). DOI 10.1145/364338. 364405

[2] Chen, T.Q., Schmidt, M.: Fast Patch-based Style Transfer of Arbitrary Style. arXiv preprint arXiv:1612.04337 (2016). **Nips** (2016). URL http://arxiv. org/abs/1612.04337

[3] Dumoulin, V., Shlens, J., Kudlur, M.: A Learned Representation For Artistic Style. Proceedings of ICLR (2017). URL http://arxiv.org/abs/1610.07629

[4] Efros, A., Freeman, W.: Image Quilting for Texture Synthesis and Transfer. Proceedings of the 28th annual conference on Computer graphics and interactive techniques **August**, 1–6 (2001). DOI 10.1145/383259.383296

[5] Elad, M., Milanfar, P.: Style-Transfer via Texture-Synthesis. IEEE Transactions on Image Processing **26**(5) (2017). DOI 10.1109/TIP.2017.2678168. URL http: //arxiv.org/abs/1609.03057

[6] Fišer, J., Jamriška, O., Lukáč, M., Shechtman, E., Asente, P., Lu, J., Skora, D.: StyLit: Illumination-Guided Example-Based Stylization of 3D Renderings. ACM Transactions on Graphics **35**, 1–11 (2016). DOI 10.1145/2897824.2925948

[7] Frigo, O., Sabater, N., Delon, J., Hellier, P.: Split and Match: Example-based Adaptive Patch Sampling for Unsupervised Style Transfer. CVPR 2016 pp. 553–561 (2016). DOI 10.1109/CVPR.2016.66

[8] Gatys, L.A., Ecker, A.S., Bethge, M.: A Neural Algorithm of Artistic Style. arXiv preprint pp. 3–7 (2015). DOI 10.1561/2200000006

[9] Gatys, L.A., Ecker, A.S., Bethge, M.: Texture Synthesis Using Convolutional Neural Networks. Neural Image Processing Systems pp. 1–10 (2015). DOI 10.1109/CVPR.2016.265

[10] Gatys, L.A., Ecker, A.S., Bethge, M.: Image style transfer using convolutional neural networks. The IEEE conference on computer vision and pattern recognition pp. 2414–2423 (2016). DOI 10.1109/CVPR.2016.265

[11] Goodfellow, I., Bengio, Y., Courville, A.: Deep Learning. MIT Press (2016)

[12] Goodfellow, I., Pouget-Abadie, J., Mirza, M.: Generative Adversarial Networks. arXiv preprint arXiv: . . . pp. 1–9 (2014)

[13] Hertzmann, A., Jacobs, C.E., Oliver, N., Curless, B., Salesin, D.H.: Image analogies. Proceedings of the 28th annual conference on Computer graphics and interactive techniques SIGGRAPH 01 **2001**(August), 327–340 (2001). DOI 10.1145/383259.383295

[14] Hong, S., Yan, X., Huang, T., Lee, H.: Learning Hierarchical Semantic Image Manipulation through Structured Representations. Advances in Neural Information Processing Systems (2018). URL http://arxiv.org/abs/1808.07535

[15] Johnson, J., Alahi, A., Fei-Fei, L.: Perceptual losses for real-time style transfer and super-resolution. Lecture Notes in Computer Science (including subseries Lecture Notes in Artificial Intelligence and Lecture Notes in Bioinformatics) **9906 LNCS**, 694–711 (2016). DOI 10.1007/978-3-319-46475-6_43

[16] Lefebvre, S., Hoppe, H.: Parallel controllable texture synthesis. ACM Transactions on Graphics **24**(3), 777 (2005). DOI 10.1145/1073204.1073261

[17] Li, C., Wand, M.: Combining Markov Random Fields and Convolutional Neural Networks for Image Synthesis. CVPR 2016 p. 9 (2016). DOI 10.1109/CVPR. 2016.272

[18] Liao, J., Yao, Y., Yuan, L., Hua, G., Kang, S.B.: Visual Attribute Transfer through Deep Image Analogy. arXiv (2017). URL http://arxiv.org/abs/1705.01088

[19] Malik, J., Belongie, S., Shi, J., Leung, T.: Textons, Contours and Regions: Cue Integration in Image Segmentation. Proceedings of the Seventh IEEE International Conference on Computer Vision 2(1), 918–925 (1999). DOI 10.1109/ICCV.1999.790346. URL http://dl.acm.org/citation.cfm?id=850924.851546

[20] Mordvintsev, A., Pezzotti, N., Schubert, L., Olah, C.: Differentiable Image Parameterizations. Distill (2018). DOI 10.23915/distill.00012. URL https://distill.pub/2018/differentiable-parameterizations

[21] Nguyen, C.H., Ritschel, T., Myszkowski, K., Eisemann, E., Seidel, H.P.: 3D Material Style Transfer. Computer Graphics Forum 31(2pt2), 431–438 (2012). DOI 10.1111/j.1467-8659.2012.03022.x

[22] Olah, C., Mordvintsev, A., Schubert, L.: Feature Visualization. Distill (2017). DOI 10.23915/distill.00007. URL https://distill.pub/2017/feature-visualization

[23] Olah, C., Satyanarayan, A., Johnson, I., Carter, S., Schubert, L., Ye, K., Mordvintsev, A.: The Building Blocks of Interpretability. Distill (2018). DOI 10.23915/distill.00010. URL https://distill.pub/2018/building-blocks

[24] Pan, S., Yang, Q.: A Survey on Transfer Learning (2010). DOI 10.1109/TKDE.2009.191

[25] Radford, A., Metz, L., Chintala, S.: Unsupervised Representation Learning with Deep Convolutional Generative Adversarial Networks. arXiv preprint arXiv:1511.06434 pp. 1–16 (2015). DOI 10.1051/0004-6361/201527329. URL http://arxiv.org/abs/1511.06434

[26] Rayar, F., Goto, M., Uchida, S.: CNN training with graph-based sample preselection: application to handwritten character recognition. Proceedings - 13th IAPR International Workshop on Document Analysis Systems, DAS 2018 March 2018, 19–24 (2018). DOI 10.1109/DAS.2018.10

[27] Ruder, M., Dosovitskiy, A., Brox, T.: Artistic Style Transfer for Videos and Spherical Images. International Journal of Computer Vision pp. 1–21 (2018). DOI 10.1007/s11263-018-1089-z

[28] Simonyan, K., Zisserman, A.: Very Deep Convolutional Networks for Large-Scale Image Recognition. ImageNet Challenge 96(2), 1–10 (2014). DOI 10.1016/j.infsof.2008.09.005

[29] Stork, D.G.: Computer vision and computer graphics analysis of paintings and drawings: An introduction to the literature. Lecture Notes in Computer Science (including subseries Lecture Notes in Artificial Intelligence and Lecture Notes in Bioinformatics) 5702 LNCS, 9–24 (2009). DOI 10.1007/978-3-642-03767-2{\_}2

[30] Szegedy, C., Liu, W., Jia, Y., Sermanet, P., Reed, S., Anguelov, D., Erhan, D., Vanhoucke, V., Rabinovich, A.: Going deeper with convolutions. Proceedings of the IEEE Computer Society Conference on Computer Vision and Pattern Recognition 07-12-June, 1–9 (2015). DOI 10.1109/CVPR.2015.7298594

[31] Uhde, F., Mostaghim, S.: Towards a General Framework for Artistic Style Transfer. In: A. Liapis, J.J. Romero Cardalda, A. Ekárt (eds.) Computational Intelligence in Music, Sound, Art and Design, pp. 177–193. Springer International Publishing, Cham (2018)

[32] Ulyanov, D., Lebedev, V., Vedaldi, A., Lempitsky, V.: Texture Networks: Feed-forward Synthesis of Textures and Stylized Images. ICML **1**(2) (2016). URL http://arxiv.org/abs/1603.03417

[33] Ulyanov, D., Vedaldi, A., Lempitsky, V.: Instance Normalization: The Missing Ingredient for Fast Stylization. arXiv preprint arXiv:1607.08022 **2016** (2016)

[34] Wang, T.C., Liu, M.Y., Zhu, J.Y., Liu, G., Tao, A., Kautz, J., Catanzaro, B.: Video-to-Video Synthesis. Advances in Neural Information Processing Systems (NeurIPS) pp. 1–15 (2018)

[35] Zhu, J.Y., Park, T., Isola, P., Efros, A.A.: Unpaired Image-to-Image Translation using Cycle-Consistent Adversarial Networks. ArXiv preprint arXiv:1703.10593 (2017)

# Images

All input images were taken from the *wikimedia commons media archive*[4]. Results, if not cited next to the figure, were generated with the General Artistic Style Transfer Framework as described in previous work by Uhde [31].

**Mermaid Parade**, Rhododendrites
*https://commons.wikimedia.org/wiki/File:*
*Mermaid_Parade_(60132).jpg*, 21.08.2018

**Bearded man with long hair**, subhamshome28
*https://commons.wikimedia.org/wiki/File:*
*Bearded_man_with_long_hair-3052641.jpg*, 21.08.2018

**Study for The Dead Alchemist**, Elihu Vedder
*https://commons.wikimedia.org/wiki/File:*
*Brooklyn_Museum_-_Study_for_The_Dead_Alchemist_-*
*_Elihu_Vedder_-_overall.jpg*, 21.08.2018

**Rosa 'Serendipity' in Dunedin Botanic Garden**, Krzysztof Golik
*https://commons.wikimedia.org/wiki/File:Rosa_*
*%27Serendipity%27_in_Dunedin_Botanic_Garden_02.jpg*,
21.08.2018

**Tuinen Mien Ruys (d.j.b.)**, Dominicus Johannes Bergsma
*https://commons.wikimedia.org/wiki/File:*
*Tuinen_Mien_Ruys_(d.j.b.)_03.jpg*, 21.08.2018

---

[4]https://commons.wikimedia.org, 21.08.2018

**Cypresses**, Vincent van Gogh
*https: // commons. wikimedia. org/ wiki/ File:*
*Vincent_ Van_ Gogh_ 0016. jpg*, 21.08.2018

**Puget Sound on the Pacific Coast**, Albert Bierstadt
*https: // commons. wikimedia. org/ wiki/ File:*
*Albert_ Bierstadt_ -*
*_Puget_ Sound_ on_ the_ Pacific_ Coast_ ( 1870) . jpg*,
21.08.2018

**Bernese Mountain Dog and Her Pups**, Benno Adam
*https: // commons. wikimedia. org/ wiki/ File:*
*Adam, _Benno, _Bernese_ Mountain_ Dog_ and_ Her_ Pups. jpg*,
21.08.2018

**Spaniel**, Johannes Deiker
*https: // commons. wikimedia. org/ wiki/ File:*
*Johannes_ Deiker_ -_Spaniel. jpg*, 21.08.2018

**Peyto Lake-Banff NP-Canada**, Tobias Alt, Tobi 87
*https: // commons. wikimedia. org/ wiki/ File: Peyto_ Lake-*
*Banff_ NP-Canada. jpg*, 21.08.2018

**Tree in Tada forest**, Praveen
*https: // commons. wikimedia. org/ wiki/ File:*
*Tree_ in_ Tada_ forest. jpg*, 21.08.2018

**The Lindens of Poissy**, Claude Monet
*https: // commons. wikimedia. org/ wiki/ File:*
*Les_ Tilleuls_ %C3% A0_ Poissy. png*, 21.08.2018

**The Cove**, Nate Dunn
*https: // commons. wikimedia. org/ wiki/ File:*
*%22The_ Cove%22_ ( v. 3) _by_ Nate_ Dunn, _1959. jpg*,
21.08.2018

**Panoramio**, thewayofthings.org
*https: // commons. wikimedia. org/ wiki/ File: -*
*_panoramio_ ( 1794) . jpg*, 21.08.2018

**VW CrossGolf**, Samoborac
*https: // commons. wikimedia. org/ wiki/ File:*
*VW_ Crossgolf. JPG*, 21.08.2018

**VW Golf 1 Cabrio front**, Rudolf Stricker
*https: // commons. wikimedia. org/ wiki/ File:*
*VW_ Golf_ 1_ Cabrio_ front_ 20071006. jpg*, 21.08.2018

# Part II

## Music

# 4

# Artificial Musical Intelligence: Computational Creativity in a Closed Cognitive World

Geraint A. Wiggins

Vrije Universiteit Brussel, Brussel, Belgium geraint@ai.vub.ac.be

**Summary.** I consider the problem of musical composition from the perspective of artificial intelligence. Music has been a subject of interest in AI since the very early days of the field. However, philosophical considerations of music itself, and the consequences of the very idea of an insensate entity "composing", have not always been foremost. Indeed, in the early days, musical composition was regelated to the category of problem solving: while there are some extraordinary contributions in this area, which still withstand critical scrutiny forty years later, they do not tell us much about human processes of musical creativity, nor, really about artificial ones. If this is not the centre of musical enquiry in AI, then what is? This chapter aims to give a philosophical viewpoint on the development of AI in music, and of what that development has taught us about music and the mind. I place my argument in the context of past and present work in the area (though this chapter is not intended to be a survey), drawing not just on AI, but also on broader cognitive science where necessary. In doing so, I aim to make the case that music has a special status in the arts, being an ephemeral construct that relies on time and memory in unique ways, and therefore that it has, potentially, special value for the science of Artificial Intelligence.

## 4.1 Music

Music is special. Alone among the creative arts and crafts, it often moves people to cheer, to weep, and, above all, to dance—though it does not *have* to do any of these things in order to be deemed successful in some part of society or other. Alone among the creative arts and crafts, music is used to prompt and intensify human emotion in contexts from Hollywood and Bollywood movies to all but the most austere of social ceremonies. Music is so powerful in its effect on humans that some parts of humanity, even in the 21st Century, view it as the work of personified evil. Music has motivated mathematicians (such as Archimedes and Isaac Newton) and specialist engineers (such as Antonio Stradivarius and Bob Moog) to try to understand systems underlying it and to build new and better means to make it.

It is therefore not surprising that music was among the earliest applications of computers. *Illiac Suite* [41] was the first attempt to compose a piece of music using

© Springer Nature Switzerland AG 2021

P. Machado et al. (eds.), *Artificial Intelligence and the Arts*, Computational Synthesis and Creative Systems, https://doi.org/10.1007/978-3-030-59475-6_4

a modern digital computer, and stands today as a competent art music composition of its period. But the idea of computer composition arose still earlier: Alan Turing wrote, "Shannon wants to feed not just data to a Brain[1], but cultural things! He wants to play music to it!" [42], p. 251. And the idea of systematic or algorithmic composition, in which part or all of the compositional process is delegated to a mathematical process, deterministic or stochastic, was well established by composers such as Witold Lutosławski [57], John Cage [17] and Milton Babbitt [7, 8] years before computers became powerful enough to enact it.[2] Where the method of a composer was sufficiently deterministic and sufficiently public, it is now possible to generate new pieces, which one can defensibly claim might really have been made by the composer himself, had he continued working longer [9].

It is equally unsurprising that music was of interest to the pioneers of Artificial Intelligence (AI). Aside from Shannon's prescient interest, cited above, Marvin Minsky, himself a practising musician, was interested in Artificial Musical Intelligence (AMI) [62]. Around the same time, interest in the cognitive sciences of music was growing, and a new research field, of Music Perception and Cognition, was effectively launched by John Sloboda's book, *The Psychology of Music* [89]. Notwithstanding that AI is the topic of the current volume, it is necessary for this chapter to consider the broader context of music, not least because perception and cognition define its very nature. In consequence, music provides an excellent and usually underrated domain for the study of cognition [110], and, conversely, to understand it in full, we must consider it from this perspective, as well as from the purely artistic viewpoint. Thus, AMI becomes a tool with which to study both music and intelligence, as well as an end in itself. To begin this discussion, therefore, the next section poses the question, "what is music?"

Subsequent sections of this paper examine selected issues from the history of AMI in the context of other questions: "what are the components of musical behaviour?", "what does music mean?" and "what does the future hold for artificial musical intelligence?" I end with a further question: "where is creativity in AMI?"

## 4.2 What Is Music?

Music must be thought of as a combination of many different aspects, each with distinctly and importantly different natures. Babbitt [5] proposes three representational domains for music: *graphemic*; *acoustic*; and *auditory*. These are, respectively: written forms; the physical movement of air; and the effect produced by music on the mind of the listener, performer and/or composer. Wiggins et al. [111] propose to extend these into further domains (for example, one might wish to capture thought specific to a composer, or to consider the contribution of embodiment[3]). Affective response is safely contained in the auditory domain.

---

[1] "Brain" here refers to a Turing Machine.

[2] Some claim that Johann Sebastian Bach used explicit mathematics in his music in the 18th Century, though the only evidence for this that I have found is circumstantial: Bach was interested in mathematics, and did join a mathematical society.

[3] Some researchers argue very strongly that embodiment is the equal of cognition in musical activity. However, it is not. To see this, consider first that a musician without a mind (that is, a dead one) cannot make music, and second that there is

Babbitt's domains are useful in considering the operations one might consider in an AMI study, and we quickly see that the auditory domain is privileged. For example, in the absence of musical intelligence, moving from the acoustic domain to the graphemic domain requires a literal recording device such as a tape recorder. The reverse involves literal playback. In the recording case, no actual musical behaviour is required: the recording device knows nothing of music, but merely denotes sound and reproduces it. In any other case, where a human is involved, the auditory domain is de facto mediating the process, because the human's mind is involved in the activity. The same is true for all of the other processes that map between the domains: acoustic to auditory (listening) and back (performing, including improvising); graphemic to auditory (score-reading[4]) and back (composing using notation). This argument is made in more detail elsewhere [103, 111].

The point is that human intervention is required in all these cases, because musical activity is not merely a matter of simply mapping notes to sound in strict order. Put another way, there is a discontinuity, sometimes misleadingly called a "semantic gap" [103], between the sounds that reach our ears, and the experience of which we are ultimately conscious. The discontinuity is, in fact, no gap at all, but the complex collection of operations performed by human perception and cognition in the auditory domain, most of which are more syntactic than semantic. Similarly, the path from musical score to human performance is mediated by the auditory domain, as a human interprets the musical meaning of the score and realises that interpretation in sound waves. It is no surprise, therefore, that the primary interest of AMI lies in the auditory domain. More strongly: anything not involving that domain (e.g. recording[5], or literal playback via CD or MIDI) is, from the perspective of AI, trivial.

## 4.3 What Are the Components of Musical Behaviour?

If asked the question, "what is musical behaviour?", many respondents will say "composition", or "performance". Some may say, "dancing", or "singing", or "clapping along". Very few will mention the key activity that precedes and underpins all of these other activities: *listening*. Indeed, musical listening is not commonly considered outside formal music education[6]: consider, for example, the language mostly used in reports on music similarity research[7], where subjectivity is rarely mentioned, and the nature of the problem is often reduced to a comparison of features explicit or nearly explicit in audio signals for the purposes of naïve classification [27]. While

---

no such thing as a mind without a body. In this sense only, cognition is primary: there can be little doubt that embodiment was and is fundamentally important in the evolution of music and its practice through time.

[4]Advanced musical activity in which a musician reads a score and hears the music in her head.

[5]It is worth noting here that the most successful audio compression technique, mp3, is perceptually motivated, and therefore primarily auditory, not acoustic.

[6]There are exceptions in the machine listening research community, but even there listening tends to be viewed as a decoding problem, rather than one of predicting and interacting.

[7]http://www.ismir.net

empirical evidence suggests that surface features are predominant in very tiny slices of musical time [36], such very short-term analysis fails to take into account the deep hierarchical structure that is fundamental to all but the most simple music. No AI-scientist could credibly deny the importance of hierarchical structure in language; the same is true in music, but that structure remains absent from a majority of studies. This is because it is only implicit in the audio signal, being an auditory, and not an acoustic, construct. Failure to consider the function of listening has been a crime of which AMI systems from the very beginning of the research field can be accused, and I include my own early work in the charge sheet. Fortunately, in more recent years the balance has been redressed [4, 29, 61].

In linguistics, theories of language (which are, de facto, theories of language cognition, because there is no language without cognition), explicate and sometimes operationalise processes (parsers) by which linguistic structure can be retrieved from sequences of words or sounds. Similar theories exist for music, in different cultures, though they are generally even more entrenched than linguistics in the perspective of studying *music* (as though it were an artefact independent of humankind), and not the auditory domain of *music perception and cognition*. Early AMI work on the generation of music [67] was often based in this theoretical background, and some of it was very successful. For example, the ground-breaking CHORAL system of Ebcioğlu [30, 31] uses detailed analysis and application of very specific music theory to generate a very specific musical form: chorale harmonisations in the style of Johann Sebastian Bach. The system is surprisingly good at what it does: if anything, to an expert ear, the music produced is *too much* like Bach, using too many of his compositional signatures in a given period of time. The fact that CHORAL, as a program, consists of human-coded musical rules (that are, in fact, in themselves a useful contribution to music theory), and is therefore firmly in the tradition of Good Old-Fashioned AI (GOFAI) [39], does not detract from its position as a shining early example.

Ebcioğlu's work very clearly shows the approach often taken in AI to tasks that are generally deemed creative: identify the class of output required, and then treat creativity as problem solving by search under constraints [100]. I return to the highly problematic issue of creativity in Section 4.6. Here, the aim is to point out how the problem-solving approach restricts the ambit of the AMI scientist. In CHORAL, and in other style-reproduction work [22, 74, 75, 84] the "problem" is framed as the attempt to reproduce the style of a well-studied and usually long deceased composer or compositional style. Doing so can be very impressive, and also a lot of fun. But what does it tell us, from a scientific and musical standpoint?

First, most such attempts tell us *nothing at all* about music. Formulation as a "problem to solve" strips the activity of any possibility of enlightening the musical world, because that formulation necessarily presupposes a solution in a particular known form. To be creative, and to distort that form, would be to fail in these terms. Perhaps work such as Ebcioğlu's may contribute to musical scholarship through its formulation of implicit rules; however, to my knowledge, that contribution is unique. Thus, AMI systems in this category are doomed forever to produce the same kinds of music until all valid permutations have been exhausted. Meanwhile, the composer in question is long deceased and the rest of the musical world has moved on.

Second, such attempts might—in principle—tell us a little about music theory, if the rules used are drawn from a particular statement of that theory. Then—in principle—the computer system may be used to generate multiple pieces of music,

some of which may not conform to the precepts of the style that the theory is supposed to capture. Thus, we could in principle show that that statement of the music theory was "incorrect", in a pale reflection of the falsificationist scientific method [76]. However, such an activity would be mostly meaningless, because music theory is essentially a descriptive entity, which makes no claim to purport such rigour.

Third, most such attempts tell us *nothing at all* about creative intelligence, again because of the formulation: the AMI system so produced is shuffling symbols so as to produce a new combination that conforms to pre-defined (i.e., known) constraints [100]. At best, this is exploratory creativity [13, 99, 100], but more often it is "mere generation" [94]: I return to these points below.

Finally, however, such attempts *can* tell us something about the particular AI technique used in the generation process: that it is capable (or not) of the relevant generation (which may be computationally complex and expensive) in the time permitted by the researcher(s) who did the work. Such a result, however, probably does not change the world.

Ultimately, then, these activities are entertaining; sometimes the music produced is enjoyable; and the engineering involved is often very impressive. In Ebcioğlu's case, the musical scholarship involved was impressive too. But they do little to enlighten us about the nature of musical intelligence, or to simulate it, in the sense of *"what applies the rules, how and why?"*

To return to the topic of this section (the components of music): the discourse above relates mostly to the idea of importing components of music as defined by music theory into a rule-based AMI composition system. What is one doing when one does so? It is important to understand that music theory does not *define* music, but rather *describes observed musical practice* in a particular part of society. To do so it must use terms that refer to intersubjectively agreed music-perceptual objects, because otherwise the theory would be unusable. Since those objects are only audible, and hence must be heard to be understood, there must be a common set of auditory percepts on which most humans can agree: music theory is, therefore, in one sense a theory of shared perception [106, 108, 109]. To see this, consider, for example, that most listeners do not hear the individual harmonics of complex sounds, but rather the timbres that arise from their combination, and the pitch that is implied by their fundamental frequency; consider next that pitch and timbre are two of the factors in terms of which music theory is usually specified. In this view, notes, chords, phrases, verses, choruses are all part of the hierarchical auditory structure that is music, and they are all agreed intersubjectively as *perceptual units*. It is self-evident that some of the advanced percepts, for example, tonal harmony, need to be learned; and there is some evidence that even more basic ones such as relative pitch are learned as well [83]. It follows, since much of this structural information is absent from the acoustic signal, that it must be reconstructed, using top-down learned schemata or grammars, in the mind of the listener—every listener, not just the musical expert, though of course some may be better at it than others.

An important task in AMI, that is closer to listening than the composition tasks discussed previously, is called "music transcription" [37]. Until recently, this task was not one that would be recognised by most human music transcribers: instead of a human-readable musical score, the output of such systems is usually a piano-roll or MIDI file, the transcription task being reduced effectively to polyphonic estimation of fundamental frequencies of notes [1]. In contrast, timing is not strictly denoted

in musical scores, but instead an abstracted representation based on metre [53] is used, so musical understanding is required both to reconstruct a true score from audio and to play that score. However, recently it has become possible to produce a true, though basic, musical score from audio input, in AMI systems that behave in ways loosely akin to human listening, specifically combining temporal and pitch information [64]. The difference is important because producing a musical score entails significantly more understanding of musical structure than does producing a piano roll, and so this progress takes us closer to musical intelligence.

The converse activity, *performance*, translates (via the auditory domain) from graphemic representations to acoustic ones. It involves the converse process, *expressive timing*. While musical styles do exist that make a virtue of robotic, precise, and non-variant temporal structure, the majority of music sounds soulless and dull—even annoying—if played in this way. There is a substantial sub-field of AMI, with its own annual competition, RenCon[8] [49], focused on the simulation of human musical expression, or, as it rather prosaically calls itself, "performance rendering". Here, again, it must be understood that a musical score does not contain a complete specification of how to play a piece: rather, it usually specifies the notes to be played, the order in which to play them, an overall tempo (speed) or temporal feel[9] and, crucially, information about temporal grouping, *but not precise temporal detail*. The performer is free to make decisions about how to express the timing of the music (and other parameters, such as volume, are variable too). The impressive comparative listening interfaces described by Müller et al. [63] throw this freedom into stark relief: there are huge variations in performance interpretation between the performances that they succeed in seamlessly synchronising. One of the most successful series of research in musical expression is that of Widmer [96]. It has focused on learning functional mappings between expression markings in musical scores and the realisation of the same music by leading performers. Immediately, one confirms that the mappings are highly style dependent and idiosyncratic to the performer. All this raises an important question which seems rarely to be asked, let alone answered, in AMI: what *drives* the decisions that are self-evidently made by performers and composers when they make their music? I return to this question in the later sections.

Naturally, the advent of "deep" machine learning has had an impact on AMI [15]. Google's Magenta library[10] for music and art can achieve remarkable results. It does so, like the early results from GOFAI AMI, discussed previously, while explaining little or nothing about either music or intelligence[11]. Therefore, it should not be allowed to overshadow more modest, but perhaps more scientifically meaningful, research from prior decades. For example, a fairly simple neural network was

---

[8]At the time of writing, its website, http://renconmusic.org was off line, with a notice promising to be back soon.

[9]Historically, tempo was not specified in terms of beats per minute, but in terms of human experience, and often metaphorically: *andante*, "at a walking pace"; *presto giocoso*, "quick and happy"; *con fuoco*, "fiery".

[10]https://magenta.tensorflow.org

[11]Ali Rahimi used his 2017 Test of Time Award lecture at the Neural Information Processing Systems conference to (polemically) accuse himself and his colleagues of being alchemists because they cannot in general explain what their deep learning systems are doing: https://www.youtube.com/watch?v=Qi1Yry33TQE.

used by Tekman and Bharucha [90] to learn musical tonality, in a way that the authors argued was human-like. The model made a surprising prediction *about musical harmony* that was subsequently tested on human listeners and found to hold true, in exactly the Popperian approach advocated by Honing [43]. Thus, AMI work contributed to musical knowledge.

Another important step forward was the work of Conklin and Witten [21, 23], who were first to propose the use of statistical learning in AMI. In particular, they proposed a way of bringing the important multi-dimensionality of melodic sequences into the range of Markov modelling. This idea has given rise to a rich vein of AMI research, supporting music generation in various styles [45], and to genuine contributions to musicology [58]. An important feature of these models, taken into a cognitive-scientific context by Pearce [70, 71], is that they are essentially predictive, in the sense that they learn from sequences, to predict what comes next in a given sequence. Huron [44] argues that prediction (or, from a human perspective, anticipation) is a major part of the human listening experience. Pearce showed that Conklin's AMI compositional models functioned surprisingly well as cognitive models of melody perception, in Huron's sense. Work with these models showed that there is a connection between musical structure and expectation [72] and that human listeners are sensitive to the certainty of their predictions, as well as to the predictions themselves [38].

As noted above, music's structure is not local; in fact, it can be very long-term indeed. Standard Markov techniques are limited to local scope [96], and are therefore not capable of capturing such long-term dependency. One thread of AMI work that aims to overcome this problem in *music analysis*[12], a task strongly related to listening, is based on a generalisation of the Markov idea into general compression [56], by identifying large-scale structural units. This idea addresses Widmer's [96] argument that *abstraction* is necessary to explain the hierarchy and dependencies within music: identification of patterns and their repetition is fundamental. The formation therefrom of abstract prototypes [28], that allow repetition to be approximate, is what enables music to develop its themes, and for its listeners to hear and enjoy that development.

Notably, however, the debate has circulated mostly around the syntax of music: what sounds must be grouped together to make music that fits a particular style or (more generally) tradition. Thus, the focus of attention is on the surface form. There has been surprisingly little discussion in AMI of what message that surface form carries. Before moving on completely to that question, no chapter on AMI would be complete without reference to the work of David Cope, whose system EMI (Experiments in Musical Intelligence) encompassed work over several decades [24, 25, 26]. It stands apart from other work in AMI, because it has a more artistic intent than most, and there is no attempt at scientific evaluation, nor really at scientific reporting [102]. A particularly laudable element of the work, however, was the attempt to use music-theoretic criteria to model human *responses* to music to guide its production, in the SPEAC system [26]. This brings me to my next question.

---

[12]Music analysis aims to explain how a piece of music works, in terms of its structure and the relations between its parts.

## 4.4 What Does Music Mean?

There can be little doubt that syntactic features of music have direct psychomotor effects on humans. A strong dance rhythm, tautologically, makes many people want to move. But the effects of music on the human psyche are much more nuanced than this. The Music Information Research community[13] has long studied the "mood" of music, which is an attempt to classify (usually) pop songs into groups labelled, for example, "happy" or "sad", with a view to proposing songs that are unknown to a particular listener, or constructing playlists from a listener's collection with these moods in mind. Music psychology has a substantially more nuanced view, not least because it is often focused on much larger-scale art music, whose associated affect changes not just from piece to piece but from bar to bar within a piece[14] [48]. Whatever the scale, or depth, of the affective effect, humans demonstrably enjoy the engagement and actively seek it out, even when the prevailing emotion is (superficially) negative [92].

For AMI, the question of affect is difficult. First, there is the distinction between affect that is *suggested* to the listener by music and affect that is *felt* by a listener [98]. For example, there is a difference between music that a listener *thinks* "sounds sad" and music that makes a listener *feel* sad. The former can happen without the latter, but presumably not the converse. Next, there is the question of subjectivity: individuals form very strong associations with music that are quite peculiar to themselves[15].

On the positive side, meaning in music is less difficult in at least one set of respects than in language: music does not have propositional, compositional semantics. Notwithstanding the fact that strong associations with situations and emotions can be formed, and also that some musical gestures seem to have reliable semantic correlates, visible at the neural level [50], music cannot make complex statements about the world. The consequence of this is that AMI does not normally[16] need to import reasoning about the real world in order to function, as do many other aspects of AI. This difference is profound: music is, in this sense, *a closed system*, referring only to itself (by repetition, exact or approximate [18, 28]), and capable of conveying affective connotation, but without epistemic content[17]. Wiggins [110] identifies five features of music that make it particularly interesting for cognitive science research:

---

[13]http://www.ismir.net

[14]This is true of much popular music too, but the question of nuance is not usually asked in that context.

[15]For example, stereotypically, the song that accompanied one's first dance with one's life-partner probably has very specific affective connotations.

[16]There are specific exceptions, such as musical onomatopoeia, but they are not common.

[17]In this epithet lies a minefield. Contrary to established epistemological usage, some members of the cognitive neuroscience community have chosen to use the word "epistemic" to connote the resolution of ambiguity [34]. Here, I use the conventional broader meaning.

1. "It is *ephemeral*: music does not exist as an object in the world[18], and is therefore *entirely* dependent on the mechanisms of memory[19] for its cognitive effect [103, 111];

2. "It is *anepistemic*: except in very unusual circumstances, essentially equating with onomatopoeia in language, and notwithstanding evidence of association [50], music is without denotational meaning, being incapable of making statements that are truth-functional [98, 103];

3. "It is *autoanaphoric*: music can refer, but in a different way from language, because, except in the same unusual circumstances as above, it always refers to itself, and usually only within a single piece [65, 66, 82, 101, 104];

4. "It is *cultural*: music (like language) is a cultural artefact and requires enculturation to be understood [106, 108, 109]: in consequence (like language), it is heavily dependent on learning;

5. "It is *enchanting*: music engages humans in strong, non-conscious and conscious motor and/or affective responses, often to the extent that they react both physically, and often involuntarily [14, 32, 93], and also by spending their hard-earned cash on recordings."

For AMI, the emphasis is a little different. The enchantment cast by music is not something for AMI to explain, since it is a human property—except in as far as an AMI agent may need to model it to evaluate its own work. The anepistemic and autoanaphoric nature of music, which render it effectively a closed world, benefit AMI in a practical sense: there is less to connect and less to explain. The ephemeral and cultural nature of the music offers opportunity, especially in an era of renewed interest in machine learning, and also a caution: when a phenomenon to be studied is cultural (and therefore subjective and intersubjective), it is necessary to question one's prior assumptions even more than in classical objective science.

The biggest difficulty for AMI is that musical meaning is mostly about feelings. To feel, one has to be conscious, and while it is certainly possible for computers to sense, in as far as analogue measurements from the world can be converted into digital representations, there is no evidence whatsoever that a silicon machine can feel in the same way as a human. Indeed, CPUs are designed to be as efficient as possible in their computations, so there is pressure to design unnecessary feelings out of a computer, even if we knew how to include them.

In the literature and the public eye, there is significant confusion between consciousness and intelligence: for example, Searle's "Chinese Room" argument [77], which was originally presented as an argument about (ill-defined) "understanding", and specifically against the aims of Strong AI [88], has since been clarified as an argument about consciousness, not about intelligence. The distinction between intelligence and consciousness remains unclear in many of these debates. The position

---

[18]Here, it is important not to confuse *music* with *music notation*: while the latter evidently exists as part of a world object, it constitutes only instructions on how to produce music, and not the music itself. A similar usage is common when referring to recordings, and the corresponding response applies.

[19]A common objection to this claim is that one should be able to experience music "in the moment". But this is an illusion: there is no such thing as an infinitessimal musical moment, for we always perceive a *segment* of time. To see this, consider that a (sound) wave does nothing at a point in time. Therefore, even when we are considering the musical present, we are considering a small slice of the past.

that equates AI with rationality [81] makes it quite clear that aesthetics have no place, unless they be the aesthetics of science applied at the meta-level to AI theories themselves. But humans are not normally rational, and nor is their musical behaviour, so AMI must look elsewhere.

This said, a brief diversion into definition is necessary. The word "aesthetics" is defined by the Oxford Dictionary of English as, "a set of principles concerned with the nature and appreciation of beauty." To consider the *nature* of beauty is a philosophical pursuit; and it is not the meaning that I intend here. I use this word here to refer specifically to the *appreciation* of music by *individual* listeners, possibly from an explicit, formalised standpoint, but certainly also from an affective, *felt* position. It is important also to note that the notion of "beauty" is itself intensely subjective, and that familiar Romantic notions of beauty are only one small aspect of what attracts listeners to music. However, the individual and intersubjective aesthetic of music, whatever it is, is demonstrably very *powerful*. Therefore, it must be acknowledged.

What, then, is the consequence for AMI? In the first place, AMI researchers must take a position on what it means to include something called "musical meaning" or "aesthetics" in their research. Some researchers in computational creativity argue that machines should develop their own aesthetic [20]; however, this would entail that the machines could feel, and, since it is near certain that they cannot, as discussed previously, the idea is meaningless. It follows that any aesthetic synthesised by a computer is a meaningless concept, in a very specific, literal sense: it is merely a mathematical construct, lacking any actual aesthetic content in its own right. While developing such a construct might be an interesting driver for a computationally creative system, it does not tell us about the aesthetics of that system, because there are none. Any aesthetic in such a system is necessarily imposed from outside, by a biological viewer. A different position, which is more defensible, is that computers might attempt to model human aesthetics, with a view to meeting or challenging their requirements. This casts the creative computer as an artist without its own aesthetic, but with logical awareness of the aesthetics of others, driven either by them, or by non-aesthetic motivations or both. It is rather hard to give human analogies for what this might mean: maybe a painter, who was blind from birth, but who has learned what sighted viewers of paintings feel, would be a comparable case [40]. The example of a deaf composer is not contradicted by the existence of Beethoven's later work: aesthetics can be connected with musical imagination (indeed, Huron [44] argues that they are driven by it, at least in part), which Beethoven had many years to develop before he lost his hearing. A computer behaving in this way would be congruent with Searle's Chinese Room: the machine is generating things according to its model of humans with only simulated, and not experienced, understanding of what is happening. The machine is musically intelligent, but not musically conscious.

This said, there are concepts in music theory that relate directly to aesthetics, and these can be and have been used in broadly style-based AMI. Harmonic tension is the most common: in tonal music (interpreted broadly, as music with a recognisable tonal centre), tension is conceptualised as how harmonically distant the harmony is, at any point in the piece, from the tonal centre. Means exist to estimate this [6, 52, 54, 55, 78], and it does seem to be a reliable measure in experienced listeners; thus it can be used by both composition and performance systems [26, 60]. Agres et al. [2] review and propose various other methods that can be used to allow AMI

systems to reflect on their own output and to improve it in these human terms; but none of these methods can confer aesthetic sensibility on the machine.

This leads us back to a key theme of this chapter. Above all, the AMI researcher must remember that music is fundamentally *defined* by human memory and human perception [103, 106, 108, 109], no matter how much some theorists [59] would like to think otherwise. It is possible to make conceptual art around music—for example, John Cage's 4′33″ works simultaneously at a conceptual level and at a musical one. But the musical function of such art is such that the majority of humanity will probably not consider it even to be music, and will also probably not *perceive or cognitively process* it as such. A reductio ad absurdum might be a piece of music transposed to audio frequencies higher than the human perceptual range. This may be conceptual art. But is it music? By my definition, no, because it can be neither heard nor (therefore) remembered. This example stands in starkly interesting contrast with the performative and perceptual aspects of Cage's most famous work: listening to 4′33″ with open ears and mind, all the sounds in the auditorium *become* conceptually musical, or at least performative, for 273 seconds. Thus, contrary to common simplistic ridicule, it is not nonsense to make a recording of 4′33″, but doing so does raise a question of what *exactly* one should record. In my opinion, a key conceptual point of Cage's piece is that music is *what is heard,* placing listening and the associated auditory processing at the centre of the activity.

I do not think that there is a realistic solution to the problem of the missing aesthetic. Ultimately, since no computer with feelings is currently available, nor expected in the near future, AMI researchers need to consider and state their position on these and related questions; otherwise, it becomes difficult or impossible to interpret and to evaluate their work in terms of its contribution to the understanding of music or the musical mind. In the absence of a reasoned philosophical position on this matter, AMI risks degenerating (in the Lakatosian sense [51]) as a scientific pursuit, and becoming an engineering discipline in which the highest attainable goal is to challenge techniques to capture superficial musical phenomena (as described previously). In this event, progress in understanding of music is unachievable through AMI, and only two musical results can arise: pastiche, where new music, or new performances of music, are manufactured effectively as varied copies of current work, constrained by surface features; or serendipity, where a computer system stumbles upon creative novelty without a theoretical basis, and therefore is reliant upon a human evaluator to identify the success. Neither of these results should properly be labelled AMI, because *musical understanding*, in Searle's initial sense of "understanding", is missing from the computational process. In anepistemic and autoanaphoric music, that sense of "understanding"—aesthetic sensibility—is almost everything, because, in contrast with the case of meaningful and referential language describing the world and its events, there is almost nothing else.

## 4.5 What Does the Future Hold for Artificial Musical Intelligence?

How, then, can AMI escape from the Chinese Room?

A computer that feels is not currently foreseeable. But since, I have argued here and elsewhere [103, 106, 108, 109, 111], music is defined by human perception and

cognition, AMI can defensibly take the approach of simulated aesthetics, also discussed previously, so long as it stays firmly within the boundaries of music defined, not as conceptual art, but as a human, auditory, embodied, affective social construct. The key words here are Babbitt's "auditory" (recall that it entails perceptual and cognitive processing of acoustic input) and "affective" (which entails awareness of consciousness of feeling to function). This entails a new focus for AMI, not on the surface forms, nor even on the deeper music-theoretic structures such as harmonic structure, but on human responses to these things. While the problem of subjectivity remains, it may be overcome in precisely the same way that human musicians overcome it: by making a virtue of the fact that different listeners perceive and appreciate the same music in different ways, but, nevertheless, by communicating with them by whatever component is indeed shared.

To avoid misunderstanding, it is important again [105] to deny the misconception that composers *in general* are attempting to impose particular brain states on the listener[20] [10]. While we must simulate brain states to predict the response of a human to an AMI-generated piece of music, it does not follow that the aim of that musical activity is normally to force humans into those same brain states. AMI's need for simulation of human response arises not from a campaign to execute authoritarian compositions, but from the need to understand *other* music (in other words, to *listen*) in order to *compose*, and then to *reflect* on what one has composed in terms of one's own listening (imagined or otherwise), in order to *evaluate* it as part of one's creative process.

From a practical perspective, this presents a significant barrier: those wishing to practice AMI must become at least knowledgeable about, if not expert in, music perception and cognition, or, better, these two fields with so much in common must start to work together. Fortunately, the International Conference on Music Perception and Cognition[21], and its plethora of participating societies[22], provide AMI scientists and engineers with a veritable banquet of food for thought.

In short, for AMI to succeed, in a deliberate, non-serendipitous way, and in a way that humans recognise, its practitioners must focus less on medium (i.e., surface form), and more on message (i.e., human response). In language, this principle would be blindingly obvious—who would seriously consider generating literary narratives using syntax alone?—but in AMI it seems to remain obscure.

The positive corollary of this is that AMI systems ought to learn from listening, in a human-like way, if they are to exhibit human-like behaviour. Music theory does not capture the knowledge and experience of a composer—important indicator of intersubjective perceptual primitives though it be. The way forward, then, is to focus on what comes first in human musical development—listening—and to build on that as it is properly understood.

---

[20] Of course, I do not deny that some functional music is indeed intended this way, such as religious music or music in advertising.

[21] http://icmpc.org

[22] http://www.icmpc.org/icmpc_societies.html

## 4.6 Where Is Creativity in AMI?

Ultimately, if AMI is to succeed in terms of science and of art, as well as engineering, I believe we need an approach that is more radical than most current approaches. Involvement in music, as a composer, as a performer, and even as a careful listener (because musical structure needs to be reconstructed in context of the perceived sound), requires a human capacity which sets us apart from most other animals: creativity. AMI scientists need to address creativity directly [11, 12]. The ability to construct complex, imagined cognitive constructs, both consciously and unconsciously, seems to be significantly more developed in humans than in other species, and is surely fundamental to our evolutionary success [114]. Further, the ability to build such constructs in imagined time, realise them, and to predict their consequences, seems to underpin both music and language [80, 116] as well as other uniquely human activities including dance, design, cookery, mathematics and engineering. Therefore, addressing musical creativity head on is likely to benefit understanding of humanity, as well as that of music: creativity (measured on a long scale between mundane and magnificent) seems to be a general property of humans (even if it has domain-specific elements), and the self-contained nature of music lends itself well to this study, for reasons rehearsed previously. The question, then, is of how to do so.

Earlier in this chapter, I pointed out the shortcomings, with respect to the understanding and development of music, of rule-based AI systems that "merely" generate. That potential shortcoming is not absolute: generation *of good solutions* may be extremely difficult, in cases where the solution space is sparsely populated, or the fitness landscape is highly carunculated [16, 100]. Nevertheless, one supportable criticism of such systems, from the perspective of creativity, is that the creativity is really in the programmer of the rules, and not in the system. In my opinion, to address this concern, the first step that we must take (and, of course, that many researchers have taken) is towards systems that learn. Thus, we build a learning system with engineered learning behaviour, and apply it to music (appropriately represented), and use it to generate. In this instance, the *musical* knowledge in the system is not directly engineered by a human, and thus the first criticism is disarmed. Of course, what these systems are doing is learning to listen.

However, that same criticism is now pushed up to the meta-level: we can engineer our learning system and its generator so as to generate in a certain way, and so the *creativity* may still be said to lie in the human programmer, even though it be domain-independent. The criticism is harder to deflect at this level, but we may do so by reference to the nature of the model, as follows. The argument rests on the idea, defended previously, that music as we know it is fundamentally defined by human perception and related activity, because its social evolution is bounded by these capabilities. Thus, music is an auditory (i.e., cognitive) activity, which seems to engage multiple cognitive capacities *that are used by other cognitive domains* [68, 69]. Therefore, one can generalise one's model to address not the domain, but *the relevant cognitive capacities* in general. My own theoretical approach, the Information Dynamics of Thinking [110], takes this line. Several such approaches exist in cognitive science [19, 33, 87]. The key idea is not to think about what music is, or how it works, but how a general cognitive system might *do* it. Thus, we completely eschew the traditional AMI approach to music as *a problem to be solved*, but instead address it as something of which our cognitive systems ought to be capable. To avoid

all accusations of *ad hoc* engineering, one might want to go so far as also to account for non-musical behaviours, providing further evidence. (Wiggins et al. [113] introduce this idea as a methodological device, the *meta-model*: a theory or model which accounts for data in different domains, or for different mechanisms, from those for which it was intended.) In summary, the aim is to account for musical creativity as a phenomenon emergent from pre-existing cognitive components. This is defensible in evolutionary terms, too: it seems highly unlikely that a phenomenon so complex and social as music would spring, fully formed, from a single serendipitous evolutionary moment [114].

Next, I deploy my previous argument regarding aesthetics. Music is a uniquely human activity, which is *defined* by human perception and cognition. Therefore, models of human perception and cognition, and related affective response, not only can, but *should*, underpin reflective systems in AMI: this is not a compromise in the absence of a better answer, but a principled position. To understand the effect music has on humans, we need to propose detailed, testable models of listening at all levels of abstraction. We need to implement them, test them, and, if they are not falsified, use them to endow our AMI systems with the ability to reflect on their productions. For example, work on affective response to the information dynamics of music [32, 35, 38] provides one principled route of access to such a model.

To achieve creativity that is independent of the programmer, these simulations must emerge from theoretical mechanisms which work uniformly over their data: *explanatory* models are required, and not merely descriptive ones [105]. In particular, these models must generalise beyond the data they have learned: otherwise, they will not be capable of inventing new concepts within the spaces they inhabit, which would bring us back to traditional search-based methods.

Finally, in this account, we need *motivation*: why should an AMI system produce music? Motivations are sometimes characterised as drives, for example, simulating hunger, or curiosity [85, 86, 87]. I propose a different answer, that is not often considered: *because that is what it does* [107, 110]. That is to say, it should be a property of the AMI model that internal structures that represent music are continually generated, based on the knowledge of the system. This is, arguably, what humans do: we constantly imagine, even if what we are imagining is mundane, such as the sentence we are about to utter, or the way we need to reach to open the door in front of us; even if we are unaware that we are doing it. In the case that there is sufficient exposure to musical data, then musical imagination is possible[23]. Wiggins and Bhattacharya [97] argue that the currently unexplained "noise" in a brain that is not consciously active (and therefore also in one that is consciously active) is precisely this general productive activity. The resulting productions only rarely enter conscious awareness, that arrival being experienced as having an idea [107], or as "inspiration" in the terminology of Wallas [95].

A system that generates because that is its nature, that can learn from supplied representations of data, and then generalise from that data using general principles that model auditory cognition, is a rather good model of a human composer. Richard Rodney Bennett, the English composer, commented shortly before he died

---

[23]Many people are cursed by the production of "ear-worms": known music that is performed internally in an annoying loop [46, 47]. In my opinion, the relation between this and musical creativity, conceived as generation of structures from musical memory, is likely to be considerable.

> I didn't ever decide I was going to be a composer. It was like being tall. It's
> what I was. It's what I did.                                                   [115]

I have the same experience: I am not *driven* to compose by an ancillary feeling;
rather, I cannot stop it happening, and musical ideas appear in my head whether I
like it or not. Our AI systems need the same, and since they are devoid of feeling,
they must be able to reason in terms of the feeling of human listeners, via simulated
aesthetics.

Finally, this claim entails a brief discussion of evaluation. Reflection by an AMI
system on its own output, in terms of human aesthetics, is a kind of evaluation,
and such an AI system is surely on the road to being considered "creative". But
how to evaluate the system itself as a piece of creative-AI technology? Clearly it is
necessary to evaluate its outputs as music [79]. There are several ways to do this [2]:
for example, by comparison of the music with a well-defined human equivalent (such
as undergraduate music students) with a nuanced, knowledge-based, comparative
scale (such as a 1st year harmony exam marking scheme) [112], or by reasoned and
well-informed musical analysis [75] or by appeal to musical experts in consensual
assessment tests [3, 73]; in my opinion, this last option is the best.

What does not work, in any scientific sense, is the idea of the Musical Turing
Test—used by many researchers, such as Cope [26]. This is most commonly exe-
cuted in a performance venue, but can also be done in the lab. The "Test" requires
human listeners to distinguish between human- and machine-composed music, and
the researcher claims to win if the listener is "fooled" by the machine.

The reason this approach does not work is that it is not a good reflection of the
Imitation Game as described by Turing[24] [91]. The Imitation Game requires humans
who are assumed to be native speakers—and therefore implicit experts—to make
judgements about the properties of two unseen persons (or, in Turing's version, a
person and a computer), communicating only in text. The first way in which most
AMI "Turing" Tests deviate is that they do not use experts, but at best experienced
listeners: this is like asking speakers of one language to make judgements about
poetry in another: they can comment on surface features (rhyme, rhythm, and so on),
but not much else. The second is that the Imitation Game is effectively a competition
between two unseen people, one of whom is being truthful, while the second is
not: it is the aim of each person to undermine the other. This particular element
of intelligence simply cannot arise in music, for the reasons discussed previously:
music cannot contradict other music, because music cannot be "about" things in
the same way that language can. Thus, the Musical "Turing" Test is substantially
less demanding and substantially less focused than its linguistic counterpart. Indeed,
the very point of the Turing Test applied to music, rather than language, is awry.
This is because language is the fundamental communicative function of all humans,
whereas music is a specialised form requiring particular knowledge—and learned
cognitive representations—that not everyone has. There are many, many humans

---

[24]In my opinion, Turing did not in fact intend to propose a test in this paper.
Rather he was arguing, in answer to the question "Can machines think?", that
there does come a point where we cannot distinguish between human and machine
performance, but that does not tell us whether the machine is intelligent (or possibly
conscious) or not. Since the word "think" is ill-defined, it is impossible to tell whether
Turing refers to reasoning or consciousness or both.

who cannot compose music as well as Ebcioğlu's CHORAL system. But that does not tell us anything useful about CHORAL—nor about the humans.

In fact, it simply does not matter whether a piece of music was written by a human or a computer. What matters is whether the music *succeeds* as a piece of music, in its own right. And the answer to that question *does* necessarily depend on human listeners, as I have already argued.

With this point, the loop is closed. Given an explanatory model of human response to music, AMI systems can make their own judgements about humans' responses to their outputs. They can then learn from their own mistakes, by comparing with actual human responses, to improve the human response model. Because a properly done human response model will predict response emergent from more basic properties, as argued above, AMI systems will be able to predict human response to truly novel music, and thus perhaps lead human music to unforeseen conclusions.

Thus, properly focused and equipped AMI—rigorously studying musical meaning as well as musical syntax—may capitalise on the specially human nature of music, implementing true computational creativity in this magical—but manageable—closed cognitive world.

*Acknowledgement.* I am grateful for the constructive feedback of two anonymous reviewers, which improved this chapter.

# References

[1] Abdallah, S., Plumbley, M.: Unsupervised analysis of polyphonic music using sparse coding in a probabilistic framework. In: Proceedings of ISMIR. www.ismir.net (2004)

[2] Agres, K., Forth, J., Wiggins, G.A.: Evaluation of musical creativity and musical metacreation systems. ACM Computers in Entertainment **14**(3), 3:1–3:33 (2016). DOI 10.1145/2967506. URL http://doi.acm.org/10.1145/2967506

[3] Amabile, T.M.: Creativity in Context. Westview Press, Boulder, Colorado (1996)

[4] Assayag, G., Dubnov, S.: Using factor oracles for machine improvisation. Soft Computing **8**(9), 604–610 (2004). DOI 10.1007/s00500-004-0385-4. URL https://doi.org/10.1007/s00500-004-0385-4

[5] Babbitt, M.: The use of computers in musicological research. Perspectives of New Music **3**(2), 74–83 (1965)

[6] Balzano, G.J.: The group-theoretic description of 12-fold and microtonal pitch systems. Computer Music Journal **4**(4), 66—84 (1980)

[7] Bemman, B., Meredith, D.: Generating Milton Babbitt's all-partition arrays. Journal of New Music Research **45**(2), 184–204 (2016)

[8] Bemman, B., Meredith, D.: Predicting babbitt's orderings of time-point classes from array aggregate partitions in *None but the Lonely Flute* and *Around the Horn*. Journal of Mathematics and Music **11**(2) (2017)

[9] Bemman, B., Meredith, D.: Generating new musical works in the style of Milton Babbitt. Computer Music Journal **42**(1), 60–79 (2018)

[10] Bharucha, J., Curtis, M., Paroo, K.: Musical communication as alignment of non-propositional brain states. In: P. Rebuschat, M. Rohrmeier, I. Cross, J. Hawkins (eds.) Language and Music as Cognitive Systems. Oxford University Press (2011)

[11] Boden, M.: Artificial Intelligence and Natural Man. Harvester Press (1977)

[12] Boden, M.A.: Computer models of creativity. The Psychologist **13**(2), 72–76 (2000)

[13] Boden, M.A.: The Creative Mind: Myths and Mechanisms, 2nd edn. Routledge, London, UK (2004)

[14] Bown, O., Wiggins, G.A.: From maladaptation to competition to cooperation in the evolution of musical behaviour. Musicæ Scientiæ **13**, 387–411 (2009). DOI 10.1177/1029864909013002171. Special Issue on Evolution of Music

[15] Briot, J., Hadjeres, G., Pachet, F.: Deep learning techniques for music generation - A survey. CoRR **abs/1709.01620** (2017). URL http://arxiv.org/abs/1709.01620

[16] Bundy, A.: What is the difference between real creativity and mere novelty? Behavioural and Brain Sciences **17**(3), 533–534 (1994)

[17] Cage, J.: Silence. Wesleyan University Press (1973)

[18] Cambouropoulos, E., Crawford, T., Iliopoulos, C.S.: Pattern processing in melodic sequences: Challenges, caveats and prospects. Computers and the Humanities **35**, 9–21 (2001). Special Issue on Pattern Processing in Music Analysis and Creation

[19] Clark, A.: Whatever next? predictive brains, situated agents, and the future of cognitive science. Behavioral and Brain Sciences **36**, 181–204 (2013). DOI 10.1017/S0140525X12000477. URL http://journals.cambridge.org/article_S0140525X12000477

[20] Colton, S.: Creativity versus the perception of creativity in computational systems. In: Proceedings of the AAAI Spring Symposium on Creative Systems (2008)

[21] Conklin, D.: Prediction and entropy of music. Master's thesis, Department of Computer Science, University of Calgary, Canada (1990). URL http://pharos.cpsc.ucalgary.ca:80/Dienst/UI/2.0/Describe/ncstrl.ucalgary_cs/1989-352-14?abstract=

[22] Conklin, D.: Chord sequence generation with semiotic patterns. Journal of Mathematics and Music **10**(2), 1–15 (2016)

[23] Conklin, D., Witten, I.H.: Multiple viewpoint systems for music prediction. Journal of New Music Research **24**, 51–73 (1995)

[24] Cope, D.: Computers and Musical Style. Oxford University Press (1991)

[25] Cope, D.: Virtual Music: Computer Synthesis of Musical Style. MIT Press, Cambridge, MA (2004)

[26] Cope, D.: Computer Models of Musical Creativity. MIT Press, Cambridge, MA (2005)

[27] Craft, A., Wiggins, G.A., Crawford, T.: How many beans make five? the consensus problem in music-genre classification and a new evaluation method for single-genre categorisation sysytems. In: Proceedings of ISMIR. Vienna, Austria (2007)

[28] Deliège, I.: Grouping conditions in listening to music: An approach to Lerdahl and Jackendoff's grouping preference rules. Music Perception **4**, 325–360 (1987)

[29] Dubnov, S., McAdams, S., Reynolds, R.: Structural and affective aspects of music from statistical audio signal analysis. Journal of the American Society for Information Science and Technology **57**(11), 1526–1536 (2006). DOI 10.1002/asi.20429. URL https://onlinelibrary.wiley.com/doi/abs/10.1002/asi.20429

[30] Ebcioğlu, K.: An expert system for harmonizing four-part chorales. Computer Music Journal **12**(3), 43–51 (1988)

[31] Ebcioğlu, K.: An expert system for harmonizing chorales in the style of J. S. Bach. Journal of Logic Programming **8** (1990)

[32] Egermann, H., Pearce, M.T., Wiggins, G.A., McAdams, S.: Probabilistic models of expectation violation predict psychophysiological emotional responses to live concert music. Cognitive, Affective, & Behavioral Neuroscience **13**(3), 533–553 (2013). DOI 10.3758/s13415-013-0161-y. URL http://dx.doi.org/10.3758/s13415-013-0161-y

[33] Friston, K.: The free-energy principle: A unified brain theory? Nature Reviews Neuroscience **11**(2), 127–138 (2010). DOI 10.1038/nrn2787

[34] Friston, K., FitzGerald, T., Rigoli, F., Schwartenbeck, P., O'Doherty, J., Pezzulo, G.: Active inference and learning. Neuroscience & Biobehavioral Reviews **68**, 862 – 879 (2016). DOI https://doi.org/10.1016/j.neubiorev.2016.06.022. URL http://www.sciencedirect.com/science/article/pii/S0149763416301336

[35] Gingras, B., Pearce, M.T., Goodchild, M., Dean, R.T., Wiggins, G., McAdams, S.: Linking melodic expectation to expressive performance timing and perceived musical tension. Journal of Experimental Psychology: Human Perception and Performance **42**(4), 594 (2016)

[36] Gjerdingen, R.O., Perrott, D.: Scanning the dial: The rapid recognition of music genres. Journal of New Music Research **37**(2), 93–100 (2008). DOI 10.1080/09298210802479268. URL https://doi.org/10.1080/09298210802479268

[37] Gowrishankar, B.S., Bhajantri, N.U.: An exhaustive review of automatic music transcription techniques: Survey of music transcription techniques. In: 2016 International Conference on Signal Processing, Communication, Power and Embedded System (SCOPES), pp. 140–152 (2016). DOI 10.1109/SCOPES.2016.7955698

[38] Hansen, N.C., Pearce, M.T.: Predictive uncertainty in auditory sequence processing. Frontiers in Psychology **5**(1052) (2014). DOI 10.3389/fpsyg.2014.01052

[39] Haugeland, J.: Artificial Intelligence: The Very Idea. MIT Press, Cambridge, MA (1985)

[40] Heath, D., Ventura, D.: Before a computer can draw, it must first learn to see. In: Proceedings of the Seventh International Conference on Computational Creativity, pp. 172–179 (2016)

[41] Hiller, L., Isaacson, L.: Experimental Music. McGraw–Hill, New York (1959)

[42] Hodges, A.: Alan Turing: The Enigma. Vintage, London (1992)

[43] Honing, H.: Computational modeling of music cognition: a case study on model selection. Music Perception **23**(5), 365–376 (2006)

[44] Huron, D.: Sweet Anticipation: Music and the Psychology of Expectation. Bradford Books. MIT Press, Cambridge, MA (2006)

[45] Iñesta, J.M., Conklin, D., Ramirez-Melendez, R., Fiore, T.M.: Machine Learning and Music Generation. Routledge, Taylor and Francis (2018). ISBN 978-0-8153-7720-7

[46] Jakubowski, K., Bashir, Z., Farrugia, N., Stewart, L.: Involuntary and voluntary recall of musical memories: A comparison of temporal accuracy and emotional responses. Memory & Cognition **46**(5), 741–756 (2018). DOI 10.3758/s13421-018-0792-x. URL https://doi.org/10.3758/s13421-018-0792-x

[47] Jakubowski, K., Stewart, L., Finkel, S., Müllensiefen, D.: Dissecting an earworm: Melodic features and song popularity predict involuntary musical imagery. Psychology of Aesthetics, Creativity, and the Arts **11**(2), 122–135 (2017). DOI 10.1037/aca0000090

[48] Juslin, P., Sloboda, J.: Handbook of music and emotion: theory, research, applications. Affective Science. Oxford University Press (2010). URL http://books.google.co.uk/books?id=1N85AQAAIAAJ

[49] Katayose, H., Hashida, M., Poli, G.D., Hirata, K.: On evaluating systems for generating expressive music performance: the rencon experience. Journal of New Music Research **41**(4), 299–310 (2012). DOI 10.1080/09298215.2012.745579. URL https://doi.org/10.1080/09298215.2012.745579

[50] Koelsch, S., Kasper, E., Sammler, D., Schulze, K., Gunter, T., Friederici, A.D.: Music, language and meaning: brain signatures of semantic processing. Nature Neuroscience **7**(3), 302–307 (2004)

[51] Lakatos, I.: The Methodology of Scientific Research Programmes: Philosophical Papers. Cambridge University Press, Cambridge, UK (1978). (Edited by John Worrall and Gregory Currie)

[52] Lerdahl, F.: Tonal pitch space. Music Perception **5**(3), 315–350 (1988)

[53] London, J.: Hearing in time: psychological aspects of musical metre, 2nd edn. Oxford University Press, Oxford, UK (2012)

[54] Longuet-Higgins, H.C.: Letter to a musical friend. The musical review **23**, 244–8,271–80 (1962)

[55] Longuet-Higgins, H.C.: Second letter to a musical friend. The Music Review **23**, 271–280 (1962)

[56] Louboutin, C., Meredith, D.: Using general-purpose compression algorithms for music analysis. Journal of New Music Research **45**(1), 1–16 (2016). DOI 10.1080/09298215.2015.1133656. URL http://www.tandfonline.com/doi/abs/10.1080/09298215.2015.1133656

[57] Lutosławski, W.: Jeux vénitiens [Venetian Games] (1961)

[58] Maessen, G., Conklin, D.: Two methods to compute melodies for the lost chant of the Mozarabic rite. In: Proceedings of the 8th International Workshop on Folk Music Analysis (FMA 2018). Thessaloniki, Greece (2018)

[59] Mazzola, G.: Initial text: Thinking music with precision, depth, and passion. Journal of Mathematics and Music (2012)

[60] Melo, A., Wiggins, G.A.: A connectionist approach to driving chord progressions using tension. In: P. Gervás, S. Colton (eds.) Proceedings of the AISB'03 Symposium on Creativity in Arts and Science. Aberystwyth, Wales (2003)

[61] Meredith, D., Lemström, K., Wiggins, G.: Algorithms for discovering repeated patterns in multidimensional representations of polyphonic music. Journal of New Music Research **31**(4), 321–345 (2002)

[62] Minsky, M.: Music, mind and meaning. Computer Music Journal **5**(3), 28–44 (1981)

[63] Müller, M., Konz, V., Clausen, M., Ewert, S., Fremerey, C.: A multimodal way of experiencing and exploring music. Interdisciplinary Science Reviews **35**(2), 138–53 (2010)

[64] Nakamura, E., Benetos, E., Yoshii, K., Dixon, S.: Towards complete polyphonic music transcription: Integrating multi-pitch detection and rhythm quantization. In: Processings of ICASSP (2018)

[65] Nattiez, J.J.: Is a descriptive semiotics of music possible? Language Sciences **23** (1972)

[66] Nattiez, J.J.: Fondements d'une sémiologie de la musique. Union Générale d'Editions, Paris (1975)

[67] Papadopoulos, G., Wiggins, G.A.: AI methods for algorithmic composition: A survey, a critical view and future prospects. In: Proceedings of the AISB'99 Symposium on Musical Creativity, pp. 110–117. SSAISB, Brighton, UK (1999). URL http://www.soi.city.ac.uk/~geraint/papers/AISB99b.pdf

[68] Patel, A.D.: Musical rhythm, linguistic rhythm, and human evolution. Music Perception **24**(1), 99–104 (2006)

[69] Patel, A.D.: Music, Language, and the Brain. Oxford University Press, Oxford (2008)

[70] Pearce, M.T.: The construction and evaluation of statistical models of melodic structure in music perception and composition. Ph.D. thesis, Department of Computing, City University, London, London, UK (2005)

[71] Pearce, M.T.: Statistical learning and probabilistic prediction in music cognition: mechanisms of stylistic enculturation. Annals of the New York Academy of Sciences **1423**, 378–395 (2018). DOI 10.1111/nyas.13654. URL https://nyaspubs.onlinelibrary.wiley.com/doi/abs/10.1111/nyas.13654

[72] Pearce, M.T., Müllensiefen, D., Wiggins, G.A.: The role of expectation and probabilistic learning in auditory boundary perception: A model comparison. Perception **39**(10), 1367–1391 (2010)

[73] Pearce, M.T., Wiggins, G.A.: Evaluating cognitive models of musical composition. In: A. Cardoso, G.A. Wiggins (eds.) Proceedings of the 4th International Joint Workshop on Computational Creativity, pp. 73–80. Goldsmiths, University of London, London (2007)

[74] Phon-Amnuaisuk, S., Smaill, A., Wiggins, G.: Chorale harmonization: A view from a search control perspective. Journal of New Music Research **35**(4), 279–305 (2006)

[75] Ponsford, D., Wiggins, G.A., Mellish, C.: Statistical learning of harmonic movement. Journal of New Music Research **28**(2), 150–177 (1999). URL http://www.soi.city.ac.uk/~geraint/papers/JNMR97.pdf

[76] Popper, K.: The Logic of Scientific Discovery. Routledge, Abingdon, UK (1959). Translation of German original, 1934

[77] Preston, J., Bishop, M.: Views into the Chinese Room. Oxford University Press, Oxford (2002)

[78] Riemann, H.: Harmony Simplified. Augener, London (1895). Translated from the German *Vereinfachte Harmonielehre* by Rev. H. Bewerunge.

[79] Ritchie, G.: Some empirical criteria for attributing creativity to a computer program. Minds and Machines **17**(1), 67–99 (2007)

[80] Rohrmeier, M., Zuidema, W., Wiggins, G.A., Scharff, C.: Principles of structure building in music, language and animal song. Philosophical Transactions of the Royal Society of London B: Biological Sciences **370**(1664) (2015). DOI 10.1098/rstb.2014.0097

[81] Russell, S., Norvig, P.: Artificial Intelligence – a modern approach. Prentice Hall, New Jersey (1995)

[82] Ruwet, N.: Language, musique, poésie. Editions du Seuil, Paris (1972)

[83] Saffran, J.R., Griepentrog, G.J.: Absolute pitch in infant auditory learning: Evidence for developmental reorganization. Developmental Psychology **37**(1), 74–85 (2001). URL http://www.waisman.wisc.edu/infantlearning/publications/DevPsychAP.pdf

[84] Sakellariou, J., Tria, F., Loreto, V., Pachet, F.: Maximum entropy models capture melodic styles. Scientific Reports **7**(9172) (2017). DOI http://doi.org/10.1038/s41598-017-08028-4

[85] Saunders, R.: Curious design agents and artificial creativity. Ph.D. thesis, The University of Sydney, Sydney, Australia (2001)

[86] Saunders, R., Gero, J.S.: Situated design simulations using curious agents. AI EDAM Journal **18**(2), 153–161 (2004)

[87] Schmidhuber, J.: Formal theory of creativity, fun, and intrinsic motivation (1990–2010). Autonomous Mental Development, IEEE Transactions on **2**(3), 230–247 (2010). DOI 10.1109/TAMD.2010.2056368

[88] Searle, J.: Minds, brains and programs. Behavioral and Brain Sciences **3**(3), 417–457 (1980). DOI 10.1017/S0140525X00005756

[89] Sloboda, J.: The Musical Mind: The Cognitive Psychology of Music. Oxford Science Press, Oxford (1985)

[90] Tekman, H.G., Bharucha, J.J.: Implicit knowledge versus psychoacoustic similarity in priming of chords. Journal of Experimental Psychology: Human Perception and Performance **24**, 252–260 (1998)

[91] Turing, A.: Computing machinery and intelligence. Mind **LIX**(236), 433–60 (1950)

[92] van den Tol, A.J., Edwards, J.: Listening to sad music in adverse situations: How music selection strategies relate to self-regulatory goals, listening effects, and mood enhancement. Psychology of Music **43**(4), 473–494 (2015). DOI 10.1177/0305735613517410

[93] van der Velde, F., Forth, J., Nazareth, D.S., Wiggins, G.A.: Linking neural and symbolic representation and processing of conceptual structures. Frontiers in Psychology **8**, 1297 (2017). DOI 10.3389/fpsyg.2017.01297. URL http://journal.frontiersin.org/article/10.3389/fpsyg.2017.01297

[94] Ventura, D.: Mere generation: Essential barometer or dated concept? In: Proceedings of the International Conference on Computational Creativity, pp. 17–24 (2016)

[95] Wallas, G.: The Art of Thought. Harcourt Brace, New York (1926)

[96] Widmer, G.: Getting closer to the essence of music: The con espressione manifesto. ACM Transactions on Intelligent Systems and Technology **8**(2), Article 19 (2016). DOI DOI:10.1145/2899004

[97] Wiggins, G., Bhattacharya, J.: Mind the gap: An attempt to bridge computational and neuroscientific approaches to study creativity. Frontiers in Human Neuroscience **8**(540) (2014). DOI 10.3389/fnhum.2014.00540

[98] Wiggins, G.A.: Music, syntax, and the meaning of "meaning". In: Proceedings of the First Symposium on Music and Computers, pp. 18–23. Ionian University, Corfu, Greece (1998)

[99] Wiggins, G.A.: A preliminary framework for description, analysis and comparison of creative systems. Journal of Knowledge-Based Systems **19**(7), 449–458 (2006). URL http://dx.doi.org/10.1016/j.knosys.2006.04.009

[100] Wiggins, G.A.: Searching for computational creativity. New Generation Computing **24**(3), 209–222 (2006)

[101] Wiggins, G.A.: Models of musical similarity. Musicae Scientiae **11**, 315–338 (2007). DOI 10.1177/102986490701100112

[102] Wiggins, G.A.: Review article: 'Computer Models of Musical Creativity' by David Cope. Literary and Linguistic Computing **23**(1), 109–116 (2008). DOI 10.1093/llc/fqm025. URL http://llc.oxfordjournals.org

[103] Wiggins, G.A.: Semantic Gap?? Schemantic Schmap!! Methodological considerations in the scientific study of music. In: Proceedings of 11th IEEE International Symposium on Multimedia, pp. 477–482 (2009). DOI 10.1109/ISM.2009.36

[104] Wiggins, G.A.: Cue abstraction, paradigmatic analysis and information dynamics: Towards music analysis by cognitive model. Musicae Scientiae **Special Issue: Understanding musical structure and form: papers in honour of Irène Deliège**, 307–322 (2010)

[105] Wiggins, G.A.: Computer models of (music) cognition. In: P. Rebuschat, M. Rohrmeier, I. Cross, J. Hawkins (eds.) Language and Music as Cognitive Systems, pp. 169–188. Oxford University Press, Oxford (2011)

[106] Wiggins, G.A.: The future of (mathematical) music theory. Journal of Mathematics and Music **6**(2), 135–144 (2012)

[107] Wiggins, G.A.: The mind's chorus: Creativity before consciousness. Cognitive Computation **4**(3), 306–319 (2012). DOI 10.1007/s12559-012-9151-6

[108] Wiggins, G.A.: Music, mind and mathematics: Theory, reality and formality. Journal of Mathematics and Music **6**(2), 111–123 (2012)

[109] Wiggins, G.A.: On the correctness of imprecision and the existential fallacy of absolute music. Journal of Mathematics and Music **6**(2), 93–101 (2012)

[110] Wiggins, G.A.: Creativity, information, and consciousness: the information dynamics of thinking. Physics of Life Reviews p. in press (2020). DOI 10.1016/j.plrev.2018.05.001. URL https://www.sciencedirect.com/science/article/pii/S1571064518300599

[111] Wiggins, G.A., Müllensiefen, D., Pearce, M.T.: On the non-existence of music: Why music theory is a figment of the imagination. Musicae Scientiae **Discussion Forum 5**, 231–255 (2010)

[112] Wiggins, G.A., Papadopoulos, G., Phon-Amnuaisuk, S., Tuson, A.: Evolutionary methods for musical composition. International Journal of Computing Anticipatory Systems (1999). URL http://www.soi.city.ac.uk/~geraint/papers/CASYS98a.pdf

[113] Wiggins, G.A., Pearce, M.T., Müllensiefen, D.: Computational modelling of music cognition and musical creativity. In: R. Dean (ed.) Oxford Handbook of Computer Music, chap. 19, pp. 383–420. Oxford University Press (2009)

[114] Wiggins, G.A., Tyack, P., Scharff, C., Rohrmeier, M.: The evolutionary roots of creativity: mechanisms and motivations. Philosophical Transactions of the Royal Society of London B: Biological Sciences **370**(1664) (2015). DOI 10.1098/rstb.2014.0099

[115] Wroe, N.: A life in music: Richard Rodney Bennett. The Guardian **22nd July** (2011)

[116] Zuidema, W., Hupkes, D., Wiggins, G.A., Scharff, C., Rohrmeier, M.: Formal models of structure building in music, language, and animal song. In: H. Honing (ed.) The Origins of Musicality, p. 253. MIT Press (2018)

# 5

# Evolutionary Music, Deep Learning and Conceptual Blending: Enhancing User Involvement in Generative Music Systems

Maximos Kaliakatsos-Papakostas

Institute for Language and Speech Processing, Athena Research and Innovation Centre, Marousi, Greece `maximos@athenarc.gr`

**Summary.** Making music with evolutionary computation methods has been approached by many interesting methodologies throughout the last four decades. The key-component of evolutionary methods is the accurate description of what a good result is, but when it comes to music, the matter of quality is hard to describe – or even the notion of a strictly defined quality is controversial. Some methodologies approach music quality through explicit feature extraction from the musical surface, developing feature models that can describe qualitative aspects of music in a quantitative way. Other methodologies approach quality by employing implicit machine learning models that automatically extract latent features from data and have the ability to model style. Interactive evolution, on the other hand, gives the fitness evaluation role to the user, resolving issues related to the subjectivity and controversiality of how good music can be described. All aforementioned approaches have strengths and weaknesses; after an overview, this chapter makes a first step towards new methodologies for music generation that combine the strong elements of hitherto examined approaches: transparent features that allow intuitive description of music; implicit description of style through deep learning; and user involvement by lending elements from the conceptual blending theory. Indicative results are promising and indicate that proper combination of diverse methodological elements can lead to the development of new interesting evolutionary methods for music generation.

## 5.1 Introduction

Evolutionary computation has been vastly employed for generating new music and audio content. In many examples, evolutionary computation can achieve remarkable results given a sufficiently accurate description of what needs to be achieved. In the generation of artistic or musical content, however, it is extremely difficult or, someone may argue, impossible to describe accurately what a desired result looks or sounds like. What makes a musical piece sound good? What makes it sound coherent or adherent to a specific style? Answers to such questions have been attempted by cognitive modelling of musical attributes through *explicitly* computed features from the musical surface, through *implicit* (latent) features extracted with machine

learning directly from the musical surface, or by the involvement of the user in judging which generated material is good or bad.

Evolutionary computation incorporates the succession of typically large quantities of individuals with new ones, in evolutionary "rounds" called generations. The process starts from an initial generation of random or predefined individuals; a fitness function evaluates the individuals of the current generation and according to their fitness value, individuals are selected and genetic operators are applied to them, leading a new generation of individuals that combine (hopefully the desirable) attributes of individuals in the previous generation. There are numerous variations of evolutionary methods, with diverse individual selection, evaluation and breeding schemes; the goal of all those methods is to lead successions of generations that converge in optimum (in terms of fitness evaluation) results.

Modelling the aspects that make music sound good or comply with specific stylistic constraints is the essence in generative music systems that employ evolutionary computation, since such modelling serves the purpose of the aforementioned fitness function that evaluates musical individuals throughout consecutive generations. Even though, in general, evolutionary computation in music seems to be a disjoint field of research with many directions that have significant differences, a very broad categorisation in three (sometimes overlapping) parts can be attempted:

Category 1: Methods that use *explicit* features for describing musical attributes. This class of methods employs fitness functions based on features that are "transparently" computed from data and most of the times reflect qualitative aspects of music. E.g., rhythm density can be described as the ratio of note events over the total length of musical segment, a number which intuitively describes how "fast" the music sounds in terms of the metric structure. Fitness evaluation is given in the form of "target" features that the generated music should match, e.g. a melody should be generated with a specific value for rhythm density.

Category 2: Methods that use *implicitly* learned features directly from data. Unsupervised (deep) learning methods, e.g., with neural networks are an example. Such methods extract latent features directly from data; even though these features are not intuitively transparent, they have proven effective for categorising music and predicting note events – given sufficient amounts of data. Regarding fitness evaluation in these methods, (implicitly) trained models act as critics, rating the amount to which a generated musical excerpt matches the learned latent features.

Category 3: Methods that require user involvement in evaluating individuals. Users are mainly asked to rate or rank individuals, allowing the evolutionary process to imply which ones should be used for breeding.

This chapter first presents a unified study of the core concepts behind methods pertaining to these categories, allowing an integrated scope of evolutionary computation in music and clarifying the importance of studies in music cognition. Specifically, methods pertaining to Categories 1 and 2 are analysed in Section 5.2 while methods of Category 3 are analysed in Section 5.3. Afterwards, Section 5.4 presents a new method that takes advantage of the strengths of the aforementioned approaches, lending also elements from the Conceptual Blending theory, which is a cognitive theory for human and machine creativity. An example is presented that indicates what are the benefits of this approach and allows user involvement on an intuitive level. It should be noted that throughout the chapter the term "*intuitive*" will be

used to indicate familiar and transferable knowledge from other, deeply grounded aspects of everyday life. For example, rhythm density in a musical excerpt is related to the "intuitively accessible" concept of pace and how fast events are happening, regardless of whether this concerns music. For more implications of the term "intuitive", the reader is referred to [89].

Several music generation methods pertaining to the broad category of evolutionary and biologically inspired computation are intentionally left outside this chapter. Specifically, methods that are based on cellular automata [11, 79], L-systems [23, 86], grammatical evolution [64, 75] and swarm intelligence [3, 7, 47] are not analysed, since the focus is on methods that attempt to model cognitive aspects of music understanding towards evolving meaningful musical individuals. Interested readers are referred to [56] for more details on these methods. Additionally, the readers interested in the wider scope of generative music and how evolutionary computation fits within this context are referred to [20, 27], where reviews are given for generative music methods pertaining to diverse categories.

## 5.2 Music, Information and Evolutionary Exploration of Alternatives

Processing musical information spans many levels of abstraction, i.e. from the low level of audio to the high level of harmony and structure, and allows the implementation of many tasks. Some tasks concern retrieving such information for making decisions (e.g. categorising music excerpts or categorising their content) while others concern generating new music that inherits elements of the retrieved information. Evolutionary computation has been widely employed for generative tasks given some desired music attributes described through elements of information extracted from musical data; this section provides an overview of methods related with these tasks.

### 5.2.1 Symbolic Feature Extraction and Music Information

Music Information Retrieval (MIR) encompasses many tasks that incorporate processing of information from music, either in audio or symbolic form. Among the main broad categories of MIR are content categorisation and characterisation. Content categorisation is the task of placing given musical excerpts into given categories. Content characterisation incorporates assigning high-level descriptions to parts of the content or the entire content, e.g. local/global tonality, tempo, etc. Content categorisation is directly related to the notions of abstraction and similarity [12]. For instance, the category of tonal music includes all music pieces that employ the standard tonal harmonic devices and the category of atonal music includes pieces that do not use these devices. These devices are very abstract and the concept of similarity is very broad, almost boolean: pieces that employ tonal harmonic progressions are similar (on this very abstract level) to others that do and, therefore, are included in the tonal category. In brief and even though it is beyond the scope of this chapter, the notion of a category has many levels of granularity and is subject-dependent; e.g. a person who has never listened to heavy metal music might find all pieces in this genre similar and belonging to a single category, while another who is familiar

with this style might be able to easily categorise a piece according to band, year of recording etc, or prefer some pieces over others.

Abstract concepts that describe general musical attributes and relations in human perception and cognition are called "schemas" and have been studied as tools that create abstractions from musical excerpts and facilitate the acquisition of mental knowledge structure [62]. Examples of such abstractions, as studied in [62], are the concepts of tonal centre and mode [60], which humans unconsciously extract when exposed to musical stimuli. The example of the tonal music category given earlier is very abstract and, as described, "almost" boolean; however, other abstract musical concepts may be described *quantitatively*, in the sense that they can be represented by magnitude values describing qualitative features. For example, the high-level feature of rhythm "complexity" (related to syncopation that relates to the violation of metrical expectations [40]) in one-bar musical rhythms is described with a numerical value that ranks rhythms according to a complexity scale [95]. Among other musical qualities, e.g. the sensation of tonality [60], there are successful examples in the literature that relate feature extraction methods and perceived qualities of music. Regarding the perception of rhythm, for instance, the empirical studies presented in [67, 99] have shown that there are strong correlations between the feature of syncopation and the sensation of groove in rhythms. Since different musical categories (whether they be genres, styles or music by specific artists/composers) potentially involve different combinations of feature values, such as rhythm complexity, feature extraction methods may be used for categorising musical data.

Focussing on symbolic music, there have been many studies on categorising music using abstract quantitative symbolic music features. There are also widely used methodologies and software for symbolic music feature extraction [16, 77]. Among the categorisation tasks that have been studied are composer identification [53, 54, 88, 109] or the musical style and genre [29, 31, 32, 59, 76, 116]. Along with features related to music cognition, features that extract information-theoretic quantities have been studied for the characterisation of "aesthetic" quality in music, leading to models that examine relations between complexity and human perception in music [68, 96] and also to models of subjective preference [39, 66, 71, 72].

The aforementioned features are defined "explicitly" in a sense that their computation is transparent and they encompass specific high-level meaning; e.g. degree of syncopation or correlation with the major tonality are abstractions that can be clearly understood, while there are specific methods and mathematical formulas for computing them from the musical surface. Extraction of abstract features, however, can be performed "implicitly" as well. The recent paradigm of deep learning is an example of how implicit learning[1], i.e. unsupervised extraction of abstract features given large amounts of data and many computational units in many layers of abstraction, can be very efficient in categorisation. The tradeoff, however, is that, in hitherto developed approaches at least, there is no transparency in what the latent abstract features represent. Thus, implicit learning offers efficient possibilities for

---

[1] *Implicit* learning is achieved by exposure to many examples without conscious knowledge of the underlying rules; e.g. 3-year-old children can speak correctly without knowing syntax rules through implicit learning of language. *Explicit* learning is performed by consciously applying rules and categorising incoming information; e.g. foreign languages are learned explicitly (while native languages implicitly).

categorising data but without giving information about what aspects of data allow this efficiency.

## 5.2.2 Generating Musical Alternatives with Given Specific Qualities

Evolutionary methods offer a way to generate content that is well-suited for a given purpose described by a fitness function. The feature extraction methods discussed previously, either "implicit" or "explicit", can be used in evolutionary generative methods during fitness evaluation to examine whether the generated material meets the criteria set for those features. The work of Spector and Alpern [100] and the work of Pearce [84] are early examples of using fitness functions in evolutionary methods for music generation that are based on implicit learning. These studies employed neural networks trained directly on the musical surface of music data as fitness raters. Raters (neural networks) would decide whether an evolutionary melody/rhythm was good or bad giving as output 1 or 0 respectively; during training good examples (e.g. solo phrases by Charlie Parker) and bad examples (e.g. silence or random melodies) were employed. Following recent advances in deep learning, more complex architectures have been proposed for capturing implicitly musical knowledge, as in [110], where convolutional neural networks are used in an adversarial learning scheme for capturing relevant patterns in data. The reader is referred to [10] for more methodologies that pertain to deep/implicit learning, without, however, components of evolutionary computation.

Evolutionary methods for music generation have mainly been employed with explicitly extracted features from the musical surface. These methodologies incorporated a set of target features and an evolutionary part that generated music which adapted to the target features. Examples of such evolutionary methodologies either incorporated information-related target features or features related to music cognition and theory. Information-related metrics based on the fractal dimension were presented in [73] and the normalised compression distance in [2]. Examples of systems that employed music-oriented target features have been developed that either involved quantified approaches to describe rules for counterpoint [28] and four-part harmonisations theory [15], or quantities related to how humans perceive and process music [30, 35, 74, 83, 108]. It should be noted that in [66, 73] features related to fractal dimension and transition probabilities were fed into artificial neural networks (art critics). The neural networks in this context receive many such features as input and their goal is to create abstract/latent representations of these features (instead of the musical surface, as discussed in the previous paragraph).

The aforementioned methods incorporate evolutionary processes that evolve individuals representing musical surface, i.e. the genotype comprises representations of notes. Other methods have been explored for music generation that evolve the parameters of generative systems which compose music. These methodologies attempt to take advantage of the capabilities of such systems to generate content that inherently presents structure. Such methods include grammatical evolution [87], genetic evolution of cellular automata rules [63] and genetic evolution of finite L-systems [57]. Additionally, the evolution of parameters of dynamical systems that present chaotic behaviour was examined in [46], where the parameters were tuned using differential evolution [85].

This section has discussed the important role of cognitive-related musical features, which can be extracted from data through explicitly defined methods, in generative evolutionary systems. A wide range of evolutionary methods have been examined that leverage the strength of explicitly defined features, i.e. the fact that they more or less accurately reflect specifically defined musical attributes, leading to systems that can compose music in given styles – to the extent that the employed features are able to capture characteristics of a style. While generating new music in a specific style is creative, exploration of new, possibly unforeseen, styles is an interesting application of computational creativity in music. How can such features be employed towards developing interactive methods, where user input directly defines the stylistic characteristics of the generated music? How can methods consistently extrapolate from a given style according to user-provided directives? The next section presents methods that study interactive involvement of the user, while in Section 5.4, a method is examined that allows stylistic "extrapolation" with user involvement by leveraging basic principles of conceptual blending.

## 5.3 Power to the User: Exploring Variation and Human Preference in Generative Systems

Artificial intelligence offers the fascinating perspective to engage users in co-creative processes with machines. Along these lines, it is vital to develop communication interfaces that allow efficient exchange of information, given constraints on both ends, i.e. cognitive factors affecting the perception and fatigue of the user and information-related factors regarding the processing and representational capacity of the machine. This section describes generative music methods that employ evolutionary computation in combination with user input in diverse (and often surprising) ways.

### 5.3.1 User Involvement in Generating Variations

User involvement in generative systems that do not employ interactive evolution requires a layer of human-machine communications where information is interpretable both by human and machine. Some approaches [48, 82, 106] build this intermediate "information interface" layer by taking advantage of the interpretability and computability of explicit features, e.g. they allow users to make a rhythm that is dissimilar by a given magnitude from an input rhythm. Other approaches [6, 55, 101, 107] bypass this layer by engaging human and machine in a "creative loop", where the user and the machine both play music and each part interprets and processes music information with their own means of perception.

### Variation Using Features and Distance

The idea of allowing users to explore variations of given musical excerpts has been researched through evolutionary computation. Among the first studies on generating variations of user-given material was the NEAT (NeuroEvolution of Augmented Topologies) [36] method, where the user provides a base rhythm or motif and through interaction the NEAT drummer generates more complex variations. In [4] evolutionary computation is used to allow users to retrieve variations of initial populations

of MIDI loops in selected styles, with selected values for density and syncopation. Similar approaches have been developed in [97, 98] but with the employment of probabilistic methods – not evolutionary computation.

The notion of *rhythm divergence* was introduced in the evoDrummer [48], where the user is able to select a divergence rate and an input *base* rhythm and get a new rhythm that corresponds to the desired divergence. Even though the notion of divergence is abstract and vague it is intuitively consistent, in a sense that higher divergence values are expected to produce rhythms that are perceived as more diverse from the input/base rhythm. The divergence value is computed in terms of 40 cognitively-relevant features, i.e. generated rhythms incorporate features that are different from the features of the base rhythm by a user-defined amount. The total divergence is measured as the Mean Relative Distance (MRD) between the features of the base and the generated rhythm; the MRD is employed for avoiding scale-related issues on how predominant the contribution of a feature is among the 40 features used in the computation of the total divergence value.

A different approach for producing variations of a user-provided input rhythm was presented in [82], where, as with the evoDrummer, the user provides an input rhythm and selects a target fitness value, but the "divergence" computation is more straightforward. In this approach the "divergence" between the user-given input rhythm and the system-generated output rhythm is measured through their Hamming and swap distances; no features are involved since distance computation relies directly on the musical surface. An expansion of this approach was presented in [106], where several methods along with evolutionary computation were tested for generating rhythm variations. As a short notice towards future possibilities, an interesting approach to rhythm "morphing" was introduced by Milne and Dean [78], where intermediate rhythms between two input rhythms were generated. In Milne and Dean's approach, morphing was based on the "evenness" of well-formed rhythms and rhythm generation was implemented through preserving some mathematical properties of rhythms. It would be interesting to study rhythm morphing under a perspective of evolutionary methodologies, with fitness evaluations that are based both on feature and on surface distance.

## Towards a User-Machine Creative Loop

Generating variations with a user-specified amount of divergence does not immerse the user in a "creative loop", in the sense that users do not employ their own creativity in the process; they passively receive what the system has to offer and can intervene by mere adjustment of parameters. Evolutionary computation has been studied under a scope that enables a "creative loop". These approaches consider a user who is an improviser and performs either concurrently or non-concurrently with a system. Non-concurrent approaches follow the jazz improvisation prototype of "trading fours", where the user and the system are engaged in exchanging solo phrases in specific time intervals during the improvisation. The concurrent approach presented herein considers the system as a set of accompanying agents which try to play relevant but not identical material in comparison with what the user plays.

An early example of non-concurrent human-machine improvisation is the pioneering work of Biles [6] who presented GenJam, a hybrid performance-driven system that employs genetic algorithms to generate musical responses to a human improviser, exchanging phrases in a jazz-style improvisation, while being rated for

these responses by the user. The user/improviser feeds GenJam with the music phrases she/he plays, and GenJam genetically evolves them to generate novel music responses. These responses are then rated/evaluated by the improviser and evolved to form melodies. In an extension of this work, an initial database of of jazz phrases is incorporated into GenJam and new phrases are composed by combining existing phrases through crossover [5]. This way the improviser's ratings are not necessary and GenJam is allowed to generate melodic responses and improvise autonomously, without having to constantly receive ratings from the improviser. An approach similar to the autonomous GenJam was presented in [107], which also involved physical participation of the software through a two-armed robot device performing on a xylophone. Therein, the initial database of phrases included recordings of a jazz piano improviser stored to the memory of the system. These phrases were combined with the input phrases from the human improviser using genetic algorithms, forming a music response that included a satisfactory combination of novelty and relatedness to the human improviser's phrases. Similar approaches to melodic solo generation have also been presented without the use of evolutionary computation (e.g., with Markov-based process [101]), but a thorough review of such methods is outside the scope of this paper.

A system that generates responses to user-performed phrases is "Monterey Mirror" [70]. This system generates initial populations of phrases using probabilistic methodologies and evolves them using genetic algorithms. Specifically, the initial population is created by employing the Markov transition probabilities of pitches and rhythms extracted from the phrases provided by the human performer during performance. Fitness evaluation is based on "aesthetic criteria" defined by several features computed through information-theoretic quantities such as the ones described in Section 5.2.1 (i.e. the fractal dimension of several distributions of pitch and rhythm features) [73].

An alternative approach to performance driven interactive composition was followed in [55], where user and system performances are "concurrent": the system is accompanying while the user is performing. In this approach the system generates accompaniment using instrument specific setups in terms of pitch register and polyphony (e.g. a bass player and a piano player); this accompaniment, given the instrument-specific characteristics, has a certain degree of dissimilarity (or divergence) with what the user plays. This approach employs the concept of feature divergence discussed earlier (e.g. in the evoDrummer [48]) and the features considered incorporate information about pitches and tonality along with chord characteristics, Shannon information entropy of the pitch class profile, rhythm characteristics (using some rhythmic features describing note density, syncopation, etc.) and intensity variations. This study, however, constitutes a very basic exploration of constrain-free improvisation and needs clarification in fundamental issues related to the role of harmony and memory; currently this system is unable to process any information related to harmonic sequences and prediction which are fundamental for Western music.

### 5.3.2 Interactive Evolution: Capturing, Assessing and Expanding User Preference

Interactive evolution comprises methods that incorporate direct human evaluation in the assignment of fitness values for individuals in the population in the form of

rating, ranking or selection. In the case of music, several studies have been presented where rating is assigned [21, 52, 65, 65, 105], or individuals are selected for reproduction [90]. Methodologies for music generation based on interactive evolution offer new possibilities, but also introduce additional problems in comparison with methods that involve fitness criteria based on features or dissimilarity on the musical surface. An advantage is that the evaluation of musical individuals is "guaranteed" to be aesthetically meaningful, since it is directly given by the user, according to their preference. Additionally, non-interactive evaluation techniques aim to generate music that matches some specific target features. These features, in order to be meaningful, need to be retrieved from a specific style (e.g. corpus [73]) or excerpt, which deteriorates the subjective musical directions that a user might want to give. The most severe drawback of interactive evolution systems in music, however, is the dismantlement of the most powerful elements in evolutionary computation: combining and altering large numbers of individuals within the course of many generations. The users are simply not able to undergo vast amounts of listening and rating (or selecting) sessions, since it takes an overwhelmingly large amount of time to evaluate large populations of individuals/melodies evolved throughout a large number of generations, leading to *user fatigue*; this effect additionally increases the uncertainty in ratings or selection and consequently "detunes" the evolutionary effectiveness.

Among the first studies on music generation through interactive evolution was a system for generating rhythms according to fitness values that corresponded to user ratings [37]. A similar approach was presented in [41] with a system that evolved initial populations of random note sequences through rearrangement using music function combinations (such as play mirror, play twice, and shift down). Other methods incorporate the evolution of musical individuals based on user ratings on several musical aspects such as rhythm, tonality, and style [21, 80]. An early approach to reduce the effect of user fatigue employed a combination of GA and GP [102]. In this work, short individual melodies were considered as chromosomes and were evolved using GA, while in parallel, functions that determined their successive arrangement were evolved using GP. User ratings were used again for evaluating melodies but they were additionally fed into a neural network that was thereby trained to identify poorly performing individuals and discard them before the melodies were presented to the user.

Interactive evolution has not only been employed for mere music generation but also for assessing aspects of user preference based on their ratings. In [52] a genetic programming methodology was developed that evolves functions able to create interesting sounding waveforms [26] in the style of 8-bit music. Through a rating scheme, users could lead the evolution of 8-bit melodies from initially simple and less interesting ones to more complex and preferred melodies. Agreement was observed among many users in the successive increase in ratings, with parallel agreement in significant deviations of feature values between melodies in the initial and the final population. This fact indicated that there are some critical values in specific audio features that an 8-bit melody needs to satisfy in order to be perceived as more pleasant. Along these lines, a methodology has been developed that employed depth-adaptive genetic operators in genetic programming [45]. Specifically, mutation and crossover operators were applied on specific depths of the tree representation of individuals/functions according to the ratings assigned to these individuals. For instance operators were modifying individuals closer to the root for more poorly rated individuals, leading to more drastic alterations. Subjective experiments indi-

cated that convergence to more preferable individuals was significantly faster for the depth-adaptive version of the operators.

An entirely different approach to interactive evolution was presented in [49], where user ratings and music evolution concerned the features of the music rather than the music per se. Users were given four melodies (comprising a generation) and rated them according to their preference in rhythm and pitch. An evolutionary scheme that consisted of two-levels was employed: the higher level was based on the particle swarm optimisation (PSO) algorithm and the lower level on feature-driven music generation modules that employed genetic algorithms (GAs). Excerpts were represented by two agents on the higher PSO level, one describing rhythm and one pitch characteristics; the position of those agents in their respective feature spaces determined the rhythmic and pitch characteristics of the excerpt. The fitness value of each agent in the rhythm and pitch swarms was provided by the user, leading the agents in locations that describe more desirable musical characteristics. The lower level GA modules generated music according to the features provided by the location of each PSO agent; therefore, the generated music incorporated features that were more desirable to the user as the PSO iterations progressed.

The music generated by the GA-level algorithms was expected to converge to the positions indicated by the PSO agents, however, this convergence would not be "absolute" most of the time: the produced melodies were placed in close proximity, but not exactly to the locations of the PSO agents in the feature space. This introduced a "noise factor" to the system which was evaluated with the use of "artificial raters" that incorporated predefined, fixed music preferences throughout the rating rounds (PSO iterations). Exhaustive experimentation with multiple simulations using four types of artificial raters and four PSO setups indicated that the system is swiftly converging to the ideal features that the automatic rater desired. Additionally, the ability of several PSO setups to maintain a greater variability during iterations was examined. The primary contribution of this work was that evolution was performed on the level of features instead of the actual music surface, allowing users to explore feature spaces rather than music excerpts. The advantage of feature evolution is the fact that neighbouring points in the feature space describe melodies with similar musical characteristics as reflected by features on a higher level; in turn, those features describe similarity on higher levels of musical information, e.g. style, and potentially allow the user to explore musical spaces on a more intuitive level, e.g. explore different styles.

Summarising this section, three general, and in some sense orthogonal, "dimensions" of human interaction with evolutionary musical systems have been identified:

1. Dissimilarity-based interaction: methods pertaining to this category have been discussed in Section 5.3.1. Such methods accept a user-given musical segment and a user-defined dissimilarity value; genetically modified musical segments are then evolved towards generating segments that are desirably dissimilar to the user-given segment. The dissimilarity value is computed according to some features that the user is not aware of.

2. "Active" musical interaction: such methods have been discussed in Section 5.3.1. According to this interaction dimension the user generates musical objects and expects relevant musical responses from the system, leading to a "creative loop". Such methods might use the notion of dissimilarity for regulating the responses of the system (e.g., in [55]).

3. Rating-based interaction: in methods focusing on this dimension of interaction, the user simply rates generated individuals and the ratings become directly the fitness values of individuals; such methods pertain to the typical "interactive evolution" scheme and have been discussed in Section 5.3.2. The user is again not aware of the underlying processes that produce the musical output and variations of such methods incorporate either direct evolution of individuals (musical excerpts) or evolution of target features (e.g. as in [49]).

These dimensions can be considered orthogonal since all of those could be potentially involved concurrently in complex interaction schemes, where, for example, the user plays a musical segment, then selects a dissimilarity value, rates generated musical segments and then plays a new musical segment based on the system output. Such a scheme is arguably too complex to be practically useful, but it is nonetheless feasible. The next section discusses a new possible dimension of interaction, where the user is aware of the system's representation of musical segments with explicit musical features and selects such feature combinations for constructing new musical segments.

## 5.4 Breaking New Ground: Evolution, Machine Learning and Conceptual Blending

When it comes to involving the factor of human choice in the generative processes of evolutionary algorithms, explicit and implicit feature learning have complementary advantages that could potentially be combined. Explicit feature extraction methods are intuitively transparent and offer the possibility of intuitive control of characteristics in the generated music; e.g. an evolutionary computation system can compose a melody that is more complex in terms of pitches, or a rhythm that is more syncopated. Relying only on explicitly defined features for music generation, however, has some disadvantages. Using a small number of target features makes generated music sound odd, since it is easy for the evolutionary algorithms to "trick" the fitness criteria by generating an excerpt that indeed captures the target features but totally violates other significant aspects of style that are not captured by the considered features. On the other hand, using too many features as fitness targets makes user control impossible. When a user, for instance, wants to make a rhythm with increased syncopation it is impossible for her/him to identify the features that play even a tiny role in the increase of syncopation – and the same holds for the designer of the system. Using too many features to "corner" the generative process n making music that covers many stylistic aspects ultimately removes the advantage of feature-based methods, which is allowing intuitive control.

Implicit feature learning methods, e.g. deep sequence learning, given sufficient amounts of data and many units for feature representation can capture multiple aspects of musical style. By definition, however, such methods are intuitively non-transparent (so called "black box" models). For instance, by the way such methods employ learning processes, at least so far, it is impossible to know which neurons of a neural network are responsible for increasing the syncopation in a learned set of rhythms and how to treat their input/output to achieve that. Recent work in deep learning is progressing towards making sequence learning based on neural networks "steerable" or "controllable". For instance, controlling (or explicitly defining)

the metric structure in topologies of neural network-based sequence learners has been studied in DeepBach [25] or with the Conditional Sequence Learners architecture [69]. The recent paradigm of score filling [38] can also be included in the broader scope of "controlling" the output of a neural network, even though indirectly, through filling empty parts of the score according to initial user-provided note layouts. Ongoing research [50] examines the direct infusion of values describing simple features (rhythm density and pitch height) in the inputs of Long Short-Term Memory (LSTM) [34] neural networks during training along with artificial data augmentation for achieving maximum feature variability; such networks allow user control of the feature values during generation and the reported results show that the generated music generally adapts to the user-defined feature values. However, the aforementioned approaches for explicit control of implicit learning methods need to be tested with more diverse features that describe several aspects of musical meaning.

Summarising the important components that this chapter has discussed so far, the following remarks can be made:

1. *Cognitive-related features* allow intuitive access to qualities of the generated music. As discussed in Section 5.2.1, such features computed from the musical surface (e.g. rhythm density and syncopation, pitch class profile entropy etc.) have proven valuable for categorising music and generating music in specific styles through evolutionary computation methods (Section 5.2.2). These characteristics can be explicitly defined and intuitively understood, e.g. for describing a melody as having low rhythmic syncopation and high pitch class profile complexity.
2. *Unsupervised feature learning* allows the capture multiple qualities. Using neural networks for implicitly learning features from the musical surface has proven useful for generating music as discussed in Section 5.2.2, both using evolutionary computation and using generative variants of the neural networks (especially lately, with the advent of deep learning). The important role of implicitly learned features is that they potentially capture characteristics of the musical surface that are not profound and therefore hard/impossible to capture with explicitly defined features.
3. *Cognitive factors* affect user engagement and involvement in the generative process. In Section 5.3 user involvement was discussed, showing that presenting novel yet meaningful results to the user is important. Therefore, incorporating thoroughly studied cognitive theories of computational creativity should prove useful in evolutionary computation.

## 5.4.1 Cognitive Models of Creativity and Conceptual Blending

Methods pertaining to the field of computational creativity aim to generate content that presents novelty and meaning. Studies on theoretical models of human creativity have given inspiration for the development of algorithmic frameworks that can generate creative content. According to Boden [9] there are three main types of creativity: *exploratory* in which new material is generated by exploring a given space of rules and background knowledge; *transformational* in which the rules of a given space are transformed, providing new rules for generating material; and *combinational*, which Boden [8] maintains is the hardest to describe formally, in which

the rules of multiple spaces are combined in meaningful ways, producing rule combinations that allow the generation of creative output that inherits characteristics from the combined spaces. According to this discrimination of types of creativity, evolutionary computation in music, as discussed in this chapter, mainly associates with exploratory creativity (with methods discussed in Section 5.2 that explore alternative musical surfaces given a space described by target features) and, possibly, transformational creativity (with methods discussed in Section 5.3 that allow the transformation of given spaces of target features to new spaces, mainly by involving user input).

Combinational creativity has been studied in cognitive science under the scope of Conceptual Blending (CB), a theory developed by Fauconnier and Turner [19] describing the cognitive mechanisms that allow creative combinations of elements from diverse conceptual input spaces, leading to the emergence of new conceptual spaces that incorporate new interesting properties. In music the CB theory has been primarily used for interpreting musical concepts through extra-musical meaning, e.g. see [104, 114, 115]. CB has also been studied as a method for generating new concepts, rather than interpreting existing ones, mainly through methodologies that are based on the category theory formalisation of CB by Goguen [24]. In music, specifically, generative methods based on conceptual blending have been presented for the invention of blended cadences [17, 111], melodies [33], or the generation of blended harmonic spaces through blending chord transitions [44, 51]. The concepts describing the cadences or the chord transitions in these studies incorporated the analytical description of specific low-level elements, e.g. the root notes, chord types, existence of leading note to the tonic etc. Such methods have been formally evaluated [112, 113] and results indicate that the intended goals were achieved: the generated, blended output incorporated characteristics that were perceived as novel, while they were perceived as incorporating combined characteristics from the blended, input spaces.

Interpretational CB theory, however, discusses the combination of concepts that potentially incorporate higher-level information, while the aforementioned studies on generative methodological applications of CB focus on combining low-level information, e.g. individual notes or chord types. Some explicit features described in the studies presented in this chapter offer a way to describe abstract, high-level concepts within (low-level) musical surfaces. Examples of such abstract concepts are the tonal centre [62] and mode [60], which can be approximated by employing the high-level feature of pitch class profile. Another example is the concept of "rhythm complexity" (related to syncopation) in one-bar musical rhythms, for which human listeners can consistently attribute numerical values, ranking rhythms according to a complexity scale [95]. Empirical studies [67, 99] have shown that methods for computing syncopation from musical surfaces correlate with the sensation of groove in rhythms reported by human listeners.

Therefore, employing high-level features in generative CB is arguably a meaningful attempt to bridge the gap between the initial interpretational development of CB theory (e.g. in the work of [104, 114, 115]) and the recent generative methodologies that are based on CB theory. Further theoretical concerns on how high-level features extracted from melodic excerpts are related to concepts and how the importance of features could play a role in identifying distinctive concepts in specific melodies are discussed in [43].

Even though a thorough description of the CB methodologies for blending is outside the scope of this paper, a short description follows in this paragraph; the reader

is referred to [93] for a more detailed description. In the generative formalisation of the CB theory, two *input spaces* are described as sets of properties and relations. The *generic space* of these inputs is computed, which is the conceptual space that keeps the common structure of the input spaces, guaranteeing that this structure also exists in the blended space, and generalises or abstracts over the parts of the inputs that are distinct. Afterwards, an *amalgamation* process [13, 18] generalises the input concepts until the generic space is found and then "combines" generalised versions of the input spaces to create blends that are "*consistent*" and satisfy certain properties that relate to the knowledge domain. Regarding blends, the term "consistent" refers to whether all logical relations in the blend and the background knowledge are satisfied, i.e. there are no mutually cancelling contradictions. Among the many possible blends that emerge, the best one is retained based on some *blending optimality principles* [19], which are mostly domain-depended criteria that a blend needs to satisfy.

### 5.4.2 Evolutionary Computation, Machine Learning and User-Driven Conceptual Blending for Melody Generation

Inspired by generative CB, a simplified version of *feature blending* is proposed that combines evolutionary computation (specifically, genetic algorithms) and neural networks. This very basic methodology is by no means fully developed, nor it is thoroughly tested herein; it serves the purpose of practically showing possible future directions in music generation with intuitive user involvement. The aim of this methodology is to perform melodic generation by incorporating all important aspects about generative evolutionary music systems described in the beginning of this section and summarised in this chapter: allow *user involvement* by hand-picking "intuitively transparent" melodic features; integrate *implicit learning* for describing style; and employ aspects of *combinational creativity* and CB for attempting to make blends that move across or in-between styles. This type of interaction could be associated with a fourth "dimension" of interaction, as discussed at the end of Section 5.3:

4. Blending-based interaction: the user can select combinations of explicit features in specific individuals. Subsequent generations will ideally comprise individuals that reflect the blended target features.

The theoretical backbone along with a methodological implementation of this dimension is attempted in the remainder of this section.

Figure 5.1 illustrates the proposed methodology. The use-case scenario is that the user wants to generate a new melody that involves feature combinations from two melodies in a database. Following the numbering in Figure 5.1:

1. The user asks the system to generate a melody with desirable attributes using high-level descriptions, e.g. low rhythm inhomogeneity and high pitch class complexity.
2. The system looks at the database of melodies and picks up the feature values from different melodies that are more pertinent to what the user asked (i.e. the highest numerical value if the user selects "high", or lower values respectively). This constructs a "blended" set of high-level features that the new melody should comply with.

3. A recurrent neural network (using the LSTM [34] architecture) learns note progressions from the melodies in the database.
4. An array of *composite* target features is constructed which incorporates two parts: the blended features constructed according to user selections and an additional "feature" that measures the probability that a generated melody has been produced by the trained LSTM (more details will be given later).
5. A genetic algorithm generates melodies according to the vector of composite target features. The blended features guide the evolutionary process to converge to melodies that incorporate the user-selected features while the probability feature ensures that the generated melodies pertain to the style learned by the LSTM.

The aim of the blended features that are used as a target during evolution is to incorporate the elements selected by the user, taking elements from melodies in the database regardless of the style they belong to. The aim of the LSTM is to impose stylistic coherency (in any of the learned styles preserved) to the generated melodies, at least in parts.

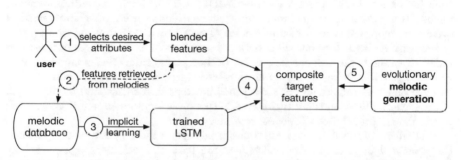

Fig. 5.1: Overview of the proposed system for melodic generation through intuitive user descriptions, high-level feature blending and implicit learning constraints.

This methodology can be applied in many fields, using different definitions of explicit features. Depending on how the employed features are defined, it is possible that the user selects feature combinations that are intrinsically conflicting, leading to feature combinations that are impossible to satisfy. The features discussed in this chapter are somehow "orthogonal", in the sense that there is no direct correlation between them. This, however, should not be the general case. An example of "non-orthogonality" has been studied in [42], where the combinations of low rhythm density and high syncopation could not be satisfied in the generation of melodies. Even though a thorough discussion on this issue is outside the scope of this paper, a solution to such cases could be approached in two ways:

1. Apply multi-objective optimisation techniques: this would allow the genetic algorithm to find good compromises in violating, to the least possible extent, a combination of correlated feature values instead of potentially ignoring the value of one feature.

2. Reject such blends because of "inconsistency": in the CB methodology, rejecting inconsistent blends is a core-element in the methodology. Using the example of animal blends [81] for illustrational purposes, there cannot be a blend between a snake and a tiger that has no legs (as the snake) and sharp claws on toes (as the tiger), since there would be no legs to "mount" the toes on. Rejecting such blends is a fundamental part of generative CB that is not incorporated in the presented methodology. Implementing such rejection criteria, however, is not trivial, since the relations between features should be known beforehand, e.g. that low rhythm density cannot possibly lead to high syncopation.

## Melodic Representation, Learning and Generation

The database of melodies is obtained from a small subset of 100 Chinese (han) and 100 German (altdeut1) melodies from the Essen corpus [91, 92] and is processed using the music21 toolbox [14]. Melodies are initially quantised to sixteenth notes and all pitches are transposed to C major or A minor using the Krumhansl-Schmuckler [60] algorithm for key finding. Notes are then octave-transposed to have their lowest note in the fifth octave (over MIDI pitch 60). Each sixteenth note of the melody is represented by a column vector; since melodies are monophonic, musical events are represented by a column vector of size 37 with one-hot encoding (i.e. a vector with a single 1 among 36 zeros): indexes 2 to 37 encode three octaves and index 1 represents the lack of a note event (either pause or duration of current note). Therefore, at this point, a melody is represented as a matrix with 37 rows and so many columns as the number of sixteenth time steps that correspond to the length of the melody. Duration is not considered in this basic experiment and it is set equal to the inter-onset interval of successive notes.

Melodies have dual, interrelated representations for the LSTM learning part and the genetic algorithm. For the LSTM learning part, the melody is represented by the aforementioned matrix that has columns for each sixteenth time step and every column corresponds to an event. For the genetic algorithm (genotype) each melody is represented by an array that has the length of the columns of the aforementioned matrix. Each position in the array is filled by an integer that corresponds to the non-zero component in the respective row of the matrix representation. For ensuring that the genotypes of all melodies have equal lengths, all melodies are cut to their first 64 sixteenths – thus all genotypes have a length of 64.

### *Explicit Melodic Features*

Six high-level features are extracted from melodies that are related to basic high-level descriptions of some of their cognitively-relevant rhythmic and pitch attributes. A greater number of such features could have been used (e.g. see [103]) but only a representative number of two rhythmic and four pitch-related features were sustained for focussing more clearly on the effect that feature blending has on each feature. These features are forming a vector that describes each melody in the database, $\mathbf{m_i} = \{f_1^{(i)}, f_2^{(i)}, \ldots, f_6^{(i)}\}$, where $i$ is the index of the melody. A list of these features along with a short description is given as follows:

$f_1$ *Rhythm inhomogeneity:* ($r_{\text{hom}}$) Rhythm inhomogeneity can be viewed as an aspect of rhythm complexity in terms of length distribution of successive inter-onset intervals, where more similar intervals (fewer rhythmic deviations) elicit

the sensation of a less complex rhythm and vice versa; rhythm inhomogeneity is computed as the value of the standard deviation of all inter-onset intervals over the value of the mean inter-onset interval in a melodic sequence.

$f_2$ *Pitch-class set complexity:* ($n_{pcp}$) This feature utilises the information entropy [94] of the Pitch Class Profile (PCP) set distribution of a melody for determining the relative quantities of each pitch class (pc) used in the melody; the closer a pc distribution is to the uniform distribution, the more complex the PCP content of the melody.

$f_3$ *Small pitch intervals:* ($n_{int}$) Even though there appear to be global cognitive mechanisms that favour small pitch intervals (semitone or tone) [40], different percentages of small intervals are used in different styles. This feature measures the percentage of small successive pitch intervals among all successive pitch intervals.

$f_4$ *Pitch range:* ($n_{range}$) The difference between the smallest and the greatest midi pitch values in the melody over the ratio of three octaves (36) – all involved melodies are within two octaves.

$f_5$ *Note repetitions:* ($n_{rep}$) The ratio of constant note intervals over the total number of intervals in a melody.

$f_6$ *Rhythm density:* ($r_{dns}$) The ratio of the number of sixteenths with note onset events over the number of all sixteenths in the melody.

### Implicit, Deep Machine Learning and System Architecture

The implicit learning part is built with Tensorflow [1], using a basic LSTM network trained with errors based on softmax cross entropy. The genetic algorithm is implemented with the DEAP (Distributed Evolutionary Algorithms in Python) [22] framework, using basic crossover and mutation operators with a tournament selection scheme. Regarding *fitness evaluation* in the genetic algorithm, as described earlier in Section 5.4.2, the objective function is to minimise two components: (a) the distance between the target/blended features selected by the user and the features of the evaluated individual and (b) the mean Kullback-Leibler [61] (KL) divergence values between the probability distribution predicted by the trained LSTM for each event (given all previous) and the actual events of the individual under evaluation. A weighting factor is used to define the balance between the two aforementioned fitness components which is set to equal importance of feature matching and LSTM contribution. Fitness evaluation is illustrated in Figure 5.2. The initial population is a random selection of melodies from the database.

### Example Scenario

To show how the proposed methodology works, an example scenario is examined where a hypothetical user selects a combination of different characteristics (as expressed through the aforementioned 6 features) through high-level descriptions. In this example the user selects to construct a melody that has:

1. *low* rhythm inhomogeneity,
2. *high* pitch class complexity,
3. *high* percentage of small pitch intervals,
4. *high* pitch range,

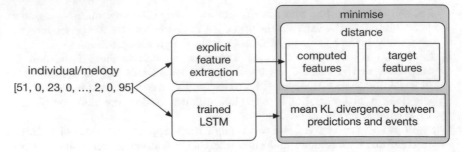

Fig. 5.2: Fitness evaluation of individuals consists of two components: (a) match the target features given by the user and (b) minimise KL divergence between trained LSTM predictions and notes.

5. *low* percentage of note repetitions and
6. *high* density.

The system therefore looks into the database and retrieves the maximum or the minimum feature values in any melody, according to whether the user asked for a high or low value in the respective features. This process constructs a set of blended target feature values that includes either the maximum (high) or minimum (low) feature values of all melodies in the database.

Two setups are compared, aiming to evaluate the influence of the implicit learning part in the evolutionary process, which includes stylistic constraints imposed by a trained LSTM. Regarding the technical setup of the example, both evolutionary setups included an initial population of 100 randomly selected melodies from the dataset; those individuals were evolved for 100 generations employing two-point crossover, index shifting and random replacement mutations. Regarding the implicit learning part, a deep LSTM architecture was employed using three layers of LSTM cells including 128, 256 and 128 units respectively. The system was trained on all 200 melodies (100 Chinese and 100 German) mentioned earlier using a softmax cross-entropy error function (since data are represented with one-hot encoding), which was minimised using the Adam algorithm [58].

Table 5.1 shows user selections, the corresponding target features and the achieved features generated by the evolutionary system with and without implicit stylistic adaptation using a deep LSTM. Specifically, the "target/blend" row shows the numerical interpretations that correspond to user selections in the examined example; the "LSTM-eval" column in this row shows the mean value and standard deviation (in parenthesis) of LSTM evaluation scores of adaptation for all melodies in the database, as a base for understanding the adaptation values produced when the LSTM restrictions were used in the fitness evaluation.

The results in Table 5.1 indicate that for this example, the imposition of the implicit stylistic constraints lead the system to produce a melody with an LSTM-eval score of 5.44, which means that the LSTM rated this melody as being stylistically close to the mean score of the melodies it was trained with (5.29). Not using the LSTM evaluations during training produced a melody that was completely outside the stylistic horizon in the database, as learned by the LSTM. Without using the LSTM evaluation during evolution, the system generated a melody that adheres

Table 5.1: Hypothetical user selection, the corresponding target features (or blend) and features achieved by the evolutionary system with and without the use of LSTM restrictions during the fitness evaluation. Bold numbers indicate which features are closer to the user-requested target features.

| | $r_{hom}$ | $n_{pcp}$ | $n_{int}$ | $n_{range}$ | $n_{rep}$ | $r_{dns}$ | LSTM-eval |
|---|---|---|---|---|---|---|---|
| | | | high-level features | | | | |
| user selection: low | high | high | high | low | high | — |
| target/blend: 0.25 | 1.97 | 0.94 | 0.67 | 0.00 | 0.84 | 9.25 (4.04) |
| LSTM used: 0.36 | **1.99** | 0.84 | 0.61 | 0.07 | 0.66 | **8.98** |
| LSTM not used: **0.34** | 2.02 | **0.90** | **0.67** | **0.02** | **0.82** | 33.41 |

slightly better to the user-requested features, however, at a sever cost in stylistic mismatch.

The effect of this cost is evident in the musical scores of the generated melodies in Figure 5.3. The melody composed without the employment of the LSTM constraints (Figure 5.3 (b)) has discontinuous jumps in the melodic texture, which are penalised when using LSTM evaluation, filtering out individuals with such jumps. Both melodies have strong chromatic elements which are required for achieving the user-requested pitch class complexity (both melodies achieved a value close to 2). In the melody generated with LSTM supervision, however, the chromatic elements are involved primarily in monotonic melodic motion. Overall, the employment of the LSTM results helped the system to generate a melody that has more coherent parts, while not using the LSTM makes it more evident that the resulting melody is mostly an evolutionary "pastiche" of parts of melodies in the database.

The adaptation of the melodies during evolution in the two schemes is shown in Figure 5.4. Those graphs concern only one run of the evolutionary part of the methodology; other runs were also exhibiting similar behaviour. The images in (a) show the adaptation regarding the explicit features, i.e. the features requested by the user. Specifically, the y-axes of images in Figure 5.4 (a) show the Euclidean distance between the six-dimensional vectors of the target/blend (user request) and the features achieved by the *best individual* in each generation. Both graphs in (a) are scaled to the same range, i.e. from 0 to the maximum distance, which is recorded at generation 0 on the left-hand side graph. Figure 5.4 (b) illustrates the respective stylistic adaptation on the y-axis, computed as the mean KL-divergence between LSTM prediction and composed notes. As expected, stylistic adaptation is not expected to happen without the employment of the LSTM for stylistic adaptation (bottom right graph) and, therefore, the KL-divergence value increases and decreases randomly, without following a convergence pattern (except from the several final generations where the best individual remains the same due to feature convergence). Regarding the evolutionary scheme that does employ the LSTM, the left-hand side graphs of Figure 5.4 show that features adaptation (top) and stylistic adaptation (bottom) are competing each other, which is evident by the strong negative correlation (-0.70) between the de-trended[2] data shown in these graphs. Additionally, it can be noted

---

[2]Data de-trending was necessary to compensate for the overall decrease of both values due to evolutionary adjustments and was performed with a moving average across 10 generations.

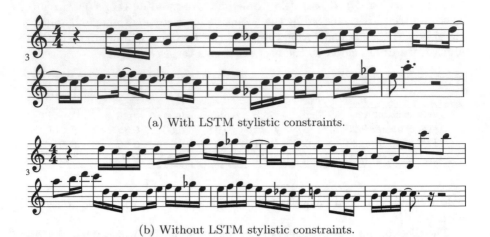

(a) With LSTM stylistic constraints.

(b) Without LSTM stylistic constraints.

Fig. 5.3: Scores of the generated melodies in the examined example. The y-axis in the top graphs refers to feature adaptation of the best melody in each generation. The y-axis in the bottom graphs refers to LSTM stylistic adaptation.

that feature distance (top graphs) is generally higher in the cases where LSTM is employed. This is due to the fact that feature adaptation is *part* of the overall fitness value when LSTM adaptation is also employed and, therefore the feature adaptation value is "averaged" with LSTM adaptation to provide the best individual. In the case where LSTM adaptation is not used (right-hand side graphs) only feature adaptation needs to be miminised and, therefore, the fitness of the best individual depends only on feature adaptation, disregarding information on LSTM adaptation.

## 5.5 Conclusion

This chapter presented an overview of generative music approaches based on evolutionary computation. A wide variety of evolutionary music methodologies that have been proposed during recent decades were presented; these methodologies model music information and utilise elements of cognitive science with the ultimate goal to generate music that satisfies specific criteria. Two basic categories were presented according to those criteria: (a) music generation with stylistic attributes obtained from data and (b) generation of music based on user feedback and preference. Data-driven methods use data to either explicitly extract musical features (based on cognition or information science) or to implicitly learn latent features through machine learning; these features are then utilised in evolutionary computation as fitness evaluators, for generating music with specific characteristics. User-driven methods allow direct fitness evaluation from the user for either directly evolving individuals representing a musical surface (e.g. melodies, harmonies, rhythms etc.) or representing musical features.

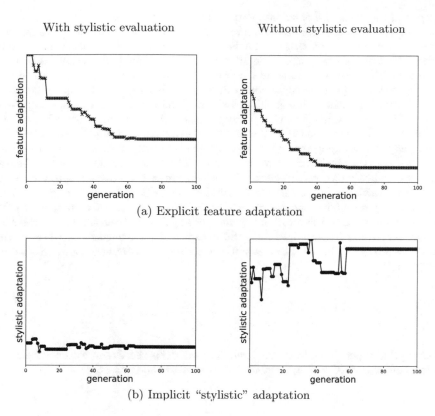

(a) Explicit feature adaptation

(b) Implicit "stylistic" adaptation

Fig. 5.4: Adaptation of melodies to requested features (explicit adaptation) and stylistic constraints with and without LSTM evaluation.

Motivated by the studies presented in the aforementioned overview, this chapter presented a basic methodology that allows user involvement in generating meaningful melodies with specific, intuitively understandable properties. The theoretic background of this methodology lends elements from the theory of Conceptual Blending, while the algorithmic backbone is based on evolutionary computation, with fitness evaluation that relies on matching user-blended (explicitly defined) features and complying with styles (implicitly) learned from data using a deep LSTM. An example application was presented where a virtual user selected the desired values of six melodic features (assigning a *low* or a *high* value for each feature) and the system produced a melody that satisfied those target features. The effectiveness of the implicit learning LSTM part was evaluated by comparing the output with and without the involvement of this component. Even though a more thorough evaluation is necessary through empirical experiments, it was evident that the LSTM component helps towards generating melodies with well-formed texture, i.e. without sudden jumps and meaningless (non-resolving) chromaticism.

The example presented herein is just a basic indication about the possible benefits of utilising a proper combination of the diverse methodological elements em-

ployed in the literature of evolutionary computation in music. Possible future versions of such systems could incorporate many advanced features related to human-machine communication that can further enhance user involvement. A finer granularity of options, for instance, would allow users to not only select between attributes as *low* and *high*, corresponding to maximum and minimum values, but also to employ more scales (or even continuous values). Another important step would be to incorporate argumentation techniques for letting the system assist users in adjusting their selections towards achieving better results. A basic example of such a system for music evaluating blended harmonic spaces was presented in [44], where the user could adjust the importance of internal system representations for generating harmonic spaces that included desired attributes. The system presented in the chapter at hand readily knows which aspects of a melody are satisfied according to user selections and which are not. Therefore, it could either guide the user to adjust her/his selections by specifying the desired values for specific features, or propose to the user to leave some features without specifying any desired values. Such approaches, of course, require much more thoughtful design and implementation, however, the work presented herein could be a step towards showing how these approaches would be possible.

*Acknowledgement.* This work has been supported by the Greek National Scholarships Foundation (Grant Agreement Number: 2016-050-0503-8138).

# References

[1] Abadi, M., Barham, P., Chen, J., Chen, Z., Davis, A., Dean, J., Devin, M., Ghemawat, S., Irving, G., Isard, M., et al.: Tensorflow: a system for large-scale machine learning. In: OSDI, vol. 16, pp. 265–283 (2016)

[2] Alfonseca, M., Cebrián, M., Ortega, A.: A simple genetic algorithm for music generation by means of algorithmic information theory. In: Evolutionary Computation, 2007. CEC 2007. IEEE Congress on, pp. 3035–3042. IEEE (2007)

[3] Apergis, A., Floros, A., Kaliakatsos-Papakostas, M.: Sonoids: Interactive sound synthesis driven by emergent social behaviour in the sonic domain. In: Proceeding of the 15th Sound and Music Computing Conference (SMC), SMC 2014, p. (to appear) (2018)

[4] Bernardes, G., Guedes, C., Pennycook, B.: Style emulation of drum patterns by means of evolutionary methods and statistical analysis. In: Proceedings of the Sound and Music Conference, pp. 1–4 (2010)

[5] Biles, J.A.: Autonomous GenJam: Eliminating the fitness bottleneck by eliminating fitness. In: Proceedings of the 2001 Genetic and Evolutionary Computation Conference Workshop Program. GECCO (2001). San Francisco, USA (2001)

[6] Biles, J.A.: GenJam: evolution of a jazz improviser. In: P.J. Bentley, D.W. Corne (eds.) Creative evolutionary systems, pp. 165–187. Morgan Kaufmann Publishers Inc., San Francisco, CA, USA (2002)

[7] Blackwell, T.: Swarming and music. In: Evolutionary Computer Music, pp. 194–217. Springer (2007)

[8] Boden, M.A.: The creative mind: Myths and mechanisms. Psychology Press (2004)

[9] Boden, M.A.: Computer Models of Creativity. AI Magazine **30**(3), 23 (2009)

[10] Briot, J.P., Hadjeres, G., Pachet, F.: Deep learning techniques for music generation-a survey. arXiv preprint arXiv:1709.01620 (2017)

[11] Burraston, D., Edmonds, E.: Cellular automata in generative electronic music and sonic art: a historical and technical review. Digital Creativity **16**(3), 165–185 (2005)

[12] Cambouropoulos, E.: Melodic cue abstraction, similarity, and category formation: A formal model. Music Perception: An Interdisciplinary Journal **18**(3), 347–370 (2001)

[13] Confalonier, R., Schorlemmer, M., Plaza, E., Eppe, M., Kutz, O., Peñaloza, R.: Upward Refinement for Conceptual Blending in Description Logic – An ASP-based Approach and Case Study in $EL^{++}$. In: International Workshop on Ontologies and Logic Programming for Query Answering, International Joint Conference on Artificial Intelligence (IJCAI) 2015 (2015)

[14] Cuthbert, M., Ariza, C.: Music21: A toolkit for computer-aided musicology and symbolic music data. In: Proceedings of the 11th International Society for Music Information Retrieval Conference, ISMIR 2010, pp. 637–642 (2010)

[15] Donnelly, P., Sheppard, J.: Evolving four-part harmony using genetic algorithms. In: European Conference on the Applications of Evolutionary Computation, pp. 273–282. Springer (2011)

[16] Eerola, T., Toiviainen, P.: MIDI toolbox: MATLAB tools for music research. Department of Music, University of Jyväskylä (2004)

[17] Eppe, M., Confalonier, R., Maclean, E., Kaliakatsos-Papakostas, M., Cambouropoulos, E., Schorlemmer, M., Codescu, M., Kühnberger, K.U.: Computational invention of cadences and chord progressions by conceptual chord-blending. In: International Joint Conference on Artificial Intelligence (IJCAI) 2015 (2015)

[18] Eppe, M., Maclean, E., Confalonieri, R., Kutz, O., Schorlemmer, M., Plaza, E.: ASP, Amalgamation, and the Conceptual Blending Workflow. In: Logic Programming and Nonmonotonic Reasoning, *Lecture Notes in Computer Science*, vol. 9345, pp. 309–316. Springer International Publishing (2015)

[19] Fauconnier, G., Turner, M.: The Way We Think: Conceptual Blending And The Mind's Hidden Complexities. Basic Books, New York (2003)

[20] Fernández, J.D., Vico, F.: AI methods in algorithmic composition: A comprehensive survey. Journal of Artificial Intelligence Research **48**, 513–582 (2013)

[21] Fortier, N., Van Dyne, M.: A Genetic Algorithm Approach to Improve Automated Music Composition. International Journal of Computers **5**(4), 525–532 (2011)

[22] Fortin, F.A., De Rainville, F.M., Gardner, M.A., Parizeau, M., Gagné, C.: DEAP: Evolutionary algorithms made easy. Journal of Machine Learning Research **13**, 2171–2175 (2012)

[23] Gogins, M.: Score Generating Lindenmayer Systems in the Generalized Contextual Group (2010)

[24] Goguen, J.: Mathematical Models of Cognitive Space and Time. In: D. Andler, Y. Ogawa, M. Okada, S. Watanabe (eds.) Reasoning and Cognition, *Interdisciplinary Conference Series on Reasoning Studies*, vol. 2. Keio University Press (2006)

[25] Hadjeres, G., Pachet, F.: DeepBach: a steerable model for Bach chorales generation. arXiv preprint arXiv:1612.01010 (2016)

[26] Heikkilä, V.M.: Discovering novel computer music techniques by exploring the space of short computer programs. arXiv preprint arXiv:1112.1368 (2011)

[27] Herremans, D., Chuan, C.H., Chew, E.: A functional taxonomy of music generation systems. ACM Computing Surveys (CSUR) **50**(5), 69 (2017)

[28] Herremans, D., Sörensen, K.: Composing first species counterpoint with a variable neighbourhood search algorithm. Journal of Mathematics and the Arts **6**(4), 169–189 (2012)

[29] Herremans, D., Sörensen, K., Martens, D.: Classification and generation of composer-specific music using global feature models and variable neighborhood search. Computer Music Journal **39**(3), 71–91 (2015)

[30] Herremans, D., Weisser, S., Sörensen, K., Conklin, D.: Generating structured music for bagana using quality metrics based on Markov models. Expert Systems with Applications **42**(21), 7424–7435 (2015)

[31] Hillewaere, R., M, B., Conklin, D.: Global feature versus event models for folk song classification. In: Proceedings of the 10th International Society for Music Information Retrieval Conference, (ISMIR 2009), pp. 729–733. Kobe, Japan (2009)

[32] Hillewaere, R., Manderick, B., Conklin, D.: Melodic models for polyphonic music classification. In: Proceedings of the 2nd International Workshop on Machine Learning and Music, (MML 2009), held in conjunction with The European Conference on Machine Learning and Principles and Practice of Knowledge Discovery in Databases (ECML-PKDD 2009), pp. 19–24. Bled, Slovenia (2009)

[33] Hirata, K., Tojo, S., Hamanaka, M.: Melodic morphing algorithm in formalism. Mathematics and Computation in Music pp. 338–341 (2011)

[34] Hochreiter, S., Schmidhuber, J.: Long short-term memory. Neural computation **9**(8), 1735–1780 (1997)

[35] Hofmann, D.M.: A genetic programming approach to generating musical compositions. In: Evolutionary and Biologically Inspired Music, Sound, Art and Design, pp. 89–100. Springer (2015)

[36] Hoover, A.K., Stanley, K.O.: Neat drummer: Interactive evolutionary computation for drum pattern generation. Tech. rep., Technical Report TR-2007-03 (2007)

[37] Horowitz, D.: Generating rhythms with genetic algorithms. In: Proceedings of the twelfth national conference on Artificial intelligence (vol. 2), AAAI'94, pp. 1459–1460. American Association for Artificial Intelligence, Menlo Park, CA, USA (1994)

[38] Huang, A., Chen, S., Nelson, M., Eck, D.: Towards mixed-initiative generation of multi-channel sequential structure. In: Proceedings of the 2018 International Conference on Learning Representations, Workshop Track (2018)

[39] Hughes, D., Manaris, B.: Fractal dimensions of music and automatic playlist generation: Similarity search via MP3 song uploads. In: 2012 Eighth International Conference on Intelligent Information Hiding and Multimedia Signal Processing (IIH-MSP), pp. 436–440. Piraeus, Greece (2012)

[40] Huron, D.B.: Sweet anticipation: Music and the psychology of expectation. MIT press (2006)

[41] Johanson, B.E., Poli, R.: GP-Music: an interactive genetic programming system for music generation with automated fitness raters. Tech. Rep. CSRP-98-13, University of Birmingham, School of Computer Science (1998)

[42] Kaliakatsos-Papakostas, M.: Generative conceptual blending of high-level melodic features: Shortcomings and possible improvements. In: Proceedings of the Internation Conference of New Music Concepts (ICNMC 2019) (2019)

[43] Kaliakatsos-Papakostas, M., Cambouropoulos, E.: Conceptual blending of high-level features and data-driven salience computation in melodic generation. Cognitive Systems Research 58, 55–70 (2019)

[44] Kaliakatsos-Papakostas, M., Confalonier, R., Corneli, J., Zacharakis, A., Cambouropoulos, E.: An argument-based creative assistant for harmonic blending. In: Proceedings of the 7th International Conference on Computational Creativity (ICCC) (2016)

[45] Kaliakatsos-Papakostas, M., Epitropakis, M., Floros, A., Vrahatis, M.: Controlling interactive evolution of 8-bit melodies with genetic programming. Soft Computing 16, 1997–2008 (2012)

[46] Kaliakatsos-Papakostas, M., Epitropakis, M., Floros, A., Vrahatis, M.: Chaos and music: a study of tonal time series and evolutionary music composition. International Journal of Bifurcation and Chaos (2013)

[47] Kaliakatsos-Papakostas, M., Floros, A., Drossos, K., Koukoudis, K., Kyzalas, M., Kalantzis, A.: Swarm lake: A game of swarm intelligence, human interaction and collaborative music composition. In: Proceeding of the joint 11th Sound and Music Computing Conference (SMC) and 40th International Computer Music Conference (ICMC), ICMC–SMC 2014 (2014)

[48] Kaliakatsos-Papakostas, M., Floros, A., Vrahatis, M.N.: evodrummer: Deriving rhythmic patterns through interactive genetic algorithms. In: Evolutionary and Biologically Inspired Music, Sound, Art and Design, Lecture Notes in Computer Science, vol. 7834, pp. 25–36. Springer Berlin Heidelberg (2013)

[49] Kaliakatsos-Papakostas, M., Floros, A., Vrahatis, M.N.: Interactive music composition driven by feature evolution. SpringerOpen 5(1), 826 (2016)

[50] Kaliakatsos-Papakostas, M., Gkiokas, A., Katsouros, V.: Interactive Control of Explicit Musical Features in Generative LSTM-Based Systems. In: In Audio Mostly 2018: Sound in Immersion and Emotion (AM'18), p. 7. ACM, New York, NY, USA (2018)

[51] Kaliakatsos-Papakostas, M., Queiroz, M., Tsougras, C., Cambouropoulos, E.: Conceptual blending of harmonic spaces for creative melodic harmonisation. Journal of New Music Research 46(4), 305–328 (2017)

[52] Kaliakatsos-Papakostas, M.A., Epitropakis, M.G., Floros, A., Vrahatis, M.N.: Interactive evolution of 8-bit melodies with genetic programming towards finding aesthetic measures for sound. In: Proceedings of the 1st International Conference on Evolutionary and Biologically Inspired Music, Sound, Art and Design, EvoMUSART 2012, Malaga, Spain, LNCS, vol. 7247, pp. 140–151. Springer Verlag (2012)

[53] Kaliakatsos-Papakostas, M.A., Epitropakis, M.G., Vrahatis, M.N.: Musical composer identification through probabilistic and feedforward neural networks. In: Applications of Evolutionary Computation, *LNCS*, vol. 6025, pp. 411–420. Springer Berlin / Heidelberg (2010)

[54] Kaliakatsos-Papakostas, M.A., Epitropakis, M.G., Vrahatis, M.N.: Feature extraction using pitch class profile information entropy. In: Mathematics and Computation in Music, *Lecture Notes in Artificial Intelligence*, vol. 6726, pp. 354–357. Springer Berlin / Heidelberg (2011)

[55] Kaliakatsos-Papakostas, M.A., Floros, A., Vrahatis, M.N.: Intelligent real-time music accompaniment for constraint-free improvisation. In: Proceedings of the 24th IEEE International Conference on Tools with Artificial Intelligence (ICTAI 2012), pp. 444–451. Piraeus, Athens, Greece (2012)

[56] Kaliakatsos-Papakostas, M.A., Floros, A., Vrahatis, M.N.: Intelligent music composition. In: X.S. Yang, Z. Cui, R. Xiao, A.H. Gandomi, M. Karamanoglu (eds.) Swarm Intelligence and Bio-Inspired Computation, pp. 239 – 256. Elsevier, Oxford (2013)

[57] Kaliakatsos-Papakostas, M.A., Floros, A., Vrahatis, M.N., Kanellopoulos, N.: Genetic evolution of L and FL-systems for the production of rhythmic sequences. In: Proceedings of the 2nd Workshop in Evolutionary Music held during the 21st International Conference on Genetic Algorithms and the 17th Annual Genetic Programming Conference (GP) (GECCO 2012), pp. 461–468. Philadelphia, USA (2012)

[58] Kingma, D.P., Ba, J.: Adam: A method for stochastic optimization. arXiv preprint arXiv:1412.6980 (2014)

[59] Kranenburg, P.V., Backer, E.: Musical style recognition - a quantitative approach. In: R. Parncutt, A. Kessler, F. Zimmer (eds.) Proceedings of the Conference on Interdisciplinary Musicology (CIM04), pp. 1–10. Graz, Austria (2004)

[60] Krumhansl, C.L.: Cognitive foundations of musical pitch. Oxford University Press (2001)

[61] Kullback, S., Leibler, R.A.: On information and sufficiency. Annals of Mathematical Statistics **22**(1), 79–86 (1951)

[62] Leman, M.: Music and schema theory: Cognitive foundations of systematic musicology, vol. 31. Springer Science & Business Media (2012)

[63] Lo, M.Y.: Evolving cellular automata for music composition with trainable fitness functions. Ph.D. thesis, University of Essex (2012)

[64] Lourenc, B.F., Brand, C.P.: L-systems, scores, and evolutionary techniques. In: Proceedings of the SMC 2009 - 6th Sound and Music Computing Conference, pp. 113–118 (2009)

[65] MacCallum, R.M., Mauch, M., Burt, A., Leroi, A.M.: Evolution of music by public choice. Proceedings of the National Academy of Sciences **109**(30), 12,081–12,086 (2012)

[66] Machado, P., Romero, J., Manaris, B., Santos, A., Cardoso, A.: Power to the critics - a framework for the development of artificial critics. In: Proceedings of 3rd Workshop on Creative Systems, 18th International Joint Conference on Artificial Intelligence (IJCAI 2003, pp. 55–64. Acapulco, Mexico (2003)

[67] Madison, G., Sioros, G.: What musicians do to induce the sensation of groove in simple and complex melodies, and how listeners perceive it. Frontiers in psychology **5** (2014)

[68] Madsen, S.T., Widmer, G.: A complexity-based approach to melody track identification in MIDI files. In: Proceedings of the International Workshop on Artificial Intelligence and Music, (MUSIC-AI 2007), held in conjunction with the 20th International Joint Conference on Artificial Intelligence (IJCAI 2007), pp. 1–9. Hyderabad, India (2007)

[69] Makris, D., Kaliakatsos-Papakostas, M., Karydis, I., Kermanidis, K.L.: Combining LSTM and Feed Forward Neural Networks for Conditional Rhythm Composition. In: International Conference on Engineering Applications of Neural Networks, pp. 570–582. Springer (2017)

[70] Manaris, B., Hughes, D., Vassilandonakis, Y.: Monterey mirror: Combining Markov models, genetic algorithms, and power laws. In: Proceedings of 1st Workshop in Evolutionary Music, 2011 IEEE Congress on Evolutionary Computation (CEC 2011), pp. 33–40. Citeseer (2011)

[71] Manaris, B., Purewal, T., McCormick, C.: Progress towards recognizing and classifying beautiful music with computers - MIDI-encoded music and the Zipf-Mandelbrot law. In: Proceedings IEEE SoutheastCon, 2002, pp. 52–57. IEEE (2002)

[72] Manaris, B., Romero, J., Machado, P., Krehbiel, D., Hirzel, T., Pharr, W., Davis, R.B.: Zipf's law, music classification, and aesthetics. Computer Music Journal **29**(1), 55–69 (2005). ArticleType: research-article / Full publication date: Spring, 2005 / Copyright 2005 The MIT Press

[73] Manaris, B., Roos, P., Machado, P., Krehbiel, D., Pellicoro, L., Romero, J.: A corpus-based hybrid approach to music analysis and composition. In: Proceedings of the 22nd national conference on Artificial intelligence - Volume 1, pp. 839–845. AAAI Press, Vancouver, British Columbia, Canada (2007)

[74] Matic, D.: A genetic algorithm for composing music. Yugoslav Journal of Operations Research **20**(1), 157–177 (2010)

[75] McCormack, J.: Grammar-based music composition. Complexity International **3** (1996)

[76] McKay, C., Fujinaga, I.: Automatic genre classification using large high-level musical feature sets. In: Proceedings of the 5th International Society for Music Information Retrieval Conference, (ISMIR 2004), pp. 525–530. Barcelona, Spain (2004)

[77] McKay, C., Fujinaga, I.: jsymbolic: A feature extractor for midi files. In: ICMC (2006)

[78] Milne, A.J., Dean, R.T.: Computational creation and morphing of multilevel rhythms by control of evenness. Computer Music Journal (2016)

[79] Miranda, E.R., Al Biles, J.: Evolutionary computer music. Springer (2007)

[80] Moroni, A., Manzolli, J., Zuben, F.V., Gudwin, R.: Vox populi: An interactive evolutionary system for algorithmic music composition. Leonardo Music Journal pp. 49–54 (2000)

[81] Neuhaus, F., Kutz, O., Codescu, M., Mossakowski, T.: Fabricating monsters is hard: towards the automation of conceptual blending. In: Computational Creativity, Concept Invention, and General Intelligence, Proc. of the 3rd Int. Citeseer (2014)

[82] Nuanáin, C.O., Herrera, P., Jorda, S.: Target-based rhythmic pattern generation and variation with genetic algorithms. In: Sound and Music Computing Conference (2015)

[83] Özcan, E., Ercal, T.: A genetic algorithm for generating improvised music. In: N. Monmarché, E.G. Talbi, P. Collet, M. Schoenauer, E. Lutton (eds.) Artificial Evolution, *Lecture Notes in Computer Science*, vol. 4926, pp. 266–277. Springer Berlin / Heidelberg (2008)

[84] Pearce, M.: Generating rhythmic patterns: a combined neural and evolutionary approach. Ph.D. thesis, Master's thesis, Department of Artificial Intelligence, University of Edinburgh, Scotland, 2000. URL http://www. soi. city. ac. uk/ek735/msc/msc. html (2000)

[85] Price, K., Storn, R.M., Lampinen, J.A.: Differential evolution: a practical approach to global optimization. Springer Science & Business Media (2006)

[86] Prusinkiewicz, P.: Score generation with L-systems. Computer pp. 455–457 (1986)

[87] De la Puente, A., Alfonso, R., Alfonseca, M.: Automatic composition of music by means of grammatical evolution. In: ACM Sigapl Apl Quote Quad, vol. 32, pp. 148–155 (2002). DOI 10.1145/602231.602249

[88] Purwins, J., Graepel, T., Blankertz, B., Obermayer, C.: Correspondence analysis for visualizing interplay of pitch class, key, and composer. In: G. Mazzola, T. Noll, E. Luis-Puebla (eds.) Perspectives in Mathematical and Computational Music Theory, pp. 432–454. Universities Press (2004)

[89] Raskin, J.: Intuitive equals familiar. Communications of the ACM **37**(9), 17–19 (1994)

[90] Sánchez, A., Pantrigo, J.J., Virseda, J., Pérez, G.: Spieldose: An interactive genetic software for assisting to music composition tasks. In: Proceedings of the 2nd international work-conference on The Interplay Between Natural and Artificial Computation, Part I: Bio-inspired Modeling of Cognitive Tasks, IWINAC '07, pp. 617–626. Springer-Verlag, Berlin, Heidelberg (2007)

[91] Schaffrath, H.: The Essen Associative Code: A Code for Folksong Analysis. In: E. Selfridge-Field (ed.) Beyond MIDI, pp. 343–361. MIT Press, Cambridge, MA, USA (1997)

[92] Schaffrath, H., Huron, D.: The Essen folksong collection in kern format. [computer database]. Menlo Park, CA: Center for Computer Assisted Research in the Humanities (1995)

[93] Schorlemmer, M., Smaill, A., Kühnberger, K.U., Kutz, O., Colton, S., Cambouropoulos, E., Pease, A.: Coinvent: Towards a computational concept invention theory. In: 5th International Conference on Computational Creativity (ICCC) 2014 (2014)

[94] Shannon, C.E.: Prediction and entropy of printed English. Bell Labs Technical Journal **30**(1), 50–64 (1951)

[95] Shmulevich, I., Povel, D.J.: Measures of temporal pattern complexity. Journal of New Music Research **29**(1), 61–69 (2000)

[96] Shmulevich, I., Yli-Harja, O., Coyle, E., Povel, D.J., Lemstram, K.: Perceptual issues in music pattern recognition: Complexity of rhythm and key finding. Computers and the Humanities **35**, 23–35 (2001)

[97] Sioros, G., Guedes, C.: Complexity driven recombination of midi loops. In: ISMIR, pp. 381–386 (2011)

[98] Sioros, G., Guedes, C., et al.: A formal approach for high-level automatic rhythm generation. Proceedings of the BRIDGES (2011)

[99] Sioros, G., Miron, M., Davies, M., Gouyon, F., Madison, G.: Syncopation creates the sensation of groove in synthesized music examples. Frontiers in psychology **5** (2014)

[100] Spector, L., Alpern, A.: Induction and recapitulation of deep musical structure. In: Proceedings of International Joint Conference on Artificial Intelligence, IJCAI, vol. 95, pp. 20–25 (1995)

[101] Thom, B.: Machine learning techniques for real-time improvisational solo trading. In: Proceedings of the 2001 International Computer Music Conference (ICMC) (2001)

[102] Tokui, N.: Music composition with interactive evolutionary computation. Communication **17**(2), 215–226 (2000)

[103] Towsey, M., Brown, A., Wright, S., Diederich, J.: Towards melodic extension using genetic algorithms. Educational Technology & Society 4(2), 54–65 (2001)

[104] Tsougras, C., Stefanou, D.: Conceptual Blending and Meaning Construction: A Structural/hermeneutical Analysis of the 'Old Castle' from Musorgsky's 'Pictures at an Exhibition'. In: Proceedings of the 9th Triennial Conference of the European Society for the Cognitive Science of Music (ESCOM) (2015)

[105] Unehara, M., Onisawa, T.: Music composition by interaction between human and computer. New Generation Computing **23**(2), 181–191 (2005)

[106] Vogl, R., Leimeister, M., Nuanáin, C.Ó., Jordà, S., Hlatky, M., Knees, P.: An intelligent interface for drum pattern variation and comparative evaluation of algorithms. Journal of the Audio Engineering Society **64**(7/8), 503–513 (2016)

[107] Weinberg, G., Godfrey, M., Rae, A., Rhoads, J.: A real-time genetic algorithm in human-robot musical improvisation. In: Computer Music Modeling and Retrieval. Sense of Sounds., pp. 351–359. Springer-Verlag, Berlin, Heidelberg (2008)

[108] Wiggins, G., Papadopoulos, G.: A genetic algorithm for the generation of jazz melodies. In: Proceedings of the Finnish Conference on Artificial Intelligence (STeP'98), Jyväskylä, Finnland (1998)

[109] Wolkowicz, J., Kulka, Z., Keselj, V.: n-gram based approach to composer recognition. Archives of Acoustics **33**(1), 43–55 (2008)

[110] Yang, L.C., Chou, S.Y., Yang, Y.H.: Midinet: A convolutional generative adversarial network for symbolic-domain music generation. arXiv preprint arXiv:1703.10847 (2017)

[111] Zacharakis, A., Kaliakatsos-Papakostas, M., Cambouropoulos, E.: Conceptual blending in music cadences: A formal model and subjective evaluation. In: Proceedings of the 4th International Conference on Music Information Retrieval (ISMIR 2015). Malaga, Spain (2015)

[112] Zacharakis, A., Kaliakatsos-Papakostas, M., Tsougras, C., Cambouropoulos, E.: Musical blending and creativity: An empirical evaluation of the CHAMELEON melodic harmonisation assistant. Musicae Scientiae **22**(1), 119–144 (2018)

[113] Zacharakis, A., Kaliakatsos-Papakostas, M., Tsougras, C., Campouropoulos, E.: Creating musical cadences via conceptual blending: Empirical evaluation and enhancement of a formal model. Music Perception: An Interdisciplinary Journal p. (forthcoming) (2017)

[114] Zbikowski, L.M.: Conceptualizing Music: Cognitive Structure, Theory, and Analysis. Oxford University Press (2002)

[115] Zbikowski, L.M.: Metaphor and music. The Cambridge handbook of metaphor and thought, pp. 502–524 (2008)
[116] Zheng, E., Moh, M., Moh, T.S.: Music genre classification: A n-gram based musicological approach. In: Advance Computing Conference (IACC), 2017 IEEE 7th International, pp. 671–677. IEEE (2017)

# 6

# Representation Learning for the Arts: A Case Study Using Variational Autoencoders for Drum Loops

James McDermott

National University of Ireland, Galway, Ireland james.mcdermott@nuigalway.ie

**Summary.** Representation is a key issue in generative and interactive AI systems for art and creativity. With the right representation, tasks such as random generation of new material, variation of or interpolation between existing material, and interactive control of generated material, all become possible. Recent research in neural networks offers the possibility of representation learning, that is learning an appropriate representation by training a neural network and then using (part of) the network as a generative mapping. Interesting issues arise, such as the required dimensionality of the representation and the entanglement between its dimensions. In this chapter, recent related work is described, and a set of desirable properties is set out for learned representations. In a case study, a representation is learned for MIDI drum loops. A large library of MIDI drum loops is used to train variational autoencoder neural networks in an unsupervised fashion. The resulting representations are low-dimensional and capture variation in the data. Numerical results, listening tests, and user experience of direct navigation in the representations are reported.

**Key words:** Representation learning; neural networks; variational autoencoder; music; drums; drum loops; MIDI

## 6.1 Introduction

Many digital musical instruments are controlled by a large number of numerical parameters. Choosing a timbre for a typical synthesizer, for example, amounts to a search problem in a space consisting of one dimension per parameter. Geometric operations such as *tweaking* a single timbre, *blending* between a pair of timbres, and following a *trajectory* are possible in this space. These operations are valuable as a means of control both for novice and expert users ("I'll try a variation of the current sound"), and as a means of communication between users ("can you push that sound a bit farther?"). They also enable alternative methods of control such as random generation of novel timbres, and interactive evolutionary search. Similar geometric ideas are seen as a core achievement of recent work on learned representations [39], which become components in machine learning algorithms: a well-known example is the "king - man + woman = queen" vector algebra of Mikolov et al. [29].

© Springer Nature Switzerland AG 2021
P. Machado et al. (eds.), *Artificial Intelligence and the Arts*, Computational
Synthesis and Creative Systems, https://doi.org/10.1007/978-3-030-59475-6_6

The internal representation used by such a synthesizer has several properties which are useful for AI creativity applications more generally. The dimensionality is not so high as to be inaccessible to a human user, but is high enough for the user to exert real control. The dimensions are mostly real-valued, though some binary or categorical dimensions may be used also. Some dimensions may have an exponential or logarithmic effect, rather than linear, so typically the synthesizer designer uses a mapping to avoid this. There may, however, be unavoidable interactions among the parameters, so that although they can be changed independently, the result of changing one may depend on the values of others. These are seen as an impediment to the accessibility of the synthesizer. When operating on the synthesizer's internal representation, it is possible to experience the output in real-time, enabling tight interactive control.

In comparison to the internal representation of a typical synthesizer, the natural representations for some other AI creativity tasks have less desirable properties. For example, when editing a picture, it may be regarded as a grid of pixels, or as a set of parameterised strokes: in both cases, operations such as blending or random generation tend not to be meaningful. For another example, editing music using a *sequencer* equates to manual control of a large number of note-on/note-off, velocity, and pitch parameters, arranged into a time-grid. Although geometric operations can be defined in such a space, in practice the results fail to give a meaningful sense of tweaking, blending, or trajectory. What is needed is a new representation, that is an alternative space together with a mapping from that space to the concrete data (images, music, etc.), such that these geometric operations become meaningful for users and usable in algorithms.

Recent work in neural networks suggests several possibilities for creating new representations which can serve as accessible representations for graphical art, music, and other AI creativity applications. In particular, the autoencoder (AE) [18] can learn a new representation from a corpus in an unsupervised fashion. It is trained to reproduce its input at the output. The middle hidden layer of the AE is usually much smaller (fewer neurons) than the input, forcing the AE to find regularities in the data and take advantage of them. Such regularities amount to an implicit sense of "what the corpus is like". By discarding the input half of the AE, and working in the space of the hidden layer, we obtain a new representation. Running the AE forward from the hidden layer gives a new item (e.g. a piece of music or art) from the same distribution as the corpus. The *variational autoencoder* (VAE) [21] is a variant which allows tighter control of the distribution of data in the hidden layer, when mapped from the input [21]. This distribution is important because operations such as random generation and blending are carried out directly in it. It is hypothesized that geometric operations on the hidden layer variables tend to map to geometric operations as experienced by humans, such as well-formed variations of an object (formed by a small change from a point in the hidden layer space) or a conceptual blend or interpolation (formed by an interpolation between a pair of points in the hidden layer space). A well-behaved distribution at the hidden layer allows the user to explore and use geometric operations freely, and helps to prevent the creation of "holes" in the new representation where the training data is of low density.

AEs and variants have been used for such tasks in the domain of image processing and computer vision, and to some extent for audio processing, and have also begun to be used for AI creativity applications in graphics and music. In this chapter we discuss the possibilities and issues for representation learning for AI cre-

ativity applications. We then present a case study in which we use VAEs to learn a representation for a corpus of drum tracks.

## 6.2 Approaches and Issues in Representation Learning

In the type of creativity application we are concerned with, there is some concrete output, such as a piece of music or graphics. We will say that the *concrete space* is the space containing these outputs. For graphics applications, the concrete space is the set of images in PNG format, for example (perhaps constrained in size).

A *representation*, in our context, will mean a space, together with a mapping from it to the concrete space. (As a special case, the concrete space is itself a representation by this definition.) The new space typically corresponds to a low-dimensional manifold embedded in the concrete space. In the context of neural representation learning, the new space may be called the *latent space*, and points in it *latent codes*.

Introducing a second space is motivated by the possibility that it will have better properties than the original. Ideally, we would like to have a representation of dimensionality which is not too high to be accessible, but high enough to express the essential variation of the space. Ideally, geometric operations in the learned representation should correspond to some extent to human understanding of these operations; for example, the "blend" of two outputs should correspond to a stylistic conceptual blend [19, 36, 37], rather than a mere cross-fade or superposition. These properties enable navigation in the space. For practical reasons we also require a representation in which the mapping can run in real-time.

Such a representation would be useful as a component in human-computer interfaces; for example, we could allow a user to explore the space of images or pieces of music by moving sliders on a synthesizer-style interface. It would also be useful in algorithms; for example, evolutionary search could proceed more successfully when geometric operations give appropriate results.

There are several possible approaches to creating representations, which will be discussed in the following subsections:

- Dimensionality-reduction algorithms;
- Manual design; and
- Representations learned from data by neural networks.

### 6.2.1 Dimensionality Reduction

Algorithms such as multi-dimensional scaling (MDS, [22]) and $t$-distributed stochastic neighbour embedding ($t$-SNE, [24]) allow a dataset to be embedded into a new, lower-dimensional space, preserving distances between pairs of points. However, these methods do not allow new points to be mapped to the new space, and do not allow a mapping from the new space to the original. Thus, they do not serve as representations for our purposes.

Principal components analysis (PCA) is a well-known linear method for dimensionality reduction. The new space is (a rotation of) the most important dimensions of variation in the original data. A point sampled in the low-dimensional space can be mapped to a point in the concrete space. Therefore, PCA qualifies as a method of representation learning.

## 6.2.2 Manual Design of Representations

Manual design of representations can be carried out by choosing "landmark" points of the concrete space, and arranging them in the representation space. The forward mapping is then defined by interpolation. Dawkins [8], in the context of interactive evolutionary computation, described the natural triangulation scheme for interpolation among points arranged in 2D. The AudioMulch Metasurface [2] was one of the first projects to use this method for sound synthesis, as shown in Figure 6.1. The Apple Logic Pro software provides the "Transform Pad", which interpolates among 8 fixed synthesizer presets, as shown in Figure 6.2. A possible disadvantage of these approaches is that the process of choosing and arranging landmarks may be time-consuming or error-prone. Previous work [28] has also used this method for control of sound synthesis but with the "landmarks" chosen iteratively by an interactive evolutionary algorithm, rather than being fixed or manually chosen.

Fig. 6.1: AudioMulch Metasurface: interpolation among user-chosen landmark synthesizer patches. From `http://www.audiomulch.com/info/what-is-audiomulch#!prettyPhoto/5/`

All of these representations rely on geometric operations (e.g. linear interpolation between landmarks) working reasonably well. Onishi [30] goes further by using a self-organising map (SOM), a type of neural network, to learn non-linear interpolation among pre-chosen landmark points. This is in data-mining and voice control applications, rather than for generation of creative content. The same approach would be possible for drum tracks, but would require us to choose the landmark points and arrange them manually, which would be subjective. Our focus is instead on learning a representation in an unsupervised fashion and directly from data.

Manual design of representations can also be done in another way, by defining the desired dimensions directly and implementing them as feature-extraction algorithms. This has the advantage that the dimensions have exactly the desired properties. The disadvantage is that there is no direct mapping from the new space to the

Fig. 6.2: Apple Logic Pro Transform Pad: interpolation among 8 landmark synthesizer presets.

original. An evolutionary search or similar method must then be used to find a point in the original space corresponding to the desired point in the new space. Kaliakatsos-Papakostas [19] and Eigenfeldt and Pasquier [9] have described methods which work in this way for drum loop applications. The remaining disadvantage is that the mapping does not run in real-time and so is unsuitable for some interactive applications.

### 6.2.3 Representation Learning with Neural Networks

When learning representations with neural networks, we define a space (e.g. a Cartesian space of given dimension) and use data to learn a mapping from it to the original space. The process can be unsupervised, i.e. there is not necessarily a requirement for labelled data. This is an advantage for the many situations where labelled data is difficult to acquire.

In recent years, the field of representation learning has made great progress through novel neural network architectures. In particular, VAEs [21] and *generative adversarial networks* (GANs) [15] and their many variants represent the state of the art. Each uses an interesting neural architecture for training on unlabelled data. Each has been used extensively in learning representations for image corpora.

In this chapter, we consider the VAE only. It is a bottleneck architecture, where the input is passed through an encoder to a narrow middle layer, to be then passed through a decoder to the output, which is of the same size and shape as the input, with the goal of *reconstructing* the input at the output.

The main difference between a typical bottleneck autoencoder (AE) and a VAE is extra complexity in the hidden layer. The encoder takes a drum loop as input, and outputs a pair of vectors representing the mean and variance of its latent code. The decoder takes as input samples from a Gaussian distribution with the given mean and variance, and outputs a drum loop. The purpose of this complexity is that it allows tight control over the distribution of latent codes. It prevents the manifold from being "fractured" [17]. This is desirable because it allows us to sample from a Gaussian distribution in the latent space with confidence that the decoder has previously succesfully decoded similar points to well-formed drum loops. Without this control, the danger would be that a point sampled at the hidden layer was left "unused" by the network, and so would lead to a malformed result.

## Dimensionality

In many approaches to creating representations, the new space is a subset of $\mathbb{R}^n$. Choosing $n$ requires a trade-off. Larger $n$ may allow more granularity, finer control, and better co-location of points which are perceptually similar but which differ in the concrete space. In the context of VAEs, small $n$ will lead to weak reconstructions.

On the other hand, smaller $n$ may make navigation in the representation easier by allowing the user to build and retain a mental model of the representation. For example, Apple Logic Pro provides a Drummer facility which generates drum tracks automatically. As described by Vogl et al. [38], "the style of the drum track can be varied by moving in a two-dimensional panel that represents the dimensions soft-loud and simple-complex". The designers presumably chose a low-dimensional representation for user experience reasons, despite this apparent over-simplification. Kaliakatsos-Papakostas [19] designed a drum pattern representation of $n = 32$ dimensions, while Eigenfeldt and Pasquier [9] used $n = 9$.

## Disentangled Representations

In representation learning, a common goal is a semantic or "disentangled" quality in the representation. This means that varying just one dimension of the represntation will cause just one perceptual property of the output to vary. This property is partly achieved in typical sound synthesizers, for example [27]. There may be no way to define just what a perceptual property is for any particular domain, but for example in the well-known MNIST dataset of handwritten digits, it is possible to learn [5] a disentangled representation in which, for example, one of the dimensions represents the *slant* of the digit (from left-slanting to right-slanting), as illustrated in Figure 6.3 (left). The property of *slant* is semantic and closely aligned to human perception.

Fig. 6.3: Two types of representation of the MNIST digits. Left: a "disentangled" representation where axes are semantic (from Chen et al. [5]); right: a representation where axes are not consistently semantic but outputs are well-grouped (from Makhzani et al. [25]).

We can see disentangled representations as an alternative to landmark-oriented representations, as illustrated in Figure 6.3. As described, both types of representa-

tion have been shown to be useful in creative applications. The undesirable alternative is a representation in which neither clear areas nor clear axes exist.

## $L_2$ Normalisation

A common technique in neural representation learning is to $L_2$-normalise latent codes so that they are distributed on the surface of a hypersphere, e.g. [12]. The goal is to learn "angularly discriminative features", effectively removing an asymmetry that would exist between points which are mapped near the origin and points which are mapped far from it. Similarly, White [39] argues that when carrying out interpolation between points it is best to interpolate via a great circle rather than linearly. The reasoning is that in high dimensions, most random points have a similar norm, whereas linear interpolation between a pair of points will come upon areas with a much lower norm, i.e. areas of low density in the training data.

However, in a direct navigation interface, the user may find it more natural to interact with a "filled" representation, not a "hollow" one. In this paper we will also restrict attention to low-dimensional representations. Therefore, we will not use these normalisation and interpolation techniques. In fact, we hypothesize that allowing asymmetry is rather natural for some applications. E.g. in a corpus of drum loops there may be some which are perceived as more typical than others, and users may expect them to be located centrally in an interface. The VAE encourages outliers in the data to map to outlying positions in the latent space [4].

## 6.2.4 Neural Networks and Music

As discussed, good progress has been made using neural network approaches to representation learning in recent years. Many of the applications are in the domain of image processing and computer vision, and to a lesser extent in audio processing [35] and music at the audio (sample) level [10]. Of more interest in the current context is recent research in representation learning at the symbolic (MIDI) level.

Vogl et al. [38] used a neural network to generate variations on a "seed" drum pattern. They worked in a concrete space of 4 drum types and 16 time-steps. This mechanism was incorporated into a user interface which allowed the user to browse through variations and set the magnitude of variation.

The Google Magenta project has released several models for representation learning and generation of both drums and melodic material, using VAEs and recurrent neural networks (RNNs), e.g. [14, 32]. The multitrack MusicVAE model [32] allows for multiple musical instruments playing simultaneously, together with drums. It combines a VAE and an RNN. The authors emphasise the ability to carry out interpolations and meaningful transformations in the latent space, such as increasing the overall pitch range. They can also condition on user-input chord sequences. Others have also explored neural networks for musical style transfer [3, 7]. The latter also achieves successful interpolation between pieces of music.

Several other authors have also used recurrent networks, including Trieu and Keller [34], who used a generative adversarial network (GAN) to improvise jazz, and Sturm [33] who used an RNN for folk music and added deep analysis of its inner workings. Joslyn et al. [20], Genchel and Lerch [13], and Savery and Weinberg [31] all used RNNs in more complex representations for music generation at

the symbolic level. Meanwhile, Manzelli et al. [26] combined both audio and symbolic representations.

### 6.2.5 Evaluating Representation Learning

Evaluating unsupervised representation learning is difficult [23]. A variety of techniques are used in practice [39]. In some synthetic datasets, the true axes of variation are known in advance and can be used to evaluate the success of representation learning. In real-world problems this is not generally possible. Moreover, Locatello et al. [23] show that good unsupervised representation learning techniques do not necessarily transfer from one problem to another, and that there is more variability due to random seeds and hyperparameters than there is due to choice of representation learning model. Therefore, it is not possible to choose the best techniques on a synthetic dataset and transfer them to a real-world problem.

In some situations, especially when learning a representation for natural images, authors may resort to exhibiting many samples which can be fairly judged by the reader, e.g. [39].

In other situations, performance on a down-stream task (e.g. search) is a suitable proxy for the quality of the representation. For example, Vogl et al. [38] proposed a drum pattern system which used a learned representation as a component. To evaluate the system, they asked users to spend time with the system, compare it to alternative mechanisms, and report on experiences, including by answering a survey. They did not evaluate the learned representation directly.

For creative AI applications, user perception of the concrete objects (images, drum loops, etc.) and the relationships between them is important. Thus, user studies are useful. One difficulty is that users without machine learning expertise may find it difficult to evaluate relevant concepts such as disentanglement.

Several techniques for representation learning with neural networks have been mentioned, and many more could be added. An apparent gap in the literature is reporting on the "user experience": how does it feel to directly interact with the learned representations? As described, it seems that purely numerical results are insufficient for evaluation of a representation. In the case study which follows, we report a combination of subjective user experience, numerical results, and figures and videos which allow the reader to evaluate particular aspects of the learned representations.

## 6.3 Case Study: Representation Learning for MIDI Drum Tracks

Next, we present a case study in representation learning for short drum loops. We will use a symbolic representation of 9 drum types and 64 time-steps per loop as the concrete space. There is a direct mapping from this space to MIDI and thence to audio output via any software drum machine.

The vast majority of points in this concrete space will correspond to "ill-formed" drum loops, effectively sounding like random drum hits, rather than sounding musical. Of course, some proportion will also exist in a grey area which may or may

not be musical, depending on context and taste. The space is also high-dimensional. Moreover, as already discussed, several operations in the space of drum loops which might be useful to musicians or algorithms turn out not to work well, such as random generation, tweaking, blending, or following trajectories. Thus, the goal is to learn a new representation which addresses these issues and will be useful in composers' tools, e.g. as will be described in Section 6.3.3. We do not have an initial preference for a disentangled or a landmark-type representation as described in Section 6.2.3.

We choose to operate at the symbolic level, rather than raw audio, for several reasons. As we will see, this task is sufficiently large to be interesting and challenging, and as discussed above, also has useful applications in novel user interfaces. It is natural to consider the symbolic level, since the computational cost will be far lower; the features present at the symbolic level are higher-level; and good symbolic corpora are available.

### 6.3.1 Data and Preprocessing

The data used is a commercially-available library of drum loops in MIDI format, the *Mega Pack* from Groove Monkee[1]. The library is categorized by style and tempo, but we ignore both. For each "song", several loops are provided, giving (for example) an intro, a main beat, and a fill. 29,694 loops are provided. We discard any loops not in a power-of-2 time signature. To bring all loops to a standard length, loops of less than 32 beats are repeated, and loops greater than 32 beats are truncated. We quantize all hits to the nearest half-beat, giving 64 time-steps. We consider only 9 types of drum hits: BD (bass), SD (snare), OH (open hi-hat), CH (closed hi-hat), RD (ride), CR (crash), LT (low tom), MT (mid-tom), and HT (high tom). Any other drums are mapped to their nearest equivalents. As a result of this preprocessing, we have 25,106 drum loops, each a matrix of shape ($9\times64$), where the real value in each cell in each matrix gives the velocity ("volume") of the drum hit. The resulting dataset is thus comparable in size to MNIST[2], which is nowadays regarded as a very simple dataset.

Although the library is commercially available, a sample is available for free download[3]. Our code for preprocessing the data and for learning the representation is available[4] and works also with the cut-down library. The neural network is implemented using Keras [6], and our code is partly based on a previous model[5].

### 6.3.2 Proposed Model

Based on our literature review, it is clear that recurrent neural architectures are common for musical applications. They are a natural choice because, like language, music is essentially sequential. However, the short drum loops we consider may have

---

[1] https://groovemonkee.com/collections/midi-loops/products/mega-pack

[2] http://yann.lecun.com/exdb/mnist/

[3] The `drum-freebie-pak-gm` pack from https://groovemonkee.com/pages/free-midi-loops

[4] https://github.com/jmmcd/drum-manifold

[5] The file `variational_autoencoder_deconv.py` from https://github.com/keras-team/keras/blob/master/examples/

less need for memory. Dependencies between the information at different time-steps in the loop can be sufficiently captured by a relatively small feed-forward network. Also, drum loops have a particular "timeless" or "constant" quality, rather than being experienced as a sequential journey from beginning to end as in full pieces of music. In this work, we have chosen to focus on feed-forward networks only.

In some respects, a drum loop can be regarded as analogous to a 2D image, with a single colour channel, where the velocity ("volume") of a drum hit corresponds to the intensity of a single pixel. This gives us the basis for using a 2D convolutional network for our drum data. However, there are interesting differences. Convolution is based on the assumption of spatial correlation – in a real-world image, a pixel is usually similar to its neighbour. In a drum loop, the assumption must be slightly different. A drum hit may not be similar to its neighbour in the time axis, but it is certainly related to it, and so a convolution over the time axis is appropriate. The other axis represents the choice of drum type, from kick drum to high tom. In this axis, there is no reliable sense of "neighbours". Instead, we may consider treating all drums as neighbours of each other, leading to a vertical kernel size of 9. Secondly, in power-of-2 time signatures, it is natural to consider a horizontal kernel size of 4 time steps. Because $3 \times 3$ is the most common kernel size for image processing, we will consider values 3 and 4 for horizontal and 3 and 9 for vertical.

The details of the architecture are illustrated in Figure 6.4.

The loss function to be optimised in the VAE is: $L = L_R + \lambda L_{KL}$, where the reconstruction loss $L_R = \text{BCE}(x, \hat{x})$, BCE is binary cross entropy, $x$ is a datapoint, $\hat{x}$ is the reconstruction of $x$, $L_{KL}$ is the Kullback-Leibler divergence from the desired distribution to the distribution observed in the latent codes, and $\lambda$ is a hyperparameter controlling the strength of the Kullback-Leibler regularisation.

## Hyperparameters

Several variants on the initial model are defined by varying the following hyperparameters, giving a total of 96 models.

- The latent dimension: $z \in \{2, 10\}$. These values are chosen as $z = 2$ allows direct control and visualisation, while $z = 10$ is a reasonable trade-off point between this control and representation power. It is comparable in size to the drum pattern representation obtained by Eigenfeldt and Pasquier [9].
- The weighting on the KL (regularisation) loss: $\lambda \in \{0.01, 0.03, 0.1\}$. Values $\lambda < 0.01$ tend not to lead to a Gaussian representation, while values $\lambda > 0.1$ tend to lead to degenerate representations, to be discussed in Section 6.3.3.
- The dropout rate $d \in \{0, 0.2\}$.
- The kernel sizes $k = (k_0, k_1) \in \{(3, 3), (3, 4), (9, 3), (9, 4)\}$.
- The expansion in number of filters per convolutional layer: $f \in \{1, 2\}$. In the initial model there is an expansion by a factor of $f = 2$, giving 32 and then 64 filters. Such an increase in later layers is common in image-processing networks. The alternative with $f = 1$ is 16 and then 16 filters.

### 6.3.3 Evaluation

We now analyse and evaluate the training and the resulting representation.

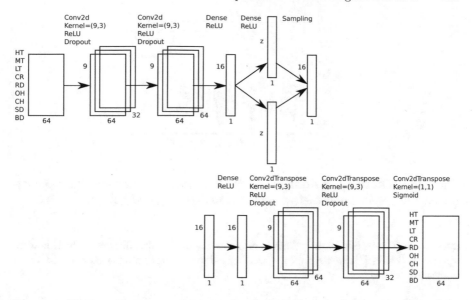

Fig. 6.4: VAE architecture: encoder (top) and decoder (bottom). The input to the decoder is of size (9 × 64), a direct representation of a drum loop. In the encoder, there are two convolutional layers with kernel size (9×3), with 32 and then 64 filters, with dropout. A dense layer of 16 neurons then leads to a pair of dense layers giving the variational outputs $\mu$ and $\sigma$, each of size $z$. All activations are ReLU. In the decoder, the input is a sampled vector of size $z$. The first layer is dense with 16 neurons. The next two layers are "deconvolutional" (implemented by Keras as Conv2DTranspose) with 64 and then 32 filters. The kernel is the same, and dropout is applied at each. Finally there is a deconvolutional layer with a single filter and (1×1) kernel, giving an output of size (9 × 64). In the decoder all activations are ReLU except at the output, which is sigmoid.

**Loss During Training**

For a typical model, we observe validation loss during training as shown in Figure 6.5.

**Distribution of Latent Codes**

We wish to develop an intuition for the overall behaviour of the representation by visualising the distribution of the data. In some models there appear to be "spokes", as shown in Figure 6.6 (left), and these are consistent between the training and test sets. They may suggest that the user will experience this representation as composed of areas, rather than disentangled axes. In some cases, we observe that the representation is "degenerate", i.e. has little or no variation in one or more of the

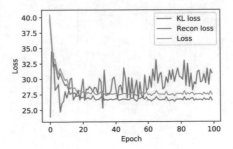

Fig. 6.5: Validation loss during training. The values shown are the two components of the loss and their weighted sum $L = L_R + \lambda L_{KL}$.

axes, as in Figure 6.6 (right). This is reminiscent of "mode collapse" which is well-known in GANs [1]. In remaining cases, the distribution appears as a well-formed Gaussian.

Fig. 6.6: Distribution of the test set: (left) in a good representation learned with $z = 2$; (right) in a "degenerate" representation with $z = 10$ (first two dimensions only).

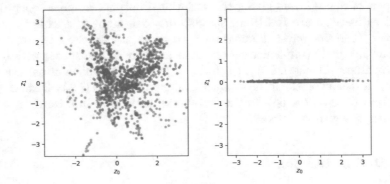

## Numerical Experiments

We can also investigate the learned representations and the effect of hyperparameters through numerical measures. Some of the quantities of interest are as follows:

- Whether the representation is "degenerate" as described. Notated as "degen".
- The mean over many data points of the norm of $dx/dz$, where $dx/dz$ is the (vector-valued) change in output vector $x$ with respect to a small change in the latent vector $z$. Smaller is better. Notated as "mean $\|dx/dz\|$".

- The maximum value in the vector-valued mean of $dx/dz$ over many data points, when $z$ is varied by a short constant vector parallel to $z = (1, 1, \ldots 1)$. Larger is better as it indicates a more consistent direction in the concrete space for a fixed movement in the representation. Notated as "max mean $dx/dz$".
- The mean BCE reconstruction loss. Smaller is better. Notated as "mean recon loss".

The results are shown in Table 6.1. The best values per column are underlined (lowest for mean $\|dx/dz\|$ and mean reconstruction loss, and highest for max mean $dx/dz$, excluding degenerate results). We observe that degenerate representations are more common for $z = 10$, large $\lambda$, and larger kernel sizes. Concerning max mean $dx/dz$, it seems that a smaller kernel and $f = 1$ tend to lead to a larger value here, indicating that a fixed movement in $z$ has a more consistent effect on the output, relative to larger kernels and $f = 2$. Among the non-degenerate representations, $z = 10$ allows much better reconstruction than $z = 2$, and much more fine-grained control (smaller $\|dx/dz\|$). There is no clear effect of the other hyperparameters on reconstruction loss.

### Samples

Here we have trained a network using $z = 10$, $\lambda = 0.01$, $d = 0.2$, $f = 2$, $k = (9, 4)$. We take the origin $z_0 = (0, 0, \ldots, 0)$ and run it forward to give a drum loop. Figure 6.7 shows some of the results at different stages of training.

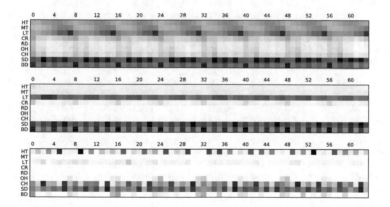

Fig. 6.7: Samples from the new representation after 1, 3, 5, and 100 epochs (from top). The 9 drum types are arranged on the vertical axis and time is on the horizontal.

In the early epochs (top) almost nothing has been learned except that bass drums (BD) are common on multiples of 8 time-steps, and snare drums (SD) and toms (LT, MT, HT) are common overall. After 3 epochs, the result becomes a recognisable drum loop. At the end of training (bottom), the model has learned to produce "clean"-looking loops.

Table 6.1: Results of numerical experiments. For each combination of hyper-parameter values we show four results as described previously.

| $\lambda$ | $d$ | $f$ | $k_0$ | $k_1$ | degen | mean $\|dx/dz\|$ | max mean $dx/dz$ | mean recon loss | degen | mean $\|dx/dz\|$ | max mean $dx/dz$ | mean recon loss |
|---|---|---|---|---|---|---|---|---|---|---|---|---|
| | | | | | | $z=2$ | | | | $z=10$ | | |
| 0.01 | 0.0 | 1 | 3 | 3 | ok | 0.058 | 0.011 | 4.696 | ok | 0.027 | 0.008 | 3.656 |
| 0.01 | 0.0 | 1 | 3 | 4 | ok | 0.052 | 0.011 | 4.791 | ok | 0.029 | 0.008 | 2.987 |
| 0.01 | 0.0 | 1 | 9 | 3 | ok | 0.064 | 0.010 | 4.636 | ok | 0.022 | 0.004 | 3.364 |
| 0.01 | 0.0 | 1 | 9 | 4 | ok | 0.065 | 0.007 | 4.596 | ok | 0.028 | 0.006 | 3.033 |
| 0.01 | 0.0 | 2 | 3 | 3 | ok | 0.071 | 0.006 | 4.497 | ok | 0.031 | 0.006 | 3.665 |
| 0.01 | 0.0 | 2 | 3 | 4 | ok | 0.088 | 0.007 | 4.473 | ok | 0.031 | 0.006 | 2.889 |
| 0.01 | 0.0 | 2 | 9 | 3 | ok | 0.099 | 0.007 | 4.363 | ok | 0.030 | 0.005 | 2.955 |
| 0.01 | 0.0 | 2 | 9 | 4 | ok | 0.101 | 0.009 | 4.376 | ok | 0.031 | 0.005 | 3.302 |
| 0.01 | 0.2 | 1 | 3 | 3 | ok | 0.048 | 0.009 | 4.694 | ok | 0.040 | 0.008 | 2.952 |
| 0.01 | 0.2 | 1 | 3 | 4 | ok | 0.052 | 0.009 | 4.642 | ok | 0.022 | 0.005 | 3.750 |
| 0.01 | 0.2 | 1 | 9 | 3 | ok | 0.058 | 0.010 | 4.577 | ok | 0.025 | 0.006 | 3.433 |
| 0.01 | 0.2 | 1 | 9 | 4 | ok | 0.059 | 0.012 | 4.622 | ok | 0.025 | 0.005 | 3.229 |
| 0.01 | 0.2 | 2 | 3 | 3 | ok | 0.069 | 0.008 | 4.523 | ok | 0.033 | 0.007 | 2.856 |
| 0.01 | 0.2 | 2 | 3 | 4 | ok | 0.061 | 0.011 | 4.544 | ok | 0.026 | 0.007 | 3.431 |
| 0.01 | 0.2 | 2 | 9 | 3 | ok | 0.068 | 0.009 | 4.411 | ok | 0.020 | 0.004 | 3.529 |
| 0.01 | 0.2 | 2 | 9 | 4 | ok | 0.073 | 0.008 | 4.451 | bad | 0.027 | 0.007 | 3.056 |
| 0.03 | 0.0 | 1 | 3 | 3 | ok | 0.067 | 0.010 | 4.708 | ok | 0.025 | 0.008 | 3.654 |
| 0.03 | 0.0 | 1 | 3 | 4 | ok | 0.063 | 0.014 | 4.744 | ok | 0.025 | 0.009 | 3.879 |
| 0.03 | 0.0 | 1 | 9 | 3 | ok | 0.060 | 0.008 | 4.590 | ok | 0.027 | 0.009 | 2.971 |
| 0.03 | 0.0 | 1 | 9 | 4 | ok | 0.071 | 0.010 | 4.522 | ok | 0.025 | 0.005 | 3.281 |
| 0.03 | 0.0 | 2 | 3 | 3 | ok | 0.079 | 0.009 | 4.485 | ok | 0.040 | 0.007 | 2.736 |
| 0.03 | 0.0 | 2 | 3 | 4 | ok | 0.091 | 0.007 | 4.459 | ok | 0.035 | 0.007 | 3.017 |
| 0.03 | 0.0 | 2 | 9 | 3 | ok | 0.107 | 0.008 | 4.444 | bad | 0.030 | 0.004 | 3.394 |
| 0.03 | 0.0 | 2 | 9 | 4 | ok | 0.106 | 0.011 | 4.320 | bad | 0.032 | 0.005 | 2.970 |
| 0.03 | 0.2 | 1 | 3 | 3 | ok | 0.056 | 0.011 | 4.708 | ok | 0.031 | 0.009 | 3.692 |
| 0.03 | 0.2 | 1 | 3 | 4 | ok | 0.066 | 0.014 | 4.694 | ok | 0.034 | 0.008 | 3.065 |
| 0.03 | 0.2 | 1 | 9 | 3 | ok | 0.057 | 0.011 | 4.574 | ok | 0.024 | 0.006 | 3.359 |
| 0.03 | 0.2 | 1 | 9 | 4 | ok | 0.058 | 0.010 | 4.578 | bad | 0.021 | 0.004 | 4.777 |
| 0.03 | 0.2 | 2 | 3 | 3 | ok | 0.063 | 0.012 | 4.543 | ok | 0.037 | 0.008 | 2.696 |
| 0.03 | 0.2 | 2 | 3 | 4 | ok | 0.067 | 0.010 | 4.595 | ok | 0.031 | 0.006 | 3.247 |
| 0.03 | 0.2 | 2 | 9 | 3 | ok | 0.085 | 0.008 | 4.472 | bad | 0.025 | 0.005 | 3.545 |
| 0.03 | 0.2 | 2 | 9 | 4 | ok | 0.085 | 0.009 | 4.416 | bad | 0.024 | 0.004 | 3.202 |
| 0.10 | 0.0 | 1 | 3 | 3 | bad | 0.000 | 0.000 | 6.217 | bad | 0.026 | 0.007 | 3.548 |
| 0.10 | 0.0 | 1 | 3 | 4 | ok | 0.065 | 0.011 | 4.677 | bad | 0.028 | 0.008 | 3.161 |
| 0.10 | 0.0 | 1 | 9 | 3 | ok | 0.074 | 0.010 | 4.614 | bad | 0.026 | 0.006 | 3.469 |
| 0.10 | 0.0 | 1 | 9 | 4 | ok | 0.068 | 0.010 | 4.578 | bad | 0.023 | 0.005 | 3.571 |
| 0.10 | 0.0 | 2 | 3 | 3 | ok | 0.089 | 0.013 | 4.504 | ok | 0.034 | 0.007 | 2.766 |
| 0.10 | 0.0 | 2 | 3 | 4 | ok | 0.093 | 0.011 | 4.527 | bad | 0.036 | 0.007 | 2.971 |
| 0.10 | 0.0 | 2 | 9 | 3 | ok | 0.099 | 0.011 | 4.485 | bad | 0.031 | 0.005 | 3.217 |
| 0.10 | 0.0 | 2 | 9 | 4 | ok | 0.099 | 0.010 | 4.428 | bad | 0.033 | 0.005 | 3.185 |
| 0.10 | 0.2 | 1 | 3 | 3 | ok | 0.054 | 0.013 | 4.798 | ok | 0.031 | 0.008 | 3.123 |
| 0.10 | 0.2 | 1 | 3 | 4 | ok | 0.052 | 0.011 | 4.788 | bad | 0.022 | 0.008 | 4.233 |
| 0.10 | 0.2 | 1 | 9 | 3 | ok | 0.058 | 0.011 | 4.654 | bad | 0.021 | 0.005 | 4.076 |
| 0.10 | 0.2 | 1 | 9 | 4 | ok | 0.062 | 0.011 | 4.528 | bad | 0.023 | 0.006 | 4.346 |
| 0.10 | 0.2 | 2 | 3 | 3 | ok | 0.074 | 0.013 | 4.557 | bad | 0.026 | 0.007 | 3.545 |
| 0.10 | 0.2 | 2 | 3 | 4 | ok | 0.068 | 0.009 | 4.564 | bad | 0.034 | 0.007 | 2.993 |
| 0.10 | 0.2 | 2 | 9 | 3 | ok | 0.080 | 0.010 | 4.454 | bad | 0.026 | 0.006 | 3.604 |
| 0.10 | 0.2 | 2 | 9 | 4 | ok | 0.077 | 0.010 | 4.544 | bad | 0.027 | 0.005 | 4.575 |

As already described, PCA can be used to learn a low-dimensional representation directly from the data. Here, we implement the standard PCA algorithm, retaining the $z = 10$ dimensions which capture the greatest variance in the data. We then sample from this low-dimensional PCA space. A typical result is shown in Figure 6.8: it demonstrates almost none of the learning demonstrated by the neural model. Thus, PCA fails to provide a useful representation in this case. This is an expected result. It seems that the distribution of the drum loops in the original space cannot be well captured by the linear transformation offered by PCA. A VAE uses non-linear transformations, and these seem to be essential.

Fig. 6.8: A typical sample from a PCA representation.

## Listening Tests and Reconstructions

The ability to reconstruct (encode and then decode) a drum loop is a good test of the quality of the learned representation.

We have carried out an informal listening test to report on the perceived quality of reconstructions and the relationship between the perceived quality and the numerical reconstruction loss values already reported. At each step in the listening test, a random model from those trained is chosen, along with a random drum pattern from the test set. The original and its reconstruction via the model are played consecutively, and the user is asked for a numerical rating of reconstruction quality in the range $[1, 10]$. The test was carried out by the author, so overall judgements of quality are vulnerable to inter-subject biases. However, because the test was blinded, differences in perceived quality from one model to another are scientifically useful, assuming that different subjects will make approximately the same judgements of similarity. The results are shown in Figure 6.9.

There is a reasonably strong correlation $R = -0.55$ between the BCE reconstruction loss and perceived reconstruction quality. This gives us some confidence that we can use the overall reconstruction error to help us choose the best models. However, there is a stronger correlation $R = -0.64$ between MSE and perceived reconstruction quality, suggesting that MSE might be a better loss function. It was tested in some preliminary experiments and did not give a noticeable improvement in reconstruction quality, or representation user experience, versus BCE. It is known to result in more "blurry" results in image-processing VAE tasks.

Concerning the qualitative experience of the reconstruction listening tests, we have observed that many of the trained models achieve good reconstructions, but only a few achieve consistent, excellent reconstructions. The models which produced the greatest number of excellent reconstructions (perceived quality of 9 or 10) were trained with hyperparameters $z = 10$, $\lambda = 0.01$, $f = 2$, $d = 0.0$ or $d = 0.2$, and all

Fig. 6.9: Listening test results: correlation between perceived quality of reconstruction and BCE loss (left, $R = -0.55$) and MSE (right, $R = -0.64$). The most noticeable hyperparameter effect is the size of the latent dimension: $z = 10$ gives much better results than $z = 2$ as shown.

kernel sizes other than $k = (3, 4)$. The main weaknesses which can be observed in the reconstructions are as follows:

- Sometimes, especially for $z = 2$, the reconstruction is highly blurred – consisting of the right set of drum types, but struck on almost every beat with medium velocity. These reconstructions are failures.
- The blurring effect also occurs in some good reconstructions. A strong, clear beat may be reconstructed with "ghost notes", i.e. notes of low velocity just before or after the true hits. The true hits may in this case be reconstructed with lower velocity than they should have. An example is shown in Figure 6.10. In practical use, ghost notes could be filtered out with a velocity threshold.
- Some irregular and unusual features, such as a pattern which begins with a hi-hat intro before breaking into a full drum pattern, can be missed: the reproduction may simply use the full pattern throughout.

Fig. 6.10: Reconstruction of drum loops: original (top) and reconstruction (bottom).

## Interpolations

Fig. 6.11: Interpolation in the latent space. The top loop has the latent code $(-3, 0, 0, \ldots, 0)$, and the bottom has $(+3, 0, 0, \ldots, 0)$. The others are intermediate. Thus, the interpolation is along a single dimension only. The two values (-3, 3) are quite "extreme" in a Gaussian distribution with a standard deviation of 1.

To demonstrate interpolation visually, we choose two fixed points in a good representation, and take several points evenly spaced in the linear interpolation between them. For each point, we map it to a drum loop via the VAE decoder, and plot the results in Figure 6.11. There is some sense of stylistic rather than linear interpolation: e.g. the bass drum BD does not linearly "fade out" but changes character and then disappears. It is somewhat obscured by the presence of some ghost notes. Meanwhile, a typical descending pattern gradually emerges in the high to low tom drums (HT, MT, LT). However, on the whole it is fair to say that long-range interpolations (as here, going from $-3$ sd to $+3$ sd) give a sense of traversing different areas, rather than a single stylistic interpolation. Short-range interpolations

work better. Videos demonstrating some successful long-range interpolations are provided on our GitHub page.

## User Interface and User Experience

We have created a simple user interface for direct exploration of the learned representation. For a representation of $n$ dimensions ($n$ even), it shows $n/2$ controllers, each movable in 2D by the mouse, as shown in Figure 6.12.

Although the Gaussian distribution used by the VAE for the latent space is natural for statistical approaches, a human user may prefer to think of the representation as being uniform in a hypercube. We map each dimension controlled by the user from the range $[0, 1]$ as shown on-screen to a Gaussian with centre 0 and variance 2. We clip values to the range $[-10, 10]$. (This is a relatively large range, allowing the user to go outside the normal range encountered in the training data. We have observed that good patterns are sometimes present in these areas.) The resulting values become the $z$-values of the latent code. Decoding produces a drum track.

Fig. 6.12: A user interface for direct navigation in the learned representation. Here, five controllers control two dimensions each. Buttons for saving and randomisation are provided. At the bottom, the current drum loop is shown in real-time. See our GitHub page for video demonstration.

We next give subjective descriptions of experience with the learned representations. This is intended to complement the numerical results in Section 6.3.3. Video evidence (and runnable code and models) is provided via GitHub links, allowing the reader to verify the properties described.

With a good representation of latent dimension $z = 2$, we observe that most random locations give rise to potentially usable drum patterns. Small changes in the representation give rise to small changes in the output, with some exceptions, especially at the boundaries: a minimal movement inward from the boundary may give a small discontinuity in the output. There is not a strong sense of consistent changes in the output resulting from fixed changes in the representation. Instead, there is an overall sense of areas in the space, reminiscent of the right-hand image in Figure 6.3. Overall, the system is enjoyable to use. The low dimensionality makes it possible to explore for just a few minutes and get an overall sense of the "geography" of the representation, making it very usable[6].

With a good representation with $z = 10$, overall the system is similar to that for $z = 2$, but much more controllable. More fine-grained control of the output is possible. Small movements result in small, controllable changes in the output. There is some evidence that axes are disentangled, e.g. as shown in the video[7], a sweep of the $z_0$ parameter from minimum to maximum value generally results in a more tom-heavy and more insistent beat, as hi-hats drop out. This effect is reasonably strong but certainly not universal.

Finally, we demonstrate[8] one of the best models as indicated by the reconstruction results discussed in Section 6.3.3. We choose $z = 10$, $\lambda = 0.01$, $d = 0.2$, $f = 2$, $k = (9, 4)$. As shown it is very controllable, with good blending and tweaking behaviour. Again, most random points are good. It is possible to "perform" with the controller, e.g. adding a drum fill to an ongoing simple beat.

**Disentanglement and the Beta VAE**

As already described, some of the representations learned with $z = 10$ are slightly but not strongly disentangled. An example is demonstrated in video[9]. The Beta VAE [16] strongly increases the regularisation penalty, which is claimed to have the effect of encouraging disentangled representations. In our model, we have investigated the effect of the $\lambda$ hyperparameter. However, with $z = 10$ and for $\lambda \geq 0.03$, we start to see degenerate representations, as reported in Table 6.1, so this approach to disentanglement is not possible here.

## 6.4 Conclusions

In this chapter we have discussed the main issues in representation learning for creative applications, and described a case study in representation learning for drum loops. The idea of using a variational autoencoder to learn a representation from

---

[6]See the video at: `https://youtu.be/3kzbQI2LiOk`

[7]See the video at: `https://youtu.be/7x4df0JhgQg`

[8]See the video at: `https://youtu.be/qZxjE6fngJI`

[9]See the video at: `https://youtu.be/BBidFxZ4IaU`

an unlabelled MIDI corpus has been motivated and investigated. A simple VAE architecture has been proposed. The effects of several hyperparameters have been investigated, and we have found that a reasonably small network is sufficient to obtain good reconstructions, samples, and interpolations in the latent space. They are far better than could be obtained with a simple baseline such as PCA. Experience with the learned representation shows that it is directly usable as a drum controller.

### 6.4.1 Future Work

Several avenues remain open for future work.

RNNs and other sequence-oriented network architectures can be considered.

The representation learned by the VAE with $z = 10$ is partly but not strongly disentangled. As described, we have experimented with the strength of the regularisation to try to disentangle it further, without success. Alternatives including the Shrink AE and Dirac Delta VAE also enforce a very tight distribution, forcing the network to use the non-saturating parts of a tanh activation function, which may have the same effect [4]. An interesting possibility for the purpose of musical control is the infoGAN, i.e. information-theoretic GAN, in which a semantic/disentangled property of a subset of the dimensions in the latent code is explicitly maximised by the loss function [5].

It is common in neural networks research to visualise the behaviour of each layer by finding the input pattern which maximally activates each neuron [11]. This type of investigation may yield useful insight into the drum loop representation and is planned for future work.

Gillick et al. [14] have recently released a large dataset of MIDI drum patterns. Comparison between the representations learned on different corpora is an interesting avenue. Music information retrieval applications are also enabled by taking a cross-corpus view.

*Acknowledgement.* The author acknowledges the DJEI/DES/SFI/HEA Irish Centre for High-End Computing (ICHEC) for the provision of computational facilities and support. This chapter is partly based on work presented at the ISSTA 2017 and CSMC 2018 conferences: thanks to the reviewers and participants in those conferences. Thanks also to the editors and the reviewers of this chapter.

# References

[1] Arjovsky, M., Chintala, S., Bottou, L.: Wasserstein GAN. arXiv:1701.07875 (2017)

[2] Bencina, R.: The Metasurface: applying natural neighbour interpolation to two-to-many mapping. In: Proceedings of New Interfaces for Musical Expression 2005, pp. 101–104 (2005)

[3] Brunner, G., Konrad, A., Wang, Y., Wattenhofer, R.: MIDI-VAE: Modeling dynamics and instrumentation of music with applications to style transfer (2018). URL https://arxiv.org/abs/1809.07600

[4] Cao, V.L., Nicolau, M., McDermott, J.: Learning neural representations for network anomaly detection. IEEE Transactions on Cybernetics 49(8), 3074–3087 (2019). DOI 10.1109/TCYB.2018.2838668

[5] Chen, X., Duan, Y., Houthooft, R., Schulman, J., Sutskever, I., Abbeel, P.: Info-GAN: Interpretable representation learning by information maximizing generative adversarial nets. In: Advances in Neural Information Processing Systems, pp. 2172–2180 (2016)

[6] Chollet, F., et al.: Keras. https://keras.io (2015)

[7] Dai, S., Zhang, Z., Xia, G.G.: Music style transfer: A position paper (2018). URL https://arxiv.org/abs/1803.06841

[8] Dawkins, R.: The Blind Watchmaker. Longman Scientific and Technical, Harlow, England (1986)

[9] Eigenfeldt, A., Pasquier, P.: Evolving structures for electronic dance music. In: Proceedings of the 15th Annual Conference on Genetic and Evolutionary Computation, pp. 319–326. ACM (2013)

[10] Engel, J., Resnick, C., Roberts, A., Dieleman, S., Eck, D., Simonyan, K., Norouzi, M.: Neural audio synthesis of musical notes with WaveNet autoencoders. arXiv preprint arXiv:1704.01279 (2017)

[11] Erhan, D., Bengio, Y., Courville, A., Vincent, P.: Visualizing higher-layer features of a deep network. Tech. Rep. 1341, Université de Montréal (2009)

[12] Fan, X., Jiang, W., Luo, H., Fei, M.: Spherereid: Deep hypersphere manifold embedding for person re-identification. Journal of Visual Communication and Image Representation 60, 51–58 (2019). DOI https://doi.org/10.1016/j.jvcir.2019.01.010. URL http://www.sciencedirect.com/science/article/pii/S1047320319300100

[13] Genchel, B., Lerch, A.: Lead sheet generation with musically interdependent networks. In: R. Loughran (ed.) Proceedings of Computer Simulation of Musical Creativity. Dublin, Ireland (2018). https://csmc2018.wordpress.com/programme/

[14] Gillick, J., Roberts, A., Engel, J., Eck, D., Bamman, D.: Learning to groove with inverse sequence transformations. In: ICML (2019)

[15] Goodfellow, I., Pouget-Abadie, J., Mirza, M., Xu, B., Warde-Farley, D., Ozair, S., Courville, A., Bengio, Y.: Generative adversarial nets. In: Advances in neural information processing systems, pp. 2672–2680 (2014)

[16] Higgins, I., Matthey, L., Pal, A., Burgess, C., Glorot, X., Botvinick, M., Mohamed, S., Lerchner, A.: Beta-VAE: Learning basic visual concepts with a constrained variational framework. In: ICLR (2017). URL https://openreview.net/forum?id=Sy2fzU9gl

[17] Hinton, G.: CSC 2535: Lecture 11, non-linear dimensionality reduction. https://www.cs.toronto.edu/~hinton/csc2535/notes/lec11new.pdf (2013)

[18] Hinton, G.E., Salakhutdinov, R.R.: Reducing the dimensionality of data with neural networks. Science 313(5786), 504–507 (2006)

[19] Kaliakatsos-Papakostas, M.: Generating drum rhythms through data-driven conceptual blending of features and genetic algorithms. In: International Conference on Computational Intelligence in Music, Sound, Art and Design, pp. 145–160. Springer (2018)

[20] Kevin Joslyn, N.Z., Hua, K.A.: Deep segment hash learning for music generation. In: R. Loughran (ed.) Proceedings of Computer Simulation of Musical Creativity. Dublin, Ireland (2018). https://csmc2018.wordpress.com/programme/

[21] Kingma, D.P., Welling, M.: Auto-encoding variational Bayes. arXiv preprint arXiv:1312.6114 (2013)

[22] Kruskal, J.: Multidimensional scaling by optimizing goodness of fit to a nonmetric hypothesis. Psychometrika **29**(1), 1–27 (1964). DOI 10.1007/BF02289565. URL http://dx.doi.org/10.1007/BF02289565

[23] Locatello, F., Bauer, S., Lucic, M., Rtsch, G., Gelly, S., Schlkopf, B., Bachem, O.: Challenging common assumptions in the unsupervised learning of disentangled representations (2018). URL https://arxiv.org/abs/1811.12359

[24] Van der Maaten, L., Hinton, G.: Visualizing data using t-SNE. Journal of Machine Learning Research **9**(2579-2605), 85 (2008)

[25] Makhzani, A., Shlens, J., Jaitly, N., Goodfellow, I., Frey, B.: Adversarial autoencoders. arXiv preprint arXiv:1511.05644 (2015)

[26] Manzelli, R., Thakkar, V., Siahkamari, A., Kulis, B.: An end to end model for automatic music generation: Combining deep raw and symbolic audio networks. In: P. Pasquier, O. Bown, A. Eigenfeldt (eds.) 6th International Workshop on Musical Metacreation (MUME 2018). Salamanca, Spain (2018). Held at the Ninth International Conference on Computational Creativity, ICCC 2018

[27] McDermott, J.: Evolutionary computation applied to the control of sound synthesis. Ph.D. thesis, University of Limerick (2008). http://www.skynet.ie/~jmmcd/papers/thesis.pdf

[28] McDermott, J., O'Neill, M., Griffith, N.J.L.: Interactive EC control of synthesized timbre. Evolutionary Computation Journal **18**(2), 277–303 (2010)

[29] Mikolov, T., Yih, W.t., Zweig, G.: Linguistic regularities in continuous space word representations. In: Proceedings of the 2013 Conference of the North American Chapter of the Association for Computational Linguistics: Human Language Technologies, pp. 746–751 (2013)

[30] Onishi, A.: Landmark map: An extension of the self-organizing map for a user-intended nonlinear projection (2019). URL https://arxiv.org/abs/1908.07124

[31] Savery, R., Weinberg, G.: Shimon the robot film composer and deepscore. In: R. Loughran (ed.) Proceedings of Computer Simulation of Musical Creativity. Dublin, Ireland (2018). https://csmc2018.wordpress.com/programme/

[32] Simon, I., Roberts, A., Raffel, C., Engel, J., Hawthorne, C., Eck, D.: Learning a latent space of multitrack measures. arXiv preprint arXiv:1806.00195 (2018)

[33] Sturm, B.: What do these 5,599,881 parameters mean? an analysis of a specific LSTM music transcription model, starting with the 70,281 parameters of the softmax layer. In: P. Pasquier, O. Bown, A. Eigenfeldt (eds.) 6th International Workshop on Musical Metacreation (MUME 2018). Salamanca, Spain (2018). Held at the Ninth International Conference on Computational Creativity, ICCC 2018

[34] Trieu, N., Keller, R.: JazzGAN: Improvising with generative adversarial networks. In: P. Pasquier, O. Bown, A. Eigenfeldt (eds.) 6th International Workshop on Musical Metacreation (MUME 2018). Salamanca, Spain (2018). Held at the Ninth International Conference on Computational Creativity, ICCC 2018

[35] Van Den Oord, A., Dieleman, S., Zen, H., Simonyan, K., Vinyals, O., Graves, A., Kalchbrenner, N., Senior, A., Kavukcuoglu, K.: WaveNet: A generative model for raw audio. arXiv preprint arXiv:1609.03499 (2016)

[36] Veale, T.: From conceptual mash-ups to bad-ass blends: A robust computational model of conceptual blending. In: ICCC, pp. 1–8 (2012)

[37] Veale, T., O Donoghue, D., Keane, M.T.: Computation and blending. Cognitive Linguistics **11**(3/4), 253–282 (2000)

[38] Vogl, R., Leimeister, M., Nuanáin, C.Ó., Jorda, S., Hlatky, M., Knees, P.: An intelligent interface for drum pattern variation and comparative evaluation of algorithms. Journal of the Audio Engineering Society **64**(7/8), 503–513 (2016)

[39] White, T.: Sampling generative networks: Notes on a few effective techniques. CoRR **abs/1609.04468** (2016). URL http://arxiv.org/abs/1609.04468

# Part III

## 3D

# Case Studies in Computer Graphics and AI

Tom De Smedt[1], Ludivine Lechat[2], Ben Burtenshaw[3], and Lucas Nijs[4]

[1] St Lucas School of Arts, Antwerp, Belgium tom@organisms.be
[2] St Lucas School of Arts, Antwerp, Belgium ludivinelechat@gmail.com
[3] University of Antwerp, Antwerp, Belgium ben.burtenshaw@gmail.com
[4] St Lucas School of Arts, Antwerp, Belgium lucasnijs@gmail.com

**Summary.** In the past 15 years, the Experimental Media Research Group (EMRG) at the St Lucas School of Arts in Antwerp has engaged in Computer Graphics and AI research, exploring possibilities of self-organizing simulations of nature, models of human creativity, and applications and toolkits that allow users to harness new technologies independent of their technological skill. In this chapter, we discuss our work by means of a number of case studies, offering a look under the hood and raising discussion points that we hope can help progress the state of the art.

## 7.1 Introduction

Only 40 years ago, in the late 70s, there was no such thing as a personal computer. Art students cut, pasted, glued paper, and used colored sheets, pencils, markers, paints, and what not, for aesthetic effect. At the St Lucas School of Arts in Antwerp, the first computer was an Apple IIe+ that (future) EMRG co-founder Lucas Nijs moved from his home to the institute in 1983, welcomed with piquant criticism. How could this lifeless, useless, dangerous machine bring value to Art? Students quickly expressed interest however, producing makeshift animations programmed in Basic. Not long after, new technological standards such as PostScript and new applications such as PageMaker disrupted the field entirely. Cutting, pasting and glueing were now becoming metaphors. By the late 80s, the art school invested in 3 Mac SE/30s... for 300 art students. By the late 90s, every student at the art school had access to a Mac and digital storage space, to explore new areas such as animation and interaction design. Not long after, early research at the institute began introducing methods from computer science, cognitive science, and psychology. Today, the Experimental Media Research Group (EMRG) of the St Lucas School of Arts has been experimenting with Computer Graphics (CG) and Artificial Intelligence (AI) for over a decade, with the primary aim to develop tools that allow students and non-experts to express themselves creatively, and operationalize new technology in an intuitive way, for example to create evolving artworks or to build data-driven visualizations that provide new insight into societal challenges [21].

Below, we offer an overview of some of our computer-generated artworks based on well-known AI techniques, such as agent-based systems, evolutionary algorithms

and supervised machine learning, in the context of our ongoing efforts to produce new iterations of our open source software toolkits NodeBox[5] and Pattern.[6] The rest of the chapter is organized as follows. In Section 7.2, we provide a concise overview of the technology. In Section 7.3, we present case studies realized using such toolkits. We have included Python code examples that may be interesting to newcomers, to get an idea of the techniques used. In Section 7.4, we evaluate some of the challenges with the application of our projects to real-life problems. In Section 7.5, we discuss future perspectives.

## 7.2 Materials and Methods

*NodeBox*

NodeBox 1 (NB1, 2004) is a Mac OS X application that generates 2-D visuals (static or animated) using Python programming code (Figure 7.1) [12]. It has a set of drawing commands, such as `rect(x, y, width, height)` which draws a rectangle with the given dimensions at the given coordinates, that can be combined (e.g., in a `for`-loop with some randomness) to render various graphics. Over the years, the command set was expanded with add-on extensions for image compositing, network visualization, agent-based simulation and web data mining, to name a few. In recent years, newer versions of NodeBox have also adopted Dataflow paradigms for users with no programming background [42].

*Pattern*

Pattern (2011) is an easy-to-use Python toolkit for Natural Language Processing (NLP), Machine Learning (ML), web data mining and network analytics [17]. It contains multilingual NLP tools for part-of-speech tagging (e.g., is *can* a noun or a verb in a given sentence), sentiment analysis (e.g., is the tone of the given sentence positive or negative), word inflection (e.g., noun and verb conjugation, which is useful for Natural Language Generation), well-known supervised and unsupervised ML algorithms (e.g., k-means clustering, $k$-NN, SVM, Perceptron), a robust HTML scraper and wrappers for social media APIs (e.g., Google, Twitter, Wikipedia), math functions from graph theory and statistics, and so on.

## 7.3 Results

Today, computer graphics applications such as NodeBox 1 are ubiquitous (e.g., HTML5 Canvas), but the concept was novel in 2004, in a large part originating from John Maeda's work at the MIT Media Lab, and the work of his students Ben Fry and Casey Reas on Processing, which is similar to NodeBox except that it uses Java programming code [28, 43]. Applications like Processing and NodeBox quickly attracted open source communities, whose enthusiastic members helped popularize

---

[5]`http://nodebox.net`
[6]`http://www.clips.uantwerpen.be/pattern`

Fig. 7.1: Screenshot of NodeBox 1.

Generative Art, or art generated by "a set of natural language rules, a computer program, a machine, or other procedural invention, which is set into motion with some degree of autonomy contributing to or resulting in a completed work of art" [29].

Following are two case studies in generative art using NodeBox 1: EVOLUTION[7] (2006) and its successor CREATURES[8] (2008). Both projects use techniques from Artificial Life and Procedural Generation to populate a virtual world with autonomous agents (e.g., insects, plants). Artificial Life refers to simulations or robotics based on natural life [40]. Well-known examples include Craig Reynolds' BOIDS (1987), which simulates flocking behavior, and Karl Sims' VIRTUAL CREATURES (1994), which simulates evolution [54, 56]. Well-known techniques include genetic algorithms and agent-based systems, which typically use a small amount of randomness to elicit emergent or self-organizing behavior [31, 44, 45].

### 7.3.1 Evolution (Agent-Based + Genetic Algorithm)

The EVOLUTION project (2006) uses an agent-based approach based on flocking to simulate chasing and evading between different "insects". Each insect is randomly composed from a library of visual building blocks (e.g., legs, wings), with various related strengths and weaknesses, such as faster flight or sharper steering (Figure 7.2). Stronger creatures will be tempted to attack their opponents head-on while weaker creatures will attempt to flee. Depending on their evasion skills, they may then wander into the attacker's relatives, or lure the attacker into their own posse if they are clever. Then, any survivors are allowed to reproduce. Using a genetic algorithm

---

[7]http://www.nodebox.net/code/Evolution
[8]http://www.cityinabottle.org

(GA), survivors are paired with other recent ("fertile") survivors and recombined into new creatures that are then again pitted against each other. The simulation shows a scoreboard of the current species with some statistics, and then a new match will commence. After a number of rounds, we might start to see very fast insects with large wings inherited by one ancestor, combined with pincers inherited from another ancestor, that dominate the virtual arena – until some random newcomer introduces a new trait or tactic to defeat them, and so on.

Listing 7.1 shows example NB1 source code of an agent-based algorithm. Each agent will steer in a random direction, while all agents also steer in the general direction of the mouse pointer. These two simple rules result in complex behavior that can also be observed in swarms of insects and schools of fish. Adjusting the parameters in the algorithm elicits different behavior. Note that actual approaches such as BOIDS or EVOLUTION use more involved rules for flocking, chasing, evading, intercepting, etc., where each rule exerts some force on the agent's heading. For a good introduction to steering, chasing and evading, see [4] or Daniel Shiffman's e-learning tutorials (2012).[9]

Listing 7.1: Example algorithm for agent-based simulation in NodeBox 1

```
from math import cos, sin, atan2

class Agent(object):

    def __init__(self, x, y):
        self.x  = x
        self.y  = y
        self.vx = 0
        self.vy = 0

    def steer(self, m=10, v1=0.075, v2=0.025, to=None):
        # rule 1: steer randomly
        self.vx += random(-v1, +v1)
        self.vy += random(-v1, +v1)

        # rule 2: steer to a given point (x,y)
        if to:
            a = atan2(to[1] - self.y, to[0] - self.x)
            self.vx = (1 - v2) * self.vx + v2 * cos(a)
            self.vy = (1 - v2) * self.vy + v2 * sin(a)

        self.vx = max(self.vx, -1)
        self.vy = max(self.vy, -1)
        self.vx = min(self.vx, +1)
        self.vy = min(self.vy, +1)
        self.x += self.vx * m
        self.y += self.vy * m

swarm = [Agent(0, 0) for i in range(30)]
```

--------

[9]https://natureofcode.com/book/chapter-6-autonomous-agents

```
# NodeBox-specific:
speed(100)
def draw():
    stroke(0)
    transform(CORNER)

    for agent in swarm:
        agent.steer(to=(MOUSEX, MOUSEY))
        push()
        translate(agent.x, agent.y)
        oval(-2.5, -2.5, 5, 5)
        pop()

    oval(MOUSEX-25, MOUSEY-25, 50, 50, fill=(0, .1), \
        stroke=None)
```

Listing 7.2 shows example source code of a genetic algorithm in Python. The fitness function determines a score (0.0-1.0) for each creature in the population, where creatures are represented as sets of feature-weight pairs (e.g., speed = 0.5). During multiple iterations, the system attempts to optimize the average fitness score for the population's siblings, by recombining the fittest creatures and their features. A small amount of randomness (i.e., mutation of creatures) is used to introduce unexpected combinations that could prove beneficial. Note that the code is only for demonstrative purposes. Its most important part, the **fitness()** function, just rewards creatures with the highest feature weights. In real applications that require a GA, we wouldn't know what (complex) combinations of internal features work best, and the fitness function would be based on an external test, like a tournament round in EVOLUTION or $k$-fold cross-validation in ML.

Listing 7.2: Example algorithm for genetic recombination in Python code

```
from random import random, choice, sample

def avg(a=[]):
    # avg([0,1]) => 0.5
    return sum(a) / float(len(a) or 1)

class Creature(dict):
    def __init__(self):
        self.update({
            'speed'    : random(),
            'strength' : random(),
            'sight'    : random(),
            'savvy'    : random()
        })

def fitness(c):
    return avg(c.values())
```

```
def combine(c1, c2):
    f = set(c1) & set(c2)
    c = Creature()
    c.clear()
    c.update({k: choice((c1.get(k), \
            c2.get(k))) or 0 for k in f})
    return c

def mutate(c, v=0.1):
    f = choice(c.keys())
    c[f] += choice((-v, +v))
    c[f]  = max(c[f], 0)
    c[f]  = min(c[f], 1)

def evolve(creatures=[], top=0.25, mutation=0.25):
    # selection (top 25%)
    p = sorted(creatures, key=fitness, reverse=True)
    p = p[:int(len(creatures) * top)]
    g = []
    # reproduction
    for _ in creatures:
        c = combine(*sample(creatures, 2))
        if random() < mutation:
            mutate(c)
        g.append(c)
    return g

p = [Creature(), Creature()]

# Just a quick test:
for i in range(100):
    e = evolve(p)
    f1 = avg(map(fitness, p))
    f2 = avg(map(fitness, e))
    if f2 > f1:
        p = e
        print(f2)
```

For an interesting online HTML5 demonstration of a GA, see Rafael Matsunaga's project GENETIC ALGORITHM WALKERS (2014).[10]

## 7.3.2 Creatures (Procedural Generation)

The CREATURES project (2008) is an advanced iteration of EVOLUTION, with more intricate insects in a virtual 3-D world populated by procedurally generated plants

---

[10]https://rednuht.org/genetic_walkers

Fig. 7.2: Example of virtual creatures in EVOLUTION, competing in a test of fitness

(Figures 7.3 and 7.4). The insects are again composed from a library of building blocks, while the terrain is generated using Perlin noise (2002), and the plants are generated using L-systems [53]. Such techniques are also used more and more often in industry video games like Spore[11] (2008) and No Man's Sky[12] (2016), which sometimes exhibit weaknesses similar to CREATURES, i.e., bounded variation does not meet the unbounded expectations of the players, and/or generated life forms look and act unrealistically. This problem is also discussed in Section 7.4 in an ethical context.

Listing 7.3 shows NB1 source code of an L-system algorithm. An L-system is a so-called formal grammar that exploits the principle of recursion, as in: "a branch ends in a number of smaller branches". Different seed strings of symbols defined in the grammar result in different plant forms. Note the drawing commands push() and pop(), which respectively mean: "this is now the origin point for translate (i.e., move), rotate and scale transformations" and "revert to the previous origin point".

---

[11] http://www.spore.com
[12] http://www.nomanssky.com

Fig. 7.3: Example of procedurally-generated scenery in CREATURES

Fig. 7.4: Example of procedurally-generated agents in CREATURES

For an overview of what kind of output is possible, Paul Bourke's website (1991) demonstrates many variations of rendered L-systems.[13]

Listing 7.3: Example algorithm for procedural plant growth in NodeBox 1

```
def lsystem(rules, root='X', l=60, a=10, n=8, f=None):
    if n < 1:
        l *= n
    if root == '@' and f:
        f(l, a, n)
    elif root == '[':
        push()
    elif root == ']':
        pop()
    elif root == '<':
        scale(1 - 0.1)
```

---

[13]http://paulbourke.net/fractals/lsys

```
        elif root == '>':
            scale(1 + 0.1)
        elif root == '+':
            rotate(+a)
        elif root == '-':
            rotate(-a)
        elif root == 'F':
            line(0, 0, 0, -1)
            translate(0, -1)
        elif root in rules and n > 1:
            for root in rules[root]:
                lsystem(rules, root, 1, a, n-1, f)

def node(1, a, n):
    oval(-2, -2, 4, 4)

speed(50)
def draw():
    transform(CORNER)
    stroke(0)
    translate(300, 500)
    a = min(60, FRAME * 0.90)
    b = min(30, FRAME * 0.15)
    c = min( 8, FRAME * 0.05)
    g = {'X': 'F[<-X][<+X]@'}
    lsystem(g, 1=a, a=b, n=c, f=node)
```

Due to limitations of NB1 (e.g., performance), a new spin-off NodeBox version was developed for this project. NodeBox for OpenGL (NOGL) takes advantage of GPU hardware acceleration to render animated graphics faster [19]. The toolkit builds on Pyglet, a Python interface to the OpenGL framework [35, 64]. NOGL comes bundled with most of the functionality in the NB1 add-ons (e.g., pixel shaders, physics systems), but it might not run on newer systems anymore. We then experimented with various rules to link the creatures' behavior to their visual building blocks. For example, wings would offer faster speed, larger paddles would offer better defense against pincers, flyers might be drawn to tall flowers, and so on. Further research was pursued less enthusiastically once the video game Spore was released – there is little point in competing with the large development teams in the video game industry, and even such well-funded teams have struggled with the vision of a completely autonomous virtual world while facing unexpected challenges (e.g., poor performance, poorly-looking creatures, no narrative). Those users that tested CREATURES mostly remarked: "So, what can I do next?".

Around this time, research at EMRG also became entangled with general AI challenges during the GRAVITAL project (2008), where we attempted to create a natural language interface for procedural generation, with limited success [20, 22]. The incentive for this approach was that our own art students experienced difficulty with programming code and its unforgiving error messages. In GRAVITAL, users would write: "draw a collection of colorful shapes" to generate an image. Such approaches date back to Terry Winograd's BLOCKS WORLD (1973) and the AI frame problem

[14, 63]. The frame problem refers to implicit knowledge (assumptions) that might be common sense to humans but very difficult for machines. For example, human artists will implicitly grasp that colorful shapes look more pleasing when restricted to a subset of all available colors, whereas such insights would have to be explained in minute detail to a machine. Essentially, rule-based systems might require an infinite amount of rules to solve open-ended (i.e., creative) problems: an if-statement added here, tweaking a parameter value there, and so on.

The GRAVITAL project sparked two new projects: a new NodeBox (NB3) and Pattern. NodeBox 3 uses a dataflow interface where "nodes" or visual building blocks of functionality (e.g., draw rectangle, rotate) are connected in a network, instead of writing code [13]. Today, NB3 is a popular application mainly used for Data Visualization, a field of applied research in the intersection of art, data mining, statistics and social sciences [27]. The diverse range of AI functionality in the Pattern toolkit enabled us to explore new creative experiments in the field of Computational Creativity [6], from poetry generators using WordNet ("Oh tumultuous specular specter!") and twitterbots using sentiment analysis ("Many people tweeted nasty things about Cinderella today!") [18] to automatic ideation and automated curators. The latter two case studies are briefly discussed here.

### 7.3.3 Perception (Knowledge Representation)

One example idea generator is PERCEPTION (2008), which uses a semantic network of common sense to yield "creative ideas" [15]. A semantic network represents relations between concepts, e.g., *rose* is-a *flower*, *rose* has-property *red*, and so on [9]. Techniques from graph theory (e.g., shortest paths and central nodes) and conceptual blending can then be used to discover analogies between seemingly unrelated concepts, as a model of human creativity [3, 26, 38, 61]. The literature on what constitutes a creative idea is abundant [57]. It suffices to say that creative ideas are both novel and useful, where novelty is an exponent of combining already established ideas, and usefulness a criterion enforced by the task at hand. For example, when asked to devise a logo for the capital of the EU (the city of Brussels) PERCEPTION suggests a toad (*slow*, *slimy*) or a stag (*strong*, *proud*), which are both novel, and perhaps useful depending on the contractor's political sentiment.

Figure 7.5 shows the semantic network of relations between *Brussels* and *toad* in the PERCEPTION search space, which has about 9,000 relations in total, added manually or mined from the web with NOUN-is-ADJECTIVE search patterns (e.g., *Brussels* is *slow*). Concepts with an is-property-of relation (i.e., *slow*, *slimy*) are shown in a black box. The algorithm's reasoning is as follows: if most paths from *Brussels* to any other concept pass by *slow*, then it is somewhat similar to concepts whose paths also mainly pass through *slow*. Hence, something like a *toad* might be a good analogy for *Brussels*, because both have the salient property *slow*. This is also called a featural approach to similarity, in other words, comparing concepts by looking at the features or properties that they have in common [58].

By introducing heuristics in the semantic search space we can model different thinking styles. For example, a "goth bot" might fixate on relations with a negative sentiment (has-property *creepy*, has-property *nostalgic*), coming up with logo suggestions like *mockingbird*. In general, the limited PERCEPTION search space often leads to whimsical or even crude comparisons (e.g, "Arnold Schwarzenegger is like a president" or "George W. Bush is like a donkey") but the approach can be useful

Fig. 7.5: Example of semantic relations between *Brussels* and *toad* in PER-
CEPTION

for out-of-the-box brainstorming. For example, an international dredging company
struggled with communicating complex personnel safety regulations in a simple way,
where PERCEPTION's lively analogies proved beneficial.

### 7.3.4 Timeline of Paintings (Knowledge Representation)

In another project, we combined the $k$-NN machine learning algorithm in Pattern
with NB1 to generate a TIMELINE OF THE HISTORY OF PAINTING (2015). We used
Pattern's Wikipedia API to retrieve all Wikipedia articles of painters [16].[14] The ar-
ticle length was used as a rough estimate of a painter's importance. Various features
in each article (i.e., period, region, style, links) were used to train the $k$-NN algorithm
to discover similar painters. Then, images of paintings (mined from Wikipedia) by
the "most important" painters were drawn on the empty timeline. In multiple itera-
tions, the next most important paintings were assigned a free space on the timeline,
next to the most similar painters. The result is a visually rich timeline of 1,250
famous works of art, which approximates what an art curator would have come up
with (Figure 7.6).

---

[14]http://en.wikipedia.org/wiki/List_of_painters_by_name

Fig. 7.6: Example of machine learning applied to art history © 2015 Lucas Nijs

Listing 7.4: Example algorithm for k-nearest neighbors machine learning in Python

```python
import collections, random

class Vector(dict):
    def __init__(self, features={}, label=None):
        self.update(features)
        self.label = label

def distance(v1, v2):
    return sum((v1[f]-v2.get(f, 0)**2) for f in v1)**0.5

def knn(v, vectors=[], k=3, distance=distance):
    nn = sorted((1 - distance(v, x), x) for x in vectors)
    nn = reversed(nn)
    nn = list(nn)[:k]
    return nn

def majority(a=[], default=None):
    f = collections.Counter(a)
    try:
        m = max(f.values())
        return random.choice([k for k, v in f.items() \
                if v == m])
    except:
        return default

def predict(v, model=[], k=3, dist=distance, def=None):
```

```
    nn = knn(v, model, k, dist)
    return majority((v.label for d, v in nn), def)

v1 = Vector({'tail': 1, 'meow': 1}, 'cat')
v2 = Vector({'tail': 1, 'woof': 1}, 'dog')
v3 = Vector({'wing': 1, 'hoot': 1}, 'owl')

print(predict(Vector({'wing':1}),(v1,v2,v3),k=1))  # owl
print(predict(Vector({'tail':1}),(v1,v2,v3),k=2))  # cat/dog
```

Listing 7.4 shows a simple Python implementation of the $k$-NN algorithm. In brief, a set of vectors (i.e., the model), where each vector is a set of feature-weight pairs and a label, can be used to predict the label of unknown vectors, using Euclidean distance as a similarity metric. For example, for *Pieter Bruegel the Elder* (Dutch Renaissance painter ca. 1550), the most similar painters are *Pieter Brueghel the Younger* and *Jan Brueghel the Elder* (Flemish Baroque painters ca. 1600), as their Wikipedia articles share links to *Brussels, Mayken Verhulst, Guild of Saint Luke*, etc. This encourages their works to be placed closer together on the timeline. In actuality, the former painter was the father of the latter two, who were trained by Mayken Verhulst (their grandmother) to further their father's style after his death. Since there is no optimal solution to creating a timeline of art (there are always more artworks than available space) curators responded favorably to the proposed technique, but they also criticized the algorithm's omission of pop artist Keith Haring.

At the same time our interest in physical devices had intensified, for example to control virtual lifeforms or visualizations of data using body gestures. This area of research is now well known as Human-Computer Interaction (HCI). Below is a brief description of two case studies that use agent-based systems controlled by external input, like an EEG headset and a 3-D motion camera, where EMRG became involved with applied research and real-life challenges.

### 7.3.5 Valence (Human-Computer Interaction)

The VALENCE project (2010) is a relaxation game controlled by brain activity, initially conceived as a demonstrator of state-of-the-art wireless EEG technology at the Creativity World Forum 2011 [23]. The headset we used was a prototype from Imec designed to track ambulant patients [30], which we connected to an agent-based simulation in NOGL. Neural activity in the brain generates electrical currents along the scalp, which can be detected as alpha waves (i.e., relaxation), beta waves (i.e., awareness), and so on. Valence refers to the belief that the left-brain hemisphere is dominant for processing positive emotions. During a training phase the system learns the user's baseline alpha and valence levels, and then responds to spikes by updating the visualization. The visualization consists of "cells" that drift around, but are attracted to the center by higher alpha levels. High valence also introduces more colorful cells. The visual result is that relaxed players are able to "dream up" complex cell structures formed by a physics-based algorithm (Figure 7.7) [10].

In a test sample of 25 users varying in age and gender, over 90% were able to control the game within a minute, with the main visual effect being cells packing

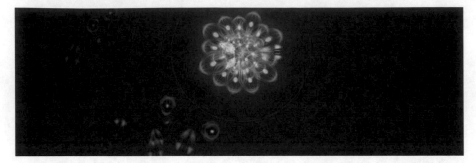

Fig. 7.7: Example of cell structures controlled by "The Force" in VALENCE

in the center (alpha). More colorful cells mostly appeared randomly (valence). The most effective user claimed proficiency with yoga and meditation. In our experience, EEG monitoring can be useful for coarse-grained HCI in creative applications (say, VR headsets) but challenges with fine-grained monitoring have also been described in the literature (e.g., thought-to-speech [47]).

### 7.3.6 Virtual Underwater World (Human-Computer Interaction)

The VIRTUAL UNDERWATER WORLD project (2015) is a culmination of our prior experiments in collaboration with the healthcare sector [41]. We worked with the pediatrics ward of the University Hospital Leuven to develop an interactive surface that emulates an underwater environment controlled by body movements and gestures. Hospitalized children can stand in front of the interactive wall to interact with colorful sea creatures (Figure 7.8), that will swim over to say *Hi!* when children wave their arms, as a means to mitigate stress and boredom. The prototype was realized using affordable consumer electronics (Microsoft Kinect) and open source tools such as Box2D, a library for simulating realistics physics [7].

Hospitalized children experience stress because they are confined to a functional environment that is alien from their safe home, and they are often bored because they are unable to play with their school friends [52]. Studies on healthcare infrastructure find that positive distraction can have a beneficial effect on our mood, perhaps expediting recovery [49]. The primary goal of this project is to create a safe space in the hospital's waiting area or playroom. The installation has a passive state (i.e., observing sea creatures go about their life) and an active state (i.e., coming up to the wall projection to say *Hi*). The active state adds a new player to the system as soon as the child is within the camera's view range. The camera constructs a model of the player, estimating distance, body contours and hand movements, which can be used to interact with the lifeforms in the simulation in various ways.

The setup has gone through a number of design iterations, for example to track multiple users at the same time or to enable wheelchair users to play. In a test sample of 33 children (aged 2-15), 25 showed interest and 15 actually played, amounting to a more pleasurable hospital experience for 75% of the children. Surprisingly, the setup appeared to work well even in the absence of hospital staff giving play instructions, promoting free exploration and socialization. Other initiatives with virtual aquariums in hospitals have since emerged (see for example [51]).

Fig. 7.8: Example of lifeforms in VIRTUAL UNDERWATER WORLD © 2015 Ludivine Lechat

### 7.3.7 AI Stories (NLG + ML)

Finally, imagine that our sea creatures could actually talk, interacting with children about how they feel. The AI STORIES project (2016) aims to develop a story generation algorithm encapsulated in a chat interface for hospitalized children, in collaboration with three university hospitals, using a Deep Learning dialogue system, a plan-based narrative engine, and a "safeguard" (e.g., to filter profanity) [5]. The system initially goes through a story generation phase where aspects of the story (e.g., genre, setting, characters) are discussed with and validated by the user. The system then returns a narrative burst (i.e., a micro-story) after which it reiterates the story generation phase, retaining those already established aspects of the story. As the process continues, user and system negotiate an ever-richer story

Such interactive narratives, adapted on-the-fly within a conversation, are a recently adopted domain in Computational Creativity [1, 60]. Evidence from pedagogical literature suggests that collaborative stories, as opposed to receptive stories (i.e., books), may be more rewarding to children, promoting language activation and personal creativity, and a sense of achievement [48]. Micro-stories within a story universe are also more feasible right now than complex narratives, and in line with communication on social media platforms like Instagram and Snapchat, which may appeal to what children are familiar with today [62]. Storytellers have used micro-stories for millennia, and it was only the print medium that demanded narratives to confine themselves to single arching structures [55].

Since creativity is inherently situated, we can benefit from applied research as an evaluation metric. While a given system can be creative in many ways (i.e., novel), involving the users verifies whether it is creative and appropriate in the intended use environment (i.e., useful). In the context of healthcare, there are a number of risks involved with this approach. For example, the system should not subject children to stories about a child-gobbling creepy octopus. Using state-of-the-art methods such as Deep Learning thus presents a risk, since their divergent output is not moderated. Exploring this area of research may yield advances in the field of NLG as a whole, but to be useful in pediatrics we need to limit their potential with a safeguard function, which itself is also a novel contribution and a step towards responsible AI.

Since creativity is inherently divergent, there is no fixed set of rules on how to create "the best story". To illustrate this, when asked to articulate how and

why they are creative, even human artists struggle to do so [11, 36]. This stands in contrast to other tasks that AI seeks to replicate, where steps and goals can be outlined, and systems can be statistically shown to replicate the results of their human counterparts. The advantage of applied research is, again, that it involves the users, so the creative process can be constructed progressively rather than planned explicitly. This is not unlike how human artists work [24].

## 7.4 Analysis

Recent advances in free and easy-to-use computer graphics toolkits and AI frameworks allow us to engage in applied research in the intersection of art, science, technology, and society. Applied research is not just a worthwhile endpoint for research prototypes; the "messy real world" is also a useful evaluation metric for the methodology, development, and implementation of creative AI systems. In the creative industry, where definitions and guidelines are notoriously hard to pin down, the real-world context helps us decide whether to focus on the creative process or the creative output, and on historically creative output or personally creative output that appeals to one given user [3, 11].

Releasing creative apps into the wild also raises ethical questions. For example, when content is increasingly automatically generated, and autonomous, knowing that it has an impact on our state-of-mind, how will we regulate it? Natural Language Generation (NLG) can now be used to proliferate fake news on social media to polarize political sentiment, and we can expect the same for visual content.[15] What if, in a hypothetical future iteration of the VIRTUAL UNDERWATER WORLD, the friendly sea creatures evolve autonomously into creepy octopuses that hunt other creatures, for example to make room to better display their happily waving tentacles, making children afraid instead of relaxed?

*Evidence-based design*

For this reason, we have recently increased our interests in evidence-based design. Particularly in the context of healthcare, the aesthetic experience, i.e., (dis)pleasure that results from sensory perception, should foster the patient's well-being, and therefore the choice of artwork should be grounded in prior evidence rather than the personal opinion of its maker or curator [32, 33]. This is called evidence-based design. We want to leverage the benefits of generative art (e.g., scalability, variation) but minimize potential adverse side-effects (e.g., generating a random "creepy" creature). The aesthetic look & feel of our VIRTUAL UNDERWATER WORLD is grounded in several studies. For example, in the 80s sociobiologist E. O. Wilson already hypothesized that human beings take pleasure in connecting with nature and other lifeforms, which has later been asserted in the case of children as having a positive influence on patients' mental well-being [37, 39]. Also, in the case of hospital art, depictions of nature (slowly moving water, foliage, flowers) seem to offer the most benefit, and digital representations of nature are better than no nature at all [37, 59]. Finally, while more research is needed on the preferences of children, it has been shown that all age groups prefer nature art over abstract art, in particular forests, wildlife, waterscapes and underwater worlds [2, 8, 25].

---

[15]https://mashable.com/2018/04/17/jordan-peele-fake-obama-psa

*Participatory design*

Since visual preferences can differ strongly between children in different age groups, there is no one-size-fits-all approach, but previous findings provide a basis to argue that applications such as the VIRTUAL UNDERWATER WORLD offer a viable and cost-effective alternative to relocating our children's hospitals to forests [46]. Such applications can in turn be used to collect new evidence. In our case, we are adopting a participatory approach where stakeholders (children, healthcare staff, artists) can collaborate on the contents of a building box of visual components, which can then be recombined into compositions algorithmically. The AI algorithms should then negotiate with their users what is desirable.

To better understand what games children would like to play, what these games should look like, and hence how we should stock our building box, we are conducting observational studies where school children test new prototypes, discuss our artwork, create their own artwork, and imagine narratives for the artwork. For example, the 18 children that have so far participated prefer depictions of nature and are curious about new technology – which could be a stress-relief play activity in its own right. Our ongoing new study includes 100+ school children and may provide more in-depth insights on children's creativity. Some further findings so far are that children prefer realistic depictions of animals over imaginary, and that the narratives that they come up with combine nature with contemporary technology (e.g., bears have cell phones). Children seem to greatly enjoy being active participants in research, often acting as experts.

Our next challenge is how to translate evidence-based insights into computational approaches, which can generate endless variation but also need heuristic tweaks to produce the best results, within some predefined criteria. In the rule-based case studies that we discussed, this tweaking played an important role. Since creative behavior is inherently divergent, any rule-based algorithm that seeks to simulate it is prone to a vast parameter space, with many intriguing solutions (novel) that need direction (useful) from their creator. On the other hand, machine learning approaches have been shown to be highly effective in proposing convergent solutions, but the drawback is that such systems can be hard to explain ("black boxes"), raising ethical concerns in real-world applications.

## 7.5 Conclusions

In a recent essay, Aaron Hertzmann from Adobe Research asks: "Can Computers Create Art?" [34]. From his functionalist view, he argues that in our present conceptions, art can only by created by humans, since it essentially remains a social function. Consequentially, machines are rarely credited with artistic authorship. But this also suggests that the debate on the aesthetic aspects of generative art is gradually shifting towards the social aspects of mechanical art production. Such a functionalist shift is also evident in the trends outlined in the overview of our research.

By means of case studies, we have attempted to demonstrate the creative potential of bridging different areas of expertise, and the benefits of unlocking and popularising easy-to-use tools. Concerning art, our concluding insight is that it is a useful greenhouse to experiment with new technology, and furthermore, that it

can be leveraged to impact society in meaningful ways. Ethically, these projects are not without challenges and posit fundamental questions to artistic researchers, demanding that they consider the broader implications of their work. Concerning AI, we believe that the artistic field would benefit from more explainable, intuitive, and empathic AI systems, vastly different from today's commercially focused projects.

*Acknowledgement.* Research (2004-2018) was supported by the Academic Research Fund of the St Lucas School of Arts, the Industrial Research Fund of the University of Antwerp (IOF), the Agency of Innovation by Science and Technology in Flanders (IWT), the Flemish Research Foundation (FWO), the Flemish Audiovisual Fund (VAF), and the Interuniversity Microelectronics Centre (Imec).

# References

[1] Berov, L., Khnberger, K.U.: An evaluation of perceived personality in fictional characters generated by affective simulation. In: Proceedings of the Ninth International Conference on Computational Creativity, pp. 24-31. Association for Computational Creativity (2018)

[2] Biddiss, E., McPherson, A., Shea, G., McKeever, P: The design and testing of interactive hospital spaces to meet the needs of waiting children. Health Environments Research & Design Journal **6**, 49–68 (2013)

[3] Boden, M.: The Creative Mind: Myths and Mechanisms. Psychology Press (2004)

[4] Bourg, D. M., Seemann, G.: AI for Game Developers. O'Reilly Media (2004)

[5] Burtenshaw, B.: AI Stories: an interactive narrative system for children (2018)
`http://computationalcreativity.net/iccc2017/doctoralconsortium`

[6] Cardoso, A., Veale, T., Wiggins, G.: Converging on the divergent: the history (and future) of the international joint workshops in computational creativity. AI Magazine, **30**, 15–22 (2009)

[7] Catto, E.: Box2d: A 2d physics engine for games (2011)
`https://box2d.org`

[8] Coad, J., Coad, N.: Children and young people's preference of thematic design and colour for their hospital environment. Journal of Child Health Care **12**, 33–48 (2008)

[9] Collins, A., Loftus, E.: A spreading-activation theory of semantic processing. Psychological Review **82**, 407 (1975)

[10] Collins, C., Stephenson, K. (2003). A circle packing algorithm. Computational Geometry 25, 233-256.

[11] Colton, S.: Creativity versus the perception of creativity in computational systems. In: AAAI Spring Symposium 8 (2008)

[12] De Bleser, F.: NodeBox (2004)
http://www.nodebox.net/code

[13] De Bleser, F., Gabriels, S.: NodeBox 3 (2013)
http://www.nodebox.net/node

[14] Dennett, D.: The frame problem of AI. Philosophy of Psychology: Contemporary Readings **433**, 67–83 (2006)

[15] De Smedt, T.: Modeling Creativity: Case Studies in Python. University Press Antwerp (2013)

[16] De Smedt, T., Crombez, T., Nijs, L.: Automatic Timeline Visualization of Paintings. In: Digital Humanities Conference Benelux (2016)

[17] De Smedt, T, Daelemans, W.: Pattern for python. Journal of Machine Learning Research **13**, 2063–2067 (2012)

[18] De Smedt, T., Daelemans, W.: Vreselijk mooi! (terribly beautiful): A subjectivity lexicon for Dutch adjectives. In: Proceedings of the Eighth International Conference on Language Resources and Evaluation, pp. 3568-3572. ACL (2012)

[19] De Smedt, T., De Bleser, F.: NodeBox for OpenGL (2010)
http://www.cityinabottle.org/nodebox

[20] De Smedt, T., De Bleser, F., Van Asch, V., Nijs, L., Daelemans, W.: Gravital: natural language processing for computer graphics. In: Creativity and the Agile Mind: A Multi-Disciplinary Study of a Multi-Faceted Phenomenon, pp. 81-98. Mouton (2013)

[21] De Smedt, T., De Pauw, G., Van Ostaeyen, P.: Automatic detection of online jihadist hate speech. CLiPS Technical Report Series 7 (2018)

[22] De Smedt, T., Lechat, L., Daelemans, W.: Generative art inspired by nature, using NodeBox. In: Applications of Evolutionary Computation 14, pp. 264-272. LNCS, Springer (2011)

[23] De Smedt, T., Menschaert, L.: Valence: affective visualisation using EEG. Digital Creativity **23**, 272–277 (2012)

[24] Edmonds, E., Weakley, A., Candy, L., Fell, M., Knott, R., Pauletto, S.: The studio as laboratory: Combining creative practice and digital technology research. International Journal of Human-Computer Studies **63**, 452–481 (2005)

[25] Eisen, S., Ulrich, R., Shepley, M., Varni, J., Sherman, S.: The stress-reducing effects of art in pediatric health care: art preferences of healthy children and hospitalized children. Journal of Child Health Care **12**, 173–190 (2008)

[26] Fauconnier, G., Turner, M.: The Way We Think: Conceptual Blending and the Mind's Hidden Complexities. Basic Books (2008)

[27] Fry, B.: Visualizing Data: Exploring and Explaining Data with the Processing Environment. O'Reilly (2007).

[28] Fry, B., Reas, C.: Processing. MIT Press (2007)

[29] Galanter, P.: What is generative art? Complexity theory as a context for art theory. In: Generative Art Conference 6 (2003)

[30] Gyselinckx, B., Van Hoof, C., Ryckaert, J., Yazicioglu, R., Fiorini, P., Leonov, V.: Human++: autonomous wireless sensors for body area networks. In: Proceedings of the IEEE 2005 Custom Integrated Circuits Conference, pp. 13-19 (2005)

[31] Goldstein, J.: Emergence as a construct: History and issues. Emergence **1**, 49–72 (1999)
[32] Hathorn, K., Nanda, U.: A guide to evidence-based art (2008) https://www.healthdesign.org/sites/default/files/Hathorn_Nanda_Mar08.pdf
[33] Hekkert, P.: Design aesthetics: principles of pleasure in design. Psychology Science **48**, 157–172 (2006)
[34] Hertzmann, A.: Can Computers Create Art? Arts **7**, 18 (2018)
[35] Holkner, A.: Pyglet: Cross-platform windowing and multimedia library for Python (2008) http://www.pyglet.org
[36] Jordanous, A.: A standardised procedure for evaluating creative systems: Computational creativity evaluation based on what it is to be creative. Cognitive Computation **4**, 246–79 (2012)
[37] Kahn, P.: Developmental psychology and the biophilia hypothesis: Children's affiliation with nature. Developmental Review **17**, 1–61 (1997)
[38] Kahneman, D.: Thinking, Fast and Slow. Farrar, Straus and Giroux (2011)
[39] Kaplan, S.: The restorative benefits of nature: Toward an integrative framework. Journal of Environmental Psychology **15**, 169–182 (1995)
[40] Langton, C.: Artificial Life: An Overview. MIT Press (1997)
[41] Lechat, L., Menschaert, L., De Smedt, T., Nijs, L., Dhar, M., Norga, K., Toelen, J.: Medical art therapy of the future: Building an interactive virtual underwater world in a childrens hospital. In: Applications of Evolutionary Computation 21, pp. 64-77. LNCS, Springer (2018)
[42] Lee, E., Parks, T.: Dataflow process networks. Proceedings of the IEEE 83, pp. 73-81 (1995)
[43] Maeda, J.: Design by Numbers. MIT Press (2001)
[44] Maes, P.: Modeling adaptive autonomous agents. Artificial Life **1**, 135–162 (1993)
[45] Mitchell, M.: An Introduction to Genetic Algorithms. MIT Press (1998)
[46] Nanda, U., Chanaud, C., Brawn, L., Hart, R., Hathorn, K.: Pediatric art preferences: Countering the "one-size-fits-all" approach. Health Environments Research & Design Journal **2**, 46–61 (2009)
[47] Neubig, T., Sellami, L.: Recognition of imagined speech using electroencephalogram signals. In: Smart Biomedical and Physiological Sensor Technology XV. International Society for Optics and Photonics (2019)
[48] Nikolajeva, M.: Narrative theory and childrens literature. Childrens Literature Association Quarterly **9**, 191–194 (1984)
[49] Pati, D., Nanda, U.: Influence of positive distractions on children in two clinic waiting areas. Health Environments Research & Design Journal **4**, 124–140 (2011)
[50] Perlin, K.: Improving noise. In: ACM Transactions on Graphics 21, pp. 681-682 (2002)
[51] Pohjolainen, T.: Comforting hospital walls (2019) https://www.aalto.fi/en/news/comforting-hospital-walls
[52] Prugh, D., Staub, E., Sands, H., Kirschbaum, R., Lenihan, E.: A study of the emotional reactions of children and families to hospitalization and illness. American Journal of Orthopsychiatry **23**, 70–106 (1953)

[53] Prusinkiewicz, P., Lindenmayer, A.: The Algorithmic Beauty of Plants. Springer (2012)

[54] Reynolds, C.: Flocks, herds and schools: A distributed behavioral model. In ACM SIGGRAPH 14, pp. 25-34 (1987)

[55] Ripley, J.: Looking at listening: Au'oral narrative in theory and practice. Storytelling, Self, Society **7**, 1–14 (2011)

[56] Sims, K.: Evolving virtual creatures. In ACM SIGGRAPH 21, pp. 15-22 (1994)

[57] Sternberg, R.: Handbook of Creativity. Cambridge University Press (1999)

[58] Tversky, A.: Features of similarity. Psychological Review **84**, 327 (1977)

[59] Ulrich, R., Gilpin, L.: Healing arts: Nutrition for the soul. In: Putting Patients First: Designing and Practicing Patient-centered Care, pp. 117-146. Wiley (2003)

[60] Veale, T. Appointment in Samarra. In: Proceedings of the Ninth International Conference on Computational Creativity, pp. 24-31. Association for Computational Creativity (2018)

[61] Veale, T., O'Donoghue, D.: Computation and blending. Cognitive Linguistics **11**, 253–281 (2000)

[62] Wang, T., Chen, P., Li, B.: Predicting the quality of short narratives from social media. arXiv:1707.02499 (2017)

[63] Winograd, T.: A procedural model of language understanding. In: Readings in Natural Language Processing, pp. 249-266. Morgan Kaufmann (1973)

[64] Woo, M., Neider, J., Davis, T., Shreiner, D.: OpenGL Programming Guide. Addison-Wesley (1999)

# 8

# Setting the Stage for 3D Compositing with Machine Learning

Jonathan Eisenmann

Adobe, San Francisco, CA, USA j@adobe.com

Fig. 8.1: A 3D model composited into a photograph, authored in Adobe Dimension using the camera and lighting estimation techniques describe herein. Color grading in Adobe Photoshop. Image courtesty of Vladimir Petkovic.

© Springer Nature Switzerland AG 2021
P. Machado et al. (eds.), *Artificial Intelligence and the Arts*, Computational Synthesis and Creative Systems, https://doi.org/10.1007/978-3-030-59475-6_8

**Summary.** This chapter describes the challenges of, as well as practical strategies for, embedding machine learning into design software. By way of example, the chapter includes a case study on a software project, Adobe Dimension, which makes use of machine learning techniques to automatically set up a 3D environment for compositing. Machine learning, image manipulation, and novel user interfaces work together to form a system that is capable of converting a 2D background photograph into a 3D environment ready for virtual object insertion. The 3D environment consists of a camera calibration and lighting estimation which are used to frame and illuminate an inserted 3D model, making it appear to have been present in the original photograph. By discussing machine learning approaches aimed at empowering artists within a complex, real-world production context, the reader will gain an appreciation for both the strengths and the challenges of integrating machine learning algorithms within digital content creation software. The reader will learn several practical ways of embedding machine learning technology, so that the human user can focus on creative direction and the technology can assist with the less interesting tasks.

## 8.1 Introduction

Can machine learning help with design tasks that rely on human intuition? If it could, would we want it to? After motivating the problem from the point of view of human-computer interaction, this chapter lays out several challenges related to embedding machine learning techniques in design software and dives into a case study involving a 3D compositing workflow within one such software application. Figure 8.1 shows an example creative output from this workflow. Finally, practical strategies and lessons from the case study are highlighted in hopes that they will prove useful for those looking to explore similar avenues of research and development.

There are a few different categories of tasks that humans perform while using design software.

- **Bookkeeping** – These are mindless, repetitive tasks such as copying files, renaming assets, or other organizational tasks. These tasks have zero visual impact, but are a necessary part of successful design workflows, especially when working in a multi-stage pipeline or with a team of other designers.
- **Busywork** – This term is used here to describe repetitive tasks that require creative human intuition to do well, but are often monotonous, and performed begrudgingly. Examples include animation tweening, rotoscoping, camera tracking, color correction, and light matching.
- **Creative direction** – These tasks are the interesting ones. They consist of choices that have a high visual impact and include things like experimenting with variations on a theme, forming a larger narrative, selecting or commissioning assets to fit within that narrative, exploring alternate possibilities, or considering the impact of the work.

Most designers would rather spend their time on the right side of the spectrum depicted in Figure 8.2 than spend time on the less interesting tasks on the left. One solution is, of course, to hire a team of assistants to do the low-level tasks, but that is not a practical reality for many designers, and it still results in plenty of human designers spending time on mind-numbing tasks.

Fig. 8.2: There are three categories of tasks in creative work. They can be placed on a spectrum corresponding to the ratio of visual impact to interaction time required for the task.

When building design software, software developers aim to move users further towards the **creative direction** tasks on the right side of the spectrum by minimizing the interaction time spent on tasks on the left end of the spectrum. Clever user interfaces (UI), scripting, and batch processing can often minimize the time users spend on **bookkeeping** tasks at the left end of the spectrum. However, many of the tasks in the **busywork** category are difficult to automate because they require an understanding of the semantics of a specific design domain and a deep familiarity with other examples from that domain. Scripting and novel interfaces cannot help here. This category of tasks is ripe with opportunities for machine learning to accelerate design workflows. Because machine learning models train on large datasets from the design domain, they develop a deep familiarity with a wide range of example designs and become specialists, of a particular sort. When machine learning is successful, it can generate solutions that respect the semantics of a specific design context. Given adequate training data and a capable architecture, machine learning techniques can generate a good solution for a task in the busywork category, thereby accelerating design workflows and freeing up time that can be better spent exploring, developing, or ideating. Another important benefit of machine learning approaches for this category of design tasks is that they can serve as scaffolding for those who are new to a task. This scaffolding lowers barriers to entry and accelerates human-learning.

## 8.2 Challenges

Though the promise of machine learning approaches seems worthwhile, the devil is in the details. The benefits listed above rely on the machine learning model having the right training data and architecture, but these are not the only caveats. There are plenty of other challenges involved in shipping machine learning technologies as part of production software, some theoretical and some inescapably practical.

### 8.2.1 Data

Let us start with data. There is a saying, "you are what you eat." This is true for machine learning models too. Their performance is inherently tied to the quality of the data they are fed during training. Many machine learning models in the academic literature are trained on datasets that are not aesthetically pleasing and have limited resolution, implicit bias, or narrow diversity. We focus here on datasets comprised

of digital photographs, because they are central to single-image compositing tasks. The limitations of these datasets are often caused by a lack of

1. Diversity of capture hardware – most datasets are limited to only a few camera lenses and sensors, at best;
2. Diversity of locations or capture targets – capturing data of high diversity usually requires travel to many locales;
3. Consistency of representation – achieving consistent calibration within a dataset often requires a large-scale training program or quality assurance effort;
4. Rights of use – many sources of data are subject to legal restrictions due to privacy or licensing.

These and other factors limit the diversity and quality of datasets that are publicly available. Attempts to deploy models trained on such data can be frustrating because real-world data that passes through design software is often quite different from what the network has seen during training. The obvious answer here is to collect better data. However, data collection is a difficult and expensive process. It is often an iterative process too. You may not know what data you will need to collect, until you try training your algorithms on the data you have, evaluate the results, and identify common failure cases.

## 8.2.2 Frameworks

Because deep machine learning is an extremely active area of research, frameworks for training and deploying machine learning models are changing rapidly. Research is moving so quickly in this field that, often, papers are published online [1] at the time of submission to academic conferences or journals for review, and by the time the actual presentation or publication occurs, the research is old news, having already been widely tested and cited by other researchers. Frameworks are moving quickly to try to keep up with this frantic pace of research. Some semblance of standardization is starting to emerge as more and more attempts at engineering occur, but deployment is still a challenge for the time being.

## 8.2.3 Introspection

The recent explosion of deep learning advances from complex architectures has led to impressive performance increases. It has also led to a dramatic decrease in our ability to introspect the deep learning models to find out how and why they are performing the way they are. This lack of insight can slow down development efforts, as it is often unclear how best to improve performance. In the worst case, the debugging process degrades into a sensitivity analysis of the hyperparameter space. Furthermore, at evaluation time, when there is no ground truth to compare against, it is often impossible to tell if a particular result is good or not. Most models simply provide an output, even if the input is something very far from the data on which the model was trained. The output in this case is not meaningful, and there are often no confidence estimates that can be used to decide whether or not a particular output is good enough to be presented to the human user.

### 8.2.4 Evaluation

Performance on design tasks is often hard to measure objectively. In many cases there is no clear procedural metric. There are often proxies, such as render loss or SSIM [15], but for a true performance evaluation, many results need to be viewed and subjectively ranked by a qualified human. The sheer scale of the data and size of the space of possibilities can make human evaluation a painful bottleneck during the development of machine learning models for design tasks.

## 8.3 Case Study: 3D Compositing

Before discussing possible solutions to the challenges outlined above, this section first establishes the case study context. The design domain of this case study is 3D compositing. First we will talk about typical 2D and 3D compositing workflows and then contrast that with the machine learning driven workflow embodied by Adobe Dimension. **Compositing** or **virtual photography** in this context refers to the process of inserting a foreground object into a background photograph, with the goal of achieving a photo-realistic result.

### 8.3.1 Typical Compositing Workflows

We shall discuss two different strategies for compositing: 2D and 3D compositing. **2D compositing** workflows typically start with a photo shoot or a search for stock photography assets, followed by extensive digital image manipulation. Typically, one 2D photographic element (the foreground object) is embedded into another photo (the background), and the goal is to make that embedding appear natural and seamless. Common operations include

- Perspective warp (non-affine transformation) to make the foreground elements appear as if they were photographed from the same camera angle and with the same lens as the camera that captured the background;
- Color harmonization between the foreground and background elements;
- Painting or retouching the foreground object to match the lighting of the background scene, including
  - Specular highlights,
  - Shadows cast from the foreground object both onto itself and onto the geometry of the background scene,
  - Glossy reflections from foreground to background and vice versa.

If the layout of the foreground (e.g., object orientation) or a change in the background environment is needed, the designer will need to start the process over again from scratch.

Compositing can also be done in 3D with virtual foreground objects. With **3D compositing**, an image of a virtual 3D object is produced by a ray tracing algorithm, making use of a virtual camera and light rig. Then the resulting 2D graphic is layered over a 2D background photograph. Similarly to before, the goal is to insert the virtual 3D object in such a way that it appears to have been part of the background photograph at the time it was taken. 3D virtual workflows offer several benefits.

- It is possible to collaborate asynchronously or over long distances. Traditional photo shoots require all the necessary assets and people to be in one place at the same time. Photo shoots for 3D workflows often include the use of light probes and carefully calibrated camera setups to ensure that camera calibration, high dynamic range (HDR) lighting, and color calibration are recorded accurately. These assets can be used later in physically-based rendering to simulate the environment precisely as it was at the time of the shoot.
- With physically-based 3D rendering it is possible make the imaginary look plausible and the fantastic look photo-realistic (e.g., Figure 8.1). The downside to this is that 3D rendering requires significant compute time, though it is getting faster every year. 2D flows are often computationally lightweight.
- It is easy to change the light color and intensity, rearrange the foreground object layout, or adjust the camera angle with very little additional work.

If significant changes are needed within the 3D lighting environment, then another photo shoot must be scheduled.

Fig. 8.3: An example 3D scene setup for compositing is on the left. The camera's view is shown on the right.

A standard virtual scene setup for 3D compositing can be seen in Figure 8.3. The background photo is attached to the camera so that it fills the camera's field of view, and the camera's orientation is set to mimic the orientation of the camera that captured the background photo. The 3D virtual objects are often placed onto an invisible, shadow-catching ground plane. This ground plane receives lighting effects (e.g., caustics, shadows, etc.) from the 3D objects and these effects are then composited over the background image. Optionally, a projection of the background image onto the ground plane may also show up in any reflections on the objects themselves. The environment light is wrapped around the entire scene as a large sphere which provides reflections and lighting. Finally, additional discrete lights may be added to the scene to provide specific direct illumination effects.

### 8.3.2 A Machine Learning Driven Compositing Workflow

In Adobe Dimension, the ideal user experience maximizes the time spent on creative decision-making and minimizes the effort spent on busywork (e.g., calibrating the

camera, matching the lighting, or painting reflections, highlights, and shadows). The goal of the integration of machine learning into this design software is to quickly get the user 90% of the way to a well-matched foreground and background. The remaining tweaks should be effortless, intuitive, and hopefully fun. Adobe Dimension is not the only digital content creation application that has started to utilize deep learning as a creative assistant. Other applications, such as Adobe Lightroom have also begun exploring similar possibilities for automatically setting photo adjustment parameters [3].

There are several machine learning algorithms in Adobe Dimension that analyze background photographs. They are gathered together under the umbrella feature name "Match Image." This feature enables users to apply a new background photograph to their 3D composite and quickly generate an estimate of the camera angle, environment lighting, and direct lighting that will make their 3D objects look like they "Match (the) Image." Each of these estimates is a computer vision research project on its own. Instead of focusing on the technical details of each of these research projects, this section will briefly summarize and provide pointers to relevant publications, when available, and a later section will focus on the machine learning pain points around research, development and integration into the design software.

## Perspective

Fig. 8.4: A virtual horse statue composite without camera calibration (left) and with the automatically estimated camera calibration (right). The yellow perspective grid is added to make the perspective alignment more immediately visible.

The foundational ingredient in any compositing workflow is camera alignment (e.g., see Figure 8.4), which includes orientation and field of view, at a minimum. If the perspectives of the foreground and background do not match, none of the other compositing tasks will matter. For matching image perspective, Adobe Dimension utilizes two approaches, one based on geometric analysis which is precise but only works in the presence of strong perspective-aligned edges in the image [4] and one that is based on a DenseNet convolutional neural network (CNN) architecture which is robust across a wide variety of scene types [13]. At runtime, the application determines which method to use based on two separate confidence measures. The

geometric method has a companion confidence estimator, an independent logistic regressor that examines geometric image features to determine if the algorithm is likely to find an accurate camera calibration estimate. If the geometric method is determined to be untrustworthy, then the confidence of the CNN is evaluated by looking at the shape of distribution in its softmax output bins [12]. If neither method is determined to be trustworthy, the feature becomes unavailable in the application for that specific background image. The user then has the option to use standard camera tools or a novel horizon alignment tool to align the camera perspective manually. (See Figure 8.5.) These tools can also be used to finesse a perspective estimate that is slightly inaccurate.

Fig. 8.5: The horizon alignment tool has a handle in the middle for raising or lowering the horizon (adjusting camera pitch) as well as a handle on each side for tilting the horizon (adjusting camera roll). Interactions on the ground plane itself control camera height and yaw.

### Environment Light

Environment lighting is the compositing ingredient that surrounds a virtual object with ambient color and reflections, making it feel embedded in the surroundings of the background (e.g., see Figure 8.6). Building a full 360 degree spherical environment from a background image that typically covers less than 10% of the sphere is a challenging problem. Luckily, the human visual system is not adept at discerning whether or not reflections are perfect. The detail from the background photo can easily be wrapped around the middle portion of the environment sphere in a convincing manner, but there are still large holes to fill at the top and bottom of the sphere. For compositing over a ground plane, the top is the most challenging portion to fill, because the bottom region will be covered up by any ground plane

Fig. 8.6: A virtual chrome figure and spheres with a default environment light (left) and with the automatically created environment light (right).

projection shown in reflections, as depicted in the 3D compositing diagram earlier (Figure 8.3). Match Image Environment creates the image data in the top portion of the environment using patchmatch for indoor scenes [2], but for outdoor scenes, it is important that there be a sky. The sky determines the shadow color and strength for outdoor daytime scenes. You might notice a blue tint to most outdoor shadows (e.g., see the direct outdoor lighting example in Figure 8.8). This is due to the blue light from a clear blue sky illuminating the shadowed regions where the sun cannot reach. This blue color is easily overwhelmed by the sunlight in non-shadowed areas. Obviously, it is important that we include sky pixels (either clouds, clear blue sky, or sunset/sunrise sky) whenever possible. A local patch-based algorithm like patchmatch may succeed at copying sky patches to fill the hole when there are sky pixels along the top edge of the background image, but if the top border is lined with trees or buildings, patchmatch will simply copy the trees or buildings all the way across the top of the sphere, creating a strange color cast and even stranger reflections (e.g., See the example on the left in Figure 8.7).

One solution is to use machine learning to recognize the semantic context of the image and fill the hole with common sky colors. Match Image Environment uses a generative adversarial network (GAN) [5] to fill the top region of the environment light. This GAN is often capable of creating a plausible sky when there are no sky pixels in the background image. This GAN was trained on thousands of examples of outdoor daytime skies, so it usually understands the global color distribution that is expected at the top of the environment sphere. The architecture is very similar to the base architecture of Yu [7].

## Discrete Lighting

Once the low dynamic range (LDR) ambient lighting from the environment light is in place, additional high dynamic range (HDR) lights are added on top to provide specular highlights, strong shadows, and directional illumination. There are different solutions in place for outdoor and indoor lighting. A separate CNN classifier determines which method should be used for a given background image.

Fig. 8.7: A diffuse and a reflective sphere composited into a waterfall photo with very few sky pixels at the top border. The patchmatch hole filling solution (left) simply repeats the tree pattern across the top of the environment, adding a strange green color cast to the top portion of the spheres in the 3D render. The GAN solution (right) is able to reconstruct a sky with more plausible colors (blue, grey, and white) because it has learned priors about outdoor sky colors.

Fig. 8.8: A mother and child sculpture composited with with an LDR environment light only (left) and with the automatically estimated sunlight (right).

## Outdoor Lighting

Sunlight creates an expressive range of shadow shapes and softnesses. The sun is also responsible for changes in color temperature and intensity as it travels from horizon to zenith (warm and dim near the horizon, bright and cool near the zenith). The outdoor illumination estimation in Adobe Dimension was trained to predict the parameter settings of a physically-based parametric model from a single background image [14]. The parametric model serves as both a regularizer to the network and a way to provide a user with a reduced set of parameters to adjust. The parameters include sun elevation and azimuth as well as intensity and cloudiness. Color temperature is determined by the sun elevation. The HDR sun values are added on top of the LDR values from the environment light which provides the sky illumination for outdoor scenes.

## Indoor Lighting

Indoor lighting from multiple, diverse light sources is often much more complicated than the nicely constrained case of outdoor lighting from the sun and sky. The indoor counterpart to the outdoor lighting method is a CNN that generates a low resolution image-based light (IBL) from a single background image [9]. Ideally a parametric model would be estimated for indoor lighting too, but this proves to be much more difficult. Machine learning approaches have the ability to learn priors about the world (in this case, the physics of light) and use those to decide on the most plausible solution from a set of physically valid solutions. However, for indoor lighting, there are often multiple, equally plausible solutions. In other words, one could arrange lights in a room in several different ways that might lead to the same rendered result. An IBL representation, while unfortunately high-dimensional, provides a one-to-one mapping of light to a specific direction, which makes calculating the gradient from a loss function possible (Figure 8.9). A parametric model with multiple light sources, on the other hand, is difficult to design in such a way that it can be differentiated and is prone to errors when trying to attribute the loss-derived gradient to model parameters in cases where the lights overlap. After the IBL estimation is complete, we then fit a parametric model to the result, where each light is represented by an ellipse on the environment sphere. Each light has elevation and azimuth as well as shape, intensity, and chromaticity parameters to enable easy tweaking and experimentation by the user.

Fig. 8.9: The Stanford dragon statue and a potted cactus composited over two different indoor photos with an LDR environment light only (left) and with the automatically estimated HDR indoor lighting (right).

## Final Steps

While the camera and lighting estimates are generated with the goal of plausibility, sometimes the user will want to modify the estimate. It is quite possible that one of the estimates is a bit off and needs to be tweaked, or the user may wish to exaggerate a particular effect for artistic purposes, or there may simply be multiple plausible solutions and the estimated one is not the solution the user had in mind. Adobe Dimension tries to make these edits quick and easy by providing an uncluttered and organized UI that maximizes expressive power while minimizing the number of tools and widgets presented to the user. Once the scene is set up with a satisfactory camera calibration and lighting configuration, the user can spend time making creative decisions about scene layout and how the final image composition will look. Thanks to a speedy physically-based renderer, a rendered image of the 3D virtual objects is interactively displayed in the UI with the matched lighting and camera calibration applied. This enables the user to make choices and immediately see the impact of those choices on the final composition. Alternatively, the background image can be swapped out as needed and new camera and lighting estimates can be quickly calculated with Match Image to explore how the 3D objects might look in an entirely different context. The rightmost column of Figure 8.10 illustrates this workflow. The rest of the figure demonstrates the way that the various machine learning estimates work together to create a realistic composite.

## 8.4 User Feedback

This section summarizes the feedback and user studies conducted so far on the Match Image feature. When user study participants are introduced to the feature, they are typically either excited, or incredulous, or both. One participant expressed this perfectly, saying, "That would be awesome, but I do not think it is possible." Another excited user in the user study said, "It is pretty magical. That is pretty doggone amazing." Apart from user studies, users "in the wild" have also responded positively. One said:

> It has always been very difficult to match color, light, and perspective with 3D objects and [background photos]. I hope you will.. fine tune this part of the software, because that is what is really missing out there.

Naturally the Match Image models do not provide the best estimate every time, so occasionally users have pointed out specific examples where the models fail and requested improvements. It is helpful to receive this kind of feedback as it helps us to identify missing categories of images in the testing and training data and to prioritize plans for for fine tuning the deep learning models.

The user experience researcher at Adobe who conducts studies with Adobe Dimension, Rebecca Gordon, summarized the efficiency gains that users have experienced this way:

> Those users who find Match Image and understand what it does, find it valuable because it saves time and reduces the tedious work of manually adjusting parameters such as horizon and lighting so object and background will match... and makes the process of mocking up something in 3D easier.

Fig. 8.10: A series of images showing the Match Image progression from left to right: unmatched object insertion, matched camera, matched environment light, matched HDR lighting. The final Match Image result is in the rightmost column. All of the images shown were automatically generated – no manual adjustment has been done.

Reporting on a research trip to China, she found that, for the companies she visited, the Match Image feature was the most impressive feature within Dimension because it reduced time spent on busywork, adding that:

> Chinese companies... have a super competitive market... [and] most designers work incredibly long hours, and AR/VR experiences have a totally janky workflow that is full of friction so anything to refine their workflow is welcome.

A third party productivity benchmark study conducted by Pfieffer Consulting confirmed these efficiency gains. It found that the virtual photography workflow in Adobe Dimension was four times faster than a traditional photo shoot workflow. In the same report, a compositing task was completed almost five times faster in Adobe Dimension than in Adobe Photoshop [11].

In spite of the positive user experiences and impressions, Rebecca also reported that the biggest struggle from a user experience point of view was finding how to make the feature more easily discoverable, and how to more effectively communicate what it does.

## 8.5 Machine Learning Lessons

Building on the compositing challenges and various machine learning techniques covered previously, this next section lays out some lessons learned during the development process, including practical strategies and rules of thumb. The discussion will cover the following phases of machine learning development: choosing the best representation, training, evaluation, and integration.

### 8.5.1 Representation

Before choosing an architecture, one must first decide on the best representation for a given problem. Ideally, the representation used for machine learning has a one-to-one mapping to the representation with which human users will interact. For example, in the outdoor lighting case mentioned above, the CNN generates estimates for the same light angle parameters that a human user manipulates to tweak sunlight position (e.g., elevation and azimuth). Alternately, in some cases there may be two different parameter spaces that can be connected by a bijective mapping such that the machine learning algorithm can work with parameters that are more numerically stable and the users can interact with parameters that provide a more natural UI. For example, a camera orientation, with a given field of view, can be expressed either in terms of vanishing points or Euler angles. The vanishing points provide a natural search space for a perspective-analyzing computer vision algorithm, and the Euler angles provide an intuitive UI for adjusting camera orientation. Another important feature to consider when choosing a representation is overall degrees of freedom. A well-behaved parametrization can provide sufficient expressive range while constraining the dimensionality of the space of possibilities that the machine learning model has to navigate. For example, the Hosek-Wilkie parametric model of the sunlight automatically generates a physically-based sun color for a given elevation [8], reducing the degrees of freedom that the CNN needs to estimate. There are other times, such as in the indoor lighting case mentioned previously, when the nature of the problem prevents the use of the same parametrization for machine learning as the final user interface. In these cases, it is important to convert the result to an approachable parametrization that users can easily manipulate.

### 8.5.2 Training

There is another reason why the ideal parametrization may not be possible: the available training data may not live in the ideal parameter space. One prime example of

this is the dataset used to train the outdoor lighting model: a set of LDR panoramas [6]. In order to learn how to predict sunlight position from a photograph, the model needed thousands of 360 degree spherical environments from which to extract training pairs. Training pairs consisted of background images (gnomonic projections of parts of each panorama) along with elevation and azimuth values for the sun. It is quite easy to find the true position of the sun from an outdoor panorama, and from that position, the color of the light from the sun can be computed with the Hosek-Wilkie model. However, finding the sun's intensity (which controls shadow strength) and the cloudiness (which diffuses the sunlight) is not easy to do if HDR light values are not available. There is no other readily available dataset of a similar size with HDR sky imagery. Attempts to generate HDR sky textures from the Hosek-Wilkie model and fit them to the sky textures in the LDR panoramas did not succeed because of cloudiness and intensity. Neither the cloudiness parameter in Adobe Dimension, nor the turbidity parameter in the Hosek-Wilkie model is capable of producing sky textures with the high frequency texture of real-world clouds. Furthermore, without knowing the exposure setting of the camera that captured the panorama, it is impossible to find the true HDR intensity values for the clipped values in the image. In the end, the best estimates we could generate came from regressing against a much smaller dataset of panoramas and sunlight parameters that were annotated by professional artists. In general, the grand challenge of machine learning development hinges on data. The data needed for a particular problem is often not available, so the majority of the research and development time ends up being spent on transforming the data that is available into some semblance of the data that is required by the problem.

Another example of a data challenge, one that applies to all of the Match Image problems, is domain adaptation. Many of the background photos that users try to match have actually been manipulated by other software before they are imported into Adobe Dimension. The machine learning models expect the input images to behave according to the physical priors that they have learned from the natural, unedited photos in the training data. The background images that many users try to match are hopelessly non-physical due to effects such as added lens flares, dramatic vignetting, color adjustments, and multiple image sources with conflicting perspective and lighting being layered on top of one another. Sometimes it is possible to use adversarial machine learning to find a common representation in the latent space between two domains. There may not be a universal solution to this problem except to collect new data that has a distribution that matches the distribution observed in user data.

One final recommendation around training is to stay organized. Often the difference between a performant model and a mediocre one comes down to hyperparameters. Deep learning models can be sensitive to not only small network architectural changes, but also to training changes such as batch size, learning rate, seemingly benign image pre-processing steps (e.g., resize [10]), loss functions, and termination time. Adversarial architectures, in particular, are sensitive to termination time, creating strange artifacts in the output imagery if training continues for too long. Needless to say, hyperparameter tuning often requires numerous experiments. It is important to carefully track each of these experiments so that the best models can be easily found and compared against each other.

## 8.5.3 Evaluation

As mentioned in the previous section, the choice of loss function dramatically affects learning behavior. It is equally important to have an accurate evaluation function and success metric for measuring the performance of a model on the test set as well. The best possible loss and evaluation functions directly mimic how users will evaluate the results in the wild (e.g., using render loss for indoor illumination), but that may be a complex and/or unknown function. Camera orientation estimation is a problem with an objective, quantitative evaluation function (e.g., the angular difference between a predicted and a true camera orientation), but even so, there are two important evaluation challenges: testing against the expected distributions and deciding on a success metric. (e.g., How many degrees of error in camera roll are undetectable by human perception?)

The expected distribution of the output parameters (e.g., for camera perspective, the histogram of camera pitch, roll, and field of view across a set of images) factors into both training and evaluation. Where possible, it is best to generate training data so that the truth values fit the expected distributions and to evaluate model performance against a test set that also fits these distributions. However, the expected distributions cannot be observed if there is no user data. This presents a "chicken and egg" problem – you cannot collect user data without first creating a solution that encourages users to import data of the correct distribution. For this reason, it can be worthwhile to ship an imperfect machine learning model if it adds value to the user experience and does not introduce unnecessary risk. Once the feature is out in the wild, it is easier to learn how people are using it and how they expect it to perform. In order to get the ball rolling for Adobe Dimension, a product manager collected a set of test images that were considered to be representative of the expected user behavior. The team annotated the test dataset with camera calibrations by hand to ensure there would be a consistent way to measure performance and track progress. During development, this test set is used to guide data acquisition decisions and to evaluate the performance of each Match Image component. At regular intervals, the team can assess the analytics on background images and adjust the test set as needed to ensure the distributions match.

In order to define a success metric for Match Image Perspective, a user study was created to measure the sensitivity of the human visual system to perturbations of camera orientation and field of view [13]. This is one way to determine a reasonable success metric, while also providing clues as to how to weight various terms in the loss function. For other problems, such as the environment map hole filling, the success metric is entirely subjective in nature. These types of problems require much more evaluation work because a human is in the evaluation loop for every test case. Making use of efficient large scale visualization strategies (e.g., Tufte's Small Multiples) can help ease the burden of quantitative evaluation. It may be tempting for the researcher or developer to do all the evaluation, but it is very important to not let confirmation bias affect the evaluation results. At regular intervals during development, the results data should be anonymized (e.g., method A, method B, etc) and sent out for comparison to several qualified people with an eye for the problem domain.

### 8.5.4 Confidence Classification

Adobe Dimension requires a 90% success rate for results shown to the user. This does not mean that we show every model output to the user. Unless, during the evaluation phase, the model exhibits a success rate greater than 90%, a confidence classifier is required to decide, for a given input image, whether or not the machine learning feature should be available. There are a variety of ways to do this, ranging from flimsy to rigorous. The most rigorous approach is, of course, to train an independent classifier on a set of images marked with success metrics from running the model in question. This option requires the most work, but will likely lead to the most unbiased confidence classification. Crowd sourcing services such as Amazon Mechanical Turk can relieve the burden of generating the success metrics to learn from, assuming the problem domain requires no special training. Two other methods that are less work, but also less rigorous, include analyzing the output distribution of the network to check for prediction sharpness (as a proxy for confidence) or training the network to also predict its own error. The former requires that the output heads of the network take the form of softmax classification bins (even for regression problems). The distribution across the bins can be analyzed to see how peak-like it is. Generally, the higher and sharper the peak, the more certain the model is that it has found an answer. It is important to note that this is not a wholly trustworthy measure of confidence – a model can be certain about its output and still be very wrong (much like humans). The latter suggestion of training the network to predict its own error may seem strange. If the network can predict its error, then why can it not just apply that error as a penalty and steer itself towards the true solution? Perhaps the task of detecting error is much easier that the task of formulating the correct answer. In any case, it is vital to filter the output of a model using a confidence classifier, and the performance of that classifier should be evaluated as rigorously as the model itself.

## 8.6 Conclusion

In summary, integrating machine learning into design software to eliminate busywork and help users focus on creative decision-making is both worthwhile and challenging. We have presented several practical strategies which help to mitigate the difficulties inherent in the deep learning development process.

1. Facilitate the optimization process by choosing a parametric representation that is numerically stable and has minimal degrees of freedom.
2. Ensure that the same parametric representation (or a bijective mapping of it) can provide an intuitive interface for users.
3. Tune the distributions of your training and testing data to match real-world data.
4. For quantitative evaluation, define performance metrics and loss functions in a data-driven way, grounded in human perception.
5. For qualitative or aesthetic evaluation, streamline the evaluation UI and ask multiple qualified people to evaluate the results.
6. Predict a confidence estimate to accompany any machine learning output.

User feedback on the Match Image feature in Adobe Dimension is proof that machine learning can assist with design tasks and do so in a way that speeds up ideation, iteration, and exploration. There are many challenges left to tackle to make design software more approachable, but the early evidence promises a bright future where machine learning can be leveraged to democratize design skills that were previously accessible only to an elite, highly-trained minority.

*Acknowledgement.* The author would like to thank Yannick Hold-Geoffroy, Marc-André Gardner, Kalyan Sunkavalli, Matthew Fisher, Geoffrey Oxholm, Sunil Hadap, Zhe Lin, Eli Shechtman, Sylvain Paris, and Xue Bai from Adobe Research and Jean-François Lalonde from the University of Laval for the hard work and ingenuity they put into our collaborations. The author is also thankful for the keen insights of Rebecca Gordon and the sharp eyes of Justin Patton, Wendy Tai, and Charles Piña. Thanks are also owed to Vladimir Petkovic for allowing the use of his artwork for the title image and to Kimberly Potvin and Arielle Karpowicz for assistance with licensing the digital assets used in the rest of the composited imagery in this chapter. Finally, many thanks to Emiliano Gambaretto and each member of the Adobe Dimension team for making this project possible.

# References

[1] arXiv. *Cornell University Library.* https://arxiv.org/. Cited 10 Sept 2018.

[2] Connelly Barnes, Eli Shechtman, Adam Finkelstein, and Dan B. Goldman. 2009. PatchMatch: A Randomized Correspondence Algorithm for Structural Image Editing. *ACM Trans. Graph.* https://dl.acm.org/citation.cfm?id=1531330.

[3] Frederic Lardinois, 2018. Adobe Lightroom's auto setting is now powered by AI. *TechCrunch* https://techcrunch.com/2017/12/12/adobe-lightrooms-auto-setting-is-now-powered-by-ai.

[4] H. Lee, E. Shechtman, J. Wang, and S. Lee. 2012. Automatic upright adjustment of photographs. *IEEE Conference on Computer Vision and Pattern Recognition* 877–884, doi: 10.1109/CVPR.2012.6247761.

[5] Ian Goodfellow, Jean Pouget-Abadie, Mehdi Mirza, Bing Xu, David Warde-Farley, Sherjil Ozair, Aaron Courville, and Yoshua Bengio. 2014. Generative

Adversarial Networks. *Proceedings of the International Conference on Neural Information Processing Systems.* pp. 2672-2680.

[6] J. Xiao, K. A. Ehinger, A. Oliva and A. Torralba. 2012. Recognizing Scene Viewpoint using Panoramic Place Representation. *Proceedings of 25th IEEE Conference on Computer Vision and Pattern Recognition.* http://vision.cs.princeton.edu/projects/2012/SUN360.

[7] Jiahui Yu, Zhe Lin, Jimei Yang, Xiaohui Shen, Xin Lu, and Thomas S. Huang. 2018. Generative Image Inpainting with Contextual Attention. *arXiv.* https://arxiv.org/abs/1801.07892.

[8] Lukas Hosek and Alexander Wilkie. 2012. An Analytic Model for Full Spectral Sky-Dome Radiance. *ACM Transactions on Graphics (Proceedings of ACM SIGGRAPH).*

[9] Marc-André Gardner, Kalyan Sunkavalli, Ersin Yumer, Xiaohui Shen, Emiliano Gambaretto, Christian Gagné, and Jean-François Lalonde. 2017. Learning to Predict Indoor Illumination from a Single Image. *arXiv.* https://arxiv.org/abs/1704.00090.

[10] Oleksandr Savsunenko. 2018. How Tensorflow's tf.image.resize stole 60 days of my life. *Medium: Hacker Noon.* https://hackernoon.com/how-tensorflows-tf-image-resize-stole-60-days-of-my-life-aba5eb093f35, Cited 10 Sept 2018.

[11] Pfieffer Consulting. Adobe Dimension CC: The Productivity of Design Visualization. https://offers.adobe.com/content/dam/offer-manager/en/na/marketing/CCE/Pfeiffer_The_Productivity_of_Design_Visualization.pdf. Cited 10 Sept 2018.

[12] Uniqtech. 2018. Understand the Softmax Function in Minutes. *Medium.com.* https://medium.com/data-science-bootcamp/understand-the-softmax-function-in-minutes-f3a59641e86d.

[13] Yannick Hold-Geoffroy, Kalyan Sunkavalli, Jonathan Eisenmann, Matt Fisher, Emiliano Gambaretto, Sunil Hadap, and Jean-François Lalonde. 2017. A Perceptual Measure for Deep Single Image Camera Calibration. *arXiv.* https://arxiv.org/abs/1712.01259.

[14] Yannick Hold-Geoffroy, Kalyan Sunkavalli, Sunil Hadap, Emiliano Gambaretto, and Jean-François Lalonde. 2016. Deep Outdoor Illumination Estimation. *arXiv.* https://arxiv.org/abs/1611.06403.

[15] Zhou Wang, A. C. Bovik, H. R. Sheikh, and E. P. Simoncelli. 2004. Image quality assessment: from error visibility to structural similarity. *IEEE Transactions on Image Processing.* 13:600–612, doi: 10.1109/TIP.2003.819861.

Part IV

Other Art Forms

# 9

# Computational Models of Narrative Creativity

Pablo Gervás

Facultad de Informática e Instituto de Tecnología del Conocimiento, Universidad Complutense de Madrid, Madrid, Spain `pgervas@ucm.es`

**Summary.** Ever since the advent of computers there have been research efforts to emulate computationally the way in which people can create stories. Artificial intelligence (AI) and the myriad of specific technologies it brought with it gave rise to more elaborate efforts. Yet the task seems to be a challenging frontier that even today still defeats efforts to achieve performance comparable to that of humans. In part, the difficulty lies in the fact that the approaches computers have been following to date differ significantly from those applied by humans on a number of points. Whereas computers generally apply a single specific AI technique to these problems, humans seem to combine several cognitive abilities into the task. Computers focus on the short end of narrative production (fairy tales and short stories) but humans produce in a much wider range, with long examples of much greater complexity (novels, plays, films) being very frequent. Where computers usually apply a one-pass algorithm that produces a single output or focus on generating small fragments of an interactive piece in co-operation with a human, the basic mode of operation for human authors is to work alone and to proceed by iteratively revising a draft based on critical appraisal of whether it meets very demanding criteria. The present chapter reviews the existing approaches to computational generation of (emulations of) narrative under the light of these differences in procedure. To inform this review, some of the existing models of how humans address the corresponding tasks are described and the existing computational solutions are examined for similarities and differences with these models of human performance. The impact of these various aspects on the quality of computer generated artifacts is considered and an analysis of current trends for future development is made, with particular emphasis on how addressing the aspects that have so far been less studied may help change the landscape of the field.

## 9.1 Introduction

Computational modelling of narrative has been a major goal of artificial intelligence since its beginnings. Systems to generate or tell stories were among the earliest attempts to model human abilities. A significant part of the difficulties involved in the task related to the fact that linguistic ability, which underlies these types of effort,

© Springer Nature Switzerland AG 2021
P. Machado et al. (eds.), *Artificial Intelligence and the Arts*, Computational Synthesis and Creative Systems, https://doi.org/10.1007/978-3-030-59475-6_9

was a major challenge for computers. Yet whereas recent years have seen significant advances in natural language processing that have led to widespread adoption of language-based interfaces for search engines, mobile phones and voice-powered home assistants, modelling literary creativity still poses a challenge to artificial intelligence. None of the language-based applications that are becoming ever present in our lives can handle simple tasks like telling the story of our day – as any one of us might do on arriving home to the family – let alone produce anything ressembling a literary piece of value. In a way, the frontier of the state of the art has shifted, and computational modelling of narrative creativity is now beyond the edge, but almost accessible. The present chapter reviews research efforts to model tasks that can in some way be related to narrative creativity.

From a terminological point of view, it is unclear what the compositions that we want to study should be called. Given that they arise from attempts to emulate the way in which people create stories, they might be considered literary efforts of some kind. However, it is clear that, as of today, they fail to achieve the quality that critics require of human efforts to be considered literary pieces in a proper sense. On an orthogonal axis, some of the pieces generated in a computational manner do not take the form of text or are not sequential, but rather involve modern media such as video-game-like experiences that deliver stories as 3D animations with accompanying audio, or constitute interactive experiences where the interactor may influence the course of the story as it is developing, sometimes controlling particular characters. For lack of a better term, in the present chapter we will refer to all of these compositions as *proto-literary drafts*.

### 9.1.1 Overview of Chapter Organization

The content of this chapter is the result of a review of a number of systems that produce proto-literary drafts of some kind, in which there is either a textual form akin to traditional literary works, or there is a narrative plot underlying more elaborate audiovisual experiences, whether sequential or interactive. The available documentation on these systems has been examined to ascertain the extent to which they operate at one of the levels of representation traditionally considered in narratology (see Section 9.2 for details on this point): representation of the content as either a storyworld or a fabula, representation of discourse, rendering as text or other media. An additional section has been introduced to deal with systems that include explicit modelling of cognitive aspects of the task of literary creation, including implementation of procedures for appreciation of narrative quality. The chapter is structured to provide an overview of the solutions that are available at each level of representation, and reviews specific solutions provided by particular systems. This implies that systems including solutions at different levels may appear repeatedly over the course of the chapter, as the different levels at which they operate are addressed. As a result of this decision, it may be difficult for the reader to get a complete picture of individual systems. Instead, the chapter intends to provide a broad overview of how the elementary ingredients of the relevant narrative expertise have been addressed by existing computational solutions. It is assumed that readers interested in particular systems can consult the entries provided in the bibliography for details.

The present chapter is organized along the following lines.

Section 9.2 introduces a number of relevant concepts from related fields that are important to understand the way the chapter is structured.

Section 9.3 reviews features of computational systems mainly focused on the creation of conceptual content to be conveyed in a proto-literary draft. Section 9.4 reviews features of computational systems that focus either on the direct construction of discourse or on the production of discourse to convey a given fabula. Section 9.5 reviews features of computational systems designed either to render a given fabula or discourse in some medium or to generate the medium directly.[1] Section 9.6 reviews features of computational systems intended to capture cognitive aspects of the authorial processes applied by human authors.

Section 9.7 outlines the conclusions drawn from the effort of compilation and analysis, and outlines possible lines of future work for the field.

## 9.2 Relevant Concepts from Related Fields

A review of existing approaches to the generation of narrative pieces of this kind must consider the views of the subject from several different fields. Narratology and literary studies have much to say on the nature of these pieces. The field of natural language generation studies the computational considerations involved in the generation of them. Cognitive sciences study the mental processes that humans apply to the tasks of processing experience and composing text. Some insights from these fields need to be outlined at this point to provide a framework in which to structure the review. Other relevant concepts will be presented as needed in the body of the chapter.

### 9.2.1 Narratology

The field of narratology studies narrative with special emphasis on the narrative works themselves. Many efforts at computational generation of stories draw upon the body of knowledge of narratology for inspiration. The selection of sources tends to be biased towards theories that are more amenable to computational representation rather than those more recently accepted or currently in vogue in the field. As a result, computational solutions are very rarely based on the more recent trends, and may often be based on outdated or openly questioned narratological theories. Given the fact that there is a multitude of contrasting theories, and no generally accepted consensus on their relative validity, this is a pragmatic decision rather than an ideological one. Reviewing in detail the set of theories that have been used in this way is beyond the scope of a chapter such as this one, but interested readers may consult existing work on the subject [25, 73]. Nevertheless, some of the analyses of narrative provide a valuable reference to understand the proliferation of apparently different approaches to the computational generation of narrative.

One such analysis is the distinction between fabula, story and text as proposed by Mieke Bal [9]. Because it generally reports on events happening over time at a time different from the time of reading, narrative differs from other texts in that it involves a double chronology: the time of the events being reported and the time it takes to read the narrative [1]. The interplay between these two chronologies is a fundamental tool in the hands of a literary author. Important literary effects are

---

[1]This last option is generally restricted to text.

achieved by using flashbacks or flashforwards, and canny administration of how much knowledge is imparted to or withheld from the reader at each point. The events of a narrative in the chronological order they happened is referred to as the *fabula*. The events of a narrative in the chronological order in which they are told is referred to as the *story*, also described as the *discourse* by other authors. Bal refers to the actual rendering of the *story* as the *text*.

Other authors also consider alternative approaches to the rendering of the discourse in other media, such as video, audio or whatever means are employed to convey the discourse to the spectator. To avoid confusion with the common usage of the term story, we will refer to Bal's concept of story as *discourse*, and to capture the additional possible means of rendering a discourse we will refer to Bal's concept of text as *rendering*.

Because Bal's concept of fabula differs from discourse namely in the order of presentation of the events, it becomes necesary to consider the additional concept of *storyworld*, which consists of all the events that happened in the world where the story occurred, regardless of whether they are included in the narrative or not. The fabula is then the subset of the storyworld that is included in the story, and the discourse the particular order in which the fabula is presented. In most narratives authored, these events not included in the story are not known and possibly irrelevant, but they become important when one attempts to model the process by which narratives are constructed from a set of events observed in real life – or observed in a computer simulation. In such cases, the criteria for selection of which events to tell and which events to omit becomes an important issue. [2] These distinctions are valuable to understand the differences between existing approaches to computational generation of proto-literary drafts, in terms of the level of representation at which they are operating.

Whereas the existence of a narrative in some form of rendering implicitly carries with it the conceptual existence of underlying instances of discourse, fabula and storyworld, the computational processes involved in generating the rendering will differ widely depending on how many of those levels are explicitly considered. The simplest possible systems may generate a text directly and leave the inferring of all the remaining levels open to interpretation by the reader. This is the procedure most often followed for generating poetry. Very elaborate systems may build a storyworld, select what the fabula should include, compose a discourse for that fabula, and render that discourse in some medium. Systems for the generation of narrative tend to consider at least one conceptual level of representation of their content, and they become progressively more complex the more aspects of narratological theory that they consider. Because the conceptual distinctions between these levels are subtle, the reports on many of the systems reviewed in this chapter do not always explicitly refer to them. Nevertheless, an effort has been made to identify from the descriptions available in each case what levels of representation of the narrative are involved. Any errors in the attribution of these levels rest with the author. In most cases, regardless of the main focus, testimonial stages corresponding to the less addressed levels usually exist.

---

[2]This point has been addressed in more detail in [53], where the complete description is referred to as the *underlying extensive representation* and the subset of it selected to be included in the fabula is referred to as the *underlying selected representation*.

Further concepts from narratology specifically relevant to the relation between fabula and discourse are presented in Section 9.4.4 on narrative composition.

Another important point is the relatively central role assigned by modern narratology to the reader in terms of assigning value to narrative [139]. Once it is accepted that much of what a reader obtains from a given text is the result of contextual inference rather than strict decoding, the role of these inferential processes, which may vary from one reader to another, needs to be considered as part of the appreciation of a narrative.

A final point to be considered is that modern narratology pays special attention to the role of the ideology that an author portrays in a given work [80]. This follows a general concern with the intentions of the author.

### 9.2.2 Natural Language Generation

The field of natural language generation addresses the computational issues in generating text from conceptual descriptions of the content to be conveyed. Although there are many possible architectures to develop a natural language generation system, the most popular decomposition of the problem into constituent sub-tasks considers the following stages [143]. A stage of *content determination* establishes what material should be conveyed. A stage of *discourse planning* establishes how the selected material should be organized. A stage of *sentence planning* decides on the form that the sentences used to convey the material should be constructed. This includes decisions on how the entities involved are referred to at each occurrence in the discourse (*referring expression generation*), what particular terms to use to convey each concept (*lexical choice*), what syntactic constructions to use (*syntactic choice*) and whether to group together clauses or sentences that say similar or related things (*aggregation*). A stage of *surface realization* establishes how the organized material should be rendered in linguistic form according to the grammatical and typographical rules of a particular language.

Although not many of the existing systems for generating proto-literary drafts follow this architecture, it constitutes a useful framework in which to phrase an analysis of their differences and similarities. Additionally, it is possible to establish a rough correspondence between the product-based view of narratology and the process-based view of natural language generation. In this correspondence, content determination may operate in three different modes: it may build a fabula directly, it may generate a storyworld and select a fabula from it, or it may receive a representation of a storyworld from which to select a fabula. Discourse planning may receive a fabula and produce a discourse or generate a discourse directly. If a textual rendering is desired, sentence planning and surface realization can be applied to a given discourse to produce it. Alternatively, other techniques may be used to produce a text directly. If renderings in other media – such as video or 3D animation – are desired, the analogy holds partially, in the sense that content determination and discourse planning will also be required – albeit possibly of a different nature – and realization of a different kind has to be applied.

### 9.2.3 Cognitive Science

Cognitive sciences have devoted significant efforts to establish what mental processes are involved in the tasks of processing experience and composing discourse that

humans bring to bear on the problem of writing text [49, 155]. Although most of it is focused on the production of non-literary texts, much of the knowledge so obtained is relevant to literary production as well. Again, reviewing the various candidate theories is beyond the scope of the chapter, but there are two important insights to consider for structuring the present chapter. The first insight is that by observing how humans approach the task of creating and appreciating literary texts it becomes clear that it is not a single monolithic task that is involved. More often than not, the task is seen as a cycle of production and revision of what has been produced, informed by procedures for validating the suitability and quality of the partial drafts and governed by decision processes that determine when to switch from production to revision and which parts of the draft to apply them to [49, 155]. Composition of text therefore is carried out as a combination of stages that operate on the material, including actual production of new material, evaluation of what has been produced, and revision of it based on the results of the evaluation. The second insight is that humans usually address the task of creating text with particular purposes in mind. These purposes are varied and different, including entertaining, convincing, reporting, illustrating, recording, arguing, etc. These purposes have a great influence on the way the task is approached, as they shape the processes of production, evaluation and revision.

Finally, at a different level of abstraction, our general knowledge about storytelling suggests that the way humans rely on narrative involves not just inventing fictional stories, but also using the story format to describe their experiences to others, and sometimes combining the two to come up with stories partly based on experience and partly adorned with fictional detail at different levels. In a similar intuitive fashion, the accumulated folklore created by authors self-reporting on their creative process suggests that there is no single process shared by all, but rather a myriad of possible processes that might be involved, and that authors choose from them according to their personal preferences. Sometimes they use several at the same time, switching between them at will or at need, and often mixing them up.

## 9.3 Building Fabula: Inventing Content

Whereas simple stories tend to be linear, with a sequence of events happening to a single character, when complexity increases very soon there is a number of characters to deal with, not all of them always present at the same location and often involved in events that take place simultaneously with those of other characters. To model the construction of stories of this more complex type requires a representation of the material to be covered that is non-linear, much like the reality that people experience in their lifes. Some systems for the generation of proto-literary drafts first generate a conceptual description of the content of the intended text, and then apply some procedure to convert this conceptual description into some format that is easier for a person to understand. In some cases, the conceptual description is indeed rendered as text, in others it is presented in some audiovisual format such as a 3D animation showing the characters and the events mentioned in the conceptual description. This second solution has found favour in the field of video games and interactive storytelling.

The conceptual descriptions of the content to be included in the story need to be rich enough to capture the complex nature of reality that they are trying to mirror.

Two artificial intelligence technologies have been employed repeatedly to address this problem: agent-based systems [156] and automated planning [116].

Agent-based systems allow for the construction of simulations in which a set of agents interact, each with their own particular behaviour and their own particular goals. If the agents are designed to capture the behaviour desired of characters in a story, the log of the resulting simulation constitutes a valuable source for a story that can be considered a direct representation of the storyworld.

Planning allows for the construction of a causally connected graph of actions that lead from an initial situation to a set of desired outcomes. If the actions undertaken concern the characters to be included in the story, and the initial situation and the desired outcomes are chosen to be those of a desired story, the resulting causal graph or plan is again a useful representation of the content to be conveyed in the story. If all the elements in the causal graph are to be exhaustively transcribed into discourse, the causal graph can be considered a fabula. If only selected parts of it will appear in the discourse for the story the causal graph acts as a representation of the storyworld.

None of the conceptual descriptions of the content of the story obtained in these ways is linear in the form that stories usually are. Both solutions require a later stage of conversion into a linear discourse before they can be told as stories. In some cases there may even be an intermediate step of selecting which parts of the storyworld – the log of the simulation or the causal graph – are relevant to a particular story. The full log may contain not one but a number of stories (at worst, a different story for each participating agent). The causal graph may include causal connections between events that are easily inferred by the reader, and are therefore better omitted. In these cases, content determination for a prospective story can be considered in two stages: construction of the set of events on which the story will be based, and selection of the events that will be included in the desired story.

As many agent-based solutions rely on planning to determine the behaviour of the agents, the distinction between agent-based and planning-based approaches to narrative generation may become slightly blurred. To further complicate matters, many of the existing systems of this kind are designed not produce a sequential story but rather to dynamically regenerate a possible continuation for an interactive experience in response to the periodic interventions of an interactor. For ease of presentation, the mechanisms for the modelling of fabula are presented in this section grouped into two distinct groups based on the distinction between plot-based and character-based story generation as originally discussed by Mateas and Stern [99].

## 9.3.1 Plot-Based Fabula Generation

There is an extended perception that the plot of a story is very tightly related to causal connections between the events in it [50]. For this reason, computational attempts to generating conceptual descriptions of sets of events focusing on the identification of their causal coherence has often been achieved by the application of planning technology. Planning allows the construction of sets of events connected by causal links, starting from an initial situation and leading to a final goal. Early approaches to this task generated the full chain of events in a sequential manner. Later efforts exploited the ability of the planning technology to dynamically generate more than one plausible chain in response to changing requirements introduced

by interaction with a user. Such systems develop into interactive storytelling applications, in which the user and the system take turns at extending the sequence of events, and the system plans the next event in its turn based on the changing restrictions introduced by the user during her turn.

This section reviews the systems that built a description of the events in a story that can be considered a fabula, to be later conveyed as a discourse.

An early application of this approach was in the TALE-SPIN system [110], which modelled the construction of fabula for stories of woodland creatures by establishing a set of characters participating in the story, assigning goals to them, and computing the plans required for them to achieve their goals from an initial situation. The type of fabula produced by TALE-SPIN was easy to linearise into a discourse by simply respecting the precondition relation on the planning operators applied, and the resulting stories were coherent and believable but also predictable and not very interesting.

Natalie Dehn [36] posed the challenge of having to consider for story generation not only the goals of the characters but the goals of the author. Whereas the goals of a character usually involve successful and problem-free outcomes to the challenges he is faced with, an author will prefer to include failures and problems to give spice to her stories. The AUTHOR system proposed by Dehn operates on both character and author goals, but gives priority to author goals. Author goals are initially formulated at a very high level ("make the story plausible", "make the story dramatic", ...) but get progressively reformulated into simpler goals that drive what events are included in the story. The challenge posed by Dehn has been at the heart of most improvements to the application of planning technology for story generation reviewed in this chapter. The UNIVERSE system [89, 90] generated episodes for a soap opera by planning not to achieve the goals of the characters but rather a set of dramatic goals chosen by the author. These goals usually involved frustrating the specific plans of the characters. The UNIVERSE and AUTHOR systems differed in that UNIVERSE opted for an approach that gave preference to constructing a world and then establish a plot to occur in it, and AUTHOR opted for an approach that aimed to build a plot and add elements to the underlying world only if and when required by the plot. In terms of our terminology, this distinction relates closely to the choice of whether to address the problem at the level of storyworld or fabula.

Similar planning technologies were applied to generate fabulae on which to base interactive systems of different types, such as the Teatrix story creation system [122] or Cavazza, Charles, and Meads interactive sitcoms [27]. Teatrix allowed small children to interact with fairy tale characters that each had assigned predefined roles and goals associated with it. Characters perceived the world, represented it internally, and applied planning techniques to compute sequences of actions that would lead them to their desired goals. The interactive sitcoms of Cavazza, Charles, and Mead allowed a user to participate as an observer of the story of the interaction between two characters, each applying Hierarchical Task Networks (HTNs) to plan their potential behaviours. Each character had a a particular goal in a given situation, identified by a particular role and having a plan defined as a Hierarchical Task Network. Such networks organize a number of subgoals. For instance, if a character's goal is to invite a lady to dinner, this will be broken up into subgoals of acquiring information about her, catching her interest, finding an opportunity to talk to her alone, etc. Because different characters will have different plans, and these plans will rarely allign, the interaction between them may result in interesting situations

that are entertaining for the user to observe, and sometimes may trigger a desire to intervene. This decompositional approach to plans, where goals can be recursively represented in terms of simpler subgoals that together achieve the larger goal captures a granularity of representation that is important in human-authored literature, where sometimes the activities of characters over a few seconds are narrated in great detail and sometimes periods of several years are dispatched in a few sentences. As the plans of different characters may interfere with one another, planned actions may fail. Such failures are narrated as part of the ongoing story, and force the system to replan. The accumulated sequence of intended plans, failures and remedial plans constitutes the generated story, rather than any particular plan. This point is elaborated further in Section 9.4.3.

An elaboration on the use of planners to generate fabula for a story is the FABULIST system [145]. In FABULIST the planning procedures are enhanced with mechanisms to ensure that the set of actions undertaken by each character are consistent with one another overall, which helps the reader to consider the plot as coherent and the characters believable.

The IRIS system [46, 47] creates suspenseful fabulas by building an original plan for the protagonist to achieve, identifying actions in the protagonist's plan that might be thwarted by applying a suspense-creating template, applying the template to thwart that version of the plan, having the protagonist revise its intentions and replan to achieve the set goals in some other way, and iterating this procedure until there are no more actions that might be so thwarted. To make this work, the system relies on a belief desire intention (BDI) model of the protagonist, and a procedure for the character to revise its intentions on perceiving failures of its plans. The suspense evoked in the audience when following the final story arises from the audience having knowledge of the obstacles to the protagonist's plan (as introduced by the described generation process) that the protagonist himself is unaware of. This is referred to as *dramatic irony*. The role of suspense in the creation and telling of stories is elaborated further in Section 9.4.4.

### 9.3.2 Character-Based Fabula Generation

A different approach to the generation of narrative literary pieces involves using artificial intelligence techniques to model relevant features of characters and how they may evolve, and observing the resulting simulation to create the story line that is to be told. One of the most relevant features of characters that have been modelled as drivers for story generation in this way are character emotions. Another feature that has been modelled as relevant to the development of fabula is the interaction between characters. In different systems, it has been represented in terms of affinities between characters, social norms, and conflict.

### Modelling Character Emotions

The UNIVERSE system [89, 90] was a pioneer system in that it was the first to include detailed information about the characters – including characteristic such as niceness, promiscuity, intelligence, wealth, but also a system of stereotypes – which played a role in determining what happened to them. In particular, it also included information about their emotions. Because the system was designed to produce a

continuous series of episodes, it included procedures for creating new characters along the lines of the representation already described.

The Émile system [76] was a model of emotional reasoning designed to operate in the context of dynamic, interactive, and non-scripted training environments. In this context, agents continuously appraise the environment and based on their perception compute a plausible emotional state which informs their subsequent behavior. It is relevant in the current context because it was based on a planning algorithm that integrated a stage of emotional appraisal, and its planning decisions were informed by its emotional state. The Émile system was not used to generate stories, but rather applied to simulation for military training and pedagogical agents. EMA [97] was a computational model of appraisal that addressed the issue of dynamics of emotional appraisal, being capable of modelling both both rapid and slower emotional responses. Both of these models captured computational essential features of human appraisal of emotions but were not applied to the generation of stories.

The characters in Cavazza, Charles, and Meads interactive sitcoms [27] include a representation of emotional state or mood, which is considered to inform the expansion of nodes during planning – characters not feeling "sociable" are more likely to reject invitations to socialize – and affected by the actions they undertake, including their potential failure.

The FearNot! system [5] was a virtual drama system that placed children in contexts of bullying behaviour within a virtual environment. The characters in the system have a model of emotion that influences their behaviour and drives the emotional responses they display.

The EMOEMMA system [26, 29] represents emotions at a lower level of abstraction, considering the emotions that the interactor displays in his tone of voice when speaking to the system via a microphone, and planning the emotions and the actions of the characters in response to the detected emotions. The system is based on the novel Madame Bovary, and the interactor plays the character Rodolphe in opposition to a virtual Emma. The system did not restrict the actions to the original plot of the novel, but instead allowed the interactor to explore several possible plots all constructed within the story world of the original novel.

## Modelling Affinities Between Characters

The MEXICA system [130] relied on a representation of the affinities of characters to drive the construction of the story. MEXICA generated stories about the Mexicas, the ancient inhabitants of Mexico City. In this instance, characters were assigned a set of affinities with one another and a set of tensions arising from their interaction was computed by the system. Although the representation of affinities corresponds to modelling the story at the fabula level, the MEXICA system operated by incrementally building a discourse sequence of actions undertaken by the characters, so it is also considered later in Section 9.4.1.

The Charade system [111, 112] relies on a multi-agent system to implement a model of how the affinities of a set of characters evolve over time as a result of the interactions between them. The system represents affinities on a scale of *foe*, *indifferent*, *friend* and *mate*. A set of rules governs how these affinities change based on the sequence of actions of the characters and the interactions between them.

The NetworkING system [134, 135, 136] represents the social relationships between characters in a medical drama with a cast of doctors, nurses and patients

as a social network. By visualizing the relations in this way, the system allows the construction of narratives based on how these relations are subject to continuous dramatic change. The relations considered are separated into three categories: affective (*friend, close-friend, long-term-close-friend, antagonist, extreme-antagonist, long-term-extreme-antagonist, professional-rival*), romantic (*long-term-partner, dating, secretly-dating, attracted-to, romantic-rival*) and default (*indifferent-to*). Narrative generation is achieved by means of planning actions for the characters based on their relations, and ensuring that the actions that can be considered are defined in terms of their effects on social relations.

## Modelling Social Norms

Another aspect that affects interaction between characters is the existence of social norms that characters are expected to follow. These norms constrain the behaviours that are valid, and often the interest of human-written narrative arises from the way protagonists face these constraints. To address this aspect, the Comme il faut system [104, 107] models social norms by representing characters with "a complex set of traits, feelings, and relationships, who can form intents, take actions, relate to a shared cultural space, and remember and refer to past events" and allows the authoring of "high-level rules governing expected character behavior in given social situations". In this way, the Comme il faut system acts as a narrative engine that may be used to dynamically construct storylines based on social interaction. The Comme il faut system has been used to build the game PromWeek [102, 103, 105], in which players are challenged with achieving a set of goals to complete during the week before the prom. The initial version of the system focused on the pyschological needs of individuals within the social context. This proved during testing to differ from the social games that players were expecting in the given situations. To cover this point, a later improved version [106] focused more on the logic of social statuses and relationships between characters. Although in this case the narrative engine is employed to power an interactive game, it is clear that it might as well be used to support the production of fabula.

## Modelling Conflict

Another way of going about the modelling of interactions between characters to emulate how human authors portray them in their work is to focus on conflict.

An early attempt to capture this aspect of human interaction in a computational model was the POLITICS system [19]. In this system, two actors with differing goals need to plan how to achieve them. This is referred to as counterplanning, and it can be obstructive in nature – where one of the actors attempts to impede the goal of the other – or constructive – where one of the actors aims to achieve his goal in spite of the obstructions of the other. The applicable procedures for counterplanning are encoded as a set of heuristic strategies. The POLITICS system was intended as a general inference mechanism, not as a story generator, but it is clearly a predecessor of narrative engines that consider conflict a key feature of narrative.

A system that explicitly exploited conflict for the generation of stories was that of Smith and Witten [157], which modelled conflict between a protagonist and an antagonist as a players engaged in a zero-sum game.

The IDTENSION system [159] is constructed as a narrative engine capable of predicting plausible and dramatically interesting behaviours for a set of characters, based on a representation of their goals, their moral values, and the obstacles they face. Part of the interest arises from the conflict between the moral values of the characters and the actions open to them in order to overcome the obstacles in their path.

The Émile system [76] (discussed in Section 9.3.2) was designed to keep track of the plans of other agents, identify possible conflicts with its own plans, and adjust its emotional state appropriately.

The Glaive system [173] relied on a definition of conflict based on the data structures and algorithms of artificial intelligence planning to generate stories which explicitly include the thwarting of plans. As a case study, the Glaive system was used to develop an interactive game in which a user would develop a plan for a simple task and then turn the initiative over to the game which would proceed to thwart it in some way.

The IRIS system [46, 47] (also mentioned in Section 9.3.1) created plots constructed around the idea of conflict, by thwarting the ongoing plan of the protagonist at each point.

## 9.4 Constructing Discourse: Arranging the Telling of Stories

The systems described in this section correspond to two different types, based on whether they generate a discourse from scratch or whether they create a discourse to convey a given fabula or storyworld.

With respect to the fundamental concepts outlined in Section 9.1, the generation of a sequence of actions already ordered in the sequence in which they are to be presented corresponds to generation of discourse directly, without an intervening stage of generating a fabula.

For the production of a sequential narrative discourse from scratch three different approaches have been followed. One (reviewed in Section 9.4.1) aims to mirror the structure of existing stories, as captured in narratological analysis of narrative structure. Another (reviewed in Section 9.4.2) relies on neural networks to create narrative discourse. A third approach (reviewed in Section 9.4.3) aims to produce a sequence of plausible actions to continue a story partly produced by an interactor. Systems of this third kind usually rely on planning, and are closely related to systems designed to produce fabula.

Finally, Section 9.4.4 reviews systems that generate discourse for a given fabula or storyworld.

### 9.4.1 Systems That Generate Discourse Based on Accounts of Plot

Over the years there have been many attempts to study the structure of narrative as featured in existing literary works. Some of the efforts to specify such structure arise within the field of narratology, while others appear in less academic settings. The present section reviews efforts that have been considered for the development

of computational systems, regardless of the relative merit of the sources employed in academic terms.

A very popular theory on which to base the development of story generation system is the morphology of the Russian folk tale by Vladimir Propp [140]. Propp was a Russian formalist who studied a corpus of Russian folk tales and postulated a common structure for them based on the ordered appearance of a number of abstractions of character behaviour called *character functions*. This basic structure was initially used for the development of interactive story generation systems. Grasbon and Braun [75] relied on it to build an authoring tool for interactive fiction. The OPIATE system [45] employed them to drive an interactive story generator, relying on the roles proposed by Propp to establish the relative attitude of the virtual characters to the user. The Teatrix story creation system [122] also relied on concepts from Propp's analysis, but proposed a specific set of narrative roles for a collaborative virtual environment in which children can build their own fairy tales. Propp's system was also formalised as a description logic ontology [126] to support the creation of story generation systems [123]. The efforts to apply Propp's model to interactive drama where criticized by Tomaszewski and Binsted [165] on the grounds that Propp's functions mostly impose specific actions on the hero of the story, rather than allowing her a choice. More recent efforts have focused on applying Propp's model strictly for the generation of Russian folk tales [56, 60, 61]. The underlying abstractions of the concept of a character function and a narrative role have been applied with some success to modelling other domains of storytelling, such as the plots of musical theatre [34, 68].

A different formalism that has also been employed to model the structure of stories with a view to using them for generation are story grammars. Initially proposed by Rumelhart [151, 152] as a possible representation of the abstract structure of stories, story grammars were taken up by Thorndyke [162] in an attempt to explain how structure influenced the way people remembered stories. As a young graduate, Lakoff built his own paraphrase of Propp's model as a generative grammar of fairy tales [84]. Story grammars have also been used in anthropology to capture the essence of folk tales in a particular culture, such as Colby's grammar of Eskimo folk tales [33]. In spite of criticism on the universal applicability of story grammars [11], a number of story generators have been built based on this technology, such as the JOSEPH system [85, 86] – which generated Russian folk tales based on a story grammar – or the GESTER system [128] and Wilcock's story generator [174] which both generated plots based on a grammar of Old French epic narratives [127]. A more elaborate solution was the BRUTUS system [16], which generated stories of betrayal by combining a hierarchy of grammars with a logical model of betrayal.

Less academic accounts of the concept of a master plot have also been used as reference in the construction of stories, providing a collection of story schemas to be reused wholesale. Campbell's account of the Hero's journey [18] – which is a very popular inspiration for film makers – was used to drive the narrative of an adaptive game by Champgnat et al [28]. The PropperWryter system [34, 56, 60, 63] for generating arguments for musical theatre pieces relied on a combination of accounts of plot by Booker [12], Tobias [163] and Polti [132], all articulated in a plot-descriptive vocabulary based on Propp's concept of abstracting functions and roles of the characters. William Wallace Cook's Plotto [35] – which provided around 2,000 plot fragments and instructions on how they can be combined to form plots for novels – has been used as inspiration by the Scéalextric system [170] which builds

a corpus of plot fragments mined from a corpus of n-grams, and the Plotter system [40], which worked on simple concatenation of Cook's descriptions, even though these were not intended as actual content but rather as descriptions of what should be conveyed in the corresponding part of the story.

Another popular source of inspiration for story generators based on the structure of narrative are accounts of the ideal "shape" that an interesting story should have, either in terms of emotional impact on the reader or the tension it evokes. These correspond to accounts like Freytag's dramatic arc [51] or the more recent six core emotional arcs [141]. The MEXICA system [130] generated stories about the ancient inhabitants of Mexico City by plotting the rise and fall of tensions between them and aiming to achieve an overall shape of the tension for the story akin to Freytag's dramatic arc. The Façade system [101] relied on a drama manager that would compose a sequences of *beats* – small pre-scripted fragments of how the story develops – chosen from a large pool aiming to ensure that the ups and downs of tension in the resulting story followed an Aristotelian arc [78]. The Fabulator system [10] extends a planning solution for an interactive storytelling application with a mechanism for controlling the pace of the story that unfolds so that it matches a specific tension arc. It also included a look-ahead mechanism designed to spot actions that might lead to narrative dead ends, so they can be avoided before becoming a problem. The STellA system [91] actually allowed the user to draw the shape of the curve desired for particular parameters that drive the story construction – such as the amount of love or violence to be exhibited at each point of the story as it progresses.

Stories themselves have been considered as sources of inspiration in systems based on adapting existing stories to make new ones. The MINSTREL system [167] applied case-based reasoning procedures to adapt the structure of a moral and, by successive adaptations to match an intended situation, provide a plot line for a story. The system relied on planning and problem solving for addressing a set of character goals and author goals. The same approach is applied in the Skald system [160], which originates as a rational reconstruction of MINSTREL. Knowledge intensive case-based reasoning procedures based on description logics were employed in the KIIDS system [66], which relied on an ontology of fairy tales based on Propp's model [126] and a framework of components to build storytelling systems [123]. Case-based reasoning techniques were also employed to enhance planning-based systems, such as the use of vignettes [146] to capture recurring sub-structures within a plan. The structure of existing stories has also been reused by generating new stories based on analogy with existing ones [121, 144]. Case-based reasoning techniques have also been used to add flexibility to story generation methods based on story schemas [72]. Based on simple processes of retrieval and adaptation new plots can be constructed as combination of simpler schemas [67]. More elaborate procedures based on partial-order planning are used for adapting existing plot lines to match computer role-playing games [93]. Combinations of existing stories along the lines of the cutup techniques of the Surrealists are proposed as a way of building narrative twitterbots [169].

Researchers working on the development of story generators have also found interesting ways of developing resources to drive their system by extracting information from additional sources. The Flux Capacitor system [168] is designed to generate transformative character arcs that make sense and have dramatic interest. Character arcs of this type are compiled from a corpus by searching for combinations of properties and events with contrasting meanings. These character arcs are pro-

posed either as short story pitches themselves or as supporting resources for story generators. The SCHEHERAZADE system [92] relied on crowd-sourcing methods to compile a set of linear stories for a bank robbery, which were then used to construct graphs of possible branching paths of development for an initial situation. These graphs were then used to build variants of the situation in question.

### 9.4.2 Systems That Generate Discourse Based on Neural Networks

A different approach to modelling the way in which humans address the task of literary creativity lies in the application of neural networks. The human brain is essentially neural in its construction, so it would seem that a solution to the task based on technologies that emulate that construction might be very appropriate.

Attempts have been carried out to apply deep neural networks to story generation [98]. This type of approaches require a large volume of data to train the neural networks. For story generation, such systems need to operate at the level of abstraction of event representations. Because the representation used in this approach involves a sequence of events presented in a particular order, and the system generates stories represented in this form, it corresponds to operating at the level of discourse in terms of our taxonomy.

The system is based on the hypothesis that a network trained with sufficient number of sequences of event representations corresponding to stories might be able to reproduce equivalent sequences. The effort carried out involved the development of a representation for events that might capture the relevant details, the compilation of a corpus of 42,170 sequences of events corresponding to movie plots mined from Wikipedia, and training a neural network on the resulting sequences to predict the successor event to a given partial story. The authors of the approach report poor story generation performance. This type of technology has proven to be extremely successful in other fields, but the nature of the story generation task as currently addressed seems to be ill-suited for this approach.

### 9.4.3 Emergent Discourse in Interactive Systems

Interactive systems that rely on pre-authored content to respond to the user's actions are not considered story generators, because the content of the experiences they provide has been pre-authored by the designers rather than constructed by the system. But some systems respond dynamically to user's actions by constructing plausible continuations to the accummulated interaction, and in these cases the system is indeed constructing story-like fragments. These systems usually generate a full continuation to the end of the story at each point of interaction. This happens because system operation imposes a need for recalculation when further actions by the user render invalid the continuations previously computed. Under this light, the system is generating at each point a complete story, though most of those will be discarded before the interaction ends. The actual story that the user experiences is not really one that the system has planned, but rather the accumulation of partial attempts to follow the succession of possible stories plotted by the system. In that sense, even though an intended fabula at each point is computed by the system, the discourse corresponding to the experience of the user can be considered to be emergent from the interaction rather than generated explicitly by the system.

Of the systems reviewed in Section 9.3, those that are interactive build fabula at each point of the interaction, which is used to produce only the system's contribution to the discourse at the next turn. The user's intervention is then considered and this will generally force a re-planning of the fabula. For this reason the technologies they employ were reviewed as solutions for fabula construction and their relevance to discourse generation is discussed here. In general terms, they rely on the technologies employed for developing fabula reviewed in Section 9.3, but instead of generating a complete fabula and then rendering it as discourse (as might be achieved by combining solutions from those described in Section 9.3 with solutions described in Section 9.4.4), they develop a new continuation fabula at each stage of the interaction, based on concatenating the contribution from the interactor with the context of the story so far, and generating a consistent fabula from that point on. As the contributions of the interactor may not always match the actions that had been planned in the prior version of the fabula, partial plans that were under way at the point the interaction takes place may be thwarted, and new plans need to be introduced from that point on. This leads to overall discourses that capture the essence of conflict mentioned in Section 9.3.2, without the need to provide for specific technologies to achieve them. This advantage has lead to a proliferation of systems that address interactive narrative instead of generation of complete stories as a finished whole.

A pioneer system of this type was the Façade system [100, 101], which allowed the user to attend dinner at a couple's flat, interact with the characters, and witness the deterioration of their relationship as dinner progresses. Based on the concept of *beats* – small pre-scripted fragments of how the story develops – and relying on natural language input for communicating with the system, the system provided an impressive experience.

The nature of interaction considered in Cavazza, Charles, and Meads interactive sitcoms [27] is to allow the user to interact with the objects relevant to the narrative that the characters are relying on to achieve their goals. Although the user does not appear in first person in the narrative, she has the ability to pick up objects and change their location. This may force ongoing plans of the characters to fail, forcing them onto alternative solutions.

Cavazza et al [24] present an interactive narrative experience where the user watches a story unfold as a silent movie – with dialogues presented in textual overlays – and may shout advice and encouragement to the characters over a microphone.

In the NetworkING system [134, 135, 136] the user can create their own episode of series on medical drama by constructing a desired initial network of relations between the characters and then setting the episode to run. The evolution of the relations is visualised in terms of the social network and also as a 3D animation.

The U-DIRECTOR system [115] relied on a narrative planner to implement an interactive learning environment in which a user acts as a medical detective trying to solve a science mystery in the domain of microbiology.

The Marlinspike system [164, 166] created interactives dramas by interleaving actions by a user with pre-authored scenes to build stories based on Aristotle's definition of plot [78].

The EMOEMA system [26, 29] allowed the user to speak into a microphone, detected emotional states from the tone of the user's speech, and this emotional information was used to drive the system.

### 9.4.4 Systems That Compose a Discourse for a Given Fabula or Storyworld

A different research line related to the generation of narrative addresses the production of stories as means of reporting observed facts in the form of stories. In this approach, the events to be told are already determined in some way either by observation from real life or by a preceding process of generating them via a simulation, a planning process, or some other computational procedure. In our terminology, such a set of events constitutes a fabula – if all of them are to be included in the final result – or a storyworld – if only a subset of them will be included. The goal of the process is to find the best way of communicating this set of events as a story in an optimal form. This task has been termed *narrative composition* [58, 61, 62].

The following sections review systems that address the task of narrative composition in different contexts. Section 9.4.4 outlines some relevant aspect of narrative discourse discussed by narratology. Of these, only some of them have been addressed computationally. Section 9.4.4 presents a number of simple instances of narrative composition. The reviews of more elaborate systems that address specific aspects related to narrative discourse have been grouped into three separate classes depending on which aspect they focus on mainly to organise discourse: focalization in Section 9.4.4, time in Section 9.4.4, and the suspense they evoke in a reader or interactor in Section 9.4.4.

### Basic Concepts of Narrative Discourse

The fundamental concepts required to understand this task have traditionally been considered by narratology in terms of the differences between the fabula underlying a given narrative and the discourse used to convey it. The seminal work on this subject is Genette's treatise on narrative discourse [52]. Genette focuses on the fact that the discourse arises when the fabula is narrated by someone – a narrator – to someone else – a narratee. A number of important features of such a discourse need to be considered:

- *Function:* interventions by the narrator can be oriented towards achieving goals of a different nature (the narrator reports the fabula, the narrator comments on the organization of his discourse, the narrator checks communication with the narratee, the narrator qualifies the truth of his discourse, the narrator introduces comments concerning his relation to the material presented)
- *Order:* events may be presented in the discourse in a different order than they occur in the fabula (for instance, flashbacks describe an event that has happened earlier in the fabula at a point of the discourse dealing with a later stage of the fabula)
- *Frequency:* difference in frequency of occurrence of events between fabula and discourse: events that appear repeatedly in the fabula but are mentioned once in the discourse indicating that they happen often, events that happen once in the fabula but are presented several times in the discourse, events in the fabula ommitted from the discourse, etc.
- *Time of narration:* the discourse is told at a time removed from the time at which the fabula ocurred

- *Voice:* who narrates the discourse in relation to the characters who appear in the fabula
- *Mood:* combination of distance – whether speech occurring in the fabula is reported directly or indirectly – and focalization – which character (if any) from the fabula is being followed by the discourse

A particularly important aspect of the mood of narrative discourse is focalization, which concerns which character is perceiving the story that the reader is being told. In most cases, the storyworld includes more information than will eventually be conveyed to the reader in the fabula. A frequent way of filtering what information is told is to restrict it to the view of the story that a particular character has. If this *focalizing character* apears in the story, focalization is said to be *internal,* if not, *external.* If the story is told by an omniscient narrator, this is referred to as *zero* focalization. Genette [7] further refines this classification by distinguishing narratives where the focalization is *fixed* if the story follows a particular character throughout, *variable* if focalization changes from one character to another as the story progresses, and *multiple* if the same parts of a story are presented from the point of view of different characters.

Focalization on a particular character narrows the set of events to be conveyed to those perceived by the character in question, but it may also colour the perception or interpretation of those events based on the psychology or the ideology of the character [147].

The temporal order in which events are presented in a narrative and how it impacts the reader's understanding of a story is the focus of work by Winer et al [175]. This work outlines a formal model of how the same set of events in a fabula induces different perceptions on the reader depending on the relative positions in which these events are presented in the discourse.

## Simple Instances of Narrative Composition

Eger et al [39] propose the Impulse temporal modal logic as a language for the representation of narrative, specially applicable to the task of narrative discourse generation. Impulse combines features from Interval Temporal Logic (ITL) [2] and a model of characters' beliefs, desires and intentions (BDI) [32]. The authors argue that such a complex representation language is required because, for the generation of specific types of discourse, such as first person narration or detective stories, it is imperative that the system be able to reason about the beliefs of the different characters, and about the duration and relative timing of both these beliefs and the actions in the story.

Hassan et al [79] had identified the possibility of generating stories by first building a world in which the story take place, running a simulation to generate events to configure the story, selecting a subset of those events, and finding a way to tell those events as an interesting discourse. Their system generates biography-like narratives based on a multi-agent social system combined with a natural language generation module that carried out tasks of content determination, discourse planning and surface realization.

The construction of narratives based on sport games became a focus of academic interest some years ago [3, 14, 87]. The idea was to develop technologies capable of taking as input the statistics of a given game and producing the narrative text that

a human reporter might have written to describe it. This task involves both stages of content determination – what parts of the game should be mentioned and which should be ommitted – and discourse planning – how the selected messages should be organized into a sequence and related to one another. This line of research has lead to the establishment of profitable companies.[3]

The Raconteur system [58] arose as a computational model of how people observe a broad set of facts occurring within their perception, select subsets of them that make sense as units of communication that might interest other people, and package them as a narrative discourse. The propotype operates over the algebraic notation of a chess game, understood as an exhaustive record of a baseline representation of reality – with pieces as characters, squares in the board as location, and chess movements as character actions. This corresponds to our concept of a storyworld. Perception for each chess piece is defined as a limited number of squares around them, and this allows for computational exploration of the concept of focalization, whereby the view of what happened in the game that each piece has can be constructed procedurally. This results in a set of narrative threads or *fibres*. From this information, a number of possible discourses can be composed by selecting particular fibres (or subspans of them) and interleaving them at will to reproduce the sequential nature of narrative discourse that combines more than one narrative thread (as usually seen in novels, films, or TV series). Later work based on a similar formalism reviews instances of well known stories in search of baseline heuristics that might be used to drive this process of combining narrative threads into appealing sequences of discourse [62].

The nn system [113] – later renamed Curveship – was an interactive fiction system that included modules for generating narrative variation in the textual outputs passed on to the player. In this system an underlying fabula is established by the interaction of the player with a set of pre-authored branching storylines, in the tradition of interactive fiction systems [142]. The system included functionality to generate a variety of discourse for presenting this fabula to the user, including options for altering its chronology, duration, frequency, mood and voice. This is one of the most elaborate solutions for narrative composition in existence, but its impact on the field was very limited due to the fact that its application was, by design, restricted to the contributions of a single turn in an interactive fiction setting, rather than applied to a complete fabula. As a result, the system did not address the issues of how to decide on values for its various configuration parameters over the discourse for a complete fabula.

Niehaus and Young [117] developed a system that generated narrative discourse from a partial plan representing story world facts. Their system is based on a cognitive models of how readers understand narrative discourse, and it is designed to optimise the comprehension of the resulting discourse.

Alves et al [4] present a comics summarisation system that creates comic-like summaries of the logs of stories generated by FearNot! system [5]. In this case, the log generated by the FearNot! system constitutes the fabula used as source, and the comic-like summary corresponds to the discourse generated from it.

---

[3]https://narrativescience.com/

## Discourse Generation Based on Focalisation

Modelling the way in which humans tell stories about reality by focalizing on particular characters was the main goal of the Raconteur system [58]. This was addressed from the point of view of perception exclusively, with no regard for psychology or ideology. The rationale of how the extent of perception is inferred from the objective information on relative location of the characters and events was explained in [54]. An important insight arising from this study was that in such an approach even inactive characters may require explicit mention if and when they enter or leave a character's perception as a result of the motion of the active character. Another important insight was the need for introducing explicit contextualisation statements at the point of switching between focalizers in those cases where the switch involved a significant displacement in time or space with respect to the preceding segment of discourse. In a similar set up, [57] explores the task of selecting a particular set of threads out of an exhaustive description of the storyworld. Faced with an input that includes everything that has happened to the set of characters over the whole story world – in this instance represented by a complete chess game – a number of metrics are defined over the narrative threads that result from focalizing on particular characters. The metrics capture issues such as length, coverage of the overall game, or appearance of interesting events. Based on the results of these metrics, a subset of the threads is selected to include in the final discourse, aiming to obtain the most interesting story out of the game. This effort focuses on the role of focalization in content determination.

The Virtual Storytelling system [161] combined behaviour patterns defined for particular agents actings as characters in the story with a story director agent, who was in charge of selecting events from the simulated game world that, combined together, constitute a valid instance of its model of plot. The director agent can also change the goals of characters or introduce new characters in order to improve the plot that will result.

Porteous et al [30, 133] introduce the notion of a character's *point of view* to allow the story to be told differently from the perspectives of different characters. They explore its application in their Interactive Narrative based on Shakespeare's "Merchant of Venice", which allows them to generate very different stories depending on the point of view adopted. Their planning-based solution relies on having different representations for the same narrative action to capture differences in point of view. Differences in the representation of actions may involve having different preconditions or different effects, and this leads to differences in the plans computed to represent the story. The initial point of view established for a character – describing their attitude in a generic way – leads to a choice of story actions with effects that add the correct nuances for that attitude. For instance, if Antonio starts off from the point of view of a victim, he will accept Shylock's loan with concern about the forfeit, but if he starts off from the point of view of a risk-taker he will accept without concern. This implementation shares the use of constraints on the plot to be followed presented in [138]. In this case, the constraints are employed to establish the set of actions fundamental to the plot that need to be considered regardless of the point of view. The design of the interaction involved allows the user to request changes in point of view, switching to that of another character, so that the different variants may be explored.

Bae et al [6, 7] provide another view of focalization from a planning-based perspective. In particular, they focus on how to achieve computational models of multiple internal focalization, where the same parts of the story are told from different perspective of the characters involved in it. This is achieved by providing each story character with an individual plan library to interpret the story from their own perspective, and relying on a planning algorithm for each focal character to infer information about story events not directly accessible to them. Differences in plan libraries between different characters may consist of: different operators, different preconditions, different effects. In instances of multiple internal focalization the same story is told several times from the point of view of different characters. All characters share some parts of their plan libraries to allow the reader to identify that the same story is being told. Yet in each iteration the telling of the story should provide new information to the reader, to justify the repetition. The new information arises from the difference in point of view. To model computationally this type of situation, a basic plan for the story is constructed relying only on shared events. Then each focal character fills in this shared story by applying their own plan library to fill in any gaps. This results in different stories for different focal characters, yet all sharing a core set of events. Bae et al propose a parameter provided with the input, the *focalizing factor*, to capture the psychological state of the character at a given point (beliefs, desires, intentions) that may affect how focalizing on that character should be addressed in terms of planning.

Porteous et al [137] address the challenge of extending plan-based narrative generation to deal with stories including multiple subplots rather than a single linear plot line. They prototype their approach in an Interactive Narrative in a medical hospital drama in the serial drama genre. Whereas previous efforts in the field had focused on generating single plots, sometimes allowing for multiple goals, this effort focuses on the generation of multiple subplots. It also addresses important issues such as how to distribute characters over subplots, how long to make the subplots, and when to switch between them. The coordination of subplots is addressed by heuristic search over the graph of subplots, relying on heuristic knowledge on subplot combination – duration, ratios, switching – obtained from media studies literature. The system requires as input a set of partially ordered authored subgoals for each of the subplots that act as a mechanism for structuring narrative content. This is authored by the user by means of a graphical interface. A heuristic search over the resulting space of ordered subgoals leads to the identification of the next subplot for which a segment of narrative should be generated. It also identifies the target subgoal that the segment should aim to reach. This approach interleaves the generation of content and the planning of the discourse, generating dynamically the fragments of the fabula at the point where they are required in the discourse.

The issue of multi-threaded plots arises also in the model of discourse composition proposed by Doust [38]. In this case, the heuristics proposed for combining subplots together are based on an analysis of the suspense generated at each point. They are discussed further in Section 9.4.4.

## Discourse Generation Based on Chronology

Bae and Young's Prevoyant system [8] addresses the issue of temporal re-ordering of material from the fabula when it is presented in the discourse by providing a computational method for introducing instances of flashback and foreshadowing in

the resulting discourse. They focus on solutions that contribute to the evocation of surprise in the reader's mind. Flashbacks relate to surprise in that they are used to explain how the surprising situation came about, and foreshadowing relates to surprise in that it may provide hints that the surprise is coming. The procedure they follow is based on providing a model of the process by which the reader reconstructs the story as it is read, and relying on this model to identify reactions of surprise at particular points during the interpretation. Prevoyant takes as input a plan data structure that describes the plot of the story, which would correspond to the fabula in our use of the term. A generator and an evaluator model work in an iterative generate-and-test fashion, constructing candidate discourses for the input fabula and testing them to see if they evoke surprise.

Porteous et al [138] present a system for interactive storytelling in which the basic planning and agent-based technologies are enriched with an explicit model of narrative time. This model enhances the representation of plans with information about the start time and the duration of the planned actions. The system drives an interactive narrative where virtual agents enact situations inspired by Shakespeare's play "The Merchant of Venice". The overall gist of the desired plot is described as a set of narrative constraints that impose relative timing restrictions on different events. Based on these constraints the process of narrative generation is decomposed into a sequence of sub-problems, a temporal planner is used to solve each sub-problem, and the resulting solutions are assembled into a final narrative.

## Discourse Generation Based on Suspense

The Suspenser system [31] is designed to operate on a three-stage pipeline architecture for story generation: a planning-based system generates a plan to represent the story that is to be told, the Suspenser system receives this fabula and plans a discourse for presenting it to the user, and a final stage converts the resulting discourse into some presentation medium in which an audience can access it. Although the intermediate outputs are referred to as a *fabula*, a *sjuzhet* and a *discourse*, in the terms used so far in the present chapter they would correspond to a storyworld, a discourse and a rendering. In their paper, the authors suggest that the Fabulist system (already reviewed in Section 9.3.1) may be used to produce the initial plan of the story, and Callaway's AUTHOR [17] or Jhala's Darshak [81] systems to produce narrative prose or cinematic visual discourse as a final medium (see Section 9.5.2 for details on both systems). Suspenser itself operates on a given plan for the story and a particular time point in the story, and determines what discourse should be employed to tell the story to the given time point in order to achieve a certain level of suspense (which is provided as an input parameter). To achieve this, Suspenser relies on a three module architecture consisting of a *skeleton structurer*, a *reader model*, and a *suspense creator*. The skeleton structurer identifies the core elements of the story that cannot be eliminated without harming the reader's understanding. The reader model emulates the process by which a human reader understands the story as it reads the discourse, and essentially this computes the set of plans open to the protagonist as inferred from the information available to the reader at a given point of the discourse. The suspense creator takes as input the sequence of core elements identified by the skeleton structurer, and at each step considers what additional plan steps from a portion of the story preceding the step might be added

to allow the reader to infer the minimum number of solutions (as predicted by the reader model).

Doust [38] presents a computational model of how the evocation of suspense in a reader arises from the multi-threaded nature of a narrative. This account is based on the premise that a narrative involves a sequential discourse in which focalization switches between a number of narrative threads, each focalized on a different character. The model provides procedures to compute the perceived suspense at a certain point in the discourse, in terms of issues such as whether the narrative thread in question is still to be completed (*completion-based suspense*), whether it involves potential conflict with other threads in the narrative (*conflict-based suspense*), or whether an event in a thread allows the reader to infer prior events that have led to it but which have yet to be revealed (*revelatory suspense*).

## 9.4.5 Systems That Combine Fabula and Discourse Construction

Finally, there are systems that combine the construction of fabula and discourse, basing their decision processes on inputs from both the fabula and the discourse level.

Winer and Young [176] present an approach to story generation as a dual problem, requiring the solving of a problem concerning what fabula to consider (which they describe as the *story problem*), and a problem concerning the discourse to be used to convey it (referred to as the *discourse problem*). In contrast to traditional solutions that address these problems in a sequence, as a pipeline that first creates a fabula and then a discourse to convey it, they propose a *bipartite planning* approach, in which narrative generation is driven by the discourse: a discourse planner builds a representation for the discourse and any constraints on the fabula arising from the discourse built so far are passed on to a story planner that builds a representation of the fabula ensuring it is compatible with the discourse. Because their solutions are based on planning technologies, the representations of both fabula and discourse are actually plans.

The StoryFire system [64, 65] models the way in which humans sometimes produce partly fictional stories based on real life events. The system processes an exhaustive record of facts registered over a domain limited in space and time (corresponding to a storyworld in our terms), linearises the perceptions of it that characters involved may have into narrative threads, searches for partial matches between these linear perceptions and a set of existing plot schemas, selects a pairing of narrative thread and plot schema that matches well, and builds a narrative discourse by instantiating the plot schema with details from the corresponding observed events. Because the match may be only partial, the final narrative discourse will include events that were not observed but have rather been fictionalised to fill in the gaps that observed facts from the chosen narrative thread left in the chosen plot schema. This approach blends information from the fabula level – narrative thread of events observed in the storyworld – with information from the discourse level – sequences of events expected in a chosen plot schema.

Piacenza et al [131] present a system that takes as input existing video segments of filmic content and generates narrative structures tha represent different stories that might be told including those segments. This approach combines constraints on the discourse extracted from the available video segments with constraints on the fabula imposed by the narrative generated in each case.

The PlotShot system [20] is capable of generating fabula taking into account constraints on the discourse in the form of pictures that are expected to illustrate the resulting story. The system generates illustrated stories around a set of user-supplied photos by first representing the given photos via *scene graphs* – semantic networks that describe the photos content – applying planning techniques to build a story that incorporates the scene graph material associated with the photos, and building an illustrated story that combines the generated narrative and the given photos.

## 9.5 Producing Renderings for Proto-literary Drafts

The systems described in this section correspond to two different types, based on whether they generate a text from scratch or whether they create a text to convey a given content.

### 9.5.1 Systems That Generate Text Directly

Approaches aimed at generating text directly tend to focus on the production of poetry, where the explicit form of the text is often given priority over its underlying meaning. Taking advantage of this licence, poetry generation systems often rely on techniques based on reusing existing text by carving it out into fragments to be recombined or templates to be completed and recombined [55]. Templates are usually made of chunks of text to be left untouched with gaps to be filled with words obtained from other sources. The generation of poetry exhibits important similarities to the generation of narrative in as much as the same set of levels of representation of its subject matter can be considered, and much the same cognitive processes of the authors are involved. However, there are significant differences to be considered between the genres, and the sheer volume of existing work on the subject [74] makes it advisable to leave this topic for further work.

Within the context of narrative generation, there has been some work on modelling the generation of continuations of stories from a given text representing the prior context of the story. The Creative Help application [149, 150] provides automated writing assistance in an interactive fashion by suggesting possible continuations for the story typed so far by the user. An earlier version [150] relied on case-based reasoning technology by returning suggestions based on prior stories similar to the one being written. This had the disadvantage of modelling the suggestion on the context of the prior story rather than the current one. A more elaborate solution relying on Recurrent Neural Networks has been reported recently [149].

Further work along these lines is related to the Story Cloze Test [114]. This test was proposed as a new method for the evaluation for story understanding and script learning. A system taking the test is provided with a four-sentence story and two possible endings, and it has to choose the correct ending for the story. The instantiations of the test have produced substantial corpora of five-sentence commonsense stories in textual form. Based on these corpora, machine learning approaches to the generation of a sentence to round off a given four-sentence story have been attempted using Generative Adversarial Networks [95].

In all of these cases, a textual contribution to a story is generated, but rather than being constructed independently it is constrained by an input text considered to describe the prior context. This is closely related to the emergence of discourse in the interactive setting described in Section 9.4.3, in as much as it focuses not on the construction of complete stories but rather on partial contributions to a prior context.

The use of neural network technologies for addressing this task has a significant potential for future success. However, given the complexity of identifying what is precisely being represented in the neural network in each case, it becomes difficult to classify these approaches in terms of the levels of representation of narrative that are actually considered. It is possible that the abstraction procedures involved in these techniques indeed capture features that go beyond the textual representations being represented explicitly.

## 9.5.2 Systems That Generate Renderings for a Given Discourse

Although all of the systems reviewed so far include some module to transcribe their outputs into format understandable by an interested observer – whether in the form of text or as 3D animations – in most cases the solutions applied to this stage of the process are intended to be barely functional rather than address aesthetic challenges associated with that step of the creation process. There are however special cases where specific research effort has been invested into improving the quality of these steps of rendering a discourse in specific formats. Such systems are reviewed in the present section. Reviewed efforts are grouped into those that focus on generating prose, those that focus on generating dialogue, and those that focus on generating cinematic discourse.

### Prose

Callaway's AUTHOR architecture for rendering narative prose [17] was a pioneering effort in the world of natural language processing in that it addressed the problem of generating narrative prose for a given description of a narrative discourse. The architecture relied on the FUF/SURGE unification-based functional systemic grammar [41, 42] to deal with surface realization in specific languages. The architecture accepted as input a fabula, an associated ontology to represent the entities involved, and a *narrative stream*, which corresponds closely to the concept of discourse we have been using in this chapter. The generation process took into account important narratological concepts such as the time of narration – which drives the choice of tense for verbs – distance – which affects the way in which dialogue is reported – and voice – which affects whether first or third person should be employed. It also addresses known natural language generation tasks of sentence planning such as referring expresion generation, lexical and syntactic choice, and aggregation. In this sense, this is the most complete system addressing this level of operation of a story generation system. The AUTHOR architecture was a theoretical proposal that was instantiated in the STORYBOOK narrative prose generator that generated prose for a discourse plan of the story of Little Red Riding Hood. STORYBOOK accepted a discourse plan for that particular story. As the reported evaluation is restricted to this context, it is unclear how well STORYBOOK might cope with discourse

plans for other stories. Because it relied on heavy effort of knowledge engineering to produce the required linguistic resources that inform it, it is probable that it may be difficult to port to other domains.

Li et al [94] approach the rendering of stories as text in a different fashion. Expanding on their earlier work on crowd-sourcing plot graphs for stories in a given domain [92] (reviewed above in Section 9.4.1), they collect additional possible renderings for the story segments stored in the graph. A given plot graph represents events in a story as clusters of natural language descriptions of similar meaning. When realizing a particular sequence of events for a story and aiming for a desired narrative style provided as input, the system generates a text by selecting the sentence from each cluster that best matches the desired style. This is more of a case-based reasoning approach, where descriptions for prior events are reused to describe a new event instance.

Rishes et al [148] propose a solution for generating different tellings for a given semantic description of a story. This solution accepts input in the form of a *story intention graph* representation as provided by the Scheherazade story annotation tool [43] and relies on the PERSONAGE NLG system [96] to build a textual rendering in a specific style. The approach has been tested on data from DramaBank, a collection of texts annotated with Scheherazade that range from Aesop fables to contemporary nonfiction.

Montfort's nn/Curveship system [113] was designed to produce narrative variation in interactive fiction. Based on sound narratological principles, it included procedures to deal with narrative time, alterations in chronology, speed, frequency, mood, and voice. For all of these, it implemented the corresponding functionalities required to provide appropriate linguistic renderings. To this end, it included its own microplanner and surface realization modules. These modules are integrated into the system architecture and not generally available for reuse in other contexts.

Elson and McKeown [44] propose a method for assigning appropriate English tense and aspect to the realizations of symbolically encoded narratives. This proposal focuses on calculating from the relative chronologies of discouse and fabula the linguistic parameters required for correct rendering of verbs.

The attempt to apply deep neural networks to story generation [98] (already described in Section 9.4.2) included an additional module for the generation of text from the constructed event description. An additional neural network was trained to produce a natural language sentence from the representation of an event. As with the attempt to construct a discourse in terms of a sequence of events conforming a story, the authors report poor quality in the generated text for the stories so obtained.

## Dialogue

Dialogue is a fundamental ingredient of narratives in most of their formats. Yet in most of the system reviewed dialogue is handled by inserting a description that conveys the idea that the characters had a dialogue at that point. This solution conveys the desired meaning but restricts the corresponding systems to one possible choice of Genette's concept of distance of a narrative discourse. Ideally, narrative generation systems should be able to operated across the full range of possible values for distance, including different means for reporting that characters talk. The most valued possibility is that of including dialogue between the characters.

The Façade system [100] was itself a dialogue, where the user interacted with the couple that had invited her to dinner, and whatever the user said influenced the course of the evening. The player participates in the dialogue by typing text that appears at the bottom of the screen. The system is designed to react to user intervention by altering the state of the simulation and/or having the characters reply. Replies by the characters are pre-determined as a set of beats and the system chooses among them. Strong and Mateas [158] elaborated on the construction of dialogue in Façade, describing conceptual structures they refer to as *affinity games*, where a character participating in a dialogue brings up an emotionally charged issue, argues about it, and forces other participants to take sides in their argument. The affinities characters feel towards one another are influenced by whom each one takes sides with. This work provides computational models of how dialogue can be employed as a means to test and trigger the dynamic establishment of affinities. In this model, a hierarchical task network (HTN) planner is used to create dialogue structures, as it implicitly models the way a conversation is sometimes composed of smaller spans addressing specific topics. Once a plan for the conversation has been created, an interpreter steps through the plan, relying on simple template-based generation to produce a textual rendering of it.

Cavazza and Charles [23] explore the problem of generating dialogue between characters in interactive narrative systems. They do this by relying on Bremond's analysis of the relations between narrative roles and the form of translating them into linguistic expression in dialogues between characters [15]. Dialogues are generated in units of a pair of utterances, to ensure coherence as a stimulus-response combination. They are generated in the context of a sitcom narrative, and they are designed to take into consideration affinities between the participating characters to influence the style of their dialogue contributions. The system considers decisions on modality of expression (distinguishing between explicit and implicit conveying of the desired information), actual semantic contents for the utterance, and generating the surface form of the utterance (which is presented mainly as a task of lexicalization of the content). The technologies employed to support these decisions are: a rule-based engine to drive the choice of modality, a template-based generator that returns appropriate templates for semantic content based on the input from the narrative and the decided modality, and a lexicalisation module that selects which lexical template to employ for the final linguistic utterance.

Hajarnis et al [77] developed an intelligent authoring tool to help non-technical users to generate dialogues between characters for inclusion in movie stories. They apply a case based planner with hierarchical plan adaptation capabilities to construct a dialogue act sequence, an information state update approach to ensure that dialogue content at each point is consistent with the preceding context – including the emotions of the characters – and a simple natural language generator – based on canned dialogue lines – to realize the dialogue in linguistic form.

Ryan et al [153] explore in their game *Talk of the Town* the possibility of freeform conversational interaction in playable media, relying on a combination of dialogue management, natural language generation (NLG), and natural language understanding. To achieve this, they explore a novel use of context-free grammars (CFGs) where, instead of the usual approach of terminally expanding top-level symbols to obtain a text to render them, they operate from mid-level symbols and traverse the grammar in all directions searching for optimal matches with the content to be realized. Underlying this approach is the tool Expressionist, designed to help specify a CFG to

be used to generate text in the context of a specific application. In the CFGs generated with Expressionist, the symbols in the grammar are annotated with application specific mark up. As a result, constructs built from the grammar carry with them a hierarchy of mark up that can be compared with content to be realised for optimal matches.

## Visual Discourse

Many of the narrative generation systems reviewed above rely on a 3D animation engine of some kind to present their discourses. In most cases, the specifics of how the conceptual description of the discourse is translated into cinematic discourse are not described in detail. However, that part of the process has been the focus of specific research.

The Darshak system [81] is a camera planning system that automatically constructs cinematic rendering in a 3-D virtual environment for the narrative plan of a given story.[4] Such a cinematic rendering is determined by the camera shot sequences to be used for telling the story. Darshak receives a fabula as input, identifies in it the relevant *dramatic situation patterns* – described in terms of the beliefs about the story world that the viewers should receive from them – and draws on a set of relations between these patterns and camera shot compositions and transitions – which it introduces to express them in the cinematic rendering. It uses a representation of these features based on plan operators and applies a planning algorithm to construct a plan of the visual rendering aiming to fulfill a set of communicative goals received as input. The algorithm is designed to generate a plan that captures the progress of specific story world entities, is coherent and is temporally consistent.

The Ember system [22] extends the approach in Darshak to allow the production of cinematics that include shots for explaining instances of characters deliberating about their own plans. These deliberations often involve recallling particular events already experienced, which at that point are being considered in a different light, or which linked with information recently acquired recommend a change to the plan that was being executed (hero remembers a particular scene that suddenly gives him the clue to realize that he has been tricked all along). Ember takes as input a plan for the story that includes situations in which particular characters deliberate regarding choices they make. The authors do not speculate as to how such plans might be generated, focusing instead on how they might be conveyed visually if they were present. To achieve this, they rely on a memory model of how a reader recalls events already experienced. When a deliberation step requires consideration of prior events, the planner will include a visual rendering of these events at that point in the cinematic rendering, even if the events had already been shown in an earlier segment.

---

[4]Jhala and Young refer to the cinematic rendering of the story as a *cinematic narrative discourse*. To avoid confusion with the specific use of *discourse* we are making in this chapter, we have adapted their terminology in the present description, and refer to this concept as a cinematic rendering of the discourse.

## 9.6 Modelling Cognitive Aspects of Literary Creation

Most of the generative systems discussed so far arise from an initial observation that a particular technology presents similarities with parts of the process of literary creation, or the data structures it manipulates present similarities with the structure of stories in one way or another. Planning, multi-agent systems, grammars, case-based reasoning, n-gram language modelling,... all these technologies have inspired story generation efforts based on analogies of this type. When such efforts prosper, they tend to produce artifacts that resemble human produced equivalents along some aspect of comparison – usually the one that inspired the initiative – but differ along every other one. In some cases, the resulting prototypes are later revised or extended with modules that model specific features observed in human authors. These extensions usually improve the quality of the results. There is an alternative avenue of exploration which focuses from the start on understanding the processes by which humans carry out the corresponding tasks, and aim to produce generative models that emulate the characteristics of those processes. This section reviews systems that follow this alternative path, or systems that, although based on existing technologies, present characteristics that make them similar to human processes.

Section 9.2.3 outlined the main characteristics observed in the studies of human writing carried out from the field of cognitive science. The main characteristic can be summarised as follows: the process carried out by humans involves creation of an initial draft which then gets repeatedly revised, pruned and/or extended after being evaluated for quality and suitability to the intended purpose. To model this type of process computationally would require: a method to produce material of the desired type, a method for evaluating material of that type, procedures for revising such material (ideally informed by the evaluations produced). This schema of operation corresponds closely to the evolutionary approach to problem solving. The present section reviews computational efforts of three types: systems that provide some mechanism for the automatic appreciation of proto-literary drafts, systems that build directly on cognitive models of human authoring, and systems that mirror the revision of drafts based on evolutionary methods.

### 9.6.1 Computational Appreciation of Proto-Literary Drafts

In the field of computational creativity, progress over the years has lead to an increase in the level of attention paid to the evaluation of the results of creative systems [82] and to attributing special value to systems capable of evaluating their own output [171]. As a result of these tendencies, research effort has been invested into computational solutions for the evaluation of outputs, as valuable systems in their own right. For the present chapter, it is relevant to consider research carried out on evaluation of stories in general terms [125], but also the development of formal metrics intended to provide measures of novelty of a generated story [124] or to quantify the degree of conformance of a given story to desired structural features related to focalization [59]. Bosser et al [13] propose a solution for the automation of the structural analysis of narratives by representing the narrative resources and actions in Intuitionistic Linear Logic and resorting to automated theorem provers to verify their structural properties.

Bae and Young's Prevoyant system [8] relied on a model of how the reader processes a given discourse, and this included a procedure to estimate the level of surprise experienced by a reader at a given point in the discourse.

The Event-Indexing Model [177] is an influential cognitive model for narrative comprehension. Based on this model Cardona-Rivera et al [21] tried to quantify how much agency a player would perceive from choices in an interactive fiction. Kive et al [83] used this model in Indexter, a plan-based computational model of narrative discourse that can predict the salience of events.

More elaborate models have been built to evaluate the level of suspense evoked by a given story. The Dramatis system [118] is a computational human behavior model of suspense. The model is based on Gerrig and Bernardo's definition of suspense, which assumes that readers explore the search space of options open to the protagonist, and experience a level of suspense related to the quality or quantity of possible ways to avoid impending negative outcomes. The system operates based on a model of salience that estimates which story elements are accessible to the reader at a given point of the story, and an algorithm for determining which escape plan would be perceived by the reader as most appropriate to save the protagonist. Based on these elements the system produces a rating for the level of suspense likely to be evoked at a given point in the story. This type of functionality was already implicit in the operation of the Suspenser system [31] reviewed in Section 9.4.4, however, the Dramatis system implements it as a stand-alone system to be applied to enhance other story generation systems.

Niehaus and Young [117] propose a cognitive models of narrative discourse comprehension which is designed to capture the process in which a reader understands the narrative as she reads it. The model predicts aspects of narrative focus and inferences that may be made by the reader. The model is applied in a system for the generation of narrative discourse from a partial plan representing story world facts, to inform decisions on selection and ordering of content with a view to ensuring the resulting discourse is easy to comprehend by the reader.

Fitzgerald et al [48] propose a solution to compute the affective responses that humans experience when reading or watching stories. Their solution is based on the assumption that emotional responses by the reader arise from a process of applying problem solving skills to any undesirable situations in which characters find themselves. A measure of relative tension is computed by identifying possible futures outcomes, estimating their utility and the probability that they will ocurr, and using these values to estimate expected utility.

O'Neill and Riedl [119] developed an intelligent agent capable of acting as a synthetic audience, modelling the reactions of a story recipient and providing constructive feedback.

Some recent work based on the use of neural networks attempts to simulate human appreciation of narratives. Wang et al [172] trained a classifier based on neural networks on a corpus of stories obtained from social media, based on the hypothesis that upvotes in social media may be taken as an approximate measure for story quality. Sagarkar et al [154] develop a metric for the quality of automatically-generated stories that is applicable to the task of story continuation as described in Section 9.5.1. They train a number of neural network models to predict whether a story continuation can be said to be interesting, relevant, and have high overall quality.

## 9.6.2 Generation Systems Based on Cognitive Accounts of Writing

The work of Natalie Dehn [37] explores the way in which a story construction procedure might be developed to mirror the way in which human authors operate by combining transitions from long term to short term memory, drafting solutions and storing them in long term memory, and fetching more than one partial solution from long term memory to re-elaborate them in short term memory into more concise partial solutions to be further stored in long term memory. The proposed solution is justified by a prior analysis of the operations observed in the creative processes of human authors. This underlying theoretical model of reconstructive and dynamic memory was used to implement the AUTHOR system described in Section 9.3.1. The Ember system [22] (reviewed above in Section 9.5.2) also includes a model of how a viewer remembers that story that he has already seen.

The MEXICA system [129] was developed as an implementation of the engagement and reflection model of the writing task proposed by Sharples [155]. This model conceives the writing task as an iterative cycle moving between a stage of engagement – in which material is produced – and reflection – in which the material already produced is revised and directives for the revision or further production of material are created. In the MEXICA system, the engagement stage is implemented as selection of further story actions to extend a given draft of the story discourse, and the reflection stage is implemented as an evaluation of the draft to compute the set of emotions of the characters and the tensions between them. The interaction between these engagement and reflection stages is designed to ensure that the draft of the discourse exhibits a rise in tension at the start of the story, a peak in the tension around the middle, and a decline in tension towards the end.

The need for computational models of tasks of literary creativity to contemplate such combinations of generation, evaluation, and revision has been explicitly addressed in the ICTIVS model [69]. This model proposed a set of five inter-operating stages involving *invention* – where fabula is determined by creating or selecting which content to include – *composition* – where discourse to convey the fabula is constructed – *interpretation* – where a existing draft is interpreted to estimate what a reader might infer from its perusal – and validation – where the result of interpretation is compared with the intended fabula and the desired purpose to assess quality and suitability. The model has been refined [70, 71] to consider how cycling through these stages may lead to trimming, extending or modifying the draft, but also how it might lead to trimming, extending or modifying the initial specification of the task - an extension that allows the concept of serendipitous findings to be modelled formally.

## 9.6.3 Evolutionary Generation Systems

Although the evolutionary approaches described in this section are not specifically intended to model human performance, they are included at this point of the chapter because the way in which they operate does mirror quite closely the approach of progressive refinement of a draft that human authors often apply.

The HEFTI system [120] proposes a mechanism for the generation of variants for a given story that is based on a genetic algorithm. An author specifies a story in terms of a story template built from story components, each one of which is defined as a chromosome containing genes. A chromosome represents a particular variant

of the story component at that point of the story template. The genetic algorithm relies on crossover and mutation operators to explore combination of the various story components in the given template.

McIntyre and Lapata [109] propose a data-driven approach to story generation that operates in two stages, one for compiling data on story structure from a corpus and one for finding combinations of those data into valid new stories by applying an evolutionary algorithm. The first stage compiles statistics on predicate-argument and predicate-predicate co-occurrence from corpora of stories. These are used to build knowledge structures that encode the likelihood of them appearing sequentially in a story. These knowledge structures are then used in the second stage to inform the generation process. Stories are generated by a three step process of content planning - choosing sequences of elements from the knowledge structures – sentence planning – applying a grammar – and surface realization relying on the RealPro realizer [88]. The system generates stories exhaustively, and applies a ranking method that quantifies stories based on a model of interest and coherence. An elaboration of this method [108] applies a genetic algorithm to explore the search space that results from the generate-and-rank method described.

## 9.7 Conclusions

The review presented in this chapter uncovers a number of issues that required discussion.

For a start, the organization of the review has shone a light on the complexity of the levels of representation that underlie narrative works. The distinction between storyworld, fabula, discourse and rendering allows us to study processes and criteria at each level of representation. The review of the systems included in the chapter shows that there is considerable complexity operating on the tasks to be carried out at each level, and considerable challenges to be addressed in the transitions across levels. In view of this consideration, it is clear that systems that decide not to represent particular levels known to be relevant to narrative are in fact opting out of the opportunity to really emulate human performance.

Another important insight is that the task of literary creation can be subdivided into a problem of inventing what to say, and a problem of coming up with good ways of saying it. These two problems are closely interlinked. It is indeed possible to think of something to say and simply say it with no concern about how it is said. Or to think of an interesting phrase and say it without really intending to convey a particular message by doing so. Yet the perceived quality of the literary works that humans appreciate is greatly influenced by both their content and their form, and indeed by achieving a pleasing balance between them. Computational systems trying to emulate human authors ignore this insight at their peril.

Regarding the task of deciding what to say, the review has also pointed out that, in the process of producing valuable proto-literary drafts, sometimes it is very important to work out what does not need saying. Even where content is correct and valuable, exhaustive transcription fails to mirror the way in which human authors approach the equivalent tasks.

Overall, it is clear that there has been a significant accumulated research effort over recent years in the field of computational modelling of narrative creativity.

From the initial efforts that simply generated a sequence of actions linked by some sense of purpose related to a basic goal, the field has gone a long way. Some of the recent systems are focusing on issues that narratologists consider important and valuable features of human narratives. Yet the review also points out that the efforts at computational modelling to date are still far from covering the breadth of phenomena that narratology considers relevant to narrative.

First, in terms of how many of the relevent phenomena are actually covered by existing research. Whereas order and perception-based focalization are being addressed in systems that build discourse, and time and distance are addressed in systems that render such discourses (and voice as well in some partial way), important issues such as narrator function or ideological or psychological focalization still remain unexplored in computational terms. Part of the problem is that these features are closely tied with having a rich and complex model of the minds of the characters that appear in the story. Some of the reviewed efforts consider computational solutions such as the BDI framework to inform their processes, but this is still restricted to a few cases, and even there the exploitation of this rich source of information is restricted to achieving particular effects.

Second, because even for those phenomena that have been explored specifically in experimental solutions there has yet to be an uptake of the demonstrated improvements across other story generation systems. The efforts made so far have taken place mostly as a result of individual doctoral theses aimed at targeting a specific problem and demonstrating a potential for solving it. In most cases once the doctorate has been achieved the researcher is driven on to work on problems with higher chances of receiving funding. Whereas more complex solutions that integrate solutions addressing more than one specific phenomena would have significantly higher chances of coming closer to human performance, the current ecosystem for research – with its tight focus on solving problems directly applicable in industry in the short term – is not conducive to such projects being undertaken.

Third, because complex narratological features involve consideration of the effect of the narrative upon the reader. Computational modelling has gone a long way in this sense, with many of the reviewed systems including simple models of the reader, but those models are restricted to specific features, and even though considered together they cover a valuable set of aspects, in truth each of them is applied to a different system, and each such system usually ignores most of the other aspects even if computational models for them exist. In contrast, human authors have available extremely complex psychological models of human behaviour, which they are free to apply to both their characters and their readers. This is a significant advantage that computational efforts will find very difficult to emulate.

Finally, as an overarching conclusion of this survey, it seems important to point out that, for a task as complex as narrative generation, the prevailing tendency towards single technology systems – where a single technology is applied to a problem in exclusion of all other available technologies – appears to be inadequate. If narrative generation has been shown to benefit from technologies as different as agent-based systems, planning, case-based reasoning, logic, rule-based systems, evolutionary approaches and neural networks, and if observation of human authors at work suggests that many of the corresponding capabilities are combined into the construction of a single draft, the scientific community should accept that solutions to the problem of narrative generation would obtain better results if they considered combinations of technologies rather than spend further efforts to demonstrate that

any particular technology is the silver bullet that will solve the task. At the time of writing, it seems that important breakthroughs await whoever manages to find such combinations.

*Acknowledgement.* The work reported in this chapter has been partially supported by the IDiLyCo project (TIN2015-66655-R) funded by the Spanish Ministry of Economy, Industry and Competitiveness and the FEI-EU-17-23 project InViTAR-IA: Infraestructuras para la Visibilización, Integración y Transferencia de Aplicaciones y Resultados de Inteligencia Artificial.

# References

[1] Abbott, H.: The Cambridge Introduction to Narrative. Cambridge Introductions to Literature. Cambridge University Press (2008). URL https://books.google.es/books?id=Jyyt1826rhsC

[2] Allen, J.F., Ferguson, G.: Actions and events in interval temporal logic. Journal of Logic and Computation 4(5), 531–579 (1994). DOI 10.1093/logcom/4.5.531. URL http://dx.doi.org/10.1093/logcom/4.5.531

[3] Allen, N.D., Templon, J.R., McNally, P., Birnbaum, L., K.Hammond: Statsmonkey: A data-driven sports narrative writer. In: Computational Models of Narrative: AAAI Fall Symposium 2010 (2010)

[4] Alves, T., Simões, A., Figueiredo, R., Vala, M., Paiva, A., Aylett, R.: So tell me what happened: Turning agent-based interactive drama into comics. In: Proceedings of the 7th International Joint Conference on Autonomous Agents and Multiagent Systems - Volume 3, AAMAS '08, pp. 1269–1272. International Foundation for Autonomous Agents and Multiagent Systems, Richland, SC (2008). URL http://dl.acm.org/citation.cfm?id=1402821.1402848

[5] Aylett, R.S., Louchart, S., Dias, J., Paiva, A., Vala, M.: Fearnot!: An experiment in emergent narrative. In: T. Panayiotopoulos, J. Gratch, R. Aylett, D. Ballin, P. Olivier, T. Rist (eds.) Lecture Notes in Computer Science, pp. 305–316. Springer-Verlag, London, UK, UK (2005). DOI 10.1007/11550617_26. URL http://dx.doi.org/10.1007/11550617_26

[6]  Bae, B., Cheong, Y., Young, R.M.: Automated story generation with multiple internal focalization. In: 2011 IEEE Conference on Computational Intelligence and Games (CIG'11), pp. 211–218 (2011). DOI 10.1109/CIG.2011.6032009

[7]  Bae, B.C., Cheong, Y.G., Young, R.M.: Toward a computational model of focalization in narrative. In: Proceedings of the 6th International Conference on Foundations of Digital Games, FDG '11, p. 313315. Association for Computing Machinery, New York, NY, USA (2011). DOI 10.1145/2159365.2159423. URL https://doi.org/10.1145/2159365.2159423

[8]  Bae, B.C., Young, R.M.: A use of flashback and foreshadowing for surprise arousal in narrative using a plan-based approach. In: Proc. ICIDS 2008 (2008)

[9]  Bal, M., van Boheemen, C.: Narratology: Introduction to the Theory of Narrative. Narratology: Introduction to the Theory of Narrative. University of Toronto Press (2009). URL https://books.google.es/books?id=jPj4Bq0H4JoC

[10]  Barros, L.M., Musse, S.R.: Towards consistency in interactive storytelling: Tension arcs and dead-ends. Comput. Entertain. 6(3), 43:1–43:17 (2008). DOI 10.1145/1394021.1394036. URL http://doi.acm.org/10.1145/1394021.1394036

[11]  Black, J.B., Wilensky, R.: An evaluation of story grammars. Cognitive Science 3(3), 213–230 (1979)

[12]  Booker, C.: The Seven Basic Plots: Why We Tell Stories. The Seven Basic Plots: Why We Tell Stories. Continuum (2004). URL http://books.google.pt/books?id=qHJj9gOlOj8C

[13]  Bosser, A.G., Courtieu, P., Forest, J., Cavazza, M.: Structural Analysis of Narratives with the Coq Proof Assistant. In: M. van Eekelen, H. Geuvers, J. Schmaltz, F. Wiedijk (eds.) Interactive Theorem Proving, pp. 55–70. Springer Berlin Heidelberg, Berlin, Heidelberg (2011)

[14]  Bouayad-Agha, N., G.Casamayor, Wanner, L.: Content selection from an ontology-based knowledge base for the generation of football summaries. In: Proc. ENLG 2011, pp. 72–81 (2011)

[15]  Brémond, C.: Logique du récit. Collection Poétique. Éditions du Seuil (1973). URL https://books.google.es/books?id=8e9YAAAAMAAJ

[16]  Bringsjord, S., Ferrucci, D.A.: Artificial Intelligence and Literary Creativity: Inside the Mind of BRUTUS, a Storytelling Machine. Lawrence Erlbaum Associates (1999)

[17]  Callaway, C.B.: Narrative prose generation. Artificial Intelligence 139(2), 213–252 (2002). DOI http://dx.doi.org/10.1016/S0004-3702(02)00230-8

[18]  Campbell, J.: The Hero with a Thousand Faces, second edn. Bollingen series. Princeton University Press, Princeton (1968)

[19]  Carbonell, J.G.: Counterplanning: A strategy-based model of adversary planning in real-world situations. Artificial Intelligence 16(3), 295 – 329 (1981). DOI https://doi.org/10.1016/0004-3702(81)90003-5. URL http://www.sciencedirect.com/science/article/pii/0004370281900035

[20]  Cardona-Rivera, R., Li, B.: Plotshot: Generating discourse-constrained stories around photos. In: AAAI Conference on Artificial Intelligence and Interactive Digital Entertainment (2016). URL https://aaai.org/ocs/index.php/AIIDE/AIIDE16/paper/view/14007/13587

[21]  Cardona-Rivera, R.E., Robertson, J., Ware, S.G., Harrison, B., Roberts, D.L., Young, R.M.: Foreseeing meaningful choices. In: Proceedings of the Tenth

AAAI Conference on Artificial Intelligence and Interactive Digital Entertainment, AIIDE'14, pp. 9–15. AAAI Press (2014). URL http://dl.acm.org/citation.cfm?id=3014752.3014755

[22] Cassell, B.A., Young, R.M.: Ember, toward salience-based cinematic generation. In: Intelligent Narrative Technologies (2013)

[23] Cavazza, M., Charles, F.: Dialogue generation in character-based interactive storytelling. In: Proceedings of the First Artificial Intelligence and Interactive Digital Entertainment Conference, June 1-5, 2005, Marina del Rey, California, USA, pp. 21–26 (2005)

[24] Cavazza, M., Charles, F., Mead, S.J.: Under the influence: using natural language in interactives storytelling. In: Entertainment Computing: Technologies and Applications, IFIP First International Workshop on Entertainment Computing (IWEC 2002), May 14-17, 2002, Makuhari, Japan, pp. 3–11 (2002)

[25] Cavazza, M., Pizzi, D.: Narratology for interactive storytelling: A critical introduction. In: Proceedings of the Third International Conference on Technologies for Interactive Digital Storytelling and Entertainment, TIDSE'06, pp. 72–83. Springer-Verlag, Berlin, Heidelberg (2006). DOI 10.1007/11944577_7. URL http://dx.doi.org/10.1007/11944577_7

[26] Cavazza, M., Pizzi, D., Charles, F., Vogt, T., André, E.: Emotional input for character-based interactive storytelling. In: 8th International Joint Conference on Autonomous Agents and Multiagent Systems (AAMAS 2009), Budapest, Hungary, May 10-15, 2009, Volume 1, pp. 313–320 (2009). DOI 10.1145/1558013.1558056. URL http://doi.acm.org/10.1145/1558013.1558056

[27] Cavazza, M.O.M., Charles, F.F., Mead, S.J.S.: Planning characters' behaviour in interactive storytelling. The Journal of Visualization and Computer Animation 13(2) (2002 May). DOI 10.1002/vis.285. URL http://hdl.handle.net/10149/103486

[28] Champagnat, R., Delmas, G., Augeraud, M.: A Storytelling Model for Educational Games: Hero's Interactive Journey. Int. J. Technol. Enhanc. Learn. 2(1/2), 4–20 (2010). DOI 10.1504/IJTEL.2010.031257. URL http://dx.doi.org/10.1504/IJTEL.2010.031257

[29] Charles, F., Pizzi, D., Cavazza, M., Vogt, T., André, E.: Emoemma: emotional speech input for interactive storytelling. In: 8th International Joint Conference on Autonomous Agents and Multiagent Systems (AAMAS 2009), Budapest, Hungary, May 10-15, 2009, Volume 2, pp. 1381–1382 (2009). DOI 10.1145/1558109.1558305. URL http://doi.acm.org/10.1145/1558109.1558305

[30] Charles, F., Porteous, J., Cavazza, M.: Changing characters' point of view in interactive storytelling. In: Proceedings of the 18th International Conference on Multimedia 2010, Firenze, Italy, October 25-29, 2010, pp. 1681–1684 (2010). DOI 10.1145/1873951.1874321. URL http://doi.acm.org/10.1145/1873951.1874321

[31] Cheong, Y.G., Young, R.M.: Suspenser: a story generation system for suspense. IEEE Transactions on Computational Intelligence and Artificial Intelligence in Games 7(1), 39–52 (2015)

[32] Cohen, P.R., Levesque, H.J.: Intention is choice with commitment. Artif. Intell. 42(2-3), 213–261 (1990). DOI 10.1016/0004-3702(90)90055-5. URL http://dx.doi.org/10.1016/0004-3702(90)90055-5

[33] Colby, B.N.: A Partial Grammar of Eskimo Folktales. American Anthropologist **75**(3), 645–662 (1973). DOI 10.1525/aa.1973.75.3.02a00010. URL http://dx.doi.org/10.1525/aa.1973.75.3.02a00010

[34] Colton, S., Llano, M.T., Hepworth, R., Charnley, J., Gale, C.V., Baron, A., Pachet, F., Roy, P., Gervás, P., Collins, N., Sturm, B., Weyde, T., Wolff, D., Lloyd, J.: The Beyond the Fence Musical and Computer Says Show Documentary. In: 7th International Conference on Computational Creativity (ICCC 2016). Paris, France (2016)

[35] Cook, W.: Plotto: The Master Book of All Plots. Tin House Books (2011). URL https://books.google.es/books?id=HDOPLTOWer8C

[36] Dehn, N.: Story generation after tale-spin. In: Proc. IJCAI 1981, pp. 16–18 (1981)

[37] Dehn, N.: Computer story-writing: the role of reconstructive and dynamic memory. Ph.D. thesis, Yale University (1989)

[38] Doust, R.: A domain-independent model of suspense in narrative. Ph.D. thesis, The Open University (2015)

[39] Eger, M., Barot, C., Young, R.M.: Merits of a temporal modal logic for narrative discourse generation. In: Proceedings of the 8th Workshop on Intelligent Narrative Technologies (INT8). Santa Cruz, California (2015)

[40] Eger, M., Potts, C., Barot, C., Young, R.M.: Plotter: Operationalizing the master book of all plots. In: AAAI Conference on Artificial Intelligence and Interactive Digital Entertainment, pp. 30–33 (2015). URL http://www.aaai.org/ocs/index.php/AIIDE/AIIDE15/paper/view/11602

[41] Elhadad, M.: Using argumentation to control lexical choice: A functional unification implementation. Ph.D. thesis, Columbia University, New York, NY, USA (1993). UMI Order No. GAX93-33756

[42] Elhadad, M., Robin, J.: An overview of SURGE: a reusable comprehensive syntactic realization component. In: Eighth International Natural Language Generation Workshop, INLG 1996, Herstmonceux Castle, Sussex, UK, June 12-15, 1996 - Posters and Demonstrations (1996). URL https://aclanthology.info/papers/W96-0501/w96-0501

[43] Elson, D.K., McKeown, K.R.: A tool for deep semantic encoding of narrative texts. In: Proceedings of the ACL-IJCNLP 2009 Software Demonstrations, pp. 9–12. Association for Computational Linguistics (2009). URL http://www.aclweb.org/anthology/P09-4003

[44] Elson, D.K., McKeown, K.R.: Tense and aspect assignment in narrative discourse. In: J.D. Kelleher, B.M. Namee, I. van der Sluis, A. Belz, A. Gatt, A. Koller (eds.) INLG 2010 - Proceedings of the Sixth International Natural Language Generation Conference, July 7-9, 2010, Trim, Co. Meath, Ireland. The Association for Computer Linguistics (2010)

[45] Fairclough, C.: Story games and the opiate system: Using case based planning for structuring plots with an expert story director agent and enacting them in a socially simulated game world. Ph.D. thesis, Trinity College Dublin (2004)

[46] Fendt, M.: Leveraging intention revision in narrative planning to create suspenseful stories. Ph.D. thesis, North Carolina State University (2014)

[47] Fendt, M.W., Young, R.M.: Leveraging intention revision in narrative planning to create suspenseful stories. IEEE Transactions on Computational Intelligence and AI in Games **9**, 381–392 (2017)

[48] Fitzgerald, A., Kahlon, G., Riedl, M.O.: A computational model of emotional response to stories. In: Interactive Storytelling, Second Joint International Conference on Interactive Digital Storytelling, ICIDS 2009, Guimarães, Portugal, December 9-11, 2009. Proceedings, pp. 312–315 (2009). DOI 10.1007/978-3-642-10643-9\_37. URL https://doi.org/10.1007/978-3-642-10643-9_37

[49] Flower, L., Hayes, J.: A cognitive process theory of writing. College Composition and Communication **32**(4), 365–387 (1981)

[50] Forster, E.: Aspects of the Novel. Clark Lectures. RosettaBooks (2010). URL https://books.google.es/books?id=FLS1tV-UXawC

[51] Freytag, G., MacEwan, E.: Freytag's Technique of the Drama: An Exposition of Dramatic Composition and Art. An Authorized Translation from the 6th German Ed. by Elias J. MacEwan. Scott, Foresman (1894). URL https://books.google.es/books?id=nD8PAQAAMAAJ

[52] Genette, G.: Narrative discourse : an essay in method. Cornell University Press (1980)

[53] Gervás, P.: Corpus annotation for narrative generation research: A wish list. In: First International AMICUS Workshop on Automated Motif Discovery in Cultural Heritage and Scientific Communication Texts Satellite event of the Supporting the Digital Humanities Conference (SDH-2010). Vienna, Austria (2010). URL http://ilk.uvt.nl/amicus/amicus_ws2010_proceedings.html

[54] Gervás, P.: From the fleece of fact to narrative yarns: a computational model of narrative composition. In: Proc. Workshop on Computational Models of Narrative 2012 (2012)

[55] Gervás, P.: Computational modelling of poetry generation. In: Artificial Intelligence and Poetry Symposium, AISB Convention 2013. University of Exeter, United Kingdom (2013). URL http://www.macs.hw.ac.uk/~ruth/ai&p-proc.html

[56] Gervás, P.: Propp's morphology of the folk tale as a grammar for generation. In: Workshop on Computational Models of Narrative, a satellite workshop of CogSci 2013: The 35th meeting of the Cognitive Science Society. Schloss Dagstuhl – Leibniz-Zentrum für Informatik GmbH, Dagstuhl Publishing, Saarbrücken/Wadern, Germany, Schloss Dagstuhl – Leibniz-Zentrum für Informatik GmbH, Dagstuhl Publishing, Saarbrücken/Wadern, Germany, Universität Hamburg Hamburg, Germany (2013)

[57] Gervás, P.: Stories from games: Content and focalization selection in narrative composition. In: First Spanish Symposium on Digital Entertainment, SEED 2013 (2013)

[58] Gervás, P.: Composing narrative discourse for stories of many characters: a case study over a chess game. Literary and Linguistic Computing **29**(4) (2014)

[59] Gervás, P.: Metrics for desired structural features for narrative renderings of game logs. Journal of Entertainment Computing (2014)

[60] Gervás, P.: Reviewing Propp's story generation procedure in the light of computational creativity. In: AISB Symposium on Computational Creativity, AISB-2014, April 1-4 2014. Goldsmiths, London, UK (2014)

[61] Gervás, P.: Computational Drafting of Plot Structures for Russian Folk Tales. Cognitive Computation (2015)

[62] Gervás, P.: Empirical determination of basic heuristics for narrative content planning. In: Proceedings of Computational Creativity and Natural Language

Generation Workshop, International Conference on Natural Language Generation (INLG 2016). Edimburgh, Scotland (2016)

[63] Gervás, P.: Comparative evaluation of elementary plot generation procedures. In: 6th International Workshop on Computational Creativity, Concept Invention, and General Intelligence. Madrid, Spain (2017)

[64] Gervás, P.: Storifying Observed Events: Could I Dress This Up as a Story? In: 5th AISB Symposium on Computational Creativity. AISB, AISB, University of Liverpool, UK (2018)

[65] Gervás, P.: Targeted Storyfying: Creating Stories About Particular Events. In: Ninth International Conference on Computational Creativity, ICCC 2018. Association of Computational Creativity, Salamanca, Spain (2018)

[66] Gervás, P., Díaz-Agudo, B., Peinado, F., Hervás, R.: Story Plot Generation Based on CBR. Knowledge-Based Systems. Special Issue: AI-2004 **18**, 235–242 (2005)

[67] Gervás, P., Hervás, R., León, C.: Generating plots for a given query using a case-base of narrative schemas. In: Creativity and Experience Workshop, International Conference on Case-Based Reasoning. Bad Homburg, Frankfurt, Germany (2015)

[68] Gervás, P., Hervás, R., León, C., Gale, C.V.: Annotating musical theatre plots on narrative structure and emotional content. In: Seventh International Workshop on Computational Models of Narrative. OpenAccess Series in Informatics, OpenAccess Series in Informatics, Kravow, Poland (2016)

[69] Gervás, P., León, C.: Reading and writing as a creative cycle: The need for a computational model. In: 5th International Conference on Computational Creativity, ICCC 2014. Ljubljana, Slovenia (2014)

[70] Gervás, P., León, C.: When reflective feedback triggers goal revision: a computational model for literary creativity. In: AI and Feedback, IJCAI 2015. CEUR-WS, CEUR-WS, Buenos Aires (2015). URL http://nil.fdi.ucm.es/sites/default/files/AInF2015paper5_crc.pdf

[71] Gervás, P., León, C.: Integrating purpose and revision into a computational model of literary generation. In: M.D. Esposti, E. Altmann, F. Pachet (eds.) Creativity and Universality in Language, Lecture Notes in Morphogenesis, chap. Integrating Purpose and Revision into a Computational Model of Literary Generation. Springer (2016). URL http://www.springer.com/us/book/9783319244013

[72] Gervás, P., León, C., Méndez, G.: Schemas for narrative generation mined from existing descriptions of plot. In: Computational Models of Narrative. Scholoss Dagstuhl OpenAccess Series in Informatics (OASIcs), Scholoss Dagstuhl OpenAccess Series in Informatics (OASIcs), Atlanta, Georgia, USA (2015)

[73] Gervás, P., Lönneker, B., Meister, J.C., Peinado, F.: Narrative models: Narratology meets artificial intelligence. In: International Conference on Language Resources and Evaluation. Satellite Workshop: Toward Computational Models of Literary Analysis, pp. 44–51. Genova, Italy (2006)

[74] Gonçalo Oliveira, H.: A survey on intelligent poetry generation: Languages, features, techniques, reutilisation and evaluation. In: Proceedings of the 10th International Conference on Natural Language Generation, pp. 11–20. Association for Computational Linguistics, Santiago de Compostela, Spain (2017). DOI 10.18653/v1/W17-3502. URL https://www.aclweb.org/anthology/W17-3502

[75] Grasbon, D., Braun, N.: A morphological approach to interactive storytelling. In: Conference on Artistic, Cultural and Scientific Aspects of Experimental Media Spaces (CAST), 2001, St. Augustin¿ (2001)

[76] Gratch, J.: Émile: Marshalling passions in training and education. In: Proceedings of the Fourth International Conference on Autonomous Agents, AGENTS '00, pp. 325–332. ACM, New York, NY, USA (2000). DOI 10.1145/336595.337516. URL http://doi.acm.org/10.1145/336595.337516

[77] Hajarnis, S., Leber, C., Ai, H., Riedl, M.O., Ram, A.: A case base planning approach for dialogue generation in digital movie design. In: Case-Based Reasoning Research and Development - 19th International Conference on Case-Based Reasoning, ICCBR 2011, London, UK, September 12-15, 2011. Proceedings, pp. 452–466 (2011). DOI 10.1007/978-3-642-23291-6\_33. URL https://doi.org/10.1007/978-3-642-23291-6_33

[78] Hardison, O., Aristotle: Poetics:. Prentice-Hall (1968). URL https://books.google.es/books?id=CVVZAAAAMAAJ

[79] Hassan, S., León, C., Gervás, P., Hervás, R.: A computer model that generates biography-like narratives. In: International Joint Workshop on Computational Creativity. London (2007)

[80] Herman, L., Vervaeck, B.: Ideology and narrative fiction. In: P. Hühn, J.C. Meister, J. Pier, W. Schmid (eds.) The living handbook of narratology. Walter de Gruyter (2009)

[81] Jhala, A., Young, R.M.: Cinematic visual discourse: Representation, generation, and evaluation. IEEE Trans. on Comp. Int. and AI in Games 2(2), 69–81 (2010)

[82] Jordanous, A.: Evaluating evaluation: Assessing progress in computational creativity research. In: Proceedings of the Second International Conference on Computational Creativity, pp. 102–107 (2011)

[83] Kives, C., Ware, S.G., Baker, L.J.: Evaluating the pairwise event salience hypothesis in Indexter. In: Proceedings of the 11th AAAI International Conference on Artificial Intelligence and Interactive Digital Entertainment, pp. 30–36 (2015)

[84] Lakoff, G.: Structural complexity in fairy tales. The Study of Man 1, 128–150 (1972)

[85] Lang, R.R.: A formal model for simple narratives. Ph.D. thesis, Tulane University (1997)

[86] Lang, R.R.: A declarative model for simple narratives. In: Proceedings of the AAAI Fall Symposium on Narrative Intelligence, pp. 134–141. AAAI Press (1999)

[87] Lareau, F., Dras, M., Dale, R.: Detecting interesting event sequences for sports reporting. In: Proc. ENLG 2011, pp. 200–205 (2011)

[88] Lavoie, B., Rambow, O.: A fast and portable realizer for text generation systems. In: Proceedings of the Fifth Conference on Applied Natural Language Processing, ANLC '97, pp. 265–268. Association for Computational Linguistics, Stroudsburg, PA, USA (1997). DOI 10.3115/974557.974596. URL https://doi.org/10.3115/974557.974596

[89] Lebowitz, M.: Creating characters in a story-telling universe. Poetics 13, 171–194 (1984)

[90] Lebowitz, M.: Story-telling as planning and learning. Poetics 14, 483–502 (1985)

[91] León, C., Gervás, P.: Creativity in story generation from the ground up: Non-deterministic simulation driven by narrative. In: 5th International Conference on Computational Creativity, ICCC 2014. Ljubljana, Slovenia (2014)

[92] Li, B., Lee-Urban, S., Johnston, G., Riedl, M.O.: Story generation with crowd-sourced plot graphs. In: Proceedings of the 27th AAAI Conference on Artificial Intelligence, AAAI '13 (2013)

[93] Li, B., Riedl, M.O.: An offline planning approach to game plotline adaptation. In: Proceedings of the Sixth AAAI Conference on Artificial Intelligence and Interactive Digital Entertainment, AIIDE 2010, October 11-13, 2010, Stanford, California, USA (2010). URL http://aaai.org/ocs/index.php/AIIDE/AIIDE10/paper/view/2125

[94] Li, B., Thakkar, M., Wang, Y., Riedl, M.O.: Storytelling with adjustable narrator styles and sentiments. In: A. Mitchell, C. Fernández-Vara, D. Thue (eds.) Interactive Storytelling, pp. 1–12. Springer International Publishing, Cham (2014)

[95] Li, Z., Ding, X., Liu, T.: Generating reasonable and diversified story ending using sequence to sequence model with adversarial training. In: COLING (2018)

[96] Mairesse, F., Walker, M.A.: Towards personality-based user adaptation: Psychologically informed stylistic language generation. User Modeling and User-Adapted Interaction 20(3), 227–278 (2010). DOI 10.1007/s11257-010-9076-2. URL http://dx.doi.org/10.1007/s11257-010-9076-2

[97] Marsella, S.C., Gratch, J.: EMA: A process model of appraisal dynamics. Journal of Cognitive Systems Research 10(1), 70–90 (2009). URL http://ict.usc.edu/pubs/EMA-%20A%20process%20model%20of%20appraisal%20dynamics.pdf

[98] Martin, L.J., Ammanabrolu, P., Wang, X., Hancock, W., Singh, S., Harrison, B., Riedl, M.O.: Event representations for automated story generation with deep neural nets. In: Proceedings of the Thirty-Second AAAI Conference on Artificial Intelligence, New Orleans, Louisiana, USA, February 2-7, 2018 (2018). URL https://www.aaai.org/ocs/index.php/AAAI/AAAI18/paper/view/17046

[99] Mateas, M., Stern, A.: Towards integrating plot and character for interactive drama. In: Working notes of the Social Intelligent Agents: The Human in the Loop Symposium, AAAI Fall Symposium. AAAI Press (2000)

[100] Mateas, M., Stern, A.: The interactive drama façade. In: AIIDE, pp. 153–154. AAAI Press (2005)

[101] Mateas, M., Stern, A.: Invited talk: Façade: Architecture and authorial idioms for believable agents in interactive drama. In: J. Gratch, M. Young, R. Aylett, D. Ballin, P. Olivier (eds.) Intelligent Virtual Agents, pp. 446–448. Springer, Berlin, Heidelberg (2006)

[102] McCoy, J., Treanor, M., Samuel, B., Reed, A.A., Mateas, M., Wardrip-Fruin, N.: Prom week. In: AIIDE. AAAI (2013)

[103] McCoy, J., Treanor, M., Samuel, B., Reed, A.A., Mateas, M., Wardrip-Fruin, N.: Prom week: Designing past the game/story dilemma. In: FDG, pp. 94–101. Society for the Advancement of the Science of Digital Games (2013)

[104] McCoy, J., Treanor, M., Samuel, B., Reed, A.A., Mateas, M., Wardrip-Fruin, N.: Social story worlds with comme il faut. IEEE Transactions on

Computational Intelligence and AI in Games **6**(2), 97–112 (2014). DOI 10.1109/TCIAIG.2014.2304692

[105] McCoy, J., Treanor, M., Samuel, B., Tearse, B., Mateas, M., Wardrip-Fruin, N.: Authoring game-based interactive narrative using social games and comme il faut. In: Proceedings of the 4th International Conference & Festival of the Electronic Literature Organization: Archive & Innovate (ELO 2010). Providence, Rhode Island, USA (2010)

[106] McCoy, J., Treanor, M., Samuel, B., Tearse, B., Mateas, M., Wardrip-Fruin, N.: Comme Il Faut 2: A Fully Realized Model for Socially-oriented Gameplay. In: Proceedings of the Intelligent Narrative Technologies III Workshop, INT3 '10, pp. 10:1–10:8. ACM, New York, NY, USA (2010). DOI 10.1145/1822309. 1822319. URL http://doi.acm.org/10.1145/1822309.1822319

[107] McCoy, J., Treanor, M., Samuel, B., Wardrip-Fruin, N., Mateas, M.: Comme Il Faut: A System for Authoring Playable Social Models. In: Proceedings of the Seventh AAAI Conference on Artificial Intelligence and Interactive Digital Entertainment, AIIDE'11, pp. 158–163. AAAI Press (2011). URL http://dl. acm.org/citation.cfm?id=3014589.3014617

[108] McIntyre, N.: Learning to tell tales: Automatic story generation from corpora. Ph.D. thesis, University of Edinburgh (2011)

[109] McIntyre, N., Lapata, M.: Learning to tell tales: A data-driven approach to story generation. In: Proceedings of the Joint Conference of the 47th Annual Meeting of the ACL and the 4th International Joint Conference on Natural Language Processing of the AFNLP: Volume 1 - Volume 1, ACL '09, pp. 217–225. Association for Computational Linguistics, Stroudsburg, PA, USA (2009). URL http://dl.acm.org/citation.cfm?id=1687878.1687910

[110] Meehan, J.R.: Tale-spin, an interactive program that writes stories. In: Proc. IJCAI 1977, pp. 91–98 (1977)

[111] Méndez, G., Gervás, P., León, C.: A model of character affinity for agent-based story generation. In: 9th International Conference on Knowledge, Information and Creativity Support Systems. Springer-Verlag, Limassol, Cyprus (2014)

[112] Méndez, G., Gervás, P., León, C.: On the Use of Character Affinities for Story Plot Generation, *Advances in Intelligent Systems and Computing*, vol. 416, chap. 15, pp. 211–225. Springer (2016). DOI 10.1007/978-3-319-27478-2_15. URL http://www.springer.com/us/book/9783319274775

[113] Montfort, N.: Generating narrative variation in interactive fiction. Ph.D. thesis, University of Pennsylvania, Philadelphia, PA, USA (2007)

[114] Mostafazadeh, N., Roth, M., Louis, A., Chambers, N., Allen, J.: LSDSem 2017 Shared Task: The Story Cloze Test. In: Proceedings of the 2nd Workshop on Linking Models of Lexical, Sentential and Discourse-level Semantics, pp. 46–51. Association for Computational Linguistics, Valencia, Spain (2017). DOI 10. 18653/v1/W17-0906. URL https://www.aclweb.org/anthology/W17-0906

[115] Mott, B.: Decision-theoretic narrative planning for guided exploratory learning environments. Ph.D. thesis, Department of Computer Science, North Carolina State University (2006)

[116] Nau, D., Ghallab, M., Traverso, P.: Automated Planning: Theory & Practice. Morgan Kaufmann Publishers Inc., San Francisco, CA, USA (2004)

[117] Niehaus, J., Young, R.M.: Cognitive models of discourse comprehension for narrative generation. Literary and Linguistic Computing **29**(4), 561–582

(2014). DOI 10.1093/llc/fqu056. URL http://dx.doi.org/10.1093/llc/fqu056

[118] O'Neill, B.: A computational model of suspense for the augmentation of intelligent story generation. Ph.D. thesis, Georgia Institute of Technology, Atlanta, Georgia (2013)

[119] O'Neill, B., Riedl, M.: Supporting human creative story authoring with asynthetic audience. In: Proceedings of the Seventh ACM Conference on Creativity and Cognition, C&C '09, pp. 399–400. ACM, New York, NY, USA (2009). DOI 10.1145/1640233.1640320. URL http://doi.acm.org/10.1145/1640233.1640320

[120] Ong, T., Leggett, J.J.: A genetic algorithm approach to interactive narrative generation. In: Proceedings of the Fifteenth ACM Conference on Hypertext and Hypermedia, HYPERTEXT '04, pp. 181–182. ACM, New York, NY, USA (2004). DOI 10.1145/1012807.1012856. URL http://doi.acm.org/10.1145/1012807.1012856

[121] Ontañón, S., Zhu, J.: On the role of domain knowledge in analogy-based story generation. In: Proceedings of the Twenty-Second International Joint Conference on Artificial Intelligence - Volume Volume Two, IJCAI'11, pp. 1717–1722. AAAI Press (2011). DOI 10.5591/978-1-57735-516-8/IJCAI11-288. URL http://dx.doi.org/10.5591/978-1-57735-516-8/IJCAI11-288

[122] Paiva, A., Machado, I., Prada, R.: Heroes, villians, magicians, . . . : Dramatis personae in a virtual story creation environment. In: Proceedings of the 6th International Conference on Intelligent User Interfaces, IUI '01, pp. 129–136. ACM, New York, NY, USA (2001). DOI 10.1145/359784.360314. URL http://doi.acm.org/10.1145/359784.360314

[123] Peinado, F.: A Framework for the Development of Automated Storytelling Applications based on Reusable Ontological Components. Ph.D. thesis, Universidad Complutense de Madrid, Madrid (2008)

[124] Peinado, F., Francisco, V., Hervás, R., Gervás, P.: Assessing the novelty of computer-generated narratives using empirical metrics. Minds and Machines 20(4), 588 (2010). DOI 10.1007/s11023-010-9209-8

[125] Peinado, F., Gervás, P.: Evaluation of automatic generation of basic stories. New Generation Computing 24(3), 289–302 (2006)

[126] Peinado, F., Gervs, P., Daz-Agudo, B.: A description logic ontology for fairy tale generation. In: Fourth Int. Conf. on Language Resources and Evaluation: Workshop on Language Resources for Linguistic Creativity, pp. 56–61 (2004)

[127] Pemberton, L.: Story structure: A narrative grammar of nine chansons de geste of the guillaume d'orange cycle. Ph.D. thesis, University of Toronto (1984)

[128] Pemberton, L.: A modular approach to story generation. In: Proceedings of the Fourth Conference on European Chapter of the Association for Computational Linguistics, EACL '89, pp. 217–224. Association for Computational Linguistics, Stroudsburg, PA, USA (1989). DOI 10.3115/976815.976845. URL https://doi.org/10.3115/976815.976845

[129] Pérez y Pérez, R., Sharples, M.: MEXICA: A computer model of a cognitive account of creative writing. Journal of Experimental & Theoretical Artificial Intelligence 13(2), 119–139 (2001)

[130] Pérez y Pérez, R.: Mexica: A computer model of creativity in writing. Ph.D. thesis, The University of Sussex (1999)

[131] Piacenza, A., Guerrini, F., Adami, N., Leonardi, R., Porteous, J., Teutenberg, J., Cavazza, M.: Generating story variants with constrained video recombination. In: Proceedings of the 19th ACM International Conference on Multimedia, MM '11, pp. 223–232. ACM, New York, NY, USA (2011). DOI 10.1145/2072298.2072329. URL http://doi.acm.org/10.1145/2072298.2072329

[132] Polti, G., Ray, L.: The Thirty-six Dramatic Situations. Editor Company (1916). URL http://books.google.pt/books?id=NHOOAAAAIAAJ

[133] Porteous, J., Cavazza, M., Charles, F.: Narrative generation through characters' point of view. In: 9th International Conference on Autonomous Agents and Multiagent Systems (AAMAS 2010), Toronto, Canada, May 10-14, 2010, Volume 1-3, pp. 1297–1304 (2010). DOI 10.1145/1838206.1838375. URL http://doi.acm.org/10.1145/1838206.1838375

[134] Porteous, J., Charles, F., Cavazza, M.: Networking: Using character relationships for interactive narrative generation. In: Proceedings of the 2013 International Conference on Autonomous Agents and Multi-agent Systems, AAMAS '13, pp. 595–602. International Foundation for Autonomous Agents and Multiagent Systems, Richland, SC (2013). URL http://dl.acm.org/citation.cfm?id=2484920.2485015

[135] Porteous, J., Charles, F., Cavazza, M.: A social network interface to an interactive narrative. In: Proceedings of the 2013 International Conference on Autonomous Agents and Multi-agent Systems, AAMAS '13, pp. 1399–1400. International Foundation for Autonomous Agents and Multiagent Systems, Richland, SC (2013). URL http://dl.acm.org/citation.cfm?id=2484920.2485244

[136] Porteous, J., Charles, F., Cavazza, M.: Using social relationships to control narrative generation. In: Proceedings of the Twenty-Ninth AAAI Conference on Artificial Intelligence, January 25-30, 2015, Austin, Texas, USA., pp. 4311–4312 (2015). URL http://www.aaai.org/ocs/index.php/AAAI/AAAI15/paper/view/9936

[137] Porteous, J., Charles, F., Cavazza, M.: Plan-based narrative generation with coordinated subplots. In: ECAI 2016 - 22nd European Conference on Artificial Intelligence, 29 August-2 September 2016, The Hague, The Netherlands - Including Prestigious Applications of Artificial Intelligence (PAIS 2016), pp. 846–854 (2016). DOI 10.3233/978-1-61499-672-9-846. URL https://doi.org/10.3233/978-1-61499-672-9-846

[138] Porteous, J., Teutenberg, J., Charles, F., Cavazza, M.: Controlling narrative time in interactive storytelling. In: 10th International Conference on Autonomous Agents and Multiagent Systems (AAMAS 2011), Taipei, Taiwan, May 2-6, 2011, Volume 1-3, pp. 449–456 (2011). URL http://portal.acm.org/citation.cfm?id=2031681&CFID=54178199&CFTOKEN=61392764

[139] Prince, G.: Reader. In: P. Hühn, J.C. Meister, J. Pier, W. Schmid (eds.) The living handbook of narratology. Walter de Gruyter (2009)

[140] Propp, V.: Morphology of the Folk Tale. Akademija, Leningrad (1928)

[141] Reagan, A.J., Mitchell, L., Kiley, D., Danforth, C.M., Dodds, P.S.: The emotional arcs of stories are dominated by six basic shapes. EPJ Data Science 5(1), 31 (2016). DOI 10.1140/epjds/s13688-016-0093-1. URL https://doi.org/10.1140/epjds/s13688-016-0093-1

[142] Reed, A.: Creating Interactive Fiction with Inform 7, 1st edn. Course Technology Press, Boston, MA, USA (2010)

[143] Reiter, E., Dale, R.: Building Natural Language Generation Systems. Cambridge University Press, New York, NY, USA (2000)

[144] Riedl, M., León, C.: Generating story analogues. In: AIIDE (2009). URL http://www.aaai.org/ocs/index.php/AIIDE/AIIDE09/paper/viewFile/797/1060

[145] Riedl, M., Young, M.: Narrative planning: Balancing plot and character. J. Artif. Intell. Res. (JAIR) **39**, 217–268 (2010)

[146] Riedl, M.O., Sugandh, N.: Story planning with vignettes: Toward overcoming the content production bottleneck. In: Interactive Storytelling, First Joint International Conference on Interactive Digital Storytelling, ICIDS 2008, Erfurt, Germany, November 26-29, 2008, Proceedings, pp. 168–179 (2008). DOI 10.1007/978-3-540-89454-4\_23. URL https://doi.org/10.1007/978-3-540-89454-4_23

[147] Rimmon-Kenan, S.: Narrative Fiction: Contemporary Poetics. New Accents. Taylor & Francis (2003). URL https://books.google.es/books?id=a2CBAgAAQBAJ

[148] Rishes, E., Lukin, S.M., Elson, D.K., Walker, M.A.: Generating different story tellings from semantic representations of narrative. In: Proceedings of the 6th International Conference on Interactive Storytelling - Volume 8230, ICIDS 2013, pp. 192–204. Springer-Verlag, Berlin, Heidelberg (2013). DOI 10.1007/978-3-319-02756-2_24. URL https://doi.org/10.1007/978-3-319-02756-2_24

[149] Roemmele, M.: Writing stories with help from recurrent neural networks. In: Proceedings of the Thirtieth AAAI Conference on Artificial Intelligence, AAAI'16, pp. 4311–4312. AAAI Press (2016). URL http://dl.acm.org/citation.cfm?id=3016387.3016571

[150] Roemmele, M., Gordon, A.S.: Creative Help: A Story Writing Assistant. In: Interactive Storytelling, vol. 9445, pp. 81–92. Springer International Publishing, Copenhagen, Denmark (2015). URL http://link.springer.com/10.1007/978-3-319-27036-4_8

[151] Rumelhart, D.: Notes on a schema for stories. In: D.G. Bobrow, A. Collins (eds.) Representation and Understanding: Studies in Cognitive Science, pp. 211–236. Academic Press, Inc, New York (1975)

[152] Rumelhart, D.E.: Notes on a schema for stories. Representation and Understanding: Studies in Cognitive Science pp. 211–236 (1975)

[153] Ryan, J.O., Mateas, M., Wardrip-Fruin, N.: Characters who speak their minds: Dialogue generation in talk of the town. In: AIIDE, pp. 204–210. AAAI Press (2016)

[154] Sagarkar, M., Wieting, J., Tu, L., Gimpel, K.: Quality signals in generated stories. In: Proceedings of the Seventh Joint Conference on Lexical and Computational Semantics, pp. 192–202. Association for Computational Linguistics, New Orleans, Louisiana (2018). DOI 10.18653/v1/S18-2024. URL https://www.aclweb.org/anthology/S18-2024

[155] Sharples, M.: How We Write: Writing As Creative Design. Routledge (1999). URL http://www.amazon.ca/exec/obidos/redirect?tag=citeulike09-20&path=ASIN/0415185874

[156] Shoham, Y., Leyton-Brown, K.: Multiagent Systems: Algorithmic, Game-Theoretic, and Logical Foundations. Cambridge University Press, New York, NY, USA (2008)

[157] Smith, T.C., Witten, I.H.: A planning mechanism for generating story text. Literary and Linguistic Computing **6**(2), 119–126 (1991). DOI 10.1093/llc/6.2.119. URL http://dx.doi.org/10.1093/llc/6.2.119

[158] Strong, C.R., Mateas, M.: Talking with NPCs: Towards Dynamic Generation of Discourse Structures. In: AIIDE. The AAAI Press (2008)

[159] Szilas, N.: Idtension: a narrative engine for interactive drama. In: Technologies for Interactive Digital Storytelling and Entertainment. TIDSE 2003 Proceedings, pp. 187–203 (2003). URL http://nicolas.szilas.free.fr/research/Papers/Szilas_tidse03.pdf

[160] Tearse, B.R., Mawhorter, P.A., Mateas, M., Wardrip-Fruin, N.: Skald: Minstrel reconstructed. IEEE Trans. Comput. Intellig. and AI in Games **6**(2), 156–165 (2014)

[161] Theune, M., Faas, E., Nijholt, A., Heylen, D.: The virtual storyteller: Story creation by intelligent agents. In: Proceedings of the Technologies for Interactive Digital Storytelling and Entertainment (TIDSE) Conference, pp. 204–215 (2003)

[162] Thorndyke, P.W.: Cognitive structures in comprehension and memory of narrative discourse. Cognitive Psychology **9**, 77–110 (1977). DOI 10.1016/0010-0285(77)90005-6

[163] Tobias, R.: 20 Master Plots: And How to Build Them. F+W Media (2012). URL http://books.google.pt/books?id=EZgEqCYlBwsC

[164] Tomaszewski, Z.: Marlinspike: An interactive drama system. Ph.D. thesis, University of Hawai'i (2011). AAI3485491

[165] Tomaszewski, Z., Binsted, K.: The Limitations of a Propp-based Approach to Interactive Drama. In: Intelligent Narrative Technologies, Papers from the 2007 AAAI Fall Symposium, pp. 167–173 (2007). URL http://www.aaai.org/Papers/Symposia/Fall/2007/FS-07-05/FS07-05-028.pdf

[166] Tomaszewski, Z., Binsted, K.: Demeter: An implementation of the marlinspike interactive drama system. In: AAAI Spring Symposium: Intelligent Narrative Technologies II (2009)

[167] Turner, S.R.: Minstrel: a computer model of creativity and storytelling. Ph.D. thesis, University of California at Los Angeles, Los Angeles, CA, USA (1993)

[168] Veale, T.: Coming good and breaking bad: Generating transformative character arcs for use in compelling stories. In: Proceedings of the Fifth International Conference on Computational Creativity. Ljubljana, Slovenia (2014). URL http://computationalcreativity.net/iccc2014/wp-content/uploads/2014/06//11.4_Veale.pdf

[169] Veale, T.: Running with scissors: Cut-ups, boundary friction and creative reuse. In: L. Lamontagne, E. Plaza (eds.) Case-Based Reasoning Research and Development, pp. 3–16. Springer International Publishing, Cham (2014)

[170] Veale, T.: When worlds and scripts collide. In: N. Streitz, P. Markopoulos (eds.) Distributed, Ambient and Pervasive Interactions, pp. 380–391. Springer International Publishing, Cham (2016)

[171] Ventura, D.: Mere generation: Essential barometer or dated concept? In: Proceedings of the Seventh International Conference on Computational Creativity (ICCC 2016). Sony CSL, Sony CSL, Paris, France (2016). URL http://www.computationalcreativity.net/iccc2016/wp-content/uploads/2016/01/Mere-Generation.pdf

[172] Wang, T., Chen, P., Li, B.: Predicting the quality of short narratives from social media. In: Proceedings of the Twenty-Sixth International Joint Conference on Artificial Intelligence, IJCAI-17, pp. 3859–3865 (2017). DOI 10.24963/ijcai.2017/539. URL https://doi.org/10.24963/ijcai.2017/539

[173] Ware, S.G.: A plan-based model of conflict for narrative reasoning and generation. Ph.D. thesis, North Carolina State University (2014)

[174] Wilcock, C.C.: An Automated Story Generator of the Old French Epic. Bachelor of Computer Science Thesis (2005)

[175] Winer, D.R., Amos-Binks, A.A., Barot, C., Young, R.M.: Good Timing for Computational Models of Narrative Discourse. In: M.A. Finlayson, B. Miller, A. Lieto, R. Ronfard (eds.) 6th Workshop on Computational Models of Narrative (CMN 2015), *OpenAccess Series in Informatics (OASIcs)*, vol. 45, pp. 152–156. Schloss Dagstuhl–Leibniz-Zentrum fuer Informatik, Dagstuhl, Germany (2015). DOI 10.4230/OASIcs.CMN.2015.152. URL http://drops.dagstuhl.de/opus/volltexte/2015/5289

[176] Winer, D.R., Young, R.M.: Discourse-driven narrative generation with bipartite planning. In: INLG 2016 - Proceedings of the Ninth International Natural Language Generation Conference, September 5-8, 2016, Edinburgh, UK, pp. 11–20 (2016). URL http://aclweb.org/anthology/W/W16/W16-6602.pdf

[177] Zwaan, R.A., Langston, M.C., Graesser, A.C.: The construction of situation models in narrative comprehension: An event-indexing model. Psychological Science **6**(5), 292–297 (1995)

# 10

# Learning from Responses to Automated Videogame Design

Michael Cook

Queen Mary University of London, London, UK `mike@gamesbyangelina.org`

**Summary.** ANGELINA is an automated game design system that has engaged with many different communities as it has been developed and iterated upon. The system has exhibited work in museums; been the subject of articles in both popular and specialist games press; entered game development contests alongside other game developers; and designed games live in front of gaming enthusiasts at big public events. Each of these encounters has changed perceptions of the software; as well as changing our own perception as researchers. In this chapter we explore how different stakeholder groups reacted to our system, how that impacted the project, and how this relationship is driving our future work.

## 10.1 Introduction

Developing games, especially videogames, is a complex creative task that brings in many different creative subproblems that all need to be solved in tandem. This makes it a rewarding challenge for people, and a good domain to do research in for Computational Creativity [1]. ANGELINA is a computationally creative system that works in the domain of videogames (henceforth 'games' as shorthand). It uses a variety of artificial intelligence techniques, underpinned by philosophical ideas from Computational Creativity, to design and distribute complete games, while taking on increased amounts of creative responsibility as we develop the system further.

There have been six major versions of ANGELINA to date, each one developing a different genre of game, usually on a different platform with a different distribution method. Throughout this chapter we will occasionally refer to a specific version of ANGELINA using a superscript, like this: $\text{ANGELINA}^n$. The general term 'ANGELINA' is used to refer to the project as a whole. ANGELINA has achieved many milestones across its eight years of development: it was the first AI system to enter a game jam alongside people; it co-designed mechanics and levels for a Top 500 Android game; it has been commissioned by Wired and the New Scientist; it had its work exhibited at *babycastles*, a New York digital art gallery; and in 2018 it designed games at a major UK games event. This list shows how Computational Creativity, especially in games, has a tendency to cut across a creative field and interact with

© Springer Nature Switzerland AG 2021
P. Machado et al. (eds.), *Artificial Intelligence and the Arts*, Computational
Synthesis and Creative Systems, https://doi.org/10.1007/978-3-030-59475-6_10

it on many different levels. ANGELINA has been exposed to critics, developers, curators, the public and the press, and each of these groups has responded differently and in return shaped our thinking about how the project should be developed.

### 10.1.1 Stakeholders

One of the popular definitions for Computational Creativity is stated in [2] as follows:

> The philosophy, science and engineering of computational systems which, by taking on particular responsibilities, exhibit behaviours that unbiased observers would deem to be creative.

An important part of this definition is the mention of 'unbiased observers' – it highlights the importance of the audiences a system may have in validating the work it is doing (at least with respect to *conscious* biases). This is not a competition we can win by producing a really good output – outside sources, usually people, must agree with us that our system is working creatively. But it is also important that we as researchers do not view these observers as merely a measuring post for us to assess the quality of our research, feel satisfied, and move on. The groups who evaluate our systems make up the communities of people who create, curate, critique and consume the domain our system works in.

These observers shouldn't be asked to come into a laboratory and assess our systems in sterile environments. Rather, our software should go out into the world and immerse itself in the same space these observers occupy. Observation must be *in situ* to be meaningful. Thus, computationally creative chefs must post their recipes to food sites, and invite people to cookouts; computationally creative artists should exhibit their work in galleries and have people sit for portraits. Both our software and us as researchers should seek to become part of the communities we seek to impact with our work, which often necessitates change and adaptation.

This chapter is about several groups within the games community, and the lessons we've learned from interacting with them over the last eight years of work on ANGELINA. We refer to these groups as *stakeholders*, in the sense of Colton *et al* [3]. It's important to recognise that while observers are important to Computational Creativity, different people approach topics like this from different perspectives, with their own expectations and biases. Many people will belong to multiple stakeholder groups – a journalist who also curates exhibitions, for example, or a game developer who also plays games. These groups are more like lenses, allowing us to view one particular perspective at a time, and consider what is important to this group, and what issues arise when interacting with them.

Computational creativity is a dialogue between research and these stakeholder groups. In Csikszentmihalyi's *Flow And The Psychology Of Discovery And Invention* he outlines how creative domains are occupied by many different kinds of person who act in different roles, and many of these people act as gatekeepers, consciously or unconsciously affecting which ideas and works are accepted by larger communities, or allowed to influence trends and techniques [4]. This model of social communities is useful when thinking about how our software acts creatively, but we can also use this same thinking to recognise how Computational Creativity itself is accepted by a particular creative community. These same gatekeepers – influential critics, respected curators, well-known developers and even large groups of players – will

decide whether systems like ANGELINA are accepted into their spaces, just as readily as they decide what kinds of game are acceptable or celebrated.

## 10.1.2 Background

ANGELINA began as a PhD project – I had no background as a researcher, no track record of work, and no expectations for how research should be done. At the beginning of the project, however, I committed to two things: first, that I would write regularly about my research; and second, that whatever ANGELINA produced would always be easy to access and play. The first commitment stemmed from my enthusiasm for science communication and past aspirations as a journalist. I had no idea if anyone would be interested in what I wrote, but I had started and abandoned many writing projects in the past, so it was straightforward to begin another without any expectations.

The second aim, that ANGELINA's output would be accessible, derived from a gap I perceived in games research: despite working in an area that was extremely contemporary and accessible, most games research was highly *inaccessible*. Software was often not released online, and when it was it frequently required additional libraries or utilities to run. Regardless of what ANGELINA would go on to make, I wanted to avoid this, so that people could engage with the output of our research and hopefully understand the project better.

These two decisions were, in retrospect, highly serendipitous and had a large impact on how the system would eventually be perceived, and its potential total reach. Ease of access helps connect scientific research with all groups – not just people who come to play the games, but journalists seeking our more information, or developers trying to find out technical details. We consider it an extreme stroke of luck that we were prepared from the beginning of the project, and that as a result there is a good archive of the entire history of ANGELINA, making it easier to chart the change and progress the project has made.

My own background as a game developer also informs the development of the software, and explains how our interactions with these stakeholder groups changed over time. When I began working on ANGELINA I had never made a game before, or even tried to use a game engine. This made the early stages of work on ANGELINA extremely slow and riddled with mistakes. Prototypes of the system, prior to ANGELINA[1], attempted to evolve keyboard controls for arbitrary shapes on a screen, the equivalent of building a story generator by having it draw pixels on a screen until they resembled letters. However, starting from the beginning also helped with the slow and gradual growth of the system.

Before ANGELINA could work in a particular domain or with a particular technology, I would first have to learn how to work with it myself. Each new version of ANGELINA is preceded by a phase where I learned how to work in the engine and develop games of that genre. We can see the gradual increase in the system's complexity, but this growth had an impact on the project beyond just the technology used – we can also track ANGELINA's relationship with outside communities in relation to my own understanding of game development too. As I gain more confidence and meet more people, ANGELINA's remit expands to include writing commentaries and maintaining a social media presence; ANGELINA's involvement in game jams (explained later in this chapter) closely follows my own exposure to them; and ANGELINA's most recent shift to focus on larger, more detailed games

mirrors my own decision to stop making small games and focus my efforts on a larger work.

While I would be hesitant to draw comparisons between myself and the software, there is a link between our growth as creative entities, and my own understanding of games as a creative medium has influenced the trajectory of the research. This is relevant for two important reasons: firstly, because the lessons laid out in this chapter are partly unique to our experience working on ANGELINA, and may need to be viewed in this context to understand how they can be applied to other media or projects. Secondly, because this growth is not finished and may never be, and so the changes and lessons learned in this chapter are only a snapshot of where we are today. As time continues, both ANGELINA and myself will continue to change, and the project's relationship with the games industry will also shift.

## 10.2 Press

In 2012 a science journalist contacted us wishing to write about ANGELINA for *Develop*, a magazine mostly circulated to games industry professionals and students. The result was a double-page spread with the headline *Hello Game World*, with a subheader that asked the question '*Could machines really take creativity from the hands of us mere humans?*'. The article spread can be seen in Figure 10.1[1]. This was the first time ANGELINA was written about in the press – since then it has been covered in dozens of articles, ranging from news stories to interviews. This press coverage is the primary way people learn about the software's existence, which means that it has a huge impact on how the general public (as well as the game development community) perceive our work. In this section we discuss three key topics which arose during our engagement with journalists: the question of whether humans would be replaced by AI; the issue of naming and gendering an AI system; and the problem of secondary online reporting.

### 10.2.1 Replacing Humans

The article in Develop had two main focuses: explaining how ANGELINA worked; and discussing the implications for people employed in the games industry. The former is a fairly standard expectation for any writing about research, while the latter is more unique to Computational Creativity systems and has been a feature of almost every interview we have conducted to date. In the Develop article, I gave the following quote in response:

> Artists and designers are not going anywhere. Programmers are not going anywhere. I like this idea that AI will become a collaborator in the design process, not replace it.

Videogames have a healthy arts scene as well as a large and profitable industry. While both are celebrated in the specialist press, a large proportion of readers are interested in and knowledgeable about big-budget game development, and so the

---

[1] A full PDF of this article can be downloaded at `gamesbyangelina.org/press/develop.pdf`

potential impact of AI on the large-scale production of games is of particular interest to them. Even though most coverage of ANGELINA acknowledges that its games are unlikely to become best-sellers now (one article even goes as far as describing one of ANGELINA's games as 'terrible' in the headline) there is an awareness that this may lead to a future in which this technology is integrated into modern games production.

While we have maintained an optimistic view about the future in all of our conversations with journalists, over time we've been more careful in separating our intentions as researchers from the potential trajectory that employers in the industry may take. Initially we feel we were possibly too optimistic or naive about the likely behaviour of the games industry, especially at its most profit-driven extremes. The interest in this from journalists, as well as conversations with other stakeholder groups like developers and players, has shaped our thinking about this over time, and we've changed in two important ways.

Firstly, we're clearer about the risk of automation when we talk about AI, and especially our own research. Initially we were afraid that talking too frankly about this might bias people against our work, which has no particular motivation or interest in replacing humans. But this ignores the fact that our work may be repurposed, and also raises awareness of the potential for automation throughout the games industry. We're now clearer in distinguishing our goals and work from those of the industry, and explain that while some jobs may be at risk from automation, our research is not interested in furthering that cause directly.

In addition to a change in how we discuss the topic, we've also shifted the focus of our research. As we developed ANGELINA further, we expanded the system's connection with other people. At first this meant giving the software the ability to talk through social media, but the latest version of ANGELINA will begin collaborating with humans during the development process, employing people as testers, and hopefully commissioning artists and musicians to collaborate on a game with it. We hope that by putting other people as central collaborators in ANGELINA's process that we can emphasise co-operation between people and AI, rather than portraying ANGELINA as a standalone entity that does not need help.

This is not only helpful in allaying fears about our research, but we've also come to view this as a more realistic way to build computationally creative software in the domain of videogames – since most games come out of a collaboration between individuals with different skillsets and creative visions. It also makes it easier to think about new applications for ANGELINA in the future, such as a game designer teacher or mentor, or a critic. We've also changed the internal structure of the software, so that instead of building games in hours, we now aim for it to take days, weeks or even months. This not only has huge philosophical benefits for our work (which we outline in [5]), but it again reduces the emphasis on efficiency and productivity, and instead makes our work put people and the creative process at the centre. Overall, reshaping our thinking about the system to include more humans in the process has been a huge net positive for us, and conversations with journalists were a major catalyst in this change.

## 10.2.2 Gender and Names

ANGELINA's name was originally chosen because I believed a human name would help people view the system as an individual creator, but as the project progressed

it became clear that this choice was also causing problems for the project. Foremost of these problems was the fact that encouraging people to view the system as an individual also raised their expectations accordingly. While this was initially something I thought would be beneficial, it soon became clear that raising expectations without meeting them led to frustration. This was a useful learning experience: from then on, everything about the system and how we presented it was designed to be as clear, unambiguous, and lacking in anthropomorphism as possible. Nevertheless, the name has persisted as a reminder of this small, early mistake.

Another key problem that arises from using a human name is the corresponding baggage that comes with it, especially relating to gender. A common focus in articles was commenting on our choice of pronouns with which to refer to ANGELINA. Even before the first press coverage, we were trying to use 'it' to emphasise the fact that the system is not human despite its name. Nevertheless, it was easy to slip up, something which journalists always were interested in. This is often picked up by coverage, including in Develop:

> She's also not human. Halfway through a chat... Cook stops himself. "I have to avoid calling it 'she' and 'her', he admits."

And in a profile in Eurogamer [6], an online publication aimed at people who play games:

> But to understand this – to understand the program Cook calls AN-GELINA... to understand why ANGELINA's definitely an 'it' rather than a 'she'...

Fig. 10.1: *Hello Game World*, by Douglas Heaven, published in the February 2012 issue of Develop.

Using a female-coded name for the system raised many issues. I only later became aware of the common trend in computer science for artificial intelligence systems to be female-coded, and often developed by male computer scientists. I greatly regretted the name after learning this, and the sense of regret peaked in 2014 when Dazed published an article titled *Ten women reshaping modern tech*, in which ANGELINA – an inorganic piece of software – was listed, taking up a spot that should have gone to a woman [7]. Since 2014 there has been a sharp uptick in the presence of female-coded AI, especially in subservient roles – such as Amazon's Alexa, Apple's Siri and Microsoft's Cortana. By contrast, IBM's Watson – a machine which is promoted as being rational, intelligent, and capable of outperforming humans – is marketed with a male-coded persona.

It's worth noting that despite this being something I have tried to distance myself and the project from, other researchers have done similar with the explicit intention of exaggerating and focusing this (often female-coded) anthropomorphising, notably David Cope's EMI system and its successor, Emily Howell [8]. Cope went as far to describe the computer program Emily Howell as EMI's "daughter", with its first name a nod to EMI's name, and its second name taken from Cope's own father. Cope appears happy for people to write about Emily Howell using gendered pronouns, and even uses them himself [9]. On Cope's website, there is a long quote about beauty and creation, addressed to David from the perspective of and attributed to Emily Howell, with no commentary or explanation [10]. This is, in my opinion, far beyond unintentional slip-ups and very heavily playing up a human persona for perceptual gain. At this point I would argue that Cope is actively harming the public's ability to form a true understanding of or relationship with the software he's created.

Amidst these problems, we've also found positive ways to view the situation that ANGELINA's name has created. Later in 2014 I met Dr. Amanda Phillips, an academic well-versed in both game studies and race, gender and queer theory. We spoke at length about ANGELINA and she proposed that while the existing perception of the software cannot be changed, there were positives we could embrace too; in particular, Phillips suggested that while existing perceptions couldn't be changed, they could be subverted, and that by emphasising ANGELINA as a gendered identity in an industry that is overwhelmed with male-coded identities, we might end up doing something positive. Writing about our meeting later [11], she noted:

> Against a backdrop of human women struggling to achieve legitimacy in the games industry (and games journalism and gamer culture), the accident of Angelina's gender becomes quite a bit more complicated – and potentially problematic. But... the truly strange and wonderful games that Angelina creates are really quite queer. I'm looking forward to watching how this project develops and thinking about how it might have a place in commentary or even intervention on the current troubles in game development.

The name is now a major part of the software's identity, and has helped create a sense of continuity for the project out of what is essentially several pieces of software. Although it encourages anthropomorphism, names are also part of how we prime people to interpret our software, as they are often the first thing a person learns about the project besides our overall research aim. Using a human name encourages people to talk and think about the software as an individual, and while this can unfairly raise expectations, as well as resonate problematically with contemporary social problems, it also helps people to examine *why* they feel uncomfortable about

the gap between human creators and ANGELINA, and by understanding this gap better, we can improve how we present and design software in the future. I remain torn on the ongoing use of the name, and am considering retiring the name in the near future, at least as the umbrella name for the project.

### 10.2.3 Secondary Sources

In early 2012 a writer for the New Scientist contacted us wanting to write an article about ANGELINA, having read about the system in Develop. The resulting piece went out in their magazine, but it was the online version of the article that had the most impact, not only because it was shared widely, but because journalists from around the world came across the article and were inspired to write the story up for their own sites [12]. This resulted in several other journalists writing articles about ANGELINA, many of whom did not contact us for comment but instead wrote shorter posts using information in the New Scientist article, sometimes linking back to it.

Articles sometimes contain inaccuracies, usually because we explained something poorly, or because something wasn't mentioned at all and the writer had to infer the answer for themselves. When this happens we've usually tried to contact the author to correct the mistake, but even then mistakes are still not noticed by us sometimes. For example, the New Scientist article about ANGELINA mentions that "Angelina creates a level by randomly selecting from a list, then scattering enemies and power-ups throughout the level" which is a misunderstanding of the evolutionary process that guided ANGELINA$^3$'s level design system. This quote still persists in the article today, as we didn't contact the author in time.

Small misunderstandings like this are a natural part of the science communication process, and working with writers to correct them after publication has always been straightforward. However, the nature of online journalism means that the second wave of articles – written not based on primary contact with us, but based on content in other articles – repeats and sometimes even exaggerates these inaccuracies, and publishes them in places we may not be aware of, or have no means to contact. Even if we fix the mistake in the original article, we may not be able to correct the secondary articles (and this process is extremely time-consuming, in any case).

In most scientific disciplines this is simply a matter of communication, but in Computational Creativity these misunderstandings can drastically impact how people perceive the systems the articles describe. If an article overstates a system's ability, or even *implies* a higher level of understanding than really exists, our other audiences may find themselves disappointed when they discover the truth. While there's no way to control or even keep track of the world's journalists, one approach we have employed to mitigate the problem of misinformation spread through articles is to maintain a core of useful information on our own website[2]. This site contains detailed explanations of the research as it progresses, with clear and unambiguous descriptions of what the system can and cannot do. This helps in two ways: journalists seeking out extra information will easily be able to find good-quality explanations of current work; and readers who look for answers to their questions can hopefully find first-hand information if they search online for our work.

---

[2] www.gamesbyangelina.org

# 10.3 Public

Earlier in this chapter we quoted a definition of Computational Creativity as fundamentally concerned with the views of 'unbiased observers'. While the other stakeholder groups in this chapter are influential and important to our work, the general public makes up the largest group by far. This group is the primary audience for our software and the artefacts it produces, and understanding the different views held by different subgroups helps us understand how perceptions about creativity are shaped, and how we can either play into them, subvert them, or learn from them.

For automated game design the most important subgroup within the general public is *players*, people who regularly play and read about games. Games are a popular medium but have not yet reached either the ubiquity or social acceptance of films, music or books. Presenting ANGELINA or its output to these groups is daunting – while many are excited by the prospect of new ideas and research, most are only interested in the raw quality of games on offer. As one commenter on a gaming site put it when discussing ANGELINA: 'Wake me up when it makes *Halo*[3]'.

In this section we explore two important issues arising when presenting our system to the general public: first, tackling the impact of prior knowledge an audience might have about creativity or artificial intelligence; and second, how the way in which systems are presented both at physical events and online can have an impact on how people perceive the project as a whole.

## 10.3.1 Expectations

It is impossible to approach artificial intelligence research without preconceptions, and this is only becoming more evident as the 21st century progresses. Popular culture, press coverage, government policy and corporate public relations all influence how the public perceive AI, and this baggage influences how people think about our software from the moment they first encounter it. This is something that affects all AI research, but especially for Computational Creativity as it is so grounded in perception, culture and community.

This is most evident through the comments left on articles and videos about the software, which are usually the first way someone encounters the software. Several common themes emerge when considering responses from the public over the history of the project so far.

### Mass Production of Creative Artefacts

A common concern among commenters is that this would lead both to job losses (a topic that journalists also were keen to discuss, as mentioned earlier in this chapter) and also to the trivial mass production of media. The following comment was left on a 2013 article on games site *Eurogamer*:

Surely Activision and EA are already using a version of this technology?

---

[3] A very popular videogame series, first released in 2001.

Activision and Electronic Arts are two of the largest companies in the games industry, and have drawn criticism for producing repetitive games in popular franchises year after year. This comment is partly tongue-in-cheek, but also reflects two things: a perception that ANGELINA is and may always remain unable to truly innovate; and that the primary beneficiary of this research would be large corporations looking to make a profit as easily as possible. The tone of these comments are usually not critical of our research, but more cynical about the likely uses of it by the games industry.

Such comments often touch upon the common theme of job losses through automation, too, especially where large corporations are involved. Another comment on an *Ars Technica* article [13] reads:

> Part of me is sitting here thinking "that's pretty cool" and the other part is laughing at the mental image I've got of a bunch of game developers screaming "Don't give the publishers ideas to replace us!!!"

In general, these comments acknowledge that our research is in its very early stages, but also show an awareness of the potential economic impact of work into automation. In response to this, we've tried to acknowledge the reality that these problems may one day impact the games industry, but at the same time have tried to offer reassurance too. Particularly in the case of ANGELINA, our model for the system is not a large development company, but an individual person working creatively. Thus, our aim is not to supplant large-scale industrial production, but instead to make another member of a creative community who has peers, critics, mentors and fans. This perspective helps people understand our own goals, and also provides hope for a post-automation future, as it underscores the human connection at the heart of a lot of media consumption, which can't simply be replaced by copying the artefact creation process.

## Fear

A major change in the perception of AI over the last five years has been in whether people view the technology as generally good or bad for humanity. While AI has always been a source of tension and drama in pop culture, it is only recently that the question about existential risk has seriously been raised in public debate. In the opinion of this chapter's author, these discussions are usually poorly-founded, and many of them only serve to benefit groups who stand to benefit from greater public interest in AI. Nevertheless, the impact of these discussions can be felt even in online discussions about automated game design. The following is a joke made by a commenter on a games site:

> Just one question: are you a robot sent from the future to create Skynet, or do you simply hate humanity?

While no-one to our knowledge is specifically afraid of ANGELINA, videogames are often perceived as a violent medium, and people are sometimes concerned about AI being trained on these problems. In reality an AI has no awareness of the symbolism of games about conflict or even notions of playing 'head-to-head' with another human being, but this doesn't make the public perception any less real or valid. A lot of work in automated game design and game AI focuses on competitive and

conflict-driven games, even though that only makes up a portion of what games are capable of as a medium. We've previously written about the need to broaden automated game design's scope in this regard [14] because it is healthy for the research area, but in some small way it probably also allays people's concerns – while they may be disguised as jokes – that AI research is largely about conflict.

## 10.3.2 Exhibition Structure

The latest version of ANGELINA represents a major departure from our earlier work and a large step forward for the system's creative independence. Rather than being a closed system which produces games on demand, ANGELINA is now a *continuously creative* system which moves from task to task and project to project without stopping, working over much longer periods of time than before. In addition to this, ANGELINA now only works on one aspect of game development at a time, rather than parallelising the process. This means that we can visualise what it is doing, and so people can watch it design games and make decisions in real time. Figure 10.2 shows a screenshot of the level design visualisation.

In early 2018 we were invited to bring the latest version of our software, ANGELINA[6], to Eurogamer's Rezzed expo, a large games exhibition held annually in London across three days. Over 20,000 people attend the event, and it plays host to a range of unreleased games, talks from games industry figures, and opportunities to meet and talk to the people who make games. Because of ANGELINA's new focus on visualising its process, this was a perfect opportunity to demonstrate the system in front of a live audience of players – a group we have largely only interacted with indirectly in the past, through interviews or through releasing ANGELINA's games after the fact. This was the first time the public were able to see and interact with the system directly, during the creation of a game.

Fig. 10.2: A screenshot of ANGELINA[6]'s design visualisation, showing how levels are designed.

On the first day of the event we had one machine available to us, which we set ANGELINA up on and had it run throughout the day. Attendees could watch the process and also interact with the system in a limited way to give it new information about the world which it could use in its game designs. Attendees on the first day had a mixed response to the system, particularly those who came into the exhibit during slower or less visual parts of the game design process, like the design of game rulesets. Some would ask questions about the system and were interested in the way it worked, but found it hard to engage with any particular part of the design process in isolation.

On the second day we gained access to a second machine and loaded it with games that ANGELINA had designed, including a new game designed on the first day of the event. From here onwards, there was a noticeable increase in enthusiasm from attendees, who could now perceive a clearer narrative to the system's work. Since attendees would only spend a few minutes at any particular stand, seeing part of a long game development process made it hard to appreciate the system as a whole. But by being able to see both a glimpse of a larger process, and then see the kind of game that would emerge from it, people were able to better appreciate what the system was capable of. Figure 10.3 shows the exhibit setup at Rezzed, with people playing ANGELINA's games in the background.

While observing a creative system at work can be persuasive and interesting, as can seeing and interacting with its output, we learned from our time at Rezzed that using both in tandem is more powerful than either is individually. This has influenced our thinking on how to present the system publicly in future at events like Rezzed, but also how to shape the online presence of the system as well. We had already planned to stream the software's creative process live on the Twitch.tv streaming platform, but now recognise that it is important to clearly promote games alongside this, so that people can put the system's work in the context of real, playable output. This is also true in reverse – ANGELINA's online games catalogue

Fig. 10.3: The Rezzed live design exhibit. Left: a machine running ANGELINA in design mode. Right: an attendee playing a game designed by ANGELINA.

must be supported by links to access information about the creative process and experience the system's live work. We believe that social media integration may be the key to connecting the two, so that ANGELINA can communicate with its audience and bridge between discussing its existing output and its ongoing creative process.

## 10.4 Peers

The development of ANGELINA has been closely paralleled by my own progress as a game developer. In order for ANGELINA to adopt a new technology, work in a new genre, or take responsibility for a new aspect of design, I would have to go and learn about it myself first. As my understanding developed, so too did the quality of ANGELINA's games. This progress was not purely technical though – my understanding of the cultures and societies within game development also changed and developed, and this too is reflected in the development of ANGELINA. As the project has developed, we've cultivated closer and closer links with game development communities, particularly the independent game developer community.

### 10.4.1 Optimism

In 2012 I began entering *game jams* – time-limited creativity challenges where people develop games, usually starting from a blank project, in a very short space of time. Game jams are a huge part of game developer culture, partly because they represent ways to practice creating a complete game in a focused and rapid way, but also because they act as networking spaces where people can make friends and connections that may last for decades. People sometimes form teams to enter jams, they share progress and encourage one another, and many jams also include a curation or review phase where people exchange feedback. They are vital spaces for the incubation of new ideas, the honing of skills, and the creation of prototypes for larger, future projects. The largest game jams have in excess of 40,000 participants globally.

In 2013 we began work on ANGELINA[5], with the express aim of developing a system that was capable of entering a game jam. ANGELINA was incapable of performing all parts of game development on its own (at that time it sourced art and music from the internet, for instance) so we chose to enter the Ludum Dare game jam, which has a track which allows the use of external or pre-existing material in a game. The main problem we needed to overcome in order to enter a game jam was the interpretation of the jam's *theme*, a word or phrase which people must incorporate into their entry somehow. ANGELINA[5] was capable of using various word association databases and other linguistic tools to identify relevant parts of a theme and expand upon them to style a fairly simple game design.

We first entered Ludum Dare in December 2013. An important feature of Ludum Dare is that there is a review phase after the jam ends, during which time entrants are encouraged to rate each others' games on various categories, with rankings being announced a few weeks later. We have always avoided hiding the fact that ANGELINA is an AI when presenting its games to people, and so we planned to supply some text accompanying the submission. It came in two parts: a statement

from us as researchers explaining the project and requesting that people evaluate the game, not the research; and then a short passage from ANGELINA describing the choices it had made in designing the game.

Although we usually are not in favour of 'Turing test'-style attempts to evaluate creative software, we were curious about the rating system for Ludum Dare, since this was the first big exposure ANGELINA would have directly to the game developer community. We decided to enter ANGELINA into the game jam twice: once with a public explanation that a piece of software had created the game submission, and once under a pseudonym with no such declaration attached. For a more in-depth exploration of this experiment, along with ANGELINA[5], we direct the reader to [15].

When the ratings were finalised, we were pleasantly surprised with ANGELINA's performance: out of 780 entries to the jam track, ANGELINA rated 180th for Mood, and 211th for Audio. Its lowest rating was in the Theme category (533rd) which was disappointing given how important it was in the game jam process. The anonymised entry, however, scored much lower across almost all categories except Humour. When reading the comments left by reviewers, we can also see a distinct shift in tone. In the main entry, people qualify their criticisms with support and encouragement:

> Not particularly interesting in its own right, but fascinating to read that this was somehow generated from thematic inputs.

> Angelina seems really good at creating an atmosphere with both sound and visuals. But the game part of it seems a bit lacking still.

> the fact that this was made by an AI is staggering. it lacks in depth and creativity, tho. the funny thing is, that this is better than some of the games I have tested for this ludum dare :)

By contrast, reviews of the other entry are more open in their confusion and bemusement at the weird nature of ANGELINA's games:

> That was... Well it was... How should I put this... It umm... I feel... Well... Hmmmm.

> Argh, that audio! :D

> I....am not sure how I feel about this

> this was a rather annoying experience.

In general, developers were kinder to us (both in their scores, and their written comments) when they were aware that the game was made by an AI, and as part of a research project. While 'silicon bias' is a phenomenon that has been observed in some areas of Computational Creativity, it seems that in videogames there is generally a positive view of this kind of research, and developers were excited to play the system's output and have a voice in the discussion surrounding our research and where it should go in the future.

Experiences like this, as well as many productive and optimistic conversations with game developers since then, have given us the confidence to reach out to developer communities directly and talk to them about what they hope to see out of automated game design research. Far from being afraid or skeptical, most of the

designers we talk to are excited about the potential of this research as a source of ideas or collaboration in the future, and they are keen to provide their views and insights into how this software could be built to help people the most. We have worked directly with independent game designers as industry collaborators on our research grants, and hope to do so again in the near future.

This optimism and positive bias is important to note, and we believe this partly comes from an open and engaged approach towards interacting with creative communities. Additionally, our vocal interest in game development and a desire to help, rather than supplant, game developers may help people view us as part of an evolving set of tools, rather than an omen for an automated future.

## 10.4.2 Peer Communication

Evaluating games is a subjective act. While some aspects of ANGELINA's games are celebrated, its games are not highly regarded in general, although they might be if a person had made them (a young child, perhaps). Games from the ANGELINA[1] system possess mechanical variation but lack in depth, narrative or design; games from ANGELINA[3] are visually and thematically interesting, but overly short and poorly structured; and games from ANGELINA[5] pose little to no challenge, instead emphasising a mood or tone. One player likened this set of games to *LSD: Dream Emulator*, an experimental game made for the PlayStation in 1998, which lacked any structure or purpose but is regarded as "one of the most unnerving and unpredictable weird video games ever made".

For the press or the general public, the low quality of ANGELINA's games may not impact their enthusiasm for the project, or their view of it as a sign of the future of the games industry. However, feedback from those working in the games industry suggested that the system was seen as of little use. There was no clear message about how a system like ANGELINA would change their job, and the main evidence for the system's performance – the games it produced – suggested the system was also not very up to commercial standards, whether that was big-budget blockbusters or even a more modest independently-developed game.

This state of affairs came from our original goals for communicating about ANGELINA, which revolved around a desire for science communication, and to establish the software as an independent creative entity. We had no intention of ANGELINA being used by the games industry, or taking on roles within a game development project, and so most of our work talking about the system was framed as a slow growth of the software's independence and creativity. This meant that we de-emphasised a lot of the technical advances made in developing the system, and failed to raise awareness about a lot of the system's capabilities in design and analysis.

This became obvious when we met with developers in one-on-one discussions at conferences and events and told them anecdotes about ANGELINA's more design-oriented systems, such as the code-generation system used to generate game mechanics in ANGELINA[4] (also referred to as *Mechanic Miner*) [16]. This system used metaprogramming techniques to invent new game mechanics, and then tested them on specific levels to assess whether they had an impact on gameplay. This feature led to the reinvention of game mechanics from a well-known platforming game, as well as the discovery of unusual mechanics that took advantages of hidden parameters or bugs in the game engine.

When describing these systems to developers, many were immediately excited about the implications for prototyping or to provide inspiration for extending an existing game. Some said that they could see ANGELINA being useful as a collaborator in future, either testing levels, suggesting new features, or showing alternative solutions to existing design problems. Discussing the technology behind the software and using specific examples of what it was capable of was far more useful to developers and gave a much clearer picture of how the software could impact their jobs, compared to talking about the creative independence of the system or showing its games. Note that this different approach did not change their view of ANGELINA as a creative entity – they described a desire to 'collaborate' or 'co-operate' with the software, rather than to 'use' it – but it made it clearer why such a system would be impactful on their day-to-day work.

We also noticed a change in how developers perceive the software when we redesigned ANGELINA to have a more modular, linear design [17]. As we mentioned in the previous section, ANGELINA[6] recently was on display at a major games event in the UK, designing games for a live audience of attendees. Many of the developers exhibiting at the event also came to see ANGELINA and talked to us about the project. The pattern we observed in the general public also followed when showing the system to developers: being able to see the games and the system side-by-side enhanced their appreciation of both. But the linear structure of the system, as well as the emphasis on visualising the process, also made it easier to convey to developers how the system might act as a collaborator. Being able to see the system working on a particular task, and see how it solves a problem, seems to make it easier for people to imagine how the system might integrate into their own creative process, and demystifies artificial intelligence by making it seem more like an ordinary piece of technology, without diminishing their enthusiasm for its capabilities.

## 10.5 Conclusions

Throughout this chapter we've explored some of the groups who have interacted with and responded to our work over the course of the project so far, and highlighted some of the ways this has influenced the shape of our software and the way we view our research. In this concluding section, we try to summarise these ideas in a more general sense, to help those working on computationally creative systems to be able to prepare for their own interactions with groups like this, and to help plan in advance how their systems should be built, be presented, and be used.

### 10.5.1 Everything Is Context

As researchers we like to think that we maintain a certain level of distance from our work, no matter how passionate or excited we are to work on it. This is perhaps a particularly important belief in Computational Creativity, where a common criticism of the systems we build is that they are mimicking or depending upon their creators for much of their skill or creativity. This leads us to downplay connections between us and our software, and to try to think about and talk about our software as being distinct from us.

In terms of developing creative systems, it's helpful to find ways to reduce our influence on the software (Simon Colton calls this 'climbing the meta-mountain' and 'handing over responsibility' [18]). Successive versions of ANGELINA certainly did take over more responsibility from us – the latest version, for example, no longer produces games on demand, and will eventually be capable of restructuring its creative process entirely. These are concrete, technical things that can be demonstrated to people to show our software gaining independence and autonomy.

However, it's also important to recognise that every aspect of a research project provides useful context for people to understand the system itself. Several press interviews about ANGELINA noted that I was also a game developer and inquired about how my own growth as a game designer had impacted my work on ANGELINA. Not only is this relevant to people reading about the work, it also caused me to reflect on this and made me realise that a lot of the topics I had worked on over the years paralleled my own personal development as a creative individual. This doesn't mean ANGELINA is less creative, or reliant on my own growth, but it does provide extra depth to the project, and ways to understand what sets apart my approach to computational creativity from that of other automated game design researchers, or even researchers in other domains.

While we don't write about such topics in research papers, there is a lot of additional information that becomes relevant when talking to people outside of academic contexts, as this chapter shows. This information helps ground the work in the real world, which is especially important when the system in question is not yet fully embedded in a real-world creative community, as is the case for so many Computational Creativity projects. In the absence of being a published game designer or a respected creative peer, people can understand ANGELINA's place in the world by learning more about the people who made it, what they find valuable, and what the project means to them. We are a way for them to understand where this project is ultimately leading, and what values it is being guided by.

## 10.5.2 Stakeholder Goals

Different groups of people are interested in different aspects of computationally creative software, and often need explanations or demonstrations that emphasise those aspects of a project to fully understand how it relates to their interests. This may seem obvious, as it did to us, but it is only over time that we've appreciated how important this point is. Historically, we demonstrated ANGELINA's ability to engage with real-world concepts and justify its creative decisions, as we felt that emphasised the creative independence of the software. In doing so, we downplayed the technical ability of the software, which we now believe may have made the system less appealing to creatives working in the games industry.

For example, journalists are often interested in what the future implications for the system are, as part of the aim of writing about scientific work is to extrapolate from small prototypes to the potential for future global impact. The public benefits from immediate output, interactive examples of what the system is capable of now. Developers, as we've discussed, are interested in finer details about what the system can do, so they can relate it back to their own process. Note that these are generalisations – no individual fits perfectly into any group, and we've met plenty of journalists who are interested in technical details and so forth. Nevertheless, these

trends are worth bearing in mind, and other groups will have their own unique emphasis as well (this chapter does not cover, for example, curators and exhibition organisers).

When one is aware of the needs of a group it becomes easy to meet them, but it requires an initial open-mindedness to how we communicate about the systems we build. We made the mistake of assuming people would not be interested in the internals of our software initially, however with ANGELINA[6] we have completely reversed this approach. The technical process of the system is now more emphasised than ever before, which is helping us rebalance the picture we paint of our software.

### 10.5.3 Relationships

Several projects in Computational Creativity have been running for long periods of time, with some running for over ten years. The Painting Fool's publication record stretches back to at least 2006 [19], and The MEXICA project recently celebrated its 20th anniversary with a published anthology of stories [20]. While ANGELINA is not as long-running as these examples, it is now in its eighth year as a single cohesive project, and the examples used in this chapter are drawn from the entirety of this period, from our first interaction with journalists to the most recent public demonstration. The longer a computationally creative system runs, the more opportunity the project has to find new audiences, build connections with different groups, and adapt to the expectations of the communities it interacts with.

ANGELINA began as a small exploratory project, and grew through both big and small events. Some articles published or milestones reached by the software had a huge impact on the perception of the software and the number of people aware of its existence. However, the individuals we met at various events, the dialogue we have had online through social media and other channels, the small communities of a few dozen creatives who chose to engage with us, have all built up over time to contribute to ANGELINA's position in the games community as it stands today, insofar as it can be said to have one.

The important lesson to take away here is that engagement with stakeholder groups is not something that can be rushed, optimised or sped up. It is a long-term process that we are contributing to all the time, not just through the papers we write, but through the way we talk about our system to people at events, through casual conversations or blog posts, or the examples we release online. Every new person who learns about our work grows the community that surrounds it, and while a single individual may not impact the project on their own in a single day's encounter, the long-term impact of hundreds or thousands of small encounters can completely change how we think about our software.

Sustained effort helps keep a project alive, and in doing so extends the time the project spends in the eyes of the public, the press or other creatives. While the advances that we make and the new features we add to software drive forward the state of the art and enhance the dialogue we have with other researchers, the simple fact of keeping our software maintained, putting it out into other communities, and speaking about our work and our goals for the future, all contribute to the long-term development of relationships between us and the people who observe, and ultimately judge, the creativity of our systems.

# References

[1] Liapis, A., Yannakakis, G.N., Togelius, J.: Computational Game Creativity. In: Proceedings of the Fifth International Conference on Computational Creativity (2014)

[2] Colton, S., Wiggins, G. A.: Computational creativity: the final frontier?. In: Proceedings of the 20th European Conference on Artificial Intelligence (2012)

[3] Colton, S., Pease, A., Corneli, J., Cook, M., Hepworth, R., Ventura, D. Stakeholder Groups in Computational Creativity Research and Practice. In: Computational Creativity Research: Towards Creative Machines. Atlantis Press. ISBN 978-9462390843 (2014)

[4] Csikszentmihalyi, M. Creativity: Flow and the psychology of discovery and invention. Harper Collins. ISBN 978-0062283252 (1996)

[5] Cook, M. A Vision For Continuous Automated Game Design. In: Proceedings of the Experimental AI in Games Workshop at AIIDE (2017)

[6] Donlan, C. Plastic Soul: One man's quest to build an AI that can create games. Eurogamer (2013) https://www.eurogamer.net/articles/2013-04-02-plastic-soul-one-mans-quest-to-build-an-ai-that-can-create-games

[7] Ong, A. Ten women reshaping modern tech. Dazed (2014) http://www.dazeddigital.com/artsandculture/article/18631/1/the-top-ten-women-taking-over-tech

[8] Hofstadter, D.: Looking EMI Straight In The Eye. In: Virtual Music: Computer Synthesis of Musical Style. MIT Press (2001)

[9] Adams, T. David Cope: 'You pushed the button and out came hundreds and thousands of sonatas'. The Guardian (2010) https://www.theguardian.com/technology/2010/jul/11/david-cope-computer-composer

[10] Cope, D. Emily Howell – Blog. http://artsites.ucsc.edu/faculty/cope/Emily-howell.htm

[11] Phillips, A. Dispatch from a Computer Science Conference. https://gamertrouble.wordpress.com/2014/10/07/dispatch-from-a-computer-science-conference-my-time-at-aiide14/

[12] Aron, J. AI designs its own video game. New Scientist (2012) https://www.newscientist.com/article/mg21328554-900-ai-designs-its-own-video-game/

[13] Geuss, M. Artificial intelligence project builds video games from scratch. Ars Technica (2012) https://arstechnica.com/gaming/2012/03/artificial-intelligence-angelina-builds-videogams-from-scratch/?comments=1

[14] Cook, M, Smith, G. Formalizing Non-Formalism: Breaking the Rules of Automated Game Design. In: Proceedings of the Seventh Conference on the Foundations of Digital Games (2015)

[15] Cook, M., Colton, S. Ludus Ex Machina: Building A 3D Game Designer That Competes Alongside Humans. In: Proceedings of the Fifth International Conference on Computational Creativity (2014)

[16] Cook, M., Colton, S., Raad, A., Gow, J. Mechanic miner: reflection-driven game mechanic discovery and level design. In: Proceedings of the 16th European Conference on Applications of Evolutionary Computation (2013)

[17] Cook, M., Colton, S. Redesigning Computationally Creative Systems For Continuous Creation. In: Proceedings of the Ninth International Conference on Computational Creativity (2018)

[18] Colton, S. Seven Catchy Phrases for Computational Creativity Research. In: Computational Creativity : An Interdisciplinary Approach, Dagstuhl Seminar Proceedings (2009)
[19] Steele, J. Art by Roboticelli. The Metro Newspaper, London (2006)
[20] Pérez y Pérez, R.: MEXICA: 20 Years – 20 Stories. Counterpath Press. ISBN 978-1933996646 (2018)

# 11

# Artificial Intelligence for Designing Games

Antonios Liapis

Institute of Digital Games, University of Malta, Msida, Malta
antonios.liapis@um.edu.mt

**Summary.** Making a game requires a diverse set of skills and talents: visual design, sound design, level design and narrative design require developers to be creative within their own domain but also to consider how their creations impact other facets of the game. Since games are interactive media, however, players also exercise their own creativity in order to overcome challenges introduced by the game's designers or by other players in multi-player settings. This chapter will analyze games under the prism of the six facets of creativity which go into the play experience: visuals, audio, narrative, levels, rules, and gameplay. Important examples of human creativity in commercial games will be highlighted for each facet, as well as how artificial intelligence has been applied to generate content for each facet. The chapter concludes with a discussion on how an artificially intelligent system can facilitate the collaboration of different generators, and possibly human designers and artists.

## 11.1 Introduction

Over the last five decades, digital games have become a mainstay source of entertainment for millions. Games are now available for a broad variety of devices including personal computers, dedicated game consoles, mobile devices, social media, virtual reality headsets and much more. As digital games are becoming ubiquitous, the demographics of players continuously shift: in the United States, for instance, 45% of gamers are women while more than a quarter are aged 50 years or older [45]. The massive number of potential players, and the breadth of interests they may have, has pushed the game industry towards diversifying the themes in games as well as the interaction paradigms: from massively-multiplayer online games which can be played over a period of many hours, to simple-to-grasp puzzle games played within minutes on a mobile device. The massive market for games (the US video game industry generates more than $30 billion a year [45]) has incentivized many aspiring game developers to join large game studios with thousands of employees, to make games on their own or with a small group of friends, and anything in-between. As more accessible tools for game development become available, such as the *Unity* game engine [175], the demographics of game developers similarly shift: today, it is easier than ever to create a game with minimal technical knowledge. This has led to a huge variety of games designed by — and for — a very diverse set of people.

© Springer Nature Switzerland AG 2021
P. Machado et al. (eds.), *Artificial Intelligence and the Arts*, Computational
Synthesis and Creative Systems, https://doi.org/10.1007/978-3-030-59475-6_11

While making a game is now easier than ever in terms of technical competence, the creativity required from game designers can not be understated. A game's visuals, soundscape and plot structure are reminiscent of traditional art forms such as painting and sculpting, music and storytelling. While confined to an art direction that lends itself well to an interactive digital medium (for instance, game narrative follows specific themes and presumes that it will be exposed in a non-linear fashion), game artists and writers face similar challenges as their peers in traditional arts. Games, however, are interactive media tailored towards entertainment and prolonged engagement. Therefore, other dimensions of the creativity going into game development is the design of game levels and game rules. Finally, end-users also insert their own creativity when playing the game in order to overcome challenges introduced by the game's designers or by other players in multi-player settings.

Creativity in game design and development therefore must be introduced into several different facets of the game experience, and at different times — from concept development to interaction with the final artifact. Traditionally, these creative roles were undertaken by teams of human game developers, designers and artists. However, time and budget constraints as well as the desire to innovate has led commercial studios to offload some content design and development efforts to algorithms. Currently, procedural content generation (PCG) is often a selling point for games, especially promoting the benefits of perpetually fresh and unique game content such as new levels or enemies in every playthrough. One of the most ambitious games which largely relied on PCG for its promotion and marketing was *No Man's Sky* [60], with trailers preceded with the text "Every atom procedural". The appeal of a vast galaxy that *No Man's Sky* could produce thanks to PCG led its small team of developers to enjoy a large commercial success, with the game being the second-highest selling game in North America by revenue in the month of its release. Similarly, negative criticisms raised towards *No Man's Sky* were largely towards the expressivity of its generators [115] (with new planets not being meaningfully different than previously visited ones) as well as more mundane issues such as the lack of multi-player interactions.

Beyond commercial games, there has been a growing academic interest in artificial intelligence (AI) for generating game content for over a decade [146]. Evolutionary computation, machine learning, constraint programming and a plethora of other approaches have been applied to generate game content of different facets, from game levels to visuals and plot structure. In the process of such research, many important findings regarding design patterns, evaluations of game quality, and good design practice for specific types of games have surfaced, enriching our knowledge of game design. One of the core aims of PCG research is the design of complete games by AI; to achieve this, algorithms must show skill in creating quality content in one or more facets. Additionally, algorithms must assess how harmonious the entire game outcome is, i.e. *orchestrate* different generative algorithms [98].

This chapter will analyze games under the prism of the different facets of creativity which go into the play experience. In Section 11.2, six facets are identified (visuals, audio, narrative, levels, rules, and gameplay) and important examples of human creativity in commercial games are highlighted for each facet. Section 11.3 highlights how the different facets must be orchestrated in order to produce a cohesive whole. Section 11.4 provides an overview of generative algorithms in commercial games, while Section 11.5 focuses on generative algorithms broadly based on artificial intelligence principles. Algorithms and key examples of AI-based content generation

for specific types of content (usually in one facet) are described in Section 11.5.1, while approaches for AI-based orchestration are described in Section 11.5.2 and important cases of full or partial game generation are highlighted in Section 11.5.3. The chapter concludes in Section 11.6 with key stepping stones and hurdles on the road ahead towards a fully orchestrated artificially intelligent game designer.

## 11.2 Games as a Multi-faceted Creative Domain

Games lie at the intersection of a multitude of creative domains, from art and music to rule systems and architecture. These domains influence each other, with flashy visuals reinforcing a fantasy narrative and creepy background sounds adding to the player's tension during gameplay. Games are by their very nature multifaceted: based on [98], we identify six facets of games where creative input by either a computer or a human is necessary.

### 11.2.1 Visuals

Like any digital medium, the vast majority of games are displayed on a screen. A game's visuals are primarily geared towards representation: in *Super Mario Bros.* [125] for example, visuals allow players to identify that their player's avatar is a plumber, that the enemies are turtles, or that some of the tiles can be walked on. More than that, however, visuals provide hints about the functions of the elements they represent: cracked floor tiles in *Prince of Persia* [20] hint that these tiles may fall if the player stands on them, while a boss monster's windup animation may hint at an imminent barrage of attacks that the player must avoid. Finally, on-screen visuals may depict items outside the gameworld, such as user interfaces in the form of menus or heads-up displays.

The gameworld where players interact with in-game objects (enemies, puzzles, hazards, other players, etc.) can have two-dimensions (2D) or three-dimensions (3D). For example, classic 2D platformer games such as *Super Mario Bros.* are displayed as a cross-section of a hypothetical world, from a side-view perspective. Modern games such as *Candy Crush Saga* [85] follow a similar 2D appearance, from a top-down perspective. Both side-scrolling and top-down perspectives have been extensively used for 2D games from the 8-bit era of the 1980s to modern-day mobile devices. The illusion of the third dimension (depth) can be simulated using two-dimensional graphics through scaling and depth ordered drawing, as in *Wolfenstein 3D* [1], or using an angled isometric view with a three-quarters perspective [31]. Truly 3D games became mainstream in the 1990s, and have since then dominated the marketplace, especially for larger (AAA) game companies. Games set in 3D environments offer an immersive experience, and can allow the player to see through their avatar's eyes (first-person camera). When players have full control of their first-person camera, interaction becomes more natural. Therefore, virtual reality games almost exclusively use the first-person camera view.

Due to the variety of ways that games can be rendered, visual design offers game makers immense creative freedom. On the other hand, game visuals are representational and may be constrained to resemble real-world references. This is particularly relevant for 3D games that aim for a realistic and immersive experience.

(a)     **Photorealism:** (b)     **Caricaturism:** (c) **Abstract:** Geometry
Madden     NFL     18 Limbo ©Playdead, 2011 Wars ©Activision, 2007
©Electronic     Arts,
2017

Fig. 11.1: Different visual styles in games.

*Photorealism* in games attempts to closely match the real world, from the appearance of the assets themselves (e.g. high-polygon meshes, high-resolution textures) to the way that light reflects on different surfaces. Similar to several art movements with similar goals (realism of the 1800s being an obvious example), photorealistic game art may attempt to painstakingly detail everyday real-world objects, such as cars' rims in racing games or athlete's faces in *Madden NFL 18* [43] (see Figure 11.1a). More interestingly, however, photorealism can be used for game objects with no real counterparts or references in the real world, although rules of physics and lighting are presumed to still exist. This is particularly relevant in fantasy or science-fiction gameworlds, which abound in the game marketplace. Järvinen [72] identifies the former type of photorealism in game art as *televisualism* and the latter as *illusionism* or fictional photorealism.

Contrary to photorealism, many games borrow from comic art style to exaggerate certain elements of a gameworld or the characters within it. The motivations for such *caricaturism* in game art are manifold: caricatures draw players' gaze towards important visual cues, but also elicit and accentuate specific aesthetics to the players. Caricaturism was necessary during the early eras of games (e.g. the 8-bit era of the 1980s), where each visual element consisted of a few dozen pixels and a handful of stark and vibrant colors. In this constrained medium, game makers had to design monochrome or duochrome enemies which could stand out in a monochrome background: this often resulted in oversized weapons and eyes versus undersized bodies and legs. While newer technologies have alleviated many such constraints, the ability of caricatures to grasp player attention is still exploited in games with many disparate elements on screen at any time. Caricaturization allows players to control diverse hordes of units in real-time strategy games such as *Warcraft II* [15], and to notice patterns in a screen full of sweets in *Candy Crush Saga*. Caricatures geared towards eliciting specific aesthetics also offer a broad range of options to a visual designer, from the monochrome and unwelcoming world of *Limbo* [135] where all characters are black outlines with white eyes (see Figure 11.1b) to the vibrant particle effects and chaotic shifting backgrounds in *Super Smash Bros.* [127].

On the extreme end of caricaturization, game art veers into non-representational approaches similar to abstract expressionism in the visual arts. Since games usually

revolve around a player trying to overcome challenges in an environment, the environment (and the player's avatar) usually must be somehow represented. Therefore, abstract game art is fairly rare: however, games focusing on mechanics rather than a player's immersion can use abstract game art (see Figure 11.1c). Examples of early games that feature abstract game art are *Tetris* [130] or *Pong*[1] [4]. *Thomas Was Alone* [120] is an interesting example of a modern abstract game where an elaborate story and character dialog is juxtaposed by an abstract representation of the world and characters as rectangles.

## 11.2.2 Audio

Similarly to films, a game's audio has a complementary role to the game's visuals and is often overlooked. Early game audio was challenged by technological limitations and largely revolved around a handful of monophonic channels, i.e. "the blips and bloops of Pac-Man and Super Mario Brothers" [177]. However, music and audio in games has evolved rapidly in recent decades and has been recognized with awards by BAFTA ("Audio Achievement", "Music"), Spike TV ("Best Original Score", "Best Song in a Game") and most game festivals. Coupled with visuals, game audio aims to immerse the player through "a shift of perceptual focus, from an awareness of 'being in and part of' reality to 'being in and part of' virtuality" [54]. As argued by Collins [30], sound in interactive media is dissimilar to film or music (sound that you listen to) but instead merges with the player's actions in-game (such as an avatar jumping) and out-of-game (such as a player pressing the "D" button on a keypad) as much as it merges with the player's visual stimuli.

Game audio could be further split into background music, sound effects, voice acted dialog, and musical score for the game's introduction or cinematics. The latter follows a pre-scripted format as it can not be interacted with but only consumed in a similar way to film or music; it is therefore less relevant in our analysis. Voice acting is now a staple feature in major commercial games, especially by larger companies; an abundance of Hollywood actors have lent their voices in games, such as Sir Patrick Stewart and Sean Bean in *The Elder Scrolls IV: Oblivion* [10] or Jack Black in *Brütal Legend* [42] (see Figure 11.2a). While a player's interaction with non-player characters (NPCs) through dialog can be a core part of the gameplay experience, such interaction is with the narrative content of the dialog; voice acting merely adds a level of immersion, making characters more relatable or memorable but is consumed in a similar way as the cinematic musical score.

Sound effects are particularly strong examples of Collins' position for game audio merging with a player's actions [30]. A player's actions are often accompanied with a sound effect, usually unique to this action. Examples include the jumping sound for the player-controlled Mario in *Super Mario Bros.*, or the short acknowledgment in English by a unit receiving a harvest command by the player in *Warcraft II*. Some sound effects are tied to the outcomes of player actions: an example is the delayed sound effect when three or more jewels are removed in *Bejeweled* [136] due to a player swapping their positions. Such sound effects (and the accompanying particle effects) provide an audiovisual reward to the player and further motivate interaction with the game. Similarly, opponents' actions are often followed by sound

---

[1]Pong is a reference to ping-pong (or table tennis) although the rectangular paddles, square ball and its movement do not resemble table tennis in any way.

(a) **Voice Acting** by Jack Black in Brütal Legend ©Double Fine, 2013

(b) **Sound Effects** as hints to the player in Thief: The Dark Project ©Looking Glass, 1998

(c) **Soundtrack** and matching its rhythm in Guitar Hero ©Harmonix, 2005

Fig. 11.2: Different uses of audio in games.

effects, such as the "huh?" sound of guards starting to investigate a suspicious sound in the stealth game *Thief: The Dark Project* [109] (see Figure 11.2b). Such sound effects attract players' attention, alerting them of dangers or notifying them that their actions have had unexpected outcomes. For instance, players may pick up a weapon by walking through it without noticing in a first person shooter game; they are alerted of the fact by a weapon cocking sound. Finally, there are sound effects that help situate the player in the environment: examples include the sound of the player's footsteps which may change depending on the surface that is being walked on. Such environmental sounds, often modified based on its source's position in the world and the head position or rotation or the player's avatar [61], can be coupled with the background music to become part of the soundscape (described below).

Background music in games is often perceived as decorative, providing ambience or some aural stimulus during certain repetitive tasks. However, background audio can be foregrounded when it affects gameplay: examples include rhythm games such as *Guitar Hero* [57] where the music hints when certain keys must be pressed by the player (see Figure 11.2c), or similarly in *Crypt of the NecroDancer* [19] where timing player actions to the musical beat is the key to avoiding getting hurt and losing the game. Background music is often customized to a specific game level (or part thereof) or to a specific player activity. For example, the 28 tracks in the awarded soundtrack of *The Elder Scrolls IV: Oblivion* are split between "explore", "public", "dungeon", "battle" and "special" categories: a random track is played when the player is exploring the overworld (from the "explore" category) or underground locations (from the "dungeon" category), fading into a random track from the "battle" category when the player is attacked. Transitions between background music tracks may be as basic as the above, with simple fade-ins and one random track in one category chosen when the current track finishes. Interest in more dynamic background music in games has led to adaptive music in games such as *Tom Clancy's EndWar* [172], where the music does not loop or fade but is dynamically adapted to the evolving narrative of the strategy game being played, or *Proteus* [84] where the carefully crafted and impeccably synchronized music channels are turned on or off based on the location and camera view of the player.

(a) Books with complete stories provide atmosphere and clues in The Elder Scrolls V: Skyrim ©Bethesda, 2011

(b) Uncovering a prewritten narrative structure in L.A. Noire ©Rockstar Games, 1999

(c) Players making their own stories in The Sims ©Maxis, 2000

Fig. 11.3: Examples of narrative structures in games.

### 11.2.3 Narrative

While not all games rely on a story structure, dialog, or plot exposition, a plethora of large-scale digital games rely on their narrative to draw players into their story-world and action. Early digital games such as *ZORK* [69] were closer to hypertext [76] or "choose-your-own-adventure" booklets, where pre-scripted narrative events were presented textually as a response to specific player commands (such as "examine leaflet" or "go north"). Many contemporary adventure games are similarly structured to reveal segments of a pre-authored narrative (usually via an embellished audiovisual cutscene) when players find pre-determined solutions to puzzles. Similarly, a gameworld's history is often revealed through in-game interactable items, such as books that can be read (see Figure 11.3a); such items often contain short stories which are individually authored with a clear beginning and end. The freedom of players to explore a vast gameworld poses a challenge to narrative structures as designers can not anticipate where players may go first, which actions they will take, or which characters they will converse with. This very *interactivity* has been identified by Ryan [142] as a crucial component for deciding what kind of stories can be told by digital media: specifically, a user being able to change the conditions. Ryan goes further to distinguish interactivity along the axes of internal (the users projecting themselves as a member of the fictional world) versus external (when the user is outside the fictional world), and exploratory ("the user is free to move around the database but does not make history alter the plot" [142]) versus ontological (the user can send the story down one road of a forking path). Narrative in games can follow many different paradigms along this typology, such as the exploratory nature of mystery games such as *L.A. Noire* [141] (see Figure 11.3b) where players can move freely but will inevitably uncover a pre-written history about what happened (exploratory-internal), or games such as *The Sims* [118] (see Figure 11.3c) where players can swap control of different characters and decide who they will fall in love with, fight and so on (external-ontological).

(a) **Unrealistic** sprites as obstacles in Pokémon: Gold ©Nintendo, 1999

(b) **Full view** of the level in Pac-Man ©Namco, 1980

(c) **Open World** based on real locations in Assassin's Creed II ©Ubisoft, 2009

Fig. 11.4: Examples of level structures in games.

## 11.2.4 Levels

A player's actions within a digital game take place in a virtual space traditionally referred to as a *game level*. Game levels can be as abstract and minimal as those of *Tetris* [130] or *Pong* [4], where only the surrounding walls (which are often invisible) are designed to constrain the player's actions. A game may consist of one vast level, such as the gameworld of *The Elder Scrolls V: Skyrim* [12] or the galaxy of *Stellaris* [131]; it can be made out of a large number of self-contained levels experienced sequentially, as in *Super Mario Bros.* or *Arkanoid* [161]; different levels can also be presented as options to the player as in *Cities: Skylines* [32]. Similar to visuals, game levels may not necessarily reflect the real world: as noted above, abstract levels such as those of *Tetris* and *Arkanoid* are merely spaces designed to challenge a player without reflecting the real world. On the other hand, a large number of games rely on real-world tropes for designing levels regardless of whether their visuals are photorealistic or caricaturized. For example, levels in *Pokémon* games [50] feature villages, beaches, forests and rivers, even though the trees in its forests are unrealistically small and set in a dense grid to create a maze-like structure (see Figure 11.4a). When games' visuals and general direction is closer to the real world, levels have to closely mimic natural habitats, from the type and density of fauna around rivers in *Far Cry 5* [174] to the layout of European cities in *Call of Duty* [68]. Similarly, level design in science-fiction or fantasy worlds must balance between the known and the evocative unknowns, with large-scale mega-structures reminiscent of modern skyscrapers as in *Mass Effect* [13] or bombed and repurposed Washington landmarks in *Fallout 3* [11].

Regardless of their style or proximity to real-world structures and physics, designing game levels is similar in many ways to architecture. Similar to architecture, level design must find the appropriate balance between "form" and "function", i.e. how evocative and appealing the game level is versus how easy it can be for the player

to navigate and recognize. In the spirit of the Bauhaus movement, game levels could be designed to be purely functional without any ornamentation: an example is the *Pac-Man* [121] maze where the goal is function, i.e. allowing the player (Pac-Man) to clearly see the entire level, the game's goals (pellets) and the game's challenge (ghosts), and navigate it (see Figure 11.4b). Conversely, adventure games are known to include useless clutter in their levels for the purpose of increasing the challenge of the primary mechanic (identifying a useful if obscure item or solution on the screen) as well as providing humorous descriptions or responses by the protagonist when other non-solutions are selected by the player. Between these two extremes, most game levels have to provide some decoration to help the player identify with the game's setting, such as Venetian architecture in *Assassin's Creed II* [173] (see Figure 11.4c), while at the same time ensuring that players can take advantage of most of the game's mechanics at their disposal in a rewarding and straightforward way. In the same example, buildings in *Assassin's Creed II* must be tall (perhaps taller than normal buildings in 15th century Venice) in order to motivate and reward the climbing mechanic while roads must be wide and obstacles evenly spaced apart to allow for the Parkour-style movement that the game is known for.

## 11.2.5 Rules

The rules of a game are paramount to its interactivity, as they constrain and guide the player towards specific goals and gameplay patterns. Some rules determine the game's ending conditions, i.e. when the game is won and when the game is lost, which respectively provide the player with a goal and a challenge. Among other game rules, of particular interest are those pertaining to player actions: these *mechanics* dictate how the player can interact with the game and are the primary drivers of player agency. Mechanics are usually described as verbs [73] such as "jump" in *Super Mario Bros.* or "take cover" in *Gears of War* [46]. Mechanics are often differentiated from other game rules, which determine the transition between game states, as "rules are modeled after [player] agency, while mechanics are modeled for agency" [148]. The use of a mechanic, e.g. Mario jumping over a Goomba enemy, can trigger a rule-driven state transition, e.g. removing the Goomba from the game. The interaction between the many rules, mechanics and winning conditions lead to complex dynamics and shape the player experience, which we discuss in Section 11.2.6.

## 11.2.6 Gameplay

Designing a digital game can be a complex creative task, but a game's ultimate purpose is to be played by the end-user. Gameplay refers to the experience of playing the game, or "the phenomenological process of an epistemic agent interacting with a formal system" [149, page 104]. During gameplay, a player interacts simultaneously with all other facets; their interrelations can shape the player's affective state and immersion [23]. Each player interprets the visuals, level structures, narrative and game rules in their own way, based as much on cultural and ethical preconceptions as on their in-game decisions (e.g. the order in which they visit locales in an open-world game such as *Far Cry 5*).

Of particular interest is how players interact with the formal systems: the game's rules and mechanics. While this ruleset is pre-scripted by the game's designers, each

player can use it in different ways — potentially exploiting it in unforeseen ways which can break the intended game balance. An example unforeseen exploit was discovered by players in *The Elder Scrolls V: Skyrim*: a player could pick up a bucket or other concave container and place it over an NPC's head, effectively blocking their line of sight completely and allowing the player to steal all of the NPC's valuables lying around. More interestingly, the interaction between different rules and mechanics could lead to emergent *dynamics* [67]. Such dynamics can be influenced by social and competitive concerns on the part of the player community, which can lead to an ever-changing *metagame* [27] of strategies and counter-strategies — especially in (multi-player) e-sports games such as *StarCraft* [14]. Beyond the primarily functional concerns of dynamics, however, the interaction among all facets (and especially visuals and audio) can evoke strong emotional responses from the player. These responses range from basic emotions such as fear and joy [41] to a broader range of *aesthetics* such as sensation and discovery [67]. While the intended emotions and aesthetics of players can be designed a priori, they can only be elicited during gameplay and may vary immensely from player to player and from those imagined by the designer.

## 11.3 Orchestration

While the different creative domains incorporated in games are fairly well-defined, it is important to note that games are more than the sum of their levels, winning conditions or visual styles. Elements in each facet contribute to the final play experience and need to be harmonious with other elements in this or other facets. At the simplest level, a decision made by a creator of one facet can constrain the possibilities of designers in the same or other facets; for example, a rule that determines the delay between the player avatar's death and the game restarting constrains the duration of the animation of the avatar's death and the sound effect that accompanies it. More broadly, the style adopted in one facet will likely constrain the style in other facets: an obvious example is the choice for photorealistic visuals, which necessitates that game levels' architecture closely follows real-world tropes and game rules that also match real-world physics.

In most cases, however, the interaction of facets and their impact on the play experience is less straightforward. As an example, *Amnesia: the Dark Descent* [48] is a horror game set in an ancient manor or castle, where the lone male protagonist must explore the different floors armed only with a lantern while avoiding enemies which can either kill him or drive him insane. The losing conditions (death or insanity) are reinforced by the rule that darkness slowly lowers sanity and the rule that the oil for a lantern (which can be turned on or off) can run out. These rules force the levels to be designed with some areas already lit by ever-burning torches, which are connected via dark or lit areas: the player is bound to navigate through the lit corridors to avoid using up the lantern's oil. On the other hand, the level design places most oil resource pickups in dark rooms, forcing the player to explore in unsafe, scary areas. The visuals reinforce the tension of the experience, with post-processing filters on the player's screen making it more difficult to see when sanity is low: since sanity drops in dark areas, the filters on the visuals make it even harder to see in an already dark space, and thus increase frustration and panic. Finally, ambient sound effects such as creaks or moans (even when nothing is there) keep

players on edge, while at low health or sanity the background audio includes the character's erratic heartbeat as an aural indication of the game state (rules) but also as another source of stress. While the design decisions on each of these facets — and more, such as the protagonist's backstory or the design of the enemies — are harmonized and perfectly aligned towards an intended gameplay experience, it is difficult to identify which facet was fleshed out first and constrained others in this process. It is far more likely that the level design, visuals, audio and rules all evolved together through iteration and playtesting (i.e. feedback from the gameplay facet).

Finally, the design decisions in different facets (and their harmonization) can be guided by established game patterns such as player repertoire and game genre. Player repertoire consists of "the skills and methods for overcoming the challenges of the game" [77, page 56]. Playing any game requires the player to expand their repertoire and perfect their reflex time or tactical response to challenges. Moreover, "a player approaches every game with whatever repertoire of skills he or she has" [77, page 5] and thus the design of new games can take advantage of patterns of play from past games that players are likely to have experienced. Elements such as the avatar's death abound in games, and thus will be easily understood by the player community. Designers can take advantage of this fact, and either use common rule, level or visual patterns (respectively, avatar death, maze-like structures, or hovering icons above important NPCs) to make the game more accessible. Alternatively, designers can go against a few of those patterns in order to subvert and challenge the players' repertoire. Game genre plays a similar role: players expect specific elements from specific types of games, and *genre* has been a staple way of categorizing games since the 1980s (e.g. adventure games, shooter games, puzzle games). Player repertoire is tied to genre: most puzzle games do not feature the avatar's death, while most shooter games do. All facets are tied in one way or another to genre: music rhythm games presume simple visuals so that the player easily understands which button to press while the audio needs to feature tracks of high musicality; horror games almost always feature a ghost story (narrative), overpowering monsters (rules) and intense negative feelings during gameplay. Using these pre-existing formulas in the design of, and relationships between, game facets can be a shortcut for many of the challenges in designing a new game.

## 11.4 Procedural Content Generation in Games

Digital games have de facto relied on algorithmic processes for handling mundane tasks such as collision checking, capturing key strokes and transforming them into in-game actions, or rendering visuals onto the screen. However, even in the earliest days of digital games, algorithms were at times allowed to take creative decisions which affected the player's engagement and perceived challenge. For instance, in the computer game *Rogue* [169] an algorithmic process was tasked with creating a fresh new dungeon every time the player started a new game. The dungeon consisted of rooms and corridors, as well as monsters and traps that were designed to challenge the player. The game was designed explicitly to highlight and take advantage of this algorithmic generation process: the game would delete the player's save game if their avatar died while exploring the dungeon, and thus the player would need to start anew, in a new dungeon, without being able to anticipate the layout or encounters within it. Another instance of algorithmic generation is the video game

(a) Level Generation in Diablo III ©Blizzard, 2012

(b) **Weapon Generation** in Borderlands ©Gearbox, 2009

(c) **Enemy Generation** in Shadow of Mordor ©Warner Bros, 2014

Fig. 11.5: Different types of generated content in commercial games.

*Elite* [18] where a vast universe (8 galaxies, each with 256 planets) is generated at the start of the game, letting players explore new galaxies if they wish to start a new game. As *Elite* is an open-ended game where exploration, trading and combat can be undertaken over a very long period of gameplay, the generative process allows the vast gameworld to be stored in a few parameters (e.g. a random seed) and past games can be saved and loaded despite the small memory available to 1980s computers. Many of the early instances where games offloaded creative tasks to algorithmic processes were motivated by these two factors: the desire to provide new experiences in every playthrough, and the ability to compress complex game assets (such as a vast gameworld) into a few bytes of memory. Development of new generative algorithms was largely driven by these factors, in a similar way that graphics renderers were developed to be as efficient and as impressive to players as possible despite limitations of the technology available at the time.

As digital games diversified over the past 30 years, algorithms have similarly been used for creative tasks in a variety of roles. Some of the original motivations for algorithmic generation are still applicable; for instance, *No Man's Sky* based its advertisement campaign on the vast number of procedurally generated planets (and their contents), which could be compacted into a small save file due to the compressible generator parameters. Similarly, when presenting *Diablo III* [16] the developers touted the series' "hallmarks: randomized levels, the relentless onslaught of monsters and events in a perpetually fresh world, unique quests, tons of items, and an epic story [...]" [17], similar to the perpetually fresh world of *Rogue* in each playthrough. However, modern games often use algorithmic processes during development and not just to generate content unique for each player. For example, to recreate the mountainous landscape of Montana in *Far Cry 5* developers had to encode some of the physical characteristics (e.g. erosion) or biomes (e.g. vegetation) into a generative algorithm which could create the vast gameworld. This first draft of the gameworld was then enhanced by game designers, e.g. to add game-specific objects such as quest locations or characters [26].

While the majority of commercial games that use generative algorithms focus on the creative facet of level design (see Figure 11.5a), there are interesting examples of generation in commercial games for the other facets. Of note is the algorithmic design of weapons in *Borderlands* [51] (see Figure 11.5b), which generates both visuals of the 3D weapon and its game rules (e.g. bullet speed, damage, etc.). *Borderlands* created

new weapons by combining 3D models of existing weapons (e.g. long barrel, sniper sight) and calculating the weapon's in-game behavior based on those (e.g. a laser rifle with a sniper scope which freezes targets hit by its slow bullets). Other games use algorithms to generate non-player characters: of particular note is *Middle-Earth: Shadow of Mordor* [176] in which orc antagonists are generated with a matching name and appearance (e.g. "Ruktuk the corrupt" is likely to have a face full of sores) as well as special powers and weaknesses that the player must discover and exploit in order to defeat them (see Figure 11.5c). Several games use algorithms to generate aspects of the narrative, such as the Radiant Storytelling system in *The Elder Scrolls V: Skyrim* which customizes quests' locations and characteristics, or Nemesis quests in *Middle Earth: Shadow of Mordor* which are instantiated according to orc chiefs' personalities and their history with the player. The algorithmic generation of 3D models and textures abounds in games for mundane features, such as small variations in plant life, through generative grammars and L-systems [167]. Similarly, procedural textures are a mainstay of the game industry — although they arguably lack any aspect of computational creativity or decision-making from the algorithms' part. Finally, a small number of games have experimented with procedural music, such as *Tom Clancy's EndWar* which can provide endless music or *Proteus* where the soundscape adapts to the player's view. In all known cases of procedural audio in games, the algorithms are scripted to turn human-authored bits of music on or off, or to apply filters to pre-made sound effects.

## 11.5 Artificial Intelligence and Game Design

While commercial games for the most part use simple scripts to design parts of a game, there is an increased interest within academia to ascribe more creative freedom (and more complex artificial intelligence) to algorithmic game design. For over 10 years, a number of conferences[2] and journals[3] have tackled artificial intelligence (AI) applied to games — both for playing and for designing them — while AI algorithms for game design have been accepted in many highly-ranked journals. Two books on the topic of procedural content generation have been published in the last couple of years, one focusing on the academic [146] and one on the practitioner [147] perspective, while a comprehensive handbook on AI applied in games more broadly has also been recently published [180].

### 11.5.1 Generating Content Through AI

Research in PCG has explored a broad range of algorithms to generate an equally broad range of game content. Characteristics of such PCG algorithms were put forth by Togelius *et al.* [168], considering the moment of use (online while the game is

---

[2]Indicatively, the IEEE conference on Computational Intelligence in Games, the AAAI conference on Artificial Intelligence in Interactive Digital Entertainment, and several tracks of the ACM conference on Foundations of Digital Games.

[3]A core journal on the topic is the IEEE Transactions on Games and its predecessor, the IEEE Transactions on Computational Intelligence and Artificial Intelligence in Games.

played versus offline during development), the type of content produced (content necessary for gameplay versus optional or decorative content), as well as the potential for parameterization and the stochasticity of PCG algorithms. More broadly, Togelius *et al.* [168] also distinguished between *constructive* algorithms, which use scripts to generate content without assessing whether the result is satisfactory, and *generate-and-test* algorithms which verify whether the output satisfies certain constraints. While commercial games almost exclusively use carefully scripted generators to ensure that all output is playable (constructive approaches), the main interest within game AI research has been on generate-and-test methods. What makes generate-and-test algorithms so compelling is that they require theorizing and formalizing of constraints and evaluations on what constitutes an appropriate type of content; often, such assessment necessitates that the game is played with the new content.

There are many different approaches to generate and test game content: a simple approach would be to generate one artifact, test it and re-generate it if it fails any designer-specified constraint. While this simple approach can work well when the generative scripts are likely to produce viable artifacts, it can lead to an endless or nigh-endless re-generation loop in cases where the constraints are strict or the generators are very likely to produce unwanted content. A subset of generate-and-test approaches are search-based [168], in which content that is not satisfactory is iterated upon to improve it — rather than re-generate it from scratch. Evolutionary computation (EC) is often used to perform this cycle of iterative improvement. At its most high-level description, EC evaluates a population of candidate solutions, selecting the best among them to create new candidate solutions via a set of genetic operators, and replacing some or all past solutions with the newly created ones [75]. This iterative testing and improvement is an ideal paradigm for search-based content generation: an initial population of often random content is iteratively improved upon, based on a *fitness function* which can provide a measure of game content quality, until an individual satisfies some minimal threshold of quality or until the computational budget is spent. Evolutionary approaches have been used extensively for content generation, with many variations. Notable variations include fitness functions which evaluate content based on simulations of gameplay, requiring an automated playtesting framework so that the notion of playability, balance or others can be computed based on the playtraces [94]; using human input instead of mathematically formulated fitness functions to assess content based on visual inspection or human playtests with the candidate solutions [97, 162]; constrained optimization by combining a granular fitness function for playable content with hard constraints on what constitutes unplayable content [99]; and evolution towards novelty [108] or surprise [52] to create a broader range of output rather than explicitly "better" output.

Other PCG algorithms follow alternative paradigms for constructing or assessing game content. Declarative programming has been used extensively, for example, to formalize a design space of desirable content via hard constraints [154]. Using variations of declarative programming such as Answer Set Programming (ASP), search problems can be reduced to stable models and subsequently searched in a straightforward fashion, for example via backtracking. The appeal of ASP-based content generation is the fact that these algorithms always terminate, returning all possible solutions to the given constraints with a minimal computational budget, while its knowledge representation as "what to compute instead of how to compute it" [154] can be highly compact and error-free. These algorithms have limitations,

however, as they are ideal for a specific set of problems, e.g. puzzle games [152], and can not handle stochasticity well (such as random weapon damage); moreover, formulating the design problem as a set of (usually complex) constraints may be as difficult as finding the solution to the problem itself.

Related to declarative programming, planning approaches have often been used to generate content in games — especially for game narrative. Since planning approaches create a plan, i.e. "a temporally ordered sequence of operations" [138], they are ideal representations for a linear plot where events are chronologically and logically ordered (e.g. a player must first pick up a sword and learn the location of a monster, then kill it). Planning algorithms such as the one used by Mimesis [181] rely on *steps* for each event in the story: each step "is defined by a set of *preconditions*, the conditions in the world that must hold immediately prior to the step's execution in order for the step to succeed, and a set of *effects*, the conditions in the world that are altered by the successful execution of the action" [182]. Plans need to address *flaws* (i.e. open preconditions that have not been established by a prior plan step) and *threats* which can undo an established causal relationship in the plan [28]. Variations of this basic architecture such as hierarchical planners [83, 163] which decompose abstract task into primitive sub-tasks and partial planners where temporal orderings are only established to resolve threats [78] have been used for creating both static and interactive narrative. Interactive narrative and drama management, which can often be found in games, comes with challenges of its own as the player's agency may break certain preconditions for the execution of some of the plan's steps. This would require re-planning in order to adhere to the author's original intent or to satisfy the newly established intent of the player's character [137].

In a different direction, game generation algorithms often rely on external data: the vast real-world knowledge encoded in modern online or offline data repositories can prove useful in discovering mappings between in-game and real-world information. Two different approaches for exploiting game-external data are common, broadly identified here as a direct and an indirect approach. The direct approach queries online databases and transforms the results into game content. Examples of this approach include a Google image search with a specific AI-discovered keyword, and the subsequent transformation of the image into an appropriately sized and colored sprite [36]. The transformation can be more or less direct; Barros *et al.* [6] provide examples of game generators spanning the spectrum of transformation versus fidelity to the original data. The indirect approach parses a vast database — often consisting of content in games similar to the one the content is intended for — to discover patterns and exploit them to generate new content. The term "procedural content generation via machine learning" (PCGML) identifies machine learning methods which can be used to directly form new content [160]. Examples include probabilistic Markov models for deciding the next tile in a platformer game level based on preceding tiles [156], or filters that can automatically repair poorly formed platformer game levels based on patterns of well-formed levels [71]. Machine-learned models can also be used to assess content, for example by using computer vision models to assess what real-world object matches an artifact [91], or by optimizing game levels based on learned models of a designer's style [95, 101, 107].

Using this broad range of AI techniques, game content of many different types has been generated. Indicative examples per facet are discussed below:

- **Visuals:** While most methods for generating visuals are based on computer graphics techniques and orginate from mathematical models of noise [89], there have been a few attempts at AI-based generation of visuals. In [66], graphic shaders were evolved towards a designer-specified color palette: the designer could specify the intended color for a certain scene and shaders would be evolved in order for that color to be dominant in the final rendered scene. In [171], procedural filters on textures could apply slight visual changes to modeled scenes based on semantic information such as "high vandalism" on models of houses. The Galactic Arms Race game [59] allows players to interactively evolve the particle effects which represent the players' weapons, influencing their color, animation and trajectory. In the *Petalz* social game [139], the appearance of flowers was generated through pattern-producing networks [158]; the flowers themselves could be shared among users and further evolved via mutation or recombination with the current player's flower collection. In [92], arcade-style spaceships were evolved towards designer-specified visual properties such as symmetry, simplicity and other patterns or towards visual novelty. More broadly, there is extensive work on evolving shapes for spaceships to match a machine-learned model of user taste [100] or to disrupt current patterns in generated content [96].
- **Audio:** While games such as *Proteus* [84] used pre-authored pieces and simple rules to adapt the soundscape, AI has been used sparsely for game audio. Of note is the *Sonancia* system [110] which chooses from a range of pre-written sound tracks to play for specified events or areas of a game. Scirea *et al.* [144] use music generated in real-time to foreshadow game events according to a pre-written narrative arc. *AudioInSpace* [65] uses pattern-producing networks which the player can evolve to decide the timing and pitch of the game's background audio. *Audioverdrive* [63] is a side-scrolling space shooter with a procedural audio system that interacts via a rule-based system with the level design: for instance, the height of the bottom terrain controls the pitch of the bass synth, while treble sound events trigger the placement and timing of enemies. Earlier examples of procedural music in games are surveyed in [29].
- **Narrative:** Building on extensive work in interactive narrative and drama management [28], games such as *Façade* [117] and *Prom Week* [119] model the game state in a way that allows the manager to choose which NPCs utter which lines of pre-authored dialog. In these cases, a sequence of utterances is chosen as a reaction to a player's action, or as a way to introduce a new narrative beat (such as introduce an argument between NPCs). On the other hand, a repository of stories can be used as a basis for automatically constructing interactive plots in a fairly author-free manner [55]. Not all games are focused on story and dialog, but may still use AI to craft a companion narrative: *Charbitat* [3] generates game worlds and then generates quests to fit them, while the General Mediation Engine [140] creates levels (as sequences of rooms) based on a narrative created via planning (which adapts to player actions while the game is played), and can also take some decisions regarding game rules (such as the presence of an inventory).
- **Levels:** Level generation is by far the most popular PCG subdomain, both in academia and in commercial titles of the last 30 years. Level generation can be performed in a constructive manner [145], especially in commercial games. However, many AI techniques have been applied for level generation such as generative grammars [40], artificial evolution [168], declarative modeling [150], and constraint solving [122, 155]. Level generation has often been driven from

a mathematically defined quality formulation based on the similarity with an archetypical "example" [2], a popular level design pattern [105] or an intended affective response [132]. Level evaluation can also be offered directly to players, e.g. using interactive evolution to directly select a preferred level [24], as input to a learned model of users' level preferences [95], or indirectly based on gameplay logs such as time spent in combat [25]. Patterns found via a corpus of similar levels [159] or based on gameplay feeds [56] have also been used directly to generate game levels [160] rather than as an evaluation function. Finally, AI has been used for level generation in design interfaces, as a companion to human level designers [47, 103, 104, 155].

- **Rules:** AI-based generation of rules and mechanics is one of the most challenging aspects of game generation [165] for two main reasons: (a) rules greatly affect the playability of the game [5]; (b) their quality can arguably only be assessed via playtesting. In board games, the *Ludi* system evolved interaction rules [21, 22] in a complex evolutionary cycle of level and rule generation and subsequent gameplay generation (see Section 11.5.3 for more details). In a more constrained analog medium, symmetric chess-like games have been generated by Pell *et al.* in order to create robust game playing agents [133], while EC was used in [87] to guide the search of new rules for new pieces based on simulations with different heuristic-based game playing agents. In digital games, several early attempts at automated game design have focused on abstract arcade games, generating movement schemes and collision rules based on designers' constraints [153] or based on the ability of an AI controller to learn the game [166]. Game mechanics have been generated via planning algorithms in [185], attempting to make the least possible change to existing mechanics in order to achieve the satisfaction of different playbility constraints such as end-game goals (e.g. reach the exit), maintenance goals (e.g. stay alive) and engine constraints (e.g. not occupy the same space as another entity). Finally, game mechanics in [114] were generated based on similarities with existing sprites and their rules or interactions; importantly, these mechanics were provided as suggestions for a human game designer rather than automatically added and tested in a game.

- **Gameplay:** As noted in Section 11.2, gameplay is unique among the facets as it is a task not undertaken by designers but by players. Simulating a human player through artificial intelligence is much closer to domains such as robotics [90] or self-driving cars [49, 116]. In the context of AI-based game design, game playing agents are primarily useful for *automated playtesting* of other game content. These automated playtests can then inform the evaluation of the underlying game content, and test for constraint satisfaction or provide a heuristic that can be optimized via search-based PCG [168]. In simulated playthroughs, it is common that the game playing agent plays optimally, especially when creating levels for an AI competition [134]. However, some degree of human-like behavior can be desirable as well from an automated playtester. For instance, artificial drivers [64] maximized an "objective" efficiency (i.e. distance covered in a preset time) while minimizing deviations from captured player data in terms of steering and acceleration. In other work on AI playtesting, artificial agents attempt to play the *MiniDungeons* puzzle game [62] with different objectives, such as collecting the most treasure or taking the fewest steps.

## 11.5.2 Orchestrating Game Generation

The ideal of AI-based game design presumes an AI taking design decisions on most — if not all — aspects of a game. To reach this ideal, the AI system must be able to orchestrate the various facets of a game. Similar to a human designer or team, the computer must understand how choices in the game rules may require a tweak in the game's visuals or a complete re-write of its backstory. As argued in Section 11.3, most elements of a game are intertwined. When building a generator of game levels in an existing game, the programmer can make assumptions on the genre, rules, visuals and general gameplay style from a design document, prequels to the title, or tropes in similar games. In a game designed primarily by an artificial intelligence, however, these links between facets and game elements must be considered during the process of design. In [98], purely algorithmic game design was hypothesized along a spectrum between a purely hierarchical, top-down process and an organic, bottom-up process. Specifically, a top-down approach would involve a generated high-level frame for the game (e.g. a game pitch) which would be used as a guide to generators that could iteratively add details to it — going from a vague color direction/palette down to the most minute details such as wall texture generation. A bottom-up approach could use a system similar to the blackboard [44] and allow expressive generators able to create a large variety of content (e.g. labyrinthine single-player game levels as well as strategy game levels for multi-player competitions) to contribute to a general framework. Cohesion between the elements on the blackboard could be tested by an internal or external algorithm (or even by a human designer) and incoherent content could be regenerated until there was a cohesive whole game. As suggested in [98], AI orchestration could target the production of a complete game directly playable by end-users, or create a draft schema which could be further refined, edited or partially re-generated by designers. In the latter case, the AI system could be partially interactive, allowing designers to tweak parts of the requirements such as the AI-generated game pitch for a top-down approach or "manually" test for cohesion in a bottom-up approach. Finally, the source of real-world knowledge on game design could be embedded into the algorithm, provided as human input directly from the designer (e.g. via parameterization or initial seeds), or discovered from crowdsourced data such as open data repositories, direct player feedback and playtests, or computational models learned from a large corpus of past games and/or player annotations.

A core challenge of AI orchestration and thus AI-based game design is finding a computational mapping between dissimilar facets. At a smaller scale, a number of research projects have attempted to address this issue in a more constrained space. For example, a mapping between the color of sprites in the *Pokémon* games (visuals) and their in-game type (rules) was built as a decision tree and then used to drive generation of appropriate visuals for designer-specified variant Pokémon [93]. Similarly, the mapping between the strategic qualities of chess pieces was mapped to their visual appearance, allowing the generation of pieces for newly generated chess-like rulesets [86]. Mappings between players' affect during gameplay and the structures of a game level has been attempted in numerous ways [179], while similarly the affective response of players to game audio has been learned from experiments done using crowdsourcing [113]. Machine learning seems to be an ideal tool for finding such mappings, although the task is challenging due to the limited or non-uniformly formatted game data available [160].

Other ways of combining facets, without using a data-driven model of their relationships, have been fairly successful in generating games. Using simulations of gameplay as an evaluation function is an example of hierarchical orchestration where game content such as levels or rules is generated first, and then the gameplay is generated based (usually) on artificial playtraces. Unlike previous examples where the mapping from, e.g., levels to a player's affective response during gameplay was predicted via a computational model, simulations actively generate the gameplay facet rather than predict high-level responses to it. Gameplay is simulated in level generators via pathfinding between the level's start and finish, e.g. in [157], or via rules regarding when players should use a mechanic, e.g. in [70], or via solvers for optimal puzzle solution, e.g. in [151, 155]. Such simulation-based evaluations usually trivialize the player's expected experience or aesthetics. On the other hand, [34] uses the same trivial A* pathfinding playtraces but takes into account the computer agent's camera view in order to assess whether certain markers are visible or not visible. This artificial playtrace evaluates generated levels based on the visual stimuli rather than purely functional aspects of player experience (i.e. completing the level). Player precision is simulated via rule-based systems in [70] by introducing some randomness to the timing of an artificial player's use of a mechanic. This better captures player experience and can be used to assess how accessible or difficult a game is to novice players. *Ludi* [22] created gameplay logs using agents as they were learning to play the game. Similarly, [166] evaluated generated collision and scoring rules for simple arcade games based on controllers evolved explicitly for this game. Unlike *Ludi*, the evaluation was based on the average fitness of these controllers throughout evolution, simulating how difficult it would be for a player to learn (optimize) their gameplay towards maximizing the score. Finally, racing track generation in [164] was informed by gameplay traces of computational agents that simulated specific players' skills captured via machine learning. Focusing instead on human players' different priorities when playing a game, levels for *MiniDungeons* [94] were evolved for different procedural personas, i.e. artificial agents with archetypical player goals such as treasure collection, challenge (monster killing), or survival [62].

## 11.5.3 Cases of AI-Based Game Design

While the task of producing a playable game and all its facets by an artificially intelligent creator is an ambitious goal, there have been significant steps towards it. The following sections highlight important stepping stones towards fully orchestrated, fully autonomous game design.

**Angelina**, in its 2012 implementation [38], scrapes information from online sources (e.g. stories from The Guardian news site) to create simple platformer games. Angelina evaluates the mood of the article based on natural language processing, chooses appropriate image backgrounds and sound-bytes based on the text contents (e.g. an image of a sad British Prime Minister if the article is a negative piece on U.K. politics). While the generated platformer level is not affected by the article's content or mood, the game's visuals and soundscape are orchestrated by the high-level narrative of the news piece.

**Game-O-Matic**   [170] generates games by transforming human-provided schemas into simple but playable arcade games. Human input is provided in the form of a graph where nodes are nouns which are transformed into game objects and edges are verbs which are transformed into mechanics. An example is "man (node)

(a) **Data Agent:** in-game footage of the latest data adventures generator, used with permission from [53].

(b) **AudioInSpace:** in-game footage, used with permission from [65].

(c) **Sonancia:** in-game footage, used with permission from [112].

Fig. 11.6: Cases of AI-based Game Design.

eats (edge) burgers (node)" which may be transformed into a game where the player controls a "burger" chased by "man" avatars, and the game is lost if it collides with a "man" avatar, or the player controls the single "man" avatar who wins by colliding with all on-screen "burgers". When combined together, the different verb-entity triplets may create infeasible game rules [170] or games which can not be completed: the partial game description is then modified by one of many possible *recipes* which best fits the partial game description. Sprites for entities (e.g. "burger") are based on Google image search results for that entity's name. Game-O-Matic transforms human-authored concept maps (micro-rhetorics) into a complete ruleset (i.e. with custom game mechanics, goals and instruction sets). Visuals generation is of minor importance as it is based on a direct online search of human-provided nouns; similarly, level generation is superficial as it decides the placement and number of game objects in the level but does not generate an elaborate level structure.

A **Rogue Dream** [36] uses online sources to discover associations between game objects for a rogue-like game where a player-controlled avatar must combat enemies, gather healing items and reach the exit. The four game objects (the avatar, enemies, healing items, exit) are chosen based on the name of the player's avatar, which is provided as human input before generation. The *avatar name*, as provided by the player, acts as a proto-narrative: semantic associations for the other three game objects are discovered via Google's autocomplete results. For instance, enemies are identified as the next word in a Google query "why do *avatar name* hate...". The visuals for the game objects are sprites transformed from Google image searches on the names of the avatar and discovered associations. The player's abilities, which can be used against the enemies, are based on pre-authored rules templates but influenced by the Google query "why do *avatar name*...". The game takes place in a generated level, using fairly simple scripted algorithms which are not influenced by the avatar's name or any other facets.

**Data Adventures** [8, 9] is a suite of generators which transforms open data into playable adventure games. Different versions of the generators placed a different emphasis on the narrative, with the latest installment [53] having an elaborate hand-crafted narrative regarding a murder committed by a time-traveling doppelganger masquerading as a famous historical figure (see Figure 11.6a). The player

takes the role of a detective who travels around the world to meet different non-player characters (who are historical figures in their own right) in order to find who killed a famous person. The only human input to the system is the name of the victim, while the suspects, locations (i.e. levels), items, and dialogue is generated based on open data. Using primary sources of open content such as Wikipedia for data, Wikimedia Commons for images and OpenStreetMap for levels, Data Adventures recombine that information in novel (and often absurd) ways to create adventures [7]. As an exemplar where semantically linked open data has been used to impart real-world information into a fairly semantically-dependent generated game (as adventure games often are), it has been an important case for exploring ways to use crowdsourced data as input for orchestration [6].

**Game Forge** [58] generates a game's narrative and then the level in which this narrative can take place. While the game is fairly pre-determined in terms of the theme, tileset, visual identity, and gameplay, it is an important example of hierarchical generation where a thorough narrative (unlike proto-narratives in other examined cases) drives the level generation. The narrative is generated as a sequence of hero and NPC actions at specific plot points; a level layout is generated as a graph so that the locations specified in the plot are visited in the right order. The level's target features (e.g. world size, number and length of side-paths) are specified by the player and form an objective for evolving the level towards the player-specified features and the narrative constraints. Game Forge uses the designer-provided or computer-generated story to guide level generation, but also accounts for player preferences as additional human input.

**AudioInSpace** [65] is a space shooter game where specific elements — the weapons and the soundtrack — are generated based on the player's in-game feedback (see Figure 11.6b). The weapon's bullets are represented as particles, the position and color of which are controlled by a compositional pattern producing network (CPPN) [158] that uses the game audio's current pitch information and the position of the bullet (relative to where it was fired from) as its input. This allows the audio to indirectly control the trajectory, speed and color of the players' bullets. The player can control the behavior of their weapons via interactive evolution [162], choosing their favorite weapon among 12 options. On the reverse, the player's bullets (part of the rules facet) and the player's firing actions (part of the gameplay facet) affect the audio being played. New notes occur when the bullet hits an enemy or otherwise at the end of the current note. The new note's pitch and its duration is controlled by a second CPPN which takes the color and position of the last fired bullet and its time delay as input. This creates an interesting loop where one CPPN uses the audio to influence the weapons, while another CPPN makes the weapons' and player's behavior affect the music played. Both CPPNs can be evolved by the player who is indirectly controlling the mapping between facets.

**Sonancia** [111] generates levels and their soundscapes for horror games based on a desired progression of tension (see Figure 11.6c). The model of tension defines how tension should increase or decrease as the players get closer to the end of the level. This tension model is generated first or provided by a game designer [110] and acts as the blueprint which the level generator tries to adhere to. Levels are evolved so that the level's tension progression matches the intended model of tension. In the level, tension increases if there is a monster in a room along the path to the exit, and decays if there are no monsters. The generated level's tension model is used to allocate pre-authored background sounds to each room in the level. Each sound has

a tension value, which can be defined by an expert designer [110] or derived from crowdsourcing [113]. Sonancia uses a hierarchical generative pipeline, starting from a proto-narrative (the desired progression of tension) to drive the level generation which in turn influences the background audio choices for each room.

**Mechanic Miner** [39] generates game rules by adapting the source code of a platformer game (e.g. generating a player action that sets gravity to a negative value), and then generates levels which can only be completed (i.e. the exit can be reached) with these new rules. Playability of generated levels is ensured by an agent performing random actions. Mechanic miner is another instance of a hierarchical generative pipeline, where the game rules are generated first and influence the level generation; the generated gameplay is a trivial simulation as it uses random actions, and is merely used to ensure playability of the generated game.

**Ludi** [21, 22] generates two-player adversarial games, abstract in nature and similar to checkers or tic-tac-toe. Ludi generates all relevant facets of such games, although admittedly the fact that board games of this type do not rely on visuals, audio or narrative makes orchestration more feasible. Ludi combines rules and board layout (levels) in the same "game description" which is evolved towards a plethora of desired gameplay properties. Gameplay is simulated in most evolving game descriptions (provided their rules are well-formed and not derivative of past games) by two adversarial agents that use a policy evolved specifically for this game from a set of pre-authored policy advisors. The produced gameplay logs are parsed to assess objective properties (e.g. completion rate, game duration) but also aesthetic properties (e.g. drama, uncertainty). Unlike many other examined cases, orchestration in Ludi largely follows a bottom-up approach, adapting game rules and board layouts based on feedback from the artificial players which in turn adapt to the specific generated game and take advantage of its board layout.

The **Extensible Graphical Game Generator** (EGGG) [129] is an early automated programming system that generates playable user interfaces for games that are specified in a description language. The generated interfaces respect features of the ruleset, such as hiding information which is intended to be hidden. In addition, for two-player games it generates an AI player specialized to that game. EGGG is a hierarchical generator which matches rules to visuals (as the user interface) and to gameplay (as the AI opponent). This is the only instance among the examined cases where the generated AI agents are intended as opponents to the end-user rather than only for simulating gameplay as a player proxy.

The work of Karavolos *et al.* [80, 81] on **shooter game generation based on surrogate models** offers an example where the mappings between different facets are encoded as a computational model. Deep learning is applied on a custom corpus of first person shooter games, where the levels and character classes of two opposing players are used as input to predict the gameplay outcomes of the match duration and balance (in terms of number of kills scored). The mappings between the level, which is provided as an image of the top-down map, and the rules as parameters referring to the players' hit points or their weapons' accuracy could be used instead of simulations of gameplay. This allows for a fast (although not always accurate) search-based generation of levels or character classes towards desired gameplay outcomes such as a balanced long match. The system is able to make small changes to a level created by a human or generated through a constructive process, to balance a specific matchup against two character classes [81]; conversely, it can tweak the character classes' parameters to balance their match in a specific game level [80].

This is the only instance among the examined cases where gameplay simulations are replaced by a priori learned models.

In their work on **generating WarioWare-style micro-games**, Nelson and Mateas [123, 124] proposed a four-facet model that partly overlaps with the facets of Section 11.2, and implemented a generator of *WarioWare* [128] style games orchestrating a subset of those facets. Those four facets were: abstract mechanics (similar to the rules facet), concrete game representation (a mixture of the visual and audio facets), thematic mapping (similar to the narrative facet, plus the aspects of visuals that establish setting and meaning), and control mappings (subsumed in the rules facet). The generator takes a high-level micro-narrative provided by the user (such as a game about *chasing*), and finds a combination of game mechanics and sprites from a pre-authored set to produce the narrative. It thus follows a hierarchical process that starts from the proto-narrative facet, using ConceptNet and WordNet to decide the mechanics and names for game objects based on a player-provided verb, and then jointly searches the rules and visuals facets for a suitable content pair.

## 11.6 Conclusions

Throughout this chapter, we have argued that game design is a highly creative activity as designers need to consider the audiovisual presentation, the plot and its exposition, the rules and spatial layouts of a game as well as how their interrelations might influence players' perceptions and emotions while playing through it. In order to impart the creativity inherent in game design to algorithms, artificial intelligence must reach new heights and overcome a number of challenges. Throughout the history of commercial games and academic projects on content generation, several shortcuts have been taken to balance the quality of the resulting game content, in order to be appealing to end-users, with a unique and unexpected player experience when interacting with "perpetually fresh" content. Recent cases of AI-based game design, surveyed in Section 11.5.3, highlight such shortcuts through the use of broader databases such as Wikipedia for Data Adventures, newspaper articles for Angelina, Google's image search or autocomplete in A Rogue Dream, or player preference in AudioInSpace. Due to academic efforts in the last 10 years, a plethora of new AI algorithms have been devised for game design or game content design — and even more non-game AI algorithms have been repurposed for these tasks.

### 11.6.1 Future Directions

The road ahead for algorithmic game design has several interesting directions. Indeed, research efforts in all directions will be necessary for purely algorithmic game design to be achievable.

In one direction, the interrelations between different facets must be better imparted to generative systems in order to create a cohesive game that goes beyond unrelated constituent parts. Efforts in orchestration so far feature constrained design spaces such as board games [22], arcade games [170] or adventure games [53]. Computational models so far learn patterns within a very narrow scope of games — often the same game [159] or a game prototype [79]. Recent work in combining

learned patterns from different arcade games [143] is a promising step, although the lack of playable output shows that extensive work is still needed in this direction.

Another important direction is in the algorithm's ability to explain its decisions to a designer working alongside it: explainable AI is becoming a necessity in other fields such as data mining but is only now being considered as a feedback mechanism for game designers [184]. Along with the ability to explain their decisions, the generative algorithms should also impart a sense of intent, where each decision can be traced to an overall goal, style or aesthetic (generated or otherwise) [74, 102]. The ability to provide context and intent in a natural language format easily consumable by a human audience has been argued for and actualized in several creative software programs [33, 35, 88] but has only been attempted in very few AI-based game designers such as Angelina [37].

Finally, an important direction is the human-computer interaction aspect of AI-based game designers; while the focus of this chapter has been on fully automated game design, there is a significant benefit in using AI as a companion to game designers in a mixed-initiative setting [178] where both the human and the computational creator can assess, provide suggestions or take over parts of the creative process. Research in interfaces, design paradigms, or points in the creative process where human input is most needed [82, 97] can be of use in the short term for commercial game design — where human designers prefer to be in creative control — but also to identify key points where AI needs to be strengthened for a fully automated game designer in the longer term.

## 11.6.2 Challenges

While there is intense interest from both the game industry and the research community for pursuing algorithmic game design, there are a number of challenges which must be tackled or circumvented in order to make tangible progress towards a creative computational game designer.

An important challenge is the questionable capability of computational models to capture patterns within content of the same facet (such as levels [159]) or between facets (such as levels and rules [79]). Despite leaps of machine learning algorithms and a reinvigorated research interest in the topic, the recent success of deep learning is in no small part due to the vast data repositories made available. Games have similarly enjoyed a boost in the number of titles released yearly as well as the size and breadth of their gameworlds, levels, lines of dialog or textures. However, data related to games are difficult to use from a machine learning perspective for a variety of reasons such as copyright concerns or non-uniform data formats.

On the one hand, in-game data such as textures are understandably covered by strict copyrights. On the other hand, player data (such as game logs and churn patterns) are proprietary and often carefully guarded secrets as they can inform the design of future titles or patches. Game companies are also concerned that machine learning systems could overfit and unwittingly recreate content from another game. This could cause copyright infringement issues for any other company or institution that uses such a system.

On the other hand, the broad variety of games is detrimental as far as machine learning is concerned. Content such as levels can be formatted very differently from one game to the next: examples include 3D levels with overlapping floors which

can not be represented as a top-down map in the same way as, for example, 2D levels in *The Legend of Zelda* [126]. Similarly, while some facets of games — such as visuals [183] — may be easy to apply machine learning to, other facets such as the game's ruleset are far less straightforward. Rulesets of different games would require extensive processing to be compatible with each other and also useful as input to a machine learning system.

### 11.6.3 Parting Words

Despite the challenges ahead, the path towards automated intelligent design within games is exciting, especially for academic research in artificial intelligence and computational creativity. As AI becomes ever more relevant, its application as a creative force in the highly complex task of game design would be a milestone. An important stepping stone towards such an end would be an increased interest and commercial appeal from the game industry towards full game generation, to complement the already burgeoning academic interest. Similar to games such as *Rogue*, *Elite* or even *No Man's Sky* which pioneered level generation and succeeded based on it, commercially successful games which embrace full game generation would invigorate commercial and broader public attention towards such a task. There are important initiatives, outreach activities, and ongoing research on the topic which we expect will bring us closer to a fully orchestrated AI-based game.

*Acknowledgement.* An important part of this work is based on the publications of [98, 106] which introduced and refined the six creative facets of games and proposed ways of orchestrating them via AI. This chapter builds on [98], including descriptions of game facets and case studies of AI-based game design. This work is largely inspired by the contributions of researchers and developers of the respective systems cited in the paper, particularly those highlighted in Section 11.5.3. Finally, I would like to thank Georgios N. Yannakakis, Mark J. Nelson, Mike Preuss and Rafael Bidarra for their contributions to [98] and also to Michael Cook and Julian Togelius for discussions on computational creativity applied to games.

# References

[1] Apogee: Wolfenstein 3D (1992)

[2] Ashlock, D., McGuinness, C.: Landscape automata for search based procedural content generation. In: Proceedings of IEEE Conference on Computational Intelligence and Games (2013)

[3] Ashmore, C., Nitsche, M.: The quest in a generated world. In: Proceedings of the 2007 DiGRA Conference, pp. 503–509 (2007)

[4] Atari: Pong (1972)

[5] Barros, G.A., Togelius, J.: Exploring a large space of small games. In: Proceedings of the IEEE Conference on Computational Intelligence and Games (2014)

[6] Barros, G.A.B., Green, M.C., Liapis, A., Togelius, J.: Data-driven design: A case for maximalist game design. In: Proceedings of the International Conference of Computational Creativity (2018)

[7] Barros, G.A.B., Green, M.C., Liapis, A., Togelius, J.: Who killed Albert Einstein? from open data to murder mystery games. IEEE Transactions on Games 11(1), 79–89 (2019)

[8] Barros, G.A.B., Liapis, A., Togelius, J.: Data adventures. In: Proceedings of the FDG workshop on Procedural Content Generation in Games (2015)

[9] Barros, G.A.B., Liapis, A., Togelius, J.: Playing with data: Procedural generation of adventures from open data. In: Proceedings of the International Joint Conference of DiGRA and FDG (2016)

[10] Bethesda: The Elder Scrolls IV: Oblivion (2006)

[11] Bethesda: Fallout 3 (2008)

[12] Bethesda: The Elder Scrolls V: Skyrim (2011)

[13] Bioware: Mass Effect (2007)

[14] Blizzard: StarCraft (1998)

[15] Blizzard: Warcraft II (1999)

[16] Blizzard: Diablo III (2012)

[17] Blizzrd: What is Diablo III? https://us.diablo3.com/en/game/what-is. Accessed 26 July 2018

[18] Braben, D., Bell, I.: Elite (1984)

[19] Brace Yourself Games: Crypt of the NecroDancer (2015)

[20] Brøderbund: Prince of Persia (1989)

[21] Browne, C.: Evolutionary Game Design. Springer (2011)

[22] Browne, C., Maire, F.: Evolutionary game design. IEEE Transactions on Computational Intelligence and AI in Games 2(1), 1–16 (2010)

[23] Calleja, G.: In-Game: From Immersion to Incorporation. MIT Press (2011)

[24] Cardamone, L., Loiacono, D., Lanzi, P.L.: Interactive evolution for the procedural generation of tracks in a high-end racing game. In: Proceedings of the Genetic and Evolutionary Computation Conference, pp. 395–402. ACM (2011)

[25] Cardamone, L., Yannakakis, G., Togelius, J., Lanzi, P.L.: Evolving interesting maps for a first person shooter. In: Applications of Evolutionary Computation, pp. 63–72. Springer (2011)

[26] Carrier, E.: The procedural world generation of Far Cry 5. https://blog.us.playstation.com/2018/03/22/the-procedural-world-generation-of-far-cry-5/ (2018). Accessed 26 July 2018

[27] Carter, M., Gibbs, M., Harrop, M.: Metagames, paragames and orthogames: A new vocabulary. In: Proceedings of the Foundations of Digital Games Conference (2012)

[28] Cheong, Y.G., Riedl, M.O., Bae, B.C., Nelson, M.J.: Planning with applications to quests and story. In: Procedural Content Generation in Games: A Textbook and an Overview of Current Research. Springer (2016)

[29] Collins, K.: An introduction to procedural music in video games. Contemporary Music Review **28**(1), 5–15 (2009)

[30] Collins, K.: Playing with Sound. MIT Press (2013)

[31] Collins, S.: Game graphics during the 8-bit computer era. SIGGRAPH Computer Graphics **32**(2), 47–51 (1998)

[32] Colossal Order: Cities: Skylines (2015)

[33] Colton, S., Valstar, M.F., Pantic, M.: Emotionally aware automated portrait painting. In: Proceedings of the 3rd international conference on Digital Interactive Media in Entertainment and Arts (2008)

[34] Cook, M.: Would you look at that! Vision-driven procedural level design. In: Proceedings of the AIIDE Workshop on Experimental AI in Games (2015)

[35] Cook, M., Colton, S.: Automated collage generation - with more intent. In: Proceedings of the International Conference on Computational Creativity (2011)

[36] Cook, M., Colton, S.: A Rogue Dream: Automatically generating meaningful content for games. In: Proceedings of the AIIDE Workshop on Experimental AI in Games (2014)

[37] Cook, M., Colton, S.: Ludus ex machina: Building a 3D game designer that competes alongside humans. In: Proceedings of the International Conference on Computational Creativity (2014)

[38] Cook, M., Colton, S., Pease, A.: Aesthetic considerations for automated platformer design. In: Proceedings of the AAAI Conference on Artificial Intelligence and Interactive Digital Entertainment (2012)

[39] Cook, M., Colton, S., Raad, A., Gow, J.: Mechanic miner: Reflection-driven game mechanic discovery and level design. In: Proceedings of Applications of Evolutionary Computation, vol. 7835, LNCS (2012)

[40] Dormans, J., Bakkes, S.C.J.: Generating missions and spaces for adaptable play experiences. IEEE Transactions on Computational Intelligence and AI in Games **3**(3), 216–228 (2011)

[41] Ekman, P.: Emotional and conversational nonverbal signals. In: Proceedings of the Sixth International Colloquium on Cognitive Science. Springer (2004)

[42] Electronic Arts: Brütal Legend (2009)

[43] Electronic Arts: Madden NFL 18 (2017)

[44] Engelmore, R., Morgan, T.: Blackboard Systems. Addison-Wesley (1988)

[45] Entertainment Software Association: Essential facts about the computer and video game industry report. http://www.theesa.com/wp-content/uploads/2018/05/EF2018_FINAL.pdf (2018). Accessed: 25 July 2018

[46] Epic Games: Gears of War (2006)

[47] Font, J., Alvarez, A., Holmberg, J., Dahlskog, S., Nolasco, C., Österman, A.: Fostering creativity in the mixed-initiative evolutionary dungeon designer. In: Proceedings of the FDG workshop on Procedural Content Generation in Games (2018)

[48] Frictional Games: Amnesia: The Dark Descent (2010)

[49] Gaidon, A., Wang, Q., Cabon, Y., Vig, E.: Virtual worlds as proxy for multi-object tracking analysis. In: Proceedings of the IEEE Conference on Computer Vision and Pattern Recognition (2016)

[50] Game Freak: Pokémon Red and Blue (1996)

[51] Gearbox Software: Borderlands (2009)

[52] Gravina, D., Liapis, A., Yannakakis, G.N.: Constrained surprise search for content generation. In: Proceedings of the IEEE Conference on Computational Intelligence and Games (2016)

[53] Green, M.C., Barros, G.A.B., Liapis, A., Togelius, J.: Data agent. In: Proceedings of the Foundations of Digital Games Conference (2018)

[54] Grimshaw, M.: Sound and immersion in the first-person shooter. International Journal of Intelligent Games & Simulation 5(1) (2008)

[55] Guzdial, M., Harrison, B., Li, B., Riedl, M.O.: Crowdsourcing open interactive narrative. In: Proceedings of the Foundations of Digital Games Conference (2015)

[56] Guzdial, M., Riedl, M.: Game level generation from gameplay videos. In: Proceedings of the AAAI Conference on Artificial Intelligence and Interactive Digital Entertainment (2016)

[57] Harmonix: Guitar Hero (2005)

[58] Hartsook, K., Zook, A., Das, S., Riedl, M.O.: Toward supporting stories with procedurally generated game worlds. In: Proceedings of the IEEE Conference on Computational Intelligence in Games (2011)

[59] Hastings, E.J., Guha, R.K., Stanley, K.O.: Automatic content generation in the Galactic Arms Race video game. IEEE Transactions on Computational Intelligence and AI in Games 1(4), 245–263 (2009)

[60] Hello Games: No Man's Sky (2016)

[61] Henein, M.: 6 ways 3D audio can expand gaming experiences. Gamasutra article (2013)

[62] Holmgård, C., Liapis, A., Togelius, J., Yannakakis, G.N.: Evolving personas for player decision modeling. In: Proceedings of the IEEE Conference on Computational Intelligence and Games (2014)

[63] Holtar, N.I., Nelson, M.J., Togelius, J.: Audioverdrive: Exploring bidirectional communication between music and gameplay. In: Proceedings of the International Computer Music Conference, pp. 124–131 (2013)

[64] Niels van Hoorn Julian Togelius, D.W., Schmidhuber, J.: Robust player imitation using multiobjective evolution. In: Proceedings of the IEEE Congress on Evolutionary Computation (2009)

[65] Hoover, A.K., Cachia, W., Liapis, A., Yannakakis, G.N.: AudioInSpace: exploring the creative fusion of generative audio, visuals and gameplay. In: Evolutionary and Biologically Inspired Music, Sound, Art and Design, vol. 9027, LNCS. Springer (2015)

[66] Howlett, A., Colton, S., Browne, C.: Evolving pixel shaders for the prototype video game Subversion. In: AISB 2010 Symposium on AI and Games (2010)

[67] Hunicke, R., Leblanc, M., Zubek, R.: MDA: A formal approach to game design and game research. In: Proceedings of AAAI Workshop on the Challenges in Games AI (2004)

[68] Infinity Ward: Call of Duty (2003)

[69] Infocom: ZORK (1980)

[70] Isaksen, A., Gopstein, D., Togelius, J., Nealen, A.: Exploring game space of minimal action games via parameter tuning and survival analysis. IEEE Transactions on Computational Intelligence and AI in Games (2017)

[71] Jain, R., Isaksen, A., Holmgård, C., Togelius, J.: Autoencoders for level generation, repair, and recognition. In: Proceedings of the ICCC Workshop on Computational Creativity and Games (2016)

[72] Järvinen, A.: Gran stylissimo: The audiovisual elements and styles in computer and video games. In: CGDC Conference (2002)

[73] Järvinen, A.: Games without frontiers: Theories and methods for game studies and design. Ph.D. thesis, University of Tampere (2008)

[74] John, B.E., Kieras, D.E.: The GOMS family of user interface analysis techniques: Comparison and contrast. ACM Transactions on Computer-Human Interaction **3**(4), 320–351 (1993)

[75] Jong, K.A.D.: Evolutionary computation - a unified approach. MIT Press (2006)

[76] Joyce, M.: Of Two Minds: Hypertext Pedagogy and Poetics. University of Michigan Press (1995)

[77] Juul, J.: Half Real. Videogames between Real Rules and Fictional Worlds. MIT Press (2005)

[78] Kambhampati, S., Knoblock, C., Yang, Q.: Planning as refinement search: A unified framework for evaluating the design tradeoffs in partial order planning. Artificial Intelligence **76**(1-2), 167–238 (1995)

[79] Karavolos, D., Liapis, A., Yannakakis, G.N.: Learning the patterns of balance in a multi-player shooter game. In: Proceedings of the FDG workshop on Procedural Content Generation in Games (2017)

[80] Karavolos, D., Liapis, A., Yannakakis, G.N.: Pairing character classes in a deathmatch shooter game via a deep learning surrogate model. In: Proceedings of the FDG Workshop on Procedural Content Generation (2018)

[81] Karavolos, D., Liapis, A., Yannakakis, G.N.: Using a surrogate model of gameplay for automated level design. In: Proceedings of the IEEE Conference on Computational Intelligence and Games (2018)

[82] Karimi, P., Grace, K., Maher, M.L., Davis, N.: Evaluating creativity in computational co-creative systems. In: Proceedings of the International Conference on Computational Creativity (2018)

[83] Kelly, J., Botea, A., Koenig, S.: Offline planning with hierarchical task networks in video games. In: Proceedings of the AAAI Conference on Artificial Intelligence and Interactive Digital Entertainment (2008)

[84] Key, E., Kanaga, D.: Proteus (2013)

[85] King: Candy Crush Saga (2012)

[86] Kowalski, J., Liapis, A., Żarczyński, Ł.: Mapping chess aesthetics onto procedurally generated chess-like games. In: Applications of Evolutionary Computation. Springer (2018)

[87] Kowalski, J., Szykula, M.: Evolving chess-like games using relative algorithm performance profiles. In: Proceedings of Evolutionary Applications, vol. 9597, LNCS, pp. 574–589. Springer (2016)

[88] Krzeczkowska, A., El-Hage, J., Colton, S., Clark, S.: Automated collage generation - with intent. In: Proceedings of the International Conference on Computational Creativity, pp. 36–40 (2010)

[89] Lagae, A., Lefebvre, S., Cook, R., DeRose, T., Drettakis, G., Ebert, D., Lewis, J., Perlin, K., Zwicker, M.: State of the art in procedural noise functions. In: Eurographics 2010 State of the Art Reports (2010)

[90] Laird, J., Lent, M.V.: Human-level AI's killer application: Interactive computer games. AI Magazine **22** (2001)

[91] Lehman, J., Risi, S., Clune, J.: Creative generation of 3D objects with deep learning and innovation engines. In: Proceedings of the International Conference on Computational Creativity (2016)

[92] Liapis, A.: Exploring the visual styles of arcade game assets. In: Proceedings of Evolutionary and Biologically Inspired Music, Sound, Art and Design. Springer (2016)

[93] Liapis, A.: Recomposing the pokémon color palette. In: Applications of Evolutionary Computation. Springer (2018)

[94] Liapis, A., Holmgård, C., Yannakakis, G.N., Togelius, J.: Procedural personas as critics for dungeon generation. In: Applications of Evolutionary Computation, vol. 9028, LNCS. Springer (2015)

[95] Liapis, A., Martínez, H.P., Togelius, J., Yannakakis, G.N.: Adaptive game level creation through rank-based interactive evolution. In: Proceedings of the IEEE Conference on Computational Intelligence and Games (2013)

[96] Liapis, A., Martínez, H.P., Togelius, J., Yannakakis, G.N.: Transforming exploratory creativity with DeLeNoX. In: Proceedings of the International Conference on Computational Creativity, pp. 56–63 (2013)

[97] Liapis, A., Smith, G., Shaker, N.: Mixed-initiative content creation. In: N. Shaker, J. Togelius, M.J. Nelson (eds.) Procedural Content Generation in Games: A Textbook and an Overview of Current Research, pp. 195–214. Springer (2016)

[98] Liapis, A., Yannakakis, G.N., Nelson, M.J., Preuss, M., Bidarra, R.: Orchestrating game generation. IEEE Transactions on Games **11**(1), 48–68 (2019)

[99] Liapis, A., Yannakakis, G.N., Togelius, J.: Neuroevolutionary constrained optimization for content creation. In: Proceedings of IEEE Conference on Computational Intelligence and Games, pp. 71–78 (2011)

[100] Liapis, A., Yannakakis, G.N., Togelius, J.: Adapting models of visual aesthetics for personalized content creation. IEEE Transactions on Computational Intelligence and AI in Games **4**(3), 213–228 (2012)

[101] Liapis, A., Yannakakis, G.N., Togelius, J.: Limitations of choice-based interactive evolution for game level design. In: Proceedings of AIIDE Workshop on Human Computation in Digital Entertainment (2012)

[102] Liapis, A., Yannakakis, G.N., Togelius, J.: Designer modeling for personalized game content creation tools. In: Proceedings of the AIIDE Workshop on Artificial Intelligence & Game Aesthetics (2013)

[103] Liapis, A., Yannakakis, G.N., Togelius, J.: Sentient sketchbook: Computer-aided game level authoring. In: Proceedings of the Foundations of Digital Games Conference, pp. 213–220 (2013)

[104] Liapis, A., Yannakakis, G.N., Togelius, J.: Sentient world: Human-based procedural cartography. In: Proceedings of Evolutionary and Biologically Inspired Music, Sound, Art and Design (EvoMusArt), vol. 7834, LNCS, pp. 180–191. Springer (2013)

[105] Liapis, A., Yannakakis, G.N., Togelius, J.: Towards a generic method of evaluating game levels. In: Proceedings of the AAAI Conference on Artificial Intelligence and Interactive Digital Entertainment (2013)

[106] Liapis, A., Yannakakis, G.N., Togelius, J.: Computational game creativity. In: Proceedings of the International Conference on Computational Creativity (2014)

[107] Liapis, A., Yannakakis, G.N., Togelius, J.: Designer modeling for sentient sketchbook. In: Proceedings of the IEEE Conference on Computational Intelligence and Games (2014)

[108] Liapis, A., Yannakakis, G.N., Togelius, J.: Constrained novelty search: A study on game content generation. Evolutionary Computation **23**(1), 101–129 (2015)

[109] Looking Glass Studios: Thief: The Dark Project (1998)

[110] Lopes, P., Liapis, A., Yannakakis, G.N.: Targeting horror via level and soundscape generation. In: Proceedings of the AAAI Artificial Intelligence for Interactive Digital Entertainment Conference (2015)

[111] Lopes, P., Liapis, A., Yannakakis, G.N.: Framing tension for game generation. In: Proceedings of the International Conference on Computational Creativity (2016)

[112] Lopes, P., Liapis, A., Yannakakis, G.N.: A holistic approach for semantic-based game generation. In: Proceedings of the IEEE Conference on Computational Intelligence and Games (2016)

[113] Lopes, P., Liapis, A., Yannakakis, G.N.: Modelling affect for horror soundscapes. IEEE Transactions on Affective Computing (2017)

[114] Machado, T., Bravi, I., Wang, Z., Nealen, A., Togelius, J.: Shopping for game mechanics. In: Proceedings of the FDG Workshop on Procedural Content Generation (2016)

[115] Maiberg, E.: 'No Man's Sky' is like 18 quintillion bowls of oatmeal. https://www.vice.com/en_us/article/nz7d8q/no-mans-sky-review (2016). Accessed 13 May 2019

[116] Marin, D., G., V.D., Lopez, A.M.: Learning appearance in virtual scenarios for pedestrian detection. In: Proceedings of the IEEE Conference on Computer Vision and Pattern Recognition (2010)

[117] Mateas, M., Stern, A.: Procedural authorship: A case-study of the interactive drama Façade. In: Digital Arts and Culture (2005)

[118] Maxis: The Sims (2000)

[119] McCoy, J., Treanor, M., Samuel, B., Reed, A.A., Mateas, M., Wardrip-Fruin, N.: Prom Week: Designing past the game/story dilemma. In: Proceedings of the Foundations of Digital Games Conference (2013)

[120] Mike Bithell: Thomas Was Alone (2012)

[121] Namco: Pac-Man (1980)

[122] Nelson, M., Smith, A.M.: ASP with applications to mazes and levels. In: N. Shaker, J. Togelius, M.J. Nelson (eds.) Procedural Content Generation in Games: A Textbook and an Overview of Current Research, pp. 143–157. Springer (2016)

[123] Nelson, M.J., Mateas, M.: Towards automated game design. In: AI*IA 2007: Artificial Intelligence and Human-Oriented Computing, pp. 626–637. Springer (2007). Lecture Notes in Computer Science 4733

[124] Nelson, M.J., Mateas, M.: An interactive game-design assistant. In: Proceedings of the 13th International Conference on Intelligent User Interfaces, pp. 90–98 (2008)

[125] Nintendo: Super Mario Bros. (1985)

[126] Nintendo: The Legend of Zelda (1986)

[127] Nintendo: Super Smash Bros. (1999)

[128] Nintendo: WarioWare (2003)

[129] Orwant, J.: EGGG: Automated programming for game generation. IBM Systems Journal **39**(3.4), 782–794 (2000)

[130] Pajitnov, A.: Tetris (1984)

[131] Paradox Interactive: Stellaris (2016)

[132] Pedersen, C., Togelius, J., Yannakakis, G.N.: Modeling player experience in super mario bros. In: Proceedings of the IEEE symposium on Computational Intelligence and Games, pp. 132–139 (2009)

[133] Pell, B.: A strategic metagame player for general chess-like games. Computational Intelligence **12**(1), 177–198 (1996)

[134] Perez, D., Togelius, J., Samothrakis, S., Rohlfshagen, P., Lucas, S.M.: Automated map generation for the physical traveling salesman problem. IEEE Transactions on Evolutionary Computation **18**(5), 708–720 (2014)

[135] Playdead: Limbo (2010)

[136] PopCap Games: Bejeweled (2001)

[137] Riedl, M., Young, R.: Narrative planning: balancing plot and character. Journal of Artificial Intelligence Research **39**(1), 217–268 (2010)

[138] Riedl, M.O.: Narrative generation: Balancing plot and character. Ph.D. thesis, North Carolina State University (2004)

[139] Risi, S., Lehman, J., D'Ambrosio, D.B., Hall, R., Stanley, K.O.: Petalz: Search-based procedural content generation for the casual gamer. IEEE Transactions on Computational Intelligence and AI in Games **8**(3), 244–255 (2016)

[140] Robertson, J., Young, R.M.: Automated gameplay generation from declarative world representations. In: Proceedings of the AAAI Conference on Artificial Intelligence and Interactive Digital Entertainment, pp. 72–78 (2015)

[141] Rockstar Games: L.A. noire (2011)

[142] Ryan, M.L.: Beyond myth and metaphor: The case of narrative in digital media. Game Studies **1**(1) (2001)

[143] Sarkar, A., Cooper, S.: Blending levels from different games using LSTMs. In: Proceedings of the AIIDE workshop on Experimental AI in Games Workshop (2018)

[144] Scirea, M., Bae, B.C., Cheong, Y.G., Nelson, M.: Evaluating musical foreshadowing of videogame narrative experiences. In: Proceedings of Audio Mostly (2014)

[145] Shaker, N., Liapis, A., Togelius, J., Lopes, R., Bidarra, R.: Constructive generation methods for dungeons and levels. In: Procedural Content Generation in Games: A Textbook and an Overview of Current Research, pp. 31–55. Springer (2016)

[146] Shaker, N., Togelius, J., Nelson, M.J.: Procedural Content Generation in Games: A Textbook and an Overview of Current Research. Springer (2016)

[147] Short, T.X., Adams, T.: Procedural Generation in Game Design. CRC Press (2017)

[148] Sicart, M.: Defining game mechanics. Game Studies **8** (2008)

[149] Sicart, M.: Digital games as ethical technologies. In: The Philosophy of Computer Games, pp. 101–124. Springer (2012)

[150] Smelik, R.M., Tutenel, T., de Kraker, K.J., Bidarra, R.: A declarative approach to procedural modeling of virtual worlds. Computers & Graphics **35**(2), 352–363 (2011)

[151] Smith, A.M., Andersen, E., Mateas, M., Popović, Z.: A case study of expressively constrainable level design automation tools for a puzzle game. In: Proceedings of the Foundations of Digital Games Conference, pp. 156–163 (2012)

[152] Smith, A.M., Butler, E., Popović, Z.: Quantifying over play: Constraining undesirable solutions in puzzle design. In: Proceedings of the Foundations of Digital Games Conference (2013)

[153] Smith, A.M., Mateas, M.: Variations Forever: Flexibly generating rulesets from a sculptable design space of mini-games. In: Proceedings of the IEEE Symposium on Computational Intelligence and Games (2010)

[154] Smith, A.M., Mateas, M.: Answer set programming for procedural content generation: A design space approach. IEEE Transactions on Computational Intelligence and AI in Games **3**(3), 187–200 (2011)

[155] Smith, G., Whitehead, J., Mateas, M.: Tanagra: Reactive planning and constraint solving for mixed-initiative level design. IEEE Transactions on Computational Intelligence and AI in Games **3**(3) (2011)

[156] Snodgrass, S., Ontañón, S.: Experiments in map generation using markov chains. In: Proceedings of the Foundations of Digital Games Conference (2014)

[157] Sorenson, N., Pasquier, P., DiPaola, S.: A generic approach to challenge modeling for the procedural creation of video game levels. IEEE Transactions on Computational Intelligence and AI in Games **3**(3), 229–244 (2011)

[158] Stanley, K.O.: Exploiting regularity without development. In: Proceedings of the AAAI Fall Symposium on Developmental Systems. AAAI Press (2006)

[159] Summerville, A., Behrooz, M., Mateas, M., Jhala, A.: The learning of Zelda: Data-driven learning of level topology. In: Proceedings of the Foundations of Digital Games Conference (2015)

[160] Summerville, A., Snodgrass, S., Guzdial, M., Holmgård, C., Hoover, A.K., Isaksen, A., Nealen, A., Togelius, J.: Procedural content generation via machine learning (PCGML). IEEE Transactions on Games (2018)

[161] Taito: Arkanoid (1986)

[162] Takagi, H.: Interactive evolutionary computation: Fusion of the capabilities of EC optimization and human evaluation. Proceedings of the IEEE **89**(9), 1275–1296 (2001). Invited Paper

[163] Tate, A.: Generating project networks. In: Proceedings of the International Joint Conference on Artificial Intelligence, pp. 888–893 (1977)

[164] Togelius, J., De Nardi, R., Lucas, S.M.: Towards automatic personalised content creation for racing games. In: Proceedings of the IEEE Symposium on Computational Intelligence and Games, pp. 252–259 (2007)

[165] Togelius, J., Nelson, M.J., Liapis, A.: Characteristics of generatable games. In: Proceedings of the FDG Workshop on Procedural Content Generation (2014)

[166] Togelius, J., Schmidhuber, J.: An experiment in automatic game design. In: Proceedings of the IEEE Symposium on Computational Intelligence and Games (2008)

[167] Togelius, J., Shaker, N., Dormans, J.: Grammars and l-systems with applications tovegetation and levels. In: N. Shaker, J. Togelius, M.J. Nelson (eds.) Procedural Content Generation in Games: A Textbook and an Overview of Current Research, pp. 73–98. Springer (2016)

[168] Togelius, J., Yannakakis, G.N., Stanley, K.O., Browne, C.: Search-based procedural content generation: A taxonomy and survey. IEEE Transactions on Computational Intelligence and AI in Games **3**(3) (2011)

[169] Toy, M., Wichman, G.: Rogue (1980)

[170] Treanor, M., Blackford, B., Mateas, M., Bogost, I.: Game-O-Matic: Generating videogames that represent ideas. In: Proceedings of the FDG Workshop on Procedural Content Generation (2012)

[171] Tutenel, T., van der Linden, R., Kraus, M., Bollen, B., Bidarra, R.: Procedural filters for customization of virtual worlds. In: Proceedings of the FDG Workshop on Procedural Content Generation. ACM (2011)

[172] Ubisoft: Tom Clancy's EndWar (2008)

[173] Ubisoft: Assassin's Creed II (2009)

[174] Ubisoft: Far Cry 5 (2018)

[175] Unity Technologies: Unity (2005)

[176] Warner Bros: Middle-Earth: Shadow of Mordor (2014)

[177] Yabsley, A.: Back to the 8-bit: A study of electronic music counter-culture. http://www.gamemusic4all.com/back-to-the-8-bit/. Accessed 27 July 2018

[178] Yannakakis, G.N., Liapis, A., Alexopoulos, C.: Mixed-initiative co-creativity. In: Proceedings of the Foundations of Digital Games Conference (2014)

[179] Yannakakis, G.N., Togelius, J.: Experience-driven procedural content generation. IEEE Transactions on Affective Computing **99** (2011)

[180] Yannakakis, G.N., Togelius, J.: Artificial Intelligence and Games. Springer (2018). http://gameaibook.org

[181] Young, R.M.: An overview of the mimesis architecture: Integrating intelligent narrative control into an existing gaming environment. In: The Working Notes of the AAAI Spring Symposium on Artificial Intelligence and Interactive Entertainment (2001)

[182] Young, R.M.: Story and discourse: A bipartite model of narrative generation in virtual worlds. Interaction Studies **8**(2), 177–208 (2007)

[183] Zhang, X., Zhan, Z., Holtz, M., Smith, A.M.: Crawling, indexing, and retrieving moments in videogames. In: Proceedings of the Foundations of Digital Games Conference (2018)

[184] Zhu, J., Liapis, A., Risi, S., Bidarra, R., Youngblood, G.M.: Explainable ai for designers: A human-centered perspective on mixed-initiative co-creation. In: Proceedings of the IEEE Conference on Computational Intelligence and Games (2018)

[185] Zook, A., Riedl, M.O.: Automatic game design via mechanic generation. In: Proceedings of the AAAI Conference on Artificial Intelligence (2014)

Artistic Perspectives

# 12

# Bees Select Flowers, Humans Select Images: New Designs for Open-Ended Interactive Evolutionary Computation Inspired by Pollination Ecology

Alan Dorin

Faculty of Information Technology, Monash University, Monash, Australia
alan.dorin@monash.edu

**Summary.** Interactive evolution may have the potential to facilitate open-ended human creativity through image search and synthesis, but it hasn't yet lived up to expectations. Unfortunately, research seems to point towards the fact that the rendering and modelling software employed in an implementation are the dominant factors determining its range of visual styles. Ideally this would not be the case. We would prefer that the person involved in the loop provides sufficient impetus to harness the creative potential of the human-computer interaction and not to be limited by particular rendering and modelling approaches in their exploration of image style. This chapter explores the characteristics of a natural ecological interactive evolutionary system – the pollination and "design" of flowers by bees – to provide insight into where our software goes wrong. Drawing on the ecological interaction between insects and plants, we suggest several ways in which our software processes might be improved. These include organising the search space conceptually to enhance inter-image navigation; modelling the search space as multiple interacting communities of images; facilitating human learning of the search space; enhancing the human's ability to remember locations they have previously visited in the search space; and enabling the human to manipulate a collection of parallel searches of the image space. Together, these ideas provide novel ways to think about interactive evolution that may help it break through the human-computer creativity barrier.

## 12.1 An Introduction to the Open-Ended Interactive Evolution of Images

For nearly 130 million years, insects, especially bees, have collectively and subconsciously been designing flowers [23, 77, 89]. The relationship between bees and floral form runs so deep that "design" may be more than just a convenient metaphor for the interaction. In particular, the evolutionary coupling of flowers and bees has a lot in common with the process of human design by interactive evolutionary computation. In this latter process, human users interactively "breed" digital images for their aesthetic qualities. But, the interactions of pollination ecology are different

© Springer Nature Switzerland AG 2021
P. Machado et al. (eds.), *Artificial Intelligence and the Arts*, Computational
Synthesis and Creative Systems, https://doi.org/10.1007/978-3-030-59475-6_12

from human-image artificial evolutionary interactions in significant ways too. This chapter compares attributes of the two processes with the intention of improving our evolutionary software for image-making.

Since Dawkins' *Blind Watchmaker* software [27], and Todd and Latham's *Mutator* [93], interactive evolutionary computation (IEC) has been used to evolve 2D images in response to human aesthetic input [32, 90]. This thirty-year period might seem like plenty of time for the method to have proven itself, or fallen by the wayside. But, the method has done neither – it hasn't become a mainstream design technique, nor has it fallen from grace. Instead, IEC remains in its own niche [31]. No single implementation of IEC has shown itself capable of generating anything like the level of diversity in its output that natural evolution has produced overall. Not even a diversity matching that of flowers generated by bee-flower interactions, a tiny subset of evolutionary creations, has been replicated. Why is that? What limitations have programmers and users run up against? And what can we learn from nature's approach that might help to overcome any barriers?

### 12.1.1 What Is IEC?

For clarity, in this paper "artificial evolution" refers to the process of evolving human-selected traits in a population of *phenotypes*, individual organisms or artefacts, generated from a bio-chemical or digital blueprint, the *genotype* (see [32] for an explanation of the genotype/phenotype metaphor in generative art and IEC). By repeatedly selecting for desirable traits across generations, humans have artificially bred fast horses, greyhounds and pigeons; docile and pretty domestic cats and dogs; tasty, large, nutritious, drought-tolerant and pest-resistant fruits and vegetables; and beautiful flowering plants for our gardens. Our goals have been entertainment, companionship, attractiveness, food production, and others. Flourishing since the early 17th century, debates on whether or not artificial breeding was subsumed by nature, or vice-versa, have occupied the thoughts of luminaries including William Shakespeare, Robert Boyle, Francis Bacon and, importantly, even Charles Darwin centuries later [51]. The understanding gained through artificial selection continues to be essential for unravelling the complexities of natural selection. The reverse perspective is also potentially valuable. And since it turns out that bees are engaged in a process very much like IEC, with flowers as their collaborators, it stands to reason we might gain by studying their interactions. As this chapter will explain, bees have selected flowers for their scents, colours, patterns, structures and mechanics. The "goals" of the bees will be described below – because indeed they do have some, although they don't come into play in the same way as human design goals. Likewise, the flowers with which the bees cooperate benefit from the interaction, as will be explained.

By implementing artificial evolutionary processes to act on image-synthesis software humans can interactively evolve generations of digital images. In general, an IEC image-making program enables one or more human users to view and select aesthetically (or otherwise) satisfying images from a small population of machine-generated and rendered options [28, 83, 90, 93]. The software takes the underlying parameters or higher-level representations that generate each selected image; modifies these through processes akin to biological genetic operations, such as crossover and mutation; executes its autonomous image-generating software; and produces a new population of images that are the "offspring" of the selected parents. The

offspring inherit the desirable visual traits of the selected parents, but also exhibit perceptible variation. The new population of offspring images is presented to the viewer for aesthetic consideration and selection, as was the previous population containing the parents. This cycle of generation, selection and reproduction, continues as the human-computer system explores a trajectory through the space of possible images, a few at a time, to hone in on desirable outcomes. The process ends when the user identifies a suitable image; or, when they give up in despair of ever evolving one.

## 12.1.2 What Are the Limitations of IEC?

There are many reasons why the user might give up in despair. For example, the IEC software might take too many breeding generations [90]. This practical consideration is important to keep in mind. Alternatively, a particular image or image style the user has in mind might be beyond the capability of the autonomous image-synthesis software to generate, no matter how long the process continues or how many variations the user selects and breeds. Dawkins (1989) [28] noted this possibility very early on. This shouldn't really come as a surprise, imagine instead we were working with biological artificial evolution. We might seriously wonder at the possibility of evolving a species of rabbit from a population of carrot plants. Even if a user isn't fussy about the generation of a specific image, or about the general direction of human-machine creativity realised through IEC, we can still wonder whether or not a particular IEC system might continue to generate an indefinite number of creative outcomes. Can its output continue to push at the envelope of novelty? In other words, is a particular IEC system open-ended in *any* direction?

## 12.1.3 What Is the Goal of IEC?

This *open-endedness* has explicitly been a goal of some IEC programmers, although the term's meaning has been sometimes loosely assumed (e.g., [56]), and sometimes more carefully considered (e.g., [59]). To attempt to avoid the pitfalls of being unclear about the relationship between creativity and open-endedness, especially in the context of natural and artificial evolution, a short discussion will help.

Some researchers have already wondered whether it is worthwhile to consider biological evolution as a process akin to human creativity [10]. Others have enquired into the extent generally to which the term *creativity* can be applied to biology and artificial life [12]. Another subject of interest to researchers has been whether or not natural and computational evolutionary processes are in fact, or can ever be, open-ended [16, 92]. These arguments in the context of biology commonly refer to evolution's continued production of new species, and, the idea is usually associated with increase in organismic complexity over evolutionary time periods [7, 15, 54, 69]. Consequently, the relation between species production and creative image production is something that, in this chapter, we take as a key angle. Through this perspective we address the relationship between evolutionary processes' open-endedness and evolutionary software's creativity. So, we can rephrase our concerns in this much narrower context, "*Is IEC capable of supporting open-ended, and therefore creative, image-making?*" This is, more or less explicitly, a goal for IEC software. It is also a goal for research in the field of computational creativity [21], a dominant stream

of which attempts to mimic or surpass human-level creativity with machines. But to answer the question of machine creativity as we have reframed it, we must be as clear about creative image-making as biologists (try to be) about the emergence of new species.

One possible step towards autonomous software-generated open-endedness is *human*-guided software-generated open-ended creativity. For instance, can we build a creative human-in-the-loop system just for image generation? IEC might, one day, be such a system. However, criticisms were levelled at its implementations many years ago [32] that a user's creativity was not provided free reign by any one piece of software. Instead, creativity was being exhibited primarily by the programmer of the software supported by their programming environment. Is there any reason to think the situation has changed? If so, how do we recognise success when we find it? How can we tell if an IEC system (human + machine) facilitates human-level creative image-making instead of incapacitating the human in the loop? By accepting the relationship between creative image-making and open-ended evolutionary production of new species outlined previously, the question becomes analogous to discovering the conditions under which evolution generates new species. What then constitutes "new species" in the space of evolved images?

## 12.2 Creativity in Art and Evolution

This section explores the meaning of creativity in art by reference to painting, and in ecology, by reference to the evolution of new plant species with novel floral designs. The focus on *painting* is largely pragmatic, but its relevance to any creative media ought to be immediately obvious to readers with experience in other traditions. Painting, the manual production of surface-based images using pigments, is an exceedingly rich and long-lived tradition. This makes it possible to draw on examples of creativity to help us understand what we might hope to see emerging from IEC implementations as "new species" of images. The fact that a large part of traditional Western painting relates to flat surfaces, canvas, card, plaster wall and board, also simplifies bridging to screen-based image-making; even though of course painting has always been performed on many not-flat surfaces with pigments that aren't perfectly flat!

### 12.2.1 Defining Creativity

Historical accounts have *creativity* originally associated with the activity of gods, before shifting across in common use to apply to human artists, scientists, engineers, marketing and even business executives [1, 91]. The term has also been considered in relation to the form-producing interactions of matter ([85], chpt. 3) and evolutionary processes [10]. In each case, the idea is that something new is brought into existence. Hence, many current definitions of *creativity* share a requirement for novelty (see for coverage of some examples [11, 12, 30]). The usual additional requirement is for utility, value, appropriateness, or something approximating usefulness, relevance or impact [11]. In the context of image-making, if an image has met the aims of its artist it is valuable, but perhaps only to a single person. This might be insufficient for those who require broad-scale and independent "gate-keeper" valuation of an artist's

output to attribute creativity to them or their work. Imagery that attracts multiple buyers, invitations to exhibition, and public comment and critique, is arguably more impactful and can potentially stake a greater claim to creativity according to these views. Images that are relevant for centuries and provide a focus for rituals and religious or spiritual belief systems over that period, are also clearly useful to those who follow. Any image then that is novel *and* acquires the required amount of socially ascribed impact, value or utility, whatever that might be, ought to be unanimously labelled as creative.

Not everyone agrees on whether or not value, utility or impact are useful requirements for the attribution of creativity in human activity (e.g. see [11], pp. 75-76). In fact, it has been argued [30] that insistence on these socially-ascribed phenomena in addition to novelty is counter-productive, especially in the context of judging works of art from the present, and also especially in relation to machine- and computer-generated art. Bown distinguishes between adaptive creativity and generative creativity [13]. The latter, typically associated with nature, being value-free. For the purposes of many arguments presented within this chapter, the debate over the value of value is immaterial since the consensus on novelty is all that is required for us to understand the creative changes we're interested in. With hindsight, as alluded to previously, all images that are explored within the history of painting outlined here have demonstrated substantial and relevant impact.

## 12.2.2 Transformational Creativity and Painting Styles

Leaving aside the issue of utility for a moment, one means of achieving novelty, according to Boden [11, 12], is transformational creativity. Although she labels other forms of creativity too, we'll start with transformational creativity since it is particularly powerful. It occurs when "one or more of the defining constraints of the possibility-space is/are itself altered, in a more or less fundamental way, so that structures which were strictly impossible before become possible – and, by hypothesis, instantiated". In their work, Dorin and Korb (2012) [30] state something similar, but pose their definition in terms suited to the implementation of computer algorithms [55]. They write "Creativity is the introduction and use of a framework that has a relatively high probability of producing representations of patterns that can arise only with a smaller probability in previously existing frameworks." The frameworks Dorin and Korb refer to are stochastic (i.e. they have random statistical properties) generative procedures, perhaps realised through human agency, perhaps through machine or software activity, that create methods for making patterns, such as individual paintings. In this context, generative procedures can be understood to be methods for creating paintings associated with distinct artistic styles. By this definition more broadly, any stochastic system for creating a diverse but coherent collection of works, with properties that were unlikely to have appeared before, is creative. Boden alludes to something comparable [11].[1]

Styles are useful classification tools for talking and thinking about art generally. As is to be expected in any discussion of classification, styles in painting are not

---

[1]Although, as we noted, Dorin and Korb disagree with Boden about the requirement for value in addition to novelty before ascribing creativity, the attribution of value in the image-making and flowers discussed here isn't contentious, and so, this difference of opinion doesn't bear on the arguments that follow.

always easy to delineate. Many approaches to designating them co-exist and they don't always map neatly onto the visual characteristics of artefacts. Styles may be defined by reference to the period of artistic activity and the name of the civilisation or culture that produced them – Classical Roman art, Byzantine art, European Gothic art for example (refer to any introductory text on art history.) But styles needn't be so all-encompassing, it is possible to label subsets and subsubsets of works with boundaries intersecting cultures and periods. For instance, L'Art Brut ("raw art") is not defined by period (despite it being very much a philosophy of its time) so much as it is by the fact that the person making the work was not formally trained. It includes graffiti, art made by the mentally ill, by prisoners, children, and sometimes those whose style is consciously raw and unconventional [70]. In general, perhaps obviously, whatever the style label and criteria for inclusion, the aim is to single out works in such a way that selected features between images within it are less different than differences between images drawn from different styles. Consequently, styles are further complicated by the fact that many are defined, with hindsight, by reference to the works of art they contain. But the reverse is also possible, where a written manifesto may define the goals of an artistic style in advance of the production of works. This happened repeatedly to define the art movements of the early 20th century. For instance,

> 9. We want to glorify war – the only cure for the world – militarism, patriotism, the destructive gesture of the anarchists, the beautiful ideas which kill, and contempt for woman. 10. We want to demolish museums and libraries, fight morality, feminism and all opportunist and utilitarian cowardice. F. T. Marinetti, Futurist Manifesto, 1909.

In visual art this is not a substitute for the paintings produced by its practitioners, but it nevertheless sets out guidelines the artists of that style agree to abide by, or at least consider. As just demonstrated, the guidelines may not relate directly to the visual content of the images, although often there is a strong relationship between them. Here is an example commenting on one of Cubism's recognisable visual signatures,

> For the picture, a plane surface, the "accommodation" is useless. The convergence which perspective teaches us to represent cannot evoke the idea of depth. Moreover, we know that even the most serious infractions of the rules of perspective by no means detract from the spatiality of a painting. A. Gleizes and J. Metzinger, Cubism, 1912.

In painting, works are usually expected, by artist and audience alike, to be interpreted visually. Therefore, by definition, whatever other consideration artists might give to the principles underlying the realisation of their works, or the theorists and critics might assign to sets of works, visual features have ruled the interaction between artefact and audience. Hence, we may resort to visually discernible similarities and differences in trying to determine the open-endedness of image-making IEC implementations, rather than whether its users have similar or different motivations. With that in mind can we decide on the degree of difference that is required for two sets of works to be discerned as "sufficiently different" to warrant assignment to two styles? Not easily. Although we do know from long experience that humans can, in practice, often reliably assign works to a particular period, culture or individual

artist, even whilst referring only to the works' visual appearance. Lately, machine learning techniques can also be applied effectively to style classification [53]. These classification systems can then form the basis for an operational definition of a style upon which to base a discussion of novelty generation for creative IEC.

### 12.2.3 Is Painting Open-Ended, or Dead?

There is evidence of manual image-making being practiced 73,000 years ago in South Africa [50]. Evidence for the activity in Europe dates back to around 30,000 years BP in the Chauvet caves of France [3]. Since its beginnings, art's role has changed with the coming and going of empires, changes in culture, politics and philosophy. So has our Western appreciation of novelty and the value of individual creativity. In painting, novelty has been introduced in three interwoven ways. There have been practical and important innovations in painting technology, such as the introduction of new colours, developments in pigments allowing them to be stored, transported and used from a tube, or the introduction of perspective projection techniques. There have been changes in visual style, such that it is possible to distinguish between classical Roman depictions of their gods and the depictions of the same gods by the Mannerists after the Italian Renaissance. And there have been changes in the purpose of painting. To understand these interleaved strands, it is useful to think of painting as visual philosophy driven by painters and their milieu. Developments in technology and visual style influence and reflect this philosophy, but they are not the whole story, nor even, in many cases, the most important part of it. This was evident in the extracts from the Futurist and Cubist manifestos (sect. 2.2). As the philosophy of images has developed, the ideas underlying painting have changed.

At the introduction of photography in the 19th century, although apocryphal, the painter Delaroche is claimed to have said, "From today painting is dead" ([5], pp. 9, 17, 226). It didn't die though. In fact it flourished for many more decades until, in 1935, Kenneth Clark, a highly-respected art critic and young Director of the National Gallery (Britain) wrote an essay *The Future of Painting* [19]. Here, he criticised the formal art academy for its potential only to create pathetic stuffiness, and essentially all of the movements of Modernist art then under investigation. "The art of painting has become not so much difficult as impossible", he begins. However, his re-issue of painting's death warrant didn't stop artists working traditional surfaces in new ways either.

By the 1940s, World War 2 had forced many prominent artists to flee Europe for the USA. New York became a centre for Western art (see [17], pp. 501-519 or [40], pp. 20-39). From the early 20th century movements of Modern Art, Contemporary Art[2] emerged. Contemporary Art focusses very strongly on the creativity of an individual as expressed in their ability to break into territory that is unique to them, through each artist's individual experiences, culture, beliefs, values and interactions or perspectives on society. There have certainly been art movements, for instance Pop Art (1950s) and Minimalism (1960s and 70s). Yet even within this context, and especially within the now fractured, sceptical Postmodern environment, an artist is valued and marketed as a unique creative individual such that, "Successful artists can be thought of as brand managers, actively engaged in developing, nurturing

---

[2]Confusingly, Contemporary Art is also sometimes referred to as Modern Art, e.g., This is Modern Art [20] is largely about Contemporary Art.

and promoting themselves as recognizable "products" in the competitive cultural sphere", [80]. One consequence of this is that artists actively drive change and push boundaries in their media. If they don't, they are invisible. The consequences of this art market are problematic from some perspectives,

> Art fairs, jpegs and the entire bloated art market are responsible for the resurgence of painting as opposed to all other art forms", she [R.H. Quaytman] told me [J. Farago]. "I'm sad that it is the structure of the art market that has revalidated and reinvigorated painting. ...It's easy to store, it's easy to transport, it works well enough on the internet: it turned out that painting was, despite itself, the perfect tool. The problem is, whose tool is it?" Every painter should ask themself that question when they turn to the empty canvas. [39]

> The endless boom of the art market, which privileges painting and especially abstraction, has given us a new generation of 'zombie formalists', churning out safe, easily sellable pictures that look good in digital reproduction and in the booths of ever-multiplying art fairs. [39]

Does the market for "easily sellable pictures that look good" indicate the end of creativity in painting? As we saw, Delaroche and Clark had announced this end already. The reasons for the claim continue to be studied and debated [48]. Yet, "...even though that death warrant has been periodically reissued throughout the era of modernism, no one seems to have been entirely willing to execute it; life on death row lingered to longevity", at least, seemingly, until the 1960s writes one critic [24] before exploring the idea further. This lingering "undead" state is still discussed today, the death blow has not been dealt ([9], pp.193-200).

If Farago is right about art fairs, then to find new evidence for ongoing creativity and a fresh, vital, spark, we needn't wait long. Zombie art might sell, for a time. But, as long as it is immersed in fairs full of the stuff, like a flower wishing to attract a bee in a multi-coloured meadow, it must find a visual way to revitalise its brand. Or, be skipped and tumble over its own decaying roots into the chasm of extinction. As far as anyone can see, the end of traditional surface-based media hasn't been discovered. If anything, it has become a kind of cult ([9], p.200).

### 12.2.4 Exploratory Creativity in Painting

According to Boden, there are ways of being creative besides transformational creativity. Dorin and Korb might not agree that anything other than the introduction of new stochastic generative frameworks counts, but for completeness, what should we make of Boden's *exploratory creativity* [12]? Should such exploration *within* a single artistic style be considered creative? Within single styles such as those typified through the art movements discussed previously, or even within the human-discernible style of a single artist, many different images have been produced. Even though these images share the characteristics of their common style, they must have some different, even novel, features or they would simply be replicas of one another.

Some within-style images may act as exemplars of their group by demonstrating its features in novel ways. This is creative since the revelation expands the possibilities for within-style exploration. Much like opening a door within an existing period

house, a further confined space is revealed that nevertheless has attributes that define the home's identity (*cf.* Boden, 1994, p. 80). As already noted previously, since it is possible to refine a style's definition to create sub-styles, it would be just as easy to argue that the subset of images, if they can be classified anew, might be a valuable way to understand works. In that case, if our operational definition of a style, something a human (or machine learning) can more or less reliably distinguish is applied, then what was once intra-stylistic variation, becomes inter-sub-style variation. Yet if the boundary of the style superset is constrained in advance, there must eventually come a time when the search for intra-stylistic variation is exhausted. Once there is no room for novelty, the creative potential of the style has been exhausted. Hence, *exploratory-creativity* is not normally what we think of in relation to open-endedness, the goal of our IEC software. This type of creativity simply produces, by definition, *more of the same*. Whilst transformational-creativity, which breaks rules and defines new spaces to explore, has at least the potential for open-endedness.

### 12.2.5 Combinational Creativity

By combining known ideas in highly unusual ways, it is possible to generate surprising outcomes and creative insights. Even when speaking of the combinations of familiar, but more or less vaguely defined concepts in metaphor – ""Hope" is the thing with feathers - / That perches in the soul - / And sings the tune without the words - / And never stops - at all - / [...]" (Poem 314, Emily Dickinson, 1862) – the reach of *combinational creativity* [12] with its vast range of possible inputs, is practically infinite.

If the parts combined remain recognisable after their conjunction, naively we might expect the result to seem only barely innovative. However, this isn't always the case. There's joy in recognising the novelty of the combination, and seeing, despite this, that the outcome – hope is the soul's songbird, for instance – is natural, deeply evocative, insightful and creative.

Combinational creativity can also lead to insights or phenomena that seem unrelated to the inputs, even with hindsight. This extends the potential of combination as a tool for achieving transformational creativity. Examples appear in complex systems studies, Artificial Life and many other sciences, where collective phenomena generated by some combinations or interactions of basic elements are labelled as "emergent" phenomena, or the term "supervenience" is applied (see examples throughout [8]). Well-worn examples from Artificial Life's software include the combination of individual-level rules to govern bird behaviour generating a unified flock [78], and cellular automaton rules to generate a moving structure called a *glider* in Conway's *Game of Life* [43], or a self-reproducing loop structure [57]. More broadly, the behaviour of an organism may be said to be emergent from the interactions of its cells, the behaviour of a colony of social insects (sometimes labelled a *superorganism*) is also emergent from the interactions of its individuals.

It's potentially an entire thesis of its own to provide a discussion of combination in painting. But one way to approach the problem is to recognise the key role of human visual perception and to identify how combinations of inputs generate experiences that could not be generated otherwise. The Pointillists for example played with this when creating paintings from small dots of coloured paints; the Impressionists did this by using visible coloured brushstrokes instead of focussing on lines (see any introductory book on 19th century painting). Another way painting

has addressed combination is through subject-matter. The Surrealists, for example, attempted to merge dream and reality in their works, sometimes by providing objects with counterintuitive properties, to create new hybrid forms – Magritte's "Le faux miroir" (1929), depicts an eye containing the sky and clouds; Dali's "The Persistence of Memory" (1931), is famous for its liquefied clocks.

Just to be clear, metaphor in poetry, combination in painting, software agent operation, and physico-chemical behaviours of matter are different types of interaction operating on different basic elements. What these systems share though is that in each space of interactions (metaphorical, visual, simulated, physical or chemical) combinational approaches can create new stochastic generative frameworks. Permutations and combinations are therefore potentially generative mechanisms for realising transformational creativity.

## 12.3 Creativity, Biological Evolution and Pollination Ecology

The chapter so far has promised to discuss bees and flowers, but not yet moved beyond image-making. To make the connection, some basic biology is required. To produce a fertile seed, flowering plants require pollen to be transferred from the "male" organs of a plant to the "female" organs, often of another plant ([38], pp. 13-33). This pollination process may be conducted by the wind (*anemophily*), or other physical processes, but abiotic pollination can be unreliable, and very wasteful of pollen ([38], p. 34). Instead, many advanced plants have evolved ways to attract animals closely enough that pollen adheres to their bodies. The plants have also evolved structures to receive this pollen to produce viable seed from a fertilised ovule. The structures for attracting animals, for depositing and collecting pollen from their bodies, are flowers. The more successfully a plant achieves pollination, the greater its reproductive capacity. Since their origins, flowers have diversified into a surprising diversity of forms and ingenious devices to manipulate insects for pollination (*entomophily*), especially bees [23].

Bees are not the only flower visitor, but they are very important in the context of a discussion on IEC for a few reasons. Where bees occur, they are often the dominant pollinator providing evolutionary pressure on floral design. One reason for this, their *flower constancy*, is discussed soon (sect. 5.5). Also, the relationship between bees and flowering plants is particularly well studied, dating back at least as far as Aristotle (*Historia Animalum*, c.340 BCE [37]). In addition, and perhaps most importantly, the visual system of bees (the hymenopteran vision system) predates the appearance of flowers and has been phylogenetically conserved for the period of time over which flowers have been evolving – the essential properties of bee visual systems are as ancient as coloured flowers [14, 18]. This one-sided evolutionary relationship conveniently eliminates some of the complexity of co-evolution, making the case simpler to study than others, but also, it matches IEC more closely than a fully plastic co-evolutionary situation.

The mass evolution of flowering plants has resulted in the current estimate of an existent 350,000 known species, of which nearly 310,000 are animal pollinated [73]. Not all of these are unique in their approach. Ecological evolution doesn't seek novelty in the same way, or for the same reasons, that humans do. Yet, as we described

previously in the case of human creativity, value or impact are also prominent in discussions about creativity. Thoughts regarding the value of flowers have been expressed specifically, *"Without a functional background, a flower becomes meaningless morphological play..."* ([38], p. 13). In the context of insect-pollination, this means that flower designs can be understood in relation to their impact on the reproduction of a plant species. This is largely achieved by manipulating the behaviour of insects in ways akin to those used in human marketing and advertising. The morphology of flowers acts as a remote signal and symbol, indicating the potential for the rewards the animal seeks (possibly food, shelter, mating partners etc.), as a local guide indicating how to access rewards if they are available, as a physical manipulator of body movements and orientations, and as a filter on animal body morphology. The morphology of the flower also acts as a housing for the rewards it offers, keeping them safe from the weather and robbers. The flower houses the plants' reproductive organs, and is the site at which seed dispersal mechanisms are produced (fruit, for example).

Aside from Boden's novelty and value, we can also relate bee-flower interaction outcomes to Dorin and Korb's creative frameworks. A new species of flowering plant is reproductively isolated. If it has survived in a region it must therefore occupy an ecological niche different to other sympatric plants, or it would have been outcompeted according to the principle of *competitive exclusion* [47, 49]. The species is therefore a stochastic generative framework for reliably producing offspring of its own kind that would have been vanishingly improbable prior. By virtue of occupying a new niche (significantly or only slightly different to its competitors), the new plant has transformed the "possibility-space" (in Boden's words) of plant life. This is where the analogy between new biological species and new styles of painting alluded to earlier comes into play. Each is a new framework or generative procedure within its own domain (biology and art respectively).

### 12.3.1 Evolution Doesn't Prefer Novelty (But Produces It All the Same)

One very significant difference between evolutionary and human creativity is the human preference, at least in the art world, for novelty to be measured against all of world art history. Boden has called this historical creativity/novelty (*H-creativity*) and contrasted it against psychological creativity/novelty (*P-creativity*) which refers to creativity only with respect to an individual's previous experience or history of invention [12]. H-creativity is simply the case where P-creativity also turns out to be a world first. As noted previously, evolutionary biology doesn't prefer H-creativity over P-creativity. Floral designs may converge on similar petal colours and arrangements from completely different starting points. Or a single lineage may move towards one arrangement, then, as selection pressure changes, move on to a new one, before later reverting to its original form. It depends on complex community-level interactions, such as those governing competitive exclusion noted previously, and long-term evolutionary pressures applied by changing competitors, climate variation, co-evolution, and other factors, as to exactly how things pan out. But flowers are there to facilitate pollen transfer and evolved because they are useful to the plants, not to allow bees to express their creativity. As human observers of insect-flower interactions and the diverse niches flowers occupy, we may easily ascribe novelty to

the designs of flowering plants nevertheless. We might even be justified in feeling that because novelty arises without it being a conscious goal of bees, the chances that IEC will succeed, by engaging consciously creativity-seeking humans, are high.

## 12.3.2 Humans Prefer Novelty (But IEC Software Struggles to Produce It)

Of interest to researchers writing evolutionary computer software generally, including those using IEC, is that, for some reason, it can't replicate the novelty typical of speciation [87], it gets stuck producing more of the same. The biological fact that needs simulation is the seemingly unstoppable branching through the space of organism designs that has occurred since replicators first took hold on Earth, and the massive complexity of some of these organisms (such as mammals) compared with the single-celled creatures that got evolution started. The total number of Earth's species is estimated currently to be in the vicinity of 8.7 million [71]. That is an enormous amount of diversity to account for, and our software is not yet up to the task.

In the literature on evolutionary software and open-endedness, some metrics have been proposed to assess, in particular, the production of novelty that has adaptive significance, a stand-in for *value* [92]. The issue is clouded by the fact that in addition to debating what is meant by open-endedness in biological evolution, computer scientists must also debate issues such as what are appropriate computational analogies for species (just as we did previously for clarifying the analogy between artistic styles and species), the permissible complexity of software "building-blocks" for organisms, and the degree to which a programmer is allowed to hard-wire certain emergent properties of nature into their software (e.g. see [92] for some discussion). Many of these issues must also be considered with IEC. But since a human-in-the-loop assesses IEC output, not a formal metric, some measures – such as what it means for an evolved artefact to be a member of a new "species", or an image to be a member of a new style – can remain vague so long as we accept an operational definition. This avoids some of the hard problems of autonomous novelty production, but doesn't allow a sidestep around human creativity. The question remains open as to what algorithm will facilitate creativity indefinitely that matches the open-endedness, at least, of human creativity in painting.

If humans can write and operate interactive software that matches even a fraction of the novelty and species-production that has been generated by the flower-bee interaction, we will be on the way towards the kind of software-based image-making flexibility we desire. But existing software doesn't seem to have the potential to facilitate this kind of outcome. IEC hasn't arrived at anywhere near 310,000 new image "species" to match even just floral evolution. I believe it is contentious to date whether a single program has even arrived at two. The next section explains why I feel this to be the case. After that, floral biology will be described in more detail to indicate how flowering plants and bees succeed in being more creative than humans with IEC software.

## 12.4 Creativity and Open-Endedness of Syles in Digital Image-Making

Obviously, the raster display we typically use now as the output device for IEC software has not existed for anything like the time frames involved in the period spanning all of Western painting. If current advances are any indication, raster displays may be relevant for only a few more years, perhaps decades given their flexibility. Still, that is longer than many of the 20th century art movements remained current. Despite the relative longevity of raster displays, I'm not aware of any movements within computer-controlled raster-display image-making that rival the public or academic visibility, depth and breadth of exploration seen in the art movements of traditional media. Some contenders will be discussed shortly.[3] It is well beyond the scope of this chapter to develop these in a post-hoc fashion. I'm uncertain about the value in trying to synthesise a coherent narrative of screen-based image making that could be compared to the chronology of Western art history anyway (see Table 12.1 for some examples). Of course, the continued emergence of these would, as with traditional media, be evidence supporting the technology's ability to facilitate open-ended creativity. Still, a software-addressed raster display is sufficient for potentially infinite creative exploration (and, I should add, non-trivial and interesting to humans), and this can be shown simply by reference to the continued introduction of new rendering and image-synthesis techniques.

There are many different methods used to synthesise images for display on raster devices. The role of the software implementing these methods is to determine which pixels on a screen should be lit so as to allow a viewer to perceive relationships between them that generate the appearance of colour, shade, line and form, the elements of visual style. These relationships may, or may not, be explicitly reflected in the program. Sometimes a viewer recognises relationships between pixels that were "put there" by the programmer. For instance, they perceive a shape that was explicitly encoded in the computer within a data structure for storing and drawing faces with eyes, a mouth, a nose etc. This underlying representational scheme requires the software, or user, to perform a task called "geometric modelling". This is the specification of the parameters for the geometry, such as where objects will be placed in a virtual scene, their sizes, shapes, textures and colours. Following this process, a rendering program must be operated to produce an image of the scene containing the models. In this style of image-synthesis, countless different approaches to both modelling and rendering, and their combinations, have been developed, some are described below.

In other cases, a form such as a face can appear in an image without any underlying face-like geometric representation. For example, a line-drawing algorithm may render lines directly and randomly to the screen, and the result just happens to look to a viewer like a face. This algorithm has only a representation for lines that

---

[3]There are computer art movements that address approaches to art-making that encapsulate, but aren't fully contained within, adherence to particular media. For instance, Generative Art (with some claim to being a framework, if not a movement) is neutral with respect to media, as long as the media are used to implement an algorithm that constitutes or creates a work of art [31]. Generative Art though cannot be said to have made anything like the impact of the strongest, or even middling, Modern Art movements.

may be as simple as a line starts at one location on the screen and ends at another location. This scheme has no need for complex geometric models to be built by the software, or the user. Instead, each line is generated one at a time, endpoint one followed by endpoint two, and drawn, with no underlying relationship between lines being encoded.

The level at which image elements, such as faces, surfaces, lines or other marks, are specified is an important part of an image-synthesis program, just as it is in an artist's conception of painting. This pre-determines the outcomes that are likely to occur, possibly even eliminating vast sections of image space from ever being accessed. What is the chance that a random sequence of lines will produce a picture of the author's face beside your face? Vanishingly slim. Hence, the program has a major role to play in facilitating creativity, or in restricting it. Each novel program for image-synthesis significantly raises the likelihood certain kinds of images will be produced. For the same reasons, images created with each program therefore have typical visual styles.

Image-synthesis algorithms are usually developed by programmers for applications that may only include static visual Art (capital-a) as a minor contributor competing against computer games, advertising, data-visualisation, feature film production, architectural modelling or aircraft simulation. Probably all of the techniques have nevertheless been adopted by artists, sometimes even by groups of artists working towards common goals. But, the techniques themselves are not philosophical in the sense that painting is philosophical. They are not usually developed for the purposes historically associated with Art, such as for producing images that effect political change, or to generate images specifically for use in religious ceremonies, or as a way to grapple with the sublime. Yet, the algorithms do convey assumptions and thoughts about the role and meaning of digital images. I will describe three early, contrasting, examples selected from Table 12.1 to clarify what I mean by this.

### 12.4.1 Rendering Lines with Turtle LOGO

LOGO Turtle Graphics (Table 12.1, 3) encapsulates the concept of an image as a collection of lines on a surface inscribed by a "turtle" moving according to a programmed series of discrete rotations and forward motion steps. The system was introduced during the transition from vector to raster graphic display devices in the mid 1970s [60]. The turtle has a position on the canvas and a heading, as well as a pen which may be raised or lowered to move and mark, or to move without marking, the surface. LOGO was designed to teach children programming, not simply as an image-synthesis technique. The turtle was selected as the drawing paradigm, rather than say using a Cartesian coordinate system typically found in graphics packages, due to how readily children identify with it as a drawing agent ([74], p.55). A programmer's role is simply to provide sequences of instructions to the turtle, the result of which will be a line drawing it sweeps out as it moves.

### 12.4.2 Rendering Reflections, Ray-Tracing

In introducing a rendering algorithm known as ray tracing (Table 12.1, 14) Whitted (1980) writes, "Since its beginnings, shaded computer graphics has progressed toward greater realism". Here, "realism" isn't the philosophical "Realism" of Courbet

Table 12.1: A partial list of techniques, especially making mention of a few that have been tried in the context of IEC, for producing images on raster display devices. For descriptions of the un-referenced items in the list, consult an early general text on computer graphics such as [41]. Note that in this list, the distinction between modelling algorithms and rendering algorithms is not made. Some algorithms, such as ray tracing, require pre-rendering stages such as modelling, texturing and lighting. The techniques applied in each stage impact on what images can and cannot be produced. Other techniques, such as pixel/bitmap-generating LISP expressions, do not have analogous stages, they are not renderings of any underlying scene requiring geometric specifications to be made. Some algorithms fall partway between these two extremes. For instance, a line-drawing algorithm for use on a raster display may operate with Cartesian line end-points. But to render the line to a raster display, the continuous line must still be rasterised – i.e. it must be turned into instructions for lighting pixels in the raster array. Different algorithms will do this differently, allowing for variations in lines between approaches, even when they share the same end points.

| | |
|---|---|
| 1 | Text-or character-based image generation (e.g. ASCII Art [61]) |
| 2 | Wire-frame renderings of 3D geometric models [2] |
| 3 | Agent-based line-drawing algorithms (e.g. LOGO Turtle Graphics [75]) |
| 4 | Digital photography and 2D filters |
| 5 | Iteration through a fractal (e.g. the Mandelbrot set [64]) |
| 6 | Pixel-reading and writing algorithms (e.g. Langton's Virtual Ant [58]) |
| 7 | Parameterised 2D branching structures (e.g. Dawkins' *Blind Watchmaker* [27]) |
| 8 | Differential equations (e.g. Reaction-Diffusion textures [95] |
| 9 | LISP expressions taking X/Y image coordinates as input [83] |
| 10 | 2D filled polygon placement (e.g. any interactive drawing package) |
| 11 | Filled and/or shaded polygon-based renderings of 3D geometric models (e.g. using flood-filling, flat-, Gouraud-, Phong- or Blinn-Phong- reflection models) |
| 12 | Texture-, bump-, or environment-mapping |
| 13 | Depth-of-field, motion blur, lens-flare and simulations of other lens behaviours |
| 14 | Ray-traced renderings of 3D geometric models (useful for rendering repeated reflections of light and transmission of light through transparent surfaces) |
| 15 | Radiosity rendering (for rendering diffuse reflections of light from surfaces) |
| 16 | Path tracing (for correctly rendering global scene illumination to automatically account for soft shadows, depth of field, motion blur, caustics, ambient occlusion, indirect lighting [52]) |
| 17 | Painterly rendering techniques (e.g. particle-, watercolour-, or ink-flow brush simulations) |
| 18 | Convolutional Neural Network image synthesis (e.g. *Deep Dream* [72]) |

(1855); it is associated with the simulation of optical phenomena including specular reflection, shadows and transparency. The algorithm simulates a camera. "Computer graphics concerns the pictorial synthesis of real or imaginary objects from their computer-based models", wrote Foley et al., p. 2 [41] ten years after its origin. For this to be achieved, the data structures that the programmer explicitly encodes include representations of solid objects, light rays, a picture plane and an eye point. The privileged position of pictorial representation, objects and photorealism, remains a major driver of graphics algorithm development and hardware manufacture today. Ray tracing works by casting virtual light rays into a scene from an eye point. These pass through a virtual picture plane – the surface of this is the virtual canvas of the image – and into the scene described by three-dimensional geometric models. When a light ray travelling through the plane into the scene hits an object, it may pass through it onwards to further objects (if the object is transparent), it may reflect from its surface onwards to further objects (if the object is reflective), or it may simply stop here (effectively absorbed by the surface). At this point, the colour of the object at which the light ray halts is chosen to mark the pixel at the location on the picture plane through which it passed. In this way, after the paths of thousands of light rays are calculated, a picture of the objects in the virtual scene is produced.

### 12.4.3 Rendering Complexity, Fractals

Fractal rendering (Table 12.1, 5) is a narrower image-synthesis technique than either LOGO or ray tracing. It has nevertheless found diverse applications in simulating complex natural textures and structures, such as clouds and coastlines [76]. The jaggedness of a coastline, viewed from above, appears consistent as an observer zooms in from several kilometres away, down to a scale of a few metres [62]. This statistical "self-similarity" is the defining characteristic of fractals. Self-similarity may be produced with a variety of graphical primitives, it doesn't favour the lines of LOGO over the 3D geometry of ray tracing, for example. Fractals may be rendered by placing points on a plane to generate a coloured or shaded pixel-array directly. Pixel placement was Mandelbrot's original approach to investigate a mathematical function known as the Julia Set, but a similar approach can produce a pattern reminiscent of a fern leaf [6]. Alternatively, fractal rendering may involve placing, and recursively sub-dividing, lines to generate a two-dimensional "von Koch snowflake" [97]. By recursively subdividing and moving polygons in three-dimensional space, fractals can also create shapes visually reminiscent of rivers and mountain landscapes [65].

The motivation that underlies fractal image synthesis is aesthetic at two levels. One, to visualise phenomena with particular mathematical properties, "fractal geometry reveals that some of the most austerely formal chapters of mathematics had a hidden face: a world of pure plastic beauty unsuspected till now" ([64], p.4). And, fractals "[...] filled an obvious need for describing some of many conspicuous natural patterns [...] at which the straight lines, circles and ellipses, squares, and other components of classical geometry are almost completely inept" ([63], p.170). There has been debate about the truth of this latter point [4, 82]. However, fractal rendering has mathematical aesthetic origins, and it has visually replicated natural phenomena suitable for many image-synthesis applications. These are the reasons I mention it.

### 12.4.4 Image Synthesis Techniques as Visual Styles

The three examples just presented, highlight the relationship between a developer's ideas concerning the role of image synthesis and the design of algorithms. As a result, LOGO, ray-tracing and fractal rendering each have very practical strengths and weaknesses. For instance, drawing a photo-realistic reflective sphere on a checkerboard floor with Turtle LOGO is very difficult – the technique has no basic representation scheme for the concepts of 3D geometric model, light or its reflection. To create a meandering, 2D, recursively branching line with a ray-tracer is similarly difficult – the technique has no basic representation scheme for the concept of an agent, its heading, position, or even the concept of a mark on the image plane uncoupled to underlying geometry. But making the line drawing with a LOGO turtle is as trivial as rendering a sphere with a ray-tracer.

All of the techniques tabled, not just the three highlighted, encompass their own assumptions and facilitate or preference particular ways of making images. Prior to the introduction of each, particular styles of image were vanishingly unlikely to appear. Fractal imagery is a case in point – the computer graphics world and popular poster shops around the world exploded with fractal images following Mandelbrot's publications. (Google "fractal".) Similarly, the number of images of reflective spheres on checkboard surfaces must have been multiplied by the millions with the introduction of ray-tracing (Google that too!). Consequently, we can say that the introduction of each technique represents a creative step by reference to Boden's transformational creativity, by Korb and Dorin's concept of generative frameworks, or, in practice, even by reference to our suggested operational definition of visual styles. The possibility of identifying and exploring sub-styles within the set of images produced using a single algorithm remains a possibility too, as it is in painting.

The introduction of algorithms has not been dominated by the concerns of Art, and so rendering and modelling techniques do not necessarily rise and fall from favour for the same reasons as art movements. Nevertheless, in the short history of raster-based digital image synthesis we can see this as some evidence thus far, for ongoing, and potentially open-ended, creativity in the introduction of image generation techniques. There is no reason to think that the technology is intrinsically limiting the open-endedness of the algorithms running on it.

## 12.5 Open-Ended IEC

### 12.5.1 Are Existing IEC Implementations Open-Ended?

The results of a few IEC systems have been exhibited in the context of formally recognised galleries and art museums (e.g., [33, 66, 79, 83, 93]), perhaps giving credence to the idea that IEC is capable of supporting open-ended creativity. However, in each case the works created by the system were exhibited, to the author's knowledge, by artists who were also involved in the design of the systems. Each program shared important features with a generic IEC algorithm, variation between systems was not great in this regard. However, each artist applied a more-or-less unique approach to image synthesis that allowed their IEC implementation to generate images unique to them (e.g. Latham used constructive solid geometry as a modelling

technique and ray-casting/tracing [83] (chapts 7&9); Sims [84, 93] used LISP expressions and geometric graphs; Driessens and Verstappen (2006) [33] used populations of drawing agents). The creativity on display therefore appears more closely associated with the image-synthesis technique than with the search through image space conducted using the IEC algorithm. Consequently, each individual user of the software, being constrained differently to one another by the image-synthesis technique but similarly to one another by the IEC search, is able to generate a single visual style linked to a piece of software. The inter-style variation between software implementations parallels the variation in digital image synthesis techniques described in the previous section and is, given the current "artist as brand", quite in line with current expectations for professional artists.

Whereas the systems previously were used in the context of art almost exclusively by their authors, the online *PicBreeder* IEC has been used by many tens of thousands of people to generate hundreds of thousands of images, over more than ten years [81]. These may not be formally recognised as art, but they are nevertheless available online for all users to explore, rate, and continue to evolve (`http://picbreeder.org`). Its widespread use and public access to evolved images, makes this system a good candidate for consideration of the strengths and weaknesses of IEC with respect to open-ended creativity.

The image synthesis algorithm PicBreeder uses, Compositional Pattern Producing Networks (CPPNs), operates on images at the level of the pixel. Sims' and Rooke's systems operated at the pixel level also [79, 83]. This low-level manipulation may potentially allow a system to generate a greater range of images, perhaps styles even, than say, a system like Dawkins' BlindWatchmaker which operates at the very high level of manipulating binary tree segments, or Latham's system that uses constructive solid geometry of high-level arrangements of cylinders, spheres, cones and tori. At first glance though, it might seem unlikely that PicBreeder's pixel-level control would enable a user to explore representational images of solid objects. However, some of the PicBreeder images rated highly online at this author's time of access (September 2018) are representations of objects: a chicken, a fish and a wolf in front of a full moon, and the article [81] has many more examples. So, even though the image generation technique might not have an internal representation of physical objects, let alone particular animals, it is capable of natural representational image-making if desired.

Another reason for discussing the PicBreeder system carefully is the extent to which its authors have considered navigation of the search space. Instead of using a conventional evolutionary algorithm, they use a modification of this, Neuro-Evolution of Augmenting Topologies (NEAT). By coupling this with CPNNs, the authors of PicBreeder attempt to assist the user group to collectively navigate and expand the search through the huge space of potential images a 24-bit colour pixel-based display can hold. Their intention is to allow users to identify an exceedingly capital-s Small set of interesting results within the vast image space [67].

Exploration of the PicBreeder output indicates a signature style for the software typified by soft edges, a highly saturated and generally broad colour palette, soft-amorphous shapes and smooth curves. Sometimes representational images have been created, as noted previously. Often, abstract patterns of swirling colour are instead the result of users' experimentation. The PicBreeder style though, appears unchanged across the 30 users' work illustrated in the paper (Figures 13 and 15 in [81]), right through to a scan of today's most recently evolved images online in 2018.

There does't seem to be strong evidence for the unique creativity of individual users, even over many years of PicBreeder's operation. Instead, it looks much more like users have been creating *more of the same* for years with no stylistic breakthroughs. In short, it really doesn't *look* like PicBreeder is facilitating open-ended creativity of its users. So, by the operational definition of novel styles there isn't evidence akin to that for traditional surface-based art, or the last 50 years of image-synthesis techniques.

The authors of PicBreeder have attempted to rectify this using an approach they call *Novelty-Search*. This algorithm directly searches for (in this case) images that are unlike others [59]. In addition to a measure of rarity, the search also considers how difficult a particular image is to generate, i.e. how many IEC generations it would take to evolve. This is their proxy for its value. Together, the authors take this novelty plus value to be "impressiveness", a property they tie explicitly to open-ended creativity. Interestingly enough, four of the five images they present as the result of the approach have hard edges that contrast against those currently bred by the users on the PicBreeder page. There might be something going on here, although I am uncertain how much to read into the apparent difference. What is clear however, is that this still isn't a substantial change in style of the type we'd expect from Boden's transformational creativity or a new Korb-Dorin stochastic generative framework. The images are quite obviously PicBreeder output and wouldn't be mistaken, say, for Sims' or Rooke's work using pixel-level image generation techniques, let alone for figures from Dawkins' BlindWatchmaker.

## 12.5.2 A Fundamental Difficulty of Navigating the Space of Images and Styles

To achieve open-endedness, an IEC image-generator needs to search the space of possible styles, not all possible images. But the space of styles is a subset of the space of all images, so why should narrowing the search space help? All image styles within the scope of raster-displays can, theoretically, be located within the search space of *some* algorithm addressing individual pixels. For example, a brute force algorithm could do this by iterating through every pixel combination, but it might take time far in excess of the universe's ability to wait for it. It doesn't follow that every specific image-synthesis algorithm is capable of addressing all locations in the raster display space either. There is every chance that any one algorithm is constrained to what, even a relatively untrained human, will identify as a single style. This proposition is confirmed, as already remarked upon, by the visual signatures of existing image-synthesis and IEC systems.

Supposing, for argument's sake, that an IEC image-synthesis algorithm was not constrained to a single style, but could generate enough of the search space of all possible raster-based images that it encapsulates many images of many styles. Suppose also, for argument's sake, that the evolutionary search algorithm could potentially access every image in that space (even if this took an impractical amount of time). There are two overarching methods to apply this: in a directed fashion, with a goal in mind; or by exploring in an ad hoc way. A user could also conduct a hybrid of these approaches. For this search to be effective, the user needs some understanding of the relationship between neighbouring locations in the search space. They need to be able to imagine, at the very least, the kinds of results that will appear at the next

generation when selections are made from the current population. Otherwise they will not be able to navigate successfully beyond a random walk. It isn't clear at this stage how the space of styles ought to be engineered, to facilitate this insight. As yet, even the space of images synthesised using existing IEC algorithms is severely limiting in this regard. This is why, since the early days, developers have attempted to assist users to navigate coherently through the design space their implementation encapsulates ([93], pp.84-87).

To illustrate the problem with structure using the familiar case of image search spaces, suppose a designer sifts mindlessly through a few generations in a current image-focussed IEC implementation. She notices one that looks a bit like a butterfly, and starts to guide the search towards making a new image that is still more butterfly-like. This procedure harnesses pre-programmed IEC to the greatest advantage as the initial orientation allows her to identify the possibilities of the system, before she enhances the output within system constraints.

Sometimes instead, a user might want to evolve a particular pictorial representation of a butterfly right from the word go. In the space of all possible images, there will be countless examples of these. Given time, suppose one was located, a Ulysses butterfly with its wings open, viewed from above. But this wasn't quite like the intended goal. With a PicBreeder-like pixel level image specification, the solid geometry of the butterfly is not encoded – the particular set of coloured pixels on the screen is structured in 2D like a butterfly (e.g. with bi-lateral symmetry), but they are not internally structured like a butterfly in three dimensions. So, if the user wished to find an image of this "same butterfly", viewed from the side, with its wings folded, there would be no reason to think that the location in the search space of the top-view butterfly would provide information about the location of the side-view butterfly. The user is forced to search essentially from scratch because the space isn't structured to aid the search they wish to conduct. Without an underlying 3D geometric representation, the search for images of 3D geometric forms is incoherent. If programmer / artists want to produce images of 3D forms, they don't start with pixel-level representations, they begin with geometry.

Remaining with the familiarity of pictorial representation for a moment, images associated in the minds of humans with butterflies might include cocoons, leaves, flowers and caterpillars. But it isn't easy to see how these might be associated in image space with images of butterflies, either using pixel-level or three-dimensional geometric representations. Is there a coherent way to navigate using IEC from an image of a butterfly to one of a flower? This is a simple, valuable conceptual jump even for a child painter. What's also inconceivable with IEC is for a jump to an abstract idea, say, *metamorphosis*. But that too is within the grasp of a young child who has just learned in school about the lifecycle of the butterfly.

There is a way to solve this problem now, that wasn't available when IEC was getting started. The explosion of internet imagery, and the introduction of machine-learning on massive data sets, enables the mapping of the relationships between things, images and concepts that is valuable to computational creativity researchers [94]. IEC for pictorial image generation needs a network of these conceptual connections that encodes, for instance, that images of flowers are associated with images of butterflies, leaves, and the concept of metamorphosis. This multi-dimensional map of text and imagery can be created on the fly, to be overlaid on the image space generated by IEC at each generation. So, if an image of something looking like a purple butterfly is evolved, it is pinned automatically (or human-tagged as "purple" and

"butterfly" if automatic image-classification algorithms are inadequate) to the concept map at locations "purple" and "butterfly". Then, as part of the navigation IEC facilitates, it should identify web-sourced images along the concept map branches that are pinned to concepts related to purple and butterfly. For example, a Google search for *purple butterfly* returns for me many images of purple butterflies from all angles, in many rendering styles, as well as images of jewellery, women's lingerie, leaves, flowers, a baby, a pair of sandals, a faery ... and many others. Similarly, if I perform a Google image search for *metamorphosis*, I receive countless images of butterflies and caterpillars. But also, the lifecycles of frogs and other insects, and the book cover of Kafka's text. The software doesn't always turn up inter-image relationships I can fathom. Still, even with this makeshift approach to building a concept map, Google's classification algorithm has linked these concepts, for the most part, intuitively. By following through using Google's *Related Images: View more* link, I can continue to search the space of existing images with resemblances to the images I select. Unfortunately, this only provides images already in existence. I want IEC to find new images.

Now for some sensible, but as yet untried, "coulds". The images returned from the concept map could act as targets for the IEC's image-synthesis algorithm. This could, behind the scenes, automatically evolve (or otherwise identify) images bearing visual resemblance to these, whilst maintaining the underlying representation scheme the IEC algorithm requires to define its image space. Some researchers have already tried this targeted image design [22, 25, 44]. Hopefully, the next population of images presented to the user after a purple butterfly would contain some images that are purple, various different butterfly-like shapes, maybe some images resembling flowers, and even the metamorphosis of a frog. In this way, it is easy to imagine how a user could navigate the space of related objects, even without an underlying geometrical representation that encodes for an object. There are practical issues to address in making this work (especially the algorithm speed and suitability of the results of the targeted image generation), but the benefit is the construction of a space of images related conceptually. If it could be done, this would be head-and-shoulders beyond the current IEC standard space of images that look a bit more, or a bit less, like one thing at a time.

The discussion of pictorial evolution is a familiar and convenient illustration of the problem of structuring the search space, but as already explained, creativity in image-making is not predominantly about choosing new objects to represent pictorially. However, much fun it is, it isn't transformational creativity. Hence, IEC that searches for images of different things is not, by any stretch of the imagination, sufficient to warrant the label *open-ended*. The introduction of new ideas associated with new visual styles is far more important. Using the *Related Images: View more* search function of Google described previously, it is certainly possible to traverse images of consistent visual style, for instance line drawings, abstract imagery, clip art, and photographic images. Based on even a short play, there appears to be some visual relationship between styles here that might operate within IEC analogously to the approach just described for concept-object linkage. But IEC will still require a general-purpose image synthesis algorithm to generate new styles. To demonstrate the potential for open-endedness IEC, therefore, needs to navigate the possibilities for rendering directly.

A single IEC implementation could potentially allow the evolution of a specification for geometric models, as some systems currently do, *and* it could leave out

geometric models altogether for some of the images it generates, as some other systems do. It could explore choices between rendering algorithms that operate on 3D geometric models, 2D polygonal vertex or spline-bounded areas, line or point-based primitives, and pixel-level colour and texture specification. It could mix-and-match all of these for a single image. It might even take into account movement and transformation of the rendering algorithm's own components (as well as the components being rendered) as the final image is generated in an iterative procedure. For example, after a ray-traced pass over a 3D geometric model to produce a 2D image, the pixels' intensity values might be mapped to parameters for a 2D image filter. Or pixels of a particular colour, or with particular neighbour relationships in the 2D image, might become the vertices of a polygon swept out by a Turtle-LOGO-like drawing agent marking the virtual canvas with a Reaction-Diffusion chemistry-simulating dye-leaching particle system brush! All rendering components ought to include parameters open to IEC exploration including lighting and shading models, camera models, 3D to 2D projection models and transformations, 2D image-processing techniques etc. This would indeed be a broad space with the potential to generate new visual styles and, unfortunately, a lot of rubbish! The problems encountered when structuring the search around images remain, but exploration of high-level structural features in rendering space are potentially much more capable of painting's open-endedness than the evolution of pictures of new objects.

### 12.5.3 Learning from the Bees to See Beyond the Limitations of Existing IEC

Very little is known about most species of bee. Primarily, we base our understanding of their behaviour on honeybees, bumblebees and a few other species, even though these are just a handful of the 16,000+ species [36, 98].

In a summer season, bees collectively make trillions of visits to flowers. Some species, such as *Apis mellifera*, the honeybee, may operate in colonies of many tens of thousands of individuals. This one colony of individuals works a local environment, focussing on a selection of the flowers. Other bee species in the same area may simultaneously work different species of flower. The honeybee workers and other bee foragers are tireless. Unlike humans, they are forced to visit flowers every foraging day over many months of their lives. The human operator of an IEC has an unimaginably large amount of image assessment and clicking to do to replicate the selections made by even a single bee – perhaps thousands of flowers in a day – let alone a colony. Notably, if bees drop out of their process of interactive evolution, they starve. Furthermore, if bees drop out of the process, insect-pollinated plants can't reproduce. And if that happens, not only do the current worker bees starve, so do their children, and the children of other colonies, in subsequent years. This is a level of commitment to participation not expected of even a starving human artist.

As noted previously, by one estimate there are around 310,000 animal-(not just bee)-pollinated flowering plant species [73]. What of bee-pollination specifically? How is its diversity manifest in nature? Since pioneering naturalist Sprengel's 1793 text, "Discovery of the Secret of Nature in the Structure and Fertilization of Flowers", insect-pollination ecology has been key to understanding the way organisms interact with one another. Darwin himself used flower-insect interactions to strengthen his case for evolution, especially its ability to generate new species. He makes special reference to the work of Sprengel in his own writing on orchids ([26], p. 3).

It was Sprengel, late in the 18th century, who first recognised the important role of insects, especially bees, in flowering plant reproduction. He identified the extent to which flowers and bees were interdependent, well prior to Darwin and Wallace's presentations of evolution and natural selection. His main, and correct, observations are summarised in the literature [96]. Some beautifully illustrate the diversity of floral evolution, and the extent to which it has been steered by bee's perceptual, morphological and behavioural characteristics and preferences:

- **Nectar is provided by flowering plants solely to give insects a reason to visit.** The benefit to the plant is pollination; pollen adheres to bees' (typically hairy) bodies from the flower's carefully positioned or manoeuvred anthers, and/or brushes off onto the flower's similarly carefully arranged and constructed stigma.
- The brightly **coloured corolla** (set of petals) is a visual signal directed at bees to enable them to locate flowers from a distance.
- The presence of **visually contrasting marks on petals** is designed to indicate to bees, at close range, where to gain access to the nectar.
- **Some flowers are very specialised**, permitting only a single bee species to access their nectar. For instance, by forcing them to push past barriers that require a lot of strength and size, or to fit through a narrow tunnel that only a small bee can enter, or to depress a lever that only a large bee can manage.
- **Some flowers are generalists** and can be pollinated by a wide variety of insects. From the structure and arrangement of the flower's reproductive parts, it is possible to deduce a lot about the diversity and types of insects that pollinate them.
- **Flowers provide structures to protect the nectar**, such as tiny hairs, that prevent rain drops from diluting the nectar, but which don't block insect access.
- **Some flowering species deceive insects** into thinking that they offer nectar rewards when in fact they don't. This way they can still be insect-pollinated but save themselves the resources needed to make nectar.
- **Insect-pollinated flowers can be frugal with pollen**. The approach is more reliable than wind-pollination too.
- **Some flowers do not automatically release pollen** to be brushed off, they must be manipulated in specific ways, for example they must be vibrated by a bee (e.g. buzz-pollination of tomato flowers).

The range of known insect-manipulation options developed by flowers for the 16,000+ bee species is staggering. The list previously includes just the bare basics. For a taste of the ingenious contrivances (as Darwin put it) some celebrated texts on pollination ecology can serve as overviews including, Sprengel [86], Darwin [26], or much more recently, Faegri and Pijl [38]. To ensure IEC software can replicate this novelty generation, clearly, an unfathomably large workforce, acting over an unfathomably long period of time, on an unfathomably large population of images, is desirable. But we can't do that.

The hundreds of thousands of flowering plant species present just today, far exceeds the number of historically meaningful art movements, computer graphics rendering algorithms, and published IEC implementations in total. Our human image-making workforce is too tiny to compete. Since not all professional human artists and graphic designers use IEC, our expert image-evolving style-searching workforce is miniscule also. Any software replica of the bee's process is going to need a clever

shortcut, or massive brute force computational assistance. One of the shortcuts is to allow creative individuals to code, from scratch, their own IEC implementation. But with that we aren't any closer to making IEC the kind of open-ended creative tool that this paper set out to explore. With this goal in mind, there are some other aspects of bees' interaction with flowers, quite apart from the overwhelming numbers of interactions, that have been important in governing floral diversification.

### 12.5.4 Insect-Pollinated Flowering Plants Form Part of a Community

All plants live in communities, the members of which interact with one another by sharing or competing for resources such as space, sunlight, water, nutrients, and insect visits. Species may only co-exist within a community if each finds or creates its own niche. Otherwise, competitive exclusion leads to the elimination of one species (see previously). This is an aspect of ecology that drives novelty production in flowers. Notably, niche construction and other inter-species interactions, have already been touched upon in the context of evolutionary art [68].

To replicate population-level interactions, we might build into our IEC models large populations of images that are maintained by the system at all times, even if the user doesn't usually see more than a single representative of each. Such population diversity is fundamental to the evolutionary plasticity of biological evolution – populations separate from one another in phenotype space as evolution proceeds to generate species, not individuals. But our software instead attempts to replicate this with single or few image selections made by a user from a tiny population, perhaps as small as 16 individuals. This small population size eliminates the benefits of chance action on large populations, and may not be at all desirable, even when human interaction is required [29]. The pollination-ecology model suggests that to drive diversity production we should model sets of interacting populations, not just one population of competing individuals. For instance, the IEC user might be presented with an array of 16 representations, visual indications of populations of hundreds or thousands of genetically related images. Within each population there might be a specified degree of phenotypic variation. A metric might be calculated that indicates to the user the divergence between these 16 populations, as a guide to how best to continue to generate, at the next interactive selection step, a new set of populations.

Even when considering just the development of historical artistic styles, setting aside ecological considerations, a population-driven approach seems sensible. An artistic style is not defined by a single image. As discussed previously, it emerges through observation and development of an artistic oeuvre, or collections generated by several influential artists. In art, as in flowering plants, population-density effects also provide important opportunities for niches. Some art, as some flowers, thrive by establishing trends that generate imitators. Other images stand conspicuously alone, or in small collections, setting themselves at the periphery of the mainstream but persistently maintaining themselves in an unaddressed niche.

### 12.5.5 Bees learn

To distinguish between two similar objects, a viewer must be expert at recognising the features typically subject to variation. This is difficult for humans with rich,

detailed, or abstract images but easy for us when viewing faces. If we humans scan the floral diversity exhibited by individuals of a species, we would be hard pressed, unless we were experts, to identify more than, say, a little colour variation in the petals of different flowers. As noted previously, some species mimic others, making even some inter-species distinctions difficult for humans to make.

Bees can get confused too, that is one reason floral mimicry evolves. But nevertheless, bees are excellent learners that improve their ability to identify and distinguish between flower species as they gain experience, Flower colour is an important aspect of this learning behaviour [34], but so are scents, patterns and floral structures. This ability to learn is helpful to bees in order to avoid wasting time and energy by landing on a species that is not as rewarding as another that looks similar. The bees' ability to distinguish between flower species is also important as it allows the insects to master the physical manipulation of a rewarding species, which can be quite tricky in some circumstances. This enables them, for awhile, to specialise more effectively than if they were instead a jack-of-all-trades. The tendency of a bee to go after one type of flower for a period of time is known as *flower constancy*.

From the perspective of the flower, flower constancy greatly boosts the chance that pollen will be delivered from it to a conspecific, rather than wasted on another random species. And vice-versa, it lowers the chance that one flower will receive pollen from a different species which may clog its stigma and reduce the likelihood of future pollination. Consequently, over evolutionary time periods, flowers' colour signals respond to the ability of the bees to perceive and learn. Floral designs improve the likelihood that bees will be able to learn them, they need to be recognisable to bees, and they benefit from being distinguishable (unless they are mimics) because they depend on the bees for pollination. The signals are designed by bees through the selection pressure their visits apply, but they are also designed *for* bees from the perspective of the flower's reproductive success.

To an extent, a user following a particular path through design-space is being image-constant. They are training themselves to identify the subtle, but potentially important, differences of images along a trajectory. With experience, they become more adept at recognising variation likely to result in the generation of novelty at some future stage. To see this effect a user can simply play with any IEC implementation, right back to Dawkins'. Within a short amount of time, even subtle variations in output become obvious to the user who, at the beginning, may have felt like all displayed line-drawings were alike. Quickly it becomes possible to identify variations the drawing algorithm provides, say in its initial array of tree-like structures, to travel along lineages towards snowflakes, scorpions, starfish, or elsewhere. Enhancements to the IEC interface might improve the user's ability to spot these differences. The images, like the flowers, would benefit from a way to adjust their display so as to enhance a user's perception of their differences. For example, visual projections from each current individual might be presented that radiate out into image or style-space from the current population's visual centre of mass. These would assist the user to identify potential branching off points from current styles and anticipate where they might lead. Or visual markers might be generated by the evolutionary process, and applied, for example colour to otherwise black and white illustrations such as Dawkins' software generates. These could highlight to the user the differences between images currently on display, even if these are only as small as a few pixels or a branch.

## 12.5.6 Bees remember

Bees' short-term flower memory enables them to recall the last few individual flowers they have foraged – there's no point in revisiting these flowers since the nectar has just been depleted. For longer-term efficiency, bees leave a scent-mark on each flower, a chemical trace of their visit. Other bees avoid landing on flowers that have this scent to avoid wasting time trying to glean nectar [45]. This massively improves the collective foraging efficiency of a colony, but also from the flowers' perspective, spreads bee visits across multiple flowers, increasing visits likely to improve pollination. Flowers may also signal to bees that they have been pollinated, for instance by changing colour, in order that the bees should not waste visits on them [88]. In IEC, perhaps areas of the search space might be locked off or greyed out, as if scent-marked, so that the search avoids, or has reduced probability of, re-entering previously explored areas.

## 12.5.7 Bee decision-making

Individual bees choose which flower species to visit based on past successes and failures. These choices are coupled to a bee's ability to learn (see sect 5.5). Decision-making strategies differ between individuals, even within a colony, to an extent mimicking human decision-makers in their tendencies [35]. For example, honeybees can be stubborn (or loyal, depending on your preferred terminology) in refusing to stop visiting a flower species that isn't currently rewarding, because the bee had previously learnt it was offering nectar. Or a bee may be fickle, wavering between preferences for different flower species based on recent success at nectar extraction. Or a bee may deliberate, persevering with an unrewarding flower species for a time, but only until the evidence against its value stacks up. At this point the insect may suddenly change its preference to another species.

The complexity of individual bee behaviour is reflected at colony level also. Bee colonies exhibit behaviours we typically associate with complex organisms. They are renowned for their communication using the honeybee dance language [42], and hive construction ([46], e.g. chapt. 5), and many other behaviours including thermo-regulation, collective foraging and brood-rearing for instance. When coupled to the complex decision-making going on in the field, the outcomes of the interaction between flowering plants and these social insects are exceedingly rich and subtle. Even with all of the understanding we have gleaned, the implications for floral design are difficult to predict in detail. It is practically impossible for us to imagine how a species might one day diverge into multiple species of flowering plant under the influence of bees, and how these might look or function in some possible distant future. But subtle variations are the hooks on which evolution's ratchet operates.

When we use IEC, we are expected to direct long-term novelty generation that rests on potentially tiny phenotypic details, using an assisted computational imagination lumbered with myopic vision. If we used a divergence measure, such as was indicated previously, to explore and provide (at least) one possible future direction for evolution, perhaps we may overcome this. This would make a useful crystal ball on which to base human decision-making, and enhance the capability of existing IEC systems.

## 12.5.8 Bees search collectively

Bees conduct searches, in parallel, for profitable foraging patches. Once a scout has identified a viable source of food, it returns to the hive and dances instructions to its colony [42]. The more vigourous the dance, the more workers will be recruited to visit the patch. The dance tells the recruited bees the direction and distance to the patch as well as indicating its quality. Communal explorations of a search space, such as that conducted via the PicBreeder website, are a helpful step in this direction. But a few hundred users are unlikely to accelerate exploration as much as a dedicated and tireless algorithm. IEC could mimic a community by conducting a background search that occasionally shows the users a new path or patch to consider. This needn't be only a destination, but a sequence of images leading from the current position out into image space. Somewhere along the line, if the user takes the time to look at the results of this recommender system, they may find something relevant. Recent improvements in result relevance of recommender systems for music, webpages and visual art give some hope that they could be applied now in the context of IEC where even a decade ago they struggled to provide helpful suggestions.

## 12.6 Conclusion

This chapter has covered a lot of ground: painting, and digital image synthesis; open-endedness and creativity; evolution and pollination ecology; all linked through interactive evolutionary computation. When re-examining the best-known implementations of image-synthesis with IEC, it is apparent that each produces results of only a single, programmer-specified style. Within this style each piece of interactive software permits exploratory creativity. The user can look around for interesting pictures, but transformational creativity has not yet been clearly demonstrated.

Without understating the value of individual works, the practice of painting is most evident as a continually renewed experiment with visual style. This is the defining feature that has continually resurrected it, even whilst the ideas underlying and driving image-making change, and the value or purpose ascribed to images shifts over centuries and across cultures. There are similar relationships between ideas in the much shorter history of computer graphics and the visual styles that result from their implementation. Turtle LOGO, ray tracing and fractal rendering being only three of many that have been developed. To renew IEC based on this understanding, each implementation needs to explore a range of styles, allowing its users to identify a unique set of relationships in the image-synthesis algorithm, that can represent, express or otherwise reflect, their ideas. IEC can certainly be used to search for pictures of this or that object. A suggestion was made for structuring the search space to assist by linking images directly to an internet data-derived concept map. But if that is all IEC is for then it will remain only of academic interest. It certainly isn't allowing the user to practice transformational creativity. Without assisting a user to explore new styles, IEC cannot support open-ended creativity reminiscent of that demonstrated by painting and computer graphics image synthesis algorithm design. The current IEC implementations' distinctive, unique visual styles indicate, even within this very practice, the extent to which this is true.

Pollination ecology works as a model for IEC because, as explained, bees have been evolving flowers in a process very much like the process humans use to evolve

images. Is there a sense in which it is reasonable to claim bees are "designing" the flowers they visit? The goals of individual bees are immediate rewards for themselves, or for the survival and reproduction of a colony. But evolution ensures that they are also creating the future for their as yet unborn offspring. The "plan" they are executing for floral design is not theirs alone. It is shared with the flowers they visit, and the ecosystem as a whole. If bees exclusively rob flowers of nectar without pollinating them, or if they consume too much pollen for protein, or if they squander too much pollen by spreading it between flower species, then the sustainability of the food supply of the bee's own offspring breaks down. A bee's interests are served by the foraging visits of its ancestors. The scents foragers' olfactory systems detect, the colours they choose to attend to (and the order in which they attend to them), the shapes they successfully manipulate to extract rewards, are all designed, bee visit by bee visit, with an evolutionary process as intermediary. In this sense, it is sensible to talk about design.

At face value, it seems like the sheer numbers of flowers and bees, and the millions of years over which they have been interacting, provide the answer to the seemingly open-ended divergence in flowering plant species. That will be difficult to mimic in software. To some extent, we might not need to. We can adopt features of the ecological system that have taken a hundred million years to prove their worth, and implement them directly. A few examples covered here include suggestions to evolve populations instead of individuals to establish community-level divergence as occurs in nature; to automatically calculate and visualise the potential divergence of populations and individuals in such a way as to mimic our appreciation of the multimillion year divergence of flowering plant species; to mark regions of image search space in a way analogous to how bees scent mark flowers to prevent re-examination. There are certainly many more ecological evolutionary principles that might be considered for IEC. But these few and others were provided to stimulate discussion. I think there is much more that can be done with IEC. I look forward to pushing the potential of the technique into the realm where it may indeed produce variation in human visual art to rival the spectacular diversity of flowers designed by, and for, bees.

# References

[1] Albert, R.S., Runco, M.A.: A history of research on creativity. In: R.J. Sternberg (ed.) Handbook of Creativity, book section 2, pp. 16–31. Cambridge University Press, New York (1999)

[2] Appel, A.: The notion of quantitative invisibility and the machine rendering of solids. In: ACM '67, 1967 22nd National Conference, pp. 387–393. ACM (1967 Published)

[3] Arnold, M., Cachier, H., Clottes, J., Garcia, M., Geneste, J.M., Tisnerat-Laborde, N.: Palaeolithic paintings: Evolution of prehistoric cave art. Nature 413.6855, 479 (2001)

[4] Avnir, D., Biham, O., Lidar, D., Malcai, O.: Is the geometry of nature fractal? Science 279(5347), 39–40 (1998)

[5] Bann, S., Delaroche, P.: Paul Delaroche: History Painted. Reaktion Books, London (1997)

[6] Barnsley, M.F.: Fractal modelling of real world images. In: H.O. Peitgen, D. Saupe (eds.) The Science of Fractal Images, book section 5, pp. 219–242. Springer-Verlag, New York (1988)

[7] Bedau, M.: The evolution of complexity. In: A. Barberousse, M. Morange, T. Pradeu (eds.) Mapping the Future of Biology, *Boston Studies in the Philosophy of Science*, vol. 266, book section 8, pp. 111–130. Springer (2006)

[8] Bedau, M.A., Humphreys, P.: Emergence: Contemporary Readings in Philosophy and Science. A Bradford Book (2008)

[9] Bell, J.: What is painting? Thames & Hudson, London (2017)

[10] Bentley, P.J.: Is evolution creative? In: P.J. Bentley, D. Corne (eds.) Creative Evolutionary Systems, pp. 55–62. Morgan Kaufmann (2002)

[11] Boden, M.A.: What is creativity? In: M.A. Boden (ed.) Dimensions of Creativity, book section 4, pp. 75–117. MIT Press, Cambridge, Massachusetts (1994)

[12] Boden, M.A.: Creativity and a-life. Artificial Life **21**(3), 354–365 (2015)

[13] Bown, O.: Generative and adaptive creativity: A unified approach to creativity in nature, humans and machines. In: J. McCormack, M. d'Inverno (eds.) Computers and Creativity, book section 14, pp. 361–381. Springer-Verlag, Berlin Heidelberg (2012)

[14] Briscoe, A.D., Chittka, L.: The evolution of color vision in insects. Annual Review of Entomology **46**, 471–510 (2001)

[15] Bronowski, J.: New concepts in the evolution of complexity. Synthese **21**, 228–246 (1970)

[16] Bullock, S., Bedau, M.A.: Exploring the dynamics of adaptation with evolutionary activity plots. Artificial Life **12**(2), 193–197 (2006)

[17] Chipp, H.B.: Theories of Modern Art: A source book by artists and critics. California Studies in the History of Art. University of California Press, Berkeley, California (1968)

[18] Chittka, L.: Does bee color vision predate the evolution of flower color? Naturwissenschaften **83**, 136–138 (1996)

[19] Clark, K.: The future of painting. The Listener **14**(351), 543 (1935). URL https://www.tate.org.uk/sites/default/files/styles/grid-normal-16-cols/public/images/thelistener021035coverproduction.jpg?itok=5nUm4raf

[20] Collings, M.: This is Modern Art. Seven Dials, London (2000)

[21] Colton, S., Wiggins, G.A.: Computational creativity: The final frontier. In: L.D. Raedt, C. Bessiere, D. Dubois, P. Doherty, P. Frasconi, F. Heintz, P. Lucas (eds.) ECAI 2012: 20th European Conference on Artificial Intelligence, pp. 21–26. IOS Press (2012 Published)

[22] Correia, J., Machado, P., Romero, J., Carballal, A.: Evolving figurative images using expression-based evolutionary art. In: M.L. Maher, T. Veale, R. Saunders, O. Bown (eds.) Fourth International Conference on Computational Creativity, pp. 24–31 (2013)

[23] Crane, P.R., Friis, E.M., Pedersen, K.R.: The origin and early diversification of angiosperms. Nature **374**, 27–33 (1995)

[24] Crimp, D.: The end of painting. Art World Follies **16**(October), 69–86 (1981)

[25] Dahlstedt, P.: Turn-based evolution as a proposed implementation of artistic creative process. In: H. Abbass, D. Essam, R. Sarker (eds.) 2012 IEEE Congress on Evolutionary Computation (CEC), pp. 1–7. IEEE (2012 Published)

[26] Darwin, C.: On the Various Contrivances by which British and Foreign Orchids are Fertilised by Insects, 2 edn. John Murray, London (1862)

[27] Dawkins, R.: The Blind Watchmaker. W.W. Norton & Co., New York (1987)

[28] Dawkins, R.: The evolution of evolvability. In: C. Langton (ed.) Artificial Life: proceedings of an interdisciplinary workshop on the synthesis and simulation of living systems, pp. 201–220. Addison-Wesley (1989 Published)

[29] Dorin, A.: Aesthetic selection and the stochastic basis of art, design and interactive evolutionary computation. In: C. Blum, E. Alba, A. Auger, J. Bacardit, J. Bongard, J. Branke, N. Bredeche, D. Brockhoff, F. Chicano, A. Dorin, R. Doursat, A. Ekart, T. Friedrich, M. Giacobini, M. Harman, H. Iba, C. Igel, T. Jansen, T. Kovacs, T. Kowaliw (eds.) Genetic and Evolutionary Computation Conference (GECCO 2013), pp. 311–318. ACM Press (2013 Published)

[30] Dorin, A., Korb, K.B.: Creativity refined: Bypassing the gatekeepers of appropriateness and value. In: J. McCormack, M. D'Inverno (eds.) Computers and Creativity, book section 13, pp. 339–360. Springer, Berlin (2012)

[31] Dorin, A., McCabe, J., McCormack, J., Monro, G., Whitelaw, M.: A framework for understanding generative art. Digital Creativity 23(3-4), 239–259 (2013). DOI 10.1080/14626268.2012.709940

[32] Dorin, A., McCormack, J.: First iteration: A conference on generative computational processes in the electronic arts. Leonardo 34(3), 239–242 (2001)

[33] Driessens, E., Verstappen, M.: E-volver/e-volved cultures (2006)

[34] Dyer, A., Chittka, L.: Fine colour discrimination requires differential conditioning in bumblebees. Naturwissenschaften 91, 224–227 (2004)

[35] Dyer, A., Dorin, A., Reinhardt, V., Garcia, J., Rosa, M.: Bee reverse-learning behavior and intra-colony differences: simulations based on behavioral experiments reveal benefits of diversity. Ecological Modelling 277, 119–131 (2014)

[36] Engel, M.S.: The taxonomy of recent and fossil honey bees (hymenoptera: Apidae; apis). The Journal of Hymenoptera Research 8(2), 165–196 (1999)

[37] Engel, M.S.: Aristotle's historia animalium and apis reproduction. Journal of Melittology 4, 1–3 (2013)

[38] Faegri, K., Pijl, L.V.D.: The Principles of Pollination Ecology, 3 edn. Pergamon Press, Oxford (1979)

[39] Farango, J.: (2015). URL http://www.bbc.com/culture/story/20150217-is-painting-dead

[40] Fineberg, J.: Art Since 1940: Strategies of Being, 2 edn. Laurance King, London (2000)

[41] Foley, J.D., Dam, A.v., Feiner, S.K., Hughs, J.F.: Computer Graphics Principles and Practice, 2 edn. Addison-Wesley, Reading, Massachusetts (1990)

[42] Frisch, K.v.: The Dance Language and Orientation of Bees. Harvard University Press, Cambridge, USA (1967)

[43] Gardner, M.: The fantastic combinations of john conway's new solitaire game "life". Scientific American 223, 120–123 (1970)

[44] Gircys, M., Ross, B.J.: Image evolution using 2D power spectra. Complexity 2019, 1–21 (2019). DOI https://doi.org/10.1155/2019/7293193

[45] Giurfa, M., Nez, J.A.: Honeybees mark with scent and reject recently visited flowers. Oecologia 89(1), 113–117 (1992)

[46] Gould, J.R., Gould, C.G.: Animal Architects: Building and the evolution of intelligence. Basic Books, Perseus Books Group, New York (2007)

[47] Grime, J.: Competitive exclusion in herbaceous vegetation. Nature **242**, 344–347 (1973)
[48] Hammer, M.: (2013).    URL  `https://www.tate.org.uk/research/publications/tate-papers/20/kenneth-clark-and-the-death-of-painting`
[49] Hardin, G.: The competitive exclusion principle. Science **131**(3409), 1292–1297 (1960)
[50] Henshilwood, C., d'Errico, F., Niekerk, K.L., Dayet, L., Queffelec, A., Pollarolo, L.: An abstract drawing from the 73,000-year-old levels at Blombos Cave, South Africa (2018). DOI 10.1038/s41586-018-0514-3. URL `https://www.nature.com/articles/s41586-018-0514-3`
[51] Inkpen, S.A.: 'the art itself is nature': Darwin, domestic varieties and the scientific revolution. Endeavour **38**(3-4), 246–256 (2014)
[52] Kajiya, J.T.: The rendering equation. In: SIGGRAPH'86 Proceedings of the 13th annual conference on Computer graphics and interactive techniques, pp. 143–150. ACM Press (1986 Published)
[53] Karayev, S., Trentacoste, M., Han, H., Agarwala, A., Darrell, T., Hertzmann, A., Winnemoeller, H.: Recognizing image style. In: M. Valstar, A. French, T. Pridmore (eds.) Proceedings British Machine Vision Conference, pp. 1–11. BMVA Press (2014)
[54] Korb, K.B., Dorin, A.: Evolution unbound: releasing the arrow of complexity. Biology and Philosophy **26**(3), 317–338 (2011)
[55] Kowaliw, T., Dorin, A., McCormack, J.: Promoting creative design in interactive evolutionary computation. IEEE Transactions on Evolutionary Computation **16**(4), 523–536 (2010)
[56] Langdon, W.B.: Pfeiffer – A distributed open-ended evolutionary system. In: B. Edmonds, N. Gilbert, S. Gustafson, D. Hales, N. Krasnogor (eds.) AISB'05: Social Intelligence and Interaction in Animals, Robots and Agents, Proceedings of the Joint Symposium on Socially Inspired Computing, pp. 7–13. AISB (2005 Published)
[57] Langton, C.G.: Self-reproduction in cellular automata. Physica D: Nonlinear Phenomena **10**(1-2), 135–144 (1984)
[58] Langton, C.G.: Studying artificial life with cellular automata. Physica D: Nonlinear Phenomena **22**(1-3), 120–149 (1986)
[59] Lehman, J., Stanley, K.O.: Beyond open-endedness: Quantifying impressiveness. In: C. Adami, D.M. Bryson, C. Ofria, R.T. Pennock (eds.) ALIFE 2012: The Thirteenth International Conference on the Synthesis and Simulation of Living Systems, pp. 75–82. MIT Press (2012 Published)
[60] Lieberman, H.: The TV Turtle: A Logo graphics system for raster displays. Report, MIT AI Laboratory (1976)
[61] Lieberman, H.R.: Art and science proclaim alliance in avant-garde loft. The New York Times **11**, 49 (1967)
[62] Mandelbrot, B.B.: How long is the coast of Britain? statistical self-similarity and fractional dimension. Science **156**, 636–638 (1967)
[63] Mandelbrot, B.B.: Fractals and the Geometry of Nature, pp. 168–181. Encyclopaedia Britannica (1980)
[64] Mandelbrot, B.B.: The Fractal Geometry of Nature. W.H. Freeman, New York (1983)

[65] Mandelbrot, B.B.: Fractal landscapes without creases and with rivers. In: H.O. Peitgen, D. Saupe (eds.) The Science of Fractal Images, book section Appendix A, pp. 243–258. Springer-Verlag, New York (1988)

[66] McCormack, J.: Aesthetic evolution of l-systems revisited. In: G. Raidl, S. Cagnnoni, J. Branke, D. Corne, R. Drechsler, Y. Jin, C. Johnson, P. Machado, E. Marchiori, F. Rothlauf, G. Smith, G. Squillero (eds.) Proceedings of Applications of Evolutionary Computing (Evoworkshops 2004, Evo-MUSART), vol. 3005, pp. 477–488. Springer-Verlag (2004)

[67] McCormack, J.: Facing the future: Evolutionary possibilities for human-machine creativity. In: J. Romero, P. Machado (eds.) The Art of Artificial Evolution: A Handbook on Evolutionary Art and Music, book section 19, pp. 417–451. Springer-Verlag, Berlin (2008)

[68] McCormack, J., Bown, O.: Life's what you make it: Niche construction and evolutionary art. In: M. Giacobini, A. Brabazon, S. Cagnoni, G.A.D. Caro, A. Ekrt, A.I. Esparcia-Alczar, M. Farooq, A. Fink, P. Machado (eds.) Workshops on Applications of Evolutionary Computing, EvoWorkshops, vol. LNCS 5484, pp. 528–537. Springer-Verlag (2009 Published)

[69] McShea, D.W.: Complexity and evolution: what everybody knows. Biology and Philosophy **6**(3), 303–324 (1991)

[70] Minturn, K.: Dubuffet, lvi-strauss, and the idea of art brut. Res: Anthropology and aesthetics **46**, 247–258 (2004)

[71] Mora, C., Tittensor, D.P., Adl, S., Simpson, A.G.B., Worm, B.: How many species are there on earth and in the ocean? PLOS Biology (2011). URL https://doi.org/10.1371/journal.pbio.1001127

[72] Mordvintsev, A., Olah, C., Tyka, M.: (2015). URL https://ai.googleblog.com/2015/06/inceptionism-going-deeper-into-neural.html

[73] Ollerton, J., Winfree, R., Tarrant, S.: How many flowering plants are pollinated by animals? Oikos **120**, 321–326 (2011)

[74] Papert, S.: Mindstorms: Children, Computers and Powerful Ideas. The Harvester Press, Great Britain (1980)

[75] Papert, S.: Introduction: What is logo? and who needs it? In: S. Papert (ed.) Logo Philosophy and Implementation, book section Introduction, pp. IV–XVI. MicroWorlds (1999)

[76] Peitgen, H.O., Saupe, D.: The Science of Fractal Images. Springer Verlag, New York (1988)

[77] Pellmyr, O.: Evolution of insect polination and angiosperm diversification. Trends in Ecology & Evolution **7**(2), 46–49 (1992)

[78] Reynolds, C.W.: Flocks, herds and schools: A distributed behavioural model. Proceedings of SIGGRAPH '87 **21**(4), 25–34 (1987)

[79] Rooke, S.: Eons of genetically evolved algorithmic images. In: P.J. Bentley, D.W. Corne (eds.) Creative Evolutionary Systems, book section 13, pp. 339–365. Morgan Kaufmann, San Francisco, USA (2002)

[80] Schroeder, J.E.: The artist and the brand. European Journal of Marketing **39**(11/12) (2005)

[81] Secretan, J., Beato, N., D'Ambrosio, D.B., Rodriguez, A., Campbell, A., Folsom-Kovarik, J.T., Stanley, K.O.: Picbreeder: A case study in collaborative evolutionary exploration of design space. Evolutionary Computation **19**(3), 373–403 (2011)

[82] Shenker, O.R.: Fractal geometry is not the geometry of nature. Studies in History and Philosophy of Science Part A **25**(6), 967–981 (1994)

[83] Sims, K.: Artificial evolution for computer graphics. Computer Graphics **25**(4), 319–328 (1991)

[84] Sims, K.: Evolving virtual creatures. In: SIGGRAPH '94 Proceedings of the 21st annual conference on computer graphics and interactive techniques, pp. 15–22. ACM Press, New York, NY, USA (1994)

[85] Smuts, J.C.: Holism and Evolution. Macmillan and Co., London (1927)

[86] Sprengel, C.K.: Discovery of the Secret of Nature in the Structure and Fertilization of Flowers (Das entdeckte Geheimnis der Natur im Bau und in der Befruchtung der Blumen). Friedrich Vieweg, Berlin (1793)

[87] Stanley, K., Lehman, J., Soros, L.: (2017). URL https://www.oreilly.com/ideas/open-endedness-the-last-grand-challenge-youve-never-heard-of

[88] Stead, A.: Pollination-induced flower senescence: a review. Plant Growth Regulation **11**(1), 13–20 (1992)

[89] Sun, G., Dilcher, D.L., Zheng, S., Zhou, Z.: In search of the first flower: A Jurassic angiosperm, archaefructus, from Northeast China. Science **282**, 1692–1695 (1998)

[90] Takagi, H.: Interactive evolutionary computation: Fusion of the capabilities of EC optimization and human evaluation. Proceedings of the IEEE **89**(9), 1275–1296 (2001)

[91] Tatarkiewicz, W.: A History of Six Ideas, An Essay in Aesthetics. PWN Polish Scientific Publishers, Warsaw (1980)

[92] Taylor, T., Bedau, M., Channon, A., Ackley, D., Banzhaf, W., Beslon, G., Dolson, E., Froese, T., Hickinbotham, S., Ikegami, T., McMullin, B., Packard, N., Rasmussen, S., Virgo, N., Agmon, E., Clark, E., McGregor, S., Ofria, C., Ropella, G., Spector, L., Stanley, K.O., Stanton, A., Timperley, C., Vostinar, A., Wise, M.: Open-ended evolution: Perspectives from the OEE workshop in York. Artificial Life **22**(3), 408–423 (2016)

[93] Todd, S., Latham, W.: Evolutionary Art and Computers. Academic Press, San Diego (1992)

[94] Toivonen, H., Gross, O.: Data mining and machine learning in computational creativity. Data Mining and Knowledge Discovery **5**(6), 265–275 (2015)

[95] Turk, G.: Generating textures for arbitrary surfaces using reaction-diffusion. In: SIGGRAPH 91, vol. 25, pp. 289–298. ACM (1991 Published)

[96] Vogel, S.: Christian Konrad Sprengel's theory of the flower: The cradle of floral ecology. In: D.G. Lloyd, S.C.H. Barrett (eds.) Floral Biology: Studies on Floral Evolution in Animal-Pollinated Plants, book section 2, pp. 44–62. Chapman and Hall, New York (1996)

[97] Voss, R.F.: Fractals in nature: From characterization to simulation. In: H.O. Peitgen, D. Saupe (eds.) The Science of Fractal Images, book section 1, pp. 21–70. Springer-Verlag, New York (1988)

[98] Williams, P.H.: An annotated checklist of bumble bees with an analysis of patterns of description (hymenoptera: Apidae, bombini). Bulletin Natural History Museum **67**(1), 79–152 (1998). URL http://www.nhm.ac.uk/research-curation/research/projects/bombus/subgenericlist.html

# 13

# Breaking the Black Box: Procedural Reading, Creation of Meaning, and Closure in Computational Artworks

Miguel Carvalhais

INESC TEC & Faculty of Fine Arts, University of Porto, Porto, Portugal
mcarvalhais@fba.up.pt

**Summary.** Computational artworks use computation instrumentally and promote it to a central aesthetic driver. Many computational artworks are open-ended, able to operate indefinitely and to generate seemingly infinite variations or outputs. As they often centre their poetic processes and aesthetic experiences on procedurality rather than on form, narrative, or other attributes, it may be difficult to understand how readers may create meaning and achieve closure. This chapter focuses on the processes to attain closure through a procedural reading of the black boxes found in ergodic media and the development of a Theory of the System, which allows readers to anticipate behaviours and formal developments, to build knowledge about the works, develop empathy with them, and even experience something akin to intersubjectivity. These processes are paramount to how computational artworks are experienced in a fundamentally different way from other artistic forms, and how singular and unique their aesthetic experience becomes.

## 13.1 Introduction

The widespread adoption of computational systems for cultural production and consumption had a substantial impact on artistic and aesthetic experiences. Computational technologies have expanded the number of tools and resources for creativity, reduced barriers to distribution and access, spawned a range of native media forms and opened new avenues for artistic expression and aesthetic fruition.

We often interact with computational technologies when they are used to create or augment classical media forms[1] or when they simulate or remediate them,[2]

---

[1] We will use the descriptor *classical* to refer to non-computational media forms. These include the technologies for sign creation that Lévy [42] defines as *somatic* – that "imply the effective presence, commitment, energy, and sensibility of the body for the production of signs" – and *molar* – that depend on physical media – but in some cases also those he defines as *digital*.

[2] See Galloway [31] on how computational systems can be seen to remediate mediation itself, not simply using other media as content – much as McLuhan [50] or

© Springer Nature Switzerland AG 2021
P. Machado et al. (eds.), *Artificial Intelligence and the Arts*, Computational
Synthesis and Creative Systems, https://doi.org/10.1007/978-3-030-59475-6_13

acting as their ultimate solvent[3] [32]. In these cases, procedurality[4] transforms the horizon of potential aesthetic experiences, and we are led to discover systems that are increasingly different from molar media and which become eerily similar to somatic forms in how they act and react, systems that become simultaneously natural and unpredictable to us [12, 17]. This effect is stronger when computation is at the epicentre, and we are confronted with artworks which, in spite of their multi-layered technical complexity and divergence from classical conventions and canons, predispose us to a very intimate involvement with them, so we find them at once alien, familiar, and fascinating.

## 13.2 Computational Artworks

At a time when computer systems, media, and tools are so ubiquitous,[5] perhaps computational arts should not be defined merely by the presence or usage of computers or digital media, as such an all-encompassing definition would be almost useless.[6] The presence of computational systems is not enough to define a computational artwork as such, as computation itself should be fundamental for their creation or deployment. Therefore, computational systems should not only be used to simulate or emulate other systems, with the economy of means that usually follows from that, but computation itself should be a meaningful element in the work.

A computation is any process that obeys "finitely describable rules" [65], where calculations or other processes are performed in accordance with well-defined algorithmic models [60] and achieved by "finite means"[7] [71].

To compute is to count, calculate [4], manipulate and transform information [70]. And computation may happen across many frameworks[8] [75], with digital computers

---

Bolter and Grusin [10] defined it – but rather *becoming* the medium itself, incorporating an entire medium's condition.

[3] As Murray [57] suggests, computational technologies become a single medium that is able to spawn a variety of manifestations. This idea was also at the root of Manovich's understanding of new media in *The Language of New Media* [46].

[4] "Procedurality gets its name from the function of the processor (...) [it] is the principal value of the computer, which creates meaning through the interaction of algorithms." [8]

[5] We could perhaps call this time *post-digital*, as Cramer [21] or Cascone [20] do.

[6] Several alternative terms may describe the same phenomenon of process-based art, e.g. digital art, software art, computer art, algorithmic art, rules-based art, new media art, etc. There have been several attempts to clarify this terminology, e.g. by Galanter [29], Boden and Edmonds [5], or Lopes [44]; however, they don't seem to be consensual.

[7] A decidable computation is deterministic and needs to be finite in two senses: it needs to stop eventually, and the set of rules that describe it needs to be bounded.

[8] Wolfram's *Principle of Computational Equivalence* [75] suggests that regardless of variations in underlying structures – e.g. digital computers, analogue computers, biological systems, other physical systems, etc. – certain kinds of equivalence may be found between minimally complex computations, allowing them to exhibit the same level of computational sophistication across systems.

being only one of those platforms, as computation may "take place in a variety of milieu and with almost any kind of material substrate." [32]

We should be careful to note that when we talk about computation, most often we are not describing the physical process of calculation – via sprockets, relays, switches, transistors, ants [34], *simmballs* [35], neurones, etc. – but referring to the abstraction of these processes. Regardless of how it is executed, a computation is always the same [40].

Computational artworks are therefore systems where computation is not solely used to create form by describing structure and process [48], but where it also becomes an aesthetic output of the works, sometimes a fundamental aesthetic output, their essence and *raison d'être* [38].

In spite of this, computation does not need to be enacted by the artworks themselves. Works which are deployed in classical media and are apparently non-computational can sometimes be found to have a very high *process intensity*, defined by Crawford [22] as the degree to which a system emphasises processes instead of data. Having access to a human reader[9] who is able to process information means that instead of enacting processes, an artwork may offer humans the means to deploy them by conveying the relevant code and data. Examples of such systems can be found in Raymond Queneau's *Cent mille milliards de poèmes*, Marc Saporta's *Composition No. 1* or in Masahiro Miwa's *Reverse Simulation Music*. The first two are classical books – albeit with unconventional page formats in the first case, and binding in the latter – which present readers with process descriptions and data which allow them to *run* the works by enacting the processes – rearranging verses in the first case and shuffling pages in the second. The last is a performance developed from a musical methodology that creates acoustic events from intentional human actions which replicate computational processes [66].

The definition therefore covers not only physical artefacts, with their paratexts and subtexts, but also abstract machines where processes are deployed by humans, by digital computers, or by other machines or systems able to process information (Lopes 2010). For this reason, a history of computational art precedes the adoption of computers or formal computing itself[10] and should start with the deployment of computation or algorithms in artistic practice, in the various forms they have taken over time [29, 49].

## 13.3 Subface-Surface Duality

These artefacts can be described by their physical features, using any of the systems created for classical media. But they can also, perhaps more rigorously, be described through their behaviours, using characteristics such as *dynamics, determinability, transiency, access, linking, user functions*, etc. [14] If computation is at their core,

---

[9]The human counterparts in these processes may be alternatively described as *users, interactors*, even *players*, but none of these terms adequately describes them in all the contexts addressed here.

[10]Even if these formal computing processes are not calculated in a computing machine but are e.g. manually developed by a human, as Vera Molnár did with her *machine imaginaire* [53, 55].

a level of description more focused on it is likely more effective than one which is limited to superficial features.

Furthermore, as Frieder Nake says, there is no such thing as a digital image [59], or as any digital medium, because procedural systems must always be transcoded to analogue outputs to be made perceivable by humans. This reveals a fundamental property in their nature, a condition that he describes as the *subface-surface duality*.

> We do not usually have access to the subface. It is hidden, internal to the computer or the software system. (...) In ordinary terms, we may say that the subface is the algorithm, the description of the class, the program-and-data. In the same manner of describing the situation, the surface is the image on screen, in projection, be it still or dynamic, passive or interactive. [59]

We can conceptualise all computational media as manifesting this dual-layered nature, with a computational subface linked to a surface that mediates and secludes it.[11] The subface becomes a black box, an apparatus whose inner-working are concealed [27] and which readers are only able to explore through its surface effusions. Furthermore, as we shall see, some understanding of this black box becomes indispensable for a complete aesthetic experience.

Looking further at the contrasts between classical media forms and computational media forms, we may also notice how the first are characterised by formal self-sufficiency, contingency, and simply being, for their condition of *being-in-themselves* [68]. If there is any potential for transcendence in classical artefacts, it lies within the humans who read and react to them, and not within the artefacts themselves.

Computational artefacts, on the other hand, are the nihilation of the being-in-themselves of classical forms. Where in classical artefacts we find permanence and existence, in procedural artefacts we find *being* as a medium[12] [31], we find agency, freedom to make choices, to express intent, to perform actions [32], and to sometimes very literally create themselves. Where in classical artefacts we find invariability[13] and self-containment, in computational systems we discover variability and change, we find them to be in the condition of *beings-for-themselves* [68], to have the potential for transcendence.

Much as humans, computational media are mostly subface. Much as humans, they cannot dispense with surface, and it is through it that our involvement with them starts.

---

[11] As Aarseth [1] notes, these links are arbitrary and secondary to the core processes. If we have classical media forms that exist in two or more levels, such as cinema or recorded music, we find that the secondary sign production, the transformation from the internal to the external level is "if not deterministic, then at least dominated by the material authority of the first level" [1]. In computational systems, however, that relationship is unconstrained and arbitrary. Regardless of this, the external level – Nake's *surface* – can only "be fully understood only in light of the internal" – Nake's *subface*.

[12] As Galloway puts it, the computer "is not of an ontological condition, it is on that condition. It does not facilitate or make reference to an arrangement of being, it remediates the very conditions of being itself. If I may be so crude: the medium of the computer is being." [31]

[13] Classical artefacts are often valued for invariability and restored when some variability, e.g. due to decay, starts to manifest.

## 13.4 Ergodicity

We may identify another distinguishing property of computational artefacts in Aarseth's definition of *ergodic*,[14] which is more focused on the relations that artefacts develop with human readers than on physical or technological characteristics.[15] He terms as ergodic those artefacts where readers are required to develop a "nontrivial effort" in their reading or, as he also puts it, in their *traversal*, an experience that encompasses not only reading but often also the actual construction of the text being read [54]. This traversal is a crossing of the topology of a text, during which that space is brought into being. It is an experience during which the reader effectuates "a semiotic sequence", which "is a work of physical construction that the various concepts of 'reading' do not account for." [1]

Ergodic media are characterised by the existence of an ergodic level which may be developed concurrently with other levels.

> Narratives have two levels, description and narration. A game such as football has one level, the ergodic. A video game has description (the screen icons) and ergodics (the forced succession of events) but not narration (the game may be narrated in a number of ways, but like football, narration is not part of the game). A hypertext such as *Afternoon* has all three: description ("Her face was a mirror"), narration ("I call Lolly"), and ergodics (the reader's choices). [1]

It should be noted that ergodics may be as much present in the reader's choices as in the system's or, as Galloway would put it, both in "machine actions and operator actions." [30] Once empowered by *procedurality*, computational media forms express the remaining affordances of the digital medium, and they become *participatory*, *spatial*, and *encyclopaedic* [57]. Contingent and complex behaviour is therefore possible, and almost inevitable, because both machine and operator may engage in it.

## 13.5 Open-Ended Works

One of the consequences of procedurality in media forms is the emergence of works that are open-ended and able to operate indefinitely. Infinite systems, like Borges's *Book of Sand*, have often been dreamt but have never quite been fully achieved until the advent of computational media [45]. We are, of course, using the term "infinite" quite loosely, and certainly from an anthropocentric perspective and timescale. This means that sometimes "large enough" may for all purposes be considered equivalent to "infinite", at least from the perspective of an individual reader.

---

[14]Aarseth appropriates this term from physics and mathematics, where it is used with a different meaning. He goes back to the etymological roots of the term, the Greek words *ergon* and *hodos*, meaning "work" and "path" to describe works where "nontrivial effort is required to allow the reader to traverse the text." [1]

[15]Both physical characteristics, affordances, and technological infrastructure are highly influential for these relationships, but it's their outcomes, not their presence, that are relevant to Aarseth.

Subface processes breed surface form and they may breed infinite form, behaviour, or narrative. This is beneficial for many applications, allowing for endless variation and customisation; however, when we consider the aesthetic relationship between artwork and human reader, between artist, artwork, and audience, open-ended variation may also be seen as an impediment to the close-reading of a work and the experience of closure.

We should keep in mind that even within static and intransient outputs of computational systems, there are no classical images. Rather, each of these images is an enactment of the same subface, an enactment that is only fully realised when confronted with its siblings, and that conserves a "drive towards a dynamic existence" [59].

Therefore, when thinking about the processes for developing meaning in the reading of these works, and in achieving closure in their aesthetic experience, one should perhaps not focus on their sensorial surface layer but rather on the poietic subface.

But how do readers develop meaning? And how can closure be understood in computational systems?

## 13.6 Meaning

Meaning may be constructed through a variety of processes, including semantics, semiotics, context, pattern recognition, or through the consequences of the information which is gathered.

Representation by symbolisation allows syntax to emerge, which then "governs the selection and combination of information" leading to the semantics, or "the translation of information into one or more levels or kinds of meaning". Under this perspective, we find three consecutive processes of coding: *sensing* arises from coded information; it is then coded into *meaning* and consequently to *signification*. Resulting in a "dependant hierarchy supported by information." [74]

Meaning can also be derived from differentiation between signs, as posited by Sausurrean semiotics, that ascribes meaning to signifiers only in relation (and contrast) to other signifiers [6]. These differences cannot be made manifest by themselves but need to be perceived in context, so the same information interpreted in different contexts may lead to very different outcomes and meanings [74].

If consciousness is the core feature of "our human form of intelligence" for the creation of meaning [70], it often relies on other processes, such as what Michael Shermer describes as *patternicity*, when the human brain looks for patterns in all the information it has access to and is quick to make them meaningful through *agenticity*, the infusion of those "patterns with meaning, intention, and agency." [69]

> We can't help it. Our brains evolved to connect the dots of our world into meaningful patterns that explain why things happen. These meaningful patterns become beliefs, and these beliefs shape our understanding of reality. [69]

The brain's left-hemisphere interpreter, its "storytelling apparatus" then reconstructs events, weaving them in a logical sequence that may make sense as a meaningful story.

Finally, we may also consider a Wittgensteinian perspective, under which meaning is found in the actions that any information provokes, with the meaning of a computer program to be discovered in the actions performed by the computer as it interprets it [43].

> The computer program unambiguously instructs the computer to perform a particular sequence of (...) operations. The "meaning" of a computer program is thus universal, in the sense that two computers following the same instructions will perform the same set of information-processing operations and obtain the same result. [43]

## 13.7 Closure

The sense of resolution or conclusion at the end of the aesthetic experience – indeed, the very definition of *an end* for the experience – can also be studied from several perspectives. Poetic closure is sometimes understood as a formal feature, while narrative closure is usually more content-related and associated with the psychological need for closure, our general drive for answers and aversion to ambiguity.

Even the experience of open works, according to Eco, requires a minimum level of closure [26]. Molar media such as print encouraged the sense "that what is found in a text has been finalized, has reached a state of completion" [61], to the point that closure almost came to be seen as a requirement for *good shape* [3], and as something designed into a work [37].

"Narration tends towards a gestalt" [23], with its subject in closure and fixity of the completed narrative. But procedural events are ephemeral, mobile and unfixed, and therefore tend more towards incompleteness. So, in computational media, which invite us to return to them several times, to re-enact experiences, closure can be seen as a suspect quality [37] because if understood in classical terms, it will simply identify "one 'ending' among many" [25]. This led authors such as Murray to see the refusal of closure as "at some level, a refusal to face mortality" [56], and computational media as contributing to the enactment of a denial of death.

> They offer us the chance to erase memory, to start over, to replay an event and try for a different resolution. In this respect, electronic media have the advantage of enacting a deeply comic vision of life, a vision of retrievable mistakes and open options. The never-ending, ever-morphing cyberspace narrative is a place to revel in a sense of endless transformations, but in order for electronic narrative to mature, it must be able to encompass tragedy as well. [56]

We still feel closure to be fundamental, even in computational media. We may wish to re-experience systems, re-enact narratives, replay games, be involved in multiple variations and seemingly endless formal mutations of a work, but without something akin to closure, whenever we interact with an open-ended system we will always be lost in incomprehension. We will be confronted with a seemingly infinite horizon of action [72] and, to evoke Kierkegaard, we may become *lost in the infinite*, continuously sampling different paths and actions in the system, without ever managing to develop an understanding of it [17].

Regardless of how much our media changed throughout history, our nature did not. But perhaps our understanding of closure can.

# 13.8 Closure in Computational Media

How can we achieve a sense of closure in open-ended computational works? If the surface is indefinite, perhaps infinite, then closure may not be achieved solely through it. As computation is central as a driver to generate the surface and as an end in itself – i.e. as an aesthetic value – then perhaps it may also be key to attaining closure.

Classical modes of reading, rewarding as they may be, will always be limited because they are not concerned with the subface. To face artefacts that are characterised by *procedural authorship*,[16] reading also needs to be procedural. By this we do not necessarily mean reading code – although that is sometimes possible – but rather reading as a way to understand the core processes in the subface. But this is not a simple process.

We may expect the subface to be in most cases directly unreachable by readers. To better understand its opaqueness, we may resort to Hunicke, LeBlanc and Zubek's MDA framework[17] [36], that formalises the consumption of computational systems by breaking them into three distinct components – *rules*, *system*, and *"fun"* – and consequently establishing their design counterparts – *mechanics*, *dynamics*, and *aesthetics*. MDA was developed in the context of game studies, focusing on the idea that the central content of videogames is behaviour, not the media they output. MDA connects these three layers through phenomena of emergence, establishing them as different views of the system that stand apart from each other but are causally connected, both from the designer's and from the reader's points of view.

> From the designer's perspective, the mechanics give rise to dynamic system behavior, which in turn leads to particular aesthetic experiences. From the player's perspective, aesthetics set the tone, which is born out in observable dynamics and eventually, operable mechanics. [36]

This means that the designer will have difficulty in understanding the full potential of aesthetic experiences that may result at the reader's end of the process. Similarly, a reader will be able to observe the layer of dynamics, but usually will not directly perceive that of mechanics,[18] which for them is a black box.

A second hurdle we must keep in mind when thinking about procedural reading is what we may describe as the *Eliza effect*, caused by humans' susceptibility "to read far more understanding than is warranted" [33] in the outputs of computational

---

[16]Procedural authorship is concerned with writing rules for involvement and establishing "the properties of the objects and potential objects (. . . ) and the formulas for how they will relate to one another" [56], not creating narrative or form but rather contexts from where these emerge, very often with the human reader's collaboration.

[17]MDA stands for Mechanics, Dynamics, Aesthetics.

[18]We should also note that the layer of mechanics is not the subface. Our understanding is that the subface not only encompasses the mechanics but also, at least partially, the layer of dynamics, hence, not only the code but also part of its run-time behaviour. The surface then starts at the perceivable phenomena in the dynamics layer and overlaps with the layer of aesthetics. But it does not include the totality of this layer because aesthetics includes phenomena that lay outside the systems, either in their context or in the reader's mind [19].

systems.[19] Hofstadter warns that perhaps a substantial part of the meaning and interest generated by computational systems may be derived from this, giving us false insights into the processes one is interacting with [39].

## 13.9 Procedural Reading

Reading of computational media is not only concerned with the interpretation of surface signs that we may identify as the media contents of the surface [47], or what Aarseth would call the omnipresent *interpretative function* [1]. Reading ergodic systems can be described in terms of additional functions such as the *explorative function*, in which readers are able to survey the phase space of the system and their horizon of action [72], or the *configurative function*, in which readers may affect media contents and/or the traversal functions.

Procedural reading is not only concerned with logical and lexical semantics, but also with procedural semantics [16, 17] and procedural rhetoric [7]. It is not only concerned with understanding the surface and extrapolating meaning from it but also – perhaps even more so – with understanding the subface and its consequences.

While exploring the aesthetics and dynamics layers of a system, the reader picks up on clues that will gradually allow the recognition of patterns and the development of hypothesis on causal relations and ultimately, on mechanics.

What is searched for are not low-level mechanics of a system, actual code, or particular functional models. In most cases, a detailed description of the mechanics would probably not be very useful to the reader and could even result in excessive cognitive burden. Rather, the reader seeks an intuitive understanding of the system, a set of heuristics that help predict its formal development, behaviours and outputs, and inform the reader's *horizon of intent*[20] [72]. Their goal is not the development of a model of *all* the computational processes in the work, but only of those that may be relevant from an aesthetic point of view.[21]

We may describe this as the construction of mental models of a system [6]. Mental models may approximate, sometimes even duplicate, the actual processes of a system, with their usefulness not being predicated on detailing all the aspects of the implementation model. They do not need to be correct, only useful in allowing the prediction of behaviour.

This is akin to how we build mental models of other persons' thoughts and intentions to predict and influence their behaviours, a capacity described as *theory of*

---

[19]The Eliza effect is named after Joseph Weizenbaum's ELIZA, a mid-1960s "computer program for the study of natural language communication between man and machine" [73]. ELIZA acted as a nondirective Rogerian psychotherapist, responding to textual inputs from users following a set of very basic rules for the manipulation of text. These simple "syntactic tricks convinced some people who interacted with ELIZA that the program actually understood everything that they were saying, sympathized with them, even empathized with them." (Hofstadter 1995)

[20]To grasp the "repertoire of possible steps and rhythms" with which the reader may "improvise a particular dance among the many, many possible dances the author has enabled" [56].

[21]Many of the processes in a system, perhaps the majority, are either transparent or extraneous from this point of view.

*mind* [51, 64]. We may therefore posit that the procedural reading of computational systems allows the development of a *Theory of the System* (ToS).

## 13.10 Development of a Theory of the System

A ToS is developed incrementally and iteratively, through processes of trial and error [13, 15]. When the reader is confronted with a system – regardless of its typology or the modes of interaction that may be available – they attempt to understand its functional and causal properties through the observation of the surface and the identification of significant actors, their actions and behaviours [11].

When systems present readers with explicit code, detailed pseudocode or procedural descriptions as part of the surface, their interpretation alone may be enough to develop an effective ToS. In this case, we may think of these systems as *white boxes*. But these cases are relatively rare, as most computational artworks are more often than not *black boxes*. We may find a variety of degrees of opacity and interpretability, depending on whether the systems are static or dynamic, transient or intransient, have random or controlled access, depending on their linking, the number and articulation of user functions, their autonomy, etc. Each particular system will pose different hurdles to the process of procedural interpretation.

If the reader identifies models that are previously known from other systems, they may be reused with minimal effort to understand the current context, as can any mechanics that fully or partially explain the phenomena being witnessed. If there are no readily available models, the reader may try to deduce new models, although this is a significantly more demanding process. In either case, the reader will start developing hypotheses about the mechanics, and to test these against the outputs of the system, validating or falsifying them, and thus refining or replacing them, and improving the model.

The aim of this process, which is largely developed subconsciously, is not to explain in detail the workings of the system, nor to achieve an accurate mental simulation, but rather to intuitively understand the system, creating a procedural connection and developing some empathy with its subface.

## 13.11 Consequences of Procedural Reading

A ToS will allow the anticipation of future behaviours of the system, of its formal development, and of how to act within it. It will help the reader reduce uncertainty, better understand the system's dynamics and grasp some of its mechanics, eventually achieving an experience of closure.

As the reader is not focusing on all the processes in the system but rather on what we may call its *core aesthetic processes*, we may also posit that when an effective ToS is developed, these processes will be transferred from the system to the reader's mind. They can then continue to be developed beyond the duration of the contact with the artwork. This dissemination of an artwork's procedural focus to human minds can be understood as perhaps one of the ultimate goals of computational artworks.

We may find here a parallel with conceptual art, as the main goal of both rests on the dissemination of concepts, procedures or instructions [2]. Both conceptual and computational art often focus on "exploring systems for their own intrinsic value" [28]; however in computational art the direct communication of code or processes to the reader is rare, and we rather find processes mediated by the artefacts' surfaces that embody, instantiate, and express them.[22] After the development of a ToS, the complexity of the aesthetic experience increases, as the artwork's mechanics, dynamics, and aesthetics layers are expanded by two concurrent virtual layers with which they are confronted: a layer of *simulated dynamics*, and one of *simulated mechanics*.

We may therefore also regard these systems not only as *beings-for-themselves* but already as *beings-for-others*, as they emerge from their subface processes, and direct their transient surface existence towards the minds and consciousness of humans [18].

## 13.12 Procedural Reading and Aesthetic Pleasure

We propose that the aesthetic enjoyment of computational artworks, the sense of closure, and the creation of meaning, are linked to an understanding of their subfaces.

The development of a ToS is also conducive to the experience of aporia, whenever the reader is unable to come to an effective model of the processes being witnessed, or when their hypotheses are falsified by comparison with the system. Aporia "becomes a trope, an absent pièce de résistance" but it does not lose its classical sense of the "transcendental resistance of the (absent) meaning of a difficult passage." [1]

When the hypotheses prove effective, the reader experiences epiphany, "the sudden revelation that replaces the aporia", that opens a universe of understanding and meaning. This pair of tropes is a central dynamic in this process and, although not being a narrative structure, their dialectic "constitutes a more fundamental layer of human experience, from which narratives are spun." [1]

This leads to the development of a unique type of aesthetic experience that resorts to cognitive processes that are somewhat rare in other media, particularly outside of narrative forms. By becoming *narrative games*, these media forms involve readers in anamorphosis,[23] leading them to assume unconventional stances towards the systems, ultimately relinquishing them and their media altogether, once processes are transferred to readers' minds.

## 13.13 Intersubjectivity and Computational Art

Appreciation of art is often an evaluation arising from the experience one develops with the artwork [24] and with the meaning extracted from it. Most definitions of

---

[22]It should be noted that this replication inevitably results in processes of mutation and variation. For while the developed ToS may be effective, in all cases that are not obviously simple, it will differ from the processes that are coded in the artwork.

[23]As defined by Aarseth, *anamorphosis* consists in hiding "a vital aspect of the artwork from the viewer, an aspect that may be discovered only by the difficult adoption of a nonstandard perspective." [1]

art imply a creator with intent and a reader that is able to understand meaning or significance. These establish a relation that is mediated by an artwork that carries meaning that is not intrinsic to it, i.e., that does not constitute an objective characteristic. As this meaning is usually not explicit, we cannot approach it objectively, and this focuses the fruition of art in *subjective* experience. The main strategy used in the appreciation of an artistic proposal is, therefore, the subjective inference of the subjective choices made by its author. The reader assumes the existence of a subject that freely made those choices and presumes intentionality behind them [62].

This process again resembles the development of a theory of mind and moral appreciation of other peoples' actions. We read behaviours within the framework of our own experience and feelings and try to build a model of the intentions behind them, to develop some empathy with their presumed authors.

We are therefore able to recognise different performances of the same piece as various instantiations of the same set of subjective choices by the author, or to recognise the outputs of a generative system as different instantiations of the same artwork. Because when "the subjective choices are the same, the artwork is the same, regardless of the range of different results that may emerge from the same process." [62]. Therefore, for an artwork to be attributed to a machine, and not to a human that devised the machine, it should be, at least partially, the result of subjective choices made by the machine, and not of human-chosen algorithms.

> As a human creator, that machine has to be a subject, it has to have intentions and it has to be able to make uncoerced choices in order to make art. It has to have a first-person perspective, i.e., it has to be sensible to ask "What is it like to be that machine?". [62]

Current computational systems are not subjects, as they are not endowed with general-purpose intelligence, consciousness, volition, etc. But we may consider that they develop a technological umwelt [41] and that they may be able to exercise some agency, thus being on the way "toward constituting a subject." [32]

However, due to the Eliza effect, during a procedural reading and the development of a ToS, human readers may project subjectivity towards computational systems. Beyond developing a ToS, we also project will on the systems' goals and drives, and we develop an aesthetic relation not only with their putative authors but also with the systems themselves, that we inevitably anthropomorphise as we build knowledge about them.[24]

As such, computational artworks become more than media for intersubjectivity. They become new targets for intersubjective experience, as readers hypothesise about causality, intention, and choices from the systems in ways that are not too dissimilar from those concerning human authors.

Procedural reading, and this projection of subjectivity, are fundamental aspects to how computational artworks are experienced in a fundamentally different way from classical artistic forms, and for how singular and unique their aesthetic experience becomes.

---

[24]Try as we can, we cannot think like a computational system or as another animal species [9, 58], and we build knowledge using resources that we developed as human beings, to model other human beings.

*Acknowledgement.* Thanks to André Rangel, Boris Debackere, Luísa Ribas, Mario Verdicchio, Pedro Cardoso, Pedro Tudela, Ricardo Melo, Rodrigo Hernández-Ramírez, Rosemary Lee, and Rui Penha for discussions and contributions leading to this text. This work was partially developed in the context of a fellowship at V2_ Lab for Unstable Media, Rotterdam. *FourEyes* is a research line within the project "TEC4Growth – Pervasive Intelligence, Enhancers and Proofs of Concept with Industrial Impact/NORTE-01-0145-FEDER-000020" financed by the North Portugal Regional Operational Programme (NORTE 2020), under the PORTUGAL 2020 Partnership Agreement, and through the European Regional Development Fund (ERDF).

# References

[1] Aarseth, Espen J. 1997. *Cybertext: Perspectives on Ergodic Literature.* Baltimore, MD: The Johns Hopkins University Press.

[2] Albert, Saul. 2009. Artware. In *Proud to Be Flesh: A Mute Magazine Anthology of Cultural Politics After the Net,* eds. Josephine Berry Slater, and Pauline van Mourik Broekman, 89-92. London: Mute Publishing.

[3] Alexander, Christopher. 2002. *The Nature of Order: An Essay on the Art of Building and the Nature of the Universe. Book One: The Phenomenon of Life.* Berkeley, CA: The Center for Environmental Structure.

[4] Berry, David M. 2011. *The Philosophy of Software: Code and Mediation in the Digital Age.* Basingstoke: Palgrave Macmillan.

[5] Boden, Margaret A., and Ernest A. Edmonds. 2009. What is generative art? *Digital Creativity* 20(1):21-46.

[6] Bogost, Ian. 2006. *Unit Operations: An Approach to Videogame Criticism.* Cambridge, MA: The MIT Press.

[7] Bogost, Ian. 2007. *Persuasive Games: The Expressive Power of Videogames.* Cambridge, MA: The MIT Press.

[8] Bogost, Ian. 2008. The Rhetoric of Video Games. In *The Ecology of Games: Connecting Youth, Games and Learning,* ed. Katie Salen, 117-140. Cambridge, MA: The MIT Press.

[9] Bogost, Ian. 2012. *Alien Phenomenology, or What It's Like to Be a Thing.* Minneapolis, MN: University of Minnesota Press.

[10] Bolter, Jay David, and Richard Grusin. 1999. *Remediation: Understanding New Media.* Cambridge, MA: The MIT Press.

[11] Cardoso, Pedro. 2016. *Playing in 7D: An Action-Oriented Framework for Video Games.* University of Porto.

[12] Carvalhais, Miguel. 2012. Unfolding and Unwinding, a Perspective on Generative Narrative. Paper presented at *ISEA 2012*, Albuquerque.

[13] Carvalhais, Miguel. 2013. Traversal Hermeneutics: The Emergence of Narrative in Ergodic Media. Paper presented at *xCoAx 2013*, Bergamo.

[14] Carvalhais, Miguel. 2016. *Artificial Aesthetics: Creative Practices in Computational Art and Design.* Porto: U.Porto Edições.

[15] Carvalhais, Miguel, and Pedro Cardoso. 2015a. Beyond Vicarious Interactions: From Theory of Mind to Theories of Systems in Ergodic Artefacts. Paper presented at *xCoAx 2015*, Glasgow.

[16] Carvalhais, Miguel, and Pedro Cardoso. 2015b. What Then Happens When Interaction is Not Possible: The Virtuosic Interpretation of Ergodic Artefacts. *Journal of Science and Technology of the Arts* 7 (1):55-62. doi:10.7559/citarj.v7i1.144.

[17] Carvalhais, Miguel, and Pedro Cardoso. 2017a. Creation of Meaning in Processor-Based Artefacts. Paper presented at *ISEA 2017*, Manizales.

[18] Carvalhais, Miguel, and Pedro Cardoso. 2017b. On Procedural Dissemination and Artificial Aesthetics (notes Towards a Philosophy of Computational Media). Paper presented at *Digicom*, Barcelos.

[19] Carvalhais, Miguel, and Pedro Cardoso. 2018. Empathy in the Ergodic Experience of Computational Aesthetics. Paper presented at *ISEA 2018*, Durban.

[20] Cascone, Kim. 2000. The Aesthetics of Failure: 'Post-Digital' Tendencies in Contemporary Computer Music. *Computer Music Journal* 24 (4):12-18.

[21] Cramer, Florian. 2013. What is 'Post-digital'? *A Peer-Reviewed Journal About Post-Digital Research.* http://www.aprja.net/?p=1318. Accessed 02/08/2018.

[22] Crawford, Chris. 1987. Process Intensity. *Journal of Computer Game Design.*

[23] Cubitt, Sean. 2004. *The Cinema Effect.* Cambridge, MA: The MIT Press.

[24] Dewey, John. 1934. *Art as Experience.* New York, NY: Perigee Books.

[25] Douglas, J. Yellowlees. 1994. How Do I Stop This Thing?: Closure and Indeterminacy in Interactive Narratives. In *Hyper / Text / Theory*, ed. George P. Landow, 159-188. Baltimore, MD: The Johns Hopkins University Press.

[26] Eco, Umberto. 1989. *The Open Work.* Trans. Anna Cancogni. Cambridge, MA: Harvard University Press.

[27] Flusser, Vilém. 1984. *Towards a Philosophy of Photography.* Trans. Martin Chalmers. Reaktion Books.

[28] Galanter, Philip. 2003. What is Generative Art? Complexity Theory as a Context for Art Theory. Paper presented at *Generative Art*, Milan,

[29] Galanter, Philip. 2006. Generative Art and Rules-Based Art. *Vague Terrain.*

[30] Galloway, Alexander R. 2006. *Gaming: Essays on Algorithmic Culture.* Minneapolis, MN: University of Minnesota Press.

[31] Galloway, Alexander R. 2010. The Anti-Language of New Media. *Discourse* 32 (3):276-284.

[32] Hayles, N. Katherine. 2005. *My Mother Was a Computer: Digital Subjects and Literary Texts.* Chicago, IL: The University of Chicago Press.

[33] Hofstadter, Douglas R. 1995. *Fluid Concepts and Creative Analogies: Computer Models of the Fundamental Mechanisms of Thought.* London: Allen Lane.

[34] Hofstadter, Douglas R. 1999. *Gödel, Escher, Bach: An Eternal Golden Braid. 20th anniversary edition.* London: Penguin.

[35] Hofstadter, Douglas R. 2007. *I Am A Strange Loop*. Cambridge, MA: Basic Books.

[36] Hunicke, Robin, Marc LeBlanc, and Robert Zubek. 2004. MDA: A Formal Approach to Game Design and Game Research. Paper presented at *Challenges in Games AI Workshop*, San Jose.

[37] Joyce, Michael. 1995. *Of Two Minds: Hypertext Pedagogy and Poetics*. Ann Arbor, MI: The University of Michigan Press.

[38] Kawano, Hiroshi. 1976. What is Computer Art? In *Artist and Computer*, ed. Ruth Leavitt. Morristown, NJ: Creative Computing Press.

[39] Kwastek, Katja. 2013. *Aesthetics of Interaction in Digital Art*. Trans. Niamh Warde. Cambridge, MA: The MIT Press.

[40] Lee, Edward A. 2009. *Computing Needs Time*. http://www.eecs.berkeley.edu/Pubs/TechRpts/2009/EECS-2009-30.html. Accessed 02/08/2018.

[41] Lee, Rosemary. 2018. The Limits of Algorithmic Perception: Technological Umwelt. Paper presented at *Politics of Machines: Art and After*, Copenhagen.

[42] Lévy, Pierre. 1997. *Collective Intelligence: Mankind's Emerging World in Cyberspace*. Trans. Robert Bononno. Cambridge, MA: Perseus Books.

[43] Lloyd, Seth. 2006. *Programming the Universe: A Quantum Computer Scientist Takes on the Cosmos*. London: Jonathan Cape.

[44] Lopes, Dominic McIver. 2010. *A Philosophy of Computer Art*. Oxon: Routledge.

[45] Ludovico, Alessandro. 2018. History of the Infinite Publication. Paper presented at *xCoAx 2018*, Madrid.

[46] Manovich, Lev. 2001. *The Language of New Media*. Cambridge, MA: The MIT Press.

[47] Manovich, Lev. 2013. *Software Takes Command: Extending the Language of New Media*. New York, NY: Bloomsbury Academic.

[48] Mateas, Michael. 2005. Procedural Literacy: Educating the New Media Practicioner. *On The Horizon. Special Issue: Future of Games, Simulations and Interactive Media in Learning Contexts* 13 (1).

[49] McLean, Alex, Dave Griffiths, and Ellen Harlizius-Klück. 2018. Digital Art: A Long History. Paper presented at *ICLI 2018*, Porto.

[50] McLuhan, Marshall. 1964. *Understanding Media: The Extensions of Man*. New York, NY: Routledge Classics.

[51] Metzinger, Thomas. 2009. *The Ego Tunnel: The Science of the Mind and the Myth of the Self*. New York, NY: Basic Books.

[52] Miwa, Masahiro. 2007. *Reverse Simulation Music*.

[53] Molnár, Vera. 1976. In *Artist and Computer*, ed. Ruth Leavitt. Morristown, NJ: Creative Computing Press.

[54] Montfort, Nick. 2003. *Twisty Little Passages: An Approach to Interactive Fiction*. Cambridge, MA: The MIT Press.

[55] Montfort, Nick, Patsy Baudoin, John Bell, Ian Bogost, Jeremy Douglass, Mark C. Marino, Michael Mateas, Casey Reas, Mark Sample, and Noah Vawter. 2013. *10 PRINT CHR$205.5 + RND(1); : GOTO 10*. Cambridge, MA: The MIT Press.

[56] Murray, Janet H. 1997. *Hamlet on the Holodeck: The Future of Narrative in Cyberspace*. Cambridge, MA: The MIT Press.

[57] Murray, Janet H. 2012. *Inventing the Medium: Principles of Interaction Design as a Cultural Practice.* Cambridge, MA: The MIT Press.

[58] Nagel, Thomas. 1974. What is it Like to be a Bat? *The Philosophical Review* 83 (4):435-450.

[59] Nake, Frieder. 2016. The Disappearing Masterpiece. In *xCoAx 2016: Proceedings of the fourth conference on Computation, Communication, Aesthetics, and X.* 11-26. Bergamo.

[60] Oliveira, Arlindo. 2017. *The Digital Mind: How Science is Redefining Humanity.* Cambridge, MA: The MIT Press.

[61] Ong, Walter J. 1982. *Orality and Literacy.* London: Routledge.

[62] Penha, Rui, and Miguel Carvalhais. 2018. Will Machinic Art Lay Beyond Our Ability to Understand It? Paper presented at *ISEA 2018*, Durban.

[63] Queneau, Raymond. 1961. *Cent mille milliards de poèmes.* Paris: Gallimard.

[64] Ramachandran, V.S. 2011. *The Tell-Tale Brain: A Neuroscientist's Quest for What Makes Us Human.* New York, NY: W. W. Norton & Company.

[65] Rucker, Rudy. 2005. *The Lifebox, the Seashell, and the Soul: What Gnarly Computation Taught Me About Ultimate Reality, the Meaning of Life, and How to Be Happy.* New York, NY: Thunder's Mouth Press.

[66] Sanches, Susana, and Luísa Ribas. 2016. Procedurality and Performativity: Concepts and Practices. Paper presented at *xCoAx 2016*, Bergamo.

[67] Saporta, Marc. 1962. *Composition No. 1.* Paris: Éditions du Seuil.

[68] Sartre, Jean-Paul. 1943. *Being and Nothingness.* London: Routledge.

[69] Shermer, Michael. 2011. *The Believing Brain: From Ghosts and Gods to Politics and Conspiracies – How We Construct Beliefs and Reinforce Them as Truths.* New York, NY: Times Books.

[70] Tegmark, Max. 2017. *Life 3.0: Being Human in the Age of Artificial Intelligence.* New York, NY: Alfred A. Knopf.

[71] Turing, Alan Mathison. 1936. On Computable Numbers, With an Application to the Entscheidungs Problem. *Proceedings of the London Mathematical Society* 2 (43):544-546.

[72] Upton, Brian. 2015. *The Aesthetic of Play.* Cambridge, MA: The MIT Press.

[73] Weizenbaum, Joseph. 1983. ELIZA: A Computer Program for the Study of Natural Language Communication Between Man and Machine. *Communications of the ACM* 26 (1):23-28.

[74] Wilden, Anthony. 1987. *The Rules Are No Game: The Strategy of Communication.* London: Routledge & Kegan Paul.

[75] Wolfram, Stephen. 2002. *A New Kind of Science.* Champaign, IL: Wolfram Media.

# 14

# Organism-Machine Hybrids

Jon McCormack[1] and Natalie Alima[2]

[1] SensiLab, Monash University, Monash, Australia `Jon.McCormack@monash.edu`
[2] SensiLab, Monash University, Monash, Australia `alimanatalie@gmail.com`

**Summary.** Biomimetic and designed interventions on natural developmental and growth processes are important new techniques for artists, architects and designers. This chapter presents new methods for hybridised design relationships between organism, human designers and programmable machines. We call this new approach a "biohybrid", representing a trivariate of three different intelligences: human, biological and artificial. We present a survey of current methods and classify approaches into five categories: nano-scale interventions, bio-scaffolds, fabricated host materials, tropisms and robotic augmentation. We then present a series of design experiments that use computational form-finding to create complex bio-scaffolds. The scaffolds form porous substrates that support and choreograph the development of Mycelium cultures.

## 14.1 Introduction: Designing with Nature

Many different disciplines – from Engineering through to Design and Computer Science – have drawn on nature, natural systems and processes as a rich source of ideas and inspiration. The field of Evolutionary Computing (EC), for example, inspired by biological evolution, has found many different applications in search, optimisation and learning [11]. Swarm Intelligence [6] borrows concepts from the collective behaviour of animals to create intelligent computational systems with built-in redundancy and bottom-up complexity [22].

Nature has amassed a vast array of novel systems, forms and techniques, developed and refined over 3.8 billion years of evolution. From structural innovations such as those found in pine cones – which use the varying response of layered material to control shape in response to moisture – to the complex emergent forms generated by eusocial insects, biology is a rich source of inspiration for both *how* to design and *why* we design. Biomimetic concepts such as generative growth, self-assembly, self-repair and functional adaptation have begun to be practically explored in many creative applications (see, e.g. [4, 5, 18, 26, 27]). From abstract and metaphorical interpretations to almost literal bio-mimicry, nature has served us very well.

However, this transfer of ideas, processes, methods and methodologies has been predominantly one way: nature serves as the inspiration, but the implementation

uses materials, tools and machines of and for human design and creativity. Indeed, the successes of EC algorithms or Swarm Intelligence systems relies on the fact that the mechanisms of nature can be abstracted and separated from their specific material instantiations.[3]

In this chapter we look at alternative possibilities for creative intelligences: ones that consider nature and natural processes themselves as a specific type of creative intelligence, and even more generally as computational systems [2, 33]. While this idea is not new, having received considerable attention in biology for example, it is only recently that people have begun researching how to build collaborations between machine and natural intelligences specifically for creative applications [20, 21].

By allowing an organism's natural chemical reactions and growth to co-direct the design process, natural processes can work in collaboration with digital fabrication technologies to generate complex and adaptive physical, living structures. Structures that develop and grow in response to genetic and developmental instructions [16] encoded into the material itself, allow those structures to develop, adapt and change without direct human intervention. This conceptualisation opens many possibilities. In architecture for example, rather than designing buildings to be made with concrete, steel and glass, a digitally fabricated bio-scaffold could serve as a model for directed growth of biodegradable organic matter such as Mycelium cultures. The building literally builds itself; or even more accurately: grows into itself. When the structure is no longer needed, it can decompose naturally back to the environment without the complex issues of waste management and recycling as is the case with conventional building materials.

For centuries human societies have manipulated and sought to command nature for the efficiencies of food production, shelter, fuel, medicine and clothing. While this approach, at the broadest level, has been successful for a few species, particularly our own, it has come at massive ecological and environmental cost [8]. Setting the design process around co-creation between human, machine and natural intelligences[4] – what we term *Biohybrids* – re-conceptualises the basic tenets of human design, because it brings into play additional creative agents in the design, development and building processes. Rather than mimicry of nature and natural systems, Biohybrid approaches seek to find ways to productively establish *collaborations* between human, natural and artificial designers.

## 14.2 Creating with Nature

### 14.2.1 The Organism as Programmable Builder

Many plants, animals and fungi, including rhizomes, insects and birds can be considered a type of natural 3D-Printer. They are able to build complex and robust

---

[3]This was also a key idea in fields such as Artificial Life (Alife) for example [15].

[4]Throughout this chapter we refer to 'natural and biological' intelligence as being distinct from the human. This is not to suggest that humans and human intelligence are not also biological, so 'non-human biological intelligence' should be assumed when we use the terms natural and biological in relation to intelligence.

Fig. 14.1: The organism as programmable fabricator. A young paper wasp queen *(Polistes dominula)* starting a new colony. Photo by Joaquim Alves Gaspar, Lisboa, Portugal, 2008 (CC BY-SA 3.0)

structures many times their own size and weight [1]. 'Mycelium mats' are vast fibrous weaves that grow under the ground, often the size of 40 or more football fields [32]. Species of bird build complex and 'aesthetic' nests from found materials and natural resins. Arachnids spin intricate silk webs. Wasps fabricate highly regular geometric structures simply by fashioning wood fibres and saliva (Figure 14.1). Such structures can scale up as required to accomodate different needs, such as incorporating a larder or nursery. Eusocial insects rely on 'bottom-up' emergent intelligence through local interactions with each other and their environment. These non-hierarchical (or distributed hierarchies) account for complex development without a centralised command or planning structure, and have formed the inspiration for numerous swarm-based algorithms.

However, less well understood is how to design algorithms that co-create, hybridise or affect natural processes to alter their natural growth or building patterns for design purposes. This is the critical topic of this chapter: while many natural organisms build, being able to program their building behaviour and the materials they use is what differentiates the approach described here.

Thinking of an organism as a natural fabrication machine opens many new possibilities for human design. It also raises many questions, including how nature can be programmed to fabricate structures for human purposes? If such programming is possible, what are the ethical considerations of treating living organisms as programmable 3D-printers? Humans have long exploited animals for food, clothing, labor and company. We genetically 'program' many of the Earth's species, optimising them for appearance, taste, durability, efficiency, and so on. So industrial farms of 3D printing insects for example, seem no stranger than livestock farms used for human food production.

## 14.2.2 Trivariate Co-Creation

We will examine some possibilities for hybridised approaches to co-creation between living organisms, generative computation and machines. We are interested in symbiotic approaches where, for example, digital fabrication and organic development both contribute to the design process (Figure 14.2). These approaches open up new possibilities for generative co-design, material aesthetics, sustainability and postanthropocentric creativity [28].

Fig. 14.2: Biohybrids are a new form of design at the intersection of three different intelligences: biological, human and machine

A co-creational approach to design acknowledges that multiple agents – human, artificial and natural – all play a role in the design and building process. This is in significant opposition to the predominate thinking about design as practiced and taught in most design schools, for example. The foundational idea of human design is grounded in the superiority and utility of human intelligence and creativity for human purposes: a conscious and deliberate process of decision making and knowledge that directs the creation of ideas or artefacts that are useful or valuable *to us*. Biohybrid approaches on the other hand, succeed some or most of the design intelligence from the human designer to other, non-human agents, who also determine and direct the creation process. Important considerations are those of *authorship*, *intention* and *control* [19]. Biohybrid design suggests that humans are no longer the central agent in control of a design or its purpose, so designs may serve multiple, non-human purposes specific to the other agents involved. Such considerations are not entirely new: in generative computational design somewhat similar issues arise [17], although it would be fair to say that genuine autonomy or agency in computational systems is rare, and the ease of programability of computational systems over natural biology mitigates many of the issues introduced here.

The remainder of this chapter is structured as follows. Section 14.3 presents a basic classification of approaches to working with natural organisms. Section 14.4 describes our studio experiments with digitally fabricated bio-scaffolds and Mycelium cultures and presents a series of computationally designed forms that scaffold and choreograph organism growth. Finally, Section 14.5 looks at future challenges.

## 14.3 Classification of Approaches

Before describing our own studio experiments with organism-machine hybrids, we present an overview of emerging methods and techniques. We divide our survey of nature-machine co-creation into five distinct categories:

Nano Scale       Where hybridisation occurs at the cellular or molecular level;

Bio-scaffolds       Where digitally or biologically created scaffolds form structures that direct and shape biological growth and development;

Fabricated Host       Where synthetic or digitally fabricated materials substitute for those designed by a natural host;

Tropisms       Where natural seeking behaviours can be exploited by machine interventions;

Robotic Augmentation       Where robotics is used to nurture, support or intervene with biological growth.

Below we explore each of these categories in more detail and illustrate the principles of each using example works.

### 14.3.1 Nano-Scale Interventions

Nano-scale interventions occur at the scale of the cell or collection of cells, or even at the molecular level. Basic experiments can include growing a medium in cultured environments, choreographing intricate patterns of growth that are possibly invisible to the naked eye. Such patterns can be metaphoric or inspirational for large-scale form finding techniques, but on a broader level can inform the design of micro-biomes that work at architectural scale. Functional aspects can include the decomposition of waste, filtering of toxins or harmful organisms from the environment or even the generation of energy to assist in powering buildings.

Typical work in this category can involve fabricating a parametrically designed enclosure for the living organism, forming a micro environment that supports nano-scale growth. This environment or enclosure will contain an active medium to encourage organism growth, such as agar or collagen. The form and layout of the medium can be used to control cellular growth. Additionally, morphological conditioning, such a protein diffusion gradients, can be used to trigger symmetry breaking or other developmental conditions [24], for example the coupled reaction in embryogenesis between the epithelium (a proto skin) and mesenchyme (free floating cells beneath the skin) [12].

Digital fabrication at these scales also presents an engineering challenge to deposit and manipulate bio-materials at cellular or molecular scales (kinetic diameters of between 250-600 pm for basic molecular interactions). While such printers exist, they are currently largely experimental and costly [31].

Some examples of nano-scale interventions include Ori Elisar's *Living Language* project that developed an ink based on *Paenibacillus vortex* bacteria placed in agar according to patterns of the Hebrew alphabet (https://orielisar.com) and Steve Pike's *Non Steril* which manipulated small colonies of cyanobacteria, whose growth and development were controlled by the application of 'facilitators and inhibitors' (http://syndebio.com/non-sterile/).

### 14.3.2 Bio-Scaffolds

Fig. 14.3: A Bio-scaffold 3D Printed using wood filament (left) and after inoculation with Mycelium the organism grows over the scaffold, consuming the wood component of the filament (right)

Digitally fabricated scaffolds have become an important component for tissue engineering [7]. Almost all cells in human tissues are anchorage-dependant, and hence require an extracellular matrix to support cellular growth. A common approach is to create a porous, biodegradable scaffold and much engineering research has focused on the development of fabrication technologies that employ specific kinds of biomaterials. Bio-printers often use an FDM[5]-like extruder that allows controlled release of cultured cells onto the scaffold. Applications include the growth of artificial skin and cartilage, and more advanced methods allow for printing of bio-inks (made from human induced pluripotent stem cells – iPSC) to grow neural cells, for example [13].

Bio-scaffolds represent significant opportunities beyond human or animal tissue engineering. In an orchestrated process of biodegradability, digitally fabricated, biodegradable or consumable nutrient substrates allow architects and designers to direct and control the growth of developing organisms over the substrate's form. Using 3D printers or robotic fabrication, intricate geometries can be printed using a range of commonly available materials, including wood, sugar or corn-starch.

An example of bio-scaffold design is shown in Figure 14.3. This example uses a special kind of wood-based FDM 3D Print filament that promotes Mycelium growth in specifically designed and designated areas. The scaffold is printed using a standard FDM 3D Printer and Mycelium cultures are manually placed at various locations on the scaffold. After several weeks of growth the Mycelium have grown over the surface of the scaffold and are consuming the wood-based filament used to fabricate the scaffold (Figure 14.3, right).

---

[5]Fused Deposition Modelling – a common 3D Printing technique, for details see [14].

### 14.3.3 Fabricated Host Materials

Works in this category fabricate structures that form a structural host for living organisms – often insects – creating an unnatural intervention into the organism's normal building process. For example, the artist Hubert Duprat intervened with the caddisfly larvae's propensity to build aquatic cocoons out of sediment found in river beds (the larvae's natural habitat). Duprat constructed an artificial environment for the developing larvae *(Trichoptera)*, replacing the standard sedimentary detritus with gold, precious stones and jewels (Figure 14.4). The larvae scavenge the materials, binding them together using a silk excreted from salivary glands near their mouths to build their cocoon [10]. While this work did not involve digital fabrication, it illustrates the possibilities of hijacking an organism's natural building process for human purposes.

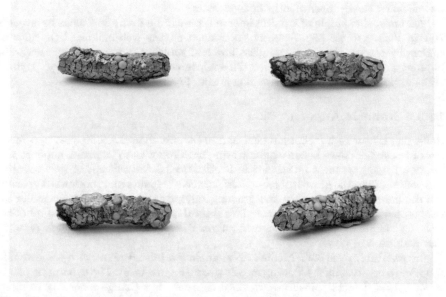

Fig. 14.4: Hurbert Duprat, *Trichoptera (caddis larva)* case, © Fabrice Gousset, 2014

Another notable work that typifies this category is the MIT Media Lab's Silk Pavilion [23]. This work used computational design methods to digitally fabricate a scaffolding envelope. After fabrication, thousands of silkworms *(Bombyx mori)* were distributed by hand over the scaffold to spin a secondary silk envelope. While the resultant form was a relatively simple geometric shape (a dome section), the computational and fabrication challenges were considerable, in part due to the lack of existing CAD tools to incorporate unpredictable biological constraints such as the conformal distance within which a silkworm can spin [23].

### 14.3.4 Tropisms

A tropism directs growth of an organism in a specific direction in response to external stimuli. Common examples are the phototropism (light seeking) and geotropism (gravity alignment) of most plants. Utilising robots to place or influence stimuli over the course of an organism's development allows programmatic and computational influence over it's final form. For example, a robot can precisely and gradually move a light source or create a shadow to influence and direct growth; similarly a robot can gradually change the orientation of a growing plant to exploit a geotropism.

As growth may often take place over months or years, robotic intervention seems ideal, since a robot never tires and can programmatically act over timescales inconvenient or impossible for human designers. Such long-term temporal interventions invite an alternative dialectic to the most common conceptions of robotics for speed and efficiency. A 'slow robotics' conception opens up less anthropocentric considerations of design and creativity, occurring at timescales often imperceptible in daily life, effecting change over months or even years.

An unusual example of tropism intervention can be found in Tomas Saraceno's *Hybrid Webs* project [29]. Saraceno intervened on the web-building behaviour of spiders by placing them inside a glass box and rotating the box during each web-building period, leading to complex silk sculptures that 'dislodge gravity'. Hybrid Webs exploits a geotropism to stunning effect (Figure 14.5).

### 14.3.5 Robotic Augmentation

Reflecting advances in robotic design and electro-mechanical components, a number of researchers have begun experimenting with robotics to augment, support and direct organic growth. As discussed in Section 14.3.4 the concept of slow robotics translates well to the growth of bio-materials, such as plants and rhizomes. Typically robotic interventions are slow and gradual, minimising energy requirements or issues of speed and efficiency that can limit typical industrial applications of robotics. Robotic components are often used to augment, enhance or give the biology additional abilities or powers.

'Elowan' from the MIT Media Lab augments a potted plant with some simple robotics to create a light following mobile plant (Figure 14.6). The cybernetic plant-robot hybrid detects "bio-electrochemical signals" that change according to light, gravity and other stimuli and a simple robotic mechanism allows the plant to move around towards, for example, more light. The system gives mobility to the immobile, augmenting the natural organism with robotic powers of motion and a new autonomy derived from the plant's electro-chemical reactions to stimuli such as light or gravity [30]. Such projects recall artistic works such as Jan Bernstein's "Ongoing" from 2010[6] or many of the biohybrid artworks of Ken Rinaldo.[7]

'BOTANICUS INTERACTICUS' introduced a technique that enabled plants to become interactive – using swept frequency capacitive sensing technology, different parts of the plant could become touch sensors [25].

The *Flora Robotica* project is an EU funded investigation to 'explore the potentials of a plant-robot society'.[8] The project focuses on 'mixed societies' of artificial

---

[6]https://vimeo.com/11134105

[7]http://www.kenrinaldo.com

[8]http://www.florarobotica.eu

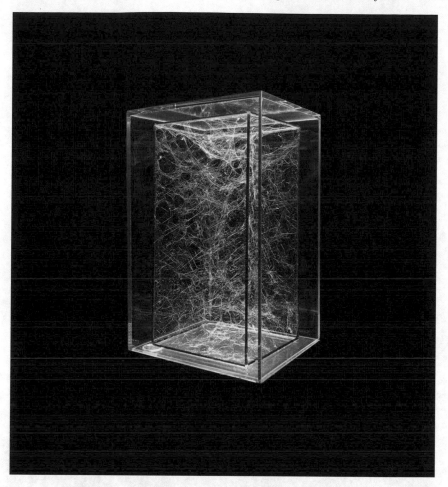

Fig. 14.5: Tomás Saraceno, *Hybrid Webs*. Esther Schipper Art Gallery, Berlin, Germany, 2012. © Photography by Andrea Rossetti, 2012

and natural organisms, using concepts based on 'Morphogenetic Engineering' [9]. The project uses robotic intervention and biohybrid approaches to augmenting and colonising plant ecosystems, often through architectural interventions.

Our own research has been looking at the planting and nurture of seeds into complex scaffolds and receptacles (Figure 14.7). Using two Universal Robots UR-3 robotic arms, we developed custom sensors and controllers to detect moisture, heat, light, etc. and for a syringe mechanism to inject nutrients, water or agar gel into large arrays of digitally fabricated material. The syringe mechanism is also used to pick up seeds and place them precisely into the structure. This allows the robots to autonomously plant seeds and nurture them as they grow to maturity without human intervention. Such experiments are the beginnings of systems that may one day be able to autonomously build, plant and grow biohybrid structures at scale,

Fig. 14.6: Elowan from the MIT Media Lab. Credit: Harpreet Sareen, CC-BY 4.0, 2018

allowing complex structures such as buildings or bridges to be fabricated on-site and to use organic growth to reinforce structure, provide natural cooling or insulation, even a supply of food as an innate part of the structure.

Fig. 14.7: Universal Robots UR-3s that work collaboratively to plant and nurture seeds in a digitally fabricated structure. Left: a robot with a customised computer-controlled electronic syringe injecting nutrients into receptacles, while the other robot supports and orientates the receptacles on a base plate. Right: Seeds in the receptacles one day after planting have just begun to sprout. © SensiLab, Monash University, 2019

## 14.4 Case Study: Mycelium Experiments

In this section we present a series of experiments that illustrate the biohybrid approach in practice. We cover details of the design approach and integration between human, robotic and natural design. In order to hack into the organism's existing chemical reactions and behavioural characteristics, a series of robotic interventions in living materials were explored. This included investigating a range of robotic techniques that orchestrate and manipulate the organism's internal chemical makeup. The organism used was Mycelium, due to its compressive structural characteristics and features, along with its ability to biodegrade through a range of fibrous moulds and host environments.

Mycelium is the collective name for vegetative fungi with characteristic mass branching growth. These long, branching filaments, known as *hyphae* are collections of one or more cells surrounded by a cellular wall. Growth occurs at the tip of each filament. For certain species the total biomass can be very large: amongst the largest living organisms known in some cases [32], where massive networks of mycelial mats form vast underground networks thousands of square meters in size. Mycelium play an important role in the decomposition of plant material and pollutants, making them important ecosystem engineers. Large mycelial mats can act as filters in an ecosystem for example.

Mycelium have a number of desirable material properties, including that they are non-toxic, fire and water resistant, good insulators, mouldable and biodegradable. The decomposition process can be exploited to direct growth of the Mycelium via the use of nutrient scaffolds. Digitally fabricated scaffolds provide a manifold for rhizome growth. As the Mycelium grows along the scaffold it decomposes and consumes the scaffold, replacing the structure with a network of fibrous growth. Growth occurs largely at the tips of the hyphae, allowing the Mycelium to spread directly over complex geometric structures as they consume the scaffold. Once the Mycelium has grown it can be rendered inactive through a simple drying process, where it retains good compressive and reasonable tensile strength.

In our experiments, a range of multi-material scaffolds were fabricated in order to examine the Mycelium's compatibility with each host environment. In these experiments we showcase a catalogue of forms and processes of rapid fabrication. This catalogue allows the materials constraints to inform the form-finding and computational process for more advanced designs.

We ran a series of small-scale experiments using Mycelium to better understand how architects and designers might work with bio-scaffolds to direct organic growth. The aim was to understand the design constraints and to develop prototype methodologies that could eventually work at larger scales. One application of this research is for architects utilising this material at a 1:1 architectural scale. However, currently lacking in the design language is expression of the symbiotic relationship and tension between computational design, robotic fabrication and living material. Through this research we are interested in how these ordinarily distinct mediums may create a new language and direct dialogue between one another. This is explored through the following methodologies:

Material Explorations    Integrations with additives and synthetic materials to improve tensile and compressive performance at larger scales.

| Design Tectonics | Experimentation with computational design tectonics to better understand the organism's growth and response to various tectonic forms. |
| Computational Simulation | Refinement of the process of digital fabrication for the inert scaffold materials and biological material. |

The following sections cover each of these processes in detail.

### 14.4.1 Material Explorations

Fig. 14.8: Catalogue of Mycelium growth under different material conditions

In order to better understand the organism's behavioural properties from a design perspective, we have experimented with a range of additive fabrication materials with the aim of improving the tensile and compressive performances of biohybrid structures. Mycelium has been shown to work excellently in compression; however, it lacks structural integrity within its tensile properties [3]. We experimented with a range of additive materials in order to improve the structural capabilities of hybrid fabrication structures. The materials used include hemp fibres, coffee grounds and sawdust (Figure 14.8). Materials are mixed together and placed in petri dishes, then kept under static environmental conditions for a fixed period (1 week). The Mycelium grows into the materials, either through consumption or fibrous binding, to form a composite final form. Each final form can then be tested for structural integrity, durability and compressive strength.

In addition to the experiments with different additives, we also experimented with different species of Mycelium, testing for growth rates, compressive strength and visual aesthetics (Figure 14.9). From these experiments it was concluded that Shiitake species had the most rapid growth and durability. Feeding different cultures into separate anchor points within the scaffold skin allows for multi-material structures to grow on a single composite form.

The ultimate aim here is to develop a design language and digital fabrication system that supports customised Mycelium extrusions which vary in material properties over a larger form or structure – using the 'material intelligence' of the different materials for variation in design or structural affect. For example areas of high tensile strength for structural integrity and more delicate flourishes that promote the fiberosity and intricacy of material growth, giving unique aesthetic properties for the final form.

Fig. 14.9: Testing different species of Mycelium for rate of growth vs. compressive strength

## 14.4.2 Design Tectonics

In order to explore and better understand this methodology of controlling the Mycelium's patterns of growth and behavioural characteristics, we undertook a parametric exploration of procedural form, using computational design tools. Each form was digitally fabricated and tested by implanting Mycelium cultures at key anchor points over the form. We examined the organism's compatibility, rates of degradation and growth for each form. As this experimentation sits at the boundary of

Fig. 14.10: Example form-finding catalogue of iterative design experiments

functional form-finding and design aesthetics, there is no fixed idea or prior research that informs the design of each form. Rather, an iterative process was used, documenting the Mycelium's reaction to each geometry, then reflecting on the successes and failures of each prototype in order to inform the design of the next iteration (Figure 14.10).

Each design was subject to a range of similar modifications, including wall thickness, skin pore ratios and geometries. This resulted in a design catalogue of forms which are not only derived from the Mycelium's compatibility but also evolve in complexity and detail.

We began with a series of form-finding experiments using conventional digital and generative design tools. We arrived at a series of complex, organic forms (Figure 14.11) deemed suitable as bio-scaffolds. Each form was then 3D printed using a wood-based PLA filament, composed of around 20% sawdust, sourced from waste.

Once the scaffold has been fabricated, liquid culture Mycelium are injected into the scaffold substrate at specific points and healthy Mycelium starts spreading quickly. In the initial experiments we used manual injection, but for larger scale this process could be undertaken by robot (Figure 14.7) as a post-printing process or integrated into the digital fabrication of the scaffold itself using a multi-material printer. This level of automation is something we are currently exploring.

Growth of the Mycelium proceeds over several days and weeks. In contrast to the precision and accuracy of digital design, organic growth is non-uniform, imprecise and influenced by environmental or other conditional changes. We have found it necessary to maintain a relatively high degree of relative humidity and a temperature of around 24 degrees Celsius in order to best promote Mycelium growth,

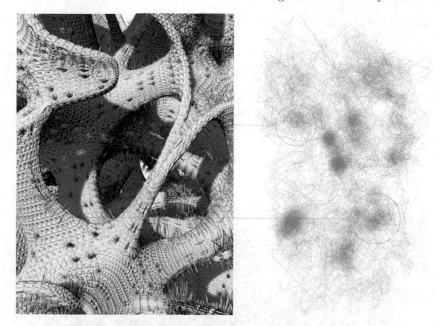

Fig. 14.11: Inserting different Mycelium species at specific anchor points (shown inside the blue circles) over a computationally designed form. Different species can be used for complimentary purposes, such as aesthetics or structural properties

although the organism is tolerant to a range of environmental conditions. Working with living materials (as opposed to static industrials ones such as glass and concrete) requires a whole new set of design restraints and architectural tectonics. Therefore, an alternative model for the generation of form is needed.

### 14.4.3 Computational Simulation

Working with living materials requires a new approach to design. Dynamic materials that grow and adapt to their natural environment are fundamentally different than human or machine fabricated materials, but we can still effectively use computational tools to support the design process.

As part of this new design approach we need to computationally capture the Mycelium's growth characteristics in order to generate suitable host environments that are designed first in simulation, then built and tested in final physical form. Simulation has the advantage of being able to test a vast number of possibilities that would be impossible to implement practically due to the long growth times of most biological organisms, reducing the time and material cost of biohybrid design.

We used simulation software that varies the geometrical and physical properties of a given material according to environmental parametric data informed by the user. The environmental inputs include Mycelium, oxygen, moisture content and temperature. The simulation includes additive materials and the quantity and location of

Mycelium inserted with the scaffolds and location. Models have been developed for several different species of Mycelium.

Simulations provide a catalogue of growth iterations. Based on simulation results we can then develop the most promising simulations in physical form, thus creating a co-creational design approach between organism, simulation and designer. A key concept in this process involves favouring material considerations over geometric expression as supporting and promoting organism growth becomes the most important design consideration.

### 14.4.4 Results

Fig. 14.12: Prototype designs with Mycelium cultures, computational design and digital fabrication

Figure 14.12 shows some results of this process. A bio-scaffold, developed first using simulation, is 3D printed into a material form and then inoculated with Mycelium. The figure shows growth after several weeks. Our standard approach is to fabricate several copies of the scaffold to allow for differences in Mycelium growth. After several weeks the Mycelium consume much of the scaffold, leaving the biomaterial following the shape of the scaffold.

The final form can then be treated to give extra structural integrity and make the structure suitable as an architectural construct, for example. Our experiments are ongoing and a major challenge is automating the placement and nurture of Mycelium growth through robotic intervention. Here, a robot looks at environmental conditions, organism growth and design tectonics, optimising all of these considerations and intervening where appropriate to support both the growth and design considerations. As growth takes place over weeks or even months, robots are perfectly placed for this slow, sustained intervention.

## 14.5 Conclusions

After many decades of research in engineering and computing where we borrowed from nature or sought to mimic it, research is now shifting to look at how we might

hybridise computation and biology for the purposes of designing co-creational systems. We have presented a series of strategies for using organism and digital fabrication in a hybridised co-design that acknowledges the different design contributions of human, biology and machine. While the developments are in their early stages, we believe the techniques outlined here have much potential as rich design strategies for architecture and design at scale. A major challenge remains to upscale working prototypes from the scientific micro to the architectural macro. Research is really very much in its infancy. Current approaches have appropriated robotics and digital fabrication hardware that was built for other purposes and designed for different materials. This makes current industrial robotic technology ill-suited for working in collaboration with biology. A big challenge for engineering is to design new kinds of robotic systems that symbiotically work with natural organisms, ultimately perhaps integrating together as cyber-physical systems.

Another key challenge remains how to integrate three intelligences (human, organism, and machine) that are all different, with different goals, purposes and kinds of intelligence for operating in the world. This remains a somewhat speculative and open challenge. However, the potential of biohybrid approaches are rich and numerous. Being able to sustainably collaborate with biological growth for the purposes of art and design is an open and largely unexplored research agenda, but rapidly becoming important as we seek to address our ecological and climate crises. To better understanding of artificial and natural intelligences, the biohybrid approach allows us to work respectfully with nature on genuinely sustainable and equal terms, something completely new in the history of human design.

*Acknowledgement.* Jon McCormack was supported by an Australian Research Council Future Fellowship grant FT170100033. Natalie Alima was supported by an ANAT Synapse Fellowship. The Robotic Syringe hardware and software was developed at SensiLab, Monash University by Paolo Alborghetti, Camilo Cruz, Jon McCormack and Elliott Wilson.

# References

[1] Arndt, I., Tautz, J.: Animal Architecture. Harry N. Abrams, New York, NY, USA (2014)

[2] Ball, P.: The self-made tapestry: pattern formation in nature. 287. Oxford University Press, Oxford (2001)

[3] Bellettini, M.B., Fiorda, F.A., Maieves, H.A., Teixeira, G.L., Àvila, S., Hornung, P.S., Júnior, A.M., Ribani, R.H.: Factors affecting mushroom pleurotus spp. Saudi Journal of Biological Sciences (2016). DOI http://dx.doi.org/10.1016/j.sjbs.2016.12.005

[4] Bentley, P.J.: Evolutionary design by computers. Morgan Kaufmann Publishers, San Francisco, Calif. (1999)

[5] Bentley, P.J., Corne, D.W. (eds.): Creative Evolutionary Systems. Academic Press, London (2002)

[6] Bonabeau, E., Theraulaz, G., Dorigo, M.: Swarm intelligence: from natural to artificial intelligence. xii, 307. Oxford University Press, New York (1999)

[7] Chan, B.P., Leong, K.W.: Scaffolding in tissue engineering: general approaches and tissue-specific considerations. European Spine Journal **17**(4), 467–479 (2008)

[8] Core Writing Team, Pachauri, R., Meyer, L.: Climate change 2014: Synthesis report. Contribution of Working Groups I, II and III to the Fifth Assessment Report of the Intergovernmental Panel on Climate Change, IPCC (2014)

[9] Doursat, R., Sayama, H., Michel, O.: Morphogenetic engineering: Reconciling self-organization and architecture. In: R. Doursat, H. Sayama, O. Michel (eds.) Morphogenetic Engineering: Toward Programmable Complex Systems. Springer-Verlag, Berlin Heidelberg (2012)

[10] Duprat, H., Besson, C.: The wonderful caddis worm: Sculptural work in collaboration with trichoptera. Leonardo **31**, 173–182 (1998). URL http://mitpress2.mit.edu/e-journals/Leonardo/isast/articles/duprat/duprat.html

[11] Eiben, A.E., Smith, J.E.: Introduction to Evolutionary Computing. Natural Computing Series. Springer (2003)

[12] Gilbert, S.F., Epel, D.: Ecological Developmental Biology: Integrating Epigenetics, Medicine, and Evolution. Sinauer Associates, Inc., Sunderland, MA, USA (2009)

[13] Gu, Q., Tomaskovic-Crook, E., Wallace, G.G., Crook, J.M.: 3D bioprinting human induced pluripotent stem cell constructs for in situ cell proliferation and successive multilineage differentiation. Advanced healthcare materials **6**(17), 1700,175 (2017)

[14] Harwood, B., Schöffer, F., Garret, B.: The 3D Printing Handbook. 3D Hubs B.V., The Netherlands (2018)

[15] Langton, C.G.: Artificial life: an overview. Complex adaptive systems. MIT Press, Cambridge, Mass. (1995)

[16] McCormack, J.: A developmental model for generative media. In: M. Capcarrere, A.A. Freitas, P.J. Bentley, C.G. Johnson, J. Timmis (eds.) Advances in Artificial Life (8th European Conference, ECAL 2005), vol. LNAI 3630, pp. 88–97. Springer-Verlag, Berlin; Heidelberg (2005)

[17] McCormack, J.: Working with generative systems: an artistic perspective. In: J. Bowen, N. Lambert, G. Diprose (eds.) Electronic Visualisation and the Arts

(EVA 2017), Electronic Workshops in Computing (eWiC), pp. 213–218. BCS Learning and Development Ltd., London (2017)

[18] McCormack, J., Eldridge, A.C., Dorin, A., McIlwain, P.: Generative algorithms for making music: Emergence, evolution, and ecosystems. In: R.T. Dean (ed.) The Oxford Handbook of Computer Music, pp. 354–379. Oxford University Press, New York; Oxford (2009)

[19] McCormack, J., Gifford, T., Hutchings, P.: Autonomy, authenticity, authorship and intention in computer generated art. Lecture Notes in Computer Science pp. 35–50 (2019). DOI 10.1007/978-3-030-16667-0\_3. URL http://dx.doi.org/10.1007/978-3-030-16667-0_3

[20] Myers, W.: Bio Design: Nature • Science • Creativity, 1st edn. Thames & Hudson, London, UK (2012)

[21] Myers, W.: Bio Art: Altered Realities. Thames & Hudson, London, UK (2015)

[22] Nehaniv, C.L., Rhodes, J.L.: The evolution and understanding of hierarchical complexity in biology from an algebraic perspective. Artificial Life **6**, 45–68 (2000)

[23] Oxman, N., Laucks, J., Kayser, M., Duro-Royo, J., Uribe, C.D.G.: Silk pavilion: A case study in fiber-based digital fabrication. In: F. Gramazio, M. Kohler, S.L. enber (eds.) Fabricate: Negotiating Design & Making, pp. 249–255. gta Verlag, Zurich (2014)

[24] Porter, B., McCormack, J.: Developmental modelling with SDS. Computers & Graphics **34**(4), 294–303 (2010)

[25] Poupyrev, I., Schoessler, P., Loh, J., Sato, M.: Botanicus interacticus: Interactive plants technology. In: ACM SIGGRAPH 2012 Emerging Technologies, p. 4. ACM, New York (2012)

[26] Reas, C., McWilliams, C., LUST: Form+Code in Design, Art, and Architecture. Princeton Architectural Press, Inc. (2010). URL http://formandcode.com/

[27] Romero, J., Machado, P. (eds.): The Art of Artificial Evolution: A Handbook on Evolutionary Art and Music. Natural Computing Series. Springer (2008)

[28] Roudavski, S., McCormack, J.: Post-anthropcentric creativity. Digital Creativity **27**(1), 3–6 (2016)

[29] Saracento, T.: Hybrid webs. URL https://studiotomassaraceno.org/hybrid-webs/

[30] Sareen, H., Maes, P.: Elowan: A plant-robot hybrid (2019). URL https://www.media.mit.edu/projects/elowan-a-plant-robot-hybrid/overview/

[31] Service, R.F.: The synthesis machine. Science **347**(6227), 1190–1193 (2015)

[32] Stamets, P.: Mycelium Running: How Mushrooms Can Help Save the World. Ten Speed Press, Berkeley, California (2005)

[33] Zenil, H. (ed.): A Computable Universe: Understanding and Exploring Nature as Computation. World Scientific, Singapore (2013)

Printed in the United States
by Baker & Taylor Publisher Services